# AutoCAD® 2009 for Interior Design
## A 3D Modeling Approach

## Zane D. Curry, Ph.D.

PEARSON

Prentice
Hall

Upper Saddle River, New Jersey
Columbus, Ohio

Library of Congress Control Number: 2008923139

**Editor in Chief:** Vernon Anthony
**Acquisitions Editor:** Jill Jones-Renger
**Editorial Assistant:** Doug Greive
**Production Coordination:** Karen Fortgang, bookworks publishing services
**Project Manager:** Louise Sette
**AV Project Manager:** Janet Portisch
**Operations Supervisor:** Deidra Schwartz
**Art Director:** Diane Ernsberger
**Cover Designer:** Michael J. Fruhbeis
**Cover image:** Super Stock
**Director of Marketing:** David Gesell
**Senior Marketing Coordinator:** Alicia Dysert
**Copyeditor:** Marianne L'Abbate

This book was set in Times New Roman by Aptara, Inc. and was printed and bound by Bind-Rite Graphics. The cover was printed by Coral Graphic Services.

Certain images and materials contained in this publication were reproduced with the permission of Autodesk, Inc., © 2008. All rights reserved. Autodesk and AutoCAD are registered trademarks of Autodesk, Inc., in the U.S.A. and certain other countries.

**Disclaimer:**
This publication is designed to provide tutorial information about AutoCAD® and/or other Autodesk computer programs. Every effort has been made to make this publication complete and as accurate as possible. The reader is expressly cautioned to use any and all precautions necessary, and to take appropriate steps to avoid hazards, when engaging in the activities described herein.

Neither the author nor the publisher makes any representations or warranties of any kind, with respect to the materials set forth in this publication, express or implied, including without limitation any warranties of fitness for a particular purpose or merchantability. Nor shall the author or the publisher be liable for any special, consequential, or exemplary damages resulting, in whole or in part, directly or indirectly, from the reader's use of, or reliance upon, this material or subsequent revisions of this material.

Pearson Education Ltd., London
Pearson Education Singapore Pte. Ltd.
Pearson Education Canada, Inc.
Pearson Education—Japan
Pearson Education Australia Pty. Limited
Pearson Education North Asia Ltd., Hong Kong
Pearson Educación de Mexico, S.A. de C.V.
Pearson Education Malaysia Pte. Ltd.

10 9 8 7 6 5 4 3 2 1
ISBN-13: 978-0-13-234276-6
ISBN-10:  0-13-234276-6

To my wife Danna. She has always been, is, and will always be my inspiration.

To my children and grandchildren: Bruce, Rachel, Kaitlyn, and Curry Lehman; Reed and Rebekah Filley; Ryan and Erica Curry; and the grandchildren who are yet to be.

To the students I have had the pleasure of knowing, teaching, and learning from over the past twenty years.

# THE NEW AUTODESK DESIGN INSTITUTE PRESS SERIES

Pearson/Prentice Hall has formed an alliance with Autodesk® to develop textbooks and other course materials that address the skills, methodology, and learning pedagogy for the industries that are supported by the Autodesk® Design Institute (ADI) software products. The Autodesk Design Institute is a comprehensive software program that assists educators in teaching technological design.

## Features of the Autodesk Design Institute Press Series

**JOB SKILLS**—Coverage of computer-aided drafting job skills, compiled through research of industry associations, job websites, college course descriptions, and The Occupational Information Network database, has been integrated throughout the ADI Press books.

**PROFESSIONAL** and **INDUSTRY ASSOCIATION INVOLVEMENT**—These books are written in consultation with and reviewed by professional associations to ensure that they meet the needs of industry employers.

**AUTODESK LEARNING LICENSES AVAILABLE**—Many students ask how they can get a copy of the AutoCAD® software for their home computer. Through a recent agreement with Autodesk®, Prentice Hall now offers the option of purchasing textbooks with either a 180-day or a 1-year student software license agreement for AutoCAD. This provides adequate time for a student to complete all the activities in the book. The software is functionally identical to the professional license, but is intended for student personal use only. It is not for professional use.

Learning licenses may be purchased only by ordering a special textbook package ISBN. Instructors should contact their local Pearson Professional and Career sales representative. For the name and number of your sales representative, please contact Pearson Faculty Services at 1-800-526-0485.

# FEATURES OF *AUTOCAD*® 2009 FOR *INTERIOR DESIGN:* A 3D *MODELING APPROACH*

This text presents a three-dimensional modeling approach to using AutoCAD. It illustrates advances in technology and software evolution and introduces commands and processes that reflect a contemporary, efficient use of AutoCAD 2009. Features include:

A "Quick Start" chapter near the beginning of the book that introduces users to the basic commands, concepts, and processes used in three-dimensional modeling. Topics and concepts in Chapter 3, "Quick Start: Learning the Basics" are illustrated so that users gain a basic understanding of the commands and processes used. Commands and processes used in this chapter are used with other commands in subsequent chapters to produce elaborate models.

Chapter Objectives, a bulleted list of learning objectives for each chapter, provide users with the commands and processes illustrated in the chapter.

Key Terms are bold and italic within the running text, and they are briefly defined in the margin. Key terms help students understand the language of computer-aided drafting.

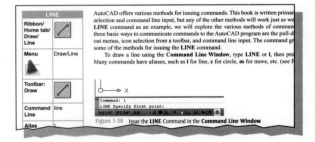

Command Grids appear in the margin, alongside the discussion of the command. These grids provide a visual of the various ways commands can be invoked using the **Menu Browser**, **Toolbar**, **Pull-Down Menu**, **Command Line**, or **Command Alias**, thus ensuring that the student knows multiple methods for invoking commands.

**End-of-Chapter** material, easily located by the shading on the page edges, provides chapter exercises, a summary, and chapter test questions to help students check their own understanding of chapter concepts and processes.

TIP    The format for entering **POLAR COORDINATES** is *@distance<angle*.

## METHODS FOR OBTAINING HELP

The AutoCAD program contains numerous methods for obtaining help. The **F1** function key retrieves the **Help** screen. The **Help** screen allows users to find help by looking at the index or the contents, or by using the search feature. AutoCAD 2009 has improved tooltips, which provide more information as you need it. Tooltips are automatically displayed as you move the cursor over tool icons. The tooltip not only displays the tool name, it also provides additional command-related information (see Figure 1-43), and after a few seconds, it displays graphic help and/or instructions pertaining to the selected command process (see Figure 1-44).

**Tip** and **Note** boxes highlight additional helpful information for the student. Such information may contain dos and don'ts, facts, warnings, and alternative ways of proceeding, as well as cross-references to other chapters and topics.

## METHODS FOR OBTAINING HELP

The AutoCAD program contains numerous methods for obtaining help. The **F1** function key retrieves the **Help** screen. The **Help** screen allows users to find help by looking at the index or the contents, or by using the search feature. AutoCAD 2009 has improved tooltips, which provide more information as you need it. Tooltips are automatically displayed as you move the cursor over tool icons. The tooltip not only displays the tool name, it also provides additional command-related information (see Figure 1-43), and after a few seconds, it displays graphic help and/or instructions pertaining to the selected command process (see Figure 1-44).

You can also access the **Help** menu from the **Menu Browser** (see Figure 1-24). The **Info Center**, located in the upper right corner of the AutoCAD window, contains a search feature window that allows you quick access for help.

GRIDLINE SET IN 1ST PP TO INDICATE SAFE AREA. TO BE REMOVED AFTER 1ST PP.

**New to AutoCAD 2009** icons indicate the commands and tools that are new to the program. This feature allows instructors and other users to quickly identify topics that are completely new, saving them a good amount of research time. It also demonstrates to students the recent improvements to the AutoCAD software, as well as the valuable updated information contained in this textbook.

## INSTRUCTOR RESOURCES

The Online Instructor's Manual provides answers to unit exercises and tests and solutions to end-of-chapter problems; drawing files to get learners started; and lecture-supporting PowerPoint® slides.

To access supplementary materials online, instructors need to request an instructor access code. Go to **www.pearsonhighered.com/irc**, where you can register for an instructor access code. Within 48 hours after registering, you will receive a confirming e-mail, including an instructor access code. Once you have received your code, go to the site and log on for full instructions on downloading the materials you wish to use.

# Preface

Computers are an integral part of the business of interior design. They contribute to the efficiency of design, specification writing, cost estimating and analysis, and record keeping. Computer-aided drafting, design, modeling, and presentation skills are in high demand in the interior design industry. It is imperative that students are able to use CAD effectively as entry-level employees so that they are competitive in their search for employment. AutoCAD has been—and continues to be—the industry standard in graphic communication for interior design and allied disciplines. AutoCAD enables individuals to create designs, visualize ideas, produce construction documents, and share design information across extended fields.

*AutoCAD® 2009 for Interior Design: A 3D Modeling Approach* develops interior design students' three-dimensional modeling skills using AutoCAD. Designed as a tutorial-based text, it utilizes the **Menu Browser**, **Ribbon**, toolbars, palettes, command line input, and icons, in primarily the prompt-response format. This easy-to-follow manual allows students to learn commands, concepts, and processes necessary for creating three-dimensional models of interior components and spaces. The beginning chapter introduces students to the latest AutoCAD features, screen layout, menu structures, and commands.

Chapter 2 provides an overview of basic drawing setup, followed by a discussion of basic concepts of three-dimensional solid modeling. The objects included in the chapter exercises increase in degree of difficulty, and so does the level of complexity of concepts and processes, which allows students to understand and construct complex composite solid models. The book includes a four-part chapter (Chapter 13) about working with soft goods such as draperies and tablecloths produced with surface modeling techniques. Chapter 15, the concluding chapter, provides students with an introduction to rendering interior environments and producing walk-through animations. Chapter 15 also introduces **SteeringWheels** and **ViewCube**, which are new features of AutoCAD 2009.

The primary objective of this book is not just to produce drawings of specific objects. The student will also gain an understanding of the concepts and processes used in the production of the objects completed in the text and to be able to apply these concepts and processes to future projects.

## Acknowledgments

I would like to thank the following reviewers:

Scott Anthony Boudreau, Joliet Junior College

Jean P. Freeman, Marymount University

Stephen Huff, Highpoint University

Rosemary Peggram, Texas Tech University

Lara Michele Pitrolo, West Virginia University

Elizabeth Pober, University of Oklahoma

Haroon Sattar, University of Arkansas

Megan M. Shaw, University of Kentucky

Robert C. South, Ball State University

Finally, I would like to thank Autodesk, Inc.

| Text Elements | Example |
|---|---|
| **Key terms**—Bold and italic on first mention (first letter lowercase) in the body of the text. Brief glossary definition in margin following first mention. | These settings are stored in ***drawing template*** files. |
| **AutoCAD commands**—Bold and upper-case. | Start the **LINE** command. |
| **Toolbar names, menu items, and dialog box names**—Bold and follow capitalization conventions in AutoCAD toolbar or pull-down menu (generally first letter capitalized). | The **Layer Manager** dialog box<br><br>The **File** pull-down menu |
| **Toolbar buttons and dialog box controls/buttons/input items**—Bold and follow capitalization convention of the name of the item or the name shown in the Auto-CAD tooltip. | Choose the **Line** tool from the **Draw** toolbar.<br><br>Click the **Open** drawing icon on the **Quick Access** toolbar<br><br>Choose the **New Layer** button in the **Layer Properties Manager** dialog box. |
| **AutoCAD prompts**—Dynamic input prompts are italic. Command window prompts use a different font (Courier New) and are boldface. This makes them look like the text in the command window. Prompts follow capitalization convention in AutoCAD prompt (generally first letter capitalized). | AutoCAD prompts you to *Specify first point:*<br><br>**Specify center point for circle or [3P/2P/Ttr (tan tan radius)]:** |
| **Keyboard input**—Bold with special keys in brackets (explanations in lowercase italic in parentheses). | Type: **3.5 <Enter ↵>**<br><br>Type: **l** *(last)* **<Enter ↵>**<br><br>Type: **C <Enter ↵>** *(to close the polyline)* |

# Contents

# Introduction to AutoCAD 2009

**1**

## Chapter Objectives

- Open AutoCAD
- Learn the AutoCAD layout and screen features
- Explore AutoCAD **Ribbon**, **Menu Browser**, menus, palettes, and toolbars
- Learn various methods of command input

## INTRODUCTION

In this chapter, we will open the AutoCAD program and begin to gain an understanding of the drawing screen components and features. We will explore the menus, palettes, toolbars, and methods for obtaining help. Throughout the book, the chapter tutorials and exercises will introduce commands.

Making the transition from 2D drafting to 3D modeling does not have to be a difficult process. Steps in the process include learning and understanding a variety of terms, commands, and variables; developing mental/visualization skills; and "learning how things are put together." In 2D drafting, the 3D properties of an object are translated into flat 2D views. In 3D modeling, all three dimensions are taken into account. Solid modeling is the culmination of the model-building options. In solid modeling, you work with three-dimensional solids that have mass and density. Complex solid models can be made by adding one solid to another, subtracting one solid from another, and/or determining the common mass between solids.

Start the AutoCAD program either by double-clicking the **AutoCAD 2009** icon  on the desktop or by selecting the **Windows Start** menu, then **Programs**, then **AutoCAD 2009**. AutoCAD starts with a blank drawing, which is based on a number of AutoCAD settings. These settings are stored in *drawing template* files.

After the AutoCAD program loads, the first screen you see should appear similar to Figure 1-1.

If you have AutoCAD open and you would like to start a new drawing, click on **File**, then **New** (or by using one of the other methods illustrated in the **New Drawing** command grid).

The **Select Template** dialog box appears (see Figure 1-2). If you want the drawing screen similar to Figure 1-1, open the **acad.dwt** template file. You can use one of the template files supplied with the AutoCAD program or create your own.

> **Note:**
> **Drawing template** files are a starting point for creating new drawings. AutoCAD provides a number of predefined template files from which to choose; typically they contain title blocks and predefined settings for text, dimensioning, and plotting.

> **Note:**
> Beginning a new drawing using a template file does not change the template file, unless you save the new drawing file as a **.dwt** file.

| NEW DRAWING | |
|---|---|
| Ribbon/ Standard tab/New Drawing | |
| Menu | File/New |
| Command Line | new *or* CTRL + N |

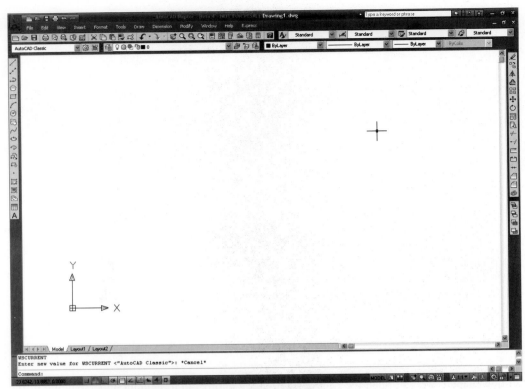

Figure 1-1    Drawing Screen Using **AutoCAD Classic** Workspace

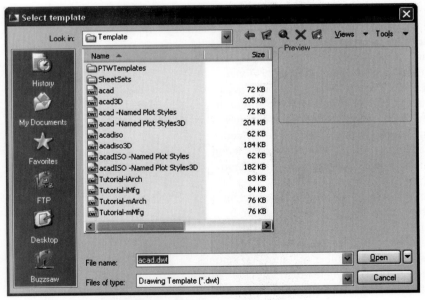

Figure 1-2    **Select Template** Dialog Box

The next time that you want to work on a drawing once you have worked on it, saved it, and closed the program, you will use the **Open** drawing option on the **Menu Browser** button flyout (see Figure 1-3). You can also click on the **Open** drawing icon on the **Quick Access** toolbar, or press **<CTRL> + <O>** at the command prompt. After you have gained experience and have developed and saved templates, you might want to use **Select template option** or set up and save a workspace to avoid having to reset **UNITS, LIMITS, LAYERS**, dimension variables, and so forth. **UNITS, LIMITS**, and **LAYERS** will be discussed in Chapter 2.

Figure 1-3   **Open** Drawing Dialog Box

*Workspaces* allow you to work in task-oriented environments. Workspaces are grouped sets of menus, toolbars, palettes, and **Ribbon** panels that are organized according to tasks relevant to drawing type. The AutoCAD program contains three predefined workspaces: **2D Drafting & Annotation**, **3D Modeling**, and **AutoCAD Classic** (see Figure 1-4).

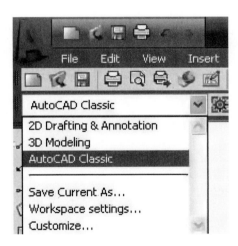

Figure 1.4   Predefined Workspace Options

The AutoCAD screen consists of several components that can be customized to the operator's convenience and style. Depending on the drawing type, you may prefer to have a minimal number of toolbars and palettes displayed. For instance, if you are working on a two-dimensional plan drawing, you would not need the **Materials** palette displayed. It is recommended that you keep the drawing window as large as possible. You can maximize the work area by using the **Ribbon**.

The **Ribbon**, located above the drawing area, provides many of the options found on the toolbars without having to display several individual toolbars. The **Ribbon** opens automatically when either the **2D Drafting & Annotation** or **3D Modeling** workspace is used (see Figure 1-5).

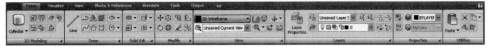

Figure 1-5   **Ribbon** with **3D Modeling** Workspace

With experience, and depending on your drafting style and drawing type, you can personalize the screen configuration so that it best suits your drawing needs.

The drawing window displays your drawing and contains a multitude of necessary components (see Figure 1-6).

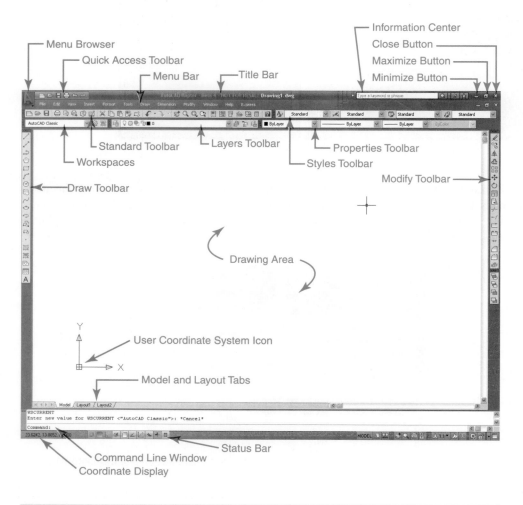

**Figure 1-6**   AutoCAD Screen and Major Components

**Figure 1-7**   Command Window

The command line window shows communication between you and AutoCAD (see Figure 1-7). The command window lets you know if a command has been correctly issued and performed. After a command has been issued, AutoCAD may prompt you to enter additional information to further define a command, tell you that a command cannot be completed, or show the results of the completed command on the drawing screen. The command window can be resized or moved as necessary or desired.

The user coordinate system (UCS) illustrates the orientation of the X, Y, and Z axes of the current coordinate system. The UCS may be turned off, but it is recommended that you keep it on. The styles used to represent the UCS are the 2D UCS icon (see Figure 1-8) and the 3D UCS icon (see Figure 1-9).

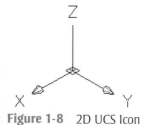

**Figure 1-8**   2D UCS Icon

The AutoCAD *status bar* has been updated with new tools and icons. Located at the bottom of the drawing screen, the status bar keeps you informed about the status of the drawing aids and indicates coordinate values (see Figure 1-10). The **Model** and **Layout** buttons have been moved to the right side of the status bar and new tools have been added. The status bar contains navigation and viewing tools, such as **Pan** and **Zoom**, and the new **SteeringWheels** and **ShowMotion** functionality.

The tools located on the left portion of the status bar contain drawing aid buttons for **Snap**, **Grid**, **Ortho**, **Polar Tracking**, **Object Snap**, **Object Snap Tracking**, **Allow/Disallow Dynamic UCS**, **Dynamic Input**, **Show/Hide Lineweight**, and **Quick Properties**. If you prefer the traditional AutoCAD text labels on the status bar, the right-click menu on the status bar enables you to switch the status bar display from icons to the traditional text labels and back.

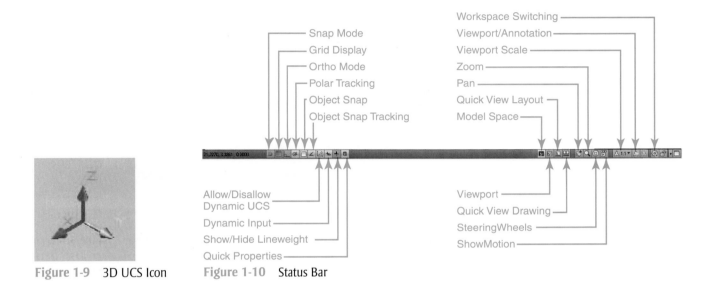

Figure 1-9    3D UCS Icon        Figure 1-10    Status Bar

The right portion of the status bar contains buttons for **Model Space**, **Viewport**, **Quick View Layouts**, **Quick View Drawings**, **Pan**, **Zoom**, **SteeringWheels**, **ShowMotion**, **Viewport Scale**, **Viewport/Annotation**, and **Workspace Switching**.

The flyout button for the status bar menu allows you to determine which of the drawing aids are contained on the status bar (see Figure 1-11).

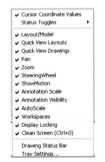

**TIP**    To activate the status bar flyout menu, right-click on an icon-free area of the status bar.

Figure 1-11    Status Bar Menu

The **Clean Screen** button, located in the far right corner of the status bar, allows you to clean the screen of toolbars and dockable windows. You can toggle between **Clean Screen On** and **Clean Screen Off** by pressing <**CTRL**> + <**0**>. **Clean Screen On** provides the maximum drawing area in which to work.

One of the new features of AutoCAD 2009 is the **Menu Browser**. The new **Menu Browser**, activated by a single button  in the upper left corner of the AutoCAD display, provides easy access to a multitude of commands and documents. The **Menu Browser** displays a vertical list of menus similar to those on the menu bar in previous versions of AutoCAD. When you select a menu from the **Menu Browser**, the menu expands (with flyouts) allowing you to invoke commands by double-clicking a listed item to launch the associated command (see Figure 1-12).

The menu bar, located at the top of the screen on previous versions of AutoCAD, is not a default setting for AutoCAD 2009. If you prefer to have the menu bar visible on the screen, at the command prompt, type: **menubar <Enter ↵>**, and set the menubar system variable to **1**, or

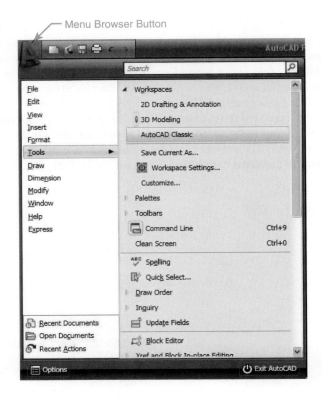

Figure 1-12    **Menu Browser**

select from the **Quick Access** toolbar, which is discussed later in this chapter. The menu bar provides access to all commands and a multitude of settings.

Becoming familiar with the **Menu Browser** items is essential to the efficient use of AutoCAD. Figures 1-13 through 1-25 illustrate the location and contents of each of the **Menu Browser** menus. Explore each of the pull-down menus and the various options that they provide.

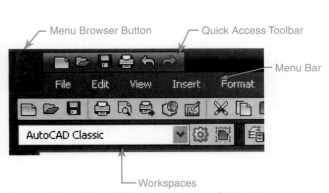

Figure 1-13    **Menu Browser** Menus and Location

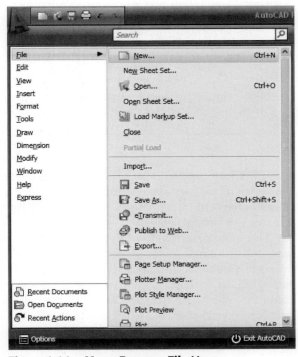

Figure 1-14    **Menu Browser File** Menu

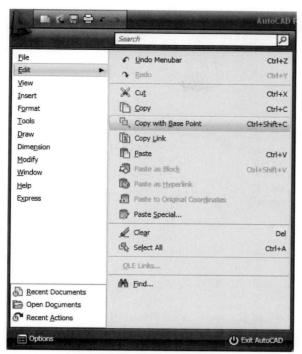

Figure 1-15    **Menu Browser Edit** Menu

Figure 1-16    **Menu Browser View** Menu

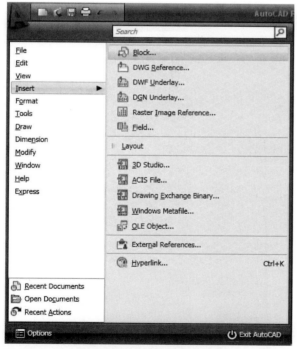

Figure 1-17    **Menu Browser Insert** Menu

Figure 1-18    **Menu Browser Format** Menu

Located in the lower left corner of the **Menu Browser** are **Recent Documents**, **Open Documents**, and **Recent Actions** menus. Each of these menus provides a listing of the associated menu items. A search tool, located at the top of the **Menu Browser**, enables you to search the **CUI** *(custom user interface)* file for key terms. For example, when you begin typing **LINE** in the search field, AutoCAD dynamically filters all entries that include the word *line*.

**Figure 1-19    Menu Browser Tools** Menu

**Figure 1-20    Menu Browser Draw** Menu

**Figure 1-21    Menu Browser Dimension** Menu

**Figure 1-22    Menu Browser Modify** Menu

A number of tools located on the toolbars are used for both 2D drafting and 3D modeling. Tool-bars used primarily for 3D modeling include **Modeling** (see Figure 1-26), located on the **Menu Browser Draw** menu; **3D Operations** and **Solid Editing** (see Figure 1-27), located on the **Menu Browser Modify** menu; and the **Menu Browser View** menu (see Figures 1-28 through 1-31), which contains 3D visualization, 3D navigation, and rendering tools.

**Figure 1-23    Menu Browser Window** Menu

**Figure 1-24    Menu Browser Help** Menu

**Figure 1-25    Menu Browser Express** Menu

Toolbars in AutoCAD provide easy on-screen access to many commands and features. In AutoCAD, you can customize your drawing screen to fit your personal preference. The **Quick Access** toolbar, located at the top of the AutoCAD window, contains commonly used tools such as **New**, **Open**, **Save**, **Plot**, **Undo**, and **Redo**. You can add tools to and remove them from the **Quick Access** toolbar with the **Custom User Interface** (CUI) dialog box (see Figure 1-32), which can be accessed by right-clicking on the toolbar. You can drag commands from the **CUI** onto the **Quick Access** toolbar, which are saved on a per-workspace basis. Additionally, the right-click menu contains options that allow you to control the display of the menu bar and toolbars.

custom user interface (CUI): Manages customized user interface items such as workspaces, toolbars, menus, shortcut menus, and keyboard shortcuts.

Figure 1-26    **Menu Browser, Draw, Modeling** Menu

Figure 1-27    **Menu Browser, Modify, 3D Operations** option

Figure 1-28    **Menu Browser, View, Visual Styles** Menu

Figure 1-29    **Menu Browser, View, Orbit** option

To activate or turn on a toolbar, right-click on the **Quick Access** toolbar and select the toolbar's flyout, then select **AutoCAD** (see Figure 1-33), and select the desired toolbar. Toolbars can be floating or docked. To dock a toolbar, left-click on the double bar at the end of a toolbar and drag it near an edge or the top of the AutoCAD drawing window. To remove a toolbar from the drawing screen, select **Toolbars** from the **Quick Access** toolbar, expand the toolbar list, and left-click on the toolbar to be removed.

**Figure 1-30**    **Menu Browser, View, 3D Views** Menu

**Figure 1-31**    **Menu Browser, View, Render** Menu

**Figure 1-32**    **Custom User Interface** Dialog Box

**Figure 1-33**    AutoCAD Toolbars

TIP    You can right-click on any tool icon on a toolbar to retrieve a pull-down list of all toolbars.

## THE NEW RIBBON

NEW
to AutoCAD
2009

AutoCAD contains 38 toolbars that can be selected from the **Quick Access** toolbar. Can you imagine what the drawing screen would look like if all these toolbars were displayed on the screen at one time? A new feature to AutoCAD 2009 is the **Ribbon**. By default, the **Ribbon** is located near the top of the AutoCAD window (see Figure 1-34). It provides easy access to Auto-CAD tools via a collection of tabs and panels. Each tab contains multiple panels, some of which can be expanded to access additional tools by left-clicking on the flyout arrow on the bottom of the panel.

**Figure 1-34**    **Ribbon,** Displayed on the **AutoCAD Classic Workspace**

Each workspace has task-oriented tabs as a default. Figure 1-35 illustrates the default **Ribbon** tabs and panels on the **3D Modeling** workspace, and Figure 1-36 illustrates the default **Ribbon** tabs and panels on the **2D Drafting & Annotation** workspace.

You can reduce the screen space that the **Ribbon** occupies by disabling the **Show Panel Titles** option or by minimizing the tabs or panel titles.

You can emulate the **Dashboard**, used in previous versions of AutoCAD, by undocking and anchoring the **Ribbon** on either side of the drawing screen (see Figure 1-37).

**Note:**
Workspaces are grouped sets of menus, toolbars, palettes, and **Ribbon** panels that are organized according to tasks relevant to drawing type.

**Figure 1-35**    **Ribbon**, Displayed on the **3D Modeling** Workspace

**Figure 1-36**    **Ribbon**, Displayed on the **2D Drafting & Annotation** Workspace

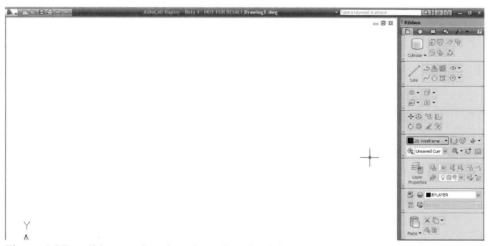

**Figure 1-37**    **Ribbon** Anchored on the Right Side of the Drawing Screen

To control the display of content within the **Ribbon**, right-click on the **Ribbon** to turn tabs or panels on or off. To customize the **Ribbon**, access the new **Ribbon** nodes in the **Customize User Interface** dialog box (right-click on the **Ribbon** and select **Customize**).

**TIP**    Identification tags are displayed as you move your mouse over tool icons.

It is recommended that you become familiar with the tools available on each toolbar as well as the command line input method. With experience and practice, you will develop your own style of drafting using AutoCAD.

## COMMAND ENTRY METHODS

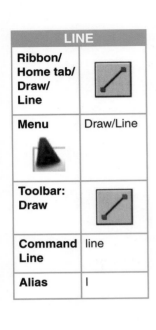

| LINE | |
|------|------|
| **Ribbon/ Home tab/ Draw/ Line** | |
| **Menu** | Draw/Line |
| **Toolbar: Draw** | |
| **Command Line** | line |
| **Alias** | l |

AutoCAD offers various methods for issuing commands. This book focuses on icon selection and command line input, but any of the other methods will work just as well. Using the **LINE** command as an example, we will explore the various methods of command input. The three basic ways to communicate commands to the AutoCAD program are the pull-down and flyout menus, icon selection from a toolbar, and command line input. The command grid illustrates some of the methods for issuing the **LINE** command.

To draw a line using the *command line window,* type **LINE** or **l**, then press **<Enter ↵>**. Many commands have aliases, such as **l** for line, **c** for circle, and **m** for move (see Figure 1-38).

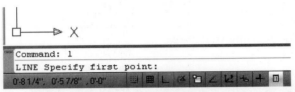

**Figure 1-38**    Issue the **LINE** Command in the Command Line Window

**Dynamic Input** is turned on by clicking on the **DYN** tab on the status bar. The input boxes are then displayed near the cursor (see Figure 1-39). Having the input boxes near the cursor alleviates the need to continually look back and forth between the command line and the point of activity on the drawing screen.

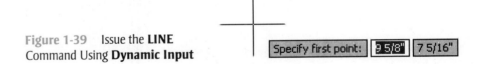

**Figure 1-39**    Issue the **LINE** Command Using **Dynamic Input**

You can also select the **LINE** command from the **Draw** toolbar (see Figure 1-40), or from the **Draw** menu on the **Ribbon**, or you can select **Line** from the **Menu Browser**, **Draw** flyout (see Figure 1-41).

**absolute coordinates:** Coordinates based on the Cartesian coordinate system. The *X* value of a Cartesian coordinate specifies horizontal distance, and the *Y* value specifies vertical distance.

**Figure 1-40**    Select the **LINE** Command from the **Draw** Toolbar

**Cartesian coordinate system:** Typically defined by two perpendicular axes in a plane. Usually, the horizontal axis is called the X axis, and the vertical axis is called the Y axis.

When you right-click the mouse in the drawing screen, you can access recent commands on the screen (see Figure 1-42).

This book is written primarily using the *Prompt/Response* format. It is quite acceptable to use any of the preceding methods for issuing commands. It is recommended that you enter the beginning points of drawn entities, such as a line or polyline using ***absolute coordinates,*** such as **2, 2**. Typically, **0,0** is located at the lower left corner of the screen. Absolute coordinates are relative to 0,0 and are based on the ***Cartesian coordinate system***.

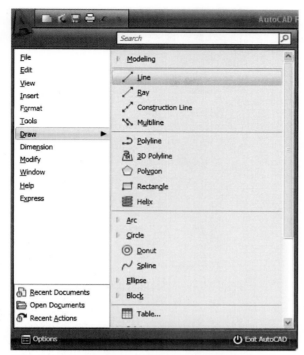

**Figure 1-41**    Select the **LINE** Command from the **Menu Browser, Draw** Flyout

**Figure 1-42**    Accessing Recent Commands by Right-Clicking the Mouse

When you enter a beginning point for a line at **2′,2′** the line begins precisely 2′ to the right of the lower left corner ($X = 2'$) and precisely 2′ above the $X$ position ($Y = 2'$). Beginning a drawing using *absolute coordinates* allows you to use the beginning point as a reference point for further drawing development and positions the drawing in an appropriate place on the drawing space. Most of the tutorials in Chapters 3 to 15 of this text are based on or use an origin point as a reference for drawing development.

After a line or polyline has been started, alternative methods for coordinate entry are acceptable. For instance, rather than typing in *polar coordinates* such as **@21.5<0** to continue a line sequence, turn **ORTHO** on, move the mouse to the right, and type **21.5**. Polar coordinates are relative to the last point entered (activated by the **@**), specify the distance (21.5 in this case), and specify the direction (0, horizontally from left to right).

**TIP**    The format for entering polar coordinates is @distance<angle.

## METHODS FOR OBTAINING HELP

The AutoCAD program contains numerous methods for obtaining help. The **<F1>** function key retrieves the **Help** screen. The **Help** screen allows you to find help by looking at the index or the contents, or by using the search feature. AutoCAD 2009 has improved tooltips, which provide more information as you need it. Tooltips are automatically displayed as you move the cursor over tool icons. The tooltip not only displays the tool name but also provides additional command-related information (see Figure 1-43), and after a few seconds, it displays graphic help and/or instructions pertaining to the selected command process (see Figure 1-44).

You can also access the **Help** menu from the **Menu Browser** (see Figure 1-24). The **Info Center**, located in the upper right corner of the AutoCAD window, gives you quick access to help through its search feature window.

Figure 1-43    Tooltip Help Information

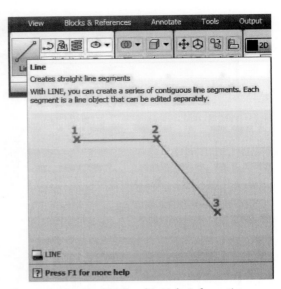

Figure 1-44    Tooltip Graphic Help Information

## SUMMARY

This chapter should have provided you with an understanding of how to open the AutoCAD program, begin a new drawing using a template file, or open an existing drawing; methods for issuing commands; and a basic familiarity with the new **Ribbon** and **Menu Browser** options, toolbars, and palette locations and features. Three basic ways to communicate commands to the AutoCAD program are by selecting commands from menus located on the **Menu Browser**, **Ribbon**, or from the traditional menu bar pull-down menu, selecting an icon from a toolbar, and using command line input.

The more you use the AutoCAD program, the more comfortable you will become setting up drawings, configuring the screen layout, and issuing commands. Drawing with AutoCAD is very similar to manual drafting, because as you gain experience and practice, you will develop a style and method that works best for you.

## CHAPTER TEST QUESTIONS

### Multiple Choice

1. To begin a new AutoCAD drawing
   a. Left-click on the blank page icon on the **Quick Access** toolbar
   b. Select **File**, then **New** on the **Menu Browser** flyout
   c. Type **new** or <CTRL> + <N> on the command line
   d. All of the above

2. Which file extension denotes AutoCAD template files?
   a. dwg
   b. .dwt
   c. .dxf
   d. .tmp

3. The **Ribbon** opens automatically when
   a. Any predefined workspace is used
   b. The **AutoCAD Classic** workspace is used
   c. Unless the **Ribbon** command is issued
   d. Either the **2D Annotation** or **3D Modeling** workspace is used

4. The **Menu Browser** provides access to
   a. All commands
   b. Only screen settings
   c. Only drawing settings
   d. Some commands

5. The left portion of the status bar contains all the following *except*
   a. **Snap**
   b. **Grid**
   c. **Dashboard**
   d. **Allow/Disallow Dynamic UCS**

6. The **View** menu located on the **Menu Browser** contains all the following *except*
   a. **Pan**
   b. **Viewports**
   c. **Dimensions**
   d. **Zoom**

7. Which of the following is *not* an AutoCAD predefined visual style?
   a. **Realistic**
   b. **Sketch**
   c. **Conceptual**
   d. **2D Wireframe**

8. The **LINE** command can be issued by
   a. Left-clicking on the **Line** icon on the **Draw** toolbar
   b. Selecting **Draw** then **Line** on the **Menu Browser**
   c. Typing **l** at the command line
   d. All of the above

9. The format for typing in polar coordinates is
   a. @distance<angle
   b. x,y
   c. @angle<distance
   d. @x,y

10. Once a drawing has been started, the screen settings
    a. Cannot be changed without starting over
    b. Can be altered at any time
    c. Can be altered only if a command has not been issued
    d. Can be changed only in certain workspaces

## Matching

Match the command and/or setting with the appropriate toolbar or **Menu Browser** menu location.

| Column A | Column B |
|---|---|
| a. **Line** | 1. **View** |
| b. **Save** | 2. **Draw** |
| c. **Orbit** | 3. **File** |
| d. **Layout** | 4. **Status bar** |
| e. **Layer** | 5. **Edit** |
| f. **Palettes** | 6. **Format** |
| g. **Array** | 7. **Tools** |
| h. **Help** | 8. **Insert** |
| i. **Dynamic Input** | 9. **Modify** |
| j. **Select All** | 10. **Help** |

## True or False

1. T or F: Each time you begin a new drawing using a template (.tmp) file, the original template file is changed, even if you do not save the new drawing as a template file.

2. T or F: The AutoCAD screen consists of several components that can be customized to the operator's convenience and style.

3. T or F: The **Ribbon** opens automatically when the **AutoCAD Classic** workspace is used.

4. T or F: Workspaces allow you to work in task-oriented environments.

5. T or F: You cannot set up and save a workspace that retains **UNITS**, **LIMITS**, and **LAYERS**.

6. T or F: Absolute coordinates are relative to the last point entered.

7. T or F: Toolbars used primarily for 3D modeling can be found on the **Draw**, **Solid Editing**, and **Ribbon View** menus.

8. T or F: You can right-click on any tool icon to retrieve a pull-down list of all toolbars.

9. T or F: The **Erase** command can be found on the **Draw** toolbar.

10. T or F: By right-clicking on the drawing screen, you can reissue recent commands.

# Drawing Setup

# 2

## Chapter Objectives

- Learn to set **Units**, **Limits**, and **Grid** for a new drawing
- Learn to save a drawing setup as a template

## INTRODUCTION

In this chapter, we will go through the basic process of drawing setup. Drafting in AutoCAD is very similar to manual drafting because knowing what you are going to draw, how it is constructed, and how you will present the drawings is essential for success. In other words, the design process is important.

As a designer, you should not ignore the conceptual development of a project; you should not begin with the final drawings before analyzing the problem and determining the desired outcome. Once the project has been developed and you know the what, how, and why, you are ready to begin the final drawings. Good CAD designers know and practice the use of sketching and layout on trash (tracing) paper in conjunction with digital drawing; it is a dynamic interface necessary for effective and meaningful design development. This is not to say that AutoCAD is not a good sketching or discovery tool because it is, but typically traditional designers do not sketch on vellum sheets complete with borders and title blocks. If you do use AutoCAD as a development tool, it is recommended that you take the time to set the appropriate units so that moving onto the preliminary stages of project development will be as efficient as possible.

After setting up a new drawing, we will use the **SAVE AS** command to save the settings for future use. Having template files as a resource with which to begin new drawings saves time because you do not have to go through drawing setup each time you wish to begin a new drawing.

The last part of this chapter will examine various methods of command input. Learning the various methods of issuing commands will help you become more proficient in producing accurate drawings.

## BEGIN DRAWING SETUP

Start the AutoCAD program. If you want to start a new drawing, open the **acad.dwt** (default) template file. Left-click on the **Menu Browser** ▲, and then from the **File** menu select **New** (see Figure 2-1). The **Select Template** dialog box contains a number of drawing templates from which to choose. Drawing templates have predefined settings that can include units, limits, grid, snap, layers, borders, title block, and so forth. Any of the settings can be changed once the drawing has been started from the template file. Template files allow you to begin a new drawing without going through

> **Note:**
> When you create a new drawing based on an existing template file and make changes, the changes in the new drawing do not affect the template file.

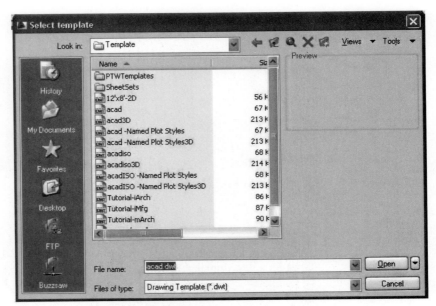

Figure 2-1    **Select Template** Dialog Box

the process of drawing setup. For example, the default template file (**acad.dwt**) opens with the following settings established: **Decimal UNITS; LIMITS** set at **0,0** and **12,9**; one **LAYER** (layer **0**); **SNAP** and **GRID** off, and so on. Saving template files based on your own drawing needs can promote consistency and time efficiency.

After AutoCAD has completed loading, your screen should appear similar to Figure 2-2.

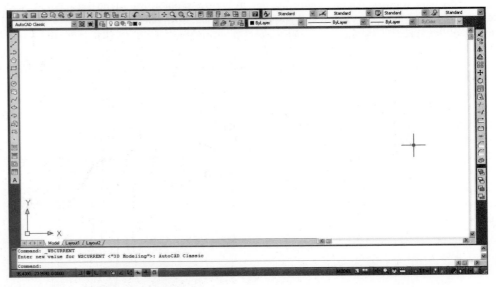

Figure 2-2    Beginning Drawing Screen

Before going further, look around the screen at the default settings. How many layers do you have? Which layer is current? Are you in model or paper space? Notice that the units displayed in the *coordinate display* window are in the decimal format.

After opening the **acad.dwt** file, the second step in setting up a drawing is to set the **Drawing Units** to **Architectural**. AutoCAD has five options for drawing units: **Scientific** (1.55E+01), **Decimal** (15.50), **Engineering** (1'-3.50"), **Architectural** (1'-3½"), and **Fractional** (15½). We will use architectural units for all the exercises in this book.

From the command prompt, type **UNITS**, or from the **Menu Browser**, **Format** flyout, select **Units**. The **Drawing Units** dialog box (see Figure 2-3) will appear and give you the option of

**Figure 2-3    Drawing Units** Dialog Box with Default Setting

**Figure 2-4    Drawing Units** Dialog Box with Architectural Units

selecting the type of units to be used. Click on the arrow to the right of the **Decimal** indication on the type of units, and then select **Architectural**. Your dialog box should appear similar to Figure 2-4.

The **Drawing Units** dialog box gives you the option of changing the unit **Precision** (smallest fraction to display), and **Angle** type and **Precision**. The **Precision** input box has no effect on the accuracy of an AutoCAD drawing; it determines only the smallest fraction to display dimensions, coordinates, and other values shown on the screen. The **Insertion scale** allows you to set the units to scale inserted content, such as blocks and drawings, into drawings (see Figure 2-5). The **Lighting** section allows you to change the units for specifying the intensity of lighting (see Figure 2-6). AutoCAD offers three choices for lighting units: **Standard** (generic), **International** (SI), and **American**. Typically, lighting units are used more for three-dimensional modeling and rendering than two-dimensional drafting. Lighting units will be explained in more detail later

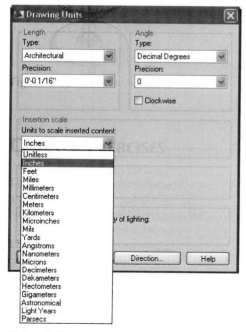

**Figure 2-5    Insertion Scale: Units to Scale Inserted Content**

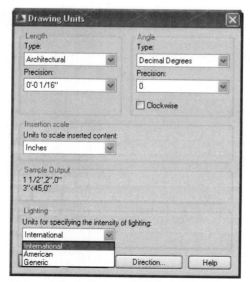

**Figure 2-6    Lighting: Units for Specifying Lighting Intensity**

in this text. The **Direction** button gives you the option of changing the **Base Angle** direction (see Figure 2-7). The default directions are as follows: **East** is to the right (0), **North** is up (90), **West** is to the left (180), and **South** is down (270). Typically, the **Direction** default should not be changed; for example, once you are comfortable with direct distance input (e.g., @15′<90), it can be confusing to change the **Base Angle** direction.

After you have set **Units** to **Architectural**, the coordinate display will reflect the change and show the X, Y, and Z coordinates in architectural format.

The next step in setting up a drawing is to set the **Limits**. You can think of *limits* in model space as the working sheet size. In AutoCAD, it is best to work in full scale. A drawing scale factor, such as $\frac{1}{4}'' = 1'\text{-}0''$, does not have to be set. You can print or plot the full-size drawing at any scale desired. Drawing at full scale simplifies the drawing process. ANSI standard drawing scales for architectural-type drawings include $1'' = 1'\text{-}0''$, $\frac{3}{4}'' = 1'\text{-}0''$, $\frac{1}{2}'' = 1'\text{-}0''$, $\frac{1}{4}'' = 1'\text{-}0''$, $\frac{1}{8}'' = 1'\text{-}0''$, and $\frac{1}{16}'' = 1'\text{-}0''$. In other words, you may need a working sheet size of several hundred feet wide and several hundred feet high for a large building. Even though limits can be reset at any time, it is recommended that you begin a drawing with the limits large enough to accommodate the object that you are drawing.

Keep in mind that you can scale the drawing for printing and plotting in paper space. To view the available sheet sizes, from the **Menu Button**, **File** flyout, select **Plot**, then left-click on the down arrow located to the right of the **Paper Size** heading (see Figure 2-8). A good rule of thumb for determining limits is about $1\frac{1}{2}$ times larger than the object that you are drawing. Another way to determine limits is to consider the final print size (in paper space) and the scale at which you wish to print the object drawings. For instance, if you know that you want to print on an $8\frac{1}{2}'' \times 11''$ sheet of paper and the drawing will be printed at $\frac{1}{4}'' = 1'\text{-}0''$ scale, then the available drawing space (limits) will be $34' \times 44'$. If you divide the width ($8\frac{1}{2}''$) by $\frac{1}{4}''$, the quotient is 34, and if you divide the height ($11''$) by $\frac{1}{4}''$, the quotient is 44.

It takes two sets of coordinates to set limits: the lower left corner, typically 0,0, and the upper right corner coordinates. The default limits are 0,0 for the lower left corner and 1′,9″ for the upper right corner. For this drawing, we will set the limits to (lower left corner) **0,0** and **12′,8′** (the upper right corner). From the command prompt, type **LIMITS**, or from the **Menu Browser**,

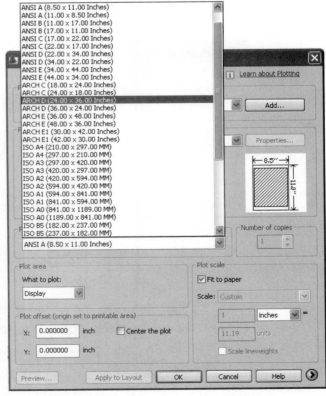

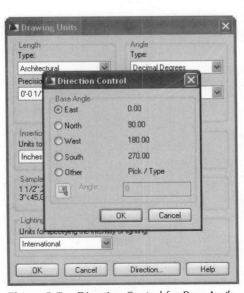

**Figure 2-7**    Direction Control for Base Angle          **Figure 2-8**    Available Sheet Sizes

**Format** flyout, select **Drawing Limits**. Type **0,0** for the lower left limits, press **<Entered>**, and type **12',8'** for the upper right limits. Be sure to type the feet indication; otherwise, AutoCAD will assume that you mean inches.

We have set the **Limits** for a 12' wide by 8' high drawing space, but in order to see the entire drawing area, we will need to **Zoom All**.

Set the grid to **6"** by typing **GRID** at the command prompt. The *grid* is a set of dots that are visible on the screen. You can toggle the grid on and off any time during the drawing process by pressing the **<F7>** function key or by right-clicking on the **Grid** tab on the status bar and then selecting **Settings**. You can change the grid spacing at any time during the drawing process by typing **GRID** at the command prompt and typing in the desired spacing or by using the **Settings** option from the status bar.

| ZOOM | |
|---|---|
| **Ribbon/ View tab/ Zoom** | |
| **Menu** | View/ Zoom |
| **Toolbar: Standard** | |
| **Command Line** | Zoom, or 'z for transparent Zoom |
| **Alias** | z |

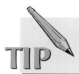

**TIP**   The **GRIDDISPLAY** system variable controls the display of the grid.

You cannot print the grid. It is only a guide, similar to using grid paper in manual drafting. Using the grid helps you to see where your drawing is located relative to the entire drawing area. After you have set the **Drawing Units**, **Drawing Limits**, and **Grid**, your screen setup should appear similar to Figure 2-9.

**Figure 2-9**   Drawing Screen After Setting Units, Limits, and Grid

Now would be a good time to save your drawing as a template file. By saving various drawing setups, you can save time by not having to go through the setup process each time you wish to begin a drawing. To save this drawing setup as a template file, left-click on the **Menu Browser**, then the **File** flyout, then **Save As**. You can also select **Save As** from the **File** pull-down menu (see Figure 2-10). If your current screen configuration does not include the menu bar, type **menubar** at the command prompt and type **1** for the system variable. A value of **0** for the menubar system variable turns off the menu bar.

**TIP**   You can also right-click on the **Quick Access** toolbar and select **Show Menu Bar**.

From the **Save Drawing As** dialog box, expand the **Files of type:** (arrow down) and select **AutoCAD Drawing Template (*.dwt)** (see Figure 2-11). After you select (**.dwt**) for type of

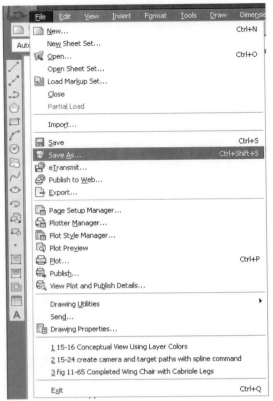

**Figure 2-10** Select **Save As** from the **File** Pull-Down Menu

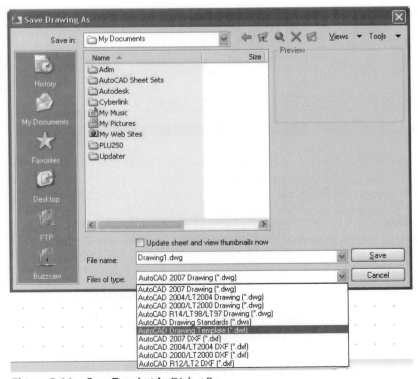

**Figure 2-11** **Save Drawing As** Dialog Box

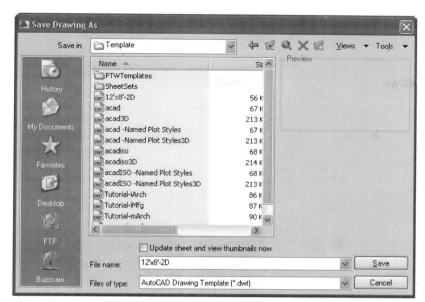

**Figure 2-12** Name and Save the Drawing as a **Template** File

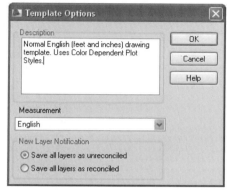

**Figure 2-13** **Template Options** Dialog Box

file to save, AutoCAD defaults to the **Template** folder in which to save the file. Name the template file and select **Save** (see Figure 2-12). After you select **Save**, AutoCAD opens the **Template Options** dialog box, where you can type a description of the **Template file** (see Figure 2-13). Other common types of files and their file extensions are illustrated in the following table.

| AutoCAD File Types | |
| --- | --- |
| **File Extension** | **Description** |
| AC$ | Temporary AutoCAD file; automatically created by AutoCAD |
| BAK | AutoCAD drawing backup file; automatically created when a drawing file is saved |
| DWG | AutoCAD drawing file |
| DWF | AutoCAD Design Web Format file |
| DWL | AutoCAD drawing lock file; automatically created by AutoCAD |
| DWS | AutoCAD Drawing Standards file |
| DWT | AutoCAD drawing template file |
| DXB | Binary AutoCAD drawing exchange format file |
| DXF | ASCII AutoCAD drawing exchange format file |
| PLT | AutoCAD plot file |
| SV$ | AutoCAD automatic save file |

## SUMMARY

This concludes the minimal steps in setting up a drawing. The steps, as a review, are to open the **acad.dwt** template file, set the drawing **Units**, **Limits**, and **Grid**, and **Zoom All**. As you become more experienced in using AutoCAD, you will probably expand the setup process to include more settings, such as defined **Layers**, **Dimension Variables**, and so on, but for now, this setup will suffice.

# Quick Start: Learning the Basics

## Chapter Objectives

- Set up a new drawing
- Create regions
- Use the **FILLET** and **CHAMFER** commands
- Create three-dimensional solids with the **EXTRUDE** command
- Learn to select points of view
- Explore **Visual Styles**
- Introduce the Boolean operations, **UNION**, **SUBTRACT**, and **INTERSECT**
- Introduce the **SWEEP** and **LOFT** commands
- Create 3D solids using 3D primitives

## INTRODUCTION

We will begin by learning the basic commands used in three-dimensional modeling. Some of the commands used to develop the three-dimensional models are also commonly used in two-dimensional drafting. We will begin by drawing a rectangle with the **POLYLINE** command, make changes to the corners of the rectangle, and extrude the resulting two-dimensional solid (region) to produce an extended profile. Keep in mind that the object drawn in this first exercise could be a piece of molding, trim around a table or shelf, or any other object that has a complex section profile. The process of developing the object—not the object itself—is the important part of this exercise.

The **REGION** command creates a two-dimensional solid from one object or a set of objects that are in the form of a closed shape. You can use a combination of commands and processes to derive the desired shape of a region. In the following example, we will use the **CHAMFER** and **FILLET** commands to modify two of the corners. We will use the **SUBTRACT** command to modify the other two corners of the original rectangle.

## DRAWING SETUP

Begin this exercise by clicking on the **AutoCAD 2009** icon ![icon]. AutoCAD will open the drawing using the default template file, **acad.dwt** If you have AutoCAD open, select **File**, then **New** from the **Menu Browser**.

The default setting for **Units** using the **acad.dwt** template file is in the **Decimal** format. Set the **Units** to **Architectural**, **Precision** to **1/16″** (default setting with architectural units), set the **Limits** to **0,0** and **12′,8′**. Set the **Grid** to **6″** and **Snap** to **3″**. Remember to **Zoom All** so that you can see the entire drawing area. Setting the **Grid** to **6″** does two things: it allows us to see the entire drawing

**Note:**
You can alter the **Grid** and **Snap** settings at any time in the drawing process by clicking on the status bar or by typing **Grid** or **Snap** at the command line.

| NEW DRAWING | |
|---|---|
| Ribbon/ Standard tab/New Drawing | |
| Menu | File/New |
| Command Line | New *or* CTRL +N |

after we have **Zoomed All** and provides us with a sense of location and scale relative to the drawing area. A **Snap** setting of 3″ allows us to precisely select points in increments of 3″.

We will begin the polyline at a specific point by using an absolute coordinate entry (**2′6,2′6**). This will precisely locate the object being drawn.

## BEGIN DRAWING

| Prompt | Response |
|---|---|
| Command: | Type: **pl <Enter ↵>** *(or select the POLYLINE icon)* |
| Specify start point: | Type: **2′6,2′6 <Enter ↵>** *(or pick a point at 2′6,2′6)* |
| Current line width is 0′-0″ Specify next point or [Arc/Close/Halfwidth/ Length/Undo/Width]: | Type: **@5′<0 <Enter ↵>** *(or with ORTHO on, move the mouse to the right and Type: 5′)* |
| Specify next point or [Arc/Close/Halfwidth/ Length/Undo/Width]: | Type: **@3′<90 <Enter ↵>** *(or move the mouse up and Type: 3′)* |
| Specify next point or [Arc/Close/Halfwidth/ Length/Undo/Width]: | Type: **@5′<180 <Enter ↵>** *(or move the mouse to the left and Type: 5′)* |
| Specify next point or [Arc/Close/Halfwidth/ Length/Undo/Width]: | Type: **C <Enter ↵>** *(to close the polyline)* |

| POLYLINE | |
|---|---|
| **Ribbon/ Home tab/ Draw/ Polyline** | |
| **Menu** | Draw/ Polyline |
| **Toolbar: Draw** | |
| **Command Line** | pline |
| **Alias** | pl |

Your drawing should appear similar to Figure 3-1. At this point, we have a rectangle drawn with the **POLYLINE** command, so it is one object. If we had drawn the rectangle with the **LINE** command, we would have to use the **PE (POLYLINE EDIT)** command to convert (join) the four sides of the rectangle into one object.

**TIP** You can also create a region with the **BOUNDARY** command, which is discussed in subsequent chapters.

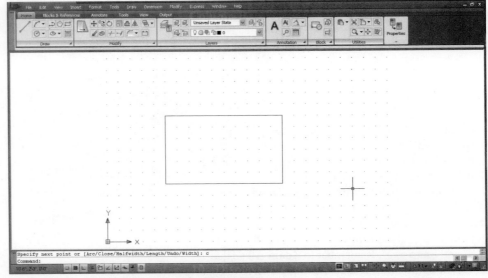

**Figure 3-1**   Rectangle Drawn with the **POLYLINE** Command

With the **POLYLINE** command, draw a 2′ square overlapping the lower right corner of the rectangle polyline (see Figure 3-2), and use the **CIRCLE** command to draw a circle with a 1′ radius centered on the lower left corner.

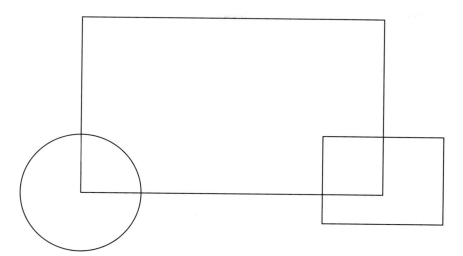

| CIRCLE | |
|---|---|
| **Ribbon/ Home tab/ Draw/ Circle** | |
| **Menu** | Draw/ Circle |
| **Toolbar: Draw** | |
| **Command Line** | circle |
| **Alias** | c |

Figure 3-2    Rectangle with Circle and Square

We will now use the **REGION** command to convert the three independent objects into three independent regions.

| Prompt | Response |
|---|---|
| Command: | Type: **REGION <Enter ↵>** |
| Select objects: | *Pick the three shapes* **<Enter ↵>** |
| 3 loops extracted. | |
| 3 regions created. | |

The objects on the screen do not appear any different than they did as polyline shapes, but they can now be combined to form complex shapes.

> **Note:**
> You cannot subtract one polyline shape from another. You can subtract one overlapping region from another. Also, to create a region, the shape must be closed and not have overlaps or gaps.

| Prompt | Response |
|---|---|
| Command: | Type: **SUBTRACT <Enter ↵>** *(or select the* **SUBTRACT** *icon)* |
| Select solids and regions to subtract from… | |
|    Select objects: | *Pick the large rectangle* **<Enter ↵>** |
| Select solids and regions to subtract … | |
|    Select objects: | *Pick the circle and square* **<Enter ↵>** |

We now have a region that has been modified. It is one object. Your drawing should appear similar to Figure 3-3.

Now we will use the **FILLET** and **CHAMFER** commands to modify two corners of the rectangle. During this process, we will fail in our first attempt. It is much better to learn how to correct mistakes on small projects such as this one rather than attempt to correct projects that are larger and more complex.

> **Note:**
> The **SUBTRACT** command combines selected regions or solids by subtraction.

| Prompt | Response |
|---|---|
| Command: | Type: **f <Enter ↵>** *(or select the* **FILLET** *icon)* |
| Current settings: Mode = TRIM, Radius = $0'\text{-}0\frac{1}{2}''$ | |

| FILLET | |
|---|---|
| Ribbon/ Home tab/ Modify/ Fillet | |
| Menu | Modify/ Fillet |
| Toolbar: Modify | |
| Command Line | fillet |
| Alias | f |

| CHAMFER | |
|---|---|
| Ribbon/ Home tab/ Modify/ Chamfer | |
| Menu | Modify/ Chamfer |
| Toolbar: Modify | |
| Command Line | chamfer |
| Alias | cha |

Select first object or [Polyline/
   Radius/Trim]:                          Type: **R <Enter ↵>**
Specify fillet radius <0'-0½">:              Type: **1' <Enter ↵>**
Command:                                     Type: **f <Enter ↵>** *(or select the **FILLET** icon)*
Current settings: Mode =
   TRIM, Radius = 1'-0"
Select first object or [Polyline/
   Radius/Trim]:                          *Pick the left edge of the rectangle*
Fillet requires two lines, arcs, or a circle.
Select first object or [Polyline/
   Radius/Trim]:

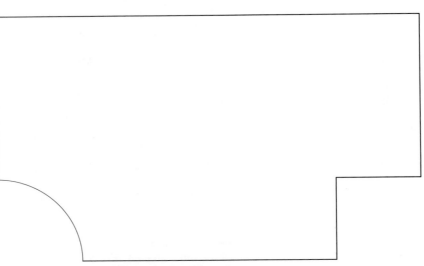

**Figure 3-3**     Rectangle (Region) After Subtraction

> **Note:**
> The **CHAMFER** command specifies the first of two edges required to define a 2D chamfer, or the edge of a 3D solid to chamfer.

The attempt to fillet the top left corner of the composite region failed. When you find yourself in this situation, think how you could have changed the process to avoid failure. We will backtrack a little, explode the region, use the **FILLET** and **CHAMFER** commands to obtain the desired two-dimensional line shape, use the **PE (POLYLINE EDIT)** command to join the edited segments, and finally use the **REGION** command to get the desired region.

| Prompt | Response |
|---|---|
| Command: | Type: **X** **(EXPLODE) <Enter ↵>** |
| Select objects: | *Pick the region <Enter ↵>* |
| Select objects: 1 found | |
| Select objects: | Type: **<Enter ↵>** |

The drawing does not appear any different than it did before the **EXPLODE** command, but if you use the **PROPERTIES** command and select the individual components, you will find that the shape has been exploded and is a collection of lines and an arc.

We can use the **FILLET** and **CHAMFER** commands before or after we have joined the individual components to form a single polyline.

| Prompt | Response |
|---|---|
| Command: | Type: **pe** *(POLYLINE EDIT)* <**Enter** ↵> |
| Select polyline: | *Pick any line segment* <**Enter** ↵> |
| Object selected is not a polyline | |
| Do you want to turn it into one? <Y> | Type: **Y** <**Enter** ↵> |
| Enter an option [Close/Join/Width/Edit vertex/Fit/Spline/Decurve/Ltype gen/Undo]: | Type: **J** *(Join)* <**Enter** ↵> |
| Select objects: | *Pick a window around the entire shape* |
| Select objects: Specify opposite corner: 7 found | |
| Select objects: | Type: <**Enter** ↵> |
| 6 segments added to polyline | |
| Enter an option [Close/Join/Width/Edit vertex/Fit/Spline/Decurve/Ltype gen/Undo]: | Type: <**Enter** ↵> |
| Command: | Type: **f** <**Enter** ↵> *(or select the **FILLET** icon)* |
| Current settings: Mode = TRIM, Radius = 1'-0" | |
| Select first object or [Polyline/ Radius/Trim]: | *Pick the left edge of the original rectangle* |
| Select second object: | *Pick the top edge of the original rectangle* |

> **Note:**
> The **FILLET** command rounds and fillets the edges of objects.

Your drawing should appear similar to Figure 3-4.

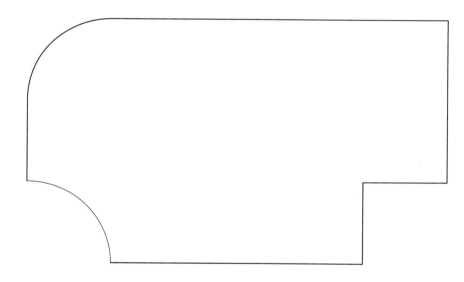

**Figure 3-4**   Shape After **FILLET** Command

Now we will make the last modification to the rectangle using the **CHAMFER** command.

| Prompt | Response |
|---|---|
| Command: | Type: **cha** <**Enter** ↵> *(or select the **CHAMFER** icon)* |
| (TRIM mode) Current chamfer Dist1 = 0'-0$\frac{1}{2}$", Dist2 = 0'-0$\frac{1}{2}$" | |
| Select first line or [Polyline/Distance/ Angle/Trim/Method]: | Type: **D** <**Enter** ↵> |
| Specify first chamfer distance <0'-0$\frac{1}{2}$">: | Type: **1'** <**Enter** ↵> |
| Specify second chamfer distance <1'-0">: | Type: <**Enter** ↵> |
| Select first line or [Polyline/Distance/Angle/ Trim/Method]: | *Pick the right edge of the original rectangle* |
| Select second line: | *Pick the top edge of the original rectangle* |

Your drawing should appear similar to Figure 3-5.

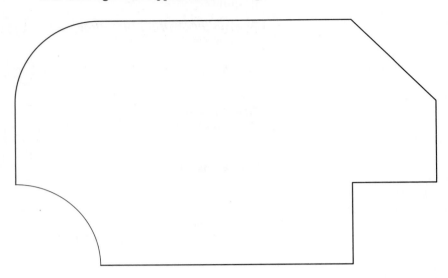

Figure 3-5    Polyline
Shape After Modifications

The final step in completing the two-dimensional solid will be to convert the polyline shape to a region. Remember, we had to explode the previously converted region to modify the corners of the original rectangle. At the command prompt, type **REGION**. Select any point on the shape. AutoCAD should respond that one loop has been extracted and one region has been created.

## SELECTING THREE-DIMENSIONAL POINTS OF VIEW

Up to this point, we have viewed the drawing in plan view. At this time, we will experiment with options for three-dimensional viewing. Even though the shape is still two-dimensional, we can use the **VPOINT** command or **3D Views** flyout to obtain isometric views of the object. Pulling down the **View** menu or selecting **View** from the **Menu Browser**, then the **3D Views** flyout, gives you numerous options for viewing three-dimensionally (see Figure 3-6). Notice that, at the bottom of the flyout, you have four options for directional isometric views. These isometric views can also be obtained with the **VPOINT** command. Figures 3-7 through 3-10 illustrate the views as they correspond to the **VPOINT** options.

Figure 3-6    **3D Views** Flyout Options

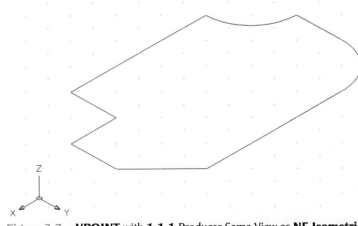

Figure 3-7    **VPOINT** with **1,1,1** Produces Same View as **NE Isometric**

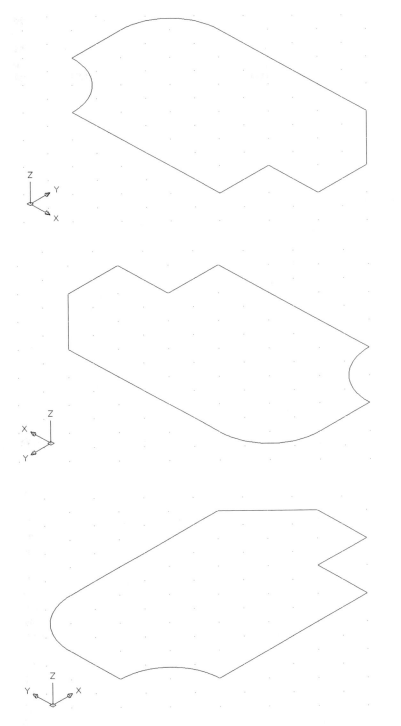

**Figure 3-8    VPOINT** with **1,−1,1** Produces Same View as **SE Isometric**

**Figure 3-9    VPOINT** with **−1,1,1** Produces Same View as **NW Isometric**

**Figure 3-10    VPOINT** with **−1,−1,1** Produces Same View as **SW Isometric**

There are a number of methods for obtaining three-dimensional views. With the **VPOINT** command, you can produce three-dimensional views using the coordinate entry method (**vpoint 1,1,1**), rotation through angles (**vpoint 45** then **45**), or the compass and tripod method (selecting a point midway between the center of the crosshairs and inside circle in the upper right quadrant of the compass). From the **View** pull-down menu or **Menu Browser**, select **3D Views**, then **NE Isometric** to produce the same view as illustrated in Figure 3-7 using the **VPOINT** command.

Another method for selecting three-dimensional views is with the **ORBIT** command, located on the **View** pull-down menu, or the **View** menu on the **Menu Browser**. The **ORBIT** command is an excellent viewing option during modeling construction because it allows you to rotate the view 360°.

The **VPOINT** command allows you to enter X,Y,Z coordinates (vector option); enter **r** (to rotate the viewpoint using angles, first along the X,Y axes beginning at the 0 direction then away from the X,Y plane in the Z direction); and select a viewing point using the compass and feedback icons.

| EXTRUDE | |
|---|---|
| **Ribbon/ Home tab/ 3D Model- ing Extrude** | 📦 |
| **Menu** | Draw/ Modeling Extrude |
| **Toolbar: Modeling** | 📦 |
| **Command Line** | extrude |
| **Alias** | ext |

Practice using the **VPOINT** command, the **3D Views** flyout from the **View** menu, and the **ORBIT** command. It is often easier to select object components in a three-dimensional view than in a two-dimensional view. Also, visual depth is not evident in plan view but is evident in a 3D view. In subsequent chapters, we will explore **SteeringWheels**, a feature new to Auto-CAD 2009.

To conclude this exercise, we will use the **EXTRUDE** command to produce 3D solids from the region. The **EXTRUDE** command adds height to a closed 2D shape in the Z direction. Two methods of determining the extrusion direction are perpendicular to the shape and along a path. Another option using the **EXTRUDE** command is to extrude with a taper angle. We will make two copies of the existing region and use the **EXTRUDE** command to produce three different object shapes.

Before we begin exploring the **EXTRUDE** command, reset the drawing **LIMITS** to **0,0** and **24′,12′**, change to plan view [**VPOINT <Enter ↵>**, then **0,0,1 <Enter ↵>** or type **PLAN, (World UCS)** at the command prompt and press **<Enter ↵>**)], and make two copies of the existing region as illustrated in Figure 3-11.

**Figure 3-11    Region Copied**

First, we will extrude the left region perpendicular to the drawing plane to a height of 5′.

| Prompt | Response |
|---|---|
| Command: | Type: **ext <Enter ↵>** (*or select the* **EXTRUDE** *icon*) |
| Current wire frame density: ISOLINES = 4 | |
| Select objects: | *Pick the region on the left* |
| Select objects: 1 found | |
| Select objects: | Type: **<Enter ↵>** |
| Specify height of extrusion or [Path]: | |
| Specify angle of taper for extrusion <0>: | Type: **5′ <Enter ↵>** |

When the drawing is viewed in plan view, the region does not appear to have changed. Change to an isometric view (**VPOINT, 1,1,1** or select **NE Isometric** from the **View** pull-down, **3D Views** flyout menus), and the change becomes obvious (Figure 3-12).

**Figure 3-12**  Region Extrusion Perpendicular to Drawing Plane

We will taper the second region as it is extruded perpendicular to the drawing plane. Remain in **VIEWPOINT 1,1,1** or **NE Isometric** view, and extrude the second region with a taper angle. Taper angles either increase or decrease the size of the original profile as it is projected in the Z direction.

| Prompt | Response |
|---|---|
| Command: | *Select the **EXTRUDE** icon* |
| Current wire frame density: ISOLINES = 4 | |
| Select objects to extrude: | *Pick the center region* |
| Select objects to extrude: 1 found | Type: **<Enter ↵>** |
| Specify height of extrusion or | |
|   [Direction/Path/Taper angle] <0'-0">: | Type: **T** |
| Specify angle of taper for extrusion <0>: | Type: **5 <Enter ↵>** |
| Specify height of extrusion or | |
|   [Direction/Path/Taper angle] <0'-0">: | Type: **5' <Enter ↵>** |

Your drawing should appear similar to Figure 3-13. Use the **HIDE** command to produce a view similar to Figure 3-14.

We will extrude the third region along a path. First, we will need to draw a path along which to extrude. We will draw an arc in plan view and use the **ROTATE3D** command to move the path in the positive Z direction.

| Prompt | Response |
|---|---|
| Command: | Type: **PLAN <Enter ↵>** |
| Enter an option [Current ucs/Ucs/World] | |
|   <Current> | Type: **W <Enter ↵>** |
| Command: | Type: **ARC <Enter ↵>** |
| Specify start point of arc or [Center]: | *Pick the lower left corner of the* |
| | *region on the right* (Figure 3-15) |
| Specify second point of arc | |
|   or [Center/End]: | Type: **C** *(for center)* |
| Specify center point of arc: | *Pick a point directly above the first point* |
| Specify end point of arc or | |
|   [Angle/chord Length]: | *Pick a point directly above the second point* |

| HIDE | |
|---|---|
| **Ribbon/ Visualize tab/Hide** | [icon] |
| **Menu** [icon] | View/Hide |
| **Toolbar: Render** | [icon] |
| **Command Line** | hide |
| **Alias** | hi |

**Note:**
The **HIDE** command regenerates a three-dimensional wireframe model, with the hidden lines suppressed.

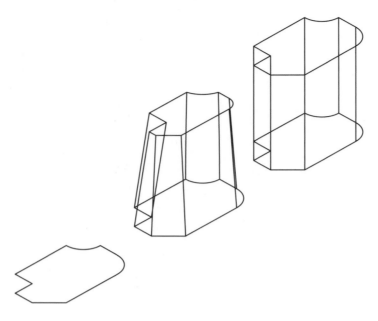

**Figure 3-13**    Extrusion
with Taper

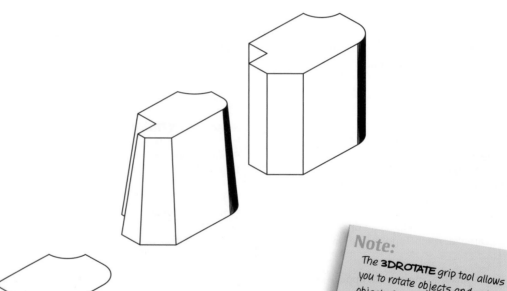

**Figure 3-14**    Extrusions After **HIDE** command

| 3DROTATE | |
|---|---|
| **Ribbon/ Home tab/ Solid edit- ing/3D Rotate** |  |
| **Menu** | Modify/ 3D Operat- ions/3D Rotate |
| **Toolbar: Modeling** | |
| **Command Line** | 3drotate |

> **Note:**
> The **3DROTATE** grip tool allows you to rotate objects and sub-objects freely or to constrain the rotation to an axis.

We will now rotate the arc so that it is perpendicular to the region using the **3DROTATE** grip tool. Change the view to **NE Isometric** (Figure 3-16).

| Prompt | Response |
|---|---|
| Command: | Type: **_3DROTATE <Enter ⏎>** *(or select the **3DROTATE** grip tool)* |
| Current positive angle in UCS: ANGDIR = counterclockwise, ANGBASE = 0 | |
| Select objects: 1 found | *Pick the arc* |
| Select objects: | Type: **<Enter ⏎>** |

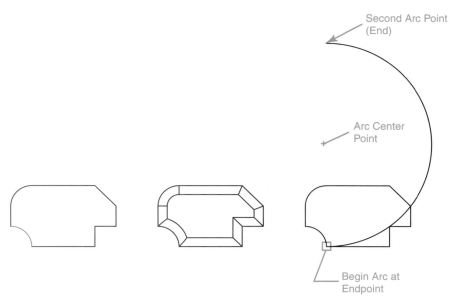

**Figure 3-15**    Arc in Plan View

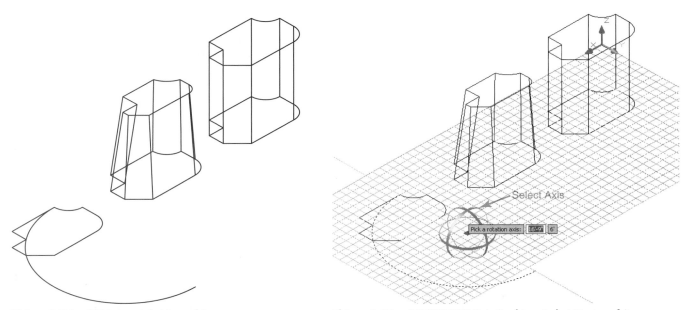

**Figure 3-16**    **NE Isometric** View of Arc

**Figure 3-17**    **3DROTATE** Grip Tool Located at Center of Arc

| | |
|---|---|
| Specify base point: | *With **OSNAP** on, move the icon so that it snaps to the **CENTER** of the arc* |
| Pick a rotation axis: | *Move the arrow around the icon until the Y axis (green axis) changes to yellow (see Figure 3-17)* |
| Specify angle start point or type an angle: | Type: **90 <Enter ↵>** |

Your drawing should appear similar to Figure 3-18.
Extrude the last region along the arc path.

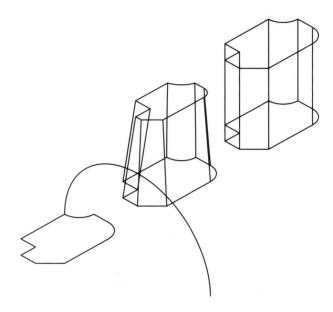

**Figure 3-18** Isometric View of Arc After **3DROTATE**

| Prompt | Response |
|---|---|
| Command: | *Select the* **EXTRUDE** *icon* |
| Current wire frame density: ISOLINES = 4 | |
| Select objects to extrude: | *Pick the region* **<Enter ↵>** |
| Select objects: 1 found | Type: **<Enter ↵>** |
| Specify height of extrusion or [Direction/ Path/Taper angle]: | Type: **P <Enter ↵>** |
| Specify extrusion path or [Taper angle]: | *Pick the arc* **<Enter ↵>** |

Your drawing should appear similar to Figure 3-19. Figure 3-20 shows the results of the **HIDE** command.

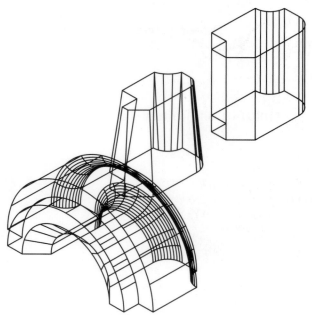

**Figure 3-19**    Extrusion Along the Arc Path

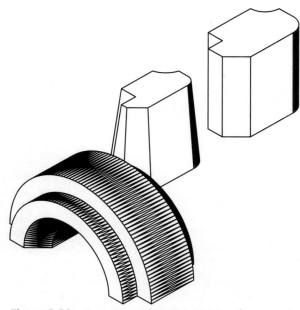

**Figure 3-20**    Extrusion with **HIDE** Command

# EXPLORING VISUAL STYLES

Up to this point, we have viewed drawings primarily as 2D wireframes (default visual style) and 2D hidden views. AutoCAD offers five predefined viewing options for 3D models, called *visual styles*. Visual styles are a collection of settings that control the display of edges and faces of 3D models. The predefined visual styles include the following: **2D Wireframe**, **3D Hidden**, **3D Wireframe**, **Conceptual**, and **Realistic** (see Figure 3-21).

Methods for applying a predefined visual style include clicking the **Visual Style** icon on the **Visual Style** toolbar; selecting **Visual Styles** from the **Menu Browser**, **View** flyout; selecting **Visual Styles** from the **View** pull-down menu (see Figure 3-21), and using the **Visual Styles Manager** palette (see Figure 3-22).

| VISUAL STYLES | |
| --- | --- |
| **Ribbon/ Visualize tab/Visual Styles** | |
| **Menu** | View/ Visual Styles |
| **Command Line** | visual-styles |

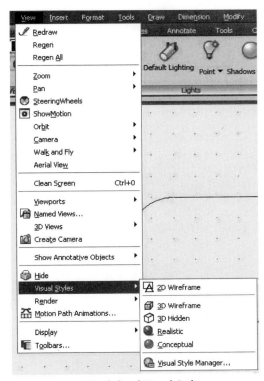

**Figure 3-21**   Predefined Visual Styles

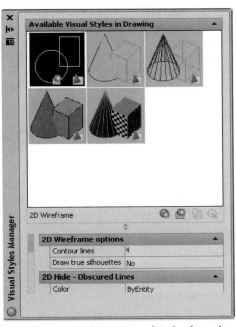

**Figure 3-22**   Selecting Visual Styles from the **Visual Style Manager** Palette

We will explore the predefined visual styles by first changing the **Layer 0** color to magenta (changing the layer color to one other than black will make the visual style differences more obvious).

| Prompt | Response |
| --- | --- |
| Command: | Type: **la <Enter ↵>** (or select the **Layer Manager** icon on the standard toolbar) Left-click on the layer color and select **magenta** |

From the **Visual Styles Manager**, select the **2D Wireframe** option (see Figure 3-23). The **2D Wireframe** visual style shows all the edges of the model and the standard UCS icon. Your drawing should be similar to Figure 3-24.

Select the **3D Wireframe** option from the control panel. The **3D Wireframe** visual style shows all the edges of the model and the 3D UCS icon. Figure 3-25 displays the drawing as a **3D Wireframe** visual style.

**Figure 3-23**    Select the **2D Wireframe** Visual Style Option

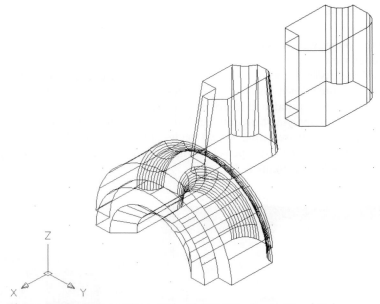

**Figure 3-24**    Drawing Illustrated with **2D Wireframe** Visual Style

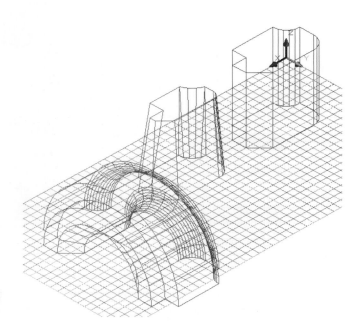

**Figure 3-25**    Drawing Illustrated with **3D Wireframe** Visual Style

The **3D Hidden** visual style removes hidden edges and objects, and displays the 3D UCS icon. Select the **3D Hidden** visual style option and your drawing should be similar to Figure 3-26.

The **Conceptual** visual style shows a warm–cool shaded face style that uses the object color for display. To show the effects of the **Conceptual** visual style, select the **Conceptual** visual style (Figure 3-27).

The **Realistic** visual style illustrates the drawing as a shaded display using the object color or the texture and color of an applied material. Because we have not applied a material to this model, the drawing is displayed with the object/layer color (see Figure 3-28).

Additional temporary drawing enhancements can be modified using the **Visual Styles** control panel (see Figure 3-29). These drawing enhancements include modifying the edges of the object with **Edge overhang**, **Edge jitter**, and **Silhouette edges**. Each of the edge modification types

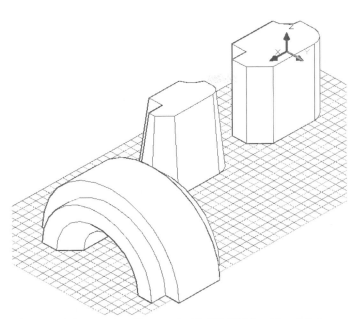

**Figure 3-26**    Drawing Illustrated with **3D Hidden** Visual Style

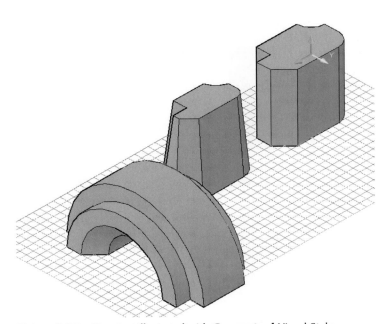

**Figure 3-27**    Drawing Illustrated with **Conceptual** Visual Style

allows you to control the degree to which edges are displayed. You can also change the color of the obscured edges or intersection edges of objects (bottom row of the **Visual Styles** control panel). Figure 3-30 illustrates the drawing using the **Conceptual** visual style with the edge modification settings (shown in Figure 3-29).

Visual style changes using the **Visual Styles** control panel are not saved for the current drawing. To permanently save the **Visual Styles** settings to a drawing file, use the **Visual Styles Manager** (see Figure 3-31). You can also save a visual style by using the **VSSAVE** command. To save a visual style using the **VSSAVE** command, you must be in model space. If you enter a name for the visual style that is already in use, you can either replace the existing visual style or enter a different name.

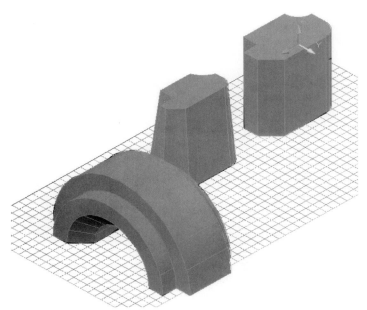

**Figure 3-28**    Drawing Illustrated with **Realistic** Visual Style

**Figure 3-29**    Edge Modifica-
tions Using the **Visual Styles**
Control Panel

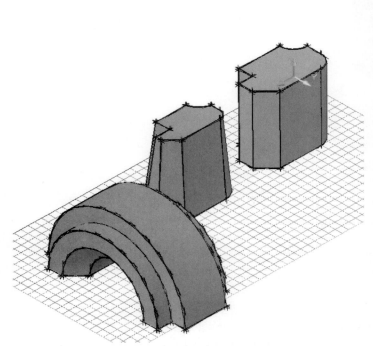

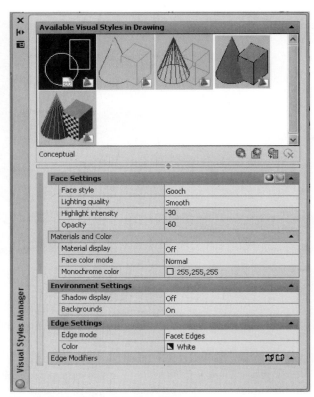

**Figure 3-30**    Drawing Illustrated with **Conceptual** Visual Style with
Edge Modifications

**Figure 3-31**    **Visual Styles Manager**

## INTRODUCTION TO BOOLEAN OPERATIONS

The three Boolean operations, **UNION**, **SUBTRACT**, and **INTERSECT**, allow you to combine regions or solids that coexist on the same plane. You will have additional practice using the Boolean operations in subsequent chapters. The **UNION** operation creates a single solid

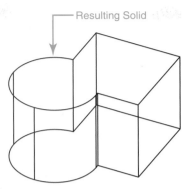

Select Objects

Resulting Solid

**Figure 3-32**    Using the **UNION** Command

by joining two or more independent solids. The process for using the **UNION** command is simple. Invoke the **UNION** command and select the solids you wish to join. Figure 3-32 illustrates two independent solids (cylinder and cube) and the resulting solid produced by using the **UNION** command.

The **SUBTRACT** command allows you to subtract one or more solids from one or more solids. When using the **SUBTRACT** command, you must select the solids to be subtracted from first, then select the solids to subtract. Figure 3-33 illustrates the concept of subtraction by subtracting a solid cylinder from a cube. The solids being manipulated with the **SUBTRACT** command must share some common space, or the **SUBTRACT** command will have no effect on the solids.

The **INTERSECT** command creates a solid from the common area of two or more solids. To create a solid from two or more solids, invoke the command and select all the solids to be included in the selection set (see Figure 3-34).

**Note:**
Objects do not have to share common space to be joined with the **UNION** command.

**Note:**
The **INTERSECT** command leaves only the common area shared by the original solids. The areas of the solids not common to all solids included in the selection set are deleted.

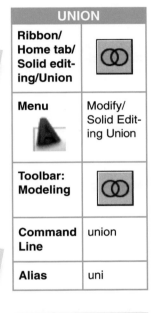

| UNION | |
|---|---|
| **Ribbon/ Home tab/ Solid editing/Union** | |
| **Menu** | Modify/ Solid Editing Union |
| **Toolbar: Modeling** | |
| **Command Line** | union |
| **Alias** | uni |

| SUBTRACT | |
|---|---|
| **Ribbon/ Home tab/ Solid editing/ Subtract** | |
| **Menu** | Modify/ Solid Editing/ Subtract |
| **Toolbar: Modeling** | |
| **Command Line** | subtract |
| **Alias** | su |

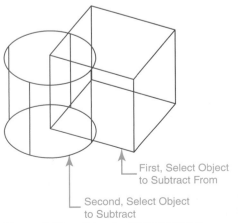
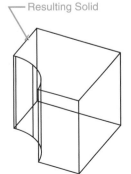

Resulting Solid

First, Select Object to Subtract From

Second, Select Object to Subtract

**Figure 3-33**    Using the **SUBTRACT** Command

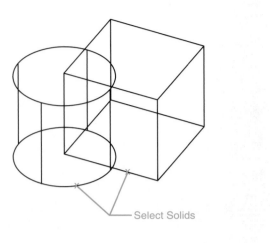
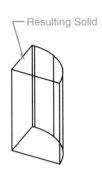

**Figure 3-34**  Using the **INTERSECT** Command

| SWEEP | |
|---|---|
| **Ribbon/ Home tab/ 3D Model- ing/Sweep** | |
| **Menu** | Draw/ Modeling/ Sweep |
| **Toolbar: Modeling** | |
| **Command Line** | sweep |

| LOFT | |
|---|---|
| **Ribbon/ Home tab/ 3D Model- ing/Loft** | |
| **Menu** | Draw/ Modeling/ Loft |
| **Toolbar: Modeling** | |
| **Command Line** | loft |

## INTRODUCTION TO THE SWEEP AND LOFT COMMANDS

The **SWEEP** command allows you to sweep a profile along a path. Using the **SWEEP** command is similar in principle to extruding a profile on a path with the **EXTRUDE** command. Once the objects are selected, options for sweeping profiles include **Aligment**, **Base point**, **Scale**, and **Twist**. These options can also be found on the **SWEEP** command shortcut menu and on the command line after the **SWEEP** command has been invoked. Figure 3-35 illustrates a circle swept along a polyline path (notice that the view is illustrated in the **Conceptual** visual style, and a square swept along a polyline path with a 90° twist.

The **LOFT** command allows you to create 3D solids by lofting two or more cross sections. Depending on the options used (**LOFT** with cross sections only, **LOFT** using a path, or **LOFT** with guide curves), you can generate three different types of 3D solids. Lofting with open guide curves produces a surface. Objects that may be used as cross sections include lines, arcs, circles, ellipses, and splines. Nonintersecting polylines and 3D polylines may also be used as cross sections. Figure 3-36 illustrates a lofting operation using two circles, one located at elevation 0, and the other circle located above the XY plane. An arc connecting the two circles is used as the path.

Figure 3-37 illustrates lofting using cross sections only. The cross sections used were a polyline and an arc. Using the cross sections only opens the **Loft Settings** dialog box, which allows you to control the appearance of the lofted 3D objects at the cross sections (see Figure 3-38).

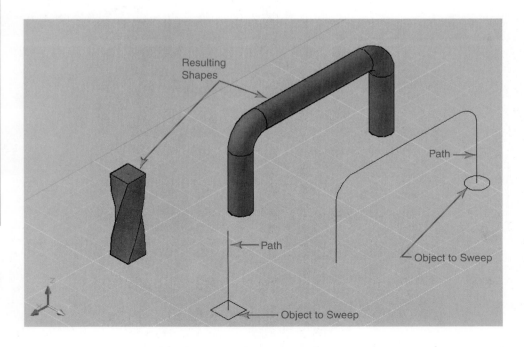

**Figure 3-35**  Circle Swept Along a Polyline Path, and Square Swept with Twist Option

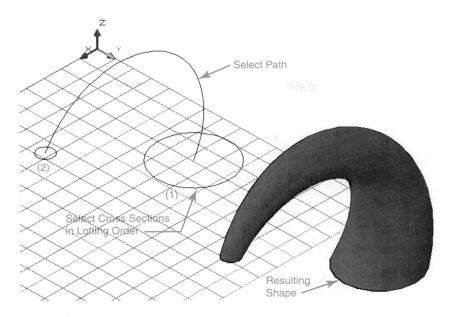

**Figure 3-36** **LOFT** Command Using Two Circles as Cross Sections and an Arc as a Path

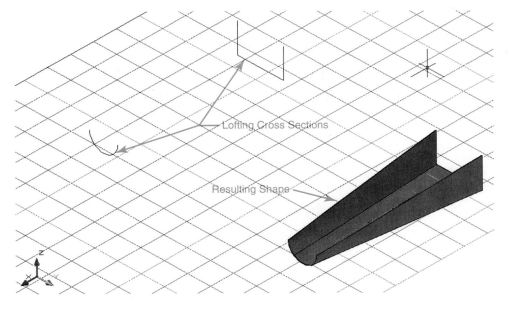

**Figure 3-37** **LOFT** Operation Using a Polyline and an Arc as Cross Sections

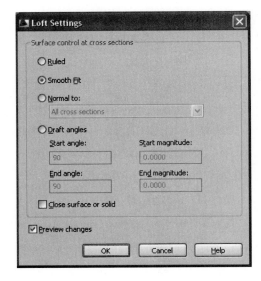

**Figure 3-38** **Loft Settings** Dialog Box

| BOX | |
|---|---|
| **Ribbon/ Home tab/ 3D Model- ing/Box** |  |
| **Menu** | Draw/ Modeling/ Box |
| **Toolbar: Modeling** | |
| **Command Line** | box |

## CREATING SOLIDS USING 3D PRIMITIVES

With AutoCAD you can create simple 3D solids called *primitives*. These solids can be selected from the **Modeling** toolbar; from the **Menu Browser**, **Draw**, **Modeling** menu; from the **Ribbon**, **Home** tab, or entered at the command line. These primitives include the polysolid, box, wedge, cone, sphere, cylinder, pyramid, and torus (see Figure 3-39). The primitive solids can be combined, modified, and/or edited to create complex solids. Furthermore, these types of solids can be modified, or edited, by moving grips or by using the **Properties** palette (see Figure 3-40). To activate the grips, select the 3D solid. Figure 3-41 illustrates a box drawn with the **Box** command and grips activated. (*Note:* The view is a **NE Isometric** view using the **Conceptual** visual style).

Six procedures are typically used for creating a solid box. These procedures include specifying a corner, opposite corner (same plane), and height; specifying two corners

**Note:**
When you draw a box, you must always enter a length, width, and height, regardless of the method for you choose for drawing the box.

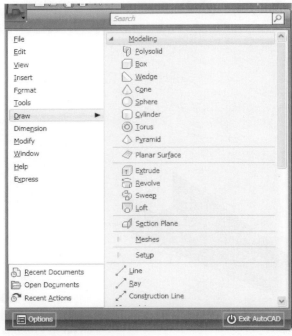

**Figure 3-39**    3D Solid Primitives Located on the **Menu Browser**, **Draw**, **Modeling** Menu

**Figure 3-40**    **Properties** Palette

**Figure 31-41**    3D Box with Grips Activated

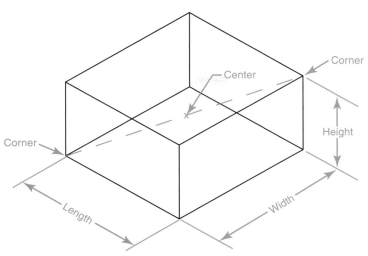

**Figure 3-42**    Points and Distances Used in Drawing a 3D Solid Box

| WEDGE | |
| --- | --- |
| **Ribbon/ Home tab/ 3D Model- ing/Wedge** |  |
| **Menu** | Draw/ Modeling/ Wedge |
| **Toolbar: Modeling** | |
| **Command Line** | wedge |

(diagonally opposite); using the **Cube** option when specifying corner point and length; specifying the center point and one corner point; specifying a corner point and then length, width, and height; and specifying the center point and then length, width, and height. Figure 3-42 illustrates the points and distances used in the process of drawing a 3D solid box.

The processes used for creating a box may also be used to create a wedge. The wedge base is parallel to the XY plane. Figure 3-43 illustrates the distance selections and points used in creating a solid wedge.

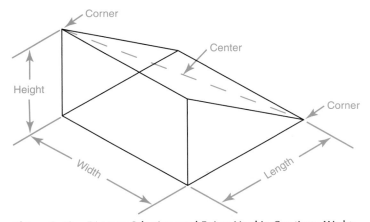

**Figure 3-43**    Distance Selections and Points Used in Creating a Wedge

| CONE | |
| --- | --- |
| **Ribbon/ Home tab/ 3D Model- ing/Cone** | |
| **Menu** | Draw/ Modeling/ Cone |
| **Toolbar: Modeling** | |
| **Command Line** | cone |

The **CONE** command is used to create a cone-shaped solid with either a circular or elliptical base. You can also specify a top radius to produce a cone that does not terminate at a point but has a flattened top instead. Figure 3-44 illustrates distance selections and points for creating a cone.

The **SPHERE** command creates a sphere-shaped solid. The midplane of the sphere is parallel to the XY plane. The most common (default) method of creating a sphere is specifying the center point and a radius or diameter (see Figure 3-45).

The **CYLINDER** command creates a cylindrical 3D solid with a circular or elliptical base (see Figure 3-46). The **CYLINDER** command works much like the **CONE** command.

**Note:**
If the center point of the sphere is located at elevation 0, the bottom half of the sphere is below the XY plane.

| SPHERE | |
| --- | --- |
| **Ribbon/ Home tab/ 3D Model- ing/Sphere** | |
| **Menu** | Draw/ Modeling/ Sphere |
| **Toolbar: Modeling** | |
| **Command Line** | sphere |

| CYLINDER | |
|---|---|
| **Ribbon/ Home tab/ 3D Model- ing/Cylinder** | |
| **Menu** | Draw/ Modeling/ Cylinder |
| **Toolbar: Modeling** | |
| **Command Line** | cylinder |
| **Alias** | cyl |

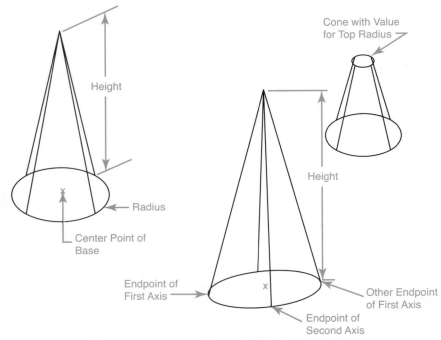

**Figure 3-44**    Distance Selections and Points Used in Creating a Cone

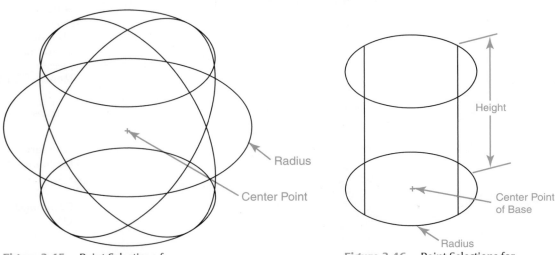

**Figure 3-45**    Point Selections for Creating a 3D Solid Sphere

**Figure 3-46**    Point Selections for Creating a 3D Solid Cylinder

The **TORUS** command creates a torus or donut-shaped 3D solid. The torus is defined by the radius of the tube and the radius of the torus (see Figure 3-47). By changing the value of the torus radius and/or the tube radius, you can produce three distinctive torus shapes (see Figure 3-48). A 3D solid football-shaped torus is produced when the torus radius is negative and the tube radius is positive. A sphere-shaped torus is produced when the torus radius and tube radius are both positive, and the torus radius is smaller than the tube radius.

The **PYRAMID** command creates a pyramid-shaped 3D solid with a polygonal base (see Figure 3-49). If a top radius is specified, a pyramid will have a top, or *apex,* that does not end at a point. The default number of sides for a pyramid is 4, but it can have between 3 and 32 sides.

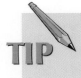

**TIP**

If you specify the height of a pyramid, you can locate the base parallel to the XY plane. If you specify the height using the **Axis endpoint** option, the pyramid axis will be aligned accordingly.

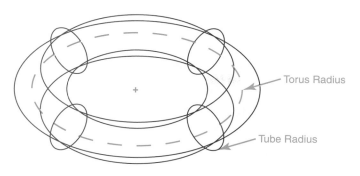

| TORUS | |
|---|---|
| Ribbon/ Home tab/ 3D Model- ing/Torus | |
| Menu | Draw/ Modeling/ Torus |
| Toolbar: Modeling | |
| Command Line | torus |

**Figure 3-47**   Radius Selection Points for Creating a 3D Solid Torus

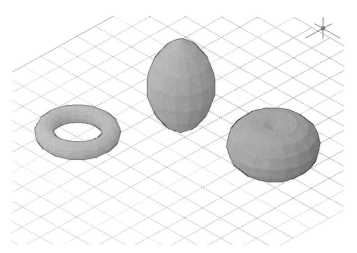

**Figure 3-48**   Alternative 3D Solid Shapes Created with the **TORUS** Command

| PYRAMID | |
|---|---|
| Ribbon/ Home tab/ 3D Model- ing/Pyra- mid | |
| Menu | Draw/ Modeling/ Pyramid |
| Toolbar: Modeling | |
| Command Line | pyramid |

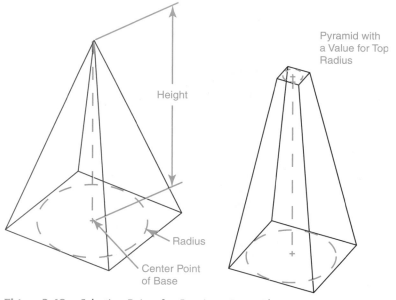

**Figure 3-49**   Selection Points for Creating a Pyramid

| POLYSOLID | |
|---|---|
| Ribbon/ Home tab/ 3D Model- ing/poly- solid | |
| Menu | Draw/ Modeling/ Polysolid |
| Toolbar: Modeling | |
| Command Line | polysolid |

## CREATING SOLIDS USING THE POLYSOLID COMMAND

The **POLYSOLID** command allows you to draw a polysolid with a specified width, height, and justification (see Figure 3-50). Drawing a polysolid is very similar to drawing a polyline. To cre- ate a polysolid, invoke the command; set the width, height, and justification; and enter/select a starting point or select the **<OBJECT>** option to convert an existing object.

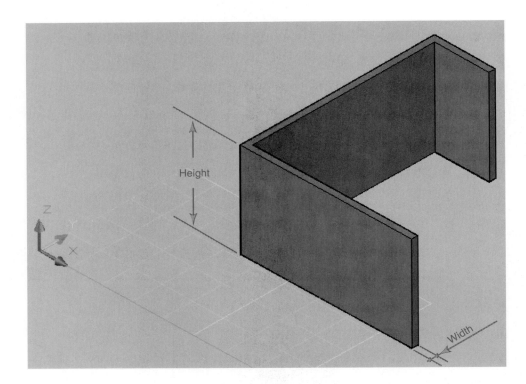

**Figure 3-50**    3D Solid
Drawn with the
**POLYSOLID** Command

You can also use the **POLYSOLID** command to convert an existing line, 2D polyline, arc, or circle to a solid with a rectangular profile; however, the system variables controlling the polysolid width (**POLSWIDTH**) and height (**POLSHEIGHT**) should be set prior to converting an object to a polysolid. Figure 3-51 illustrates converting a polyline to a polysolid.

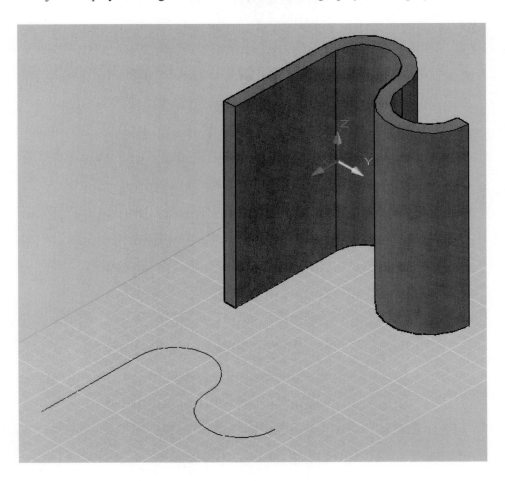

**Figure 3-51**    Polyline
Converted to a Polysolid

# CHAPTER EXERCISES

## Exercise 3-1: Crown Molding

In this exercise, you will create a piece of crown molding by extruding a profile (region). Begin a new drawing; set the **Units** to **Architectural**, **Limits** to **0,0** and **12,9**. A **Grid** spacing of $\frac{1}{2}''$ will help you visualize the placement of objects in the drawing. Draw a polyline shape $\frac{3}{4}'' \times 6''$, similar to Figure 3-52. Use the **CHAMFER** command to bevel the top edges of the profile (see Figure 3-53). Use the **FILLET** command to round the corners as illustrated in Figure 3-54. Draw circles overlapping the polyline shape as shown in Figure 3-55. Create regions from the polyline shape and five circles. Subtract the circle regions from the polyline region to finalize the profile (see Figure 3-56). The resulting region should appear similar to Figure 3-57. To complete the crown molding, change the **View** to **SW Isometric** and use the **EXTRUDE** command to extrude the profile 1′ (see Figure 3-58). Change the **Visual Style** to **Conceptual**. The crown molding should appear similar to Figure 3-59.

**Figure 3-52**   $\frac{3}{4}'' \times 6''$ Polyline Shape

**Figure 3-53**   Chamfer the Top Outside Corners of the Polyline Shape

**Figure 3-54**   Fillet the Bottom Outside Corners of the Polyline Shape

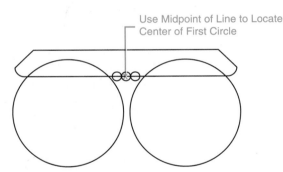

**Figure 3-55**   Draw Circles Overlapping the Polyline Shape

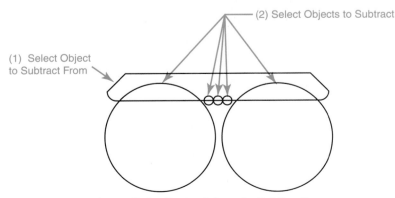

**Figure 3-56**   Subtract Circles (Regions) from the Polyline Shape

**Figure 3-57**   Resulting Region After Subtracting Circular Regions

**Figure 3-58** SW Isometric View of Extruded Region

**Figure 3-59** Conceptual View of Completed Crown Molding

Of course, this tutorial simply shows how to create a piece of crown molding. On a project such as creating a piece of crown molding for a wall you would want to verify the distance (wall length) in which to extrude the crown molding region before actually extruding the profile.

### Exercise 3-2: Floral Medallion

3D modeling in AutoCAD does not have to be a difficult process. In this exercise, you will model a stylized floral medallion using very simple commands. The commands used in this exercise include **CIRCLE**, **REGION**, **ARRAY**, **INTERSECT**, **EXTRUDE**, and **FILLET**.

Begin a new drawing; set the **Units** to **Architectural**, **Limits** to **0,0** and **12,9**, and **Grid** to $\frac{1}{2}''$. In the center of the drawing screen, draw a circle with a 1″ diameter. Using the **COPY** command, place a copy of the circle 1″ to the right of the original circle (see Figure 3-60).

Using the **REGION** command, create regions from the two circles. Using the **INTERSECT** command, select the two regions. The resulting shape should be similar to Figure 3-61.

Draw a circle with a $\frac{1}{2}''$ diameter and a center point $\frac{1}{4}''$ directly below the bottom endpoint of the region (see Figure 3-62). Change the **View** to **NE Isometric** (see Figure 3-63).

Using the **EXTRUDE** command, extrude the football-shaped region $\frac{1}{8}''$ (in the positive Z direction). Your drawing should appear similar to Figure 3-64.

Using the **FILLET** command with the radius set at $\frac{1}{8}''$, fillet the top two edges of the region (see Figure 3-65). Your drawing should appear similar to Figure 3-66.

**Figure 3-60** Original Circle and Copied Circle

**Figure 3-61** Resulting Region After Using the **INTERSECT** Command

**Figure 3-62** Circle Drawn Below Region

**Figure 3-63** NE Isometric View of Circle and Region

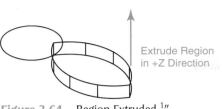

**Figure 3-64**    Region Extruded $\frac{1}{8}''$

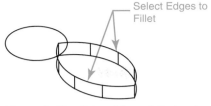

**Figure 3-65**    Select Edges of Region to Fillet

**Figure 3-66**    Edges of Region After Fillet

One petal of the floral medallion is now complete. The medallion needs an additional 11 petals and an extruded center to be complete. Rather than redraw the medallion 11 more times, use the **POLAR ARRAY** command to produce the remaining petals.

At the command prompt, type **ar (ARRAY)**, or select the **ARRAY** icon on the **Modify** toolbar. The **Array** dialog box is opened (see Figure 3-67). The **ARRAY** command allows you to create copies of objects in either a rectangular or polar (circular) pattern.

| ARRAY | |
|---|---|
| **Ribbon/ Home tab/ Modify/ Array** | |
| **Menu** | Modify/ Array |
| **Modify Toolbar** | |
| **Command Line** | array |
| **Alias** | ar |

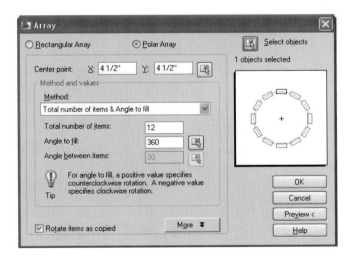

**Figure 3-67**    **Array** Dialog Box

In the **ARRAY** dialog box, make the following selections: click on the radio button for **Polar Array**; click on the **Select objects** button and select the region; click on the button to the right of the *Center point* X and Y input boxes, and using **Osnap Center**, select the center point of the circle; in the **Total number of items** box, type **12**. Select the **Preview** option in the lower right corner of the dialog box. **Accept** or **Cancel** appears at the command prompt (Figure 3-68). If the preview of the array is correct, right-click to accept. If the array is not correct, press the <**Esc**> key to return to the dialog box and make the necessary changes. Your drawing should appear similar to Figure 3-69 after arraying the region.

**Figure 3-68**    Array Preview

**Figure 3-69**    Drawing After **ARRAY** Command

Use the **EXTRUDE** command to extrude the circle $\frac{1}{8}''$, then with the **FILLET** command, round the top edge of the extruded circle with a fillet radius of $\frac{1}{8}''$. Your drawing should appear similar to Figure 3-70, which is in **2D Wireframe** visual style. Change the **Visual Style** to **Conceptual** to produce a view similar to Figure 3-71.

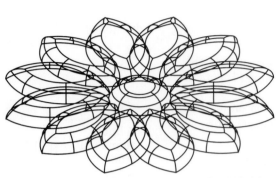

**Figure 3-70**   *2D Wireframe* View of Stylized Floral Medallion

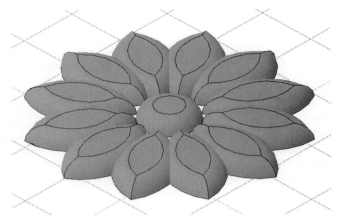

**Figure 3-71**   *Conceptual* Visual Style of Stylized Floral Medallion

| LINE | |
|---|---|
| **Ribbon/ Home tab/ Draw/Line** | |
| **Menu** | Draw/ Line |
| **Toolbar: Draw** | |
| **Command Line** | line |
| **Alias** | l |

| ARC | |
|---|---|
| **Ribbon/ Home tab/ Draw/Arc** | |
| **Menu** | Draw/Arc/ 3 Points |
| **Toolbar: Draw** | |
| **Command Line** | arc |
| **Alias** | a |

**Exercise 3-3:** Oval Mirror and Frame

In this exercise, you will draw a profile (section) suitable for a mirror frame and sweep the profile around an oval (elliptical) path. Begin by starting a new drawing. Set the **Units** to **Architectural**, **Limits** to **0,0** and **6′,4′**. Set the **Grid** to **1″** and **Zoom All**.

Zoom into an area on the right side of the drawing area approximately 6″ × 6″. Use the **LINE**, **ARC**, and **CIRCLE** commands to produce a profile similar to Figure 3-72.

Use a fillet radius of $\frac{1}{8}''$, and fillet the three corners as indicated in Figure 3-73. Use the **TRIM** command and trim the inside half of the circle and the portion of the line that is inside the circle.

**Zoom All**, and with the **ELLIPSE** command, draw an ellipse using the **axis endpoints** option with the first axis (horizontal) 2′ and second axis (vertical) 3′ on the left side of the profile (see Figure 3-74).

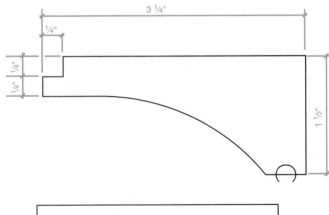

**Figure 3-72**   Beginning Mirror Frame Profile

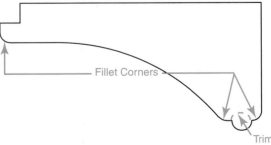

**Figure 3-73**   Fillet Three Corners and Trim the Circle and Line

Figure 3-74    2′ × 3′ Ellipse Drawn to the Left of the Profile Shape

| CIRCLE | |
|---|---|
| Ribbon/ Home tab/ Draw/ Circle | |
| Menu | Draw/ Circle |
| Toolbar: Draw | |
| Command Line | circle |
| Alias | c |

Change the **View** to **SW Isometric** (it is much easier to see three-dimensional rotation angles in 3D than in 2D plan view). Using the **3DROTATE** command or the **3DROTATE** grip tool, rotate the ellipse 90° about the X axis (see Figure 3-75). After you have rotated the ellipse 90° your drawing should appear similar to Figure 3-76.

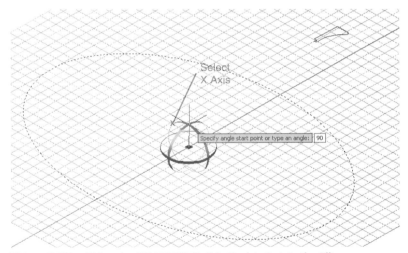

Figure 3-75    Using the **3D ROTATE** Grip Tool to Rotate the Ellipse

| FILLET | |
|---|---|
| Ribbon/ Home tab/ Modify/ Fillet | |
| Menu | Modify/ Fillet |
| Toolbar: Modify | |
| Command Line | fillet |
| Alias | f |

| 3D ROTATE | |
|---|---|
| Ribbon/ Home tab/ Solid editing/ 3D Rotate | |
| Menu | Modify/ 3D Operations/ 3D Rotate |
| Toolbar: Modeling | |
| Command Line | 3drotate |

You can use the **PE** (polyline edit) command to join the lines, arcs, and parts of circles into a closed polyline to sweep around the elliptical path. The **BOUNDARY** command, however, is a more time-efficient command to use in this case. The **BOUNDARY** command creates a region or polyline from existing objects that form an enclosed area. At the command prompt, type **BOUNDARY**. When the **BOUNDARY** command is invoked, the **Boundary Creation** dialog box is displayed (see Figure 3-77).

Using the **BOUNDARY** command, create a region by picking a point inside the profile shape. If the command is successful, you will receive a response at the command line stating "1 loop extracted; 1 Region created; BOUNDARY created 1 region". Using the **ROTATE** command, pick the region (use l for "last") and rotate the region 270°. Notice that the original shape consisting of lines, arcs, and parts of circles remains (see Figure 3-78).

**Figure 3-76**  Ellipse After Rotating 90 Degrees

**Figure 3-77  Boundary** Dialog Box

**Figure 3-78**  Rotate the Region 270 Degrees

| ELLIPSE | |
|---|---|
| Ribbon/ Home tab/ Draw/ Ellipse | |
| Menu | Draw/ Ellipse |
| Toolbar: Draw | |
| Command Line | ellipse |
| Alias | el |

Before sweeping the region around the elliptical path, make a copy using the same base point and second point of displacement of the ellipse. The copied region will serve as the framed mirror solid. Using the **MOVE** command and **l** ("last") selection option, move the copy of the ellipse 6″ in the Z direction (**m** <**Enter ↵**>, then **l** <**Enter ↵**>, then **0,0,0** for the base point and **0,0,6** for the second point of displacement (see Figure 3-79). Extrude the copied region $\frac{1}{4}$″ in the −Y direction.

The **SWEEP** command allows you to sweep a profile around a path. Invoke the **SWEEP** command and select the profile as the object to sweep. Type **B** to enter the base point option, and using **′Z** (transparent zoom), zoom in closely around the profile and select the inside corner (endpoint) of the mirror frame rabbet joint (see Figure 3-80). Select the ellipse (original, not extruded) as the path. The results should be similar to Figure 3-81.

**Figure 3-79**  Move and Extrude the Copied Ellipse

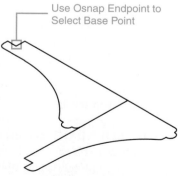

**Figure 3-80**  Base Point of Profile for **SWEEP** Command

**Figure 3-81**   Region Swept Around the Elliptical Path

Change the color of the swept region (frame) to AutoCAD #37 (brownish color) and the color of the extruded region representing the mirror to AutoCAD #131 (light blue); use **CHANGE**, **Properties**, **Color** invoked from the command line. This will allow you to produce a shaded or rendered view that would be similar to using a wood material for the frame and a mirror.

Using the **MOVE** command, move the mirror solid back to its original position (**M**, then **0,0,0** as the base point, and **0,0,−6** as the second point of displacement). Change the **Visual Style** to **Conceptual** to see the results (see Figure 3-82).

To complete this exercise, erase the original line (line, arcs, circles) drawing used to create the region. Notice in Figure 3-82 that half the model is located above the X,Y plane and half the model is located below the X,Y plane. Use the **MOVE** command, select both parts of the model (mirror and frame), and move the objects 1′-9″ in the +Z direction (**M**, then select both objects to move, then use **0,0,0** as the base point, and **0,0,1′9**, as the second point of displacement). See Figure 3-83.

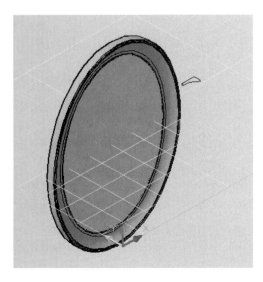

**Figure 3-82**   Mirror and Frame Displayed with Conceptual Visual Style

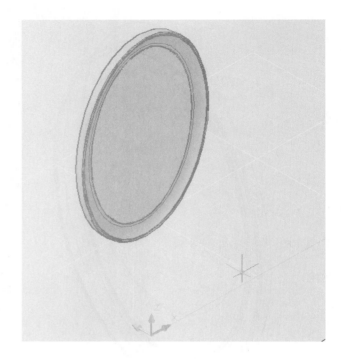

**Figure 3-83**    Mirror and Frame
Located Above the X,Y Plane

**Exercise 3-4:** Molded Seating Component

| POLYGON |  |
|---------|--|
| Ribbon/ Home tab/ Draw/ Polygon | |
| Menu | Draw/ Polygon |
| Toolbar: Draw | |
| Command Line | polygon |

In this exercise, you will use the **POLYGON** command to create a basic shape for a molded seating component. Then, you will use the **OFFSET** and **MOVE** commands to produce closed polylines at appropriate heights for the seat and back. To complete the seating component, you will perform a lofting operation using the **LOFT** command.

The **POLYGON** command creates an equilateral closed polyline. The polygon can contain from 3 to 1,024 sides. You can draw a polygon inscribed in a circle or circumscribed about a circle, or you can specify the endpoints of the first edge (see Figure 3-84).

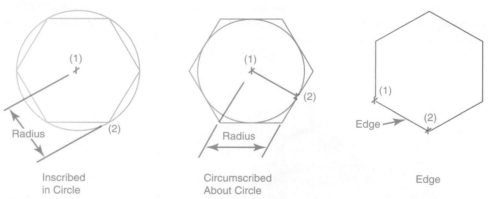

Inscribed in Circle    Circumscribed About Circle    Edge

**Figure 3-84**    Options for Drawing a Polygon

Begin a new drawing; set the **Units** to **Architectural**, **Limits** to **0,0** and **12′,9′**, and **Grid** to **6**, and **Zoom All**. The seating component will be for six individuals. With **Ortho** on, draw a polygon with six sides using the **Edge** option with a length of 36″ near the bottom center of the drawing area (see Figure 3-85).

You will use the **LOFT** command to produce the 3D solid representation of the seating component by lofting through a series of four curves. To produce the remaining three curves use the **OFFSET** command to produce two curves representing the inside seat bottom and inside seat

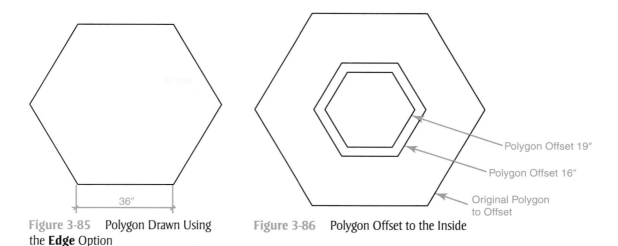

**Figure 3-85**    Polygon Drawn Using the **Edge** Option

**Figure 3-86**    Polygon Offset to the Inside

top, and the **COPY** command to produce the front seat edge. Offset the original polygon twice: 16″ to the inside, and 19″ to the inside (see Figure 3-86). Change the **View** to **NE Isometric** and copy the original (outside) polygon using a base point of 0,0,0 and a second point of displacement of 0,0,16 (see Figure 3-87).

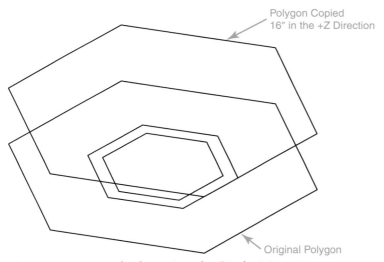

**Figure 3-87**    Original Polygon Copied 16″ in the Z Direction

Using the **MOVE** command, move the middle polygon in the Z direction 16″ (**M**, select middle polygon, base point **0,0,0**, and **0,0,16** for the second point of displacement). Move the inside polygon in the Z direction 36″ (**M**, select the inside polygon, base point **0,0,0**, and **0,0,36** for the second point of displacement). Your drawing should be similar to Figure 3-88.

Use the **LOFT** command to create a new solid by specifying a series of cross sections, in this case, the polygons just drawn and moved to heights appropriate for a seating component. The cross sections define the profile (shape) of the resulting solid.

Invoke the **LOFT** command. Select the polygons beginning with the outside bottom, then the outside top, then the middle polygon, and finally the top polygon (see Figure 3-89). Choose the **<Cross-sections only>** option in the command line and select **Smooth Fit** on the **Loft Settings** dialog box. Your drawing should appear similar to Figure 3-90.

The 2D wireframe view of the seating component does not fully illustrate a realistic view. Change the color of the seating component to #31 (light brown) or a similar color and select the **Conceptual** visual style to produce a more realistic view (see Figure 3-91).

| LOFT | |
|---|---|
| **Ribbon/ Home tab/ 3D Modeling/Loft** | |
| **Menu** | Draw/ Modeling/ Loft |
| **Toolbar: Modeling** | |
| **Command Line** | loft |

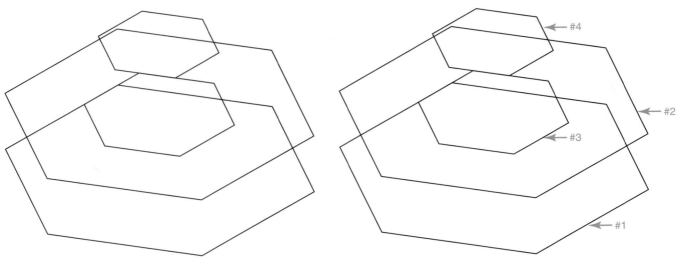

**Figure 3-88**   Inside Polygons After **MOVE** Commands      **Figure 3-89**   Order of Polygon Selections for **LOFT** Command

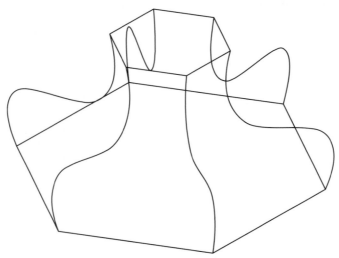

**Figure 3-90**   2D Wireframe of Completed Seating Component

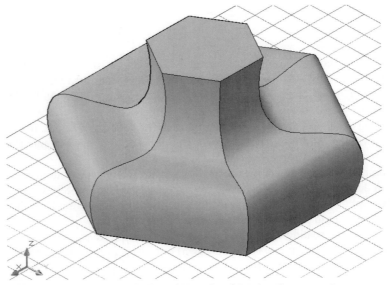

**Figure 3-91**   Conceptual View of Completed Seating Component

## SUMMARY

In this chapter, you learned the basic process for setting up a new drawing and saving a template file. The creation of complex profiles using standard 2D drafting commands allowed you to use the **REGION** and **EXTRUDE** commands to produce complex solid models. The **FILLET** and **CHAMFER** commands were used to modify edges of 3D solids. Visual styles were introduced and used to display models in five predefined viewing options.

Five methods for selecting three-dimensional points of view were discussed. Developing an understanding of methods for selecting points of view increases drafting and modeling efficiency and may reduce modeling errors.

You also learned the commands necessary for creating 3D solid primitives and how they may be modified using Boolean operation commands such as **SUBTRACT**, **UNION**, and **INTERSECT**. The **SWEEP** and **LOFT** commands were introduced and used to produce complex objects following simple processes.

The exercises in this chapter provided you with a basic understanding of solid modeling commands and techniques using simple processes. The subsequent chapters will provide you with additional experience and practice in constructing more elaborate solid models.

## CHAPTER TEST QUESTIONS

### Multiple Choice

1. Which of the following commands can be used to bevel the edges of a solid box?
   a. **FILLET**
   b. **ANGLE**
   c. **CHAMFER**
   d. **INTERFERE**
   e. **UNION**

2. Which of the following commands can be used to round the edges of a solid box?
   a. **ROUND**
   b. **SUBTRACT**
   c. **INTERSECT**
   d. **FILLET**
   e. **CHAMFER**

3. Which of following commands can be used to join solids located on the same plane?
   a. **SUBTRACT**
   b. **JOIN**
   c. **UNION**
   d. **INTERFERE**
   e. **EXTRUDE**

4. Which of the following commands can be used to create a 2D region from a closed polyline shape?
   a. **EXTRUDE**
   b. **REGION**
   c. **REGEN**
   d. **REGENALL**
   e. **PEDIT**

5. Which of the following is not a 3D solid primitive?
   a. Box
   b. Wedge
   c. Spire
   d. Cone
   e. Cylinder

6. Which of the following commands may be used to create a single solid from the common mass of two overlapping solids?
   a. **INTERSECT**
   b. **SUBTRACT**
   c. **UNION**
   d. **INTERFERE**
   e. **BISECT**

7. Which of the following commands allows you to subtract one solid from another, provided they share common mass and are located on the same plane?
   a. **INTERFERE**
   b. **INTERSECT**
   c. **UNION**
   d. **SUBTRACT**
   e. **FORMAT**

8. Which of the following settings control coordinate and angle display formats and precision?
   a. **Limits**
   b. **Area**
   c. **Architectural**
   d. **Decimal**
   e. **Units**

9. Which of the following commands creates either a region or a polyline from an enclosed area?
   a. **BOUNDARY**
   b. **REGION**
   c. **EXTRUDE**
   d. **SWEEP**
   e. **PEDIT**

10. Which of the following is not one of the five predefined visual styles?
    a. **Conceptual**
    b. **2D Wireframe**
    c. **3D Wireframe**
    d. **Realistic**
    e. **Sketch**

## Matching

**Column A**

a. **REGION**

b. **SUBTRACT**

c. **UNION**

d. **FILLET**

e. **CHAMFER**

f. **INTERSECT**

g. **BOUNDARY**

h. **EXTRUDE**

i. **LOFT**

j. **SWEEP**

**Column B**

1. Creates a 3D solid by extruding an object a specified distance and direction

2. Creates a 3D solid or surface by sweeping a 2D curve along a path

3. Converts an object that encloses an area into a region object

4. Creates a 3D solid or surface by lofting through a set of two or more curves

5. Combines selected regions or solids by addition

6. Creates composite solids from the intersection of two or more solids or regions and removes the areas outside the intersection

7. Combines selected regions or solids by subtraction

8. Bevels the edges of objects

9. Rounds and fillets the edges of objects

10. Creates a region or polyline from an enclosed area

## True or False

1. T or F: It takes two sets of coordinates to set the drawing limits.

2. T or F: You can create a region from an open polyline.

3. T or F: With the **SUBTRACT** command, you can subtract one closed polyline shape from another.

4. T or F: The **FILLET** command allows you to bevel the edges of objects.

5. T or F: Using the **VPOINT** command with **–1,–1,1** produces the same view as the predefined **SW Isometric**.

6. T or F: The **3DROTATE** command allows you to move objects about a three-dimensional axis.

7. T or F: Objects do not have to share common space to be joined with the **UNION** command.

8. T or F: Nonintersecting polylines and 3D polylines may be used as cross sections in a lofting operation.

9. T or F: If the center point of a sphere is located on the X,Y plane, half of the sphere is below elevation 0, half of the sphere is above the X,Y plane.

10. T or F: The **CONE** command may be used to create a cone-shaped solid with either a circular or elliptical base.

# Lamp

# 4

## Chapter Objectives

- Set up a new drawing
- Create a polyline lamp and lampshade profile
- Use **FILLET** to edit the lamp profile
- Use the **BOUNDARY** command
- Create three-dimensional solids with the **REVOLVE** command
- Practice using the **3DROTATE** command

## INTRODUCTION

In this chapter, you will learn how to create 3D solids by revolving profiles about an object using the **REVOLVE** command. The **REVOLVE** command allows you to create a solid or surface by revolving 2D objects about an axis.

We will draw profiles of a lamp base and lampshade using the **POLYLINE** command, and we will edit the lamp-base polyline profile with the **FILLET** command. We will draw an axis with the **LINE** command to use as the **Object** option to define the axis of revolution.

We will set the **ISOLINES** system variable (specifies the number of contour lines per surface on objects) and the **FACETRES** system variable (controls the smoothness of shaded and rendered objects). Using the **3DROTATE** command, we will rotate the lamp into an upright position.

## DRAWING SETUP

Begin a new drawing and set the **Units** to **Architectural**, **Precision** to $\frac{1}{16}''$. Set the **Limits** to **0,0** and **4',3'**. Set the **Grid** to $\frac{1}{2}''$ and **Zoom All**.

## BEGIN DRAWING

| LINE | |
|------|------|
| Ribbon/ Home tab/ Draw/ Line | |
| Menu | Draw/ Line |
| Toolbar: Draw | |
| Command Line | line |
| Alias | l |

| Prompt | Response |
|--------|----------|
| Command: | Type: **l <Enter ↵ >** (*or select the **LINE** icon*) |
| LINE Specify first point: | Type: **2',6 <Enter ↵ >** (*absolute coordinates*) |
| Specify next point or [Undo] | Type: **@1'6<90 <Enter ↵ >** (*or with **Ortho** on, move the mouse up and type 1'6*) |
| Specify next point or [Undo] | Type: **<Enter ↵ >** |

The line just created will be the axis. Make a note of the beginning point. The beginning point, also called the *absolute coordinate,* is 2',6 in this case.

We will use this beginning point as the base point on the X axis (0,0,0) to rotate the lamp three-dimensionally to the upright position, and we will use the **3DROTATE** command for the actual

| POLYLINE | |
|---|---|
| Ribbon/ Home tab/ Draw/ Polyline | 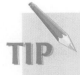 |
| Menu | Draw/ Polyline |
| Toolbar: Draw | |
| Command Line | pline |
| Alias | pl |

rotation. In the next step, we will draw a polyline profile representing the lamp-base profile or the object to be revolved. Then we will draw the lampshade profile with a polyline and use the **REVOLVE** command to revolve the polyline around an object (the endpoint of the line just drawn).

| Prompt | Response |
|---|---|
| Command: | *Select the **POLYLINE** icon* |
| Specify start point | Type: **END <Enter ↵ >** *(Osnap, Endpoint)* |
| of | *Pick the bottom of the line* |
| Current line-width is 0'-0" | |
| Specify next point or [Arc/Close/ Halfwidth/Length/Undo/Width] | Type: **@3<0 <Enter ↵ >** |
| Specify next point or [Arc/Close........] | Type: **@3/4<90 <Enter ↵ >** |
| Specify next point or [Arc/Close........] | Type: **@2-1/2<180 <Enter ↵ >** |
| Specify next point or [Arc/Close........] | Type: **@2<90 <Enter ↵ >** |
| Specify next point or [Arc/Close........] | Type: **@4<45 <Enter ↵ >** |
| Specify next point or [Arc/Close........] | Type: **@2<90 <Enter ↵ >** |
| Specify next point or [Arc/Close........] | Type: **@3<145 <Enter ↵ >** |
| Specify next point or [Arc/Close........] | Type: **PER<Enter ↵ >** |
| To | *Pick the first line drawn* **<Enter ↵ >** |
| Specify next point or [Arc/Close........] | Type: **C <Enter ↵ >** |

**TIP**     With Ortho mode turned on, you can move the mouse in a horizontal or vertical direction and enter a direct distance; that is, typing **@3′ <0** is the equivalent of moving the mouse to the right and typing **3′** with **Ortho** mode on.

Your drawing should appear similar to Figure 4-1.
Use the **FILLET** command to round the corners of the profile (see Figure 4-2).

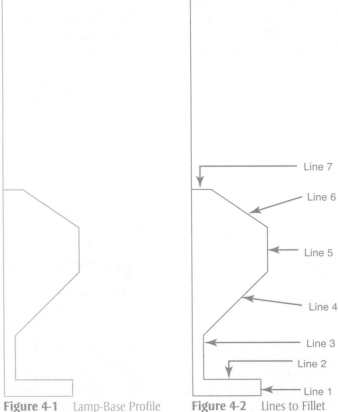

**Figure 4-1**  Lamp-Base Profile          **Figure 4-2**  Lines to Fillet

| **Prompt** | **Response** |
|---|---|
| Command: | Select the **FILLET** icon |
| Current settings: Mode = TRIM, Radius = 0′-0″ | |
| Select first object or [Undo/Polyline/ Radius/Trim/Multiple]: | Type: **R <Enter ↵ >** |
| Specify fillet radius <0′-0″>: | Type: **1/2 <Enter ↵ >** |
| Select first object or [Undo/Polyline/ Radius/Trim/Multiple]: | Type: **M** |
| Select first object or [Undo/Polyline/ Radius/Trim/Multiple]: | Pick line 1 (see Figure 4-2) |
| Select second object or shift-select to apply corner: | Pick line 2 |
| Select first object or [Undo/Polyline/ Radius/Trim/Multiple]: | Pick line 2 |
| Select second object or shift-select to apply corner: | Pick line 3 |
| Select first object or [Undo/Polyline/ Radius/Trim/Multiple]: | Pick line 3 |
| Select second object or shift-select to apply corner: | Pick line 4 |
| Select first object or [Undo/Polyline/ Radius/Trim/Multiple]: | Pick line 4 |
| Select second object or shift-select to apply corner: | Pick line 5 |
| Select first object or [Undo/Polyline/ Radius/Trim/Multiple]: | Pick line 5 |
| Select second object or shift-select to apply corner: | Pick line 6 |
| Select first object or [Undo/Polyline/ Radius/Trim/Multiple]: | Pick line 6 |
| Select second object or shift-select to apply corner: | Pick line 7 |
| Select first object or [Undo/Polyline/ Radius/Trim/Multiple]: | Type: **<Enter ↵ >** |

| **FILLET** | |
|---|---|
| **Ribbon/ Home tab/ Modify/ Fillet** | 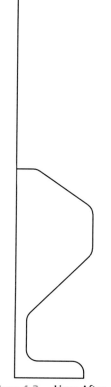 |
| **Menu** | Modify/ Fillet |
| **Toolbar: Modify** | |
| **Command Line** | fillet |
| **Alias** | f |

Your drawing should appear similar to Figure 4-3.

In the next step, we will draw a polyline profile for the lampshade. We will assign a width of $\frac{1}{8}''$ to the polyline to give it thickness.

| **Prompt** | **Response** |
|---|---|
| Command: | Select the **POLYLINE** icon |
| PLINE | |
| Specify start point: | Type: **2′2,1′11 <Enter ↵ >** |
| Current line width is 0′-0″ | |
| Specify next point or [Arc/Halfwidth/ Length/Undo/Width]: | Type: **W <Enter ↵ >** |
| Specify starting width <0′-0″>: | Type: **1/8 <Enter ↵ >** |
| Specify ending width <0′-0$\frac{1}{8}$″>: | Type: **<Enter ↵ >** |
| Specify next point or [Arc/Halfwidth/ Length/Undo/Width]: | Type: **@8<300 <Enter ↵ >** |
| Specify next point or [Arc/Close/ Halfwidth/Length/Undo/Width]: | Type: **<Enter ↵ >** |

The lamp profiles are now ready to be revolved, but before we use the **REVOLVE** command, we will set the **ISOLINES** and **FACETRES** system variables. The **ISOLINES** system variable specifies the number of contour lines per surface on objects. The default setting for **ISOLINES** is 4, but it can range from 0 to 2,047. We will set the **ISOLINES** system variable to 20. The **FACETRES** system variable controls the smoothness of shaded and rendered objects. The

**Figure 4-3**    Lines After **FILLET** Command

default setting of the **FACETRES** system variable is 0.5, but it can range from 0.01 to 10.0. We will set the **FACETRES** system variable to 5.

| Prompt | Response |
|---|---|
| Command: | Type: **ISOLINES <Enter ↵>** |
| Enter new value for ISOLINES <4>: | Type: **20 <Enter ↵>** |
| Command: | Type: **FACETRES <Enter ↵>** |
| Enter new value for FACETRES <0.5000> | Type: **5 <Enter ↵>** |

Use the **REVOLVE** command to revolve the lamp-base and lampshade profiles around the selected axis (object).

| Prompt | Response |
|---|---|
| Command: | *Select the* **REVOLVE** *icon* |
| REVOLVE | |
| Current wire frame density: ISOLINES = 20 | |
| Select objects to revolve: | *Pick the lamp-base profile* |
|   1 found | |
| Select objects to revolve: | *Pick the lampshade profile* |
|   1 found, 2 total | |
| Select objects to revolve: | Type: **<Enter ↵>** |
| Specify axis start point or define | |
|   axis by [Object/X/Y/Z] <Object>: | Type: **O <Enter ↵>** |
| Select an object: | *Pick the top portion of the axis line* |
| Specify angle of revolution or | |
|   [STart angle] <360>: | Type: **<Enter ↵>** |

| REVOLVE | |
|---|---|
| **Ribbon/ Home tab/ 3D Model- ing/Revolve** | |
| **Menu** | Draw/ Modeling Revolve |
| **Toolbar: Modeling** | |
| **Command Line** | revolve |
| **Alias** | rev |

Figure 4-4 shows the lamp-base and lampshade profiles (objects to revolve) and the axis of revolution defined by object (line). Figure 4-5 illustrates the results of the **REVOLVE** command.

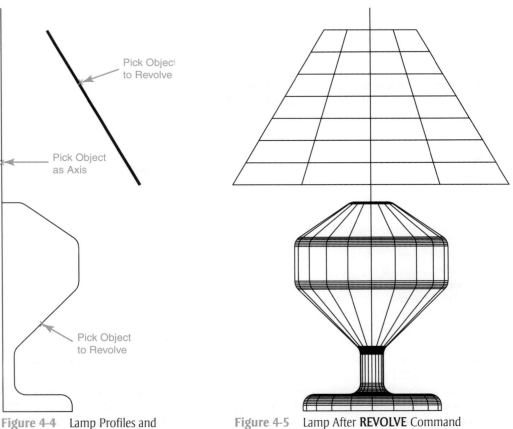

**Figure 4-4**   Lamp Profiles and Axis of Revolution

**Figure 4-5**   Lamp After **REVOLVE** Command

The two final steps in completing the lamp involve using the **3DROTATE** command to rotate the lamp to a vertical position (with the top in the Z direction) and then adding a stem between the lamp base and the lampshade. Change the view to **SW Isometric** using the **3D Views** flyout on the **View** pull-down menu or the **View** menu located on the **Menu Browser** 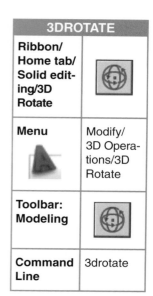.

| Prompt | Response |
|---|---|
| Command: | *Select the* ***3DROTATE*** *icon* |
| Command: _3drotate | |
| Current positive angle in UCS: | |
| ANGDIR = counterclockwise; ANGBASE = 0 | |
| Select objects: Specify opposite corner: | *Pick a window around the entire lamp* |
| 3 found | |
| Select objects: | Type: **<Enter ↵ >** |
| Specify base point: | *Select the endpoint of the line* (see Figure 4-6) |
| Pick a rotation axis: | *Select the X axis* |
| Specify angle start point or type an angle: | Type: **90** |

**3DROTATE**

| | |
|---|---|
| **Ribbon/ Home tab/ Solid editing/3D Rotate** | |
| **Menu** | Modify/ 3D Operations/3D Rotate |
| **Toolbar: Modeling** | |
| **Command Line** | 3drotate |

Your drawing should appear similar to Figure 4-7.

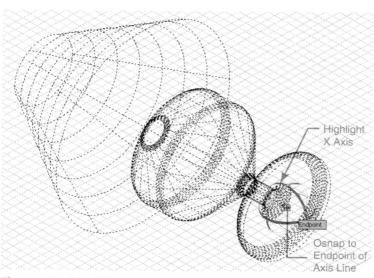

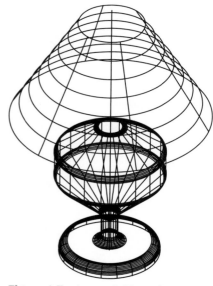

Highlight X Axis

Endpoint

Osnap to Endpoint of Axis Line

**Figure 4-6**    **3DROTATE** Command in SW Isometric View

**Figure 4-7**    Isometric View of Lamp After **3DROTATE**

When we rotated the lamp to a vertical position, we included the line we used for the axis of revolution. The line should be erased so that it will not show in elevation or isometric views. The line can easily be erased in an elevation view. Before proceeding with the following instructions, change the view to **Front** using the the **3D Views** flyout on the **Menu Browser View** menu (see Figures 4-8 and 4-9).

| Prompt | Response |
|---|---|
| Command: | Type: **ERASE <Enter ↵ >** |
| ERASE | |
| Select objects: | *Pick the top of the line used for the axis of revolution* |
| Select objects: 1 found | Type: **<Enter ↵ >** |

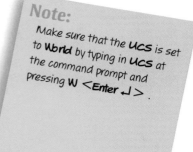

Note:
Make sure that the **UCS** is set to **World** by typing in **UCS** at the command prompt and pressing **W** <Enter ↵ > .

Drawing three-dimensionally can sometimes be confusing. Keeping notes such as beginning points can save a lot of time *and* help you produce accurate drawings. The final step in drawing the lamp in this chapter will be to add a stem that will

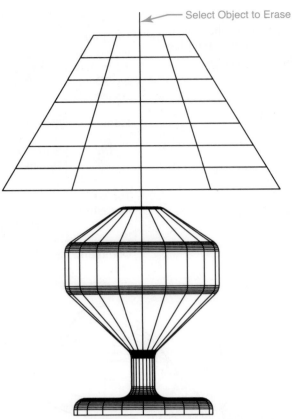

Select Object to Erase

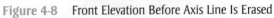

**Figure 4-8**  Front Elevation Before Axis Line Is Erased

**Figure 4-9**  Front Elevation After Axis Line Is Erased

extend from the lamp base to the approximate base height of the lightbulb. Change the view to a plan view by typing **Plan** (World UCS) at the command prompt. Then proceed with the instructions by drawing a circle with a $\frac{1}{4}''$ diameter at the point at which we began the drawing (X = 2', Y = 6, Z = 0). We will then **EXTRUDE** the circle to a height of 12″ (see Figure 4-10).

| Prompt | Response |
|---|---|
| Command: | Select **CIRCLE**, **Center**, **Diameter**, from the **Draw** menu |
| CIRCLE | |
| Specify center point for circle or [3P/2P/Ttr (tan tan radius)]: | Type: **2',6,0 <Enter ↵ >** |
| Specify radius of circle or [Diameter]: | Type: **1/8 <Enter ↵ >** |
| Command: | Type: **EXT <Enter ↵ >** (or select the **EXTRUDE** icon) |
| EXTRUDE | |
| Current wire frame density: ISOLINES = 20 | |
| Select objects to extrude: | Type: **I** (to select the last, or circle) **<Enter ↵ >** |
| 1 found | |
| Select objects to extrude: | Type: **<Enter ↵ >** |
| Specify height of extrusion or [Direction/ Path/Taper angle] <1'-0">: | Type: **12 <Enter ↵ >** |

Your drawing should be similar to Figure 4-11.

The drawing of the lamp is complete, but before you leave it, try looking at an isometric view of the lamp as a wireframe and as a conceptual view. Change the view to **NE Isometric**. From the **Ribbon, Visualize** tab, **Visual Styles**, select **2D Wireframe** (Figure 4-12) and then select **Conceptual** (Figure 4-13).

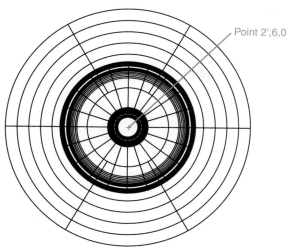

Point 2',6,0

**Figure 4-10**    Lamp in Plan View

**Figure 4-11**    Plan View of Lamp After Drawing Stem

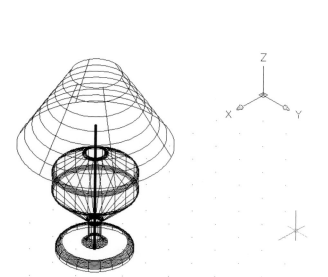

**Figure 4-12**    2D Wireframe View of Lamp

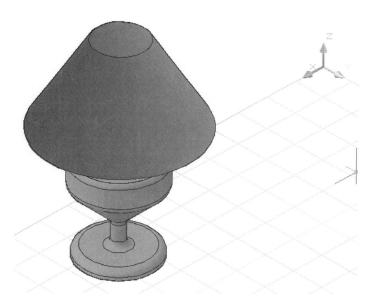

**Figure 4-13**    Conceptual View of Lamp

## CHAPTER EXERCISES

The following four chapter exercises will provide you with practice using the **REVOLVE** command. The process used to produce the wineglass, vase, shallow bowl, and column is the same, but the resulting models are quite different.

Chapter Exercises 4-1 through 4-3 will use the same drawing setup. Set the **Limits** to **0,0** and **12',8'** for Chapter Exercise 4-4; the settings for the first three exercises will be the same. Begin each exercise by starting a new drawing and set the **Units** to **Architectural, Limits** to **0,0** and **3',2', and Grid** to **1''**, and **Zoom All**. In the **Visual Styles Manager, 3D Wireframe, Edge Settings**, set the **Number of lines** (Isolines) to **20** (see Figure 4-14).

**Figure 4-14**  Visual Styles Manager, Set Number of Lines (Isolines) to 20

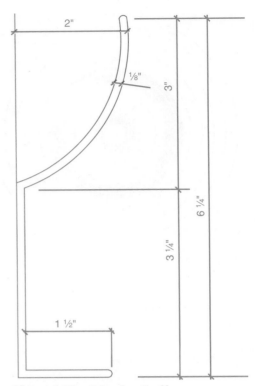

**Figure 4-15**   Wineglass Profile

### Exercise 4-1: Wineglass

| LINE | |
|------|------|
| **Ribbon/ Home tab/ Modify/ Line** |  |
| **Menu** | Draw/ Line |
| **Toolbar: Draw** | |
| **Command Line** | line |
| **Alias** | l |

Draw a 6″ vertical line on the left central portion of the drawing area. This line will serve as the object around which to revolve the wineglass profile. Using the **LINE**, **ARC**, **FILLET**, and **OFFSET** commands, produce a profile shape similar to Figure 4-15.

Using the **BOUNDARY** command, create a polyline from the wineglass profile (see Figure 4-16).

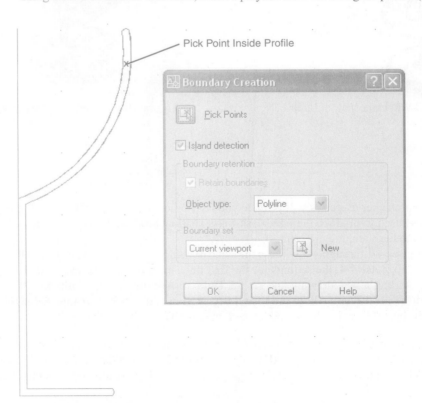

Pick Point Inside Profile

**Figure 4-16**   Create a Polyline Using the **BOUNDARY** Command

Change the view to **SW Isometric**. Your drawing should be similar to Figure 4-17.

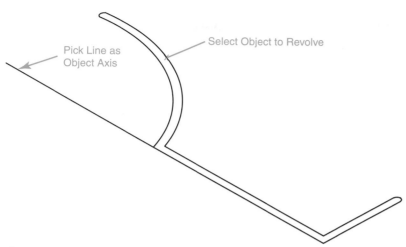

**Figure 4-17**    SW Isometric View of Wineglass Profile

Using the **REVOLVE** command, revolve the polyline profile around the original line (object) 360°. After revolving the profile, your drawing should be similar to Figure 4-18.

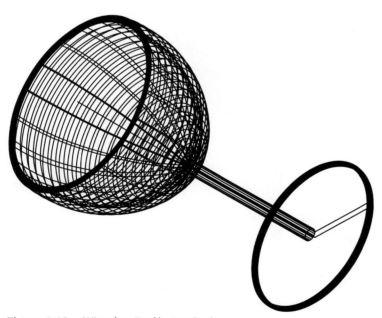

**Figure 4-18**    Wineglass Profile Revolved

Using the **3DROTATE Grip** tool, rotate the wineglass 90° about the X axis (see Figure 4-19). After you have rotated the wineglass, your drawing should appear similar to Figure 4-20.

Erase the original wineglass profile (consisting of lines, arcs, and so on) located on the X,Y plane. Change the view to **Conceptual**  (select from the **Ribbon/Visualize** tab or **Menu Browser**, **View**, **Visual Styles** flyout) of the wineglass. Your drawing should appear similar to Figure 4-21.

| ARC | |
|---|---|
| **Ribbon/ Home tab/ Draw/ Arc** | |
| **Menu** | Draw/Arc/ 3 Points |
| **Toolbar: Draw** | |
| **Command Line** | arc |
| **Alias** | a |

| FILLET | |
|---|---|
| **Ribbon/ Home tab/ Modify/ Fillet** | |
| **Menu** | Modify/ Fillet |
| **Toolbar: Modify** | |
| **Command Line** | fillet |
| **Alias** | f |

| OFFSET | |
|---|---|
| **Ribbon/ Home tab/ Modify/ Offset** | |
| **Menu** | Modify/ Offset |
| **Toolbar: Modify** | |
| **Command Line** | offset |
| **Alias** | o |

| REVOLVE | |
| --- | --- |
| **Ribbon/ Home tab/ 3DModel- ing/Revolve** |  |
| **Menu** | Draw/ Modeling/ Revolve |
| **Toolbar: Modeling** | |
| **Command Line** | revolve |
| **Alias** | rev |

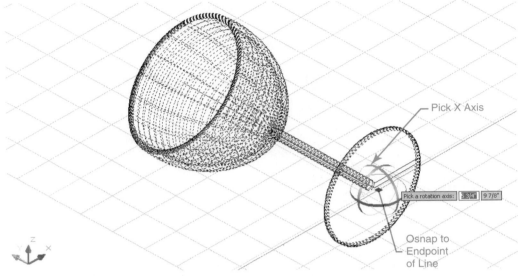

Pick X Axis

Pick a rotation axis:  3 3/4"   9 7/8"

Osnap to Endpoint of Line

**Figure 4-19    3DROTATE** of the Wineglass About the X Axis

| 3DROTATE | |
| --- | --- |
| **Ribbon/ Home tab/ Solid edit- ing/3D Rotate** |  |
| **Menu** | Modify/ 3D Operat- ions/3D Rotate |
| **Toolbar: Modeling** | |
| **Command Line** | 3drotate |

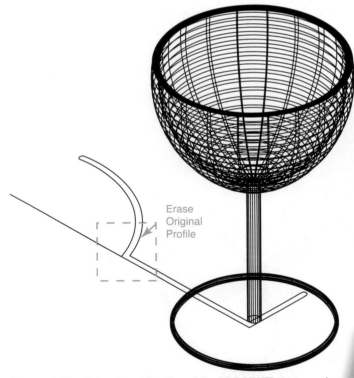

Erase Original Profile

**Figure 4-20    Wineglass After Use of the 3DROTATE** Command

**Note:** Conceptual views are produced by selecting **Conceptual** from **Visual Styles** located on the **Ribbon/Visualize** tab or from the **View** pull-down menu/**Visual Styles/ Conceptual**.

### Exercise 4-2: Shallow Bowl

Using the profile creation, revolve, and 3D rotate processes just learned, produce drawings similar to the example of a shallow bowl in Figures 4-22 and 4-23.

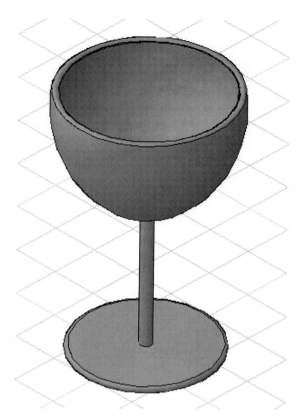

**Figure 4-21**    Conceptual View of the Completed Wineglass

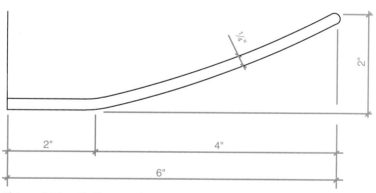

**Figure 4-22**    Shallow Bowl Profile

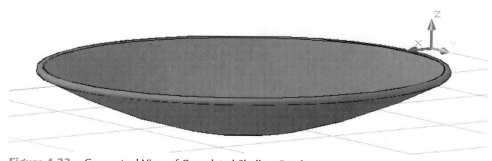

**Figure 4-23**    Conceptual View of Completed Shallow Bowl

**Exercise 4-3:** Ceramic Vase

Using the profile creation, revolve, and 3D rotate processes, produce drawings similar to the example of a ceramic vase in Figures 4-24 and 4-25.

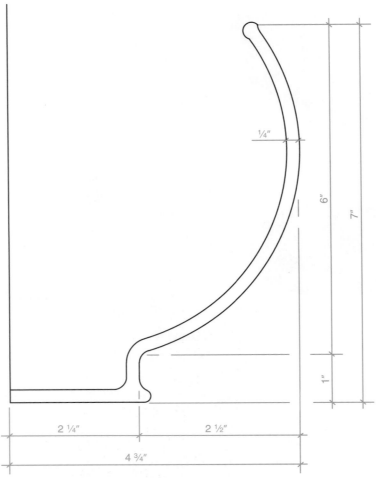

**Figure 4-24**    Ceramic Vase Profile

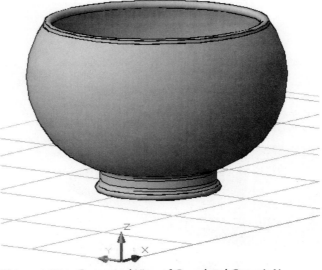

**Figure 4-25**    Conceptual View of Completed Ceramic Vase

## Exercise 4-4: Column

Using the profile creation, revolve, and 3D rotate processes, produce drawings similar to the example of a column in Figures 4-26 and 4-27. Remember to reset the **Limits** to **0,0** and **12',8'**.

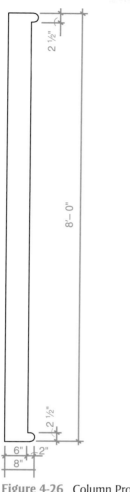

**Figure 4-26**   Column Profile

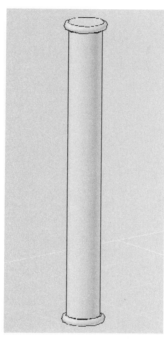

**Figure 4-27**   Conceptual View of Completed Column

## SUMMARY

In this chapter, you gained extensive practice drawing various profiles, using the **BOUNDARY** command to create closed polylines, using the **REVOLVE** command to create three-dimensional solids, and using the **3DROTATE** command to position the model in a vertical position. Additional practice was provided in viewing the model in a conceptual manner. The processes used in this chapter may be applied to any model whose final shape is produced by revolving a profile about an axis or object.

## CHAPTER TEST QUESTIONS

### Multiple Choice

1. Which of the following commands can be used to create 3D solids by revolving profiles about an object?
   a. **3DROTATE**
   b. **POLYLINE**
   c. **REVOLVE**
   d. **ANGLE**
   e. **UNION**

2. What type of objects may be revolved about an axis with the use of the **REVOLVE** command to create a solid or surface?

   a. Open polylines
   b. Closed polylines
   c. 2D line
   d. Arc
   e. All the above

3. With **Ortho** mode turned on, you can move the mouse in a horizontal or vertical direction and enter a direct distance. Therefore, typing @3'<0 is the equivalent of moving the mouse in which direction and typing 3' at the command prompt?

   a. Right
   b. Left
   c. Down
   d. Up

4. Which system variable specifies the number of contour lines per surface on objects?

   a. **3DROTATE**
   b. **POLYLINE**
   c. **REVOLVE**
   d. **FACETRES**
   e. **ISOLINES**

5. Which system variable controls the smoothness of shaded and rendered objects?

   a. **3DROTATE**
   b. **POLYLINE**
   c. **REVOLVE**
   d. **FACETRES**
   e. **ISOLINES**

6. What is the default setting of the **FACETRES** system variable?

   a. 0.1
   b. 5.0
   c. 0.3
   d. 4.0
   e. 0.5

7. Which command can be used to rotate an object about an axis?

   a. **3DROTATE**
   b. **POLYLINE**
   c. **REVOLVE**
   d. **FACETRES**
   e. **ISOLINES**

8. When the **REVOLVE** command is used, which is not one of the options that may be selected to define the axis?

   a. Object
   b. UCS
   c. X
   d. Y
   e. Z

9. The **BOUNDARY** command can be used to create which of the following from an enclosed area?

   a. 3D solid
   b. An extruded surface
   c. Region
   d. Spline curve
   e. Torus

10. Using absolute coordinates to begin a drawing allows you to

   a. Produce only 2D objects in the current drawing
   b. Locate precisely the starting point of a drawing
   c. Produce only 3D objects in the current drawing
   d. Use only absolute coordinate entry for the duration of a drawing
   e. Draw on the X,Y plane only.

## Matching

**Column A**

a. **REVOLVE**

b. **FILLET**

c. Absolute coordinates

d. **Ortho** mode

e. 0.05

f. **POLYLINE**

g. **FACETRES**

h. **BOUNDARY**

i. **ISOLINES**

j. **3DROTATE**

**Column B**

1. System variable that controls the smoothness of shaded and rendered objects

2. Coordinates entered in the X,Y,Z format

3. System variable that specifies the number of contour lines per surface on objects

4. Allows you to create a solid or surface by revolving 2D objects about an axis

5. Constrains cursor movement to the horizontal or vertical direction

6. The default setting of the **FACETRES** system variable

7. Connected sequence of line segments created as a single object

8. Used to create regions or polylines from enclosed areas

9. Rounds and fillets the edges of objects

10. Displays the **ROTATE grip** tool in a 3D view and revolves objects around a base point.

## True/False

1. T or F: The **REVOLVE** command allows you to create a solid or surface by revolving objects about an axis.

2. T or F: The **ISOLINES** system variable specifies the number of contour lines per surface for an object.

3. T or F: The **FACETRES** system variable controls the smoothness of shaded and rendered objects.

4. T or F: The **3DROTATE** command cannot be used to rotate an object about an axis.

5. T or F: After an object profile is drawn with a polyline, the **REVOLVE** command can be used to move the object to the vertical position.

6. T or F: Before an object is revolved using the **REVOLVE** command, the **ISOLINES** and **FACETRES** systems variables should be set.

7. T or F: The **FILLET** command can be used to round the edges of 3D solids.

8. T or F: The **ISOLINES** system variable can range from 0 to 2,047.

9. T or F: When the **3DROTATE** command is used to rotate an object to a vertical position while the **UCS** is set to **World**, the top of the object will be in the Z direction.

10. T or F: A line that has been used for the axis of revolution can be erased after the **REVOLVE** operation without affecting the revolved object.

# Glass Top Coffee Table

# 5

## Chapter Objectives

- Construct, edit, and extrude closed polylines
- Practice using the **FILLET**, **MIRROR**, and **OFFSET** commands
- Practice using the **SUBTRACT** and **UNION** commands
- Use the **SECTION**, **SLICE**, and **3DMOVE** commands
- Use the **SOLIDEDIT** command to extrude a 3D face

## INTRODUCTION

The glass top coffee table produced in this chapter requires a little more analysis of the model to be constructed than did the items produced in the previous chapters. For this model, composite solids must be made to form the top edge and sides of the table, and a rabbet edge must be subtracted to provide a ledge to hold the glass top.

We will draw polylines and use the **EXTRUDE**, **UNION**, and **SUBTRACT** commands to produce the table. We will learn to produce a cross-section profile of the tabletop to verify the accuracy of the rabbet ledge using the **SECTION** command.

## DRAWING SETUP

Begin a new drawing. Set the **Units** to **Architectural**, precision to $\frac{1}{4}''$. Set the **Limits** to **0,0** and **8',6'**. Set the **Grid** to **6"**, and **Zoom All**.

## BEGIN DRAWING

We will begin this exercise by using the **POLYLINE** command to draw a two-dimensional polyline profile for a coffee table leg (see Figure 5-1).

| POLYLINE | |
|---|---|
| **Ribbon/ Home tab/ Draw/ Polyline** | |
| **Menu** | Draw/ Polyline |
| **Toolbar: Draw** | |
| **Command Line** | pline |
| **Alias** | pl |

| Prompt | Response |
|---|---|
| Command: <br> PLINE | *Select the **POLYLINE** icon* |
| Specify start point: <br> Current line width is 0'-0" | Type: **2',4' <Enter ↵ >** |
| Specify next point or [Arc/Halfwidth/ <br> Length/Undo/Width]: | Type: **@1<180 <Enter ↵ >** *(or with **ORTHO** on, move the mouse to the left, Type: **1**, <Enter ↵ >)* |
| Specify next point or [Arc/Close/ <br> Halfwidth/Length/Undo/Width]: | Type: **@3<90 <Enter ↵ >** *(or with **ORTHO** on, move the mouse up, Type: **3**, <Enter ↵ >)* |

| Specify next point or [Arc/.......Width]: | Type: **@3<0 <Enter ↵ >** *(or with* **ORTHO** *on, move the mouse to the right, Type:* **3,** *<Enter ↵ >)* |
|---|---|
| Specify next point or [Arc/......Width]: | Type: **@1<270 <Enter ↵ >** *(or with* **ORTHO** *on, move the mouse down, type 1, and press <Enter ↵ >)* |
| Specify next point or [Arc/.......Width]: | Type: **C** *(to close the polyline)* |

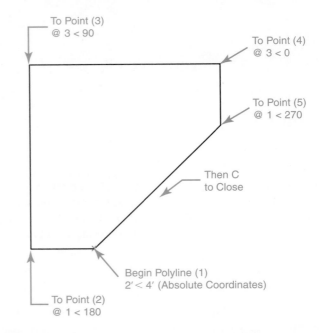

**Figure 5-1**   Coffee Table Leg
Polyline Profile

Next, we will place a radius at each of the corners of the leg profile using the **FILLET** command.

| FILLET | |
|---|---|
| **Ribbon/ Home tab/ Modify/ Fillet** | |
| **Menu** | Modify/ Fillet |
| **Toolbar: Modify** | |
| **Command Line** | fillet |
| **Alias** | f |

| Prompt | Response |
|---|---|
| Command: | *Select the* ***FILLET*** *icon* |
| FILLET | |
| Current settings: Mode = TRIM, Radius = 0'-0'' | |
| Select first object or [Undo/Polyline/Radius/ Trim/Multiple]: | Type: **R <Enter ↵ >** |
| Specify fillet radius <0'-0''>: $\frac{1}{2}$ | |
| Select first object or [Undo/Polyline/ Radius/Trim/Multiple]: | Type: **M <Enter ↵ >** |
| Select first object or [Undo/Polyline/ Radius/Trim/Multiple]: | *Pick line 1 (see Figure 5-2)* |
| Select second object or shift-select to apply corner: | *Pick line 2* |
| Select first object or [Undo/Polyline/ Radius/Trim/Multiple]: | *Pick line 2* |
| Select second object or shift-select to apply corner: | *Pick line 3* |
| Select first object or [Undo/Polyline/ Radius/Trim/Multiple]: | *Pick line 3* |
| Select second object or shift-select to apply corner: | *Pick line 4* |
| Select first object or [Undo/Polyline/ Radius/Trim/Multiple]: | *Pick line 4* |
| Select second object or shift-select to apply corner: | *Pick line 5* |
| Select first object or [Undo/Polyline/ Radius/Trim/Multiple]: | *Pick line 5* |
| Select second object or shift-select to apply corner: | *Pick line 1* |
| | Type: **<Enter ↵ >** |

Figure 5-2    Line Selection for **FILLET** Command

Figure 5-3    Completed Leg Profile

Your drawing should appear similar to Figure 5-3.

For the next step, we will draw a polyline representing the outside edge of the top of the coffee table and use the **Midpoint (Osnap)** to mirror the first table leg.

**Note:**
With **ORTHO** mode on, you can move the mouse in the horizontal or vertical direction you wish to draw, and type the distance.

| Prompt | Response |
|--------|----------|
| Command: | *Select the POLYLINE icon* |
| PLINE | |
| Specify start point: | Type: **1'11,4'3 <Enter ↵ >** |
| Current line width is 0'-0" | |
| Specify next point or [Arc/ | |
| Halfwidth/Length/Undo/Width]: | Type: **@40<0 <Enter ↵ >** |
| Specify next point or [Arc/Close........]: | Type: **@26<270 <Enter ↵ >** |
| Specify next point or [Arc/Close........]: | Type: **@40<180 <Enter ↵ >** |
| Specify next point or [Arc/Close........]: | Type: **C <Enter ↵ >** *(to close the polyline)* |

Your drawing should appear similar to Figure 5-4.

Use the **MIRROR** command to produce the upper right table leg (see Figure 5-5).

| Prompt | Response |
|--------|----------|
| Command: | Type: **MI <Enter ↵ >** *(or select the MIRROR icon)* |
| MIRROR | |
| Select objects: | *Pick the table leg profile* |
| 1 found | |

Figure 5-4    Tabletop Polyline

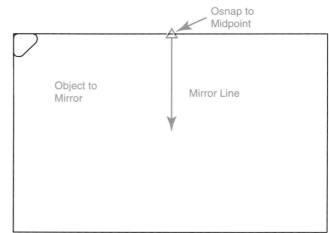

Figure 5-5    Selection Points for **MIRROR** Command

| Select objects: | Type: **<Enter ↵ >** |
| Specify first point of mirror line: | Type: **MID** |
| of | *Pick the midpoint of the top table edge line* |
| Specify second point of mirror line: | *Press the **<F8>** function key (to turn on **Ortho**) and move the mouse down toward the bottom of the tabletop and press **<Enter ↵ >*** |
| Erase source objects? [Yes/No] <N>: | Type: **<Enter ↵ >** |

After the **MIRROR** command, your drawing should appear similar to Figure 5-6.

| **MIRROR** | |
|---|---|
| **Ribbon/ Home tab/ Modify/ Mirror** |  |
| **Menu** | Modify/ Mirror |
| **Toolbar: Modify** | |
| **Command Line** | mirror |
| **Alias** | mi |

**Figure 5-6**   Top Table Legs After Mirroring

Repeat the **MIRROR** command to produce the two bottom table leg profiles.

| **Prompt** | **Response** |
|---|---|
| Command: | *Select the **MIRROR** icon* |
| MIRROR | |
| Select objects: | *Pick the two top table legs* **<Enter ↵ >** |
| Select objects: 1 found | |
| Select objects: 1 found | |
| Select objects: | Type: **<Enter ↵ >** |
| First point of mirror line: | Type: **MID<Enter ↵ >** |
| of | *Pick a point near the middle of the left table-top polyline* |
| Second point: | *With **Ortho** on, pick a point to the right* |
| Delete old objects? <N> | Type: **<Enter ↵ >** |

Your drawing should be similar to Figure 5-7.

**Figure 5-7**   Table Legs After **MIRROR** Command

In this next step, we will extrude the table leg polylines to create 3D solids with a thickness of 14″.

| EXTRUDE | |
|---|---|
| Ribbon/ Home tab/ 3D Model- ing/Extrude |  |
| Menu | Draw/ Modeling/ Extrude |
| Toolbar: Modeling | |
| Command Line | extrude |
| Alias | ext |

| Prompt | Response |
|---|---|
| Command: | Type: **EXT <Enter ↵ >** (or select the **EXTRUDE** icon) |
| Select objects: | *Pick the four leg polylines* |
| Select objects: 1 found | |
| Select objects: 1 found | |
| Select objects: 1 found | |
| Select objects: 1 found | |
| Select objects: | Type: **<Enter ↵ >** |
| Specify height of extrusion or [Direction/Path/Taper angle]: | Type: **14 <Enter ↵ >** |

In plan view, the previous extrusions are not evident, but if we change to an isometric view, the extrusions are apparent. Change the view to **NE Isometric** by selecting **NE Isometric** from the **Menu Browser**, **View**, **3D Views** flyout (see Figure 5-8).

> **Note:**
> Notice that the legs have a thickness of 14″. The tabletop profile (polyline) remains at elevation 0, with a thickness of 0.

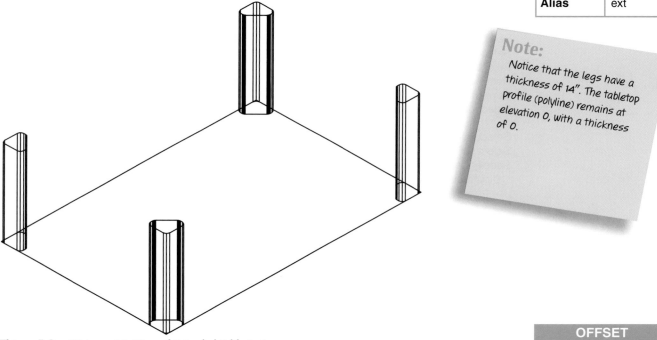

**Figure 5-8**   NE Isometric View of Extruded Table Legs

We will now create the tabletop by using the **OFFSET**, **REGION**, **SUBTRACT**, and **EXTRUDE** commands.

| OFFSET | |
|---|---|
| Ribbon/ Home tab/ Modify/ Offset | |
| Menu | Modify/ Offset |
| Toolbar: Modify | |
| Command Line | offset |
| Alias | o |

| Prompt | Response |
|---|---|
| Command: | Type: **o <Enter ↵ >** (or select the **OFFSET** icon) |
| Current settings: Erase source = No, Layer = Source, OFFSETGAPTYPE = 0 | |
| Specify offset distance or [Through/Erase/Layer] <Through>: | Type: **1 <Enter ↵ >** |
| Select object to offset or [Exit/Undo] <Exit>: | *Pick the tabletop polyline* |
| Specify point on side to offset or [Exit/Multiple/Undo] <Exit>: | *Pick a point inside the tabletop polyline* |
| Select object to offset or [Exit/Undo] <Exit>: | Type: **<Enter ↵ >** |

| REGION | |
|---|---|
| **Ribbon/ Home tab/ Draw/ Region** | |
| **Menu** | Draw/ Region |
| **Toolbar: Draw** | |
| **Command Line** | region |
| **Alias** | reg |

| Command: | Type: **reg <Enter ↵ >** *(or select the **REGION** icon)* |
|---|---|
| Select objects: | *Pick the outside tabletop polyline* |
| Select objects: 1 found | *Pick the inside tabletop polyline* |
| Select objects: 1 found | Type: **<Enter ↵ >** |
| 2 loops extracted. | |
| 2 regions created. | |

We have created two regions, or 2D solids. We will now subtract the inside region from the outside region. This will produce a continuous 1″-wide region around the perimeter of the tabletop that we can extrude to form the tabletop edge.

| **Prompt** | **Response** |
|---|---|
| Command: | Type: **su <Enter ↵ >** *(or select the **SUBTRACT** icon)* |
| Select solids and regions to subtract from… | |
| Select objects: | *Pick the outside tabletop region* |
| Select objects: 1 found | |
| Select objects: | Type: **<Enter ↵ >** |
| Select solids and regions to subtract.. | |
| Select objects: | *Pick the inside tabletop region* |
| Select objects: 1 found | |
| Select objects: | Type: **<Enter ↵ >** |
| Command: | Type: *Select the **EXTRUDE** icon* |
| Current wire frame density: ISOLINES = 4 | |
| Select objects to extrude: | Type: **I** *(last)* **<Enter ↵ >** *(or pick the tabletop region)* |
| Select objects to extrude: 1 found | |
| Select objects to extrude: | Type: **<Enter ↵ >** |
| Specify height of extrusion or [Direction/Path/Taper angle] <1′-2″>: | Type: **3 <Enter ↵ >** |

Your drawing should be similar to Figure 5-9.

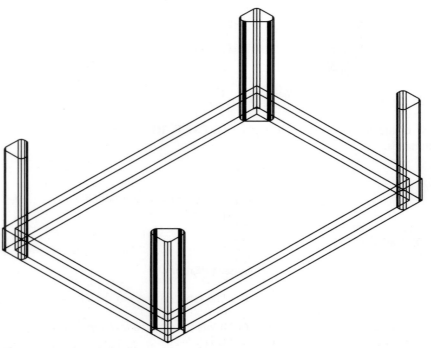

Figure 5-9    Extruded Tabletop Edge at Elevation 0

We need to change the elevation of the tabletop edge to 14″. Because we cannot change the elevation of the tabletop solid with the **CHANGE/ELEVATION** command, we will use the **3DMOVE** command.

| Prompt | Response |
|---|---|
| Command: | Select the **3DMOVE** icon |
| Command: _3dmove | Pick the tabletop edge |
| Select objects: 1 found | |
| Select objects: | Type: **<Enter ↵ >** |
| Specify base point or [Displacement] <Displacement>: | Type: **0,0,0 <Enter ↵ >** |
| Specify second point or <use first point as displacement>: | Type: **0,0,14 <Enter ↵ >** |

Your drawing should appear similar to Figure 5-10.

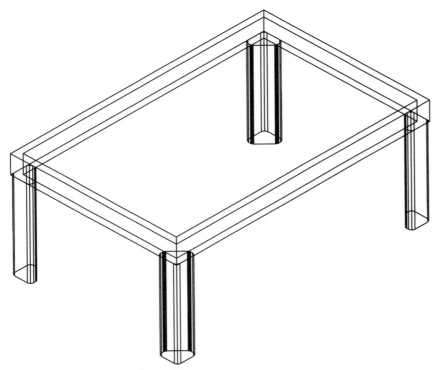

**Figure 5-10**   Tabletop Edge and Legs

| 3DMOVE | |
|---|---|
| **Ribbon/ Home tab/ Solid editing/3D Move** | |
| **Menu** | Modify/ 3D Operations/ 3D Move |
| **Toolbar: Modeling** | |
| **Command Line** | 3dmove |

| UNION | |
|---|---|
| **Ribbon/ Home tab/ Solid editing/Union** | |
| **Menu** | Modify/ Solid Editing/ Union |
| **Toolbar: Modeling** | |
| **Command Line** | union |
| **Alias** | uni |

wireframe: Displays objects using lines and curves to represent the boundaries.

Following these instructions, develop the inside portion of the tabletop. Begin by creating a 2″-wide region on the top inside edge of the tabletop edge just created. With **Osnap** mode on and using **Endpoint**, draw a closed polyline around the inside top edge of the tabletop edge. Use the **OFFSET** command to offset the polyline 2″ to the inside. With the **REGION** command, create regions from the two closed polylines. Using the **SUBTRACT** command, subtract the inside region from the outside region. With the **EXTRUDE** command, extrude the region 1″ in the −Z direction.

Your drawing should be similar to Figure 5-11. Use the **HIDE** command so that you can see more easily where the solids are located (see Figure 5-12).

To make the rabbet joint in which the glass top will fit, we need to make a $\frac{1}{4}″ \times \frac{1}{4}″$− thick solid to subtract from the inside top edge of the tabletop. This will be easier to draw if we eliminate some *wireframe* lines. Some of the lines can be eliminated by using the **UNION** command to join the two tabletop components just created.

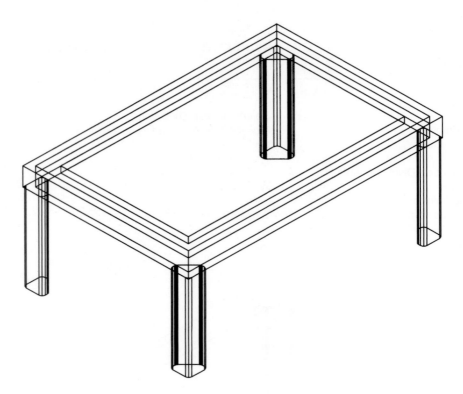

**Figure 5-11**  Inside
Tabletop Solid

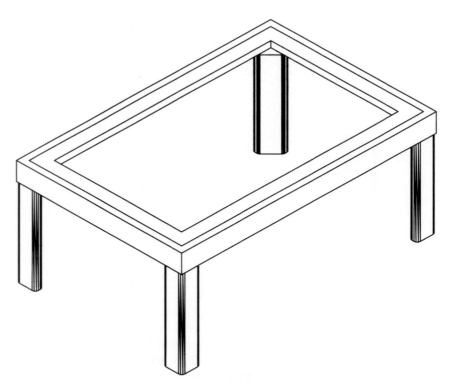

**Figure 5-12**  Hidden
View of Table

| Prompt | Response |
|---|---|
| Command: | *Select the **UNION** icon* |
| Command: _union | *Pick the inside edge of the tabletop* |
| Select objects: 1 found | *Pick the outside edge of the tabletop* |
| Select objects: 1 found, 2 total | |
| Select objects: | *Type:* **<Enter ↵ >** |

There are numerous ways to create a $\frac{1}{4}''$-wide by $\frac{1}{4}''$-thick solid that is coplanar with the inside top edge of the tabletop. The quickest method (typically) is to use existing lines or objects as construction points. For instance, we have the inside edge of the tabletop, which is coplanar with the inside edge of the solid we need to subtract to create the rabbet edge joint for the glass top. We will draw a closed polyline located on the inside top edge of the tabletop, offset the polyline $\frac{1}{4}''$ to the outside, create regions from the two polylines, subtract the inside region from the outside region, and extrude the resulting region $\frac{1}{4}''$ in the –Z direction. This will create a 3D solid that we can subtract from the tabletop to produce the rabbet edge.

On your own, use the **ORBIT** command to produce a view similar to Figure 5-13 and draw the closed polyline.

| 3DORBIT | |
|---|---|
| **Ribbon/ Visualize tab/3D Navigation panel/Orbit** | |
| **Menu** | View/ Orbit |
| **Toolbar: 3D Navigate** | |
| **Command Line** | 3dorbit |
| **Alias** | orbit |

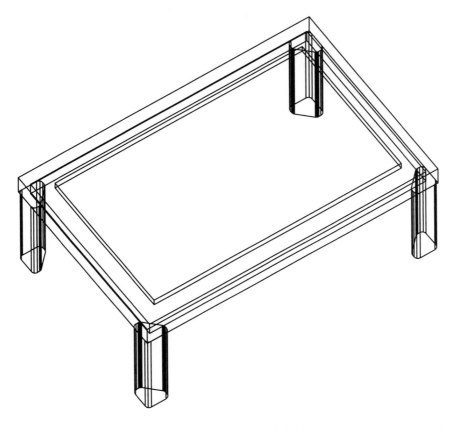

**Figure 5-13** Use the **ORBIT** Command to Select View

| Prompt | Response |
|---|---|
| Command: | Select the **POLYLINE** icon |
| PLINE | |
| Specify start point: | With **Osnap Endpoint**, pick the top inside endpoint of the lower left corner of the tabletop (see Figure 5-14) |
| Current line width is 0'-0'' | |
| Specify next point or [Arc/Halfwidth/ Length/Undo/Width]: | Pick the upper left endpoint |
| Specify next point or [Arc/Close/Halfwidth/ Length/Undo/Width]: | Pick the upper right endpoint |
| Specify next point or [Arc/Close/Halfwidth/ Length/Undo/Width]: | Pick the lower right endpoint |
| Specify next point or [Arc/Close/Halfwidth/ Length/Undo/Width]: | Type: **C <Enter ↵ >** (to close the polyline) |

On your own, use the **OFFSET** command to offset the polyline just created $\frac{1}{4}''$ to the outside of the polyline. Your drawing should be similar to Figure 5-15

Create two regions from the two polylines just created. Then using the **SUBTRACT** command, subtract the inside region from the outside region.

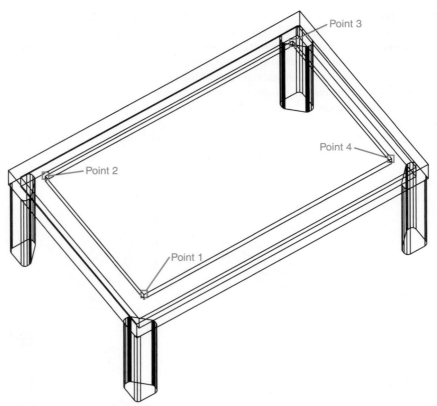

**Figure 5-14**   Selection Points for Polyline

**Figure 5-15**   Tabletop After **OFFSET** Command

With the **EXTRUDE** command, extrude the resulting region $\frac{1}{4}''$ in the $-Z$ direction.

Your drawing should appear similar to Figure 5-16. Change the visual style to **Conceptual** by selecting **Conceptual** from the **Menu Browser**, **View**, **Visual Styles** flyout. This will produce a view in which it is easier to see the resulting rabbet edge (see Figure 5-17).

**Figure 5-16** Tabletop After Subtracting for the Rabbet Edge

**Figure 5-17** Conceptual Visual Style of the Tabletop with the Rabbet Edge

The final two steps in this tutorial will be to fillet the eight edges of the completed tabletop with a $\frac{1}{2}''$ radius and create a $\frac{1}{4}''$ solid representing the glass top. With the **FILLET** command (radius set to $\frac{1}{2}''$), round the outside four vertical and outside four horizontal edges (use **ORBIT** to view the opposite of the model to fillet).

Your drawing should appear similar to Figure 5-18.

To finish the glass top coffee table model, draw a closed polyline around the top edge of the rabbet edge (see Figure 5-19).

With the **EXTRUDE** command, extrude the polyline $\frac{1}{4}''$ in the –Z direction to create a 3D solid representing the glass top.

Note:
Use **'Zoom** with the **Dynamic** option between picking points to zoom a window around each corner to help pick the appropriate points.

**Figure 5-18**   Tabletop After **FILLET** Command

On your own, change the color (**Change/Properties/Color**) of the 3D solid representing the glass top. Change the view to **Conceptual** using the **Visual Styles Manager**. Your finished glass top coffee table should appear similar to Figure 5-20.

We have completed the glass top coffee table model, but just to make sure that the section profile is correct, we will produce a section through the center of the table using the **SECTION** command. Before beginning, change the view to **NE Isometric**.

| Prompt | Response |
|---|---|
| Command: | Type: **SECTION** <Enter ↵> |
| Command: SECTION | *Pick the tabletop* |
| Select objects: 1 found | *Pick the glass* |
| Select objects: 1 found, 2 total | |
| Select objects: | Type: **<Enter ↵>** |

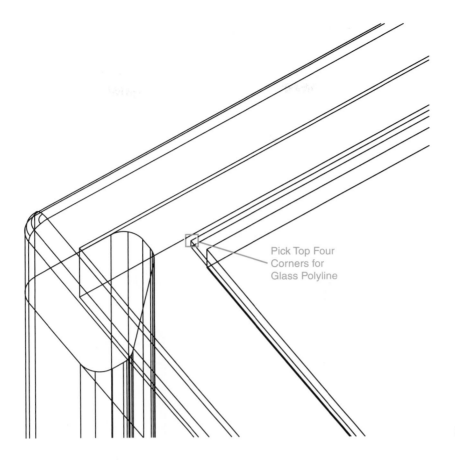

**Figure 5-19**  Selection
Points for the Glass Polyline

Pick Top Four
Corners for
Glass Polyline

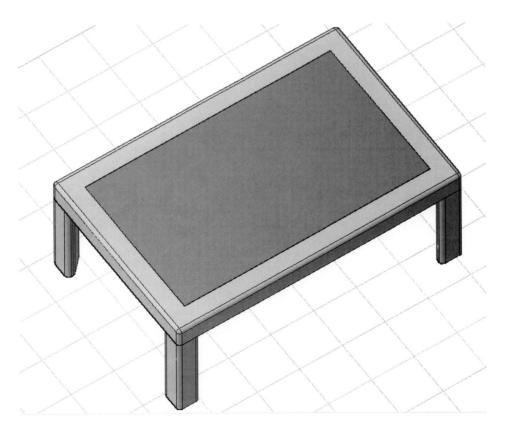

**Figure 5-20**  Conceptual
View of Completed Glass
Top Coffee Table

| | |
|---|---|
| Specify first point on Section plane by [Object/Zaxis/View/XY/YZ/ZX/3points] <3points>: | Type: **<Enter ↵ >** |
| Specify first point on plane: of | Type: **mid <Enter ↵ >** *Pick a point at the bottom center (edge) of the tabletop* (see Figure 5-21) |
| Specify second point on plane: of | Type: **mid <Enter ↵ >** *Pick a point at the top center (edge) of the tabletop* |
| Specify third point on plane: of | Type: **mid <Enter ↵ >** *Pick a point at the top center (edge) of the tabletop* |

Your drawing should appear similar to Figure 5-21.

On your own, use the **MOVE** command (with **Ortho** on) to move the section to the side of the model. You should notice that the **SECTION** command does not affect the model. It only produces a section profile of the entities selected. Your drawing should appear similar to Figure 5-22. Try zooming into the section with different viewpoints for close inspection.

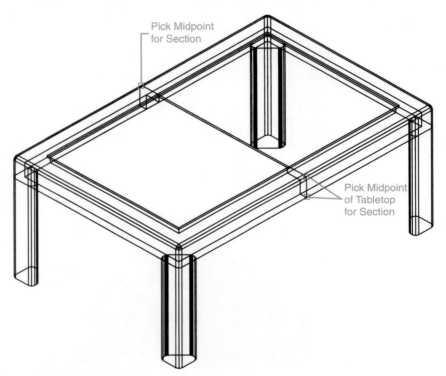

Pick Midpoint for Section

Pick Midpoint of Tabletop for Section

**Figure 5-21** Table with Section Cut Visible

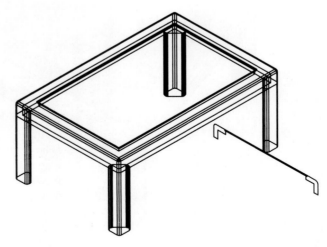

**Figure 5-22** Table with Section Moved to the Side

# CHAPTER EXERCISES

## Exercise 5-1:

Chapter Exercise 5-1 will consist of creating an end table that matches the glass top coffee table. The end table will be 1′ shorter in length and 3″ taller than the coffee table. We could follow the process used to draw the coffee table and change the length and height dimensions to make the end table. However, because we have the coffee table model drawn, we can create the end table by editing the existing coffee table. To edit the coffee table, we will use the **SLICE** and **SOLIDEDIT** commands.

To begin this exercise, open the glass top coffee table drawing. Change the view to **NE Isometric** (see Figure 5-23). The coffee table is 3′-4″ long, 2′-2″ wide, and 1′-5″ high. The matching end table will be 2′-4″ long, 2′-2″ wide, and 20″ high. We will use the **SLICE** command to slice the model (divide it with a plane located on the YZ plane), erase the unneeded components, and use the **MIRROR3D** command to mirror the remaining half of the table.

The **SLICE** command may be invoked at the command prompt by typing in **slice** or the alias **sl**, or it can be accessed from the **Menu Browser, Modify, 3D Operations** flyout (see Figure 5-24). The **SLICE** command allows you to slice (or cut) a solid with a defined plane. The options for slicing a selected solid are as follows: specifying the planar object, surface, Z axis, view, XY/YZ/ZX plane, or by selecting three points on a plane.

**Figure 5-23**　NE Isometric View of the Completed Glass Top Coffee Table

**Figure 5-24**　Selecting the **SLICE** Command from the **Menu Browser**

The **SOLIDEDIT** command can be invoked from the **Modify** toolbar; **Menu Browser, Modify** pull-down menu; or the command prompt. Figure 5-25 illustrates other solid editing options found within the **Modify/Solid Editing** flyout. The **SOLIDEDIT** command allows you to edit the face, edge, or body of a solid. The *face* of a solid can be edited by extruding, moving, rotating, offsetting, tapering, deleting, copying, changing the color, or changing the material. An *edge* of a solid can be edited by changing the color or copying individual edges. A solid *body* can be edited by imprinting, separating solids, forming shells, or cleaning (removing shared edges or vertices). For this exercise, we will use the **SOLIDEDIT** command to extrude the bottom face of the table legs 3″.

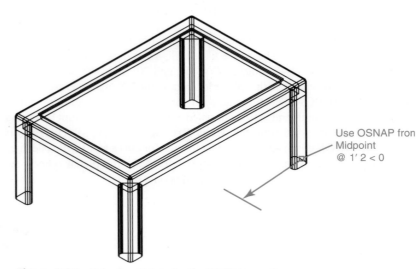

Use OSNAP from
Midpoint
@ 1′ 2 < 0

**Figure 5-25**    **Modify/Solid Editing** Flyout

**Figure 5-26**    Selection Points for the **SLICE** Operation

There are numerous ways in which to select a slice plane or point. If we wanted to slice the table in half, using the **3point** option would most likely be the easiest. Because we want to slice the coffee table 1′-2″ from one end, which is parallel to the YZ plane, selecting a point that lies on the plane will be the most time-efficient method. Following the instructions below, begin the slice operation. See Figure 5-26 for the selection points used in the process.

| Prompt | Response |
| --- | --- |
| Command: | Type: **sl <Enter ↵ >** *(or select the **SLICE** icon from the **Modify/3D Operations** flyout on the **Menu Browser**)* |
| Command: _slice | |
| Select objects to slice: | *Pick the tabletop and glass with a crossing window* |
| Select objects to slice: 1 found, 2 total | Type: **<Enter ↵ >** |
| Specify start point of slicing plane or [planar Object/Surface/Zaxis/View/ XY/YZ/ZX/3points] <3points>: | Type: **YZ <Enter ↵ >** |
| Specify a point on the YZ plane <0,0,0>: | Type: **fro <Enter ↵ >** |
| Base point: | Type: **mid <Enter ↵ >** |
| of | *Pick the midpoint of the bottom outside of the table (see Figure 5-26)* |
| <Offset>: | Type: **@1′2<0 <Enter ↵ >** |
| Specify a point on desired side or [keep Both sides] <Both>: | *Pick a point near the back (right side) of the table* |

Your drawing should appear similar to Figure 5-27.

We no longer need the two table legs that are not attached to the table. On your own, use the **ERASE** command to remove the two legs. Before we mirror this half of the table to complete the model, we will use the **SOLIDEDIT** command to extrude the two attached table legs 3″.

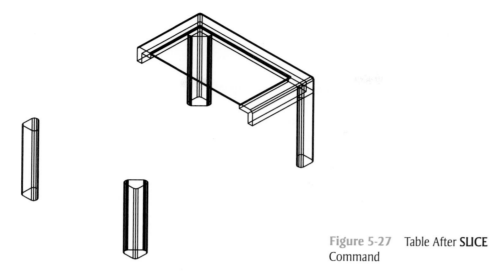

**Figure 5-27** Table After **SLICE** Command

---

| Prompt | Response |
|---|---|
| Command: | *Select **Extrude Faces** from the* **Modify/Solid Editing** *flyout* |
| Command: _solidedit | |
| Solids editing automatic checking: | |
| SOLIDCHECK = 1 | |
| Enter a solids editing option [Face/Edge/ Body/Undo/eXit] <eXit>: _face | |
| Enter a face editing option [Extrude/Move/Rotate/Offset/Taper/ Delete/Copy/coLor/mAterial/Undo/eXit] <eXit>: _extrude | |
| Select faces or [Undo/Remove]: | *Pick the bottom edge of the table leg (see Figure 5-28)* |
| Select faces or [Undo/Remove]: 2 faces found. | |
| Select faces or [Undo/Remove/ALL]: | Type: **R <Enter ↵ >** |
| Remove faces or [Undo/Add/ALL]: | *Pick the top edge of the table leg* |
| 1 face found, 1 removed. | |
| Remove faces or [Undo/Add/ALL]: | Type: **<Enter ↵ >** |
| Specify height of extrusion or [Path]: | Type: **3 <Enter ↵ >** |

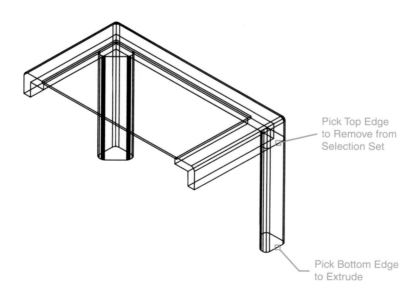

Pick Top Edge to Remove from Selection Set

Pick Bottom Edge to Extrude

**Figure 5-28** Object Selection for **SOLIDEDIT** Command

| | |
|---|---|
| Specify angle of taper for extrusion <0>: | Type: **<Enter ↵>** |
| Solid validation started. | |
| Solid validation completed. | |
| Enter a face editing option | |
| [Extrude/Move/Rotate/Offset/Taper/Delete/ | |
|   Copy/coLor/mAterial/Undo/eXit] <eXit>: | Type: **X** |

Before proceeding with the next step, repeat the previous **SOLIDEDIT** operation to extrude the other table leg 3″. Your drawing should appear similar to Figure 5-29.

We can now use the **MIRROR3D** command to produce the other half of the end table. With the **MIRROR3D** command, you can mirror objects using a specified mirroring plane. The mirror plane can be a planar object (flat); a plane parallel to the XY, YZ, or XZ axis of the current UCS that passes through a specified point; or a plane defined by three specified points.

We will use a point on the YZ axis that defines the mirror plane. Remember, we are defining a plane, so any point on the plane (in this case, any point on the end of the table showing the section cut) defines the plane.

| Prompt | Response |
|---|---|
| Command: | Type: **MIRROR3D <Enter ↵>** |
| Select objects: | *With a crossing window, select all the table objects* |
| Specify opposite corner: 4 found | |
| Select objects: | Type: **<Enter ↵>** |
| Specify first point of mirror plane (3 points) | |
|   Or [Object/Last/Zaxis/View/XY/YZ/ZX/ | |
|   3points] <3points>: | Type: **yz <Enter ↵>** |
| Specify point on YZ plane <0,0,0>: | *Pick the endpoint of the table section edge (see Figure 5-30)* |
| Delete source objects? [Yes/No] <N>: | Type: **<Enter ↵>** |

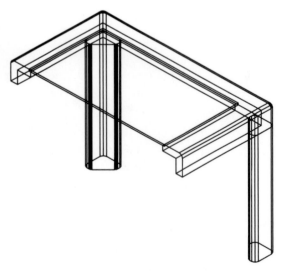

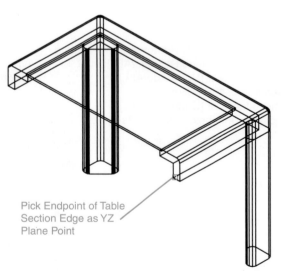

Pick Endpoint of Table Section Edge as YZ Plane Point

**Figure 5-29**  Table Legs After Extruding 3″ with the **SOLIDEDIT** Command

**Figure 5-30**  Selection Plane for **MIRROR3D** Command

Your drawing should appear similar to Figure 5-31.

The two remaining steps in completing the end table will be to use the **UNION** command to join similar table components and use the **3DMOVE** command to move the table up in the Z direction, so that it sits at elevation 0. When we extruded the legs 3″ with the **SOLIDEDIT** command, they extended down in the Z direction, causing the bottom of the table legs to be located at −3″.

| UNION | |
|---|---|
| **Ribbon/ Home tab/ Solid editing/Union** | |
| **Menu** | Modify/ Solid Editing/ Union |
| **Toolbar: Modeling** | |
| **Command Line** | union |
| **Alias** | uni |

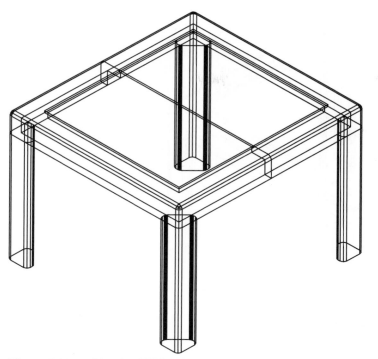

**Figure 5-31**  Table After **MIRROR3D** Command

On your own, invoke the **UNION** command, select both halves of the wooden portions of the tabletop, and press <**Enter ↵**> (see Figure 5-32). Repeat the **UNION** command, select both halves of the glass top, and press <**Enter ↵**>. Your drawing should appear similar to Figure 5-33.

| 3DMOVE | |
|---|---|
| **Ribbon/ Home tab/ Solid editing/3D Move** | |
| **Menu** | Modify/ 3D Operations/ 3D Move |
| **Toolbar: Modeling** | |
| **Command Line** | 3dmove |

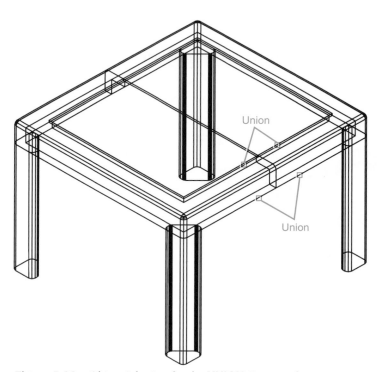

**Figure 5-32**  Object Selection for the **UNION** Command

Select the **3DMOVE** icon from the **Ribbon**, **Home** tab, **Modify** menu. With a *crossing window*, select all the table components. For the base point, use **0,0,0** and for the second point of displacement, use **0,0,3**. Your drawing should not appear any different, other than being located

crossing window: A window selection made by picking opposite corners on a window selection from right to left.

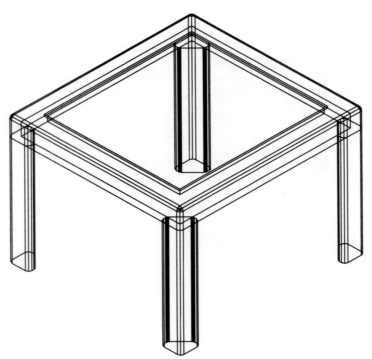

Figure 5-33    Table After the **UNION** Command

3″ higher than it was before the **3DMOVE** command (table base elevation moved from −3″ to 0″). To produce a more realistic view of the end table, change the color of the glass top using the **Properties** dialog box to a contrasting color, such as cyan, and select **Conceptual** within the **Visual Styles Manager**.

The conceptual view of the completed end table should appear similar to Figure 5-34.

Figure 5-34    Conceptual View of the Completed End Table

# SUMMARY

In this chapter, you learned how to produce somewhat complex 3D models using the **EXTRUDE**, **3DMOVE**, **FILLET**, **MIRROR**, and **OFFSET** commands. The **SECTION** command illustrated how to visually determine and produce a 2D cross section of a 3D solid. The chapter provided you with practice manipulating solids by using the **SUBTRACT** and **UNION** commands.

The exercise at the end of the chapter illustrated a process for creating new models using existing model components, through the use of the **SLICE**, **MIRROR3D**, and **3DMOVE** commands.

# CHAPTER TEST QUESTIONS

## Multiple Choice

1.  Which of the following commands can be used to cut three-dimensional solids at a precise location?
    a.  **SECTION**
    b.  **SEPARATE**
    c.  **UNION**
    d.  **EXTRUDE**
    e.  **SLICE**

2.  Which of the following commands can be used to change a two-dimensional closed polyline into a three-dimensional solid?
    a.  **3DMOVE**
    b.  **EXTRUDE**
    c.  **UNION**
    d.  **JOIN**
    e.  **FILLET**

3.  The **FILLET** command can be accessed by which of the following pull-down or **Menu Browser** menus?
    a.  **Modify**
    b.  **Draw**
    c.  **View**
    d.  **Reference**
    e.  **Tools**

4.  The **REGION** command can be accessed from which of the following toolbars?
    a.  **3D Make**
    b.  **Format**
    c.  **Window**
    d.  **Draw**
    e.  **View**

5.  Which of the following is not located on the **3D Operations** flyout?
    a.  **Align**
    b.  **Explode**
    c.  **3D Move**
    d.  **3D Rotate**
    e.  **3D Array**

## Matching

**Column A**

a.  **EXTRUDE**

b.  **SECTION**

c.  **FILLET**

d.  **REGION**

e.  **MIRROR3D**

**Column B**

1.  Rounds and fillets the edges of objects

2.  Creates a mirror image of objects about a plane

3.  Creates a 3D solid or surface by extruding an object or planar face by a specified distance and direction

4.  Creates a section profile of 3D solids about a specified plane

5.  Converts an object that encloses an area into a region object

## True or False

1.  T or F: The **UNION** command can be used to join line segments into a polyline.

2.  T or F: The **SUBTRACT** command can be used only with coplanar solids.

3.  T or F: With the **3DMOVE** grip tool, you can move 3D solids in the X, Y, or Z direction.

4.  T or F: The **REGION** command converts enclosed objects into a region object.

5.  T or F: If you extrude a closed polyline and a region, both will create a 3D solid.

# Desk

<div align="right">

**6**

</div>

## Chapter Objectives

- Learn to use project components as construction guides
- Create 3D solids from closed polylines
- Create three-dimensional solids with the **EXTRUDE** command
- Use the **SUBTRACT** command
- Use the **MIRROR3D**, **3DMOVE**, and **CHAMFER** commands
- Use the **SLICE** and **DIST** commands

## INTRODUCTION

In this chapter, we will create a 3D solid model of a desk. The overall dimensions of the desk will be 72″ wide, 29″ high, and 36″ deep.

We will begin drawing the top of the desk (36″ × 72″) with a two-dimensional polyline, and we will use absolute coordinates to start the polyline. Later, we will use the **EXTRUDE** command to give the desktop a thickness, but first, we will use the closed polyline as a guide to draw the desk base components. The second component to be drawn in the following sequence of commands with a closed polyline is the left side panel (2″ × 36″).

## DRAWING SETUP

Begin a new drawing and set the **UNITS** to **Architectural**, **Precision** to $\frac{1}{4}''$. Set the **LIMITS** to **0,0** and **8′,6′**. Set the **GRID** to **6″**, and **Zoom All**.

## BEGIN DRAWING

| Prompt | Response |
|---|---|
| Command: | *Select the* **POLYLINE** *icon* |
| PLINE | |
| Specify start point: | Type: **1′,1′6 <Enter ↵>** |
| Current line width is 0′-0″ | |
| Specify next point or [Arc/Halfwidth/ Length/Undo/Width]: | Type: **@72<0 <Enter ↵>** *(or with* **ORTHO** *on, move the mouse to the right, Type:* **72** *<Enter ↵>)* |
| Specify next point or [Arc/Close/ Halfwidth/Length/Undo/Width]: | Type: **@36<90 <Enter ↵>** *(or with* **ORTHO** *on, move the mouse up, Type:* **36** *<Enter ↵>)* |

| POLYLINE | |
|---|---|
| **Ribbon/ Home tab/ Draw/ Polyline** | |
| **Menu** | Draw/ Polyline |
| **Toolbar: Draw** | |
| **Command Line** | pline |
| **Alias** | pl |

| MIRROR | |
|---|---|
| **Ribbon/ Home tab/ Modify/ Mirror** | |
| **Menu** | Modify/ Mirror |
| **Toolbar: Modify** | |
| **Command Line** | mirror |
| **Alias** | mi |

Specify next point or [Arc/Close/
   Halfwidth/Length/Undo/Width]:

Specify next point or [Arc/Close/
   Halfwidth/Length/Undo/Width]:
Command:

PLINE
Specify start point:

Current line width is 0'-0"
Specify next point or [Arc/Halfwidth/
   Length/Undo/Width]:

Specify next point or [Arc/Close/
   Halfwidth/Length/Undo/Width]:

Specify next point or [Arc/Close/
   Halfwidth/Length/Undo/Width]:

Specify next point or [Arc/Close/
   Halfwidth/Length/Undo/Width]:

Specify next point or [Arc/Close/
   Halfwidth/Length/Undo/Width]:
Command:
Point:

of X = 1'-2"; Y = 4'-6"; Z = 0'-0'"
Command:
PLINE
Specify start point:

Current line width is 0'-0"
Specify next point or [Arc/Halfwidth/
   Length/Undo/Width]:

Specify next point or [Arc/Close/
   Halfwidth/Length/Undo/Width]:

Type: **@72<180 <Enter ↵>** *(or with **ORTHO** on, move the mouse to the left, Type: **72** <Enter ↵>)*

Type: **C <Enter ↵>** *(to close the polyline)*
Select the **POLYLINE** icon *(or press **<Enter ↵>** to repeat the **POLYLINE** command)*

*With **Osnap Endpoint**, select the beginning endpoint of the first **POLYLINE** (or Type: **pl <Enter ↵>** then Type: **1',1'6 <Enter ↵>**)*

Type:**@2<0 <Enter ↵>** *(or with **ORTHO** on, move the mouse to the right, Type: **2** <Enter ↵>)*

Type:**@36<90 <Enter ↵>** *(or with **ORTHO** on, move the mouse up, Type: **36** <Enter ↵>)*

Type: **@2<180 <Enter ↵>** *(or with **ORTHO** on, move the mouse to the left, Type: **2** <Enter ↵>)*

Type: **C <Enter ↵>** *(to close the polyline)*
Type: **ID <Enter ↵>**
Type: **End <Enter ↵>** *(pick the top inside end of the side pline to establish this point as the last point entered; see Figure 6-1)*

*Select the **POLYLINE** icon*

Type: **@8<270 <Enter ↵>** *(this point uses the last point entered, ID last command, as the reference point)*

Type: **@68<0 <Enter ↵>** *(or with **ORTHO** on, move the mouse to the right, Type: **68** <Enter ↵>)*

Type: **@2<270 <Enter ↵>** *(or with **ORTHO** on, move the mouse down, Type: **2** <Enter ↵>)*

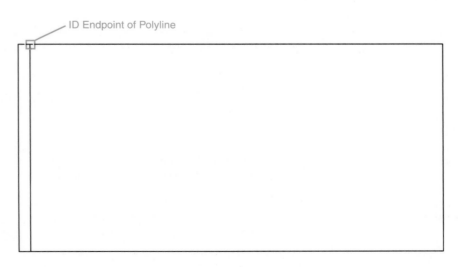

ID Endpoint of Polyline

**Figure 6-1**   ID Endpoint of Polyline

| | |
|---|---|
| Specify next point or [Arc/Close/<br>Halfwidth/Length/Undo/Width]: | Type: **@68<180 <Enter ↵>** *(or with **ORTHO**<br>**on**, move the mouse to the left, type 68,<br>and press Enter)* |
| Specify next point or [Arc/Close/<br>Halfwidth/Length/Undo/Width]: | Type:**C <Enter ↵>** *(to close the polyline)* |

We will now use the **MIRROR** command to make a copy of the left desk side panel to place on the right side.

| Prompt | Response |
|---|---|
| Command: | *Select the **MIRROR** icon* |
| Select objects: | *Pick the inside edge of the left desk side*<br>*(see Figure 6-2)* |
| Select objects: 1 found | Type: **<Enter ↵>** |
| First point of mirror line: | Type: **MID <Enter ↵>** *(or pick with **Osnap***<br>***Midpoint**)* |
| of | *Pick the midpoint of the desk privacy panel*<br>*(toggle **<F8>** to turn on **ORTHO,** or select*<br>*from the status bar)* |
| Second point: | *Pick a point above the privacy panel* |
| Delete old objects? <N> | Type: **<Enter ↵>** |

Your drawing should appear similar to Figure 6-3.

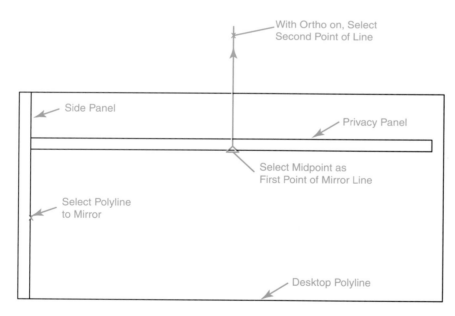

**Figure 6-2**  Select Left
Desk Side Panel to Mirror

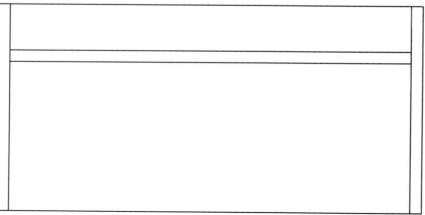

**Figure 6-3**  Desk After
Mirroring Left Side Panel

To create the desk in this chapter, we are taking a different approach than we did in previous chapters. We are completing all the major desk components as closed polylines. After we have completed the polylines, we will use the **EXTRUDE** command to extrude the components to the desired thickness, use the **3DMOVE** command to move the drawer banks, use the **SUBTRACT** command to subtract solids representing drawer reveals, and bevel the edges of the desktop with the **CHAMFER** command. As you gain experience in drafting three-dimensionally with Auto-CAD, you will begin to develop your own style and set of time-saving techniques.

The next step will be to develop the 16″-wide drawer banks. Because the two outside drawer banks are the same, we will develop the left drawer bank, then use the **MIRROR** command to produce the right drawer bank. We will begin the polyline by using **Osnap** to move to the **Endpoint** of the front inside edge of the left desk side (see Figure 6-4).

| Prompt | Response |
|---|---|
| Command:<br>PLINE<br>Specify start point: | *Select the* **POLYLINE** *icon*<br><br>Type: **END <Enter ↵>** *(or with* **Osnap**<br>**Endpoint** *pick the front inside edge of the*<br>*of the left desk side)* |
| of<br>Current line width is 0′-0″<br>Specify next point or [Arc/Halfwidth/<br>   Length/Undo/Width]: | <br><br>Type: **@16<0 <Enter ↵>** *(or with* **Ortho** *on,*<br>*push the mouse to the right and Type:* **16**) |
| Specify next point or [Arc/Close/<br>   Halfwidth/Length/Undo/Width]: | Type: **PER <Enter ↵>** *(or with* **Osnap** *on,*<br>*select* **Perpendicular** *and pick the next*<br>*point)* |
| to<br>Specify next point or [Arc/Close/<br>   Halfwidth/Length/Undo/Width]:<br>Of<br>Specify next point or [Arc/Close/<br>   Halfwidth/Length/Undo/Width]: | *Pick the privacy panel*<br><br>Type: **END <Enter ↵>** *(or use* **Osnap**)<br>*Pick the left end of the privacy panel*<br><br>Type: **C** *(to close the polyline)* |

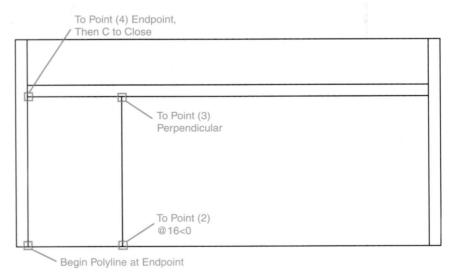

**Figure 6-4** Selection Points for Left Drawer Bank

**MIRROR** the left drawer bank polyline to produce the right drawer bank.

| Prompt | Response |
|---|---|
| Command:<br>MIRROR<br>Select objects: | *Select the* **MIRROR** *icon*<br><br>*Pick the inside edge of the left desk drawer*<br>*bank (see Figure 6-5)* |

| | |
|---|---|
| Select objects: 1 found | Type: **<Enter ↵>** |
| First point of mirror line: | Type: **MID <Enter ↵>** *(or use **Osnap Mid**)* |
| of | *Pick the midpoint of the desk privacy panel* |
| | *(toggle **<F8>** to turn on **Ortho**, or select* |
| | *from the status bar)* |
| Second point: | *Pick a point below the privacy panel* |
| Delete old objects? <N> | Type: **<Enter ↵>** |

Your drawing should appear similar to Figure 6-6.

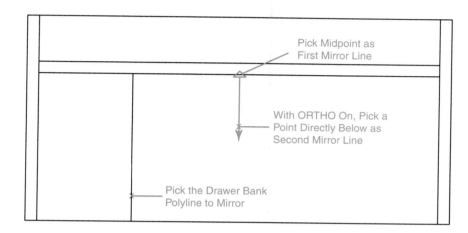

**Figure 6-5**  Mirror Left Drawer Bank

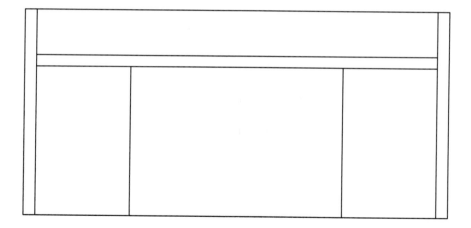

**Figure 6-6**  Desk After Mirroring Drawer Bank

We will now construct the center drawer. Because the overlapping (or *coplanar*) center drawer edge lines make them difficult to select, we will use the **EXTRUDE** and **MOVE** commands immediately after drawing the center drawer polyline. By using this process, we can use the **l** *(last)* option and not have to rely on graphic selection (manually picking) of the polyline. Also, we have endpoints at each corner of the center drawer location, making the construction process easy.

coplanar: Objects lying on the same plane.

| Prompt | Response |
|---|---|
| Command: | *Select the **POLYLINE** icon* |
| PLINE | |
| Specify start point: | *With **Osnap Endpoint**, pick the front inside* |
| | *edge of the left drawer bank (see Figure 6-7)* |
| of | |
| Current line width is 0'-0" | |
| Specify next point or [Arc/Halfwidth/ | |
| Length/Undo/Width]: | *With **Osnap** on, pick the front left end of the* |
| | *right front drawer bank* |

| | |
|---|---|
| Specify next point or [Arc/Close/ Halfwidth/Length/Undo/Width]: | With **Osnap** on, pick the back left end of the right front drawer bank |
| Specify next point or [Arc/Close/ Halfwidth/Length/Undo/Width]: | With **Osnap** on, pick the top right end of the left drawer bank |
| Specify next point or [Arc/Close/ Halfwidth/Length/Undo/Width]: | Type: **C <Enter ⏎>** *(to close the polyline)* |

Change to a **SW Isometric** view using **Presets,** selected from the **Menu Browser,** then **View**, **3D Views** flyout, to get a better idea of the status of the desk so far. Your drawing should appear similar to Figure 6-8. We will remain in this isometric view to complete the desk.

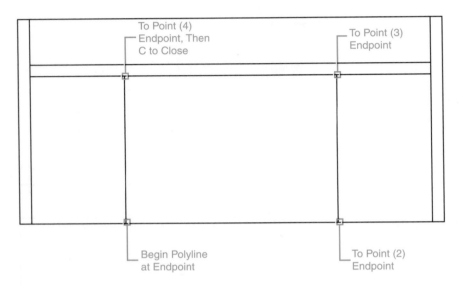

**Figure 6-7** Selection Points for Center Drawer Polyline

**Figure 6-8** **SW Isometric** View of Desk

| Prompt | Response |
|---|---|
| Command: | *Select the **EXTRUDE** icon* |
| Command: _extrude | |
| Current wire frame density: ISOLINES = 4 | |
| Select objects to extrude: | Type: **I** *(last)* **<Enter ⏎>** (or select the center drawer polyline) |
| Current wire frame density: ISOLINES = 4 | |
| 1 found | |

Select objects to extrude:
Specify height of extrusion or
   [Direction/Path/Taper angle] <0′-3″>:
Command:

_3dmove
Select objects: 1 found
Select objects:
Specify base point or [Displacement]
   <Displacement>:
Specify second point or
   <use first point as displacement>:

*Type:* **<Enter ↵>**

*Push the mouse up and Type:* **3**
*Select the **3DMOVE** tool from the **Modify**
   menu located on the **Ribbon Home** tab*

*Pick the center drawer*
*Type:* **<Enter ↵>**

*Highlight (left click) the Z axis (see Figure 6-9)*

*Type:* **24 <Enter ↵>**

| EXTRUDE | |
|---|---|
| **Ribbon/ Home tab/ 3D Model- ing/Extrude** | |
| **Menu** | Draw/ Modeling Extrude |
| **Toolbar: Modeling** | |
| **Command Line** | extrude |
| **Alias** | ext |

Your drawing should appear similar to Figure 6-10.

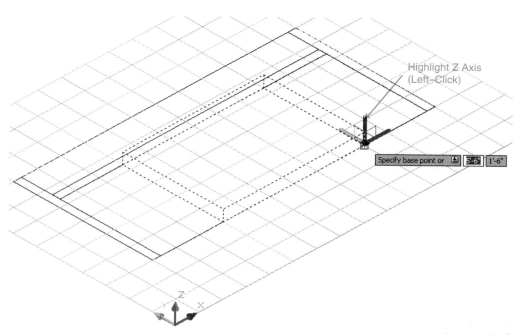

**Figure 6-9**    Use **3DMOVE** to Move the Center Drawer

| 3DMOVE | |
|---|---|
| **Ribbon/ Home tab/ Solid Edit- ing/3D Move** | |
| **Menu** | Modify/ 3D Opera- tions/ 3D Move |
| **Toolbar: Modeling** | |
| **Command Line** | 3dmove |

**Figure 6-10**    Center Drawer After **3DMOVE** Command

We will now extrude the closed 2D polylines created earlier for the desk sides and privacy panel.

| Prompt | Response |
|---|---|
| Command: | *Select the* **EXTRUDE** *icon* |
| Command: _extrude | |
| Current wire frame density: ISOLINES = 4 | *Pick the left side of the desk (see Figure 6-11)* |
| Select objects to extrude: 1 found | *Pick the right side of the desk* |
| Select objects to extrude: 1 found, 2 total | *Pick the privacy panel* |
| Select objects to extrude: 1 found, 3 total | |
|   Select objects to extrude: | Type: **<Enter ↵>** |
| Specify height of extrusion or [Direction/ | |
|   Path/Taper angle] <0'-0">: | Type: **27 <Enter ↵>** |

Your drawing should appear similar to Figure 6-12.

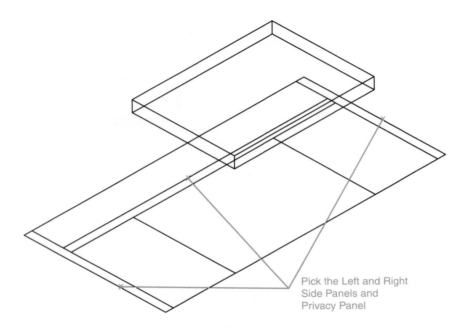

Pick the Left and Right
Side Panels and
Privacy Panel

**Figure 6-11**　Polylines to Select for Extrusion

**Figure 6-12**　Desk Sides and Privacy Panel After Extrusion

We will now extrude the desktop and move it in the Z direction 27″.

| Prompt | Response |
|---|---|
| Command: | Select the **EXTRUDE** icon |
| Command: _extrude | |
|   Current wire frame density: ISOLINES = 4 | Pick the desktop |
| Select objects to extrude: 1 found | |
| Select objects to extrude: | Type: **<Enter ↵>** |
| Specify height of extrusion or | |
|   [Direction/Path/Taper angle] <0′-0″>: | Type: **2 <Enter ↵>** |
| Command: | Type: **M <Enter ↵>** *(or select the* **3DMOVE** *icon)* |
| MOVE | |
| Select objects: | Type: **I** *(last)* **<Enter ↵>** *(or pick the desktop solid)* |
| 1 found | |
| Select objects: | Type: **<Enter ↵>** |
| Specify base point or [Displacement] | |
|   <Displacement>: | Type: **0,0,0 <Enter ↵>** |
| Specify second point or <use first | |
|   point as displacement>: | Type: **0,0,27 <Enter ↵>** |

**Note:** When using **3DMOVE**, you can also place the **3DMOVE** grip tool on the object to be moved, select the axis about which you wish the object to move, and type in the distance that you want the object to move.

Your drawing should appear similar to Figure 6-13.

**Figure 6-13** Desktop After **EXTRUDE** and **3DMOVE** Commands

The next step will be to extrude the side drawer banks to a thickness of 19″. We will then use the **3DMOVE** command to move the drawer banks in the Z direction 8″ and add $\frac{1}{2}″ \times \frac{1}{2}″$ reveals between the drawers.

| Prompt | Response |
|---|---|
| Command: | Select the **EXTRUDE** icon |
| Command: _extrude | |
| Current wire frame density: ISOLINES = 4 | Pick the left drawer bank |
| Select objects to extrude: 1 found | |
| Select objects to extrude: | Type: **<Enter ↵>** |
| Specify height of extrusion or | |
|   [Direction/Path/Taper angle] <0′-2″>: | Type: **19 <Enter ↵>** |
| Command: | Select the **3DMOVE** grip tool |

| | |
|---|---|
| Command: _3dmove | *Pick the left drawer bank* |
| Select objects: 1 found | |
| Select objects: | Type: **<Enter ↵>** |
| Specify base point or [Displacement] | |
|    <Displacement>: | *Place the **3DMOVE** grip tool at the bottom endpoint of the left drawer bank and highlight the Z axis* |
| Specify second point or | |
|    <use first point as displacement>: | Type: **8** |

Your drawing should appear similar to Figure 6-14. Note that the drawer bank has a smooth front. In the next step, we will add solids representing the reveals, or spaces, between the drawers and then use the **SUBTRACT** command to create the reveals separating the drawers.

**Figure 6-14**    Desk After Extruding and Moving Left Drawer Bank

Constructing the solid shapes to subtract from the drawer banks, which will produce the reveals between the drawers, requires some calculations. The two lower drawers will have 7″-high fronts and the top drawer will have a 4″-high front, with $\frac{1}{2}$″ spaces (reveals) between. We will return to plan view to draw the polyline representing the reveal solid. After completing the reveal polyline in plan view, we will extrude the closed polyline $\frac{1}{2}$″, move the solid to the correct location of the first reveal, copy the solid to the second reveal location, and finally, subtract the reveals from the drawer bank.

| Prompt | Response |
|---|---|
| Command: | Type: **PLAN <Enter ↵>** *(or select **Plan View** from 3D Views Presets, World UCS)* |
| <Current UCS >/Ucs/World: | Type: **<Enter ↵>** |
| Command: | Type: **Z <Enter ↵>** |
| All/Center/Dynamic/Extents/Previous/ | |
|    Scale/(X/XP)/Window/<Realtime>: | *Pick a window around the front of the left drawer bank* |
| Command: | *Select the **POLYLINE** icon* |
| Command: _pline | |
| Specify start point: | *Pick the endpoint of the left front corner of the left drawer bank (see Figure 6-15)* |

Current line width is 0'-0"
Specify next point or [Arc/Halfwidth/
    Length/Undo/Width]:                    *Pick the endpoint of the right front corner of*
                                           *the left drawer bank*

Specify next point or [Arc/Close/
    Halfwidth/Length/Undo/Width]:          Type: **@1/2<90 <Enter ↵>**
Specify next point or [Arc/Close/
    Halfwidth/Length/Undo/Width]:          Type: **@16<180 <Enter ↵>**
Specify next point or [Arc/Close/
    Halfwidth/Length/Undo/Width]:          Type: **C <Enter ↵>** *(to close the polyline)*

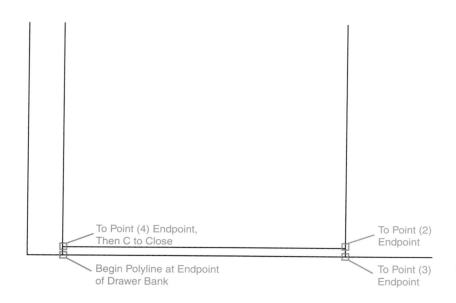

To Point (4) Endpoint,
Then C to Close

To Point (2)
Endpoint

Begin Polyline at Endpoint
of Drawer Bank

To Point (3)
Endpoint

**Figure 6-15**  Polyline
Selection Points for Drawer
Reveal

We will change to a **SW Isometric** view to see the results of the following commands. We will extrude, **3Dmove,** and copy the closed polyline just created for the drawer reveal. Notice that the polyline just created is located at elevation 0.

**Prompt**                                           **Response**

Command:                                   *Change to a **SW Isometric** view*
Command:                                   *Select the **EXTRUDE** icon*
Command: _extrude
Current wire frame density: ISOLINES = 4   *Pick the reveal polyline*
Select objects to extrude: 1 found
Select objects to extrude:                 Type: **<Enter ↵>**
Specify height of extrusion or [Direction/
    Path/Taper angle] <1'-7">:             *Push the mouse up and Type:* 1/2
Command:                                    *Select the **3DMOVE** grip tool*
Select objects:                            *Pick the reveal polyline*
1 found
Select objects:                            Type: **<Enter ↵>**
Specify base point or [Displacement]
    <Displacement>:                        *Pick a point on the screen*
Specify second point or <use first
    point as displacement>:                *Highlight the Z axis, and Type:* **15 <Enter ↵>**
Command:                                    Type: **CP** *(copy)* **<Enter ↵>**
COPY
Select objects:                            Type: **l** *(last)* **<Enter ↵>**
1 found
Select objects:                            Type: **<Enter ↵>**
Current settings: Copy mode = Multiple
Specify base point or
    [Displacement/mOde] <Displacement>:    Type: **0,0,0 <Enter ↵>**

| | |
|---|---|
| Specify second point or<br>    \<use first point as displacement>: | Type: **0,0,7.5 \<Enter ↵>** |
| Specify second point or<br>    [Exit/Undo] \<Exit>: | Type: **\<Enter ↵>** |

Your drawing should appear similar to Figure 6-16.

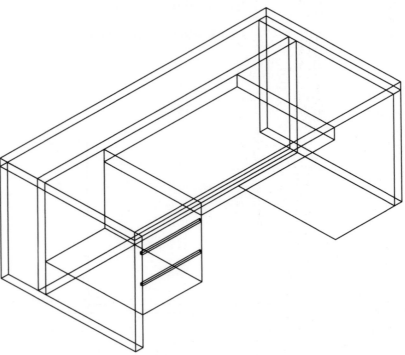

**Figure 6-16**　Desk with Left Drawer Bank Reveals

To complete the left drawer bank, we need to subtract the drawer reveal solids from the drawer bank. On your own, select the **SUBTRACT** icon from the **Menu Browser, Modify, Solid Editing** flyout, and subtract the two reveal solids from the left drawer bank. Change the view using the **Visual Styles Manager** to **Conceptual** to produce a view that more clearly illustrates the results of subtracting the reveals from the drawer bank solid. Your view should appear similar to the one in Figure 6-17.

We could repeat the processes used to create the left drawer bank and reveals for creating the right drawer bank and its reveals. We could copy the drawer bank with reveals from the left side to the right side, but it would be more time-efficient to use the **MIRROR3D** command to create the right drawer bank. The **MIRROR3D** command creates a mirror image of objects about a plane. We can use the plane established by the YZ plane located at the center (midpoint) of the desktop or center desk drawer. Remember, we will be mirroring about a plane (YZ) and not a point.

Use the **MIRROR3D** command to create the right drawer bank.

| SUBTRACT | |
|---|---|
| **Ribbon/<br>Home tab/<br>Solid<br>editing/<br>Subtract** | ◎◎ |
| **Menu**<br>▲ | Modify/<br>Solid<br>Editing/<br>Subtract |
| **Toolbar:<br>Modeling** | ◎◎ |
| **Command<br>Line** | subtract |
| **Alias** | su |

| Prompt | Response |
|---|---|
| Command: | Type: **MIRROR3D \<Enter ↵>**<br>*Select the left drawer bank* |
| Select objects: 1 found | |
| Select objects: | Type: **\<Enter ↵>** |
| Specify first point of mirror plane<br>   (3 points) or [Object/Last/Zaxis/View/<br>   XY/YZ/ZX/3points] \<3points>: | Type: **yz \<Enter ↵>** |
| Specify point on YZ plane \<0,0,0>: | *With **Osnap Midpoint**,* |
| of | *pick the midpoint of the center desk drawer* |
| Delete source objects? [Yes/No] \<N>: | Type: **\<Enter ↵>** |

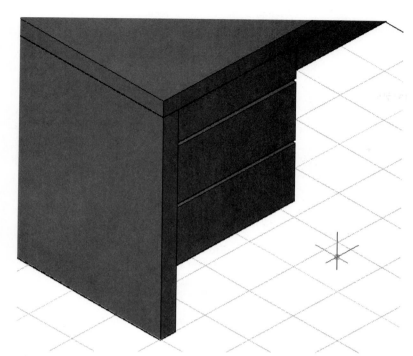

Figure 6-17    Conceptual View of the Completed Left Drawer Bank

The original polyline drawn at elevation 0 representing the right drawer bank was not used. On your own, erase the polyline and then change the visual style to **Conceptual.** Your drawing should appear similar to Figure 6-18. After looking at the conceptual view of the desk, change the visual style back to **2D Wireframe** and continue.

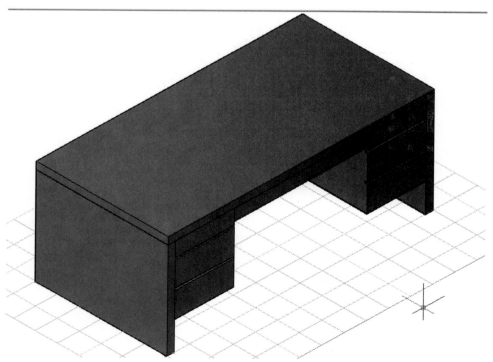

Figure 6-18    Conceptual View of Desk After **MIRROR3D** Command

| CHAMFER | |
|---|---|
| **Ribbon/ Home tab/ Modify/ Chamfer** | |
| **Menu** | Modify/ Chamfer |
| **Toolbar: Modify** | |
| **Command Line** | chamfer |
| **Alias** | cha |

The final step in completing the desk will be to add a chamfered edge to the outside edge of the desktop.

| Prompt | Response |
|---|---|
| Command: | *Select the* **CHAMFER** *icon* |
| Command: _chamfer | |
| (TRIM mode) Current chamfer Dist1 = 0'-0", Dist2 = 0'-0" | |
| Select first line or [Undo/Polyline/ Distance/Angle/Trim/mEthod/Multiple]: | *Pick a top edge of the desktop (see Figure 6-19)* |
| Base surface selection... | |
| Enter surface selection option [Next/OK (current)] <OK>: | Type: **N <Enter ↵>** |
| Enter surface selection option [Next/OK (current)] <OK>: | Type: **<Enter ↵>** |
| Specify base surface chamfer distance: | Type: **1 <Enter ↵>** |
| Specify other surface chamfer distance <0'-1">: | Type: **<Enter ↵>** |
| Select an edge or [Loop]: Select an edge or [Loop]: Select an edge or [Loop]: | *Pick the top four edges of the desktop* |
| Select an edge or [Loop]: Select an edge or [Loop]: | Type: **<Enter ↵>** |

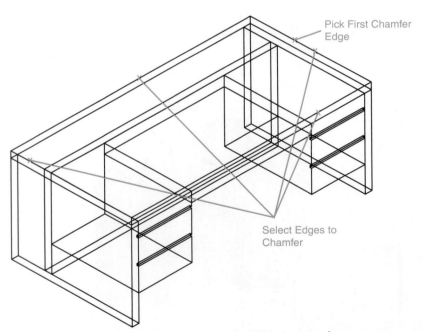

Figure 6-19     Desktop Edge Selection for **CHAMFER** Command

This completes the creation of the desk. Change the visual style to **Conceptual SW Isometric** view, and your drawing should appear similar to Figure 6-20. Using the **Menu Browser, View, 3D Views** flyout, produce the following conceptual elevation views: front, right side, and back, similar to Figures 6-21 through 6-23, respectively.

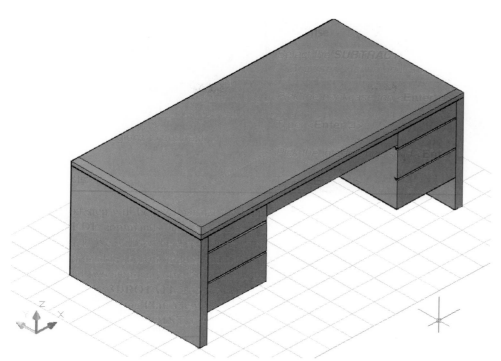

**Figure 6-20**    Conceptual SW Isometric View of Completed Desk

**Figure 6-21**    Conceptual Front Elevation View of Desk

**Figure 6-22**    Conceptual Right-Side Elevation View of Desk

**Figure 6-23**   Conceptual Back Elevation View of Desk

## CHAPTER EXERCISE

### Exercise 6-1:

Produce a credenza that matches the style of the desk created in this chapter. Make the credenza 72″ wide, 29″ high, and 26″ deep. Place four file drawers of equal size in the credenza. Use the **CHAMFER** command to place a 1″ beveled edge around the top edge of the credenza and place $\frac{1}{2}$″ reveals between the upper and lower drawers.

To begin this exercise, open the desk drawing. Follow the process like the one used in Chapter Exercise 5-1, which edited the coffee table to produce an end table. Because the drawers in the desk are different from the file-type drawers that would be used for the credenza, begin by erasing the desk drawers. After erasing the desk drawers, your drawing should appear similar to Figure 6-24.

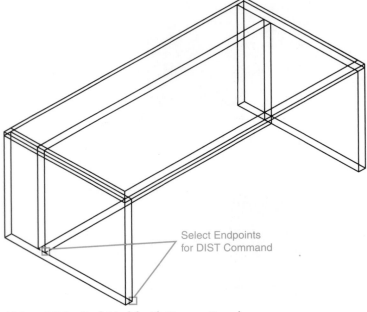

Select Endpoints
for DIST Command

**Figure 6-24**   Desk Model with Drawers Erased

| DIST | |
|---|---|
| **Ribbon/ Tools tab/ Inquiry** |  |
| **Menu** | Tools/ Inquiry/ Distance |
| **Toolbar: Inquiry** |  |
| **Command Line** | dist *or* 'dist |

Use the **DIST** command with **Osnap Endpoint** to verify the distance between the drawer side edge of the desk side panel and the inside edge of the privacy panel. The distance should be 26″ (see Figure 6-24).

The inside edge plane of the privacy panel can be used as the reference point/plane to slice and remove the front portion of the desk. Use the **SLICE** command to remove the front portions

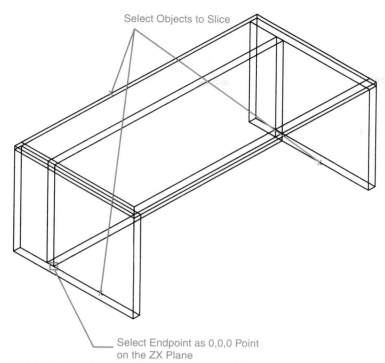

Select Objects to Slice

Select Endpoint as 0,0,0 Point
on the ZX Plane

**Figure 6-25**    Selection Objects and Plane for the **SLICE** Operation

of the desk side panels and desktop. Select the desk side panels and desktop to slice, select the inside endpoint of the privacy panel as the 0,0,0 point on the ZX plane, and pick a point on the drawer side of the desk to keep (see Figure 6-25).

Your drawing should appear similar to Figure 6-26 after the **SLICE** operation.

The privacy panel is no longer needed, so use the **ERASE** command to remove it from the model. Use the **DIST** command to determine the distance between the inside edges of of the desk side panels. The distance should be 5′8″. If you subtract $\frac{1}{2}$″ for the space between the two drawer banks from the total distance and divide by two, the total width for each drawer bank will be $33\frac{3}{4}$″. Draw a closed polyline (at elevation 0) to represent the left drawer bank. The

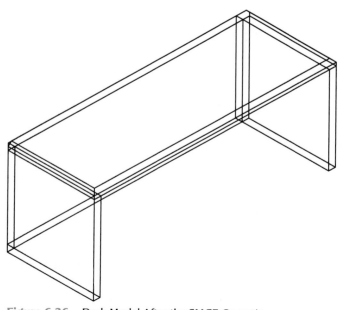

**Figure 6-26**    Desk Model After the **SLICE** Operation

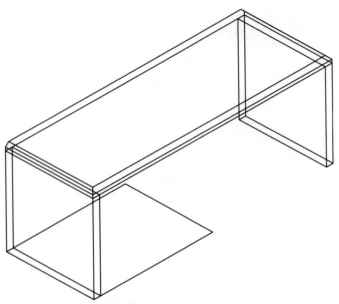

**Figure 6-27**     Closed Polyline for the Left Drawer Bank

polyline should extend from the front to the back of the credenza 26″ deep and 33$\frac{3}{4}$″ wide. Your drawing should appear similar to Figure 6-27.

Use the **EXTRUDE** command to extrude the drawer bank 19″ in the +Z direction. At elevation 0, draw a closed polyline shape the width of the drawer bank and $\frac{1}{2}$″deep. Your drawing should appear similar to Figure 6-28.

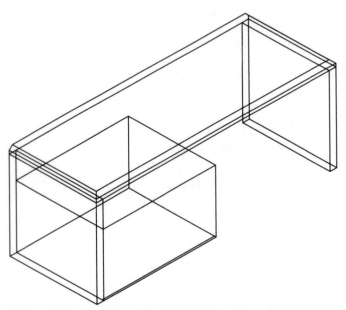

**Figure 6-28**     Left Drawer Bank Extruded and Reveal Polyline Drawn

Use the **EXTRUDE** command to extrude the reveal polyline $\frac{1}{2}$″ in the +Z direction. Use the **3DMOVE** command to move the reveal shape to the midpoint of the drawer bank, or use the **MOVE** command, base point **0,0,0**, and **0,0,9.25** as the second point of displacement. Your drawing should appear similar to Figure 6-29.

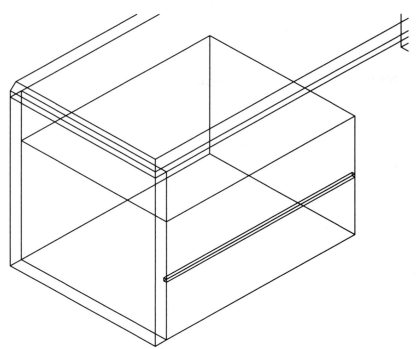

**Figure 6-29**    Drawer Reveal Located at the Midpoint of the Drawer Bank

Use the **SUBTRACT** command to subtract the drawer reveal from the drawer bank. Use the **3DMOVE** command to move the drawer bank 8″ in the +Z direction. Your drawing should appear similar to Figure 6-30.

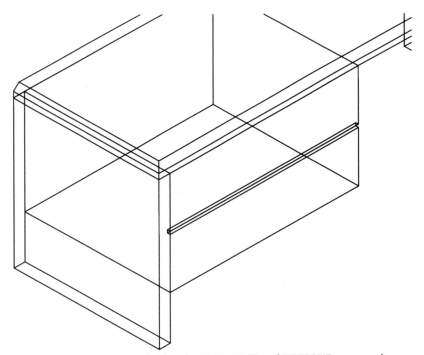

**Figure 6-30**    Drawer Bank After the **SUBTRACT** and **3DMOVE** commands

Use the **MIRROR3D** command to produce the right drawer bank. Select the left drawer bank to mirror, and use the midpoint of desktop as the 0,0,0 point on the YZ plane. Your drawing should appear similar to Figure 6-31.

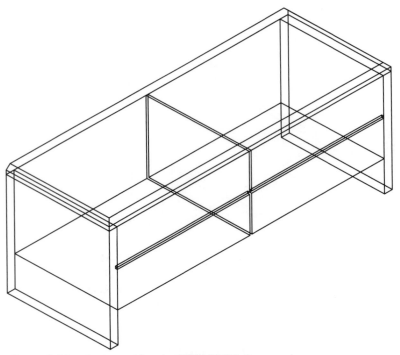

Figure 6-31     Credenza After the **MIRROR3D** Command

The final step in Chapter Exercise 6-1 will be to bevel the top back edge of the credenza. With the **CHAMFER** command, place a 1″ bevel at the top back edge of the credenza. Change to the **Conceptual** visual style. The final drawing of the credenza model should appear similar to Figure 6-32.

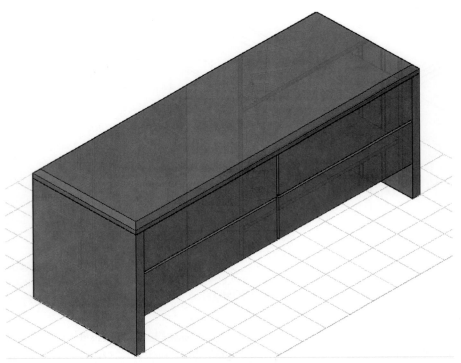

Figure 6-32     Conceptual View of the Completed Credenza

# Summary

In this chapter, you learned how to use project components as construction guides for creating new models or model components. You gained practice creating 3D solids by extruding closed polyline shapes.

Practice was provided in creating beveled edges on the edges of solids using the **CHAMFER** command. The **SUBTRACT** command was used to subtract one solid from another coplanar solid.

Chapter Exercise 6-1 included additional practice mirroring and moving objects three-dimensionally using the **MIRROR3D** and **3DMOVE** commands. Additional practice was provided for using the **SLICE** command to cut three-dimensional solids into sections. The **DIST** command was used to determine exact distances between **Osnap** points on objects.

# Chapter Test Questions

## Multiple Choice

1. The alias for typing in the **POLYLINE** command at the command prompt is which of the following?

   a. **po**
   b. **pe**
   c. **pl**
   d. **pn**
   e. None of the above

2. The **MIRROR3D** command can be used to mirror objects using which of the following?

   a. A mirror plane
   b. Only the points on the XY plane
   c. Only points on the Z axis
   d. Only 2D objects
   e. Objects above the XY plane

3. Which of the following is the most appropriate tool and/or command to use in moving 3D solid objects in the Z direction?

   a. **CHANGE/ELEVATION**
   b. **MIRROR**
   c. **3DMOVE**
   d. **EXTRUDE**
   e. **3DROTATE**

4. The **SUBTRACT** command allows you to do which of the following?

   a. Subtract one coplanar solid from another
   b. Subtract one segment of a polyline
   c. Subtract one noncoplanar solid from another
   d. Subtract portions of a closed polyline
   e. Subtract a line segment from another line segment

5. Which of the following is **not** located on the **3D Operations** flyout?

   a. **Align**
   b. **Explode**
   c. **3D Move**
   d. **3D Rotate**
   e. **3D Array**

## Matching

### Column A

a. **SECTION**

b. **UNION**

c. **3DMOVE**

d. **SUBTRACT**

e. **CHAMFER**

### Column B

1. Allows you to create a cross section through a 3D solid

2. Combines selected regions or solids by addition

3. Displays the **MOVE** grip tool in a 3D view and moves objects a specified distance in a specified direction

4. Combines selected regions or solids by subtraction

5. Bevels the edges of objects

## True or False

1. T or F: The **EXTRUDE** command can be used to extrude regions and closed polylines.

2. T or F: The **FILLET** command can be used to place a beveled edge on objects.

3. T or F: The **CHAMFER** command can be used to place a rounded edge on objects.

4. T or F: The **SLICE** command can be used to cut solids at a specified plane.

5. T or F: The **SECTION** command can be used to create 2D sections from 3D objects.

# Desk Chair

## Chapter Objectives

- Learn to use points as construction reference guides
- Create a solid cylindrical shape from a cube
- Use the **3DROTATE** grip tool
- Create three-dimensional solids with the **EXTRUDE** command
- Use the **MOVE**, **MIRROR3D**, and **ARRAY** commands
- Use the **SWEEP** command to sweep a profile around a path
- Learn to use **Coordinate Filters** to extract designated points

## INTRODUCTION

In this chapter, we will construct a small desk chair with arms. We will begin by locating a point (node) as a reference point using absolute coordinates, at X = 3′, Y = 2′, and Z = 0. This point will serve as the reference point for the center of the chair base.

We will draw one complete caster leg assembly, and we will use the **ARRAY** command to create the additional four caster leg assemblies.

## DRAWING SETUP

Begin a new drawing and set the **Units** to **Architectural**, **Precision** to $\frac{1}{4}''$. Set the **Limits** to **0,0** and **6′,4′**. Set the **Grid** to **6″**, and **Zoom All**.

## BEGIN DRAWING

| Prompt | Response |
|---|---|
| Command: | Type: **POINT <Enter ↵ >** |
| Point: | Type: **3′,2′,0 <Enter ↵>** |

| POINT | |
|---|---|
| **Ribbon/ Home tab/ Draw/ Point** | ▪ |
| **Menu** | Draw/ Point |
| **Toolbar: Draw** | ▪ |
| **Command Line** | point |
| **Alias** | po |

You most likely did not see any change on the drawing screen as a result of the previous command. The **POINT** command allows you to place point entities in a drawing. You can snap to these points by using **Osnap**, **Node**. There are numerous styles of points to select from. Use the **DDPTYPE** command to view the point styles (see Figure 7-1). The **DDPTYPE** command will display a dialog box illustrating point styles, as well as options for selecting size relative to the screen or size by absolute units. You can also set the point style with the system variable **PDMODE**, and the point size with the **PDSIZE** system variable.

Figure 7-1 **Point Style** Dialog Box

| POLYLINE | |
|---|---|
| **Ribbon/ Home tab/ Draw/ Polyline** |  |
| **Menu** | Draw/ Polyline |
| **Toolbar: Draw** | |
| **Command Line** | pline |
| **Alias** | pl |

| Prompt | Response |
|---|---|
| Command: | Type: **DDPTYPE <Enter ↵>** |
| | *Select the point style consisting of a circle with vertical and horizontal lines through the center* |
| | *Select the radio button for **Set Size in Absolute Units*** |
| | *Enter 2″ for the point size.* |
| Command: | Type: **regen <Enter ↵>** *(to see the results of changing the point size and style)* |

Now that we have a reference point representing the center of the chair base, we can begin to develop the casters. We could use the **CYLINDER** command to construct a caster and extrude it in the Z direction and then use the **ROTATE3D** command to align the cylinder with the XY plane, or we could draw a cube with the **POLYLINE**, **EXTRUDE**, and **FILLET** commands. We will use the last process; after all, a cylinder is just a cube with rounded corners.

| EXTRUDE | |
|---|---|
| **Ribbon/ Home tab/ 3D Model-ing/Extrude** |  |
| **Menu** | Draw/ Modeling/ Extrude |
| **Toolbar: Modeling** | |
| **Command Line** | extrude |
| **Alias** | ext |

| Prompt | Response |
|---|---|
| Command: | *Select the **POLYLINE** icon* |
| PLINE | |
| Specify start point: | Type: **@14<180 <Enter ↵>** |
| Current line width is 0'-0″ | |
| Specify next point or [Arc/Halfwidth/ Length/Undo/Width]: | Type: **@2.5<0 <Enter ↵>** |

**TIP** With **ORTHO** on, move the mouse in the direction you wish to draw and type in the direct distance

| Prompt | Response |
|---|---|
| Specify next point or [Arc/Close/ Halfwidth/Length/Undo/Width]: | Type: **@2.5<90 <Enter ↵>** |
| Specify next point or [Arc/Close/ Halfwidth/Length/Undo/Width]: | Type: **@2.5<180 <Enter ↵>** |

| | |
|---|---|
| Specify next point or [Arc/Close/ Halfwidth/Length/Undo/Width]: | Type: **C <Enter ↵>** *(to close the polyline)* |
| Command: | *Select the **EXTRUDE** icon* |
| EXTRUDE | |
| Current wire frame density: ISOLINES = 4 | |
| Select objects to extrude: | Type: **L** *(last)* **<Enter ↵>** |
| 1 found | |
| Select objects to extrude: | Type: **<Enter ↵>** |
| Specify height of extrusion or [Direction/Path/Taper angle]: | Type: **2.5 <Enter ↵>** |

Change the view to **NE Isometric**, and your drawing should appear similar to Figure 7-2.

Figure 7-2    Reference Point and Cube

In the next step, we will use the **FILLET** command to change the square to a cylinder for the caster. Then we will add the caster axle that will extend upward into the chair base.

| Prompt | Response |
|---|---|
| Command: | *Select the **FILLET** icon* |
| Command: fillet | |
| Current settings: Mode = TRIM, | |
| Radius = 0′-0″ Select first object or [Undo/Polyline/Radius/Trim/Multiple]: | Type: **R <Enter ↵>** |
| Specify fillet radius <0′-0″>: | Type: **1.25 <Enter ↵>** |
| Select first object or [Undo/Polyline/ Radius/Trim/Multiple]: | Type: **M <Enter ↵>** |
| Select an edge or [Chain/Radius]: | *Pick a horizontal edge of the cube (see Figure 7-3)* |
| Enter fillet radius <0′-1$\frac{1}{4}$′>: | |
| Select an edge or [Chain/Radius]: | *Pick the three remaining horizontal edges* |
| 4 edge(s) selected for fillet. | |
| Select first object or [Undo/Polyline/ Radius/Trim/Multiple]: | Type: **<Enter ↵>** |

Your drawing should appear similar to Figure 7-4.

We will now draw the caster axle that will extend from the center of the caster to the base of the chair leg. We will use the **ID** command to establish the point (node) as the last point entered and then, using *polar coordinates*, we will draw a $\frac{1}{2}$″ square using the **POLYLINE** command at elevation 0. We will then extrude the square $1\frac{3}{4}$″, and move it in the Z direction $1\frac{1}{4}$″ using the **3DMOVE** grip tool, which will result in a total height of 3″ for the caster assembly.

| FILLET |
|---|
| **Ribbon/ Home tab/ Modify/ Fillet** |
| **Menu**     Modify/ Fillet |
| **Toolbar: Modify** |
| **Command Line**    fillet |
| **Alias**    f |

**polar coordinates:** Coordinates that are relative to the last point entered, designated by using @ to precede the distance < direction format. For istance, drawing a line by typing in @2′<0 would result in placing the beginning point of the line 2′ to the right of the last point entered.

Select Edges to Fillet

**Figure 7-3**    Cube Edges to Fillet

**Figure 7-4**    Cube After Fillet

| Prompt | Response |
|---|---|
| Command: | Type: **ID <Enter ↵>** |
| Specify point: | Type: **node <Enter ↵>** *Pick the reference point* |
| of X = 3'-0" Y = 2'-0" Z = 0'-0" | |
| Command: | Type: **pl <Enter ↵>** *(or select the **POLYLINE** icon)* |
| PLINE | |
| Specify start point: | Type: **@13<180 <Enter ↵>** *(or with **Ortho** on, push the mouse in the appropriate direction, and type in the direct distance)* |
| | |
| Current line width is 0'-0" | |
| Specify next point or [Arc/Halfwidth/ Length/Undo/Width]: | Type: **@1/2<0 <Enter ↵>** |
| Specify next point or [Arc/Close/ Halfwidth/Length/Undo/Width]: | Type: **@1/2<90 <Enter ↵>** |
| Specify next point or [Arc/Close/ Halfwidth/Length/Undo/Width]: | Type: **@1/2<180 <Enter ↵>** |
| Specify next point or [Arc/Close/ Halfwidth/Length/Undo/Width]: | Type: **C <Enter ↵>** *(to close the polyline)* |
| Command: | *Select the **EXTRUDE** icon* |
| EXTRUDE | |
| Current wire frame density: ISOLINES = 4 | |
| Select objects to extrude: | Type: **l** *(last)* **<Enter ↵>** |

| | |
|---|---|
| 1 found | |
| Select objects to extrude: | Type: **\<Enter ↵\>** |
| Specify height of extrusion or | |
| [Direction/Path/Taper angle]: | Type: **1-3/4 \<Enter ↵\>** |
| Command: | Type: **m** *(move)* **\<Enter ↵\>** |
| MOVE | |
| Select objects: | Type: **l** *(last)* **\<Enter ↵\>** |
| 1 found | |
| Select objects: | Type: **\<Enter ↵\>** |
| Specify base point or [Displacement] | |
| \<Displacement\>: | Type: **0,0,0 \<Enter ↵\>** |
| Specify second point or \<use first | |
| point as displacement\>: | Type: **0,0,1-1/4 \<Enter ↵\>** |

**TIP** You can also select the **3DMOVE** icon from the **Ribbon**, **Home** tab, **Modify** menu, and then select the extruded polyline, highlight the Z axis, and move the extrusion $1\frac{1}{4}''$ in the positive +Z direction.

Your drawing should appear similar to Figure 7-5.

**Figure 7-5**    Caster Assembly

We can now change the view to plan, World UCS, and begin constructing the chair leg. The chair leg, or base member that connects the caster to the pedestal, will be drawn with the **PLINE** and **EXTRUDE** commands, then moved into place with the **3DMOVE** grip tool.

| Prompt | Response |
|---|---|
| Command: | Type: **PLAN \<Enter ↵\>** *(or select **Plan View, World UCS** from the **Menu Browser, View, 3D Views** flyout)* |
| Enter an option [Current ucs/Ucs/ World] \<Current\>: | Type: **\<Enter ↵\>** |

If you check the horizontal alignment of the center of the reference point created earlier, you will notice that the point is $\frac{1}{4}''$ below the center of the caster axle vertical member. To draw the chair leg more easily, we will move the reference point $\frac{1}{4}''$ in the north, or 90° direction.

| Prompt | Response |
|---|---|
| Command: | Type: **m** *(move)* **<Enter ↵>** |
| MOVE | |
| Select objects: | *Pick the reference point* |
| 1 found | |
| Select objects: | Type: **<Enter ↵>** |
| Specify base point or [Displacement] | *Pick any point* |
| <Displacement>: Specify second point or | |
|   <use first point as displacement>: | Type: **@.25<90 <Enter ↵>** |

Now that we have the point properly aligned, we can draw the chair base member that connects the caster to the pedestal.

| Prompt | Response |
|---|---|
| Command: | *Select the **POLYLINE** icon* |
| PLINE | |
| Specify start point: | Type: **3',1'1-3/4 <Enter ↵>** |
| Current line width is 0'-0" | |
| Specify next point or [Arc/Halfwidth/ | |
|   Length/Undo/Width]: | Type: **@1'1-1/4<180 <Enter ↵>** |
| Specify next point or [Arc/Close/ | |
|   Halfwidth/Length/Undo/Width]: | Type: **@1<90 <Enter ↵>** |
| Specify next point or [Arc/Close/ | |
|   Halfwidth/Length/Undo/Width]: | Type: **@1'1-1/4<0 <Enter ↵>** |
| Specify next point or [Arc/Close/ | |
|   Halfwidth/Length/Undo/Width]: | Type: **C <Enter ↵>** *(to close the polyline)* |
| Command: | *Select the **EXTRUDE** icon* |
| EXTRUDE | |
| Current wire frame density: ISOLINES = 4 | |
| Select objects to extrude: | Type: **l** *(last)* **<Enter ↵>** |
| 1 found | |
| Select objects to extrude: | Type: **<Enter ↵>** |
| Specify height of extrusion or | |
|   [Direction/Path/Taper angle] <0'-1¾">: | Type: **2.5 <Enter ↵>** |

Because the chair leg was just drawn at elevation 0, we will move it 3" in the +Z direction so that the bottom is located at the same elevation as the top of the caster axle. Change to a **NE Isometric** view. Select the **3DMOVE** grip tool from the **Ribbon**, **Home** tab, **Modify** menu and move the chair leg 3" in the +Z direction (or follow the instructions below using the **MOVE** command).

| Prompt | Response |
|---|---|
| Command: | Type: **m** *(move)* **<Enter ↵>** |
| MOVE | |
| Select objects: | Type: **l** *(last)* **<Enter ↵>** |
| 1 found | |
| Select objects: | Type: **<Enter ↵>** |
| Specify base point or [Displacement] | |
|   <Displacement>: | Type: **0,0,0 <Enter ↵>** |
| Specify second point or <use first | |
|   point as displacement>: | Type: **0,0,3 <Enter ↵>** |

Your drawing should appear similar to See Figure 7-6.

While the drawing is in an isometric view, round the edges of the caster and chair leg using the **FILLET** command.

**Figure 7-6**    Isometric View of Chair Leg Assembly

| Prompt | Response |
|---|---|
| Command: | Type: **f <Enter ↵>** *(or select the **FILLET** icon)* |
| FILLET | |
| Current settings: Mode = TRIM, | |
| Radius = $0'\text{-}1\frac{1}{4}''$ | |
| Select first object or [Undo/Polyline/ | |
| Radius/Trim/Multiple]: | Type: **R <Enter ↵>** |
| Specify fillet radius <$0'\text{-}1\frac{1}{4}'$>: | Type: **1/2 <Enter ↵>** |
| Select first object or [Undo/Polyline/ | |
| Radius/Trim/Multiple]: | *Pick a circular end of the caster* |
| Enter fillet radius <$0'\text{-}0\frac{1}{2}''$>: | Type: **<Enter ↵>** |
| Select an edge or [Chain/Radius]: | *Pick the opposite end of the caster* |
| Select an edge or [Chain/Radius]: | Type: **<Enter ↵>** |
| 2 edge(s) selected for fillet. | |

Your drawing should appear similar to Figure 7-7.

**Figure 7-7**    Caster After Filleting

We can also round the two long top edges of the chair leg using the **FILLET** command with a radius of $\frac{1}{4}''$ in this view.

| Prompt | Response |
| --- | --- |
| Command:<br>FILLET<br>Current settings: Mode = TRIM,<br>Radius = $0'-0\frac{1}{2}''$<br>Select first object or [Undo/Polyline/<br>    Radius/Trim/Multiple]: | Type: **f <Enter ↵>** (or select the **FILLET** icon)<br><br><br><br>Type: **R <Enter ↵>** |
| Specify fillet radius <$0'-0\frac{1}{2}''$>: | Type: **1/4 <Enter ↵>** |
| Select first object or [Undo/Polyline/<br>    Radius/Trim/Multiple]: | |
| Enter fillet radius <$0'-0\frac{1}{4}''$>: | Pick the back long top edge of the chair leg |
| Select an edge or [Chain/Radius]: | Pick the front long top edge of the chair leg |
| Select an edge or [Chain/Radius]: | Type: **<Enter ↵>** |
| 2 edge(s) selected for fillet. | |

Your drawing should appear similar to Figure 7-8.

**Figure 7-8**    Chair Leg After Filleting

We now have one chair leg assembly complete. Rather than repeat the chair leg assembly process three more times, use the **ARRAY** command to produce the additional chair leg assemblies. Return to plan view, World UCS, and use a polar array to complete the chair legs.

| ARRAY | |
| --- | --- |
| **Ribbon/<br>Home tab/<br>Modify/<br>Array** | ⊞ |
| **Menu** | Modify/<br>Array |
| **Modify:<br>Toolbar** | ⊞ |
| **Command<br>Line** | array |
| **Alias** | ar |

| Prompt | Response |
| --- | --- |
| Command: | Type: **PLAN <Enter ↵>** (or select **Plan View,<br>World UCS** from the **Menu Browser, View,<br>3D Views** flyout) |
| Enter an option [Current ucs/Ucs/World]<br><Current>: | Type: **<Enter ↵>** |
| Command: | Type: **Z** (zoom) **<Enter ↵>** |
| All/Center/Dynamic/Extents/Previous…. | Type: **A <Enter ↵>** |
| Command: | Type: **ARRAY <Enter ↵>** (or select the **ARRAY**<br>icon from the **Modify** toolbar) |

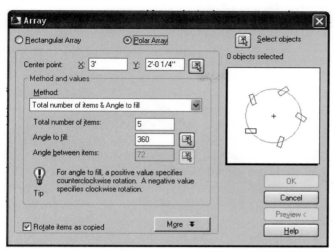

Figure 7-9    **Array** Dialog Box

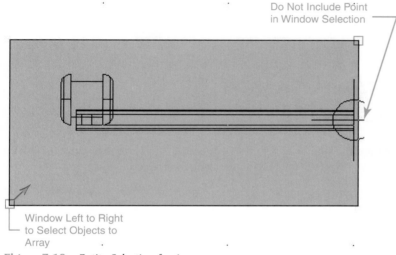

Figure 7-10    Entity Selection for Array

When the **ARRAY** command is issued, the **Array** dialog box appears on screen. Within the dialog box, make the following selections (see Figure 7-9): **Polar Array; Center point** as **X: 3′ Y: 2′$\frac{1}{4}$; Method: Rotate items as copied; Total number of items: 5;** click on the **Select objects** button; and with a window, include all items in the selection set with the exception of the point (see Figure 7-10).

After completing your work with the **ARRAY** command, your drawing should appear similar to the one in Figure 7-11.

The next step in drawing the desk chair will be to draw a pedestal that extends from the bottom edge of the chair legs to the seat bottom. We will begin by drawing a cylinder using absolute coordinates at an elevation of 3″. Then we will extrude the cylinder in the +Z direction to a height of 11″.

| Prompt | Response |
|--------|----------|
| Command: | Type: **CYL <Enter ↵>** *(or select the **CYLINDER** icon from the **Menu Browser**, **Draw** menu, **Modeling** flyout)* |
| CYLINDER | |
| Specify center point of base or [3P/2P/Ttr/Elliptical]: | Type: **3′,2′1/4,3 <Enter ↵>** |
| Specify base radius or [Diameter]: | Type: **1.5 <Enter ↵>** |
| Specify height or [2Point/Axis endpoint]: | Type: **11 <Enter ↵>** |

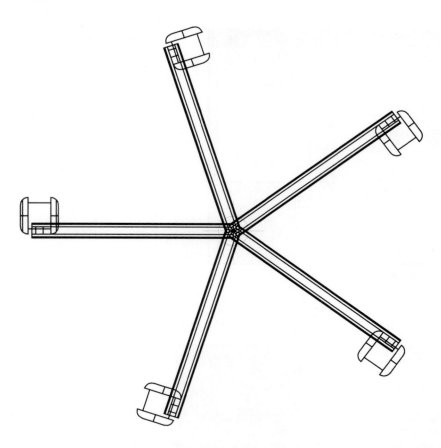

Figure 7-11     Chair Legs
After Array

Your drawing should appear similar to Figure 7-12. Select **NE Isometric** from the **Menu Browser**, **View**, **3D Views** flyout and use the **HIDE** command to produce a hidden isometric view of the chair base (see Figure 7-13).

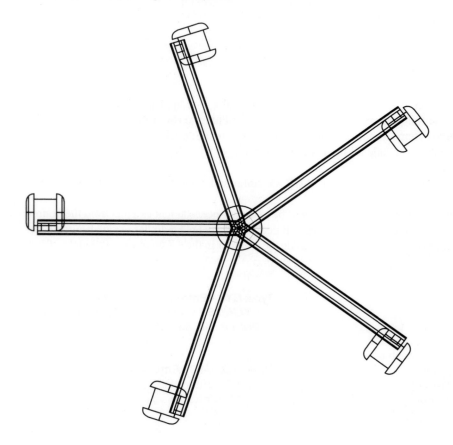

Figure 7-12     Plan View
of Chair Base

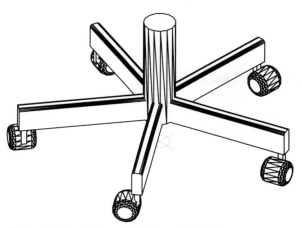

Figure 7-13    Ne Isometric View of Chair Base

We will now return to plan view and create the chair seat. The chair seat will be a 24″ square and have a thickness of 4″.

| Prompt | Response |
|---|---|
| Command: | Type: **PLAN <Enter ↵>** *(or select **Plan View, World UCS**, from the **Menu Browser, View, 3D Views** flyout)* |
| Enter an option [Current ucs/ Ucs/World] <Current>: | Type: **W <Enter ↵>** |
| Command: | Type: **ID <Enter ↵>** *(to establish last point entered)* |
| Specify point: of | Type: **NODe <Enter ↵>** *Pick the center of the reference point* |
| X = 3′-0″ Y = 2′-0$\frac{1}{4}$″ Z = 0′-0″ | |
| Command: | *Select the **POLYLINE** icon* |
| PLINE Specify start point: | Type: **@−1′,−1′ <Enter ↵>** |
| Current line width is 0′-0″ | |
| Specify next point or [Arc/Halfwidth/ Length/Undo/Width]: | Type: **@2′<90 <Enter ↵>** |
| Specify next point or [Arc/Close/ Halfwidth/Length/Undo/Width]: | Type: **@2′<0 <Enter ↵>** |
| Specify next point or [Arc/Close/ Halfwidth/Length/Undo/Width]: | Type: **@2′<270 <Enter ↵>** |
| Specify next point or [Arc/Close/ Halfwidth/Length/Undo/Width]: | Type: **C <Enter ↵>** *(to close the polyline)* |
| Command: | Type: **ext <Enter ↵>** *(or select the **EXTRUDE** icon)* |
| EXTRUDE Current wire frame density: ISOLINES = 4 | |
| Select objects to extrude: | Type: **I <Enter ↵>** *(or select the chair seat polyline)* |
| 1 found | |
| Select objects to extrude: | Type: **<Enter ↵>** |
| Specify height of extrusion or [Direction/Path/Taper angle]: | Type: **4 <Enter ↵>** |

We have drawn the chair seat at elevation 0. We will now move it vertically (in the +Z direction) to the top of the chair pedestal. Remember, we are not changing the X and Y position of the chair seat, only the Z position. Figure 7-14 illustrates the chair seat at elevation 0 (in isometric view), and Figure 7-15 illustrates the chair seat after the **MOVE** command has been executed.

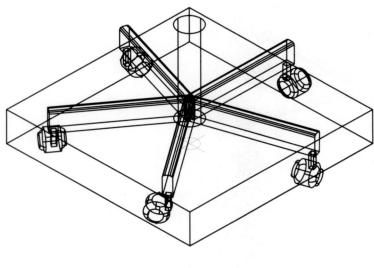

**Figure 7-14**    Chair Seat
at Elevation 0

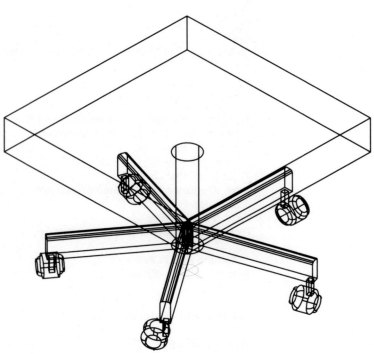

**Figure 7-15**    Chair Seat
at Elevation 14″

| Prompt | Response |
|---|---|
| Command: | *Select the **NE Isometric** view* |
| Command: | Type: **m <Enter ↵>** |
| MOVE Select objects: | Type: **l <Enter ↵>** *(or select the chair seat)* |
| 1 found | |
| Select objects: | Type: **<Enter ↵>** |
| Specify base point or [Displacement] <Displacement>: | Type: **0,0,0 <Enter ↵>** |
| Specify second point or <use first point as displacement>: | Type: **0,0,14 <Enter ↵>** |

**TIP**    You can also select the **3DMOVE** icon from the **Ribbon**, **Home** tab, **Modify** panel and select the chair seat, highlight the Z axis, and move the chair seat 14″ in the positive Z direction.

We will now draw and place a 24″-wide × 24″-high × 4″-thick chair back using the **PLINE**, **EX-TRUDE**, and **MOVE** commands. After we have drawn the chair back and moved it to the top of the chair seat, we will use the **3DROTATE** grip tool to tilt the chair back away from the chair seat.

| Prompt | Response |
|---|---|
| Command: | Type: **PLAN <Enter ↵>** *(or select **Plan View**, **World UCS**, from the **Menu Browser**, **View**, **3D Views** flyout)* |
| Command: PLAN Enter an option [Current ucs/Ucs/World] <Current>: | Type: **<Enter ↵>** |
| Command: | *Select the **POLYLINE** icon* |
| PLINE Specify start point: | Type: **END <Enter ↵>** |
| of | *Pick the lower right corner of the chair seat (see Figure 7-16)* |
| Current line width is 0′-0″ Specify next point or [Arc/Halfwidth/ Length/Undo/Width]: | Type: **@4<180 <Enter ↵>** |
| Specify next point or [Arc/Close/ Halfwidth/Length/Undo/Width]: | Type: **@2′<90 <Enter ↵>** |
| Specify next point or [Arc/Close/ Halfwidth/Length/Undo/Width]: | Type: **@4<0 <Enter ↵>** |
| Specify next point or [Arc/Close/ Halfwidth/Length/Undo/Width]: | Type: **C <Enter ↵>** *(to close the polyline)* |

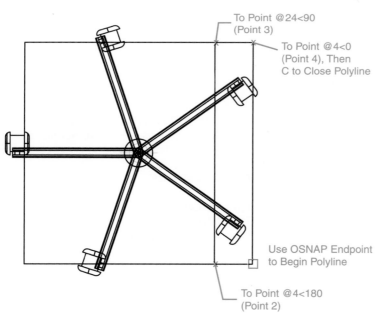

To Point @24<90
(Point 3)

To Point @4<0
(Point 4), Then
C to Close Polyline

Use OSNAP Endpoint
to Begin Polyline

To Point @4<180
(Point 2)

**Figure 7-16**    **PLINE** Point Selection for Chair Back

| Prompt | Response |
|---|---|
| Command: EXTRUDE | *Select the **EXTRUDE** icon* |
| Current wire frame density: ISOLINES = 4 Select objects to extrude: 1 found | Type: **I <Enter ↵>** |
| Select objects to extrude: | Type: **<Enter ↵>** |
| Specify height of extrusion or [Direction/Path/Taper angle] <0′-4″>: | Type: **24 <Enter ↵>** |

Change the view to **NE Isometric** (**VPOINT, 1,1,1** or select from the **View** pull-down menu, **3D Views** flyout) and look at the results of the last few commands. The chair back is at the correct elevation. By using the **Osnap**, **Endpoint** of the chair seat to begin the polyline for the back, you can draw the chair back at elevation 14″. The chair back needs to be tilted back for a more comfortable fit and pleasing appearance. We will remain in an isometric view to use the **3DROTATE** grip tool to tilt the back of the chair. Your drawing should appear similar to Figure 7-17 before you use the **3DROTATE** command to tilt the back of the chair.

**Figure 7-17**   Chair Back Before the **3DROTATE** Command

| Prompt | Response |
|---|---|
| Command: | *Select the **3DROTATE** grip tool from the **Modify** menu on the **Ribbon**, **Home** tab* |
| Command: _3drotate | |
| Current positive angle in UCS: ANGDIR = counterclockwise, ANGBASE = 0 | *Pick the chair back* |
| Select objects: 1 found | |
| Select objects: | Type: **<Enter ↵>** |
| Specify base point: | Type: **MID <Enter ↵>** |
| of | *Pick the midpoint of the bottom of the chair back (see Figure 7-18)* |
| Pick a rotation axis: | *Highlight (left-click) the Y axis* |
| Specify angle start point or type an angle: | Type: **–8 <Enter ↵>** |

Your drawing should appear similar to Figure 7-19

The next step will be to add arms to the chair. We will begin the polyline (using **Osnap, Midpoint**) at the midpoint of the chair back (see Figure 7-20). After the arm top polyline has been drawn, we will extrude the arm 1″ in the –Z direction.

| Prompt | Response |
|---|---|
| Command: | *Select the **POLYLINE** icon* |
| PLINE | |
| Specify start point: | *With **Osnap, Midpoint**, pick the midpoint of* |
| of | *the chair back, as illustrated in Figure 7-20* |
| Current line width is 0′-0″ | |
| Specify next point or [Arc/Halfwidth/ Length/Undo/Width]: | Type: **@2.5<270 <Enter ↵>** *(or with **Ortho** on, use direct distance input)* |

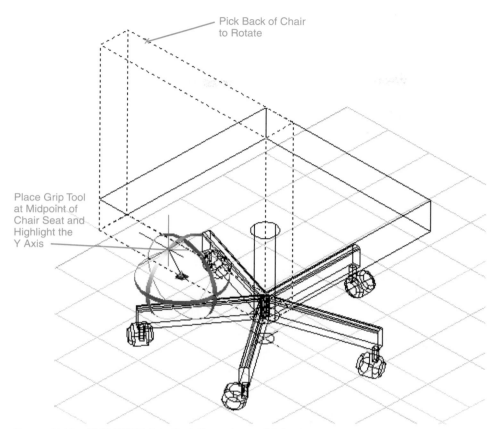

Pick Back of Chair
to Rotate

Place Grip Tool
at Midpoint of
Chair Seat and
Highlight the
Y Axis

**Figure 7-18**    **3DROTATE** Grip Tool Placement and Selection Set

**Figure 7-19**    Chair Back After Rotation

Begin Polyline at
Midpoint

**Figure 7-20**    Begin Polyline at the Midpoint of the
Chair Back

Specify next point or [Arc/Close/
    Halfwidth/Length/Undo/Width]:                    Type: **@1′4<180 <Enter ↵>**

Specify next point or [Arc/Close/
    Halfwidth/Length/Undo/Width]:                    Type: **@2.5<90 <Enter ↵>**

Specify next point or [Arc/Close/
    Halfwidth/Length/Undo/Width]:                    Type: **C <Enter ↵>** *(to close the polyline)*

| Command: | Type: **EXT <Enter ↵>** *(or select the* |
|---|---|
| | ***EXTRUDE** icon)* |
| **EXTRUDE** | |
| Current wire frame density: ISOLINES = 4 | |
| Select objects to extrude: | Type: **L <Enter ↵>** |
| 1 found | |
| Select objects to extrude: | Type: **<Enter ↵>** |
| Specify height of extrusion or | |
| [Direction/Path/Taper angle]: | Type: **−1 <Enter ↵>** |

The horizontal portion of one chair arm is complete. We will now complete the vertical part that connects the horizontal arm to the chair seat. Use the **Osnap**, **Endpoint** option to begin the vertical polyline (see Figure 7-21).

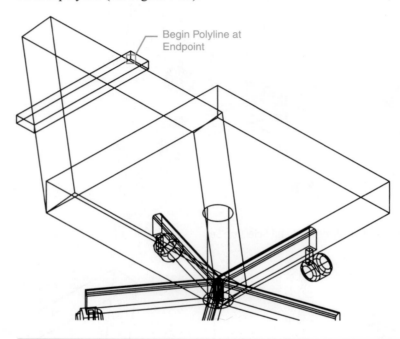

Begin Polyline at Endpoint

**Figure 7-21** Selection Points for the Vertical Component of the Chair Arm

| UNION | |
|---|---|
| **Ribbon/ Home tab/ Solid editing/Union** | |
| **Menu** | Modify/ Solid Editing/ Union |
| **Toolbar: Modeling** | |
| **Command Line** | union |
| **Alias** | uni |

| Prompt | Response |
|---|---|
| Command: | *Select the **POLYLINE** icon* |
| PLINE | |
| Specify start point: | Type: **END <Enter ↵>** |
| of | *Pick the outside front corner of the chair arm* |
| Current line width is 0′-0″ | |
| Specify next point or [Arc/Halfwidth/ Length/Undo/Width]: | Type:**@2.5<90 <Enter ↵>** *(or with **Ortho** on, use direct distance input)* |
| Specify next point or [Arc/Close/ Halfwidth/Length/Undo/Width]: | Type:**@1<0 <Enter ↵>** |
| Specify next point or [Arc/Close/ Halfwidth/Length/Undo/Width]: | Type:**@2.5<270 <Enter ↵>** |
| Specify next point or [Arc/Close/ Halfwidth/Length/Undo/Width]: | Type: **C <Enter ↵>** *(to close the polyline)* |
| Command: | *Select the **EXTRUDE** icon* |
| EXTRUDE | |
| Current wire frame density: ISOLINES = 4 | |
| Select objects to extrude: | Type: **I <Enter ↵>** |
| 1 found | |
| Select objects to extrude: | Type: **<Enter ↵>** |
| Specify height of extrusion or | |
| [Direction/Path/Taper angle] <−0′-1″>: | Type: **−11 <Enter ↵>** |

Change to the **SW Isometric** view using the **View** menu on the **Menu Browser**, then **3D Views** flyout. Your drawing should appear similar to Figure 7-22.

We must make a few enhancements to the chair in this isometric view. First, we will use the **UNION** command to join the two chair arm pieces that were just created, the **FILLET** command to fillet the top and front edges of the chair arms, and the **3DMIRROR** command to produce the opposite chair arm.

| FILLET | |
|--------|--|
| **Ribbon/ Home tab/ Modify/ Fillet** | ⌐ |
| **Menu** ◣ | Modify/ Fillet |
| **Toolbar: Modify** | ⌐ |
| **Command Line** | fillet |
| **Alias** | f |

| Prompt | Response |
|--------|----------|
| Command: | Select the **UNION** icon |
| Select objects: | Pick the top (horizontal) arm piece |
| Select objects: 1 found | Pick the front (vertical) arm piece |
| Select objects: 1 found, 2 total | Type: **<Enter ↵>** |
| Command: | Select the **FILLET** icon |
| Current settings: Mode = TRIM, Radius = 0′-0$\frac{1}{4}$″ | |
| Select first object or [Undo/Polyline/ Radius/Trim/Multiple]: | Pick the top outside chair arm edge (see Figure 7-23) |
| Select first object or [Undo/Polyline/ Radius/Trim/Multiple]: | Type: **m <Enter ↵>** |
| Select first object or [Undo/Polyline/ Radius/Trim/Multiple]: | Type: **R <Enter ↵>** |
| Enter fillet radius <0′-0$\frac{1}{4}$″>: <Osnap off> | Type: **1/2 <Enter ↵>** |
| Select an edge or [Chain/Radius]: | Pick the inside top edge of the chair arm |
| Select an edge or [Chain/Radius]: | Pick the inside front edge of the vertical chair component |
| Select an edge or [Chain/Radius]: | Pick the outside front edge of the vertical chair arm |
| Select an edge or [Chain/Radius]: | Type: **<Enter ↵>** |
| 4 edge(s) selected for fillet. | |

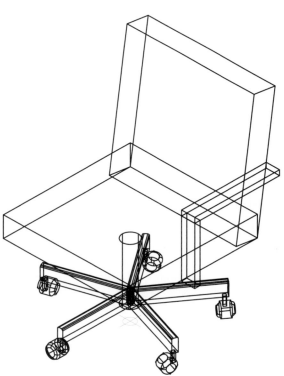

**Figure 7-22**    SW Isometric View of Chair with One Arm Complete

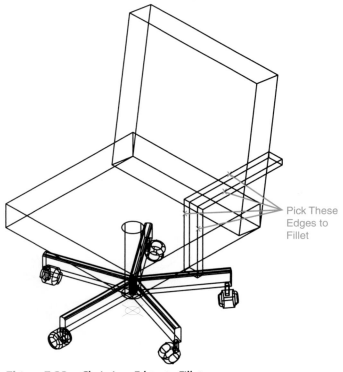

Pick These Edges to Fillet

**Figure 7-23**    Chair Arm Edges to Fillet

Your drawing should appear similar to Figure 7-24.

Now that we have completed one chair arm, we can use the **3DMIRROR** command to create the other chair arm.

| Prompt | Response |
| --- | --- |
| Command: | Type: **3DMIRROR <Enter ↵>** |
| Select objects: | *Pick the chair arm (see Figure 7-25)* |

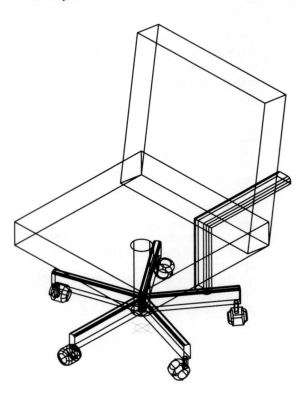

**Figure 7-24**    Chair Arm Edges After Fillet

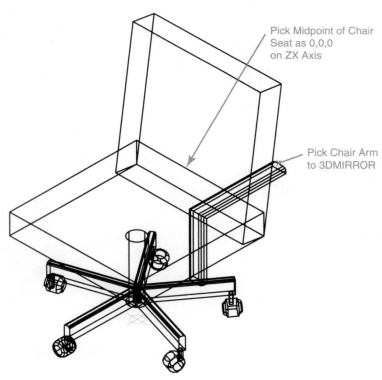

Pick Midpoint of Chair Seat as 0,0,0 on ZX Axis

Pick Chair Arm to 3DMIRROR

**Figure 7-25**    Point Selection Set for Chair Arm and **3DMIRROR** Command

| | |
|---|---|
| 1 found | |
| Select objects: | Type: **<Enter ⏎>** |
| Specify first point of mirror plane (3 points) or [Object/Last/Zaxis/View/ XY/YZ/ZX/3points] <3points>: | Type: **ZX <Enter ⏎>** |
| Specify point on ZX plane <0,0,0>: | Type: **MID <Enter ⏎>** |
| of | *Pick the midpoint of the chair seat back* |
| Delete source objects? [Yes/No] <N>: | Type: **<Enter ⏎>** |

Your drawing should appear similar to Figure 7-26.

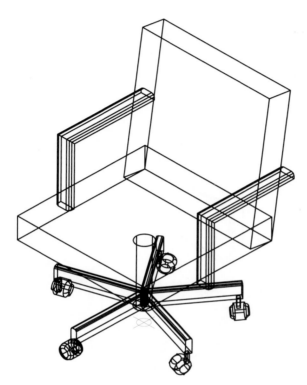

**Figure 7-26**    Chair After
**3DMIRROR** Command

To complete the chair model, we will use the **UNION** command to join the chair seat and the chair back, and then use the **FILLET** command to round the inside edges of the chair seat and chair back. The reference point still visible directly below the pedestal is not needed, so we will erase the point.

| Prompt | Response |
|---|---|
| Command: | *Select the **UNION** icon* |
| Select objects: | *Pick the chair back* |
| Select objects: 1 found | *Pick the chair seat* |
| Select objects: 1 found | Type: **<Enter ⏎>** |
| Command: | *Select the **FILLET** icon* |
| FILLET | |
| Current settings: Mode = TRIM, Radius = $0'-0\frac{1}{2}''$ | |
| Select first object or [Undo/Polyline/ Radius/Trim/Multiple]: | Type: **R <Enter ⏎>** |
| Specify fillet radius <$0'-0\frac{1}{2}''$>: | Type: **2 <Enter ⏎>** |
| Select first object or [Undo/Polyline/ Radius/Trim/Multiple]: | Type: **M <Enter ⏎>** |
| | *Pick the top edge of the chair back (see Figure 7-27)* |
| Enter fillet radius <$0'-2''$>: | Type: **<Enter ⏎>** |

| | |
|---|---|
| Select an edge or [Chain/Radius]: | *Pick the remaining five edges of the chair seat and back* |
| Select an edge or [Chain/Radius]:<br>6 edge(s) selected for fillet.<br>Command: | Type: **<Enter ↵>** |
| ERASE | Type: **ERASE <Enter ↵>** |
| Select objects: | *Pick the original reference point* |
| 1 found<br>Select objects: | Type: **<Enter ↵>** |

The chair is now complete. Use the **HIDE** command to produce an isometric view of the completed chair. Your drawing should be similar to Figure 7-28.

On your own, use the **Orbit** command and **Visual Styles Manager** to produce a conceptual view similar to Figure 7-29.

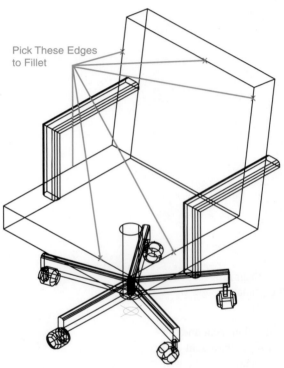

**Figure 7-27**   Edge Selection for Fillet

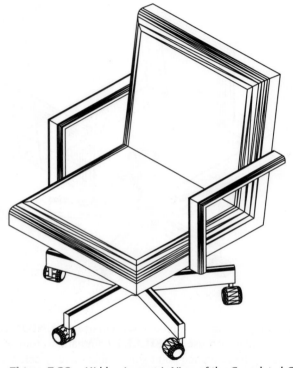

**Figure 7-28**   Hidden Isometric View of the Completed Chair

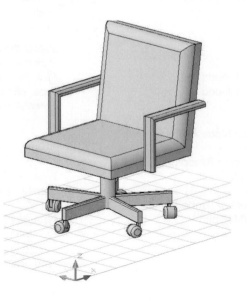

**Figure 7-29**   Conceptual View of Completed Chair Model

# Chapter Exercises

### Exercise 7-1: Desk Side Chair

In the previous two chapters, matching end table and credenza models were created by editing the original models of the glass top coffee table and desk, respectively, using the **SLICE**, **MIRROR3D**, and **SOLIDEDIT** commands. In Chapter Exercise 7-1, we will use the desk chair seat and back component to make a matching desk side chair. The **SWEEP** command, introduced in Chapter 3, will be used to produce the desk chair arm and leg components.

To begin this exercise, open the desk chair model drawing just completed and make a copy of it. Erase the pedestal base and caster assemblies. The desk chair arms will be used to establish reference points before they are erased. We will use *coordinate filters* to extract a base point (.XY) for one side of the new chair arm and leg component. Coordinate filters extract designated parts of three-dimensional coordinates. After we have drawn a chair arm and leg component polyline path in plan view, we will use the point established with the coordinate filter as the base point to align the chair arm and leg component to the chair seat and back.

After erasing the pedestal base and caster assemblies, your drawing should appear similar to Figure 7-30.

**coordinates filters:** Also called command modifiers, combine *x, y,* and *z* values from different points to specify a single point.

| Prompt | Response |
|---|---|
| Command: | Type: **POINT <Enter ↵>** *(or select the **Point** icon from the **Draw** toolbar)* |
| Command: point<br>Current point modes: PDMODE = 34,<br>PDSIZE = 0'-2"<br>Specify a point:.<br>of | Type: **.XY <Enter ↵>**<br>*With **Osnap, Midpoint**, pick the midpoint of the back bottom edge of the chair arm (see Figure 7-31)* |
| of (need Z): | Type: **0 <Enter ↵>** |

Your drawing should appear similar to Figure 7-32.

Identify the Z elevation of the back bottom edge of the chair arm (2'-1") using **ID, Midpoint**. This distance will be used to determine the height of the polyline path for the new chair arm and leg.

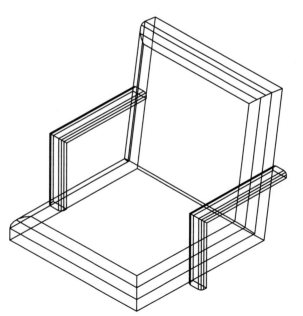

**Figure 7-30**  Desk Chair After Erasing the Pedestal Base and Caster Assemblies

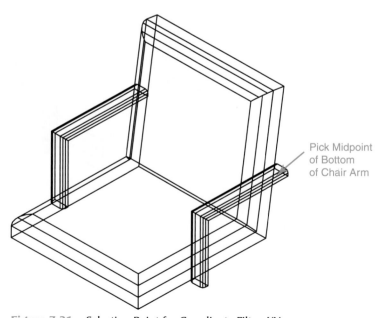

Pick Midpoint of Bottom of Chair Arm

**Figure 7-31**  Selection Point for Coordinate Filter .XY

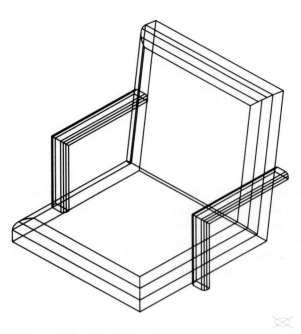

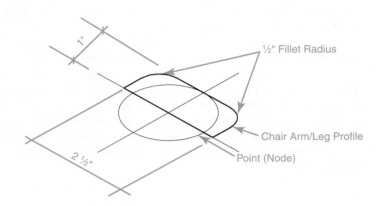

**Figure 7-32**    Point Drawn Directly Below Back Edge of
Chair Arm

**Figure 7-33**    Closed Polyline Chair Arm/Leg Profile

Draw a closed polyline representing the shape profile of the chair arm and leg similar to the
shape profile used for the arm of the original chair. Center the polyline on the point, and fillet the
edges as illustrated in Figure 7-33.

With **Ortho** on, draw a polyline with rounded corners, as illustrated in Figure 7-34, to serve
as the path about which to sweep the arm and leg profile.

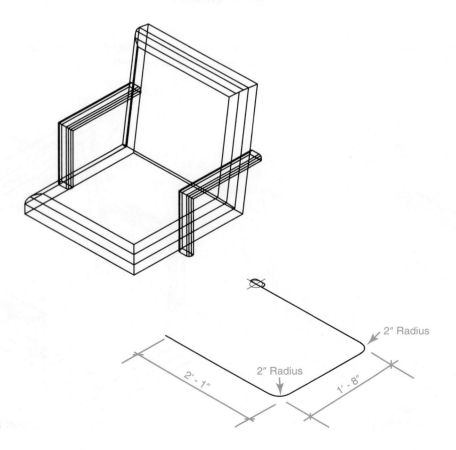

**Figure 7-34**    Polyline
Path with Rounded Corners

Use the **3DROTATE** grip tool to rotate the polyline path in the vertical direction (see Figure 7-35 for grip tool placement), highlight (left-click) the X axis, and type **−90** for the angle of rotation. After rotating the polyline, your drawing should appear similar to Figure 7-36.

| 3DROTATE | |
|---|---|
| **Ribbon/ Home tab/ Solid editing/3D Rotate** | |
| **Menu** | Modify/ 3D Operations/3D Rotate |
| **Toolbar: Modeling** | |
| **Command Line** | 3drotate |

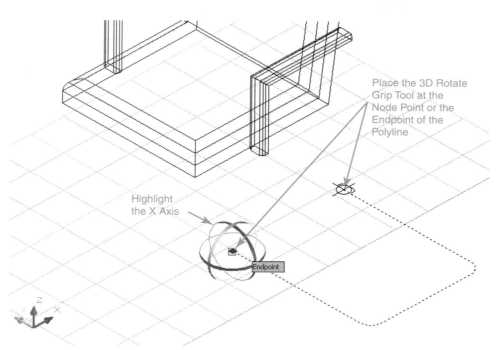

Place the 3D Rotate Grip Tool at the Node Point or the Endpoint of the Polyline

Highlight the X Axis

Endpoint

**Figure 7-35**    Place **3DROTATE** Grip Tool at the Node (Point) or Endpoint

Use the **ERASE** command to remove the original chair arms and the point drawn to establish the reference point at elevation 0. Your drawing should appear similar to Figure 7-37.

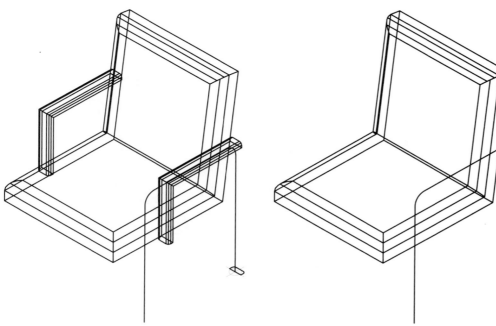

**Figure 7-36**    Polyline Path After Rotation

**Figure 7-37**    Chair After Erasing Original Arms and Point

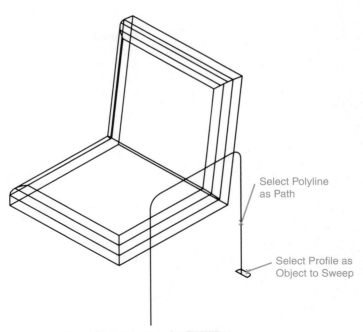

Select Polyline
as Path

Select Profile as
Object to Sweep

Figure 7-38    Object Selection for **SWEEP** Operation

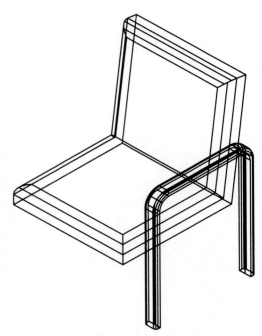

Figure 7-39    Chair with One Complete Arm
and Leg Component

| SWEEP | |
|---|---|
| **Ribbon/ Home tab/ 3D Model- ing/Sweep** | |
| **Menu** | Draw/ Modeling/ Sweep |
| **Toolbar: Modeling** | |
| **Command Line** | sweep |

Use the **SWEEP** command to sweep the arm/leg profile around the polyline path (see Figure 7-38).

After sweeping the arm and leg profile around the path, your drawing should appear similar to Figure 7-39.

Use the **MIRROR3D** command to produce the other arm and leg component. Select the arm and leg component to mirror, and mirror about the ZX plane using any midpoint on the chair seat or back as the 0,0,0 point. Your drawing should appear similar to Figure 7-40.

Using the **Visual Styles Manager**, change to a conceptual view to produce a view similar to Figure 7-41.

Figure 7-40    Wireframe View of
Completed Desk Side Chair

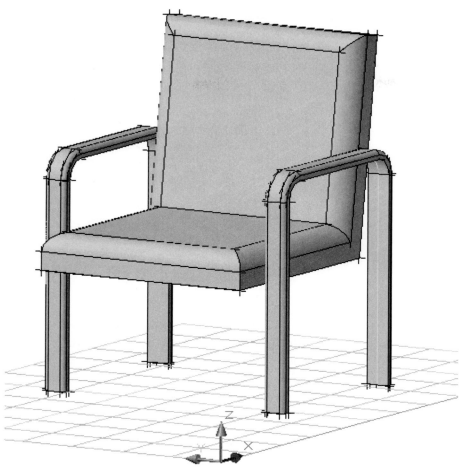

Figure 7-41    Conceptual View of Completed Desk Side Chair

## SUMMARY

This chapter provided you with additional practice using the **3DROTATE** grip tool to rotate objects three-dimensionally. You gained additional experience creating 3D solids using the **EXTRUDE, MOVE,** and **MIRROR3D** commands, and you created a solid cylindrical shape from a cube using the **FILLET** command.

You learned about the concept and process of using points as construction reference guides. You also learned how to use coordinate filters to extract designated parts of three-dimensional coordinates. You practiced using the **SWEEP** command to sweep a profile along a path. In Chapter 8, you will build a model of a bookcase with adjustable shelves using the **POLYLINE, EXTRUDE, INTERFERE,** and **COPY** commands.

## CHAPTER TEST QUESTIONS

### Multiple Choice

1. Which of the following commands can be used to sweep a profile along a path?

   a. **MOVE**
   b. **SWEEP**
   c. **ROTATE3D**
   d. **EXTEND**
   e. **POINT**

2. Which of the following extracts designated parts of three-dimensional coordinates?

   a. **POINT**
   b. **PEDIT**
   c. Coordinate filters
   d. Window selection
   e. **Ortho** mode

3. Which of the following **Osnap** modes will snap to a point entity?

   a. **QUA**
   b. **END**
   c. **MID**
   d. **NOD**
   e. **INT**

4. Which of the following commands allows you to create either a rectangular or polar array?

   a. **REVOLVE**
   b. **ROTATE3D**
   c. **ALIGN**
   d. **ARRAY**
   e. **3DMOVE**

5. Which of the following commands displays the **Point Style** dialog box?

   a. **DDPTYPE**
   b. **PDSIZE**
   c. **PDMODE**
   d. **POINT STYLE**
   e. **POINT**

## Matching

**Column A**

a. **DDPTYPE**
b. **SWEEP**
c. Coordinate filters

d. **POINT**
e. **ARRAY**

**Column B**

1. Draws a point entity.
2. Retrieves the **Point Style** dialog box
3. Creates a 3D solid or surface by sweeping a 2D curve along a path
4. Creates multiple copies of objects in a pattern
5. Allows you to extract designated parts of three-dimensional coordinates

## True or False

1. T or F: **DDPTYPE** allows you to set the point size and style.
2. T or F: The **FILLET** command can be used only to round the edges of objects.
3. T or F: Polar coordinates are relative to the origin (0,0,0).
4. T or F: The **3DMOVE** icon is located on the status bar.
5. T or F: The **SWEEP** icon is located on the **Modeling** toolbar.

# Bookcase with Adjustable Shelves

## 8

## Chapter Objectives

- Practice creating solids with the **POLYLINE** and **EXTRUDE** commands
- Use the **INTERFERE** and **SUBTRACT** commands to create a rabbet joint
- Use the **BOX** command to create a solid
- Practice moving objects three-dimensionally with the **MOVE** command
- Practice using the **COPY**, **MOVE**, and **ROTATE3D** commands
- Learn to insert one drawing into another drawing
- Learn to relocate the UCS

## INTRODUCTION

The bookcase produced in this chapter will provide additional practice creating solids using closed polyline shapes and then extruding the shapes with the **EXTRUDE** command. We will use the **MOVE** command to relocate objects drawn at elevation 0 to the point where they can be subtracted to produce a *rabbet joint* for the bookcase back solid.

The overall dimensions of the bookcase are 3'-1$\frac{1}{2}$" wide, 6'-0" high, and 1'-0" deep. The bookcase will be constructed with a $\frac{3}{4}$"-thick top, bottom, sides, and shelves. The back of the bookcase will be $\frac{1}{4}$" thick. We will add shelf standards, perforated metal components with metal clips; they will support the adjustable shelves, which are $\frac{1}{8}$" thick and $\frac{3}{4}$" wide.

**rabbet joint:** Joint that is formed when the ends of its members are joined at right angles.

## DRAWING SETUP

Begin a new drawing. Set the **Units** to **Architectural**, **Precision** to $\frac{1}{4}$". Set the **Limits** to **0,0** and **6',8'**. Set the **Grid** to **6"**, and **Zoom All**.

## BEGIN DRAWING

Begin drawing by using the **POLYLINE** command to draw a two-dimensional polyline to represent the right side of the bookcase.

| Prompt | Response |
|---|---|
| Command: | *Select the **POLYLINE** icon* |
| PLINE | |
| Specify start point: | *Type:* **4'6,1'6 <Enter ↵>** |
| Current line width is 0'-0" | |
| Specify next point or [Arc/Halfwidth/ | |
| Length/Undo/Width]: | *Type:* **@1'<0 <Enter ↵>** *(remember, you can also turn **Ortho** on, move the mouse in the direction you wish to draw, and type in the distance)* |

| POLYLINE | |
|---|---|
| **Ribbon/ Home tab/ Draw/ Polyline** | |
| **Menu** | Draw/ Polyline |
| **Toolbar: Draw** | |
| **Command Line** | pline |
| **Alias** | pl |

| Prompt | Response |
|---|---|
| Specify next point or [Arc/Close/ Halfwidth/Length/Undo/Width]: | Type: **@5'11-1/4<90 <Enter ⏎>** |
| Specify next point or [Arc/Close/ Halfwidth/Length/Undo/Width]: | Type: **@1'<180 <Enter ⏎>** |
| Specify next point or [Arc/Close/ Halfwidth/Length/Undo/Width]: | Type: **C <Enter ⏎>** *(to close the polyline)* |

We will use the **EXTRUDE** command to make the closed polyline shape we just drew $\frac{3}{4}''$ thick. As a reminder, the **EXTRUDE** command is used to assign a thickness parallel to the effective ucs, parallel to the Z axis, or along a specified path.

| EXTRUDE | |
|---|---|
| **Ribbon/ Home tab/ 3D Model- ing/Extrude** | |
| **Menu** | Draw/ Modeling/ Extrude |
| **Toolbar: Modeling** | |
| **Command Line** | extrude |
| **Alias** | ext |

| Prompt | Response |
|---|---|
| Command: | *Select the* **EXTRUDE** *icon* |
| EXTRUDE | |
| Current wire frame density: ISOLINES =4 | |
| Select objects to extrude: | |
| 1 found | Type: **l** *(last)* **<Enter ⏎>** |
| Select objects to extrude: | Type: **<Enter ⏎>** |
| Specify height of extrusion or [Direction/Path/Taper angle]: | Type: **3/4 <Enter ⏎>** |

With the current view (plan view) there is no visual difference before or after extruding the closed polyline shape. To verify that the extrusion change was made, change to a **NE Isometric** view (use the **View, 3D Views** pull-down menu or the **Menu Browser**) of the bookcase side. Your drawing should appear similar to Figure 8-1.

**Figure 8-1**    NE Isometric View of the Right Side of the Bookcase

In the next step, you will create a 3D solid to subtract from the bookcase side to produce to a rabbet joint. Return to the plan view and begin drawing.

| Prompt | Response |
|---|---|
| Command: | *Select* **Plan View**, **World UCS**, *from the* **View, 3D Views** *pull-down menu or Type:* **PLAN** *at the command prompt* |
| Command: | *Select the* **POLYLINE** *icon* |
| Specify start point: | *With* **Osnap**, **Endpoint** *pick the lower left corner of the bookcase side* |

| | |
|---|---|
| Current line width is 0′-0″ | |
| Specify next point or [Arc/Halfwidth/ Length/Undo/Width]: | Type: **@1/4<0 <Enter ↵>** *(or with **Ortho** on, move the mouse in the appropriate direction and type in the distance)* |
| Specify next point or [Arc/Close/ Halfwidth/Length/Undo/Width]: | Type: **@5′11-1/4<90 <Enter ↵>** |
| Specify next point or [Arc/Close/ Halfwidth/Length/Undo/Width]: | Type: **@1/4<180 <Enter ↵>** |
| Specify next point or [Arc/Close/ Halfwidth/Length/Undo/Width]: | Type: **C <Enter ↵>** *(to close the polyline)* |
| Command: | *Select the **EXTRUDE** icon* |
| EXTRUDE | |
| Current wire frame density: ISOLINES = 4 | |
| Select objects to extrude: | Type: **l** *(last)* **<Enter ↵>** |
| 1 found | |
| Select objects to extrude: | Type: **<Enter ↵>** |
| Specify height of extrusion or [Direction/Path/Taper angle] <0′-0$\frac{3}{4}$″>: | Type: **1/4 <Enter ↵>** |

The polyline for the rabbet was drawn at elevation 0. For the solid to be subtracted from the top of the bookcase side (inside edge when rotated), the solid needs to be moved in the +Z direction $\frac{1}{2}$″.

| Prompt | Response |
|---|---|
| Command: | Type: **m** *(move)* **<Enter ↵>** |
| MOVE | |
| Select objects: | Type: **l <Enter ↵>** |
| 1 found | |
| Select objects: | Type: **<Enter ↵>** |
| Specify base point or [Displacement] <Displacement>: | Type: **0,0,0 <Enter ↵>** |
| Specify second point or <use first point as displacement>: | Type: **0,0,1/2 <Enter ↵>** |

The **SUBTRACT** command allows you to create composite solids by subtracting one region or solid from another. To complete the rabbet, you will need to subtract the last extruded region.

| Prompt | Response |
|---|---|
| Command: | *Select the **SUBTRACT** icon* |
| SUBTRACT Select solids and regions to subtract from… | |
| Select objects: | Type: **′Z <Enter ↵>** *Zoom a window around* |
| Specify corner of window, enter a scale | *an area through the midportion of the bookcase side (see Figure 8-2)* |
| factor (nX or nXP), or [All/Center/Dynamic/Extents/Previous/ Scale/Window/Object] <real time>: | |
| Specify opposite corner: | |
| Resuming SUBTRACT command. | |
| Select objects: | *Pick the bookcase side* |
| 1 found | |
| Select objects: | Type: **<Enter ↵>** |
| Select solids and regions to subtract… | *Pick the rabbet solid* |
| Select objects: 1 found | |
| Select objects: | Type: **<Enter ↵>** |

| SUBTRACT | |
|---|---|
| Ribbon/ Home tab/ Solid edit- ing/Subtract | |
| Menu | Modify/ Solid Editing/ Subtract |
| Toolbar: Modeling | |
| Command Line | subtract |
| Alias | su |

Select Bookcase
Side to Select From

Select Rabbet
Solid to Subtract

Figure 8-2    Extrusion to Subtract

To show the resulting rabbet created on the bookcase side with the **SUBTRACT** command, change to a **NE Isometric** view.

| Prompt | Response |
|---|---|
| Command: | *Select **NE Isometric** view from the **View** pull-down menu, **3D Views** flyout or **Menu Browser*** |
| Command: | *Type: **Z** (zoom) **<Enter ↵>** and pick a window around the lower right portion of the bookcase* |

Your drawing should appear similar to Figure 8-3.

Figure 8-3    Isometric View of Bookcase Side After Subtraction

Next, we will draw the shelf standards. The two shelf standards should be located 3″ from the left and right sides and $\frac{3}{4}$″ from the bookcase bottom, and they should extend to the top of the bookcase side. Change to the plan view by typing **PLAN**, **World UCS** at the command prompt or by typing **VPOINT** at the command prompt and then typing **0,0,1**. Then zoom into the bottom portion of the bookcase side to begin drawing.

| Prompt | Response |
| --- | --- |
| Command: | Type: **VPOINT <Enter ↵>** |
| Current view direction: | |
|   VIEWDIR = 0′-0″, 0′-0″,0′-1″ | |
| Specify a view point or [Rotate] | |
|   <display compass and tripod>: | Type: **0,0,1 <Enter ↵>** |

**TIP** You can also select **Plan**, **World UCS** from the **Menu Browser**, **View** menu, **3D Views** flyout, or type **Plan <Enter ↵>**, **W <Enter ↵>** at the command prompt.

Use the **ID** command with **Osnap** on, and pick the endpoint of the lower left corner of the bookcase side to establish the last point entered. The shelf standard will be drawn relative to this point.

| Prompt | Response |
| --- | --- |
| Command: | Type: **ID <Enter ↵>** |
| Specify point: | Type: **End <Enter ↵>** |
| of | *Pick the bottom left corner of the bookcase* |
| |   *side* |
| X = 4′-6″ Y = 1′-6″ Z = 0′-0″ | |
| Command: | *Select the **POLYLINE** icon* |
| PLINE | |
| Specify start point: | Type: **@3,3/4 <Enter ↵>** |
| Current line width is 0′-0″ | |
| Specify next point or [Arc/Halfwidth/ | |
|   Length/Undo/Width]: | Type: **@3/4<0 <Enter ↵>** |
| Specify next point or [Arc/Close/ | |
|   Halfwidth/Length/Undo/Width]: | Type: **@5′10-1/2<90 <Enter ↵>** |
| Specify next point or [Arc/Close/ | |
|   Halfwidth/Length/Undo/Width]: | Type: **@3/4<180 <Enter ↵>** |
| Specify next point or [Arc/Close/ | |
|   Halfwidth/Length/Undo/Width]: | Type: **C <Enter ↵>** *(to close the polyline)* |

The shelf standard polyline was drawn at elevation 0. One alternative to moving the shelf standard in the Z direction with the **MOVE** command is changing the elevation property. You can change the elevation of a closed polyline, but you cannot change the elevation of a 3D solid.

| Prompt | Response |
| --- | --- |
| Command: | Type: **change <Enter ↵>** |
| Select objects: | Type: **l** *(last)* **<Enter ↵>** |
| 1 found | |
| Select objects: | Type: **<Enter ↵>** |
| Specify change point or [Properties]: | Type: **p** *(properties)* **<Enter ↵>** |
| Enter property to change | |
|   [Color/Elev/LAyer/LType/ltScale/ | |
|   LWeight/Thickness/Material/Annotative]: | Type: **e** *(elevation)* **<Enter ↵>** |

| | |
|---|---|
| Specify new elevation <0'-0">: | Type: **3/4 <Enter ⏎>** |
| Enter property to change | |
| [Color/Elev/LAyer/LType/ltScale/ | |
| LWeight/Thickness/Material/Annotative]: | Type: **<Enter ⏎>** |

The shelf standard is now located at elevation 0, but it does not have a thickness. We will extrude the shelf standard $\frac{1}{8}''$.

| Prompt | Response |
|---|---|
| Command: | *Select the* **EXTRUDE** *icon* |
| EXTRUDE | |
| Current wire frame density:  ISOLINES = 4 | |
| Select objects to extrude: | Type: **l** *(last)* **<Enter ⏎>** |
| 1 found | |
| Select objects to extrude: | Type: **<Enter ⏎>** |
| Specify height of extrusion or | |
| [Direction/Path/Taper angle] <0'-0$\frac{1}{4}$">: | Type: **1/8 <Enter ⏎>** |

The following sequence of commands will provide additional practice with the **ID**, **POINT**, **COPY**, **MOVE**, and **VIEW/VPOINT** commands. Before we copy the shelf standard, it would be helpful to locate the second point of displacement. One of the easiest ways of accomplishing this task is to identify the new location (second point of displacement) with a point (node). Before you **ID** the lower right corner of the bookcase, set the point size and style with the **Point Style** dialog box. Type **DDPTYPE** at the command prompt (see Figure 8-4), or at the command prompt, type **PDSIZE** and type **1**, and then type **PDMODE** and type **34**.

| Prompt | Response |
|---|---|
| Command: | Type: **ID <Enter ⏎>** |
| Specify point: | Type: **End <Enter ⏎>** |
| of | *Pick the lower right corner of the bookcase* |
| X = 5'-6" Y = 1'-6" Z = 0'-0" | *(see Figure 8-5)* |

**Figure 8-4**   **Point Style** Dialog Box

ID Lower Right
Corner of Bookcase
Side with Endpoint

**Figure 8-5**   Bookcase Corner to ID

| Prompt | Response |
|---|---|
| Command:<br>Current point modes:  PDMODE = 34<br>PDSIZE = 0'-1"<br>Specify a point: | Type: **POINT <Enter ↵>**<br><br><br>Type: **@–3,3/4 <Enter ↵>** |

Your drawing should appear similar to Figure 8-6.

Point @–3,¾

**Figure 8-6**   Point Located at –3,$\frac{3}{4}$ from the Bottom Right Corner of the Bookcase

**TIP**    The **COPY** command allows you to copy objects a specified distance in a specified direction.

| | COPY | |
|---|---|---|
| **Ribbon/<br>Home tab/<br>Modify/<br>Copy** | | |
| **Menu** | Modify/<br>Copy | |
| **Toolbar:<br>Modify** | | |
| **Command<br>Line** | copy | |
| **Alias** | cp | |

| Prompt | Response |
|---|---|
| Command:<br>COPY<br>Select objects:<br>1 found<br>Select objects:<br>Current settings:  Copy mode = Multiple<br>Specify base point or [Displacement/mOde]<br>  <Displacement>:<br>of<br>Specify second point or <use first<br>  point as displacement>:<br>of<br>Specify second point or<br>  [Exit/Undo] <Exit>: | *Select the **COPY** icon*<br><br>*Pick the shelf standard*<br><br><br><br><br>Type: **End <Enter ↵>**<br>*Pick the lower right end of the shelf standard*<br><br>Type: **NODE <Enter ↵>**<br><br><br>*Pick the point (node) located 3" to the left and 3/4" up from the lower right corner of the bookcase side* |

Change the viewpoint to **NE Isometric** view to see the effect of the copy command.

| Prompt | Response |
|---|---|
| Command: | Type: **VPOINT <Enter ↵>** *(or from the **Menu Browser**, select **View**, **3D Views**, **NE Isometric**)* |

Current view direction:
VIEWDIR = 0'-0", 0'-0", 0'-1"
Specify a viewpoint or [Rotate]
   <display compass and tripod>:          Type: **1,1,1 <Enter ↵>**
Regenerating model.

Your drawing should appear similar to Figure 8-7. Notice that the shelf standard on the left side (the copied shelf standard) is located at elevation 0. When we copied the original shelf standard, the point (node) for the second point of displacement was located at elevation 0.

Original Shelf Standard

Copied Shelf
Standard at
Elevation 0

**Figure 8-7**   Isometric
View Illustrating Copied
Shelf Standard

The shelf standard located at elevation 0, needs to be moved $\frac{3}{4}$" in the +Z direction.

| Prompt | Response |
|---|---|
| Command: | Type: **m** *(move)* **<Enter ↵>** *(or select the **3D Move** grip tool from the **Ribbon**, **Home** tab, **Modify** menu)* |
| MOVE | |
| Select objects: | *Pick the shelf standard that is located at 0 elevation* |
| 1 found | |
| Select objects: | Type: **<Enter ↵>** |
| Specify base point or [Displacement] | |
|   <Displacement>: | Type: **0,0,0 <Enter ↵>** |
| Specify second point or <use | |
|   first point as displacement>: | Type: **0,0,3/4 <Enter ↵>** |

Your drawing should appear similar to Figure 8-8.

**Figure 8-8**   Shelf Standard
After Moving to Elevation $\frac{3}{4}$"

The right side of the bookcase is now complete. The next step will be to return the drawing to the plan view, rotate the bookcase side using the **ROTATE3D** command, add a mirror line, and mirror (**MIRROR3D**) the right side of the bookcase to produce the left side of the bookcase.

| Prompt | Response |
|---|---|
| Command: | Select **Plan View**, **World UCS** from the **View, 3D Views** pull-down menu or **Menu Browser** |
| Command: | Type: **ROTATE3D <Enter ↵>** (or select the **3D Rotate** grip tool from the **Ribbon**, **Home** tab, **Modify** menu) |
| Current positive angle: ANGDIR = counterclockwise, ANGBASE = 0 | |
| Select objects: | Pick a window around the entire bookcase and Type: **<Enter ↵>** |
| Specify opposite corner: | |
| 4 found | |
| Select objects: | Type: **<Enter ↵>** |
| Specify first point on axis or define axis by [Object/Last/View/Xaxis/Yaxis/Zaxis/2points]: | Type: **Y** |
| Specify a point on the Y axis <0,0,0>: | Type: **'z** (transparent zoom) **<Enter ↵>**, and pick a window around the lower left corner of the bookcase |
| Specify corner of window, enter a scale factor (nX or nXP), or [All/Center/Dynamic/Extents/Previous/Scale/Window/Object] <real time>: | |
| Specify opposite corner: | |
| Resuming ROTATE3D command. | |
| Specify a point on the Y axis <0,0,0>: | Type: **End <Enter ↵>** |
| of | Pick the bottom left corner of the bookcase |
| Specify rotation angle or [Reference]: | Type: **−90 <Enter ↵>** |

If you zoom into the lower portion of the bookcase side in plan view, your drawing should appear similar to Figure 8-9.

While in the current view, we can erase the point created earlier and draw a line to use as the 3D mirror point on the YZ plane (see Figure 8-10).

**Figure 8-9**    Bookcase Side Showing Rabbet Joint and Standard

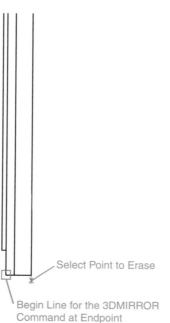

Select Point to Erase

Begin Line for the 3DMIRROR Command at Endpoint

**Figure 8-10**    Erase the Point and Begin the Line for the **3DMIRROR** command

| Prompt | Response |
|---|---|
| Command: | Type: **ERASE <Enter ↵>** |
| ERASE | |
| Select objects: | *Pick the end of the point (see Figure 8-10)* |
| 1 found | |
| Select objects: | Type: **<Enter ↵>** |
| Command: | Type: **l** *(line)* **<Enter ↵>** |
| LINE Specify first point: | Type: **End <Enter ↵>** |
| of | *Pick the lower left corner of the bookcase side (not the shelf standard)* **<Enter ↵>** |
| Specify next point or [Undo]: | Type: **@18<180 <Enter ↵>** |
| Specify next point or [Undo]: | Type: **<Enter ↵>** |
| Command: | Type: **MIRROR3D <Enter ↵>** |
| Select objects: | *Pick a window (left to right) around the entire bookcase side; do not include the line* |
| Specify opposite corner: | |
| 3 found | |
| Select objects: | Type: **<Enter ↵>** |
| Specify first point of mirror plane (3 points) or [Object/Last/Zaxis/View/ XY/YZ/ZX/3points] <3points>: | Type: **YZ <Enter ↵>** |
| Specify point on YZ plane <0,0,0>: | Type: **End <Enter ↵>** |
| of | *Pick the left end of the 18" line* |
| Delete source objects? [Yes/No] <N>: | Type: **<Enter ↵>** |
| Command: | Type: **ERASE <Enter ↵>** |
| ERASE | |
| Select objects: | *Pick the 18" line* **<Enter ↵>** |
| 1 found | |
| Select objects: | Type: **<Enter ↵>** |

Change the view to **NE Isometric** and type **HIDE** at the command prompt to see the effect of the **3DMIRROR** command (see Figure 8-11).

Figure 8-11    Hidden Isometric view of the Completed Bookcase Sides

The sides of the bookcase are now complete. In the next section, you will return the drawing to plan view and add a $\frac{1}{4}$"-thick back to the bookcase. We will set **Snap** to $\frac{1}{4}$"; Because we have not yet drawn the bookcase top shelf and it will have a $\frac{1}{4}$" rabbet to receive the back, we will extend the back $\frac{1}{4}$" above the bookcase sides. Make sure that **Osnap** is off and proceed with the following commands.

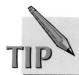

**TIP**    **SNAP** restricts the cursor movement to specified intervals.

| Prompt | Response |
|--------|----------|
| Command: | Select **Plan View, World UCS** |
| Enter an option [Current ucs/Ucs/World] <Current>: | |
| Command: | Type: **SNAP <Enter ↲>** |
| Specify snap spacing or [ON/OFF/Aspect/ Style/Type] <0'-0$\frac{1}{2}$">: | Type: **1/4 <Enter ↲>** |
| Command: | Select the **POLYLINE** icon |
| PLINE | |
| Specify start point: | Type '**Z <Enter ↲>** |
| Specify corner of window, enter a scale factor (nX or nXP), or [All/Center/ Dynamic/Extents/Previous/Scale/Window/ Object] <real time>: | |
| | Window closely around the bottom corner of the left bookcase side (see Figure 8-12) |
| Resuming PLINE command. | |
| From point: | Pick the intersection of the outside of the rabbet and bottom of the left bookcase side |
| Specify next point or [Arc/Close/ Halfwidth/Length/Undo/Width]: | Continue using '**Z** and **D** (**DYNAMIC**) to zoom into the corners of the bookcase sides to select the bookcase back points as illustrated in Figures 8-13, 8-14, and 8-15, then Type: **C <Enter ↲>** (to close the polyline) |

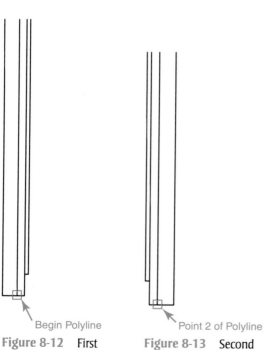

Begin Polyline

Point 2 of Polyline

**Figure 8-12**   First
Point Selection

**Figure 8-13**   Second
Point Selection

**Figure 8-14**   Third Point
Selection

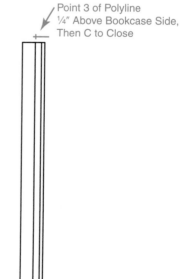

Point 3 of Polyline
¼" Above Bookcase Side

Point 3 of Polyline
¼" Above Bookcase Side,
Then C to Close

**Figure 8-15**   Fourth Point
Selection

The **EXTRUDE** command gives a thickness of $\frac{1}{4}''$ to the back of the bookcase.

| Prompt | Response |
|---|---|
| Command: | *Select the **EXTRUDE** icon* |
| EXTRUDE | |
| Select objects to extrude: | *Click on the top or bottom edge of the* |
| 1 found | *polyline or type: **I** (last) **<Enter ↵>*** |
| Current wire frame density:  ISOLINES = 4 | |
| Specify height of extrusion or | |
| [Direction/Path/Taper angle] <1'-0">: | *Type:* **1/4 <Enter ↵>** |

In the next section, we will add the top shelf with the **POLYLINE** and **EXTRUDE** commands. Then we will create a solid to subtract for the rabbet joint that will receive the bookcase back.

| Prompt | Response |
|---|---|
| Command: | *Type:* **Z <Enter ↵>** *and zoom in on the top left* |
| | *portion of the bookcase* |
| Command: | *Select the **POLYLINE** icon* |
| PLINE | |
| Specify start point: | *Type:* **End <Enter ↵>**, *and pick the left outside* |
| | *corner of the left side of the bookcase (see* |
| | *Figure 8-16)* |
| Current line width is 0'-0" | |
| Specify next point or [Arc/Halfwidth/ | |
| Length/Undo/Width]: | *Type:* **@3'1-1/2<0 <Enter ↵>** |
| Specify next point or [Arc/Close/ | |
| Halfwidth/Length/Undo/Width]: | *Type:* **@3/4<90 <Enter ↵>** |
| Specify next point or [Arc/Close/ | |
| Halfwidth/Length/Undo/Width]: | *Type:* **@3'1-1/2<180 <Enter ↵>** |
| Specify next point or [Arc/Close/ | |
| Halfwidth/Length/Undo/Width]: | *Type:* **C <Enter ↵>** *(to close the polyline)* |
| Command: | *Select the **EXTRUDE** icon* |
| EXTRUDE | |
| Current wire frame density:  ISOLINES = 4 | |
| Select objects to extrude: | |
| 1 found | |
| Select objects to extrude: | *Type:* **I** *(last)* **<Enter ↵>** |
| Specify height of extrusion or | |
| [Direction/Path/Taper angle]: | *Type:* **12 <Enter ↵>** |

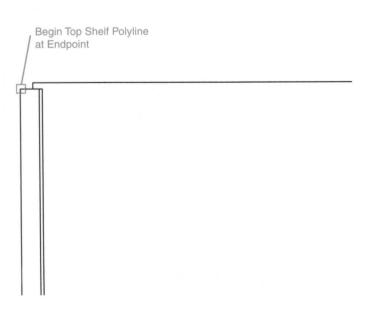

Begin Top Shelf Polyline
at Endpoint

Figure 8-16    Top Shelf
Polyline Beginning Point

At this point, we have the top shelf drawn. However, the bookcase back and the top shelf occupy the same space in the area of the rabbet joint. We need to remove the portion of the top shelf that is *coplanar* with the bookcase back.

One method of removing this interfering section would be to construct a separate extrusion representing the coincidental component and subtracting it from the top shelf. An alternative, and more efficient, method would be to use the **INTERFERE** command. The **INTERFERE** command allows you to check for overlap between two or more solids. The **INTERFERE** command also allows you to create interference solids that can then be subtracted from the appropriate solid.

A NE isometric view would be more beneficial than a plan view to determine visually the interference between the bookcase back and top shelf.

Change to the **NE Isometric** view and zoom into the lower right portion of the bookcase top (see Figure 8-17), then proceed with the **INTERFERE** command.

coplanar: Describes objects located on the same plane.

| INTERFERE | |
|---|---|
| **Ribbon/ Home tab/ Solid editing/ Interfere** | |
| **Menu** | Modify/ 3D Opera tions/Inter- ference Checking |
| **Command Line** | interfere |
| **Alias** | inf |

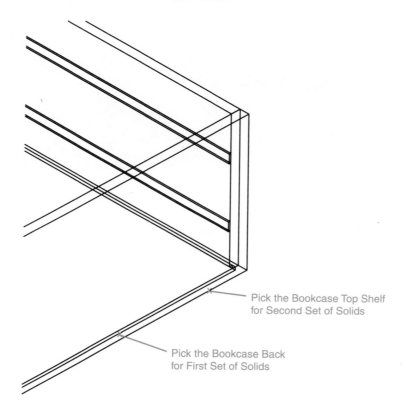

Pick the Bookcase Top Shelf for Second Set of Solids

Pick the Bookcase Back for First Set of Solids

**Figure 8-17**   Object Selection for **INTERFERE** Command

| Prompt | Response |
|---|---|
| Command: | Type: **inf <Enter ↵>** *(or select the **INTERFERE** icon)* |
| INTERFERE<br>Select first set of objects or<br>  [Nested selection/Settings]:<br>1 found | *Pick the bookcase back* **<Enter ↵>** |
| Select first set of objects or<br>  [Nested selection/Settings]: | Type: **<Enter↵>** |
| Select second set of objects or<br>  [Nested selection/checK first set] <checK>:<br>1 found | *Pick the bookcase top shelf* **<Enter ↵>** |
| Select second set of objects or<br>  [Nested selection/checK first set] <checK>:<br>Regenerating model. | Type: **<Enter ↵>** |

Once the object selections for the **INTERFERE** command have been completed, the **Interference Checking** dialog box appears (see Figure 8-18). In addition to the **Interference Checking** dialog box, notice that the interfering pair is highlighted. To create a separate set of

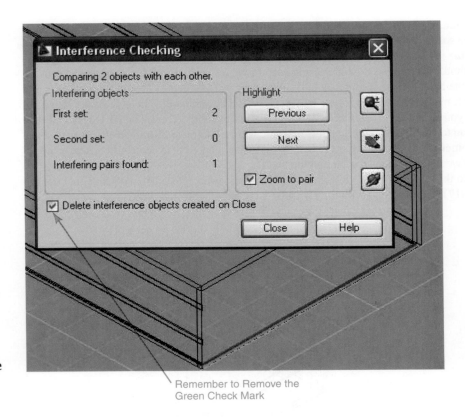

**Figure 8-18** **Interference Checking** Dialog Box with Interfering Pair Highlighted

Remember to Remove the
Green Check Mark

solids (portion of the bookcase back that interferes with the bookcase top shelf) that you can subtract from the bookcase top shelf, you must remove the check in the **Delete interference objects created on Close** box.

Proceed with the following commands to subtract the interference solid from the bookcase top shelf (see Figure 8-19).

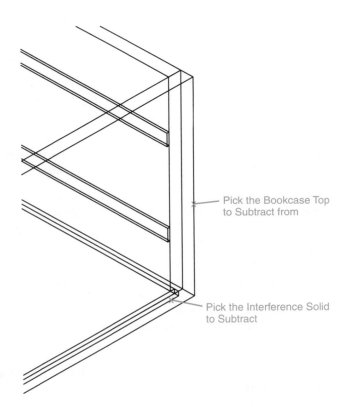

Pick the Bookcase Top
to Subtract from

Pick the Interference Solid
to Subtract

**Figure 8-19**   Interference Solids to Subtract from the Bookcase Top Shelf

| Prompt | Response |
|--------|----------|
| Command:<br>SUBTRACT | *Select the **SUBTRACT** icon* |
| Select solids and regions to subtract from…<br>Select objects:<br>1 found | *Pick the bookcase top <**Enter ↵**>* |
| Select objects: | Type: <**Enter ↵**> |
| Select solids and regions to subtract…<br>Select objects:<br>1 found | *Pick the interference solid <**Enter ↵**>* |
| Select objects: | Type: <**Enter ↵**> |

The next step will be to construct the bottom shelf of the bookcase using the **POLYLINE** and **EXTRUDE** commands. The elevation of the shelves should be above (elevation = $\frac{1}{4}''$) the bookcase back. We will set the elevation to $\frac{1}{4}''$ before we construct the shelves. We will then draw one of the adjustable shelves and use the **COPY** command to produce the remaining four shelves.

The final two steps in completing the bookcase will be to rotate the bookcase to a vertical position using the **3DROTATE** grip tool and then produce an isometric view. To proceed, return to plan view by selecting **Plan View, World UCS** from the **Menu Browser, View, 3D Views** pull-down menu, or typing **VPOINT,** then **0,0,1** at the command prompt.

| Prompt | Response |
|--------|----------|
| Command: | *Select **Plan View**, **World UCS** from the<br>**View, 3D Views** pull-down menu* |
| Enter an option [Current ucs/Ucs/World]<br>    <Current>:<br>Command:<br>ZOOM | Type **z** <**Enter ↵**> |
| Specify corner of window, enter a scale<br>    factor (nX or nXP), or<br>    [All/Center/Dynamic/Extents/Previous/<br>    Scale/Window/Object] <real time>: | *Pick a window around the bottom left corner<br>    of the bookcase (see Figure 8-20)* |
| Specify opposite corner:<br>Command: | Type: **ELEV** <**Enter ↵**> |
| Specify new default elevation <0'-0">: | Type: **1/4** <**Enter ↵**> |
| Specify new default thickness <0'-0">: | Type: <**Enter ↵**> |
| Command: | *Select the **POLYLINE** icon* |

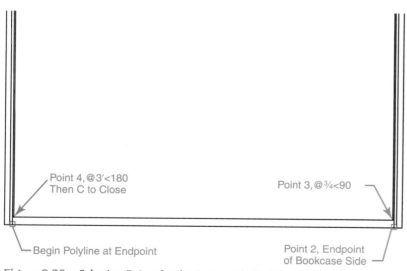

**Figure 8-20**    Selection Points for the Bottom Shelf of the Bookcase

| Prompt | Response |
|---|---|
| PLINE<br>Specify start point: | With **Osnap** on, pick the endpoint of the inside bottom edge of the left bookcase side |
| Current line width is 0'-0"<br>Specify next point or [Arc/Halfwidth/<br>Length/Undo/Width]: | With **Osnap**, **Endpoint**, pick the end of the inside bottom edge of the right bookcase side |
| Specify next point or [Arc/Close/<br>Halfwidth/Length/Undo/Width]: | Type: **@3/4<90 <Enter ↵>** *(or with **Osnap**, **End-point**, pick the endpoint of the right outside bottom corner of the shelf standard)* |
| Specify next point or [Arc/Close/<br>Halfwidth/Length/Undo/Width]: | Type: **@3'<180 <Enter ↵>** *(or with **Osnap**, **Endpoint**, pick the endpoint of the left out-side bottom corner of the shelf standard)* |
| Specify next point or [Arc/Close/<br>Halfwidth/Length/Undo/Width]:<br>Command: | Type: **C <Enter ↵>** *(to close the polyline)*<br>*Select the **EXTRUDE** icon* |
| EXTRUDE<br>Current wire frame density:  ISOLINES = 4<br>Select objects to extrude: | Type: **I** *(last)* **<Enter ↵>** |
| 1 found<br>Select objects to extrude: | Type: **<Enter ↵>** |
| Specify height of extrusion or<br>[Direction/Path/Taper angle]: | Type: **11-3/4 <Enter ↵>** |

We will now construct the five adjustable shelves. Change **Snap** to $\frac{1}{8}''$ and zoom into the lower portion of the bookcase.

| Prompt | Response |
|---|---|
| Command:<br>PLINE<br>Specify start point:<br>to | *Select the **POLYLINE** icon*<br><br>Type: **Nea** *(nearest)* **<Enter ↵>**<br>*Pick a point on the inside edge of the left shelf standard approximately 12" up from the bottom of the bookcase (see Figure 8-21)* |

Approximately 12˝

**Figure 8-21**  Adjustable-Shelf Polyline

| | |
|---|---|
| Current line width is 0'-0" | |
| Specify next point or [Arc/Halfwidth/ Length/Undo/Width]: | Type: **Per** *(perpendicular)* **<Enter ↵>** *Pick the inside edge of the right shelf standard* |
| to | |
| Specify next point or [Arc/Close/ Halfwidth/Length/Undo/Width]: | Type: **@3/4<90 <Enter ↵>** |
| Specify next point or [Arc/Close/ Halfwidth/Length/Undo/Width]: | Type: **Per <Enter ↵>** *Pick the inside edge of the left shelf standard* |
| to | |
| Specify next point or [Arc/Close/ Halfwidth/Length/Undo/Width]: | Type: **C <Enter ↵>** *(to close the polyline)* |

When using Osnap modes in three-dimensional drafting, you have to be cautious in assuming the location of objects. The elevation of objects is not always apparent, especially in plan view. For instance, use the **LIST** command to determine the elevation of the polyline just drawn.

| Prompt | Response |
|---|---|
| Command: | Type: **LIST <Enter ↵>** |
| Select objects: | Type: l *(last)* **<Enter ↵>** *(or select the adjustable-shelf polyline)* |
| Select objects: 1 found | |
| Select objects: | Type: **<Enter ↵>** |
|     LWPOLYLINE Layer: "0" | |
|       Space: Model space | |
|       Handle = 32c | |
|   Closed | |
| Constant width 0'-0" | |
|       area 26.8 square in. (0.186 square ft.) | |
|   perimeter 6'-1" | |
|   at point X = 1'-5$\frac{1}{2}$" Y = 2'-6$\frac{1}{2}$" Z = 0'-3" | |
|   at point X = 4'-5$\frac{1}{4}$" Y = 2'-6$\frac{1}{2}$" Z = 0'-3" | |
|   at point X = 4'-5$\frac{1}{4}$" Y = 2'-7$\frac{1}{4}$" Z = 0'-3" | |
|   at point X = 1'-5$\frac{1}{2}$" Y = 2'-7$\frac{1}{4}$" Z = 0'-3" | |

As you can see, the adjustable-shelf polyline is located 3" above the XY plane. The adjustable-shelf polyline should be located at elevation $\frac{1}{4}$". We will move the polyline in the negative Z direction 2$\frac{3}{4}$" and then extrude the polyline 11$\frac{3}{4}$".

| Prompt | Response |
|---|---|
| Command: | Type: **m <Enter ↵>** *(or select the **3D Move** grip tool and highlight the Z axis)* |
| MOVE | |
| Select objects: | Type: l *(last)* **<Enter ↵>** |
| 1 found | |
| Select objects: | Type: **<Enter ↵>** |
| Specify base point or [Displacement] <Displacement>: | Type: **0,0,0 <Enter ↵>** |
| Specify second point or <use first point as displacement>: | Type: **0,0,−2-3/4 <Enter ↵>** |
| Command: | Select the **EXTRUDE** icon |
| EXTRUDE | |
| Current wire frame density: ISOLINES = 4 | |
| Select objects to extrude: | Type: l **<Enter ↵>** |
| 1 found | |
| Select objects to extrude: | Type: **<Enter ↵>** |
| Specify height of extrusion or [Direction/Path/Taper angle] <0'-11$\frac{3}{4}$">: | Type: **11-3/4 <Enter ↵>** |

To verify that the adjustable shelf is located in the appropriate position, change the view to **SW Isometric** (looking toward the upper right corner).

**TIP**

You can also use **VPOINT**, then **−1,−1,1** to achieve a SW isometric view.

Your drawing should appear similar to Figure 8-22.

Next, change to plan view and copy the adjustable shelf to create the remaining four shelves.

**Figure 8-22**    SW Isometric View of Bookcase with One Adjustable Shelf

| Prompt | Response |
|---|---|
| Command: | Type: **PLAN <Enter ↵>** (*or select **Plan View, World UCS** from the **View, 3D Views** pull-down menu*) |
| Enter an option [Current ucs/Ucs/World] <Current>: | Type: **<Enter ↵>** |
| Command: | Type: **cp** (*copy*) **<Enter ↵>** |
| COPY | |
| Select objects: | Type: **l** (*last*) **<Enter ↵>** |
| 1 found | |
| Select objects: | Type: **<Enter ↵>** |
| Current settings: Copy mode = Multiple | |
| Specify base point or [Displacement/mOde] <Displacement>: | *With **Ortho** on, and **Osnap** off, pick a point near the adjustable shelf* |
| or <use first point as displacement>: | |
| Specify second point or <use first point as displacement>: | Type: **@1'<90 <Enter ↵>** (*or with **Ortho** on, move the mouse in the appropriate direction and type in the direct distance*) |

**Figure 8-23**    Plan View of Completed Bookcase

| Specify second point or [Exit/Undo] <Exit>: | Type: **@2'<90 <Enter ↵>** |
| Specify second point or [Exit/Undo] <Exit>: | Type: **@3'<90 <Enter ↵>** |
| Specify second point or [Exit/Undo] <Exit>: | Type: **@4'<90 <Enter ↵>** |
| Specify second point or [Exit/Undo] <Exit>: | Type: **<Enter ↵>** |

Your drawing should appear similat to Figure 8-23.

Change the view to **NE Isometric** and use the **3DROTATE** grip tool to stand the bookcase up (vertical in the +Z direction).

| Prompt | Response |
|---|---|
| Command: | *Select the **3D ROTATE** grip tool* |
| Command: _3drotate | |
| Current positive angle in UCS:  ANGDIR = counterclockwise  ANGBASE = 0 | |
| Select objects: | *With a crossing window, select all the bookcase components* |
| Specify opposite corner: 15 found | |
| Select objects: | Type: **<Enter ↵>** |
| Specify base point: | *Place the **3DROTATE** grip tool on the endpoint of the bottom left corner (see Figure 8-24)* |
| Pick a rotation axis: | *Highlight the X axis* |
| Specify angle start point or type an angle: | Type: **–90 <Enter ↵>** |

Produce a hidden isometric view of the completed bookcase with the **HIDE** command. The completed bookcase should appear similar to Figure 8-25 in a hidden view.

Select **Conceptual** from the **Visual Styles Manager** to produce a view similar to Figure 8-26

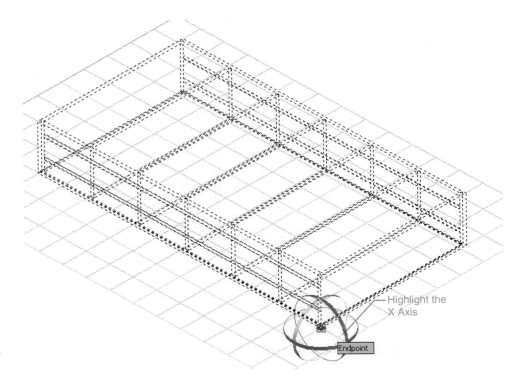

Highlight the
X Axis

Endpoint

**Figure 8-24    3DROTATE**
Grip Tool Placement

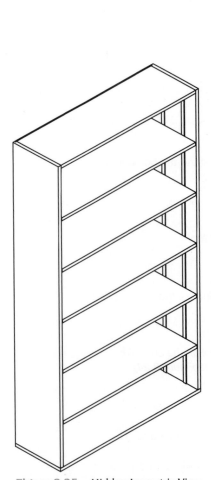

**Figure 8-25**    Hidden Isometric View
of the Completed Bookcase

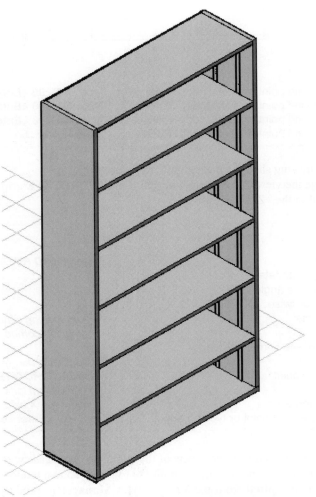

**Figure 8-26**    Conceptual View of Completed Bookcase

# CHAPTER EXERCISES

### Exercise 8-1: Adding a Hardwood Edge and Accessories to the Bookcase

In this exercise, add a $\frac{3}{4}'' \times \frac{1}{4}''$–thick solid, representing a hardwood edge, to the face of the book-case completed in this chapter. Add a few books using the **BOX** command and use the **INSERT** command to place the ceramic vase completed in Chapter 4 as an accessory.

Begin this exercise by opening a copy of the bookcase drawing. You could create the edge solid on the XY plane using the **POLYLINE**, **OFFSET**, **EXTRUDE**, and **SUBTRACT** commands and then using the **3DROTATE** and **MOVE** commands to place the edge solid on the face of the bookcase. You could also change the position of the UCS to the face of the bookcase, which would change the XY drawing plane to the face of the bookcase. Up to this point however, you have not experienced moving the UCS, so we will use this method and al-leviate the need to rotate and move the edge solid to the face of the bookcase. There are sev-eral options for specifying the UCS origin. After typing **UCS** at the command prompt, you have the following options: *Specify the origin of the UCS, or [Face/NAmed/OBject/ Previ-ous/View/World/ X/Y/Z/ZAxis]*.

With a **NE Isometric** view, zoom in on the lower left portion of the bookcase. Invoke the **UCS** command, **Face** option, and with **Osnap**, **Endpoint**, pick the front bottom edge of the bottom shelf. With the visual style set to **Conceptual**, your drawing should appear similar to Figure 8-27.

**Figure 8-27**    Conceptual View with the UCS Origin Located on the Face of the Bookcase

Using the **POLYLINE** command with **Osnap**, **Endpoint**, draw a closed polyline around the outside edge of the front of the bookcase. Use the **OFFSET** command with the **Distance to Off-set** set at $\frac{3}{4}''$ to produce the inside edge of the hardwood face solid. Extrude both of the polylines $\frac{1}{4}''$. Your drawing should appear similar to Figure 8-28.

Produce a hidden view by typing **HIDE** at the command prompt. Notice that the two ex-truded polylines that you just created are coplanar and cover the face of the entire bookcase (see Figure 8-29).

Use the **SUBTRACT** command to subtract the inside polyline extrusion from the outside polyline extrusion (see Figure 8-30). After you complete the subtraction operation, your drawing should appear similar to Figure 8-31.

**Figure 8-28**   Bookcase with Two Extruded Polylines

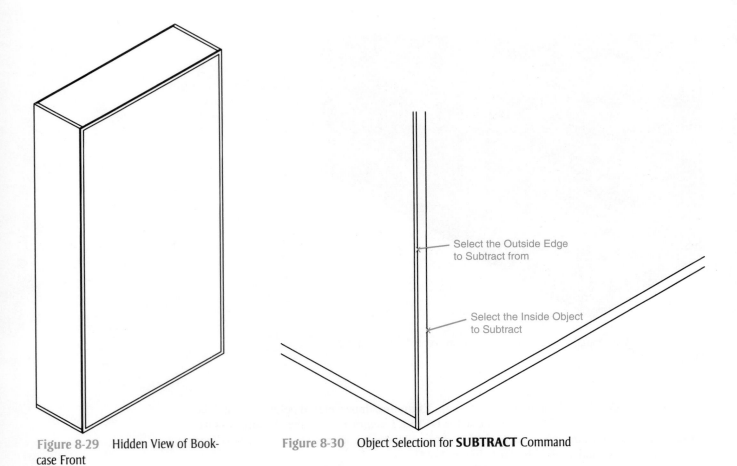

**Figure 8-29**   Hidden View of Book-
case Front

**Figure 8-30**   Object Selection for **SUBTRACT** Command

Select the Outside Edge
to Subtract from

Select the Inside Object
to Subtract

The solid edge representing a hardwood edge is complete. The next step will be to create a
few 3D solids representing books using the **BOX** command. Change the UCS back to World by
typing **UCS** at the command prompt and then **World**. From the **Menu Browser, Draw** menu,
**Modeling** flyout, select the **BOX** icon.

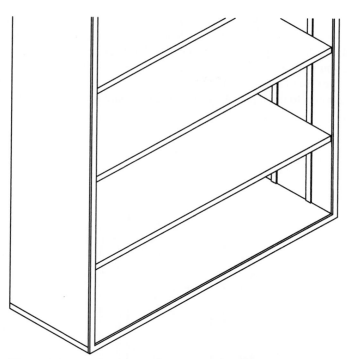

| BOX | |
|---|---|
| **Ribbon/ Home tab/ 3D Model- ing/Box** | |
| **Menu** | Draw/ Modeling Box |
| **Toolbar: Modeling** | |
| **Command Line** | box |

**Figure 8-31**    Hidden View of Bookcase Edge Solid After Subtraction

On the XY plane, in front of the bookcase, create four solids approximating different sizes of books (for instance, one might be 2″ wide, 8″ deep, 9″ high). After creating the first box, begin the second box using the **Osnap**, **Endpoint** of the first box as the first corner of the second box. Repeat the process until you have created four solids similar to Figure 8-32.

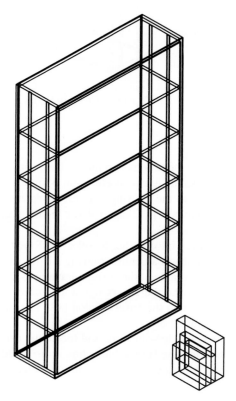

**Figure 8-32**    Solids Representing Books Drawn with the **BOX** Command

Use the **COPY** command to place the books on the shelves. Copying the books to the shelves is an easy process if you select all the books with a window. Then use **Osnap**, **Midpoint** (bottom center) of one of the books as the base point, and use **Osnap**, **NEArest** and pick a point on the top edge of the shelf where you want to books to be located. Use the **ORBIT** command to distinguish the front of the shelf edges (see Figure 8-33).

After you copy the first set of books to the top shelf, your drawing should appear similar to Figure 8-34.

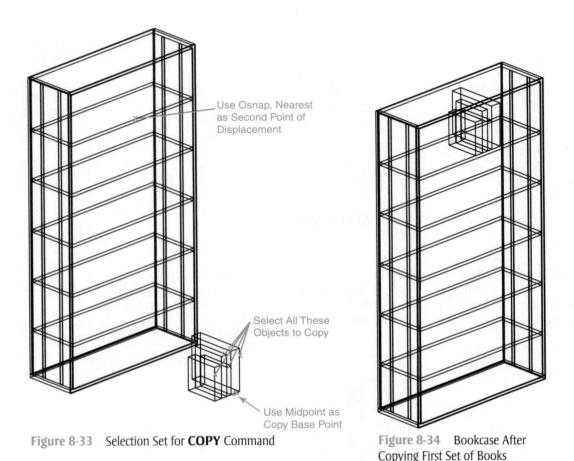

Use Osnap, Nearest as Second Point of Displacement

Select All These Objects to Copy

Use Midpoint as Copy Base Point

**Figure 8-33**    Selection Set for **COPY** Command

**Figure 8-34**    Bookcase After Copying First Set of Books

Repeat the copy process to place a few more books on the shelves, similar to Figure 8-35.

You no longer need the original box solids drawn at elevation 0 (on the XY plane), use the **ERASE** command to remove the boxes from the drawing. But the bookcase could use a couple of accessories. Place the ceramic vase created in Chapter 4 (or create a new vase using the **REVOLVE** command) on one of the shelves.

In AutoCAD, you can insert one drawing into another by selecting **Block** on the **Insert** menu located on the **Menu Browser**. When you insert an entire drawing file into another drawing, the drawing information is copied into the block table of the current drawing as a block definition. To place the ceramic vase in this drawing, expand the **Insert** flyout and select **Block.** Once **Block** has been selected, select the **Browse** button on the **Insert** dialog box. The **Insert Drawing File** dialog box appears on the screen (see Figure 8-36).

Use the **Browse** button to browse saved drawing files and locate the ceramic vase drawing file. Once the drawing file has been selected, the **Insert** dialog box is displayed (see Figure 8-37). Notice that you have the option of specifying the insertion point, the scale, and the rotation. You also have the option of exploding the block on insertion.

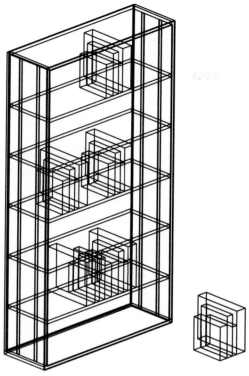

**Figure 8-35**    Bookcase After Copying Additional Books to the Shelves

**Figure 8-36**    **Insert Drawing File** Dialog Box

**Figure 8-37**    **Insert** Dialog Box

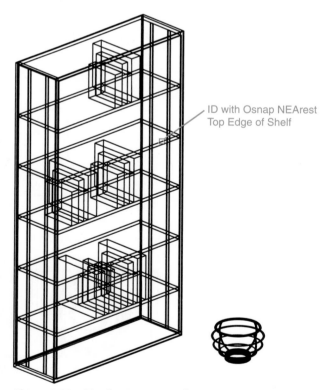

**Figure 8-38**    Use the **ID** Command to Determine the Top Elevation of the Shelf

Insert the ceramic vase in front of the bookcase. Because the ceramic vase was inserted at elevation 0, in front of the bookcase, you need to determine the final placement elevation. Use the **ID** command to determine the exact elevation of the top of the fourth shelf by typing **ID** at the command prompt, and selecting a top edge of the fourth shelf using **Osnap**, **NEArest** (see Figure 8-38).

Make a note of the Z coordinate location for the top of the shelf (the location of the top of the fourth shelf in my drawing was $3'11\frac{1}{2}''$; yours will most likely differ).

Change the view to **Plan**, **World UCS**. Use the **MOVE** command to relocate your ceramic vase to the appropriate elevation (Z coordinate determined with the **ID** command).

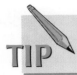

**TIP** Use the **MOVE** command, select the object (vase), then select **0,0,0** for the base point; Your determined Z coordinate is then the coordinate for the second point of placement.

In plan view, the vase does not appear any different than before you used the **MOVE** command because it was moved only in the Z direction.

Use the **MOVE** command a second time to locate the ceramic vase on the bookcase shelf. To accomplish this, type **m** *(move)* at the command prompt, select the ceramic vase as the object to move, and with **Ortho** and **Osnap** off, pick a base point away from the bookcase for the first point of displacement and drag the ceramic vase into the appropriate location. Figures 8-39 and 8-40 illustrate this **MOVE** operation.

**Figure 8-39**    Selection Objects and Points for the **MOVE** Command

**Figure 8-40**    Bookcase After Moving the Ceramic Vase

The previous two operations with the **MOVE** command could have been done in one operation. However, learning to move objects in only one direction at a time using two different methods can also be important. Change the view to **NE Isometric,** or use **Orbit** to produce a front view of the bookcase. Using the **Change/Properties** command, change the color of some of the books and the ceramic vase. From the **Visual Styles Manager**, select the **Conceptual** style. Your drawing should appear similar to Figure 8-41.

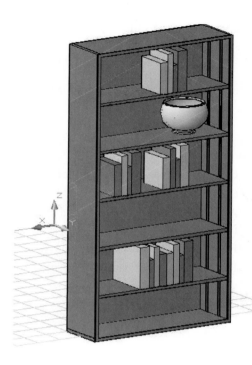

**Figure 8-41**    Frontal Conceptual
View of Completed Bookcase

## SUMMARY

This chapter provided you with additional practice creating solids by extruding closed polyline shapes. You gained additional experience using the **COPY, MOVE, SUBTRACT,** and **ROTATE3D** commands.

You also achieved a basic understanding of what the **INTERFERE** command allows you to do and how this command can be used to create a separate set of solids from two or more overlapping (coplanar) solids. This chapter illustrated how to use the **INSERT** command to insert one drawing into another. You also learned how to move the **UCS** to relocate a drawing plane.

After completing Chapter 8, you now have an understanding of creating 3D solids using the **BOX** command.

## CHAPTER TEST QUESTIONS

### Multiple Choice

1. The **CHANGE/ELEVATION** commands allow you to
   a. Change the elevation of all drawn entities
   b. Change the elevation of all solids that are not 3D
   c. Move a drawn entity in any axis direction
   d. Change the elevation of 3D solids
   e. Change the location of an entity's XY placement

2. Which of the following is **not** an option for specifying the UCS origin?
   a. **Face**
   b. **Previous**
   c. **World**
   d. **Base**
   e. **Object**

3. Selecting **NE Isometric** from the **Menu Browser**, **View** menu, **3D Views** flyout produces the same

   view as invoking the **VPOINT** command then specifying
   a. **−1,−1,1**
   b. **1,−1,1**
   c. **1,1,1**
   d. **1,1,−1**
   e. **0,0,0**

4. When performing a **SUBTRACT** operation, you must select which of the following first?
   a. The objects to be subtracted
   b. The objects to subtract from
   c. The objects to be subtracted and the objects to subtract from at the same time
   d. None of the above
   e. Any one of the above

5.  The **INTERFERE** command can be used to determine the overlapping of solids when
    a.  Two or more solids occupy some of the same space and are coplanar
    b.  Two or more solids do not overlap
    c.  Two or more solids do not overalp and are drawn on separate layers
    d.  Two or more solids are drawn on the XY plane but do not overlap
    e.  Two or more solids do not overlap but are the same color

## Matching

**Column A**

a.  **INTERFERE**
b.  **BOX**
c.  **INSERT**

d.  **COPY**
e.  **MOVE**

**Column B**

1.  Copies objects a specified distance in a specified direction
2.  Creates a 3D solid box
3.  Allows you to move objects at a specified distance and in a specified direction
4.  Highlights 3D solids that overlap
5.  Places a drawing or named block into the current drawing

## True or False

1.  T or F: Closed polyline shapes can be extruded to produce a 3D solid.
2.  T or F: Open polyline shapes can be extruded to produce a 3D solid.
3.  T or F: The **EXTRUDE** command is used to assign a thickness parallel to the effective UCS, Z axis, or along a specified path.
4.  T or F: The **SUBTRACT** command can be invoked by typing **su** at the command prompt.
5.  T or F: Selecting **Plan View, World UCS** from the **View** menu on the **Menu Browser** or from the **View** pull-down menu, **3D Views** flyout produces the same screen view as typing **VPOINT**, then **0,0,1** at the command prompt.

## *Chapter* Objectives

- Practice constructing three-dimensional solids with the **BOX** command
- Practice moving drawing objects three-dimensionally
- Use the **3DMIRROR** and **3DROTATE** commands
- Use the **FILLET** and **SLICE** commands to edit solids
- Practice using the **UNION** command

## Introduction

The processes used to produce the sofa in this chapter will provide you with additional practice creating solids. You will extrude closed polyline shapes with the **EXTRUDE** command, move objects three-dimensionally with the **MOVE** command, rotate and mirror objects three-dimensionally with the **3DROTATE** and **3DMIRROR** commands, and edit solids with the **FILLET** command.

The overall dimensions of the sofa are 87″ wide, 35″ deep, and 35″ high, with a seat height of 20″. Several individual components will be constructed to complete the sofa model. In previous chapters, you used extruded closed polylines to create rectangular solids. In this chapter, the **BOX** command will be used to create most of the rectangular solids. Both processes can be used to achieve the same results.

## Drawing Setup

Begin a new drawing. Set the **Units** to **Architectural**, **Precision** to ½″. Set the **Limits** to **0,0** and **10′,6′**. Set the **Grid** to **6″**, and **Zoom All**.

## Begin Drawing

We will begin drawing the sofa base with the **BOX** command and use this base component as basic construction guides/references points to add the remaining sofa components. By using absolute coordinates as the first corner point for the sofa base, you establish the location of the model relative to the drawing screen.

| Prompt | Response |
|---|---|
| Command: | *Select the **BOX** icon* |
| Command: _box | |
| Specify first corner or [Center]: | Type: **2′,2′ <Enter ↵>** |
| Specify other corner or [Cube/Length]: | Type: **@75,25 <Enter ↵>** |
| Specify height or [2Point] <0′-8″>: | Type: **8 <Enter ↵>** |

| BOX | |
|---|---|
| **Ribbon/ Home tab/ 3D Modeling/Box** | |
| **Menu** | Draw/ Modeling/ Box |
| **Toolbar: Modeling** | |
| **Command Line** | box |

**Figure 9-1**    Sofa Base Box

Your drawing should appear similar to Figure 9-1.

From this viewpoint (plan view), the sofa base thickness is not evident. Use the **3D Views** flyout on the **Menu Browser, View** menu and select **NE Isometric**. Your drawing should appear similar to Figure 9-2.

**Figure 9-2**    NE Isometric
View of Sofa Base

The sofa base has a thickness of 8″. The upper sofa base has the same length and width dimensions, but it needs to have a thickness of 6″. Use the **BOX** command to draw the upper sofa base.

| Prompt | Response |
|---|---|
| Command: | *Select the **BOX** icon* |
| Command: box | |
| Specify first corner or [Center]: | *With **Osnap**, **Endpoint**, pick the top left corner of the first box (see Figure 9-3)* |
| Specify other corner or [Cube/Length]: | *With **Osnap**, **Endpoint**, pick the opposite top corner of the first box* |
| Specify height or [2Point] <0′-8″>: | *Push the mouse in the positive Z direction and Type: **6 <Enter ↵>*** |

While in this isometric view of the front of the sofa bases, we will use the **FILLET** command to round the front edges of the upper sofa base and the upper edge of the lower sofa base component.

| Prompt | Response |
|---|---|
| Command: | *Select the **FILLET** icon* |
| Command: fillet | |
| Current settings: Mode = TRIM, Radius = 0′-0″ | |
| Select first object or [Undo/Polyline/ Radius/Trim/Multiple]: | *Pick the top front edge of the upper sofa base (see Figure 9-4)* |
| Enter fillet radius: | Type: **2 <Enter ↵>** |
| Select an edge or [Chain/Radius]: | *Pick the bottom front edge of the upper sofa base* |
| Select an edge or [Chain/Radius]: | Type: **<Enter ↵>** |
| 2 edge(s) selected for fillet. | |

| FILLET | |
|---|---|
| **Ribbon/ Home tab/ Modify/ Fillet** | |
| **Menu** | Modify/ Fillet |
| **Toolbar: Modify** | |
| **Command Line** | fillet |
| **Alias** | f |

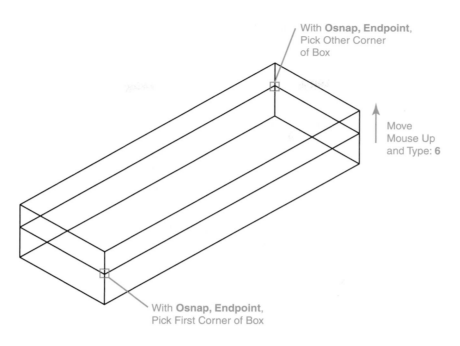

With **Osnap, Endpoint**,
Pick Other Corner
of Box

Move
Mouse Up
and Type: **6**

With **Osnap, Endpoint**,
Pick First Corner of Box

**Figure 9-3**   Selection
Points for Upper Sofa Base

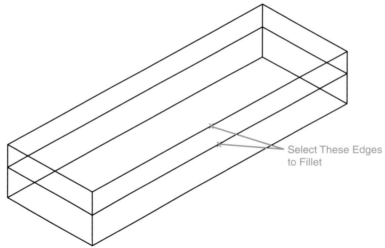

Select These Edges
to Fillet

**Figure 9-4**   Selection Set
for Upper Sofa Base Fillet

Your drawing should appear similar to Figure 9-5.

**Figure 9-5**   Upper Sofa
Base After Fillet

Use the **FILLET** command a second time to fillet the top front edge of the bottom sofa base.

| Prompt | Response |
| --- | --- |
| Command: | *Select the **FILLET** icon* |
| Command: fillet | |
| Current settings: Mode = TRIM, Radius = 0'-2" | |
| Select first object or [Undo/Polyline/ Radius/Trim/Multiple]: | *Pick the top front edge of the bottom sofa base* |
| Enter fillet radius <0'-2">: | Type: **<Enter ↵>** |
| Select an edge or [Chain/Radius]: | Type: **<Enter ↵>** |
| 1 edge(s) selected for fillet. | |

Your drawing should appear similar to Figure 9-6.

**Figure 9-6**    Bottom Sofa Base After Fillet

The next step will consist of constructing the base components for the sofa arms. Use the **BOX** command to construct the left sofa arm.

| Prompt | Response |
| --- | --- |
| Command: | *Select the **BOX** icon* |
| Command: _box | |
| Specify first corner or [Center]: | *With **Osnap**, **Endpoint**, pick the left front bottom corner of the bottom sofa base (see Figure 9-7)* |
| Specify other corner or [Cube/Length]: | Type: **@6,–25 <Enter ↵>** |
| Specify height or [2Point] <0'-6">: | *Push the mouse in the +Z direction and Type:* **22 <Enter ↵>** |

The left sofa arm base component is complete. We will use the **MIRROR3D** command to make the right sofa base component.

| Prompt | Response |
| --- | --- |
| Command: | Type: **3DMIRROR <Enter ↵>** |
| Select objects: | *Pick the sofa arm base component* |
| Select objects: 1 found | |
| Select objects: | Type: **<Enter ↵>** |
| Specify first point of mirror plane (3 points) or [Object/Last/Zaxis/View/ XY/YZ/ZX/3points] <3points>: | Type: **YZ <Enter ↵>** |

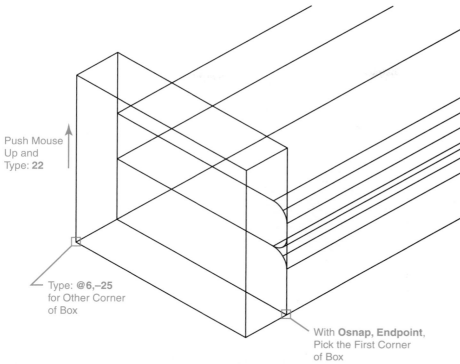

Push Mouse
Up and
Type: **22**

Type: **@6,–25**
for Other Corner
of Box

With **Osnap, Endpoint**,
Pick the First Corner
of Box

**Figure 9-7**    Selection Points for Sofa Arm Base Component

| | |
|---|---|
| Specify point on YZ plane <0,0,0>: | Type: **Mid <Enter ↵>** |
| of | *Pick a longitudinal midpoint of either sofa base (see Figure 9-8)* |
| Delete source objects? [Yes/No] <N>: | Type: **<Enter ↵>** |

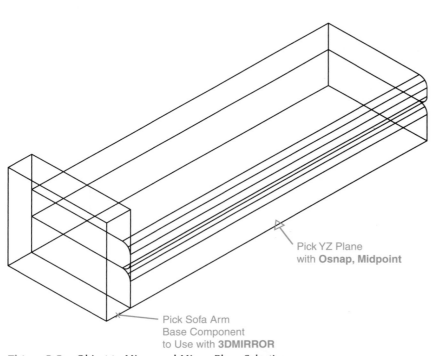

Pick YZ Plane
with **Osnap, Midpoint**

Pick Sofa Arm
Base Component
to Use with **3DMIRROR**

**Figure 9-8**    Object to Mirror and Mirror Plane Selection

After you complete the **3DMIRROR** command, your drawing should appear similar to Figure 9-9.

**Figure 9-9** Sofa After
Mirroring Sofa Arm Base
Component

In the next step, we will add the back of the sofa, and we will use the **BOX** command to draw
it. The box will be 7′-3″ long, 10″ deep, and 24″ high.

| Prompt | Response |
|---|---|
| Command: | *Select the **BOX** icon* |
| Command: box | |
| Specify first corner or [Center]: | *With **Osnap**, **Endpoint**, pick the back left bottom corner of the sofa arm component (see Figure 9-10)* |
| Specify other corner or [Cube/Length]: | Type: **@−7′3,−10 <Enter ↵>** |
| Specify height or [2Point] <1′-10″>: | *Push the mouse up (**+Z**) and Type: **24 <Enter ↵>*** |

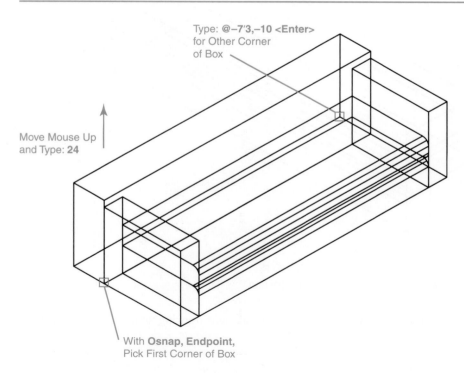

Type: **@−7′3,−10 <Enter>**
for Other Corner
of Box

Move Mouse Up
and Type: **24**

**Figure 9-10** Sofa Back
(Box) Selection Points

With **Osnap, Endpoint**,
Pick First Corner of Box

Change to plan view, World UCS, and draw a polyline to represent the top of the sofa arm. Because the polyline will be drawn at elevation 0, we will change the elevation to 24″ and then extrude the top of the sofa arm a thickness of 2″. We will then fillet the edges of the sofa arm for a softer appearance.

**TIP**   Remember, you cannot change the elevation of a 3D solid, but you can change the elevation of a polyline.

| Prompt | Response |
|---|---|
| Command: | Select **Plan View**, **World UCS** from the **Menu Browser**, **View**, **3D Views** flyout |
| Enter an option [Current ucs/Ucs/World] <Current>: | Type: **<Enter ↵>** |
| Command: | Select the **POLYLINE** icon |
| PLINE | |
| Specify start point: | Type: **1′6,2′,0 <Enter ↵>** *(or Type: **End** and pick the bottom left outside corner of the left sofa side component; see Figure 9-11)* |
| of | |
| Current line width is 0′-0″ | |
| Specify next point or [Arc/Halfwidth/Length/Undo/Width]: | Type: **@8<0 <Enter ↵>** *(or with **Ortho** on, move the mouse in the appropriate direction and type in the desired distance)* |
| Specify next point or [Arc/Close/Halfwidth/Length/Undo/Width]: | Type: **@25<90 <Enter ↵>** |
| Specify next point or [Arc/Close/Halfwidth/Length/Undo/Width]: | Type: **@9<80 <Enter ↵>** |
| Specify next point or [Arc/Close/Halfwidth/Length/Undo/Width]: | Type: **@25<270 <Enter ↵>** |
| Specify next point or [Arc/Close/Halfwidth/Length/Undo/Width]: | Type: **C <Enter ↵>** *(to close the polyline)* |

Begin Polyline at Endpoint,
or Type: **1′6,2′,0**

**Figure 9-11**   Begin Polyline for Chair Arm Top Component

Your drawing should appear similar to Figure 9-12.

**Figure 9-12**   Chair Arm Top Component Polyline

Select **NE Isometric** from the **Menu Browser**, **View**, **3D Views** flyout (or at the command prompt, type **VPOINT**, then **1,1,1**). Figures 9-13 and 9-14 show the sofa arm polyline before and after we use the **CHANGE/ELEVATION** command.

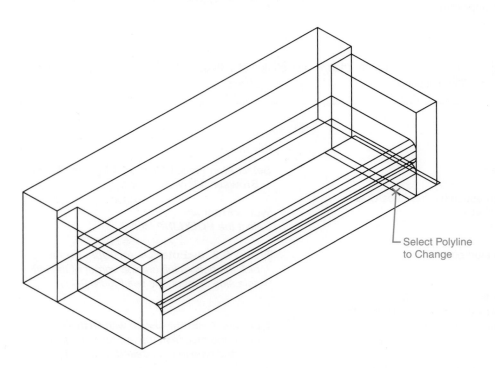

Select Polyline to Change

**Figure 9-13**   Before Sofa Arm Polyline Elevation Change

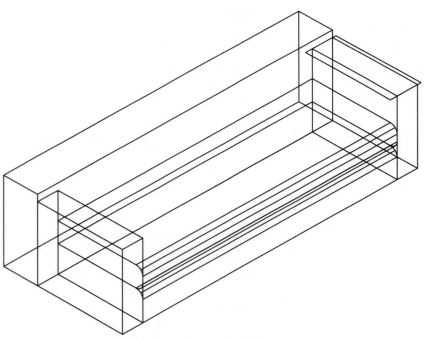

**Figure 9-14**   After Sofa Arm Polyline Elevation Change

| Prompt | Response |
|--------|----------|
| Command: | *Select a **NE Isometric** view* |
| Command: | Type: **CHANGE <Enter ↵>** |
| Select objects: | *Select the arm polyline* |
| Select objects: 1 found | |
| Specify change point or [Properties]: | Type: **P <Enter ↵>** |

| | |
|---|---|
| Enter property to change [Color/Elev/LAyer/LType/ltScale/ LWeight/Thickness/Material/Annotative]: | Type: **E <Enter ↵>** |
| Specify new elevation <0'-0">: | Type: **22 <Enter ↵>** |
| Enter property to change [Color/Elev/LAyer/LType/ltScale/ LWeight/Thickness/Material/Annotative]: | Type: **<Enter ↵>** |

Use the **EXTRUDE** command to extrude the polyline 2″, then use the **FILLET** command to round the side and front edges of the sofa arm top component 1″.

| Prompt | Response |
|---|---|
| Command: | Select the **EXTRUDE** icon |
| Command: _extrude | |
| Current wire frame density: ISOLINES = 4 | |
| Select objects to extrude: | Pick the top sofa arm component |
| Select objects to extrude: 1 found | |
| Specify height of extrusion or [Direction/Path/Taper angle]: | Move the mouse (up) in the positive Z direction and Type: **2 <Enter ↵>** |
| Window/Object] <real time>: | Zoom into an area just around the top of the sofa arm |
| Specify opposite corner: | |
| Command: | Select the **FILLET** icon |
| FILLET | |
| Command: _fillet | |
| Current settings: Mode = TRIM, Radius = 0'-2" | |
| Select first object or [Undo/Polyline/ Radius/Trim/Multiple]: | Pick one of the edges illustrated in Figure 9-15 |
| Enter fillet radius <0'-2">: | Type: **1 <Enter ↵>** |
| Select an edge or [Chain/Radius]: | Pick the remaining four edges of the top sofa arm component |
| Select an edge or [Chain/Radius]: | Type: **<Enter ↵>** |
| 5 edge(s) selected for fillet. | |

| EXTRUDE | |
|---|---|
| Ribbon/ Home tab/ 3D Model- ing/Extrude | |
| Menu | Draw/ Modeling/ Extrude |
| Toolbar: Modeling | |
| Command Line | extrude |
| Alias | ext |

| FILLET | |
|---|---|
| Ribbon/ Home tab/ Modify/ Fillet | |
| Menu | Modify/ Fillet |
| Toolbar: Modify | |
| Command Line | fillet |
| Alias | f |

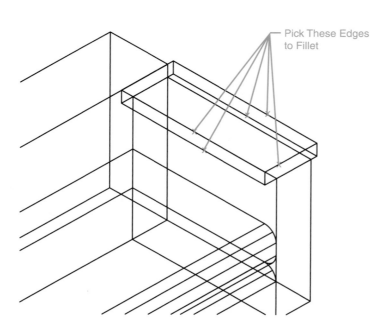

Pick These Edges to Fillet

**Figure 9-15** Edge Selection for **FILLET** Command

After you complete the **FILLET** command, your drawing should appear similar to Figure 9-16.

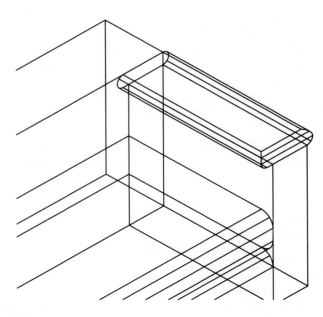

**Figure 9-16**    Sofa Arm After Fillet

Use the **3DMIRROR** command to mirror the right sofa arm top component to the left side of the sofa. Before proceeding with the **3DMIRROR** command, **Zoom All**.

| Prompt | Response |
|---|---|
| Command: | Type: **3DMIRROR <Enter ↵>** |
| Select objects: | *Pick the top of the sofa arm top component* |
| Select objects: 1 found | Type: **<Enter ↵>** |
| Specify first point of mirror plane (3 points) or [Object/Last/Zaxis/View/ XY/YZ/ZX/3points] <3points>: | Type: **YZ <Enter ↵>** |
| Specify point on YZ plane <0,0,0>: | Type: **Mid <Enter ↵>** |
| of | *Pick the longitudinal midpoint of the sofa base* |
| Delete source objects? [Yes/No] <N>: | Type: **<Enter ↵>** |

Your drawing should appear similar to Figure 9-17.

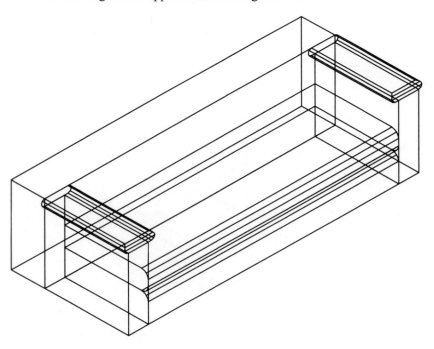

**Figure 9-17**    Sofa After
**3DMIRROR** Command

The next step in this exercise will consist of drawing the sofa seat cushions. Begin by using the **ID** command to establish the last point entered, and then draw one cushion with a closed polyline. Change the elevation of the polyline to 14″ (or use the **MOVE** command), then copy the polyline representation of the first sofa cushion for the other two cushions, use the **EXTRUDE** command to extrude the polylines 4″, and use the **FILLET** command to round the edges of the sofa cushions to add the appearance of softness.

| Prompt | Response |
|---|---|
| Command: | Type: **ID <Enter ↵>** |
| Specify point: | Type: **End <Enter ↵>** |
| of  X = 2′-0″ Y = 2′-0″ Z = 0′-0″ | *Pick the back inside corner of the sofa side (see Figure 9-18)* |
| Command: | *Select the **POLYLINE** icon* |
| PLINE | |
| Specify start point: | Type: **@1/2<0 <Enter ↵>** *(or with **ORTHO** on, move the mouse in the appropriate direction and type the desired distance)* |
| Current line width is 0′-0″ | |
| Specify next point or [Arc/Halfwidth/Length/Undo/Width]: | Type: **@2′<0 <Enter ↵>** |
| Specify next point or [Arc/Close/Halfwidth/Length/Undo/Width]: | Type: **@25<90 <Enter ↵>** |
| Specify next point or [Arc/Close/Halfwidth/Length/Undo/Width]: | Type: **@2′<80 <Enter ↵>** |
| Specify next point or [Arc/Close/Halfwidth/Length/Undo/Width]: | Type: **C <Enter ↵>** *(to close the polyline)* |

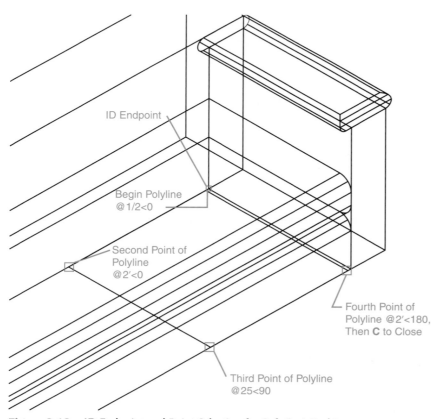

ID Endpoint

Begin Polyline
@1/2<0

Second Point of
Polyline
@2′<0

Fourth Point of
Polyline @2′<180,
Then **C** to Close

Third Point of Polyline
@25<90

**Figure 9-18**    ID Endpoint and Point Selection for Sofa Seat Cushion

| Prompt | Response |
|---|---|
| Command: | Type: **CHANGE <Enter ↵>** |
| Select objects: | Type: **l** *(last)* **<Enter ↵>** *(or pick the seat cushion polyline)* |
| 1 found | |
| Select objects: | Type: **<Enter ↵>** |
| Specify change point or [Properties]: | Type: **P <Enter ↵>** |
| Enter property to change [Color/Elev/LAyer/LType/ltScale/ LWeight/Thickness/Material/Annotative]: | Type: **E <Enter ↵>** |
| Specify new elevation <0'-0">: | Type: **14 <Enter ↵>** |

After you change the elevation of the seat cushion polyline, your drawing should appear similar to Figure 9-19.

**Figure 9-19**   Seat Cushion Polyline After Changing the Elevation to 14″

Use the **EXTRUDE** command to extrude the seat cushion polyline 4″.

| Command | Response |
|---|---|
| Command: | *Select the **EXTRUDE** icon* |
| Command: _extrude | |
| Current wire frame density: ISOLINES = 4 | |
| Select objects to extrude: | *Pick the seat cushion **POLYLINE*** |
| Select objects to extrude: 1 found | Type: **<Enter ↵>** |
| Specify height of extrusion or [Direction/ Path/Taper angle] <0'-2">: | *Push the mouse up and Type: **4 <Enter ↵>*** |

Your drawing should appear similar to Figure 9-20.

Use the **COPY** command to copy the cushion for the other two seat cushions. Before continuing, turn **Snap** off.

**Figure 9-20** Seat Cushion After Extrusion

| Prompt | Response |
|---|---|
| Command: | Type: **cp <Enter ↵>** *(or select the **COPY** icon)* |
| COPY | |
| Select objects: | *Pick the inside edge of the first sofa cushion* |
| Select objects: 1 found | *(see Figure 9-21)* |
| Current settings: Copy mode = Multiple | |
| Specify base point or [Displacement/mOde] | |
|    <Displacement>: | *With **Osnap**, **Endpoint**, pick the front inside* |
| | *bottom corner of the seat cushion* |
| Specify second point | |
|    or <use first point as displacement>: | Type: **@2'1<0 <Enter ↵>** |
| Specify second point or [Exit/Undo] <Exit>: | Type: **@4'2<0 <Enter ↵>** |
| Specify second point or [Exit/Undo] <Exit>: | Type: **<Enter ↵>** |

Your drawing should appear similar to Figure 9-22.

The final step in completing the sofa seat cushions will be to use the **FILLET** command to add the appearance of softness. **Zoom** closely around the left sofa cushion and proceed.

| Prompt | Response |
|---|---|
| Command: | *Select the **FILLET** icon* |
| FILLET | |
| Current settings: Mode = TRIM, Radius = 0'-1" | |
| Select first object or [Undo/Polyline/ | |
|    Radius/Trim/Multiple]: | *Pick the front edge of the left sofa cushion* |
| | *(see Figure 9-23)* |
| Enter fillet radius <0'-1">: | Type: **<Enter ↵>** |
| Select an edge or [Chain/Radius]: | *Pick the other seven edges to fillet* |
| Select an edge or [Chain/Radius]: . . . | |
| Select an edge or [Chain/Radius]: | Type: **<Enter ↵>** |
| 8 edge(s) selected for fillet | |

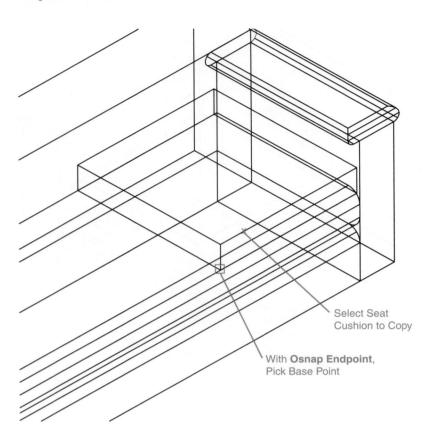

**Figure 9-21** Object and Base Point for the **COPY** Command

Select Seat Cushion to Copy

With **Osnap Endpoint**, Pick Base Point

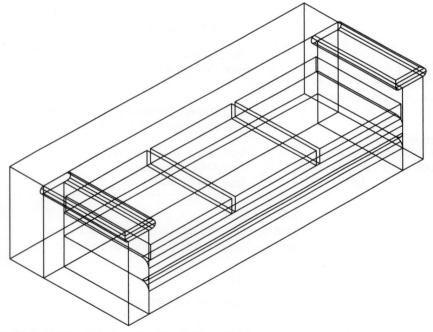

**Figure 9-22** Sofa After Copying the Seat Cushions

| BOX | |
|---|---|
| **Ribbon/ Home tab/ 3D Modeling/Box** | |
| **Menu** | Draw/ Modeling/ Box |
| **Toolbar: Modeling** | |
| **Command Line** | box |

Your drawing should appear similar to Figure 9-24.

Repeat the process and fillet the two remaining sofa cushions. After completing the **FILLET** command, your drawing should appear similar to Figure 9-25.

The next step will be to create the sofa back cushions. We will use the **BOX** command to create the first cushion at elevation 0 and then use the **MOVE** command to relocate the back cushion to elevation 18″.

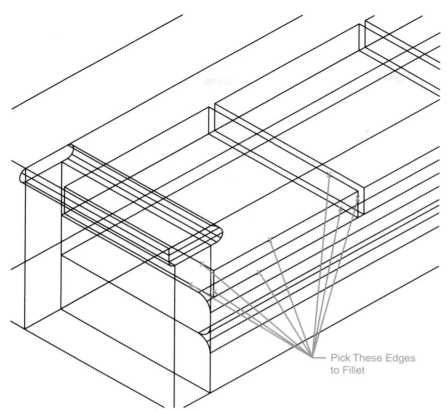

Pick These Edges
to Fillet

**Figure 9-23**    Cushion Edges to Select for **FILLET** Command

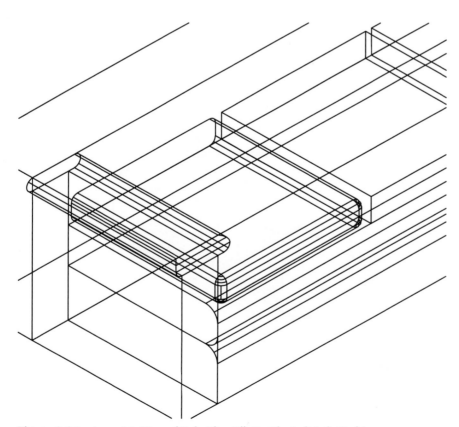

**Figure 9-24**    Isometric View of Sofa After Filleting the Left Sofa Cushion

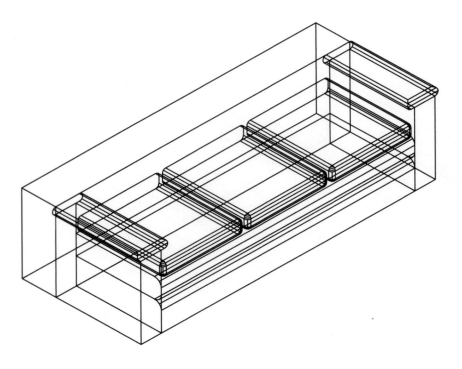

**Figure 9-25** Sofa After Completing Work with the **FILLET** Command

| Prompt | Response |
|---|---|
| Command: | *Select the* **BOX** *icon* |
| Command: _box | |
| Specify first corner or [Center]: | Type: **2′1,2′ <Enter ↵>** |
| Specify other corner or [Cube/Length]: | Type: **@2′,6 <Enter ↵>** |
| Specify height or [2Point] <0′-0″>: | *Move the mouse in the vertical direction and Type:* **1′3 <Enter ↵>** |

After you complete the first sofa back cushion (box) at elevation 0, your drawing should appear similar to Figure 9-26.

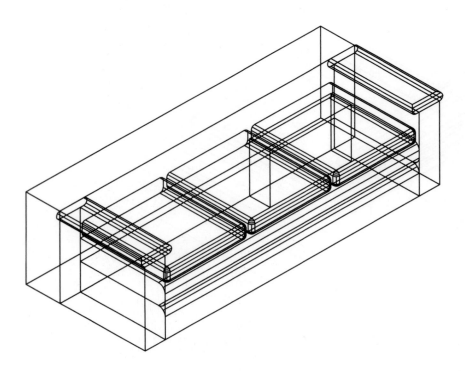

**Figure 9-26** First Sofa Back Cushion (Box) Drawn at Elevation 0

Use the **MOVE** command to relocate the sofa back cushion to elevation 18″.

| Prompt | Response |
|---|---|
| Command: | Type: **m <Enter ↵>** *(or select the **3DMOVE** icon, highlight the Z axis, and Type: **18**)* |
| MOVE | |
| Select objects: | Type: **l** *(last)* **<Enter ↵>** *(or pick the back cushion [box])* |
| 1 found | |
| Select objects: | Type: **<Enter ↵>** |
| Specify base point or [Displacement] <Displacement>: | Type: **0,0,0 <Enter ↵>** |
| Specify second point or <use first point as displacement>: | Type: **0,0,18 <Enter ↵>** |

After you move the back sofa cushion to elevation 18″, your drawing should appear similar to Figure 9-27.

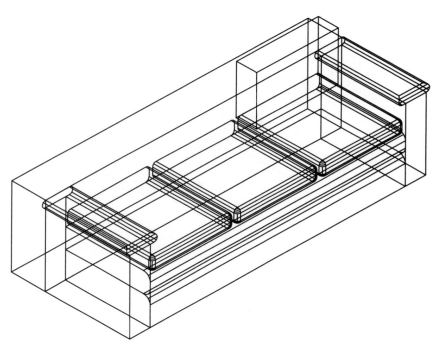

**Figure 9-27**    Sofa Back Cushion After Moving to Elevation 18″

Use the **3DROTATE** grip tool to rotate the sofa back cushion 7° on the X axis.

| Prompt | Response |
|---|---|
| Command: | *Select the **3DROTATE** grip tool from the **Ribbon**, **Home** tab, **Modify** menu* |
| Command: _3drotate | |
| Current positive angle in UCS: | |
| ANGDIR = counterclockwise, ANGBASE = 0 | |
| Select objects: | *Pick the sofa back cushion* |
| Select objects: 1 found | Type: **<Enter ↵>** |
| Specify base point: | Type: **Mid <Enter ↵>** |
| of | *With **Osnap**, **Midpoint**, place the grip tool on the midpoint of the bottom back longitudinal edge (see Figure 9-28)* |
| Pick a rotation axis: | *Highlight the X (amber) axis* |
| Specify angle start point or type an angle: | *Move the mouse slightly behind the Z (green) axis and Type: **7 <Enter ↵>**￼* |

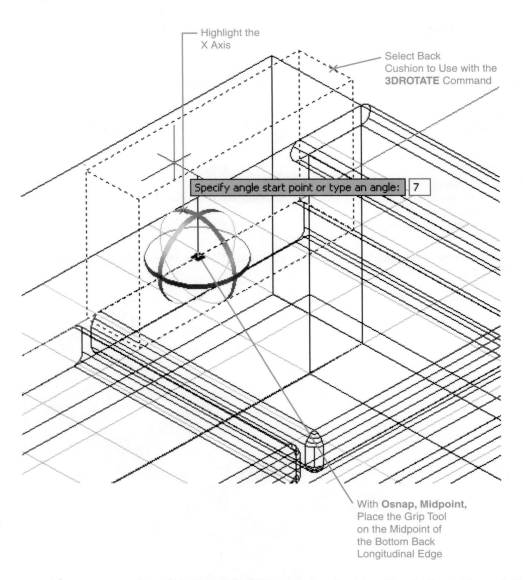

**Figure 9-28   3DROTATE**
Grip Tool Placement and
Axis Selection

After you rotate the sofa back cushion, your drawing should appear similar to Figure 9-29.
Use the **FILLET** command to round the corners of the sofa back cushion edges with a radius of
2″. Select all 12 edges of the sofa back cushion to fillet. It may be necessary to use the **′Zoom** (transparent, **′z**), **W**indow and **P**revious options, to select the cushion edges. If you miss an edge, repeat the
**FILLET** command and complete the selections (see Figure 9-30).

| Prompt | Response |
|---|---|
| Command: | *Select the **FILLET** icon* |
| FILLET | |
| Current settings: Mode = TRIM, Radius = 0′-1″ | |
| Select first object or [Undo/Polyline/ | |
|   Radius/Trim/Multiple]: | Type: **R <Enter ↵>** |
| Specify fillet radius <0′-1″>: | Type: **2 <Enter ↵>** |
| Select first object or [Undo/Polyline/ | |
|   Radius/Trim/Multiple]: | |
| Enter fillet radius <0′-2″>: | Type: **<Enter ↵>** |
| Select an edge or [Chain/Radius]: | *Select all 12 edges of the sofa back* |
| Select an edge or [Chain/Radius]: | *cushion; use **′Z** and zoom in close if* |
| Select an edge or [Chain/Radius]: | *necessary* |
| Select an edge or [Chain/Radius]: | Type: **<Enter ↵>** |
| 12 edge(s) selected for fillet. | |

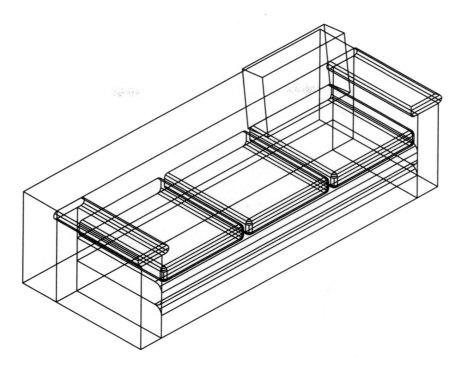

**Figure 9-29**    Sofa Back
Cushion After Using the
**3DROTATE** Command

Pick All 12 Edges
of the Sofa Back
Cushion to Fillet

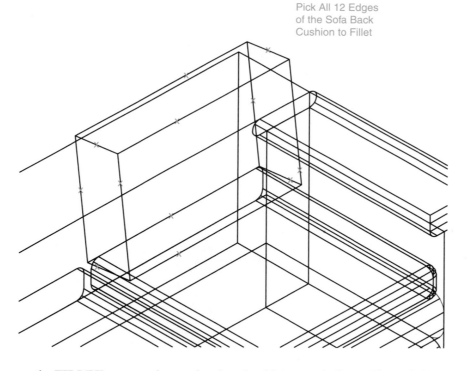

**Figure 9-30**    Sofa Back
Cushion Edge Selection for
Use with the **FILLET**
Command

After you use the **FILLET** command, your drawing should appear similar to Figure 9-31.
    One sofa back cushion is complete. Use the **COPY** command to produce the remaining two
sofa back cushions.

| Prompt | Response |
|---|---|
| Command: | *Select **Copy** from the **Modify** flyout on the **Menu Browser*** |
| COPY | |
| Select objects: | *Pick the sofa back cushion* |
| Select objects: 1 found | Type: **<Enter ↵>** |

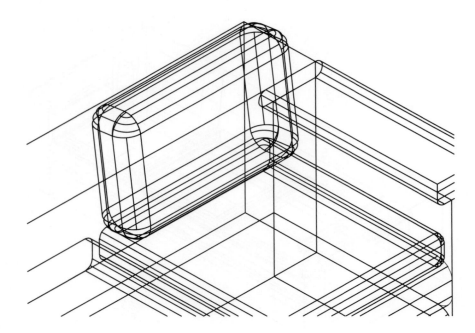

**Figure 9-31**    Sofa Back
Cushion After Using the
**FILLET** Command

Current settings: Copy mode = Multiple
Specify base point or [Displacement/mOde]
    <Displacement>:

Specify second point
    or <use first point as displacement>:

*With **ORTHO** on, pick a point above the back
    sofa cushion (see Figure 9-32)*

*Move the mouse in the +X direction and
    Type: **2'-1/2 <Enter ↵>***

With **ORTHO** On, Move the Mouse
in the +X Direction and
Type: **2'–1/2" <Enter ↵>**,
Then Type: **4'1 <Enter ↵>**

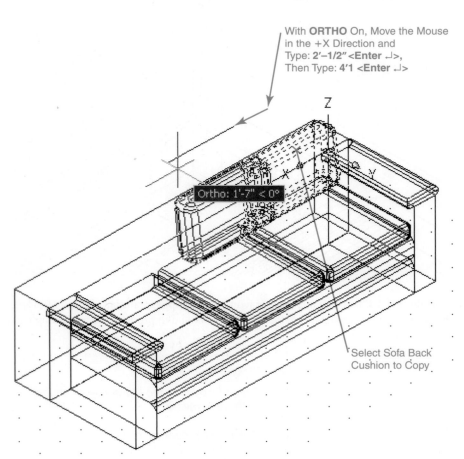

Ortho: 1'-7" < 0°

Select Sofa Back
Cushion to Copy

**Figure 9-32**    Selection
Points for Copying the Sofa
Back Cushion

| Specify second point or [Exit/Undo] <Exit>: | *Move the mouse in the +X direction and* |
| | *Type:* ***4'1 <Enter ↵>*** |
| Specify second point or [Exit/Undo] <Exit>: | Type: **<Enter ↵>** |

Your drawing should be similar to Figure 9-33. Copying objects in three-dimensional space does not have to be difficult, especially when you are copying in only one direction (sofa back cushions were copied in the X direction only).

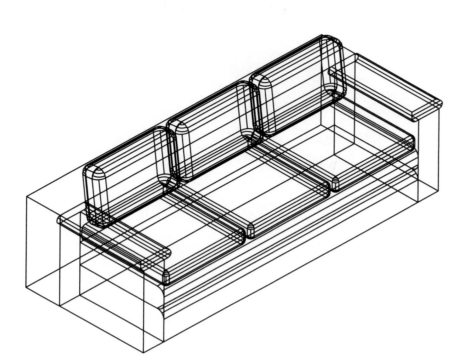

**Figure 9-33**    Sofa Back Cushions After Using the **COPY** Command

The final step will consist of adding a rounded top to the sofa back. Begin by drawing a closed polyline using the top endpoints of the original sofa back component. Then use the **EXTRUDE** and **FILLET** commands to complete the top portion of the sofa back.

Change to a SW isometric view using the **Menu Browser**, **View** menu, **3D Views** flyout, **SW Isometric**. Changing the view to SW isometric places the sofa back in front of the sofa back cushions, making point selection easier.

| Prompt | Response |
| --- | --- |
| Command: | *Select the **POLYLINE** icon* |
| PLINE | |
| Specify start point: | *With **OSNAP**, **Endpoint**, pick the back left corner of the sofa back (see Figure 9-34)* |
| Current line width is 0'-0" | |
| Specify next point or [Arc/Halfwidth/ Length/Undo/Width]: | *With **OSNAP**, **Endpoint**, pick the back right corner of the sofa back (use '**Z**, transparent zoom if necessary)* |
| Specify next point or [Arc/Close/ Halfwidth/Length/Undo/Width]: | *With **OSNAP**, **Endpoint**, pick the front right corner of the sofa back* |
| Specify next point or [Arc/Close/ Halfwidth/Length/Undo/Width]: | *With **OSNAP**, **Endpoint**, pick the front left corner of the sofa back* |
| Specify next point or [Arc/Close/ Halfwidth/Length/Undo/Width]: | Type: **C <Enter ↵>** *(to close the polyline)* |

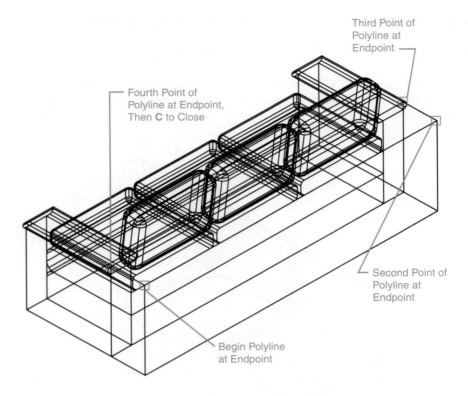

Third Point of
Polyline at
Endpoint

Fourth Point of
Polyline at Endpoint,
Then **C** to Close

Second Point of
Polyline at
Endpoint

Begin Polyline
at Endpoint

**Figure 9-34**   Sofa Back
Polyline Point Selection

| Prompt | Response |
|---|---|
| Command:<br>EXTRUDE<br>Current wire frame density: ISOLINES = 4<br>Select objects to extrude: | *Select the **EXTRUDE** icon*<br><br><br>Type: **I** *(last)* **<Enter ↵>** *(or pick the sofa back<br>    top polyline)* |
| 1 found<br>Select objects to extrude:<br>Specify height of extrusion or<br>    [Direction/Path/Taper angle] <1'-3">:<br>Specify angle of taper for extrusion <0>:<br>Specify height of extrusion or [Direction/<br>    Path/Taper angle] <1'-3">: | <br>Type: **<Enter ↵>**<br><br>Type: **T <Enter ↵>**<br>Type: **15 <Enter ↵>**<br><br>Type: **6 <Enter ↵>** |

Your drawing should appear similar to Figure 9-35.

Use the **FILLET** command with a 30 radius to round the top four edges of the tapered sofa back top component.

| Prompt | Response |
|---|---|
| Command:<br>FILLET<br>Current settings: Mode = TRIM, Radius = 0'-2"<br>Select first object or [Undo/Polyline/<br>    Radius/Trim/Multiple]:<br>Specify fillet radius <0'-2">:<br>Select first object or [Undo/Polyline/<br>    Radius/Trim/Multiple]:<br>Select an edge or [Chain/Radius]:<br>Select an edge or [Chain/Radius]:<br>Select an edge or [Chain/Radius]:<br>4 edge(s) selected for fillet. | *Select the **FILLET** icon*<br><br><br>*Pick one of the top edges (see Figure 9-36)*<br>Type: **3 <Enter ↵>**<br><br>*Pick the remaining three edges* |

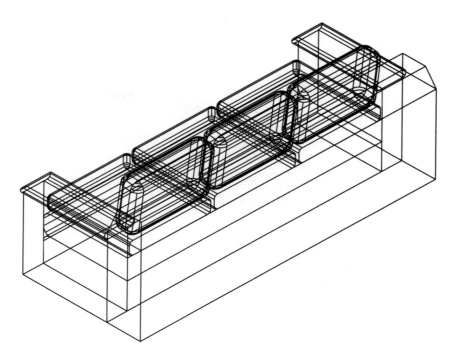

Figure 9-35    Sofa Back Component After Completing the Tapered Extrusion

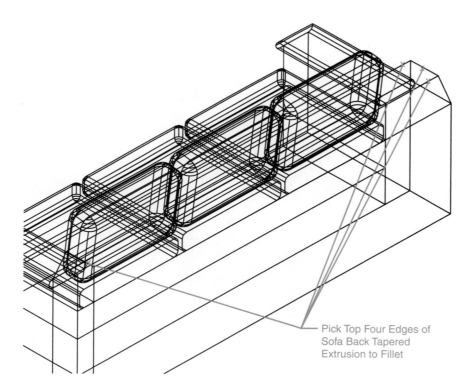

Pick Top Four Edges of Sofa Back Tapered Extrusion to Fillet

Figure 9-36    Edge Selection for **FILLET** Command

After you complete the **FILLET** command, your drawing should appear similar to Figure 9-37.
Change the view to **NE Isometric** and select **Conceptual** from the **Visual Styles Manager**.
The completed sofa model should appear similar to Figure 9-38.

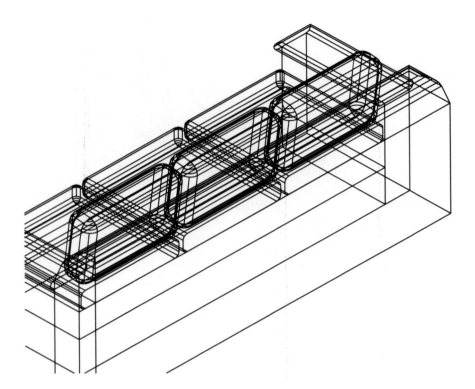

Figure 9-37   Sofa Back
After Using the **FILLET**
Command

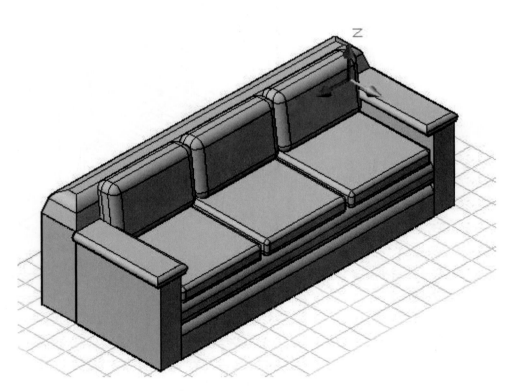

Figure 9-38   NE Isometric View of Completed Sofa
in Conceptual Style

## Chapter Exercises

### Exercise 9-1: Matching Chair

This exercise will produce a chair that matches the sofa created in Chapter 9. Use the **SLICE**, **ERASE**, **3DMIRROR**, and **UNION** commands to edit the sofa model. To begin, open a copy of the sofa drawing.

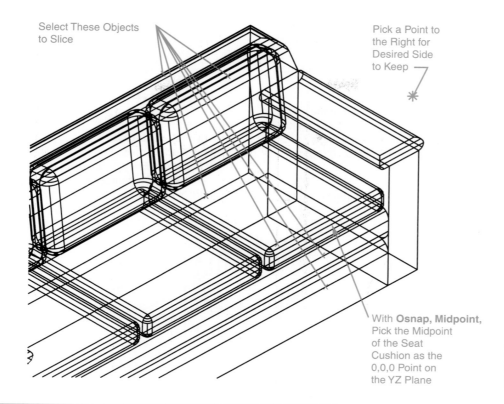

Select These Objects to Slice

Pick a Point to the Right for Desired Side to Keep

With **Osnap, Midpoint,** Pick the Midpoint of the Seat Cushion as the 0,0,0 Point on the YZ Plane

**Figure 9-39** Objects and Plane Selection Set for **SLICE** Command

| Prompt | Response |
|--------|----------|
| Command: | *Select the **SLICE** icon from the **Menu Browser, Modify** menu, **3D Operations** flyout* |
| Command: _slice | |
| Select objects to slice: | *Pick the lower sofa base (see Figure 9-39)* |
| Select objects to slice: 1 found | *Pick the upper sofa base* |
| Select objects to slice: 1 found, 2 total | *Pick the seat cushion* |
| Select objects to slice: 1 found, 3 total | *Pick the seat back cushion* |
| Select objects to slice: 1 found, 4 total | *Pick the sofa back base* |
| Select objects to slice: 1 found, 5 total | *Pick the sofa back top* |
| Select objects to slice: | *Type: **<Enter ↵>*** |
| Specify start point of slicing plane or [planar Object/Surface/Zaxis/View/ XY/YZ/ZX/3points] <3points>: | *Type: **YZ <Enter ↵>*** |
| Specify a point on the YZ plane <0,0,0>: | *Type: **Mid <Enter ↵>*** |
| of | *With **Osnap, Midpoint,** pick the front midpoint of the right sofa seat cushion* |
| Specify a point on desired side or [keep Both sides] <Both>: | *Click a point to the right of the sofa* |

After completing the **SLICE** command, your drawing should appear similar to Figure 9-40.

The sofa components to the left of the sliced sofa components are not needed for the chair model. Use the **ERASE** command to remove the left sofa cushions and sofa arm components. After you erase the unneeded components, your drawing should appear similar to Figure 9-41.

Half of the chair model is complete. Use the **3DMIRROR** command to produce the other half of the chair.

| Prompt | Response |
|--------|----------|
| Command: | *Type: **3DMIRROR <Enter ↵>** (or select **3DMIRROR** from the **Menu Browser, Modify** menu, **3D Operations** flyout)* |

Command: _mirror3d
Select objects:

Select objects: Specify opposite corner:
8 found
Select objects:
Specify first point of mirror plane
   (3 points) or [Object/Last/Zaxis/View/
   XY/YZ/ZX/3points] <3points>:
Specify point on YZ plane <0,0,0>:
of

Delete source objects? [Yes/No] <N>:

*With a crossing window (select window right to left) select all the chair components*

Type: **<Enter ↵>**

Type: **YZ <Enter ↵>**
Type: **End <Enter ↵>**
*With **Osnap Endpoint**, select the bottom left corner of the sofa base*
Type: **N <Enter ↵>**

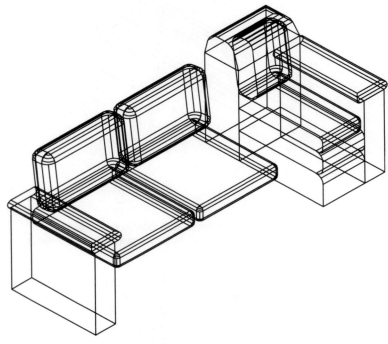

**Figure 9-40**    Sofa Copy
After Using the **SLICE**
Command

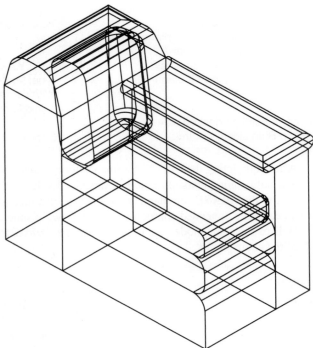

**Figure 9-41**    Sliced Portion of
Chair Model After Using the
**ERASE** Command

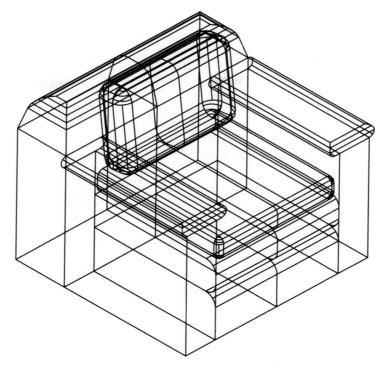

Figure 9-42    Chair Model After Using the **3DMIRROR** Command

After completing your work with the **3DMIRROR** command, your drawing should be similar to Figure 9-42.

The chair model is almost complete. The final step will be to use the **UNION** command to join similar components, that is, the original and mirrored sofa seat cushion components.

| Prompt | Response |
|--------|----------|
| Command: | *Select the **UNION** icon* |
| Command: _union | |
| Select objects: | *Select one side of the lower sofa base (see Figure 9-43)* |

Select Similar Components to Join

| UNION | |
|-------|-----|
| **Ribbon/ Home tab/ Solid editing/ Union** | |
| **Menu** | Modify/ Solid Editing/ Union |
| **Toolbar: Modeling** | |
| **Command Line** | union |
| **Alias** | uni |

Figure 9-43    Selection Set for Use with the **UNION** Command

| Select objects: 1 found | *Select the other side of the lower sofa base* |
| Select objects: 1 found, 2 total | Type: **<Enter ↵>** |

Repeat the **UNION** command to join the remaining similar components. After you have completed joining the components, your drawing should be similar to Figure 9-44.

**Figure 9-44** Chair Model After Joining the Remaining Similar Components

The chair model is complete. Insert the sofa model in the chair model drawing and select the **Conceptual** visual style to produce a drawing similar to Figure 9-45.

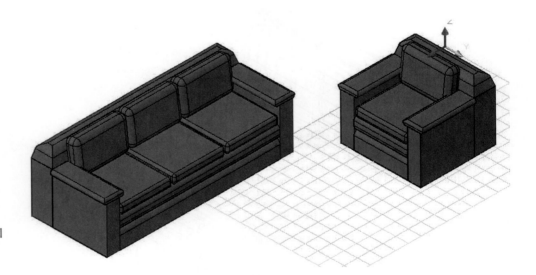

**Figure 9-45** Conceptual View of Sofa Model with Matching Chair

# Summary

While completing the work in this chapter you learned the commands and processes needed to create complex solid models. This chapter provided you with practice using the **BOX** command to create a box-shaped 3D solid.

You gained additional practice using the **POLYLINE**, **EXTRUDE**, and **3DMIRROR** commands. This chapter also provided you with additional practice using the **SLICE**, **3DROTATE**, and **FILLET** commands to edit and manipulate 3D solids. And you gained additional practice using the **UNION** command.

In Chapter 10, you will learn to use the **INTERSECT** command to produce a single solid from the common area of two overlapping solids. You will also learn to use the **ORBIT** command to view three-dimensional models.

# Chapter Test Questions

## Multiple Choice

1. The **BOX** command is used to do which of the following?
   a. Create a 3D box
   b. Create a 2D rectangle
   c. Create a 3D box with predefined dimensions
   d. Create an extruded closed polyline

2. Which of the following is **not** a **3DMIRROR** plane option?
   a. Object
   b. 3points
   c. Xaxis
   d. Zaxis
   e. YZ

3. The **SLICE** command can be used to do which of the following?
   a. Slice a 2D closed polyline
   b. Slice a 3D solid
   c. Slice a 3D polyline
   d. Place a bevel on the edges of a solid
   e. Subtract an embedded 3D solid

4. The **3DROTATE** command can be used to
   a. Rotate any object three-dimensionally
   b. Rotate only 3D solid objects three-dimensionally
   c. Make a mirror image of 3D solid objects
   d. All the above
   e. None of the above

5. The **BOX** command can be invoked by
   a. Selecting the **BOX** icon from the **Modeling** toolbar
   b. Selecting the **BOX** icon from the **Ribbon**, **Home** tab, **3D Modeling** menu
   c. Typing **box** at the command prompt
   d. All the above
   e. None of the above

## Matching

**Column A**

a. **BOX**

b. **3DROTATE**

c. **3DMIRROR**

d. **SLICE**

e. **EXTRUDE**

**Column B**

1. Moves objects about a three-dimensional axis

2. Creates a mirror image of objects about a plane

3. Creates a 3D solid by extruding an object a specified distance and in a specified direction

4. Cuts a 3D solid at a specified plane

5. Creates a box-shaped object

## True or False

1. T or F: You can rotate an object about the Y axis.

2. T or F: Identical objects can be created by using the **BOX** command or extruding a closed polyline.

3. T or F: The **FILLET** command can be used to round the edges of an object created with the **BOX** command.

4. T or F: Objects created with the **BOX** command cannot be changed or edited once they are completed.

5. T or F: The **SLICE** command can be used to cut a solid object into separate components.

# Cabriole Leg

## Chapter Objectives

- Practice constructing 3D solids with the **EXTRUDE** command
- Use the **INTERSECT** command
- Use the **COPY**, **MOVE**, and **ROTATE** commands
- Practice using the **FILLET** command
- Use the **3DROTATE** command
- Use the **BOUNDARY** command to create a region or polyline
- Use the **ORBIT** command

## INTRODUCTION

In this chapter, we will use simple 3D modeling commands to draw a conceptual cabriole leg. As always, it is best to start with a scaled sketch of the object you plan to draw. Planning saves time and increases accuracy. The cabriole leg will be used on the wing chair drawing produced in the next chapter.

The processes used to produce the cabriole leg in this chapter will provide additional practice creating solids by extruding closed polyline shapes with the **EXTRUDE** command, moving objects three-dimensionally with the **MOVE** command, rotating two-dimensionally with the **ROTATE** command, and editing solids with the **FILLET** command. We will create two overlapping three-dimensional solids and use the **INTERSECT** command to produce the resulting cabriole leg model.

## DRAWING SETUP

Begin a new drawing. Set the **Units** to **Architectural**, **Precision** to $\frac{1}{16}''$. Set the **Limits** to **0,0** and **2′,1′6**. Set the **Grid** to $\frac{1}{2}''$, and **Zoom All**.

## BEGIN DRAWING

It is sometimes helpful to create a box in which to work. Begin by drawing a 5″ × 8″ closed polyline rectangle and use the box as a guide for drawing the profile of the cabriole leg. Turn **Ortho** on and proceed.

| POLYLINE | |
|---|---|
| **Ribbon/ Home tab/ Draw/ Polyline** | |
| **Menu** | Draw/ Polyline |
| **Toolbar: Draw** | |
| **Command Line** | pline |
| **Alias** | pl |

| Prompt | Response |
|---|---|
| Command: | *Select the POLYLINE icon* |
| PLINE | |
| Specify start point: | **Type: 6,6 <Enter ↵>** |

| | |
|---|---|
| Current line width is 0'-0" | |
| Specify next point or [Arc/Halfwidth/<br>  Length/Undo/Width]: <Ortho on> | Type: **@5<0 <Enter ↵>** *(or move the mouse to<br>  the right and Type: 5)* |
| Specify next point or [Arc/Close/<br>  Halfwidth/Length/Undo/Width]: | Type: **@8<90 <Enter ↵>** |
| Specify next point or [Arc/Close/<br>  Halfwidth/Length/Undo/Width]: | Type: **@5<180 <Enter ↵>** |
| Specify next point or [Arc/Close/<br>  Halfwidth/Length/Undo/Width]: | Type: **C <Enter ↵>** *(to close the polyline)* |

Draw two edge profile shapes within the box just created to complete the overall profile of the cabriole leg. Using the grid as a guide, begin a new polyline approximately 1″ to the right of the upper left corner of the box and pick points about every $\frac{1}{2}$″, approximating the left side of the cabriole leg profile (see Figure 10-1). Turn **Ortho** off, and use **Osnap**, **Nea** (nearest) to begin the polyline, and end the polyline at the bottom edge of the box using **Onap**, **Per** (perpendicular).

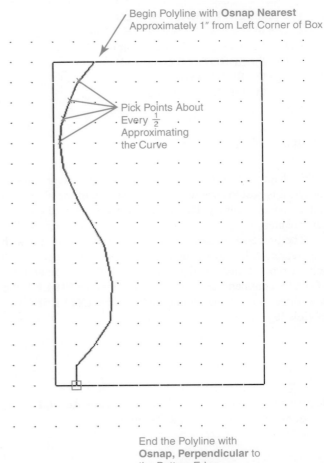

Begin Polyline with **Osnap Nearest**
Approximately 1″ from Left Corner of Box

Pick Points About
Every $\frac{1}{2}$
Approximating
the Curve

End the Polyline with
**Osnap, Perpendicular** to
the Bottom Edge

**Figure 10-1**    Left Edge Polyline
Profile

| Prompt | Response |
|---|---|
| Command: | *Select the **POLYLINE** icon* |
| PLINE | |
| Specify start point: | Type: **Nea** *(nearest)* **<Enter ↵>** |
| to | *Pick the beginning point approximately 1″ to<br>  the right of the top left edge of the box<br>  (see Figure 10-1)* |
| Current line width is 0'-0" | |

| | |
|---|---|
| Specify next point or [Arc/Halfwidth/<br>Length/Undo/Width]: | *Continue picking points about every*<br>*1/2″ approximating the left edge profile.* |
| Specify next point or [Arc/Close/<br>Halfwidth/Length/Undo/Width]: | *Approximately 3/4″ from the bottom of the box,*<br>*Type:* **Per** *(perpendicular)* **<Enter ↵>** |
| to | *Pick the point perpendicular to the bottom*<br>*edge of the box* |
| Specify next point or [Arc/Close/<br>Halfwidth/Length/Undo/Width]: | *Type:* **<Enter ↵>** |

Repeat the process for the right side of the leg profile. Begin the polyline $\frac{1}{2}$″ to the left of the top right corner of the box and pick points about every $\frac{1}{2}$″, approximating the right side of the cabriole leg profile. Use **Onap, Nea** to begin the polyline, and end the polyline at the bottom edge of the box using **Osnap, Per**. Your drawing should appear similar to the Figure 10-2.

If you need to adjust the curvature of the polylines just drawn, select a polyline and drag a *grips* box to smooth the shape (see Figure 10-3).

grips: Small, solid-filled squares that are displayed at strategic points on objects that you have selected with a pointing device.

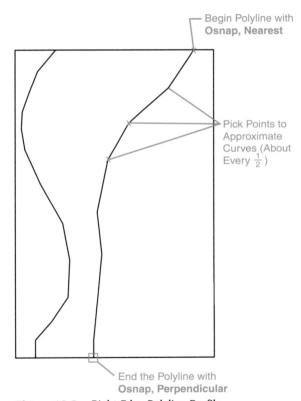

**Figure 10-2**    Right Edge Polyline Profile

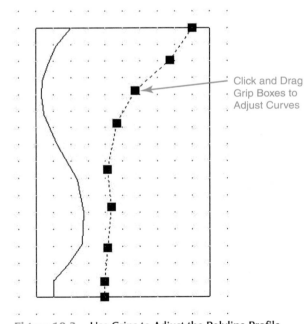

**Figure 10-3**    Use Grips to Adjust the Polyline Profile

To extrude the cabriole leg profile, we need a closed polyline or region. We could draw polylines that connect the right and left sides of the profile and then use the **PEDIT** command to join individual sections. A more time-efficient method is to use the **BOUNDARY** command. The **BOUNDARY** command allows you to create a region or a polyline from an enclosed area, which can then be extruded to produce a three-dimensional solid.

| Prompt | Response |
|---|---|
| Command: | *Type:* **BOUNDARY <Enter ↵>** *(or select the*<br>***BOUNDARY*** *icon from the* ***Ribbon, Home***<br>*tab,* ***Draw*** *flyout menu); left-click on the*<br>***Pick Points*** *button in the* ***Boundary***<br>***Creation*** *dialog box (see Figure 10-4)* |

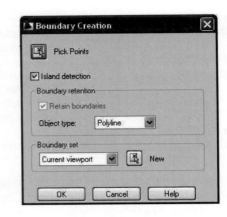

Figure 10-4     **Boundary Creation**
Dialog Box

| | |
|---|---|
| Pick internal point: Selecting everything… | *Pick a point inside the cabriole leg profile* |
| Selecting everything visible…. | |
| Analyzing the selected data… | |
| Analyzing internal islands… | |
| Pick internal point: | *Type: <Enter ↵>* |
| BOUNDARY created 1 polyline | |

For the next step, we will extrude the polyline shape just created with the **BOUNDARY** command and the original box shape. We will then copy the cabriole leg shape and use the **3DROTATE** grip tool to rotate the model to a vertical position.

| Prompt | Response |
|---|---|
| Command: | *Select the EXTRUDE icon* |
| EXTRUDE | |
| Current wire frame density: ISOLINES = 4 | |
| Select objects to extrude: | *Pick the cabriole leg profile* |
| 1 found | |
| Select objects to extrude: | *Pick the box* |
| 1 found, 2 total | |
| Select objects to extrude: | *Type: <Enter ↵>* |
| Specify height of extrusion or | |
| [Direction/Path/Taper angle]: | *Type: 5 <Enter ↵>* |

**EXTRUDE**

| | |
|---|---|
| **Ribbon/ Home tab/ 3D Model- ing/Extrude** | |
| **Menu** | Draw/ Modeling/ Extrude |
| **Toolbar: Modeling** | |
| **Command Line** | extrude |
| **Alias** | ext |

Two extruded cabriole leg profiles are needed to complete the model. We will use the **COPY** command to produce two cabriole leg shapes, with 0,0,0 as the base point and second point of displacement. By using the same base point and second point of displacement, both shapes will be located at the same location.

| Prompt | Response |
|---|---|
| Command: | *Select the COPY icon from the Menu Browser, Modify flyout (or Type: CP <Enter ↵> at the command prompt)* |
| COPY | |
| Select objects: | *Pick the leg profile* |
| 1 found | |
| Select objects: | *Type: <Enter ↵>* |
| Current settings: Copy mode = Multiple | |
| Specify base point or [Displacement /mOde] <Displacement>: | *Type: 0,0,0 <Enter ↵>* |
| Specify second point or <use first point as displacement>: | *Type: 0,0,0 <Enter ↵>* |
| Specify second point or [Exit/Undo] <Exit>: | *Type: <Enter ↵>* |

There are now two leg shapes occupying the same location. Change the view to **SW Isometric** and rotate the box and two leg shapes to a vertical position.

| Prompt | Response |
|---|---|
| Command: | Select **SW Isometric** from the **Menu Browser**, **View** menu, **3D Views** flyout |

Your drawing should appear similar to Figure 10-5.

Use the **3DROTATE** grip tool to rotate the box and leg shapes up in the +Z direction, about the X axis (see Figure 10-6).

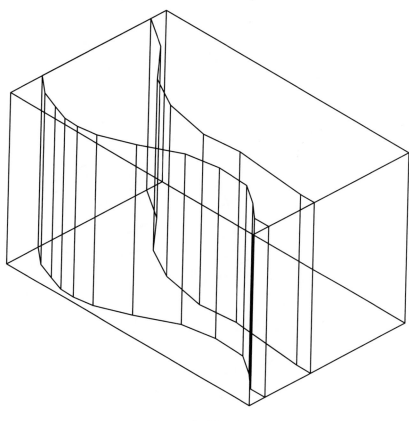

**Figure 10-5**  SW Isometric View of Box and Leg Profiles

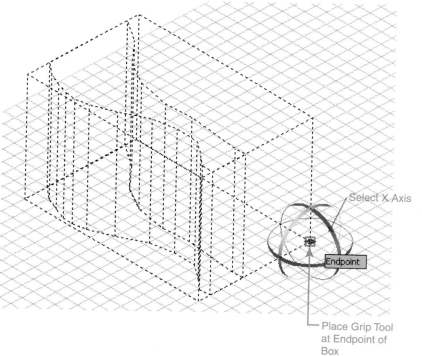

Select X Axis

Endpoint

Place Grip Tool at Endpoint of Box

**Figure 10-6**  Object Selection and **3DROTATE** Grip Tool Placement

| 3DROTATE | |
|---|---|
| **Ribbon/ Home tab/ Solid editing/ 3D Rotate** | |
| **Menu** | Modify/ 3D Opera-tions/3D Rotate |
| **Toolbar: Modeling** | |
| **Command Line** | 3drotate |

| Prompt | Response |
|---|---|
| Command: | Select the **3DROTATE** grip tool |
| Command: _3drotate | |
| Current positive angle: ANGDIR = | |
| Counterclockwise, ANGBASE = 0 | |
| Select objects: | With a crossing window (right to left), |
| Specify opposite corner: | select the box and leg components (see Figure 10-6) |
| | |
| 4 found | |
| Specify base point: | Place the grip tool at the endpoint of the bottom right corner of the box |
| | Highlight the X axis |
| Pick a rotation axis: | |
| Specify angle start point or type an angle: | Type: **90 <Enter ↵>** |

After you use the **3DROTATE** grip tool, your drawing should appear similar to Figure 10-7.

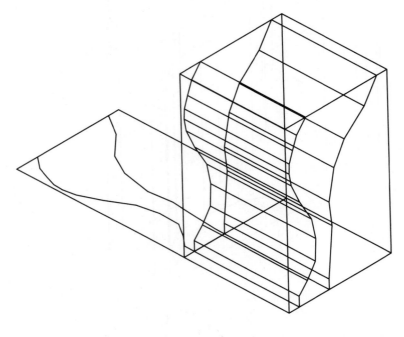

Figure 10-7    Drawing After the **3DROTATE** Command

Notice that after you rotate the model the original leg edge profiles remain at elevation 0. The leg edge profiles were necessary to create the boundary, but they are no longer needed. Erase the original leg profiles before you continue.

We now need to rotate one of the extruded leg shapes three-dimensionally to produce the crossing (intersecting) solids. We will again use the **3DROTATE** grip tool to rotate one leg shape, then use the **MOVE** command to move the rotated leg shape into the position necessary to perform the operation with the **INTERSECT** command.

| Prompt | Response |
|---|---|
| | Type: **ERASE <Enter ↵>** |
| Command: | |
| ERASE | |
| Select objects: | Pick the original leg and box polylines (see Figure 10-8) |
| | Type: **<Enter ↵>** |
| 4 found | Select the **3DROTATE** grip tool |
| Command: | |
| Command: _3drotate | |
| Current positive angle in UCS: ANGDIR = counterclockwise, ANGBASE = 0 | |
| Select objects: | Pick one leg shape |

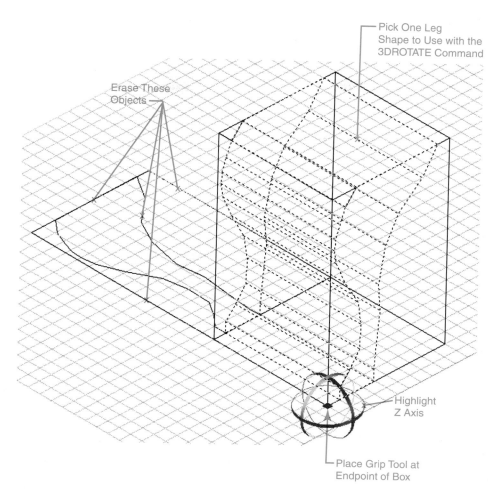

Erase These Objects

Pick One Leg Shape to Use with the 3DROTATE Command

Highlight Z Axis

Place Grip Tool at Endpoint of Box

**Figure 10-8**   Selection Set for the **ERASE** and **3DROTATE** Commands

| | |
|---|---|
| Select objects: 1 found | Type: **<Enter ↵>** |
| Specify base point: | *Place the **3DROTATE** grip tool at the front endpoint of the box* |
| Pick a rotation axis: | *Highlight the Z axis* |
| Specify angle start point or type an angle: | Type: **90 <Enter ↵>** |

Your drawing should appear similar to Figure 10-9.

Now that we have rotated one of the leg solids, we need to move the rotated leg shape back inside the box. Using the **MOVE** command with the endpoint of the leg shape as a base point and the endpoint of the box as the second point of displacement, we can move the leg shape precisely.

| Prompt | Response |
|---|---|
| Command: | Type: **m** *(move)* **<Enter ↵>** |
| MOVE | |
| Select objects: | *Pick the leg shape outside the box* |
| 1 found | *(see Figure 10-10)* |
| Select objects: | Type: **<Enter ↵>** |
| Specify base point or [Displacement] <Displacement>: | Type: **END <Enter ↵>** |
| of | *Pick the top left corner of the leg* |
| Specify second point or <use first point as displacement>: | Type: **END <Enter ↵>** |
| of | *Pick the top left corner of the box* |

**Figure 10-9** Drawing After Using the **ERASE** Command and Rotating One Leg Shape

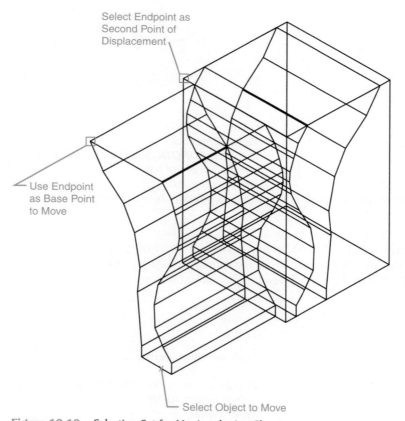

Select Endpoint as
Second Point of
Displacement

Use Endpoint
as Base Point
to Move

Select Object to Move

**Figure 10-10** Selection Set for Moving the Leg Shape

Your drawing should appear similar to Figure 10-11.

Erase the box (pick an edge of the box to erase) and use the **HIDE** command to produce a view showing the conflicting solids. The resulting hidden view should appear similar to Figure 10-12.

**Figure 10-11**    Drawing After Moving the
Leg Shape

**Figure 10-12**    Hidden View of the
Conflicting Leg Shape Solids

We have two conflicting (intersecting) solids at this point. The portion that is common to both solids is the shape that will produce the cabriole leg. Use the **INTERSECT** command to produce this shape. The **INTERSECT** command creates composite solids (or regions) from the coplanar area of two or more solids (or regions) and removes the areas outside the intersection. We could also use the **INTERFERE** command to produce a separate set of solids from the interfering solids, but in this case, the **INTERSECT** command is the more time-efficient method.

| Prompt | Response |
|---|---|
| Command: | *Select the* **INTERSECT** *icon* |
| Select objects: | *Pick the left leg shape* |
| 1 found | *(see Figure 10-13)* |
| Select objects: | *Pick the right leg shape* |
| 1 found, 2 total | |
| Select objects: | Type: **<Enter ↵>** |

After you use the **INTERSECT** command, your drawing should be similar to Figure 10-14.

To complete the conceptual cabriole leg, we need to fillet the front outside edge of the leg. Trying to select edges to fillet with the current view (Figure 10-14) would be difficult because the front edge and the back edge are aligned.

Selecting a view that is more appropriate (a view that illustrates the front outside edge) is best accomplished with the **ORBIT** command.

| Prompt | Response |
|---|---|
| Command: | Type: **ORBIT <Enter ↵>** *(or from the* **View** *menu, located on the* **Ribbon**, **Home** *tab, select* **Orbit**, **Constrained,** *and move the* **ORBIT** *icon near the center of the leg, left-click the mouse, and slowly move the cursor to rotate the view until you achieve a view similar to Figure 10-15)* |

| INTERSECT | |
|---|---|
| **Ribbon/ Home tab/ Solid editing/ Intersect** | ⬤⬤ |
| **Menu** | Modify/ Solid Editing/ Intersect |
| **Toolbar: Modeling** | ⬤⬤ |
| **Command Line** | intersect |
| **Alias** | in |

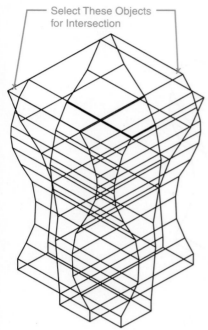

**Select These Objects for Intersection**

**Figure 10-13** Solids to Select for Using the **INTERSECT** Command

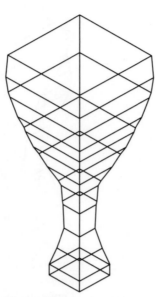

**Figure 10-14** Resulting Cabriole Leg After Using the **INTERSECT** Command

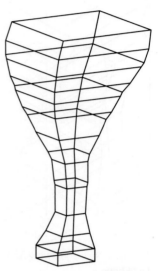

**Figure 10-15** Orbit View of the Front Edge of the Cabriole Leg

To complete the cabriole leg, use the **FILLET** command to round the front edge with a $\frac{1}{2}''$ radius (see Figure 10-16).

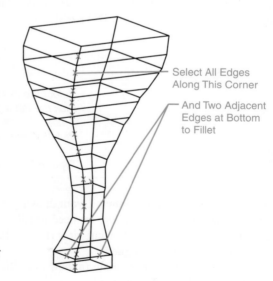

Select All Edges Along This Corner

And Two Adjacent Edges at Bottom to Fillet

**Figure 10-16** Edge Selection for the **FILLET** Command

| Prompt | Response |
|---|---|
| Command: | Type: **f <Enter ↵>** *(or select **Fillet** from the **Modify** menu on the **Ribbon, Home** tab)* |
| FILLET<br>Current settings: Mode = TRIM, Radius = 0′-0″<br>Select first object or [Undo/Polyline/<br>    Radius/Trim/Multiple]: | Type: **R <Enter ↵>** |
| Specify fillet radius <0′-0″>: | Type: **1/2 <Enter ↵>** |

| | |
|---|---|
| Select first object or [Undo/Polyline/<br>   Radius/Trim/Multiple]: | *Pick the top vertical edge (see Figure 10-16)* |
| Enter fillet radius <0'-0½">: | Type: **<Enter ↵>** |
| Select an edge or [Chain/Radius]: | *Continue picking all the vertical edges and* |
| Select an edge or [Chain/Radius]: | *the two adjacent horizontal edges* |
| Select an edge or [Chain/Radius]: | *(as shown in Figure 10-16.) Use* '**ZOOM**, *if* |
| | *necessary to zoom into the edges to select.* |
| Select an edge or [Chain/Radius]: | Type: **<Enter ↵>** |
| 14 edge(s) selected for fillet. | *(Note: The total number of edges for the* |
| | *fillet may vary; it depends on the number* |
| | *of points selected on the original polyline* |
| | *profile.)* |

The conceptual cabriole leg is now complete. Your drawing should appear similar to Figure 10-17. Using **ORBIT** and the **Visual Styles Manager**, produce a conceptual view similar to Figure 10-18 of the completed cabriole leg.

**Figure 10-17**    Wireframe View of the Completed Cabriole Leg

**Figure 10-18**    Conceptual View of the Completed Cabriole Leg

## CHAPTER EXERCISES

### Exercise 10-1: Small Table

A number of objects can be produced by projecting (extruding profiles) through a box and extracting the common mass. For example, tapered table legs can be produced with the **EXTRUDE** command with **Taper** options, but they can also be produced using the **INTERSECT** command/method utilized in the previous chapter.

In this exercise, use the same processes and commands that you used to produce the conceptual cabriole leg to produce thin tapered table legs. The table model will be 1'-1" wide, 2'-0" long, and 1'-9" high.

## DRAWING SETUP

Begin a new drawing. Set the **Units** to **Architectural, Precision** to $\frac{1}{16}$". Set the **Limits** to **0,0** and **6',4'**. Set the **Grid** to **1"**, **Snap** to $\frac{1}{2}$", and **Zoom All**.

## BEGIN DRAWING

Begin by drawing a polyline rectangle 3″ × 20″ in plan view at elevation 0. Within the rectangle, draw lines representing the profile of a tapered leg, as illustrated in Figure 10-19.

Use the **BOUNDARY** command to create a region by selecting a point inside the tapered leg profile. Use the **EXTRUDE** command to extrude the region 3″.

Change the view to **NE Isometric** either by typing **VPOINT** at the command prompt then typing **1,1,1** or by selecting **NE Isometric** from the **Menu Browser**, **View** menu, **3D Views** flyout. After extruding the tapered leg profile 3″ and changing the view to **NE Isometric**, your drawing should appear similar to Figure 10-20.

**Figure 10-19**   Rectangle with Tapered Leg Profile

**Figure 10-20**   NE Isometric View of the Tapered Leg After Extruding 3″

The original polyline box is no longer needed, so use the **ERASE** command to remove the box from the drawing. Use the **COPY** command to make a copy of the tapered leg. Place the copy of the tapered leg to the right of the original tapered leg (see Figure 10-21).

**Figure 10-21**   Original Tapered Leg Profile and the Copy

Use the **3DROTATE** grip tool to rotate the copy of the tapered leg 90° about the Y axis. Place the grip tool at the bottom endpoint farthest away from the original tapered leg profile (see Figure 10-22).

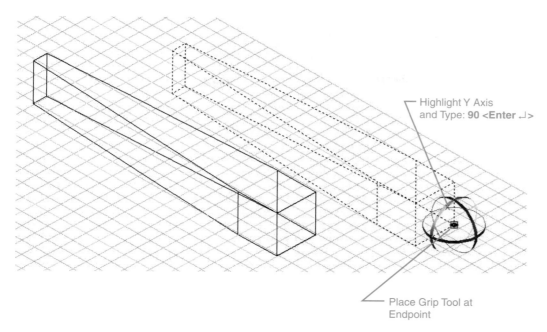

— Highlight Y Axis
and Type: **90 <Enter ⏎>**

— Place Grip Tool at
Endpoint

Figure 10-22    **3DROTATE**
Grip Tool Placement

After you rotate the copied tapered leg profile, your drawing should appear similar to Figure 10-23.

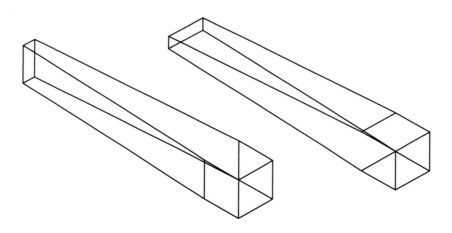

Figure 10-23    Tapered
Leg Profiles After Rotating
the Copy

Use the **MOVE** command to move the copied tapered leg so that the large ends are coplanar (see Figure 10-24). You should be able to visualize what the resulting shape will be once the **INTERSECT** command has been used. Notice that the larger (nontapered) ends of the tapered leg are the same size. The common areas of the tapered portions will form the tapered section of the leg when you remove the parts that are not common to both.

| Prompt | Response |
|---|---|
| **Command** | Type: **m** *(move)* **<Enter ⏎>** |
| MOVE | |
| Select objects: | *Pick the right leg* |
| Select objects: 1 found | Type: **<Enter ⏎>** |
| Specify base point or [Displacement] | |
| <Displacement>: | With **Osnap** on, pick the bottom left endpoint of the right leg |
| Specify second point or | |
| <use first point as displacement>: | With **Osnap** on, pick the bottom left endpoint of the left leg |

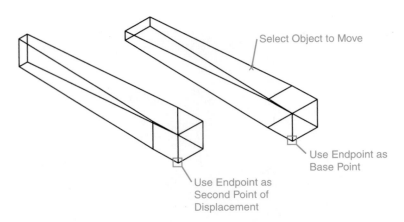

**Figure 10-24** Selection Points for the **MOVE** command

Your drawing should be similar to Figure 10-25.

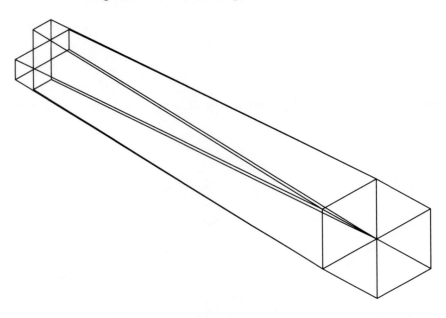

**Figure 10-25** Tapered Legs After Using the **MOVE** Command

Use the **INTERSECT** command to produce a single tapered leg from the common area of both leg shapes. After you finish using the **INTERSECT** command, your drawing should appear similar to Figure 10-26.

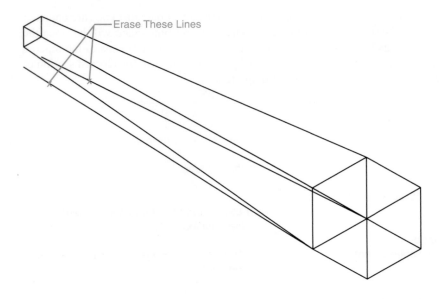

**Figure 10-26** Tapered Leg After Using the **INTERSECT** Command

The original lines drawn at elevation 0 to form the shape of the taper are no longer needed, so use the **ERASE** command to remove them from the drawing. Use the **3DROTATE** grip tool, located on the **Ribbon, Home** tab, **Modify** menu, to rotate the tapered leg 90º about the X axis (see Figure 10-27).

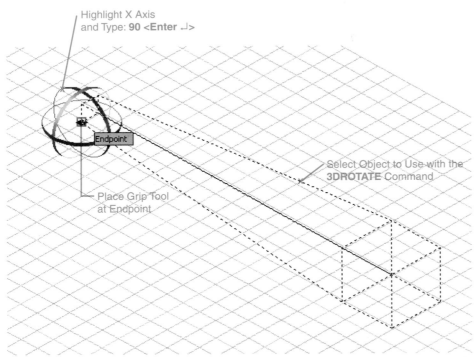

Highlight X Axis
and Type: **90 <Enter ↵>**

Endpoint

Select Object to Use with the
**3DROTATE** Command

Place Grip Tool
at Endpoint

**Figure 10-27    3DROTATE** Grip Tool Placement to Rotate the Leg

Use the **ID** command to determine the elevation of the rotated leg. The base point of the grip tool was placed at the end of the tapered portion of the leg (1″ above the XY plane), resulting in the location of the rotated leg at elevation 1″. Use the **MOVE** command (base point **0,0,0** and second point of displacement **0,0,−1**) to move the leg to elevation 0. Remember, you can also move the leg in the −Z direction with the **3DMOVE** grip tool.

Change to the **Plan** view by selecting **Plan, World UCS**, from the **Menu Browser, View** menu, **3D Views** flyout. Your drawing should appear similar to Figure 10-28.

Use the **BOX** command to create a table frame (box) that is 3″ high, 11″ deep, and 1′-10″ long. Draw the box to the side of the tapered leg (see Figure 10-29).

**Figure 10-28** Plan View of the Completed Tapered Leg

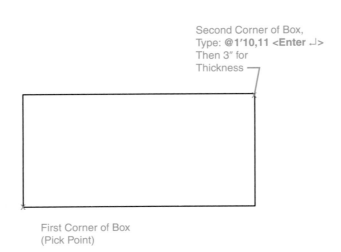

Second Corner of Box,
Type: **@1′10,11 <Enter ↵>**
Then 3″ for
Thickness

First Corner of Box
(Pick Point)

**Figure 10-29** Selection Points to Use with the **BOX** Command

Change the view to **SW Isometric**. Your drawing should appear similar to Figure 10-30.

Use the **MOVE** command to relocate the table frame box to the top of the tapered leg. Use the top corner (endpoint) of the box as the base point, and use **From**, **Endpoint** (top outside corner of the tapered leg **@1/2,1/2**) for the second point of displacement (see Figure 10-31).

After you move the table frame box, your drawing should appear similar to Figure 10-32.

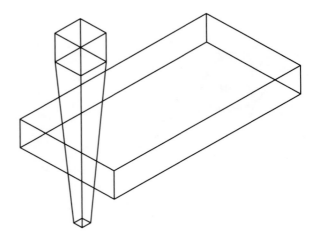

**Figure 10-30**    SW Isometric View of the Table Frame Box and Leg

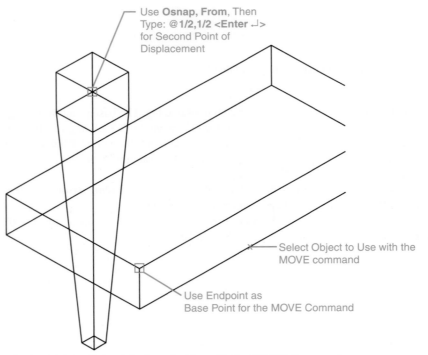

Use **Osnap, From**, Then Type: **@1/2,1/2 <Enter ↵>** for Second Point of Displacement

Select Object to Use with the MOVE command

Use Endpoint as Base Point for the MOVE Command

**Figure 10-31**    Point Selections for Use with the **MOVE** Command

Use the **COPY** command to place the other three legs at the appropriate locations. After you copy the table legs, your drawing should appear similar to Figure 10-33.

Change to the plan view to draw the tabletop box. Use the **BOX** command to draw a box representing the tabletop (see Figure 10-34). The overall dimensions of the tabletop box should be 1'-1" wide, 2'-0" long, and 1" high. Use the **MOVE** command to relocate the tabletop box to elevation 1'8" (base point **0,0,0**; second point of displacement **0,0,1'8"**) if necessary.

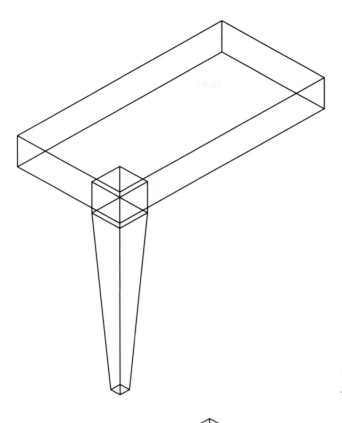

Figure 10-32    Table Frame Box After Using the **MOVE** Command

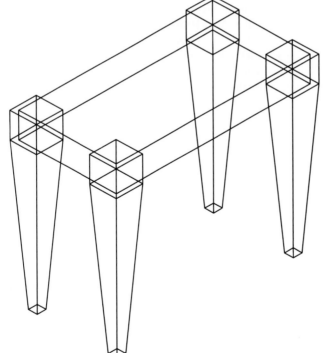

Figure 10-33    Table with Legs in Place

Figure 10-34    Selection Points for Creating the Tabletop Box with the **BOX** Command

The small table with tapered legs is now complete. With the **Visual Styles Manager**, change the visual style to **Conceptual** and use the **ORBIT** command to produce a view similar to Figure 10-35.

**Figure 10-35** Conceptual View of Completed the Table Model

## SUMMARY

In this chapter, you gained additional practice creating solids by extruding closed polyline shapes with the **EXTRUDE** command, moving objects three-dimensionally with the **MOVE** command, rotating two-dimensional objects with the **ROTATE** command, and editing solids with the **FILLET** command. You created two overlapping (coplanar) 3D solids and used the **INTERSECT** command to produce a model of a cabriole leg.

You learned that it is sometimes helpful to create a box in which to work. A number of objects can be produced by projecting (extruding profiles) through a box and extracting the common mass. Tapered table legs can be produced with the **EXTRUDE** command with **Taper** options. They can also be produced using the **INTERSECT** method.

In Chapter 11, you will complete a model of a wing chair using the **EXTRUDE**, **LOFT**, and **UNION** commands. You will also learn to use the **INSERT** command to insert one drawing into another.

## CHAPTER TEST QUESTIONS

### Multiple Choice

1. The **BOUNDARY** command can be used to create which of the following?

   a. 3D solid
   b. Open polyline
   c. Region or polyline
   d. An extruded 2D solid
   e. 2D wireframe

2. Which of the following is **not** an **Orbit** option?

   a. **Constrained**
   b. **Free**
   c. **Continuous**
   d. **Temporary**

3. Which of the following **MOVE** command coordinate entries for base point and second point of displacement, respectively, is the equivalent of using the **3D MOVE** grip tool to move an object 2′ along the Z axis only?

   a. 0,0,0; 0,0,2′
   b. 0,0,0; 0,2′,0
   c. 0,0,0; 2′,0,0
   d. 2′,0,0; 0,0,2′
   e. 0,2′,0; 2′,2′,2′

4. Which of the following is **not** a rotation axis option when you are using the **3DROTATE** grip tool?

   a. X axis
   b. XY plane
   c. Y axis
   d. Z axis

5. What is the primary purpose of the **ID** command?

   a. It tells the name of the drawing.
   b. It tells the name of the person who drew an object.
   c. It displays the coordinates of a location.
   d. It displays the name of an object's layer.
   e. It gives the user a status report on the drawing.

## Matching

**Column A**

a. **INTERSECT**

b. **ORBIT**

c. **COPY**

d. **MOVE**

e. **BOX**

**Column B**

1. Controls the interactive viewing of objects in 3D

2. Creates a 3D box

3. Creates composite solids or regions from the intersection of two or more solids or regions and removes the areas outside the intersection

4. Allows you to move objects at a specified distance and in a specified direction

5. Allows you to create duplicates of objects at a specified distance and in a specified direction

## True or False

1. T or F: You can move an object in a specified direction using only the **3DMOVE** grip tool.

2. T or F: The **INTERSECT** command gives you the option of creating a separate set of solids from two or more overlapping solids.

3. T or F: With the **3DROTATE** grip tool, you can elect to rotate objects about the Z axis.

4. T or F: The **COPY** command can be used only to copy 3D solids.

5. T or F: You can rotate 3D solids only with the **3DROTATE** grip tool.

# Wing Chair

# 11

- Practice constructing solids with the **EXTRUDE** and **LOFT** commands
- Use the **UNION** command
- Practice using the **COPY**, **MOVE** and **ROTATE** commands
- Practice using the **FILLET** command
- Practice using the **3DROTATE** and **3DMIRROR** commands
- Use the **INSERT** command
- Use the **ALIGN** command

## INTRODUCTION

In this chapter, we will use simple 3D modeling commands to draw a wing chair. As always, it is best to start with a scaled sketch of the object you plan to draw. Planning ahead saves time and increases accuracy. The cabriole leg drawn in the previous chapter will be used for the front legs on the wing chair. As in most cases, you can use a variety of drawing processes to complete a task. Determining which processes to use for a drawing task is part of the learning experience.

The processes used to produce the wing chair in this chapter will provide additional practice creating solids by extruding closed polyline shapes with the **EXTRUDE** command, moving objects three-dimensionally with the **MOVE** command, rotating objects three-dimensionally with the **3DROTATE** command, and editing solids with the **FILLET** command. We will join solids with the **UNION** command and learn to align one solid object with another solid using the **ALIGN** command.

## DRAWING SETUP

Begin a new drawing. Set the **Units** to **Architectural**, **Precision** to $\frac{1}{4}''$. Set the **Limits** to **0,0** and **8',6'**. Set the **Grid** to **2''**, and **Zoom All**.

## BEGIN DRAWING

The wing chair that we will draw in this chapter will consist of individually drawn solid components. Analyzing a model to determine which components should be drawn first and how each component should be drawn will save time and increase accuracy. It is best to start with a scaled sketch, complete with the dimensions of the object you wish to draw (see Figure 11-1).

We will begin by drawing a closed polyline profile of the chair base. Turn **ORTHO** on, and begin drawing. To ensure an easy set of coordinates to remember, use absolute coordinates to begin the polyline.

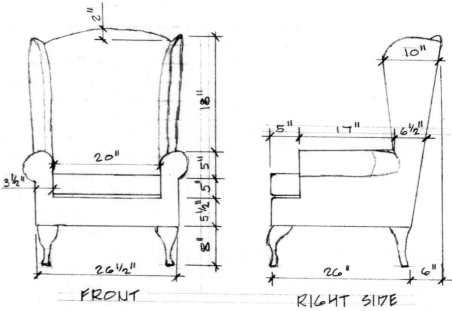

**Figure 11-1**    Scaled Sketch of the Wing Chair

**Figure 11-2**    Drawing Setup with Chair Base Profile

| **POLYLINE** | |
|---|---|
| **Ribbon/ Home tab/ Draw/ Polyline** |  |
| **Menu** | Draw/ Polyline |
| **Toolbar: Draw** |  |
| **Command Line** | pline |
| **Alias** | pl |

| **Prompt** | **Response** |
|---|---|
| Command: PLINE | *Select the **POLYLINE** icon* |
| Specify start point: Current line width is 0'-0" | *Type:* **2',2' <Enter ↵>** |
| Specify next point or [Arc/Halfwidth/ Length/Undo/Width]: | *With **ORTHO** on, push the mouse to the right and Type:* **26.5 <Enter ↵>** |
| Specify next point or [Arc/Close/ Halfwidth/Length/Undo/Width]: | *Push the mouse up and Type:* **26 <Enter ↵>** |
| Specify next point or [Arc/Close/ Halfwidth/Length/Undo/Width]: | *Push the mouse to the left and Type:* **26.5 <Enter ↵>** |
| Specify next point or [Arc/Close/ Halfwidth/Length/Undo/Width]: | *Type:* **C <Enter ↵>** *(to close the polyline)* |

Your drawing should appear similar to Figure 11-2.

We need to extrude the base profile $5\frac{1}{2}$", but before we extrude the base profile, we will use the profile lines as guidelines to draw the 5"-high vertical sections between the rounded arms and base profile.

| **Prompt** | **Response** |
|---|---|
| Command: PLINE | *Select the **POLYLINE** icon* |
| Specify start point: Base point: | *Type:* **FRO** *(from)* **<Enter ↵>** *Type:* **END** *(endpoint)* **<Enter ↵>** |
| of <Offset>: Current line width is 0'-0" | *Pick the lower left end of the base profile Type:* **@5<90 <Enter ↵>** |
| Specify next point or [Arc/Halfwidth/ Length/Undo/Width]: | *With **ORTHO** on, move the mouse to the right, and Type:* **3.5 <Enter ↵>** |
| Specify next point or [Arc/Close/ Halfwidth/Length/Undo/Width]: | *Type:* **PER** *(perpendicular)* **<Enter ↵>** |

to

| | Select the perpendicular point on the top line directly above the previous point |
|---|---|

Specify next point or [Arc/Close/
     Halfwidth/Length/Undo/Width]:

Type: **END <Enter ↵>**
*Select the top left corner of the base profile*

of
Specify next point or [Arc/Close/
     Halfwidth/Length/Undo/Width]:

Type: **C <Enter ↵>** (*to close the polyline*)

---

Use the **COPY** command to copy the polyline just created to the right side of the profile base (see Figure 11-3).

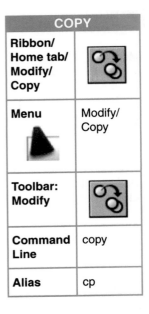

| Prompt | Response |
|---|---|
| Command:<br>COPY | *Select the COPY icon* |
| Select objects: | Type: **l** *(last)* **<Enter ↵>** *(or select the vertical arm profile)* |
| 1 found<br>Select objects: | Type: **<Enter ↵>** |
| Current settings: Copy mode = Multiple<br>Specify base point or<br>     [Displacement/mOde] <Displacement>:<br>of | Type: **END <Enter ↵>**<br>*Pick the top right end of the arm profile* |
| Specify second point or <use first<br>     point as displacement>:<br>of | Type: **END <Enter ↵>**<br>*Pick the top right end of the base profile* |
| Specify second point or [Exit/Undo] <Exit>: | Type: **<Enter ↵>** |

**COPY**

| Ribbon/<br>Home tab/<br>Modify/<br>Copy | |
|---|---|
| Menu | Modify/<br>Copy |
| Toolbar:<br>Modify | |
| Command<br>Line | copy |
| Alias | cp |

**TIP** With **Osnap** mode turned on, you can use **Osnap** to go to an endpoint rather than typing in the selection mode.

Your drawing should appear similar to Figure 11-4.

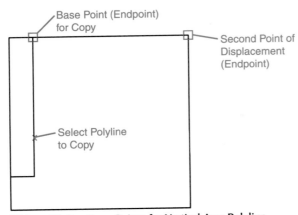

**Figure 11-3**   Copy Points for Vertical Arm Polyline

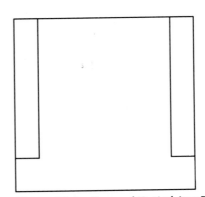

**Figure 11-4**   Base and Vertical Arm Profiles

Change from a plan view to a NE isometric view and extrude the chair base.

| Prompt | Response |
|---|---|
| Command: | *From the **Menu Browser**, **View** menu, **3D Views** flyout, select **NE Isometric*** |

The polyline profiles are currently drawn at elevation 0. We will extrude the chair base $5\frac{1}{2}''$ and the arm base profiles $7\frac{1}{2}''$. After we extrude the arm bases, we will use the **MOVE** command to move them vertically (up in the +Z direction $5\frac{1}{2}''$).

| EXTRUDE | |
|---|---|
| **Ribbon/ Home tab/ 3D Modeling/Extrude** | |
| **Menu** | Draw/ Modeling/ Extrude |
| **Toolbar: Modeling** | |
| **Command Line** | extrude |
| **Alias** | ext |

| Prompt | Response |
|---|---|
| Command: | *Select the **EXTRUDE** icon* |
| EXTRUDE | |
| Current wire frame density: ISOLINES = 4 | |
| Select objects to extrude: | *Pick the left chair arm (see Figure 11-5)* |
| 1 found | |
| Select objects to extrude: | *Pick the right chair arm* |
| 1 found, 2 total | |
| Select objects: | Type: **<Enter ↵>** |
| Specify height of extrusion or | |
| [Direction/Path/Taper angle]: | Type: **7-1/2 <Enter ↵>** |
| Command: | *Select the **EXTRUDE** icon* |
| EXTRUDE | |
| Current wire frame density: ISOLINES = 4 | |
| Select objects to extrude: | *Pick the chair base* |
| 1 found | |
| Select objects to extrude: | Type: **<Enter ↵>** |
| Specify height of extrusion or | |
| [Direction/Path/Taper angle] <0'-7$\frac{1}{2}$">: | Type: **5-1/4 <Enter ↵>** |

Your drawing should appear similar to Figure 11-6.

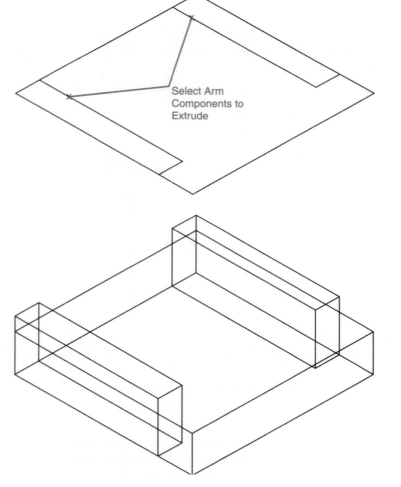

Select Arm
Components to
Extrude

**Figure 11-5**   Chair Base Polylines to Select for Extrusion

**Figure 11-6**   Chair Base Polylines After Using the **EXTRUDE** Command

We will now use the **MOVE** command to move the arm components to the top of the chair base (see Figure 11-7). Because we want to move the chair arm components up in the +Z direction only, we can use 0,0,0 as an arbitrary base point and $0,0,5\frac{1}{2}$ as the second point of displacement. You can also use the **3DMOVE** grip tool to move the chair arm components. Either method will achieve the same results. Select the **3DMOVE** grip tool, select the two chair arm components, place the grip tool at the bottom endpoint of one of the chair arm components, select the Z axis, and type **5.5"**.

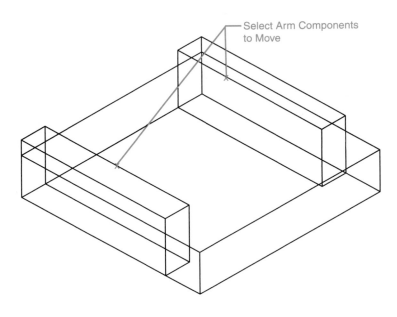

Select Arm Components to Move

**Figure 11-7**    Chair Arm Components to Move

| Prompt | Response |
|---|---|
| Command: | Type: **m** *(move)* **<Enter ↵>** |
| MOVE | |
| Select objects: | *Select the arm components* |
| 1 found | |
| Select objects: 1 found, 2 total | |
| Select objects: | Type: **<Enter ↵>** |
| Specify base point or [Displacement] <Displacement>: | Type: **0,0,0 <Enter ↵>** |
| Specify second point or <use first point as displacement> | Type: **0,0,5-1/2 <Enter ↵>** |

Your drawing should appear similar to Figure 11-8.

Now add the rounded top portions of the chair arms. Start with a 5″-diameter circle, extrude the circle 17″, rotate it three-dimensionally, copy it to the appropriate locations. Finally, use the **UNION** command to join the circular components to the box-shaped arm components.

Begin by drawing a circle with a 5″ diameter (see Figure 11-9).

| Prompt | Response |
|---|---|
| Command: | *Select the CIRCLE icon* |
| CIRCLE Specify center point for circle or [3P/2P/Ttr (tan tan radius)]: | *Pick a point in front of the chair components* |
| Specify radius of circle or [Diameter]: | Type: **D <Enter ↵>** |
| Specify diameter of circle: | Type: **5 <Enter ↵>** |
| Command: | *Select the EXTRUDE icon* |
| EXTRUDE | |
| Current wire frame density: ISOLINES = 4 | |
| Select objects to extrude: | Type: **l** *(last)* **<Enter ↵>** *(or select the circle)* |

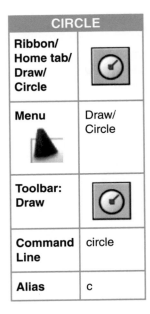

| CIRCLE | |
|---|---|
| **Ribbon/ Home tab/ Draw/ Circle** | |
| **Menu** | Draw/ Circle |
| **Toolbar: Draw** | |
| **Command Line** | circle |
| **Alias** | c |

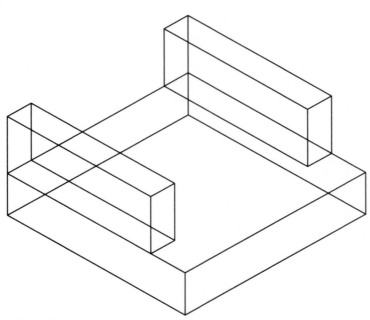

**Figure 11-8**   Arm Components After Using the **MOVE** Command

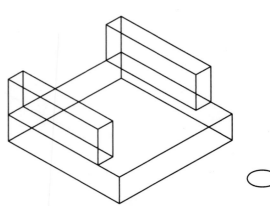

**Figure 11-9**   Circle in Front of the Chair Base Components

| | |
|---|---|
| 1 found | |
| Select objects to extrude: | Type: **<Enter ⏎>** |
| Specify height of extrusion or | |
| [Direction/Path/Taper angle] | Type: **17 <Enter ⏎>** |

Use the **3DROTATE** grip tool to rotate the extruded circle so that it is in alignment with the chair arm components (see Figure 11-10).

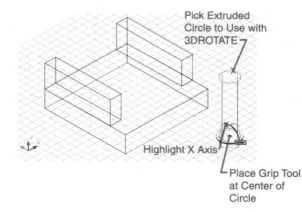

Pick Extruded Circle to Use with 3DROTATE

Highlight X Axis

Place Grip Tool at Center of Circle

**Figure 11-10**   Selection Points for the Extruded Circle Rotation

| 3DROTATE | |
|---|---|
| **Ribbon/ Home tab/ Solid editing/ 3D Rotate** | ⊕ |
| **Menu** | Modify/ 3D Opera- tions/3D Rotate |
| **Toolbar: Modeling** | ⊕ |
| **Command Line** | 3drotate |

| **Prompt** | **Response** |
|---|---|
| Command: | *Select the **3DROTATE** icon* |
| Command: _3drotate | |
| Current positive angle in UCS: | |
| ANGDIR = counterclockwise, ANGBASE = 0 | |
| Select objects: | *Pick the extruded circle* |
| Select objects: 1 found | Type: **<Enter ⏎>** |
| Specify base point: | *With **Osnap** on, place the grip at the bottom center of the extruded circle* |
| Pick a rotation axis: | *Highlight the X axis* |
| Specify angle start point or type an angle: | Type: **90 <Enter ⏎** |

Your drawing should appear similar to Figure 11-11.

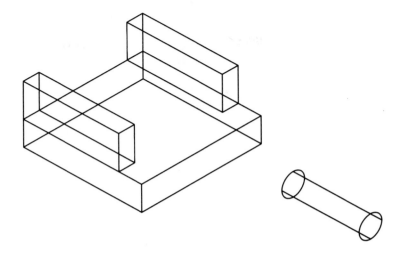

**Figure 11-11**  Drawing After Rotating the Extruded Circle

Use the **COPY** command to relocate the rounded arm components (extruded circle) to the top of the chair arm base components.

| | COPY |
|---|---|
| **Ribbon/ Home tab/ Modify/ Copy** | |
| **Menu** | Modify/ Copy |
| **Toolbar: Modify** | |
| **Command Line** | copy |
| **Alias** | cp |

| Prompt | Response |
|---|---|
| Command: | *Select the **COPY** icon* |
| COPY | |
| Select objects: | *Pick the extruded circle* |
| Select objects: 1 found | Type: **<Enter ↵>** |
| Current settings: Copy mode = Multiple | |
| Specify base point or <use first point as displacement>: | *With **Osnap** on, pick the front left center quadrant of the circle* |
| Specify second point or [Exit/Undo] <Exit>: | *With **Osnap** on, pick the inside top corner of the right chair arm component (see Figure 11-12)* |

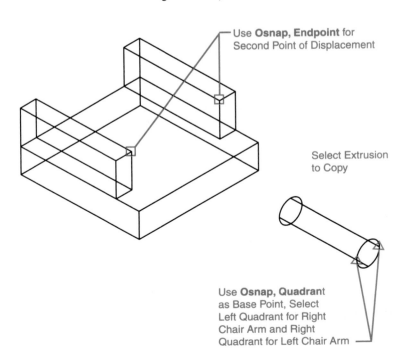

Use **Osnap, Endpoint** for Second Point of Displacement

Select Extrusion to Copy

Use **Osnap, Quadrant** as Base Point, Select Left Quadrant for Right Chair Arm and Right Quadrant for Left Chair Arm

**Figure 11-12**  Selection Points for Copying the Circular Chair Arm Components

| Command: | Select the **COPY** icon (or Type: **<Enter ↵>** to repeat the command) |
| --- | --- |
| COPY | |
| Select objects: | Pick the extruded circle |
| Select objects: 1 found | Type: **<Enter ↵>** |
| Current settings: Copy mode = Multiple | |
| Specify base point or <use first point as displacement>: | With **Osnap** on, pick the front right center quadrant of the circle |
| Specify second point or [Exit/Undo] <Exit>: | With **Osnap** on, pick the inside top corner of the left chair arm component |
| Specify second point or [Exit/Undo] <Exit>: | Type: **<Enter ↵>** |

The original extruded circle is no longer needed. Use the **ERASE** command to remove it from the drawing.

| Prompt | Response |
| --- | --- |
| Command: | Type: **e** *(erase)* **<Enter ↵>** |
| ERASE | |
| Select objects: | Pick the original extruded circle |
| 1 found | |
| Select objects: | Type: **<Enter ↵>** |

Your drawing should appear similar to Figure 11-13.

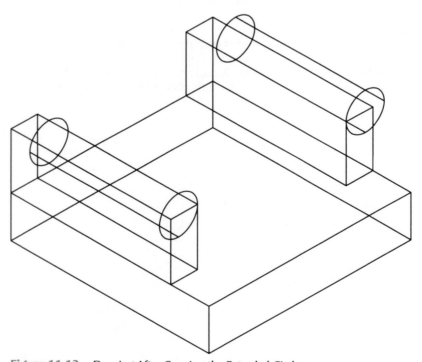

**Figure 11-13**   Drawing After Copying the Extruded Circles

Change to plan view (**VPOINT**, then **0,0,1**, or select **Plan**, **World UCS** from the **Menu Browser**, **View** menu, **3D Views** flyout to draw the line profile for the chair back. Follow the next set of instructions.

| Prompt | Response |
|--------|----------|
| Command: | Type: **l** *(line)* **<Enter ↵>** |
| LINE Specify first point: | Type: **5',4' <Enter ↵>** |
| Specify next point or [Undo]: | Type: **@26-1/2<0 <Enter ↵>** *(or with **Ortho** on, move the mouse in the appropriate direction and type in the distance)* |
| Specify next point or [Undo]: | Type: **@31-1/2<90 <Enter ↵>** |
| Specify next point or [Close/Undo]: | Type: **@26-1/2<180 <Enter ↵>** |
| Specify next point or [Close/Undo]: | Type: **C <Enter ↵>** |

Draw a 2″ line from the midpoint of the top line of the rectangle to use as the second point of an arc.

| Prompt | Response |
|--------|----------|
| Command: | Type: **l <Enter ↵>** |
| LINE Specify first point: | Type: **MID <Enter ↵>** |
| of | *Select the midpoint of the top line of the rectangle (see Figure 11-14)* |
| Specify next point or [Undo]: | Type: **@2<90 <Enter ↵>** |
| Specify next point or [Undo]: | Type: **<Enter ↵>** |

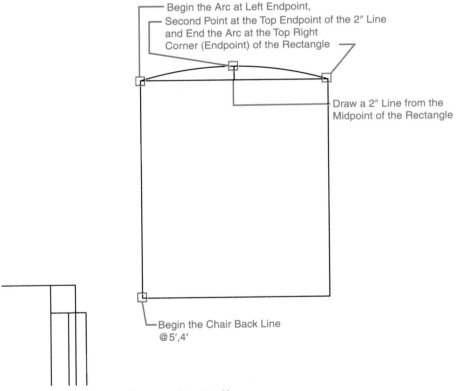

Begin the Arc at Left Endpoint,
Second Point at the Top Endpoint of the 2″ Line
and End the Arc at the Top Right
Corner (Endpoint) of the Rectangle

Draw a 2″ Line from the
Midpoint of the Rectangle

Begin the Chair Back Line
@5',4'

**Figure 11-14**    Chair Back Line and Arc Profiles

On your own, draw an arc beginning at the top left corner of the rectangle, use the top endpoint of the 2″ line as the second point of the arc, and end the arc at the endpoint of the top right corner of the rectangle.

Erase the top rectangle line and the vertical 2″ line used as guidelines for the arc. Then, use the remaining three sides of the rectangle and the arc to produce a boundary for the chair back extrusion.

| Prompt | Response |
|---|---|
| Command: | Type: **e <Enter ↵>** |
| ERASE | |
| Select objects: | *Pick the top line of the rectangle* |
| 1 found | |
| Select objects: 1 found, | *Pick the 2" vertical line* |
| 2 total | |
| Select objects: | Type: **<Enter ↵>** |
| Command: | Type: **BOUNDARY <Enter ↵>** |
| Pick internal point: Selecting everything. . . | *Select **Pick Points** in the **Boundary** dialog box* |
| Selecting everything visible. . . | |
| Analyzing the selected data. . . | |
| Analyzing internal islands. . . | |
| Pick internal point: | *Pick a point inside the chair back shape* |
| BOUNDARY created 1 polyline | |

Your chair back shape should appear similar to Figure 11-15.

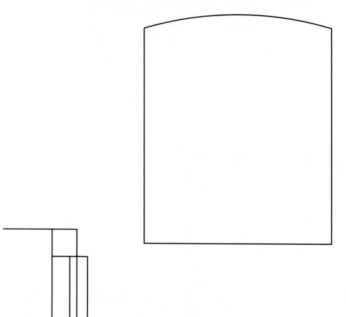

**Figure 11-15** Completed Polyline Shape for the Chair Back

Follow the instructions below. Extrude the chair back 3″. Then, change the view to **NE Isometric** to see the results of the extrusion.

| Prompt | Response |
|---|---|
| Command: | *Select the **EXTRUDE** icon* |
| EXTRUDE | |
| Current wire frame density: ISOLINES = 4 | |
| Select objects to extrude: | Type: **l** *(last)* **<Enter ↵>** *(or select the chair back polyline)* |
| 1 found | |
| Select objects to extrude: | Type: **<Enter ↵>** |
| Specify height of extrusion or | |
| [Direction/Path/Taper angle]: | Type: **3 <Enter ↵>** |
| Command: | *Select **NE Isometric** from the **View** pull-down menu, **3D Views** flyout* |

Your drawing should be similar to Figure 11-16.

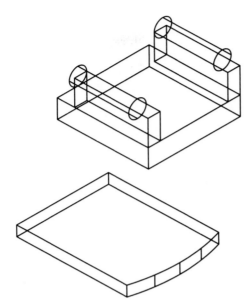

**Figure 11-16**  NE Isometric View of the Extruded Chair Back

The chair back needs to be rotated three-dimensionally, then moved into position.

| Prompt | Response |
|---|---|
| Command: | Type: **3DROTATE <Enter ↵>** |
| Current positive angle: ANGDIR = Counterclockwise, ANGBASE = 0 | |
| Select objects: | *Pick the chair back* |
| 1 found | |
| Select objects: | Type: **<Enter ↵>** |
| Specify first point on axis or define axis by [Object/Last/View/Xaxis/ Yaxis/Zaxis/2points]: | Type: **X <Enter ↵>** |
| Specify a point on the X axis <0,0,0>: | Type: **END <Enter ↵>** |
| of | *Select a bottom corner of the square end of the chair back* |
| Specify rotation angle or [Reference]: | Type: **80 <Enter ↵>** |

Your drawing should appear similar to Figure 11-17.

Follow the instructions below and refer to Figure 11-18. Move the chair back to the chair base. After moving the chair back, erase the original lines for the chair back profile.

| Prompt | Response |
|---|---|
| Command: | *Select **Move** from the **Ribbon**, **Home** tab, **Modify** menu* |
| MOVE | |
| Select objects: | *Select the chair back* |
| 1 found | |
| Select objects: | Type: **<Enter ↵>** |
| Specify base point or [Displacement] <Displacement>: | Type: **END <Enter ↵>** |
| of | *Select the bottom corner of the chair back (see Figure 11-18)* |

**Note:**
Remember, you can also use the **3DROTATE** grip tool to rotate objects three-dimensionally. For the previous operation, select the chair back polyline to rotate. Place the grip tool at the bottom square corner endpoint of the chair back, highlight the X axis, and type in 80 for the angle of rotation.

**Figure 11-17**   Chair Back After Using the
**3DROTATE** Command

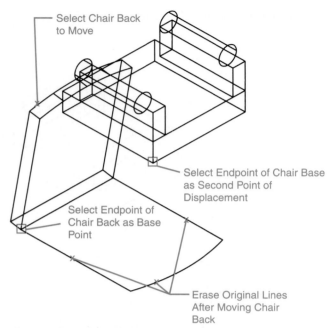

**Figure 11-18**   Selection Set for Moving Chair Back

| | |
|---|---|
| Specify second point or <use first point as displacement>: | *With **Osnap**, **Endpoint**, select the bottom left end of the chair base* |
| Command: | *Select **ERASE** from the **Modify** menu located on the **Ribbon**, **Home** tab* |
| ERASE Select objects: Specify opposite corner: 4 found Select objects: | *Pick the original chair back profile lines* Type: **<Enter ↵>** |

Your drawing should appear similar to Figure 11-19.

At this point, we need to refine the chair arm shapes. If you look closely at the chair arm components (the cylindrical top component and the rectangular chair arm base component), you will notice that the transition between the two is not smooth (see Figure 11-20). We need to develop a solid with a shape that will serve as a transition between the two profiles. One option is to use the **LOFT** command. The **LOFT** command allows you to create 3D solids or surfaces by drawing a solid or surface through a set of two or more cross-section curves. We will begin by

**Figure 11-19**   Chair Back Moved into Position

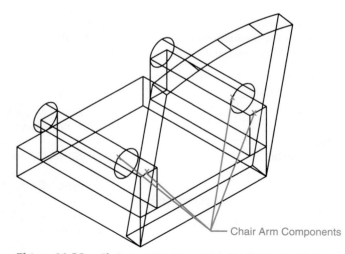

**Figure 11-20**   Chair Arm Components to Transition Between

drawing the two profiles that we need to transition between and a path to connect the profiles. Change to a NE isometric view (**VPOINT 1,1,1**, or **View/3D Views/NE Isometric**) to begin.

| Prompt | Response |
|---|---|
| Command: | *From the **Draw** menu, select **Circle/Circle**, **Diameter*** |
| CIRCLE Specify center point for circle or [3P/2P/Ttr (tan tan radius)]: | *Pick a point to the left of the chair (see Figure 11-21)* |
| Specify radius of circle or [Diameter]: _d Specify diameter of circle: | Type: **5 <Enter ↵>** |
| Command: | Type: **cp** *(copy)* **<Enter ↵>** |
| COPY | |
| Select objects: | Type: **l** *(last)* **<Enter ↵>** *(or pick the circle)* |
| 1 found | |
| Select objects: | Type: **<Enter ↵>** |
| Current settings: Copy mode = Multiple | |
| Specify base point or [Displacement/mOde] <Displacement>: | Type: **0,0,0 <Enter ↵>** |
| Specify second point or <use first point as displacement>: | Type: **0,0,4 <Enter ↵>** |
| Specify second point or [Exit/Undo] <Exit>: | Type: **<Enter ↵>** |

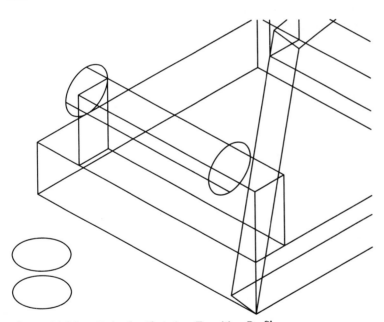

**Figure 11-21**    Circles for Chair Arm Transition Profile

The circle located at elevation 4″ will serve as the top profile of the transition shape. The circle located at elevation 0″ will be used as a guide to draw the profile shape at the back of the chair arm. Zoom in closely around the two circles and with **ORTHO** on, begin drawing the guidelines as shown in Figure 11-22.

| Prompt | Response |
|---|---|
| Command: | *Select the **LINE** icon* |
| LINE Specify first point: | *With **Osnap** on, pick the right center quadrant of the bottom circle (see Figure 11-22)* |
| Specify next point or [Undo]: | Type: **@3.5<0 <Enter ↵>** |
| Specify next point or [Undo]: | *Draw the line (up and left) past the circle* |
| Specify next point or [Close/Undo]: | Type: **<Enter ↵>** |

| LINE | |
|---|---|
| **Ribbon/ Home tab/ Draw/ Line** | |
| **Menu** | Draw/ Line |
| **Toolbar: Draw** | |
| **Command Line** | line |
| **Alias** | l |

| TRIM | |
|---|---|
| **Ribbon/ Home tab/ Modify/ Trim** |  |
| **Menu** | Modify/ Trim |
| **Toolbar: Modify** | |
| **Command Line** | trim |
| **Alias** | tr |

| ARC | |
|---|---|
| **Ribbon/ Home tab/ Draw/ Arc** | |
| **Menu** | Draw/Arc 3 Points |
| **Toolbar: Draw** | |
| **Command Line** | arc |
| **Alias** | a |

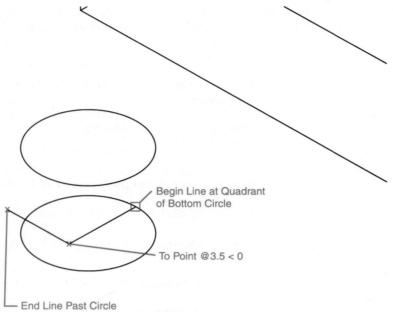

Begin Line at Quadrant of Bottom Circle

To Point @3.5 < 0

End Line Past Circle

**Figure 11-22**     Guidelines for Bottom Circle Profile

On your own, use the **TRIM** command to trim the bottom circle profile as illustrated in Figure 11-23. The **TRIM** command allows you to trim objects at a cutting edge defined by other objects.

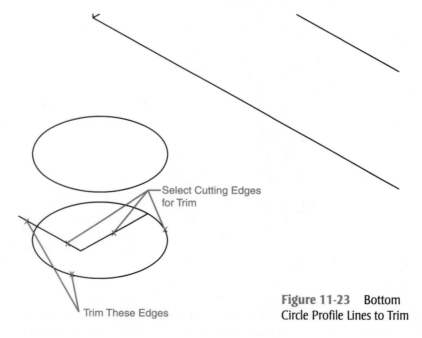

Select Cutting Edges for Trim

Trim These Edges

**Figure 11-23**     Bottom Circle Profile Lines to Trim

After trimming the bottom circle lines, your drawing should appear similar to Figure 11-24. We need to draw an arc to complete the bottom profile.

| **Prompt** | **Response** |
|---|---|
| Command: | *Select the **ARC** icon* |
| Specify start point of arc or [Center]: | *With **Osnap** on, pick the endpoint of the left line (see Figure 11-25)* |
| Specify second point of arc or [Center/End]: | *Pick the intersection of the two lines* |
| Specify end point of arc: | *Pick the right endpoint of the right line* |

Figure 11-24    Bottom Circle Profile After Trimming

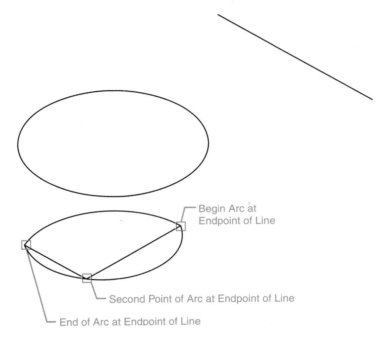

Begin Arc at Endpoint of Line

Second Point of Arc at Endpoint of Line

End of Arc at Endpoint of Line

Figure 11-25    Selection Points for Use with the **ARC** Command

We will erase the original lines in the center of the bottom profile shape and create a closed polyline with the **BOUNDARY** command in the bottom profile shape. Then, we will draw a 3D polyline from the bottom shape to the right quadrant of the top circle, as illustrated in Figure 11-26.

TIP    The **3DPOLY** command creates a polyline of line segments in 3D space.

| | ERASE |
|---|---|
| **Ribbon/ Home tab/ Modify/ Erase** | |
| **Menu** | Modify/ Erase |
| **Toolbar: Modify** | |
| **Command Line** | erase |
| **Alias** | e |

| Prompt | Response |
|---|---|
| Command: | *Select the **ERASE** icon* |
| ERASE | |
| Select objects: | *Pick the original lines* |
| 1 found | |
| Select objects: 1 found, 2 total | |
| Select objects: | Type: **<Enter ↵>** |

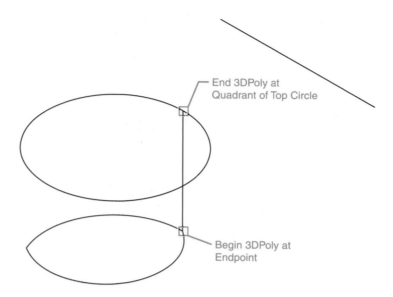

**End 3DPoly at Quadrant of Top Circle**

**Begin 3DPoly at Endpoint**

**Figure 11-26** Completed Transitional Chair Arm Profiles

| | |
|---|---|
| Command: | Type: **BOUNDARY <Enter ↵>** *(or select the* **Boundary** *icon from the* **Ribbon**, **Home** *tab,* **Draw** *menu flyout)* |
| Pick internal point: Selecting everything. . . | *Use the* **Pick Points** *option in the dialog* |
| Selecting everything visible. . . | *box* |
| Analyzing the selected data. . . | |
| Analyzing internal islands. . . | |
| Pick internal point: | *Pick a point inside the bottom profile* |
| Pick internal point: | Type: **<Enter ↵>** |
| BOUNDARY created 1 polyline | |

| Prompt | Response |
|---|---|
| Command: | Type : **3DPOLY <Enter ↵>** |
| Specify start point of polyline: | *With* **Osnap** *on, pick the right endpoint of the bottom profile (see Figure 11-26)* |
| Specify endpoint of line or [Undo]: | *With* **Osnap** *on, pick the quadrant of the top circle directly above the bottom circle endpoint* |
| Specify endpoint of line or [Undo]: | Type: **<Enter ↵>** |

We can now use the **LOFT** command to produce the solid shape for use in transitioning between the circular arm piece and the chair wing.

| Prompt | Response |
|---|---|
| Command: | *Select the* **LOFT** *icon* |
| Select cross sections in lofting order: | *Pick the bottom profile* |
| 1 found | |
| Select cross sections in lofting order: | *Pick the top circle* |
| 1 found, 2 total | |
| Select cross sections in lofting order: | Type: **<Enter ↵>** |
| Enter an option [Guides/Path/Cross | |
| sections only] <Cross sections only>: | Type: **P <Enter ↵>** |
| Select path curve: | *Pick the* **3DPOLY** *line* |

| LOFT | |
|---|---|
| **Ribbon/ Home tab/ 3D Modeling/Loft** | |
| **Menu** | Draw/ Modeling/ Loft |
| **Toolbar: Modeling** | |
| **Command Line** | loft |

Use the **HIDE** command to produce a hidden view. Your transitional chair arm piece should appear similar to Figure 11-27.

Regenerate the drawing to return to a wireframe view before proceeding. We will use the **3DROTATE** and **MOVE** commands to position the transition arm piece to complete the chair arm. To make the process of moving the transitional chair arm piece easy, use the **3DROTATE** command (see Figure 11-28) to rotate it so that it is located in the correct alignment position relative to the circular chair arm component. Then, use the **MOVE** command to place the transitional chair arm piece at the end of the circular chair arm component.

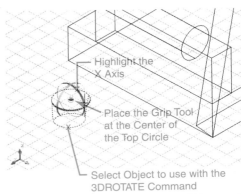

Figure 11-27    Hidden View of the Completed Transitional Chair Arm Piece

Figure 11-28    **3DROTATE** Grip Tool Placement

| Prompt | Response |
|---|---|
| Command: | *Select the **3DROTATE** grip tool from the **Ribbon**, **Home** tab, **Modify** menu* |
| Command: _3drotate<br>Current positive angle in UCS:<br>ANGDIR = counterclockwise, ANGBASE = 0<br>Select objects<br>Select objects: 1 found<br>Specify base point:<br>Pick a rotation axis:<br>Specify angle start point or type an angle: | *Pick the transitional arm piece*<br>*Type: **<Enter ↲>***<br>*Place the grip tool at the center of the top circle*<br>*Highlight the X axis*<br>*Type: **90 <Enter ↲>*** |

Your drawing should appear similar to Figure 11-29. Notice that the original shape and path were not rotated. After the **MOVE** command, these can be erased.

| Prompt | Response |
|---|---|
| Command: | *Select the **3DMOVE** icon from the **Ribbon**, **Home** tab, **Modify** menu* |
| Command: _3dmove<br>Select objects: | *Pick the transitional chair arm piece (see Figure 11-30)*<br>*Type: **<Enter ↲>*** |
| Select objects: 1 found<br>Specify base point or [Displacement]<br>    <Displacement>: | *With **Osnap** on, pick the center of the transitional arm piece circle* |
| Specify second point or<br>    <use first point as displacement>: | *With **Osnap** on, pick the center of the chair arm circle* |

**Figure 11-29** Transitional Chair Arm Piece After Using the **3DROTATE** Command

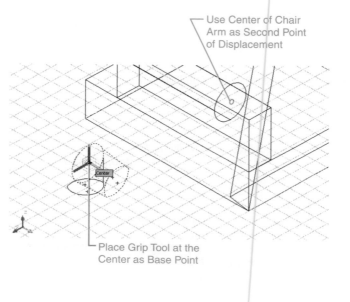

Use Center of Chair Arm as Second Point of Displacement

**Figure 11-30** Object Selection and Grip Tool Placement for the **3DMOVE** Command

Place Grip Tool at the Center as Base Point

Your drawing should appear similar to Figure 11-31.

Use the **3DMIRROR** command to produce the left chair transitional arm piece (see Figure 11-32).

| Prompt | Response |
|---|---|
| Command: | Type: **3DMIRROR <Enter ↵>** |
| Select objects: | *Pick the transitional arm piece* |
| 1 found | |
| Select objects: | Type: **<Enter ↵>** |
| Specify first point of mirror plane (3 points) or [Object/Last/Zaxis/View/ XY/YZ/ZX/3points] <3points>: | Type: **YZ <Enter ↵>** |
| Specify point on YZ plane <0,0,0>: | *With **Osnap** on, pick the midpoint of the chair base* |
| Delete source objects? [Yes/No] <N>: | Type: **<Enter ↵>** |

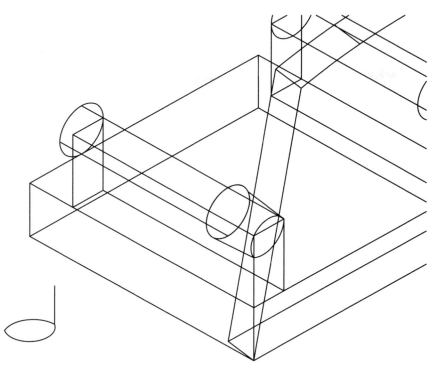

**Figure 11-31**    Chair Arm After Using the **3DMOVE** Command

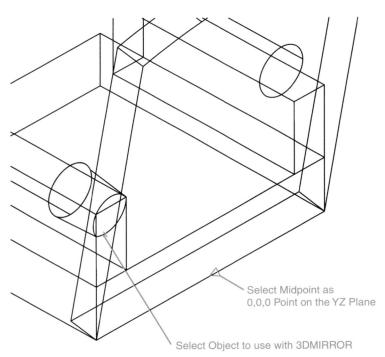

Select Midpoint as
0,0,0 Point on the YZ Plane

Select Object to use with 3DMIRROR

**Figure 11-32**    Selection Points for Use with the **3DMIRROR** Command

Your drawing should appear similar to Figure 11-33.

The next step will be to draw the wings for the chair back. We will follow a process similar to the one we used to draw the chair back. To begin, change to the plan view either by typing **PLAN** at the command prompt and pressing **<Enter ↲>** or by selecting **Plan**, **World UCS** from the **Menu Browser**, **View** menu, **3D Views** flyout.

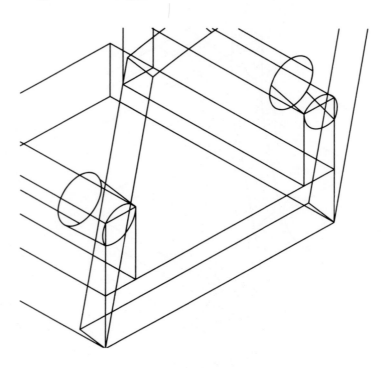

Figure 11-33    Chair Arms
After Using the **3DMIRROR**
Command

| Prompt | Response |
|---|---|
| Command: | Select the **POLYLINE** icon |
| PLINE | |
| Specify start point: | Pick a point to the right of the chair (see Figure 11-34) |
| | |
| Current line width is 0'-0" | |
| Specify next point or [Arc/Halfwidth/Length/Undo/Width]: | Type: **@6.5<0 <Enter ↵>** (with **Ortho** on, move the mouse in the appropriate direction and type in the desired distance) |
| | |
| Specify next point or [Arc/Close/Halfwidth/Length/Undo/Width]: | Type: **@20<90 <Enter ↵>** |

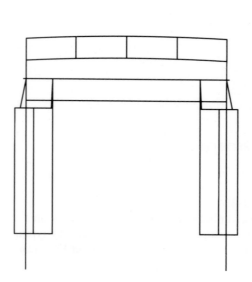

Figure 11-34    Completed
Chair Wing Profile

| Specify next point or [Arc/Close/Halfwidth/ Length/Undo/Width]: | Type: **@10<180 <Enter ↵>** |
| Specify next point or [Arc/Close/Halfwidth/ Length/Undo/Width]: | Type: **C <Enter ↵>** *(to close the polyline)* |

On your own, use the **FILLET** command with a 5″ radius to round the top left corner of the chair wing profile. After the **FILLET** command, your drawing should appear similar to Figure 11-34.

Change to a NE isometric view (**VPOINT**, then **1,1,1**, or select **NE Isometric** from the **Menu Browser**, **View** menu, **3D Views** flyout) and use the **EXTRUDE** command to give the chair wing a 2″ thickness.

| Prompt | Response |
|---|---|
| Command: | Select the **EXTRUDE** icon |
| EXTRUDE | |
| Current wireframe density: ISOLINES = 4 | |
| Select objects to extrude: | *Pick the chair wing* |
| 1 found | |
| Select objects to extrude: | Type: **<Enter ↵>** |
| Specify height of extrusion or [Direction/Path/Taper angle]: | Type: **2 <Enter ↵>** |

Using the **3DROTATE** command, we will rotate the chair wing two times, the first time to move the wing to a vertical position, and the second time to open the wings slightly so that they are wider at the front than at the chair back when we move them into position.

| Prompt | Response |
|---|---|
| Command: | Select the **3DROTATE** grip tool |
| Command: _3drotate | |
| Current positive angle in UCS: | |
| ANGDIR = counterclockwise, ANGBASE = 0 | |
| Select objects: | *Pick the chair wing* |
| Select objects: 1 found | Type: **<Enter ↵>** |
| Specify base point: | *Place the grip tool at the bottom outside endpoint of the wing (see Figure 11-35)* |
| Pick a rotation axis: | *Highlight the X axis* |
| Specify angle start point or type an angle: | Type: **90 <Enter ↵>** |

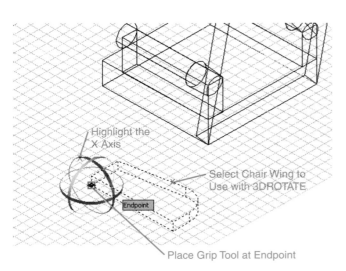

Highlight the X Axis

Select Chair Wing to Use with 3DROTATE

Endpoint

Place Grip Tool at Endpoint

**Figure 11-35**    Object Selection and **3DROTATE** Grip Tool Placement

Your drawing should appear similar to Figure 11-36.

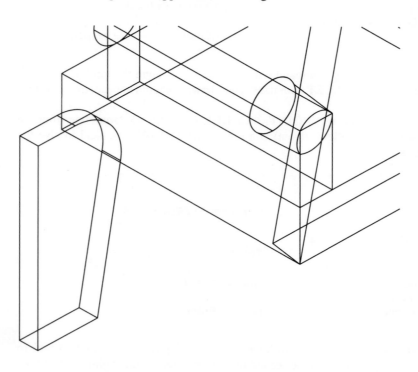

**Figure 11-36**    Chair Wing
After Using the **3DROTATE**
Command the First Time

The second rotation of the chair wing will be about the Z axis. Rotating the wing about the Z axis will make aligning the wing to the chair back easier.

| Prompt | Response |
|---|---|
| Command: | *Select the **3DROTATE** grip tool* |
| Command: _3drotate | |
| Current positive angle in UCS: | |
| ANGDIR = counterclockwise, ANGBASE = 0 | |
| Select objects: | *Pick the chair wing (see Figure 11-37)* |
| Select objects: 1 found | Type: **<Enter ↵>** |
| Specify base point: | *Place the grip tool on the chair wing endpoint as illustrated* |
| Pick a rotation axis: | *Highlight the Z axis* |
| Specify angle start point or type an angle: | Type: **95 <Enter ↵>** |

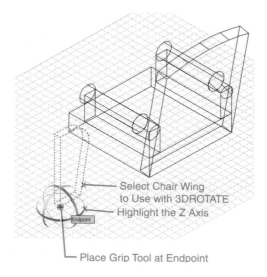

Select Chair Wing
to Use with 3DROTATE

Highlight the Z Axis

Place Grip Tool at Endpoint

**Figure 11-37**    Object Selection
and **3DROTATE** Grip Tool Placement

Your drawing should appear similar to Figure 11-38.

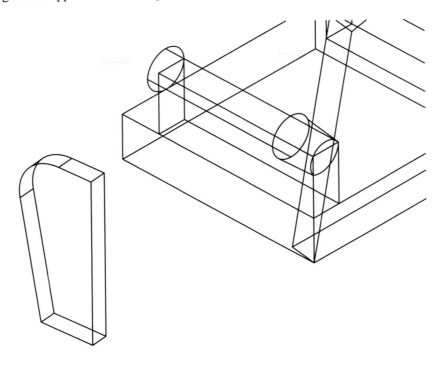

Figure 11-38    Chair Wing After Using the **3D ROTATE** Command the Second Time

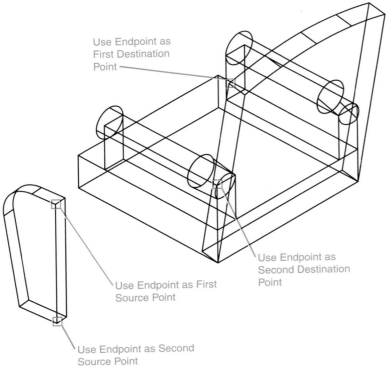

Use Endpoint as First Destination Point

Use Endpoint as Second Destination Point

Use Endpoint as First Source Point

Use Endpoint as Second Source Point

Figure 11-39    Source and Destination Points for the Wing Alignment

**Note:**
The **ALIGN** command allows you to align objects with other objects in 2D and 3D.

We will now use the **ALIGN** command to move the chair wing into the appropriate position (see Figure 11-39).

| Prompt | Response |
|---|---|
| Command: | Type: **ALIGN <Enter ↵>** |
| Select objects: | *Pick the chair wing* |

1 found
Select objects:                                          Type: **<Enter ↵>**
Specify first source point:                              *Pick the top outside end point (**Osnap**,*
of                                                       ***Endpoint**) of the chair wing (see*
                                                         *Figure 11-39)*

Specify first destination point:                         *Pick the top outside front endpoint of the*
                                                         *chair back*

Specify second source point:                             *Pick the bottom outside endpoint of the*
                                                         *chair wing*

Specify second destination point:                        *Pick the top outside corner (endpoint) of the*
                                                         *rectangular chair arm component*

Specify third source point or <continue>:                Type: **<Enter ↵>**
Scale objects based on
  alignment points? [Yes/No] <N>:                        Type: **Y <Enter ↵>**

| UNION | |
|---|---|
| **Ribbon/ Home tab/ Solid editing/Union** | 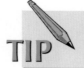 |
| **Menu** | Modify/ Solid Editing/ Union |
| **Toolbar: Modeling** | |
| **Command Line** | union |
| **Alias** | uni |

After moving the chair wing with the **ALIGN** command, your drawing should appear similar to Figure 11-40. On your own, use the **MIRROR3D** command and produce the opposite chair wing.

**TIP** For this **3DMIRROR** operation, use a midpoint on the chair base as the 0,0,0 point on the YZ axis.

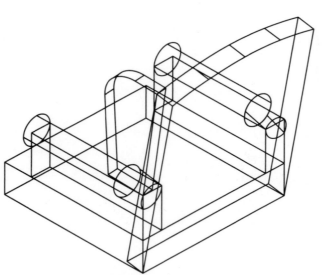

**Figure 11-40**   Chair Wing After Moving It with the **ALIGN** Command

**Figure 11-41**   Completed Chair Wings After Using the **3DMIRROR** Command

Your drawing should appear similar to Figure 11-41.

Change the view to **SW Isometric** by selecting the **View** menu, **3D Views** flyout, located on the **Menu Browser**. Your drawing should appear similar to Figure 11-42. Use the **HIDE** command to hide the lines in the current view. Your drawing should now appear similar to Figure 11-43.

The hidden line view of the chair illustrates the need to solve some problems with overlapping solids. We will use the **UNION** command to join all the existing chair components.

**Figure 11-42**   Wireframe SW Isometric View

**Figure 11-43**   Hidden Line Isometric View

| Prompt | Response |
|---|---|
| Command: | *Select the **UNION** icon* |
| Select objects: | *With a crossing window, select all chair components* |
| | |
| Specify opposite corner: 10 found | |
| Select objects: | Type: **<Enter ↵>** |

After you use the **UNION** command, use the **HIDE** command. Your drawing should appear similar to Figure 11-44.

We can now begin to make the chair look more realistic. We will use the **FILLET** command with a radius of 1″ to soften (round) some of the edges. Select a **2D Wireframe** view with the **Visual Styles Manager** and proceed using the **FILLET** command.

| Prompt | Response |
|---|---|
| Command: | *Select the **FILLET** icon* |
| FILLET | |
| Current settings: Mode = TRIM, Radius = 0′-5″ | |
| Select first object or [Undo/Polyline/ Radius/Trim/Multiple]: | Type: **R <Enter ↵>** |
| Specify fillet radius <0′-5″>: | Type: **1 <Enter ↵** |
| Select first object or [Undo/Polyline/ Radius/Trim/Multiple]: | *Pick one of the edges as illustrated in Figure 11-45* |
| Enter fillet radius <0′-1″>: | Type: **<Enter ↵>** |
| Select an edge or [Chain/Radius]: | *With **Osnap** off, select the 12 edges* |
| Select an edge or [Chain/Radius]: | Type: **<Enter ↵>** |
| 12 edge(s) selected for fillet | |

| FILLET | | |
|---|---|---|
| **Ribbon/ Home tab/ Modify/ Fillet** | | |
| **Menu** | Modify/ Fillet | |
| **Toolbar: Modify** | | |
| **Command Line** | fillet | |
| **Alias** | f | |

**Figure 11-44**    Hidden Line View
of the Chair After Using the **UNION**
and the **HIDE** Commands

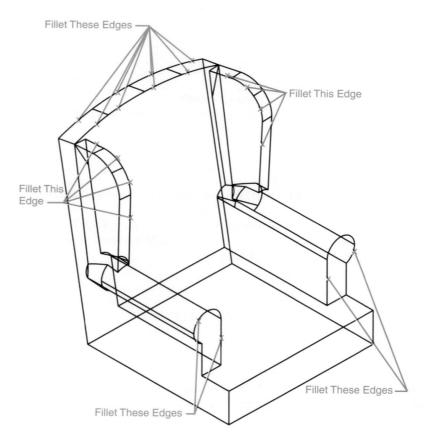

Fillet These Edges

Fillet This Edge

Fillet This
Edge

Fillet These Edges

Fillet These Edges

Note:  More or Fewer Edges
       May Need to Be Filleted.
       Visually Select Until All
       Edges Indicated Have Been
       Highlighted. Fillet One Section
       or Component at a Time.

**Figure 11-45**    Edge Selection for **FILLET** Command

Use the **HIDE** command. Your drawing should be similar to Figure 11-46.

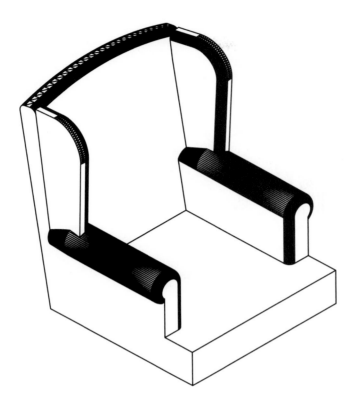

**Figure 11-46**    Hidden View of the Chair After Using the **FILLET** Command

The body of the chair is complete. We need to add the seat cushion and legs. We will draw the seat cushion first using the **POLYLINE** command. For this step, change to the plan view by selecting **PLAN**, **World UCS**, from the **Menu Browser**, **View** menu, **3D Views** flyout. **Zoom All**. Follow the next set of instructions.

| Prompt | Response |
|---|---|
| Command: | Select the **POLYLINE** icon |
| PLINE | |
| Specify start point: | Pick a point to the right of the chair |
| Current line width is 0'-0" | |
| Specify next point or [Arc/Halfwidth/ Length/Undo/Width]: | Type: **@26-1/2<0 <Enter ↵>** (with **Ortho** on move the mouse in the appropriate direction and type in the desired distance) |
| Specify next point or [Arc/Close/ Halfwidth/Length/Undo/Width]: | Type: **@5<90 <Enter ↵>** |
| Specify next point or [Arc/Close/ Halfwidth/Length/Undo/Width]: | Type: **@3-1/2<180 <Enter ↵>** |
| Specify next point or [Arc/Close/ Halfwidth/Length/Undo/Width]: | Type: **@1'7<90 <Enter ↵>** |
| Specify next point or [Arc/Close/ Halfwidth/Length/Undo/Width]: | Type: **@1'7-1/2<180 <Enter ↵>** |
| Specify next point or [Arc/Close/ Halfwidth/Length/Undo/Width]: | Type: **@1'7<270 <Enter ↵>** |
| Specify next point or [Arc/Close/ Halfwidth/Length/Undo/Width]: | Type: **@3-1/2<180 <Enter ↵>** |
| Specify next point or [Arc/Close/ Halfwidth/Length/Undo/Width]: | Type: **C <Enter ↵>** |

Change the view to **SW Isometric**, Your drawing should appear similar to Figure 11-47. The exact position of the seat cushion profile may differ, but the position is not a problem as long as the shape is correct.

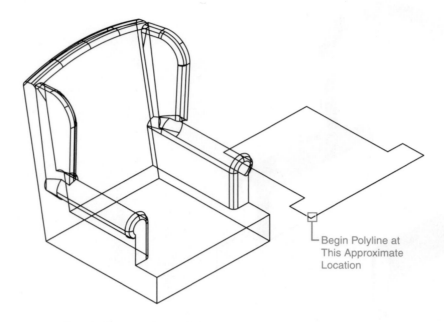

**Figure 11-47** SW Isometric View of the Chair and Seat Cushion Profile

In the next step, we will use the **EXTRUDE** command to give the chair seat cushion a thickness of 4″.

| Prompt | Response |
|---|---|
| Command: | *Select the **EXTRUDE** icon* |
| Current wire frame density: ISOLINES = 4 | |
| Select objects to extrude: | *Pick the seat cushion* |
| 1 found | |
| Select objects to extrude: | Type: **<Enter ↵>** |
| Specify height of extrusion or | |
| [Direction/Path/Taper angle] <0′-2″>: | Type: **4 <Enter ↵>** |

Your drawing should appear similar to Figure 11-48.

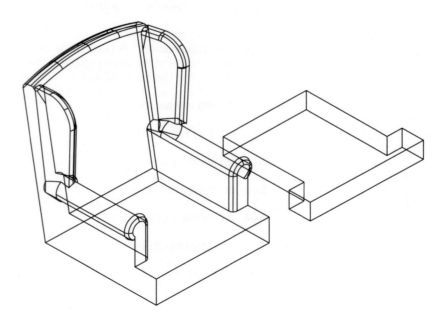

**Figure 11-48** Chair with Seat Cushion Extruded

Use the **MOVE** command to relocate the seat cushion $\frac{1}{4}''$ above the top of the chair seat base (see Figure 11-49).

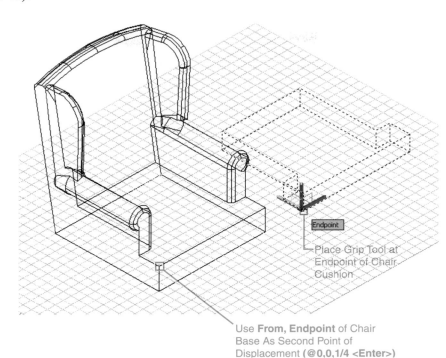

Use **From, Endpoint** of Chair
Base As Second Point of
Displacement ( **@0,0,1/4 <Enter>** )

Place Grip Tool at
Endpoint of Chair
Cushion

Endpoint

**Figure 11-49**    Object
Selection and **3DMOVE**
Grip Tool Placement

| Prompt | Response |
|--------|----------|
| Command: | Select the **3DMOVE** icon from the **Ribbon**, **Home** tab, **Modify** menu |
| Command: _3dmove | |
| Select objects: | Pick the seat cushion |
| Select objects: 1 found | Type: **<Enter ↵>** |
| Specify base point or [Displacement] <Displacement>: | Place the **3DMOVE** icon on the bottom, left corner endpoint (see Figure 11-49) |
| Specify second point or <use first point as displacement>: | Type: **FROM <Enter ↵>** |
| Base point: | With **Osnap** on, pick the endpoint of the top left corner of the chair base |
| <Offset>: | Type: **@0,0,1/4 <Enter ↵>** |

After moving the seat cushion, your drawing should appear similar to Figure 11-50.

The chair is currently located at elevation 0. We need to move the chair up in the +Z direction 8″ so that it will be at the appropriate elevation to sit on top of the legs. Use the **MOVE** command to relocate the chair.

| Prompt | Response |
|--------|----------|
| Command: | Type: **m** (move) **<Enter ↵>** |
| MOVE | |
| Select objects: | With a crossing window, select the chair base and seat cushion |
| Specify opposite corner: 2 found | |
| Select objects: | Type: **<Enter ↵>** |
| Specify base point or [Displacement] <Displacement>: | Type: **0,0,0 <Enter ↵>** |
| Specify second point or <use first point as displacement>: | Type: **0,0,8 <Enter ↵>** |

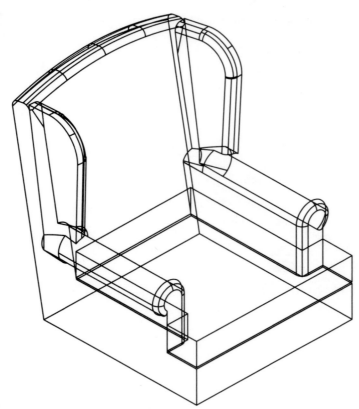

**Figure 11-50**    Chair with Seat Cushion in Place

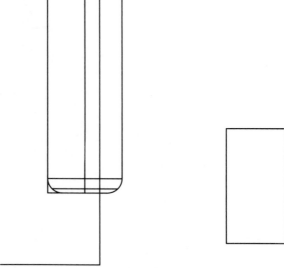

**Figure 11-51**    Line Box for the Back Chair Leg Profile

On your own, change to the **Plan View**, **World UCS** and draw a 4″ × 8″ rectangle with the **LINE** command on the right side of the chair. We will use the box as a guide to draw a profile shape for the back legs of the chair (see Figure 11-51). Within the line box, we will use the **POLYLINE** command to select points to define the shape of the leg profile.

| Prompt | Response |
|---|---|
| Command:<br>PLINE<br>Specify start point: | Select the **POLYLINE** icon<br><br>With **Osnap**, **Endpoint**, pick the top right end of the box |
| Current line-width is 0′-0″ Specify next point or [Arc/Halfwidth/Length/Undo/Width]: | Pick points approximating the curve of the leg (see Figure 11-52) |
| Specify next point or [Arc/Close/Halfwidth/Length/Undo/Width]: | To end the **POLYLINE**, pick the **Endpoint** of the bottom right corner of the box and Type: **<Enter ↵>** |

Repeat the process to draw the left side polyline.

| Prompt | Response |
|---|---|
| Command:<br>PLINE<br>Specify start point: | Select the **POLYLINE** icon<br><br>With **Osnap**, **Endpoint**, pick the top left end of the box |

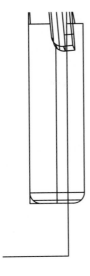
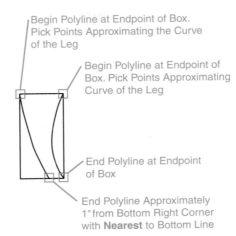

Begin Polyline at Endpoint of Box.
Pick Points Approximating the Curve
of the Leg

Begin Polyline at Endpoint of
Box. Pick Points Approximating
Curve of the Leg

End Polyline at Endpoint
of Box

End Polyline Approximately
1″ from Bottom Right Corner
with **Nearest** to Bottom Line

**Figure 11-52**    Chair Back
Leg Polyline Profiles

Current line width is 0′-0″
Specify next
    point or [Arc/Halfwidth/
    Length/Undo/Width]:

Specify next point or [Arc/Close/
    Halfwidth/Length/Undo/Width]:

*Pick points approximating the curve of the
    leg (see Figure 11-52)*

*To end the **POLYLINE**, pick a point with
    **Osnap**, **Nearest**, approximately 1″ from the
    lower right corner of the box and
    Type: **<Enter ↵>***

We will use the **BOUNDARY** command to produce a closed polyline shape that can be extruded to complete the chair back leg. If you recall, the **BOUNDARY** command creates a region or a polyline from an enclosed area. Use the **EXTRUDE** command to give the closed **POLYLINE** (the boundary just created) a thickness of 1″.

| Prompt | Response |
|---|---|
| Command: | Type: **BOUNDARY <Enter ↵>** *(or select **Boundary** from the **Ribbon**, **Home** tab, **Draw** flyout)* |
| Pick internal point: Selecting everything. . . | *Select the **Pick Points** button in the **Boundary** dialog box* |
| Selecting everything visible. . . | *Pick a point inside the leg profile* |
| Analyzing the selected data. . . | |
| Analyzing internal islands. . . | |
| Pick internal point: | Type: **<Enter ↵>** |
| BOUNDARY created 1 polyline | |
| Command: | *Select the **EXTRUDE** icon* |
| EXTRUDE | |
| Current wire frame density: ISOLINES = 4 | |
| Select objects to extrude: | Type: I *(last)* **<Enter ↵>** *(or select the leg polyline)* |
| 1 found | |
| Select objects to extrude: | Type: **<Enter ↵>** |
| Specify height of extrusion or [Direction/Path/Taper angle]: | Type: 1 **<Enter ↵>** |

Change to the SW isometric view to see the results of the **BOUNDARY** and **EXTRUDE** commands. Your drawing should appear similar to Figure 11-53.

The chair leg just drawn needs to be rotated three-dimensionally and moved to the back corner of the chair. We will stand the leg up in the +Z direction first using the **3DROTATE** grip tool.

| Prompt | Response |
|--------|----------|
| Command: | *Select the **3DROTATE** grip tool from the* ***Ribbon, Home*** *tab,* ***Modify*** *menu* |
| Command: _3drotate | |
| Current positive angle in UCS: ANGDIR = counterclockwise, ANGBASE = 0 | |
| Select objects: | *Pick the leg extrusion* |
| Select objects: 1 found | *Type:* **<Enter ↵>** |
| Specify base point: | *Place the grip tool on the bottom endpoint of the small end of the chair leg (see Figure 11-54)* |
| Pick a rotation axis: | *Highlight the X axis* |
| Specify angle start point or type an angle: | *Type:* **90 <Enter ↵>** |

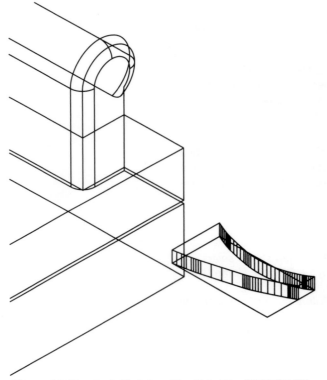

Figure 11-53    Back Chair Leg After Using the **BOUNDARY** and **EXTRUDE** Commands

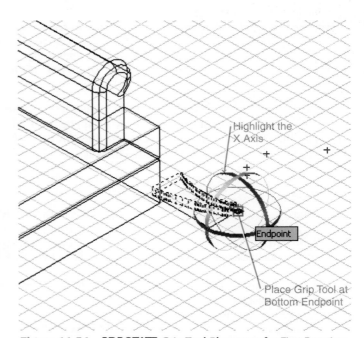

Figure 11-54    **3DROTATE** Grip Tool Placement for First Rotation

Your drawing should appear similar to Figure 11-55.

To make moving the back chair leg into position easier, we need to rotate the leg once more. On your own, use the **3DROTATE** grip tool, select the chair leg, use an endpoint at the bottom for the base point, and rotate the leg 90$^0$ about the Z axis. After your rotate the leg, your drawing should appear similar to Figure 11-56.

On your own, use the **MOVE** command to relocate the first leg into position (see Figure 11-57).

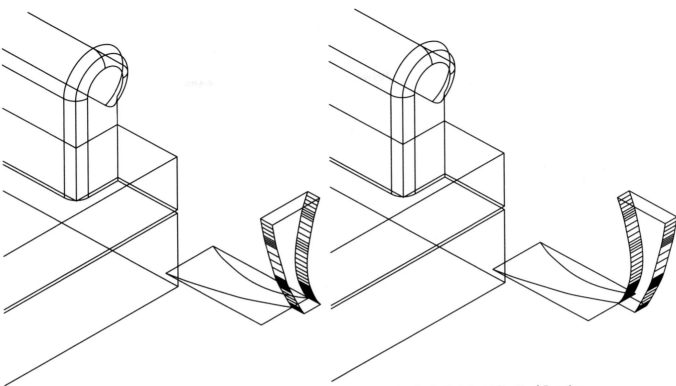

**Figure 11-55**    Back Chair Leg After First 3D Rotation          **Figure 11-56**    Back Chair Leg After Final Rotation

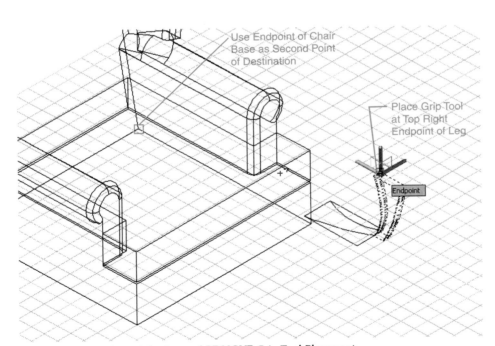

**Figure 11-57**    Object Selection and **3DMOVE** Grip Tool Placement

On your own, use the **COPY** command to create the second leg (see Figure 11-58). You can also use the **3DMIRROR** command to accomplish the same task, but in this case, the **COPY** process requires one fewer clicks of the mouse.

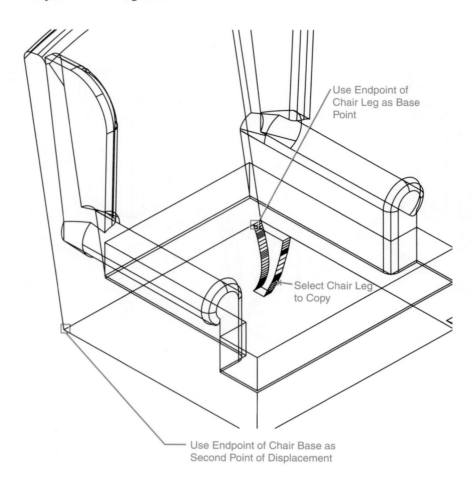

Use Endpoint of
Chair Leg as Base
Point

Select Chair Leg
to Copy

**Figure 11-58**   Use the
**COPY** Command to Add
the Second Back Chair Leg

Use Endpoint of Chair Base as
Second Point of Displacement

After you have finished using the **COPY** command, erase the original profile shape and line box. Your drawing should appear similar to Figure 11-59.

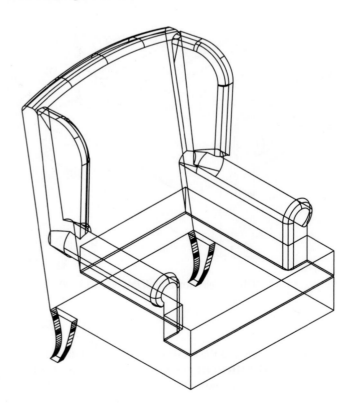

**Figure 11-59**   Chair with Back
Legs in Place

The next step will be to insert the cabriole leg that we drew in Chapter 10. We will begin by inserting the cabriole leg in front of the chair. Use the **INSERT** command, then **Block** on the **Menu Browser** to insert the cabriole leg. Use **Browse** if necessary to find the cabriole leg drawing. After you insert the cabriole leg, your drawing should appear similar to Figure 11-60.

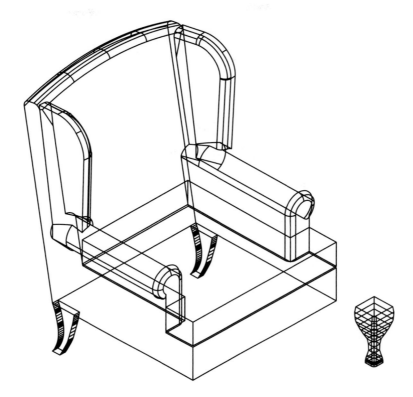

**Figure 11-60**    Chair Drawing with the Cabriole Leg Inserted

On your own, use the **3DMOVE** grip tool to locate the first leg correctly (see Figure 11-61). Use the **3DMIRROR** command to create the right front cabriole leg (see Figure 11-62). Your drawing should appear similar to Figure 11-63.

The chair would have a softer appearance if it had rounded edges on the front and side of the chair base and seat cushion. With a radius of $\frac{1}{2}''$, use the **FILLET** command and fillet the front, corners, and side edges of the seat cushion.

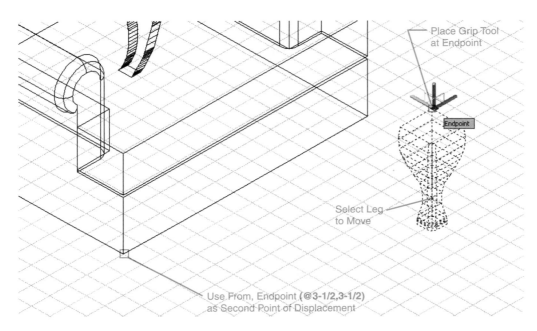

**Figure 11-61**    Selection Points for Moving the First Cabriole Leg into Place

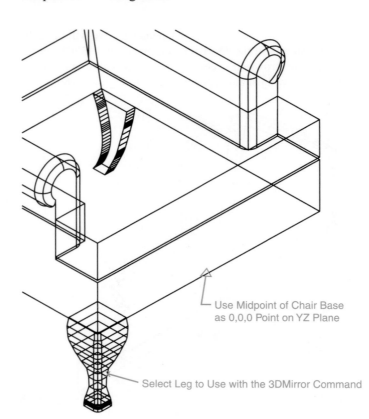

Use Midpoint of Chair Base
as 0,0,0 Point on YZ Plane

**Figure 11-62** Selection
Set to Use with the
**3DMIRROR** Command

Select Leg to Use with the 3DMirror Command

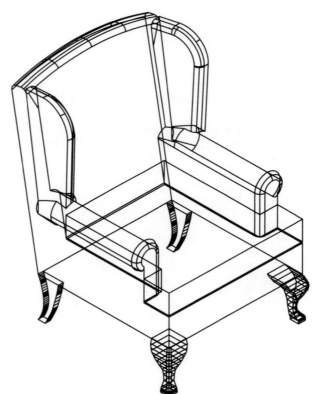

**Figure 11-63** Wing Chair
with Cabriole Legs in Place

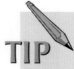

TIP

You cannot fillet the edges of multiple objects in the same **FILLET** command sequence.

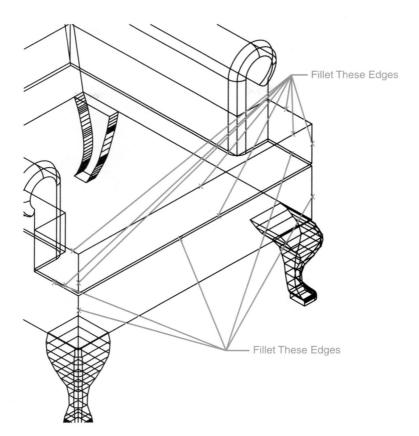

Figure 11-64    Fillet the Edges to Soften the Chair's Appearance

Repeat the **FILLET** command, and fillet the chair base as illustrated in Figure 11-64.

Use the **HIDE** command. The completed wing chair with cabriole legs should appear similar to Figure 11-65.

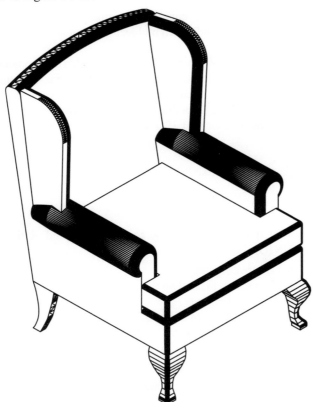

Figure 11-65    Completed Wing Chair with Cabriole Legs

From the **Visual Styles Manager**, select **Conceptual**, and use the **Orbit** command, **Constrained Orbit**, to produce a view similar to Figure 11-66.

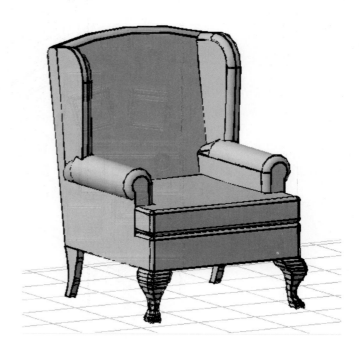

**Figure 11-66**   Conceptual View of Completed Wing Chair with Cabriole Legs

## Summary

This chapter provided you with additional practice using the **POLYLINE** command to produce the basis for 3D solids. Use of the **BOUNDARY** command strengthened your knowledge of creating regions or polylines from enclosed areas.

You gained additional experience using the **COPY**, **MOVE**, **UNION**, and **ROTATE** commands. Using the grip tools for **3DROTATE** and **3DMOVE** not only provided you with drawing skills but also increased your ability to visualize objects in 3D space.

Experience using the **LOFT** command provided you with a method for producing 3D solids and surfaces through a set of cross-sectional curves. You gained experience using the **ALIGN** command to align objects with other 2D and 3D objects.

The last part of this chapter provided additional practice by instructing you to perform tasks on your own. Learning how to identify which processes and commands are needed to complete complex 3D models is a very important component in becoming proficient at 3D modeling.

## Chapter Test Questions

### Multiple Choice

1. The **LOFT** command can be used to accomplish which of the following?
   a. Extrude closed polylines a specified distance in the Z direction
   b. Create 3D solids above the XY plane only
   c. Create 3D solids or surfaces by drawing a solid or surface through a set of two or more cross-sectional curves
   d. Align one 2D or 3D shape with another 2D or 3D shape
   e. Use a grip tool to move solids three-dimensionally

2. Which of the following cannot be joined with the **UNION** command?
   a. Two overlapping solids
   b. Two solids located on the XY plane that do not touch
   c. Extruded regions
   d. Two lines drawn on the XY plane
   e. Objects created with the **POLYSOLID** command

3. The **INSERT** command can be used to insert which of the following?
   a. One drawing file into another drawing file
   b. A block

c. A raster image

d. A drawing reference file

e. All the above

4. The **ALIGN** command allows you to do which of the following?

a. Align one 2D or 3D shape with another 2D or 3D shape.

b. Move objects using the **3DMOVE** grip tool.

c. Restructure drawing file names in a directory.

d. Move objects only in the +Z direction.

e. Move objects using only Cartesian coordinates

5. Which of the following tasks cannot be done in one **FILLET** operation?

a. Selecting more than three edges during one operation

b. Filleting edges on two separate objects

c. Filleting edges with a radius of less than 1″

d. Filleting edges with a radius of more than 1″

e. Selecting edges that meet at two faces

## Matching

**Column A**

a. **UNION**

b. **LOFT**

c. **ALIGN**

d. **ROTATE3D**

e. **MIRROR3D**

**Column B**

1. Creates a 3D solid or surface by lofting through a set of two or more curves

2. Combines selected regions or solids by addition

3. Creates a mirror image of objects about a plane

4. Moves objects about a three-dimensional axis

5. Aligns objects with other objects in 2D or 3D space

## True or False

1. T or F: The **LOFT** command allows you to create a solid or surface by lofting through a set of two or more curves.

2. T or F: The **ALIGN** command allows you to select source and destination points for alignment.

3. T or F: You cannot join two objects with the **UNION** command unless they share common mass.

4. T or F: The **3DMOVE** grip tool allows you to select (highlight) the X, Y, or Z axis and then move objects in one of the three directions only.

5. T or F: An object must be a true three-dimensional solid before it can be rotated with the **3DROTATE** command.

## Chapter Objectives

- Practice using the **BOUNDARY** command
- Practice using the **POLYLINE**, **EXTRUDE**, and **SUBTRACT** commands
- Learn to create layers
- Learn to extrude a closed polyline along a path
- Learn to sweep a closed polyline along a path
- Learn to use the **DVIEW** command

## INTRODUCTION

In this chapter, we will build a $16' \times 20'$ office space with an $8'$ ceiling. We will include a $3' \times 7' \times 2''$ door and two $3' \times 6'$ fixed glass panels. We will use wood trim for the door, fixed glass panel, and base. Note that all of the walls would most likely not terminate at the corners. For this drawing, our primary objective is to learn how to construct a three-dimensional interior space without regard to adjacent spaces; therefore, we will not continue the walls beyond the corners.

## DRAWING SETUP

Begin a new drawing. Set the **Units** to **Architectural**, **Precision** to $\frac{1}{8}''$. Set the **Limits** to **0,0** and **44',34'**. Set the **Grid** to **1'**, and **Zoom All**.

## BEGIN DRAWING

We can proceed with this drawing in several ways. For instance, we can use **LINE** or **POLYLINE** commands to draw the wall profiles, then use the **REGION, SUBTRACT**, and **EXTRUDE** commands to complete the walls. The walls can also be drawn with the **POLYSOLID** command. In this chapter, however, we will draw one closed polyline rectangle representing the outside edge of the wall, and then use the **OFFSET** command to produce the interior edge wall line. We will extrude two rectangles (closed polylines) $8'$. We can then use the **SUBTRACT** command to produce the $5''$-thick wall solids. Begin by drawing a polyline rectangle representing the outside dimensions of the office space walls using absolute coordinates to locate the drawing precisely within the established limits. Make sure that **ORTHO** is on and begin.

| POLYLINE | |
|---|---|
| Ribbon/ Home tab/ Draw/ Polyline | |
| Menu | Draw/ Polyline |
| Toolbar: Draw | |
| Command Line | pline |
| Alias | pl |

| Prompt | Response |
|---|---|
| Command: | Select the **POLYLINE** *icon* |
| PLINE | |
| Specify start point: | Type: **10',10' <Enter ↵>** |
| Current line width is 0'-0" | |
| Specify next point or [Arc/Halfwidth/ | |
| Length/Undo/Width]: | *With **Ortho** on, move the mouse to the right and Type: 20' 10 <**Enter** ↵>* |
| Specify next point or [Arc/Close/Halfwidth/ | |
| Length/Undo/Width]: | *Move the mouse up and Type: 16' 10 <**Enter** ↵>* |
| Specify next point or [Arc/Close/Halfwidth/ | |
| Length/Undo/Width]: | *Move the mouse to the left and Type: 20' 10 <**Enter** ↵>* |
| Specify next point or [Arc/Close/ | |
| Halfwidth/Length/Undo/Width]: | Type: **C <Enter ↵>** *(to close the polyline)* |

Use the **OFFSET** command to produce the inside edge of the wall line.

| | |
|---|---|
| **OFFSET** | |
| **Ribbon/ Home tab/ Modify/ Offset** | |
| **Menu** | Modify/ Offset |
| **Toolbar: Modify** | |
| **Command Line** | offset |
| **Alias** | o |

| Prompt | Response |
|---|---|
| Command: | Select the **OFFSET** *icon* |
| OFFSET | |
| Current settings: Erase source = No, Layer = Source, OFFSETGAPTYPE = 0 | |
| Specify offset distance or [Through/ Erase/Layer] <Through>: | Type: **5 <Enter ↵>** |
| Select object to offset or [Exit/ Undo] <Exit>: | *Pick the polyline just drawn* |
| Specify point on side to offset or [Exit/Multiple/Undo] <Exit>: | *Pick a point inside the polyline rectangle* |
| Select object to offset or [Exit/ Undo] <Exit>: | Type: **<Enter ↵>** |

Your drawing should appear similar to Figure 12-1.

**Figure 12-1**  Polyline Rectangles Representing the Walls

Use the **EXTRUDE** command to produce two solid rectangles 8′ high. Then use the **SUB-TRACT** command to subtract the inside rectangle from the outside rectangle.

| Prompt | Response |
|---|---|
| Command:<br>EXTRUDE<br>Current wireframe density: ISOLINES = 4<br>Select objects to extrude: | *Select the* ***EXTRUDE*** *icon*<br><br>*With a crossing window (window selection<br>right to left), pick the two polyline rectangles* |
| Specify opposite corner: 2 found<br>Select objects to extrude:<br>Specify height of extrusion or<br>   [Direction/Path/Taper angle] <8′-0″>:<br>Command:<br>Select solids and regions to subtract from...<br>Select objects: 1 found<br>Select objects:<br>Select solids and regions to subtract...<br>Select objects: 1 found<br>Select objects: | Type: **<Enter ↵>**<br><br>Type: **<Enter ↵>**<br>*Select the* ***SUBTRACT*** *icon*<br>*Pick the outside rectangle*<br><br>Type: **<Enter ↵>**<br>*Pick the inside rectangle*<br><br>Type: **<Enter ↵>** |

Change the view to an isometric view. From the **Menu Browser**, **View** menu, select **SW Iso-metric** from the **3D Views** flyout. Type **HIDE** at the command prompt to see the results of the **EXTRUDE** and **SUBTRACT** commands.

Your drawing should appear similar to Figure 12-2

**Figure 12-2**    Office Walls After Use of the **EXTRUDE** and **SUBTRACT** Commands

In the next step, we will use the **BOUNDARY** command to create openings for the door and two fixed glass panels. The fixed glass panels and the door will have $\frac{3}{4}$″-thick pieces of casing materials on each side, so we need to allow for this thickness in the rough opening sizes. We will begin by drawing lines at each side of the door and glass panel rough openings. Change back to the plan view by selecting **Plan**, **World UCS** from the **Menu Browser**, **View** menu, **3D Views** flyout. Use the **ID** command to identify the upper left inside corner of the wall and thus establish this point as the last point entered.

| EXTRUDE | |
|---|---|
| **Ribbon/<br>Home tab/<br>3D Model-<br>ing/Extrude** | |
| **Menu** | Draw/<br>Modeling/<br>Extrude |
| **Toolbar:<br>Modeling** | |
| **Command<br>Line** | extrude |
| **Alias** | ext |

| SUBTRACT | |
|---|---|
| **Ribbon/<br>Home tab/<br>Solid edit-<br>ing/Subtract** | |
| **Menu** | Modify/<br>Solid<br>Editing/<br>Subtract |
| **Toolbar:<br>Modeling** | |
| **Command<br>Line** | subtract |
| **Alias** | su |

| LINE | |
|---|---|
| **Ribbon/<br>Home tab/<br>Draw/<br>Line** | |
| **Menu** | Draw/<br>Line |
| **Toolbar:<br>Draw** | |
| **Command<br>Line** | line |
| **Alias** | l |

| Prompt | Response |
|---|---|
| Command: | Type: **ID <Enter ↵>** |
| | *With **Osnap**, **Endpoint**, pick the upper left inside corner of the office wall (to establish it as the last point entered)* |
| Specify point: X = 10'-5" Y = 26'-5" Z = 0'-0" | |
| Command: | *Select the **LINE** icon* |
| LINE Specify first point: | Type: **@6'5<0 <Enter ↵>** |
| Specify next point or [Undo]: | Type: **@1'<90 <Enter ↵>** |
| Specify next point or [Undo]: | Type: **<Enter ↵>** |

Use the **OFFSET** command to draw the jamb locations of the door and fixed glass panels. The lines will be used to create closed polylines (with the **BOUNDARY** command) that can be extruded. Remember, we have to add $\frac{3}{4}''$ to each side of the 3'-wide glass panels and door rough opening widths.

| Prompt | Response |
|---|---|
| Command: | *Select the **OFFSET** icon* |
| OFFSET | |
| Current settings: Erase source = No, Layer = Source, OFFSETGAPTYPE = 0 | |
| Specify offset distance or [Through/Erase/Layer] <0'-5">: | Type: **3'1-1/2 <Enter ↵>** |
| Select object to offset or [Exit/Undo] <Exit>: | *Pick the top of the jamb line* |
| Specify point on side to offset or [Exit/Multiple/Undo] <Exit>: | *Pick a point to the right* |
| Select object to offset or [Exit/Undo] <Exit>: | Type: **<Enter ↵> <Enter ↵>** *(to repeat the **OFFSET** command)* |
| OFFSET | |
| Current settings: Erase source = No, Layer = Source, OFFSETGAPTYPE = 0 | |
| Specify offset distance or [Through/Erase/Layer] <3'-1$\frac{1}{2}$">: | Type: **14 <Enter ↵>** |
| Select object to offset or [Exit/Undo] <Exit>: | *Pick the top of the right line* |
| Specify point on side to offset or [Exit/Multiple/Undo] <Exit>: | *Pick a point to the right* |
| Select object to offset or [Exit/Undo] <Exit>: | Type: **<Enter ↵> <Enter ↵>** *(to repeat the **OFFSET** command)* |
| Current settings: Erase source = No, Layer = Source, OFFSETGAPTYPE = 0 | |
| Specify offset distance or [Through/Erase/Layer] <0'-8">: | Type: **3'1-1/2 <Enter ↵>** |
| Select object to offset or [Exit/Undo] <Exit>: | *Pick the top of the right line* |
| Specify point on side to offset or [Exit/Multiple/Undo] <Exit>: | *Pick a point to the right* |
| Select object to offset or [Exit/Undo] <Exit>: | Type: **<Enter ↵>** |

We will center the fixed glass panel on the wall opposite the door and the fixed glass panel that we just drew. Begin with a line from the midpoint of the inside edge of the bottom wall.

| Prompt | Response |
|---|---|
| Command: | *Select the **LINE** icon* |
| LINE Specify first point: | *With **Osnap** on, pick the inside midpoint of the bottom wall* |
| Specify next point or [Undo]: | *With **ORTHO** on, move the mouse downward and Type: 1' **<Enter ↵>*** |

| Specify next point or [Undo]: | Type: **<Enter ↵>** |
| Command: | *Select the **OFFSET** icon* |
| OFFSET | |
| Current settings: Erase source = No, Layer = Source, OFFSETGAPTYPE = 0 | |
| Specify offset distance or [Through/Erase/Layer] <3′-1½″>: | Type: **1′6-3/4 <Enter ↵>** |
| Select object to offset or [Exit/Undo] <Exit>: | *Pick the line on the bottom wall* |
| Specify point on side to offset or [Exit/Multiple/Undo] <Exit>: | *Pick a point to the right of the line* |
| Select object to offset or [Exit/Undo] <Exit>: | *Pick the line on the left* |
| Specify point on side to offset or [Exit/Multiple/Undo] <Exit>: | *Pick a point to the left of the line* |
| Select object to offset or [Exit/Undo] <Exit>: | Type: **<Enter ↵>** |

Your drawing should be similar to Figure 12-3.

**Figure 12-3**    Office Walls with Lines Representing Door and Fixed Glass Panels

Before we continue, we will erase the center line of the fixed glass panel on the bottom wall. We will use the **BOUNDARY** command to create polylines from the enclosed areas and the **EXTRUDE** command to create solids with appropriate thicknesses to subtract from the walls. Place the door in the upper left wall and the fixed glass panels in the upper right and lower wall.

| Prompt | Response |
|---|---|
| Command: | Type: **BOUNDARY <Enter ↵>** *(or select the **BOUNDARY** icon)* |
| Pick internal point: | *Use the **Pick Points** option and pick a point inside the upper left door rectangle (see Figure 12-4)* |

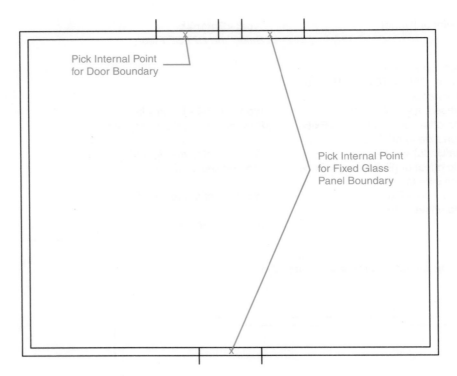

Pick Internal Point
for Door Boundary

Pick Internal Point
for Fixed Glass
Panel Boundary

**Figure 12-4** Point Selection for Use with the **BOUNDARY** Command

Selecting everything...
Selecting everything visible...
Analyzing the selected data...
Analyzing internal islands...
Pick internal point:                                    *Pick a point inside the upper right fixed glass*
                                                                    *rectangle*

Analyzing internal islands...
Pick internal point:                                    *Pick a point inside the fixed glass panel*
                                                                    *rectangle in the bottom wall*

Analyzing internal islands...
Pick internal point:                                    Type: **<Enter ↵>**
BOUNDARY created 3 polylines

---

We will use the **EXTRUDE** command to create solids to subtract from the walls for the door and fixed glass panel openings. The two fixed glass panel openings will be extruded 6′-3″ and moved in the Z axis direction $11\frac{1}{4}''$. The door opening will be extruded $7'\frac{3}{4}''$. This will produce a header height of 7′-0″ for the fixed glass panels and the door. Remember, we have to leave space for the $\frac{3}{4}''$ trim/casing around the openings.

We no longer need the lines used to create the boundaries, so we will use the **ERASE** command to remove them from the drawing.

---

| Prompt | Response |
|---|---|
| Command: | *Select the **EXTRUDE** icon* |
| EXTRUDE | |
| Current wire frame density: ISOLINES = 4 | |
| Select objects to extrude: | *Pick the top fixed glass boundary* |
| 1 found | |
| Select objects to extrude: | *Pick the bottom fixed glass boundary* |
| 1 found, 2 total | |
| Select objects to extrude: | Type: **<Enter ↵>** |
| Specify height of extrusion or | |
| [Direction/Path/Taper angle] <8′-0″>: | Type: **6′3 <Enter ↵>** |

| Command: | Type: **m <Enter ↵>** *(or select **Move** from the **Modify** toolbar)* |
|---|---|
| MOVE | |
| Select objects: | *Pick the top fixed glass solid* |
| 1 found | |
| Select objects: | *Pick the bottom fixed glass* |
| 1 found, 2 total | |
| Select objects: | Type: **<Enter ↵>** |
| Specify base point or [Displacement] <Displacement>: | Type: **0,0,0 <Enter ↵>** |
| Specify second point or <use first point as displacement>: | Type: **0,0,9-3/4 <Enter ↵>** |
| Command: | *Select the **EXTRUDE** icon* |
| EXTRUDE | |
| Current wire frame density: ISOLINES = 4 | |
| Select objects to extrude: | *Pick the door boundary* |
| 1 found | |
| Select objects to extrude: | Type: **<Enter ↵>** |
| Specify height of extrusion or [Direction/Path/Taper angle] <6′-3″>: | Type: **7-3/4 <Enter ↵>** |

To see the results of the **EXTRUDE** and **MOVE** commands, change to a SW isometric view (**Menu Browser**, **View** menu, **3D Views** flyout). Your drawing should be similar to Figure 12-5.

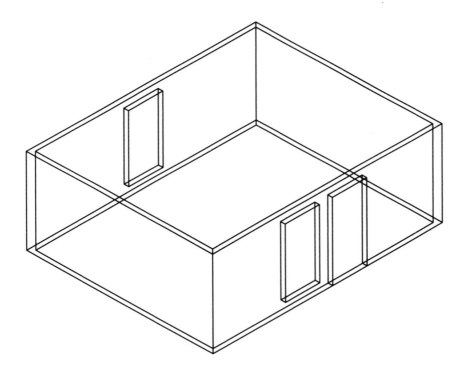

**Figure 12-5** Drawing of the Office Space After Extruding and Moving the Boundaries

Type **HIDE** at the command prompt, and you will see that the solids just created need to be subtracted from the walls to produce openings for the door and fixed glass panels. **Regen** the drawing, then use the **SUBTRACT** command to create the openings.

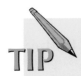

TIP

**REGEN** regenerates the entire drawing from the current viewport.

| Prompt | Response |
|---|---|
| Command: | Select the **SUBTRACT** icon |
| Select solids and regions to subtract from... | |
| Select objects: | Pick the walls |
| 1 found | |
| Select objects: | Type: **<Enter ↵>** |
| Select solids and regions to subtract... | |
| Select objects: | Pick the door opening |
| 1 found | |
| Select objects: | Pick a fixed glass panel opening |
| 1 found, 2 total | |
| Select objects: | Pick the other fixed glass panel opening |
| 1 found, 3 total | |
| Select objects: | Type: **<Enter ↵>** |

Use the **HIDE** command. Your drawing should appear similar to Figure 12-6. Notice that after the subtraction, we now have open spaces in which to construct the door, fixed glass panels, and trim.

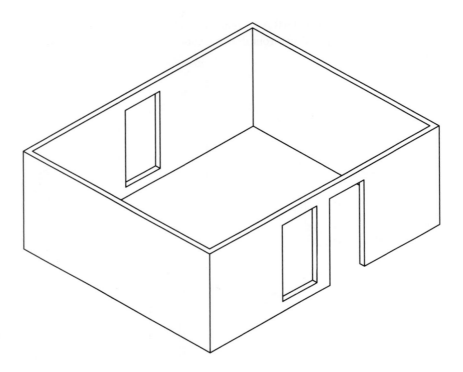

**Figure 12-6** Drawing of the Office Space with the Door and Fixed Glass Panel Openings Subtracted

The next step in completing the drawing of the office space will consist of drawing and extruding the fixed glass panel and door casing profiles along a path. We will begin by constructing the path for the door casing extrusion using a 3D polyline. The drawing will be easier to manage if we create and place similar objects on individual layers.

You can create new layers for each conceptual grouping (such as walls or trim) and assign common properties to each layer. Organizing objects into layers allows you to control the visibility and object properties separately for each layer and make changes quickly. To create a new layer, from the **Menu Browser**, **Format** menu, select **Layer**, or at the command prompt, type **layer**. Then, in the **Layer Properties Manager** dialog box, click the **New Layer** button. A layer name, such as **LAYER1**, is automatically added to the layer list. Enter a new layer name by typing over the highlighted layer name.

To change the properties, select individual icons. When you click **Color**, **Linetype**, **Lineweight**, or **Plot Style**, a dialog box is displayed. Click **Apply** to save your changes, or click **OK** to save and close.

Create a new layer for the extrusion paths and make it current. We will draw a 3D polyline, using the **3DPOLY** command, along the inside center of the door opening, and we will use **Osnap**, **Midpoint** to ensure that the path is aligned with the door opening. A 3D polyline is a polyline of line segments drawn in 3D space. Return to a wireframe view (**Ribbon**, **View** tab, **Visual Styles**, **2D** or **3D Wireframe**) and continue.

| Prompt | Response |
|---|---|
| Command: | Type: **3DPOLY <Enter ↵>** *(or select from the **Draw** menu)* |
| Specify start point of polyline: | Type: **MID <Enter ↵>** *(or select with **Osnap**, **Midpoint**)* |
| of | *Pick the midpoint of the left bottom door opening (see Figure 12-7)* |
| Specify endpoint of line or [Undo]: | *Pick the midpoint of the top left door opening* |
| Specify endpoint of line or [Undo]: | *Pick the midpoint of the top right door opening* |
| Specify endpoint of line or [Close/Undo]: | *Pick the midpoint of the bottom right door opening* |
| Specify endpoint of line or [Close/Undo]: | Type: **<Enter ↵>** |

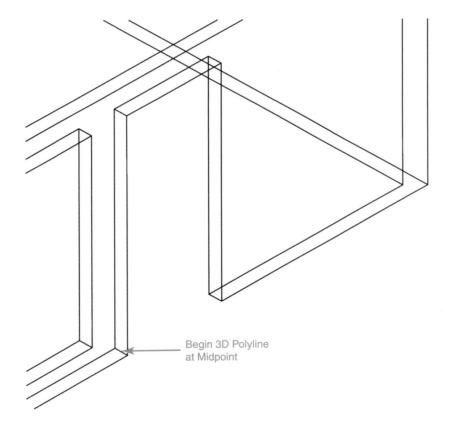

Begin 3D Polyline
at Midpoint

**Figure 12-7**   Selection Points for the 3D Polyline

To draw the door casing profile, zoom in close around the lower left door opening, set layer 0 current, and proceed (see Figure 12-8).

| Prompt | Response |
|---|---|
| Command:<br>PLINE | *Select the **POLYLINE** icon* |
| Specify start point:<br>Current line width is 0'-0" | *Pick the outside endpoint of the left side of the door opening (see Figure 12-8)* |

| Specify next point or [Arc/.../Undo/Width]: | Type: **@2-1/2<0 <Enter ↲>** *(or use **ORTHO** and direct distance input)* |
| Specify next point or [Arc/.../Undo/Width]: | Type: **@3/4<90 <Enter ↲>** |
| Specify next point or [Arc/.../Undo/Width]: | Type: **@3<180 <Enter ↲>** |
| Specify next point or [Arc/.../Undo/Width]: | Type: **@3/4<270 <Enter ↲>** |
| Specify next point or [Arc/.../Undo/Width]: | Type: **@1/4<180 <Enter ↲>** |
| Specify next point or [Arc/.../Undo/Width]: | Type: **@1-3/8<270 <Enter ↲>** |
| Specify next point or [Arc/.../Undo/Width]: | Type: **@1/4<180 <Enter ↲>** |
| Specify next point or [Arc/.../Undo/Width]: | Type: **@1-5/8<270 <Enter ↲>** |
| Specify next point or [Arc/.../Undo/Width]: | Type: **@1/4<0 <Enter ↲>** |
| Specify next point or [Arc/.../Undo/Width]: | Type: **@2<270 <Enter ↲>** |
| Specify next point or [Arc/.../Undo/Width]: | Type: **@1/4<0 <Enter ↲>** |
| Specify next point or [Arc/.../Undo/Width]: | Type: **@3/4<270 <Enter ↲>** |
| Specify next point or [Arc/.../Undo/Width]: | Type: **@3<0 <Enter ↲>** |
| Specify next point or [Arc/.../Undo/Width]: | Type: **@3/4<90 <Enter ↲>** |
| Specify next point or [Arc/.../Undo/Width]: | Type: **@2-1/2<180 <Enter ↲>** |
| Specify next point or [Arc/.../Undo/Width]: | Type: **C <Enter ↲>** *(to close the polyline)* |

Your drawing should appear similar to Figure 12-9.

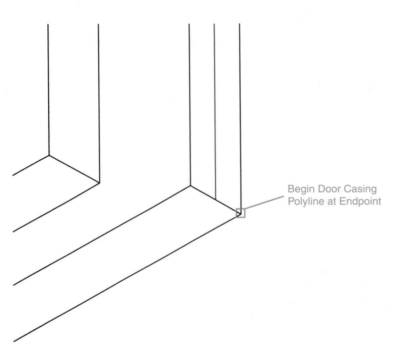

Begin Door Casing
Polyline at Endpoint

**Figure 12-8**    Beginning Point for the Door Casing Polyline

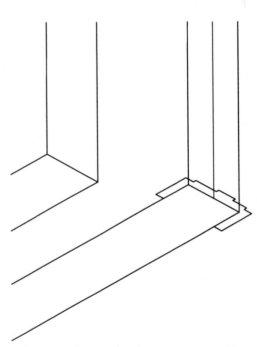

**Figure 12-9**    Completed Door Casing Profile

Use the **EXTRUDE** command to extrude the door casing profile along the path created with the **3DPOLY** command.

| Prompt | Response |
| --- | --- |
| Command: | *Select the **EXTRUDE** icon* |
| EXTRUDE | |
| Current wire frame density: ISOLINES = 4 | |
| Select objects to extrude: | *Pick the door casing profile* |
| 1 found | |
| Select objects to extrude: | Type: **<Enter ↲>** |
| Specify height of extrusion or [Direction/Path/Taper angle]: | Type: **P <Enter ↲>** |
| Select extrusion path or [Taper angle]: | *Pick the **3DPOLY** line* |

Your drawing should appear similar to Figure 12-10. Use the **HIDE** command to produce a view similar to Figure 12-11.

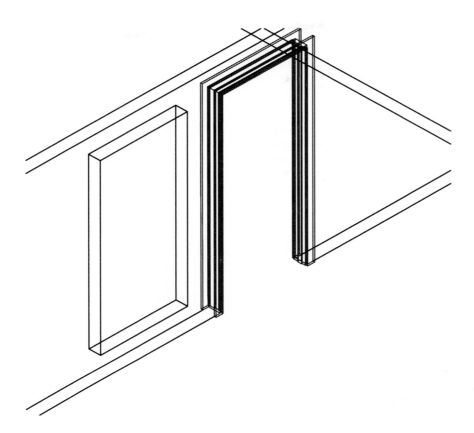

Figure 12-10    Wireframe View of the Completed Door Casing

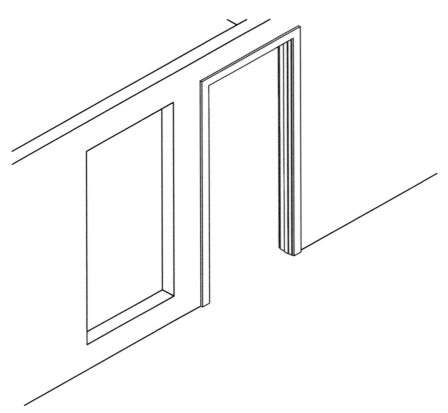

Figure 12-11    Hidden View of the Completed Door Casing

We will now construct the casing for the fixed glass panel. The process we will use is similar to the one we used for the door casing because we will use a polyline profile to extrude around a 3D polyline path. To begin, zoom in around the lower left corner of the fixed glass panel opening.

| Prompt | Response |
|---|---|
| Command: | Type: **3DPOLY <Enter ↵>** *(or select from the **Draw** menu)* |
| Specify start point of polyline: | Type: **MID <Enter ↵>** *(or select with **Osnap, Mid**)* |
| of | *Pick the lower left midpoint of the opening (see Figure 12-12)* |
| Specify endpoint of line or [Undo]: | *Pick the upper left midpoint of the opening* |
| Specify endpoint of line or [Undo]: | *Pick the upper right midpoint of the opening* |
| Specify endpoint of line or [Close/Undo]: | *Pick the lower right midpoint of the opening* |
| Specify endpoint of line or [Close/Undo]: | Type: **C <Enter ↵>** |

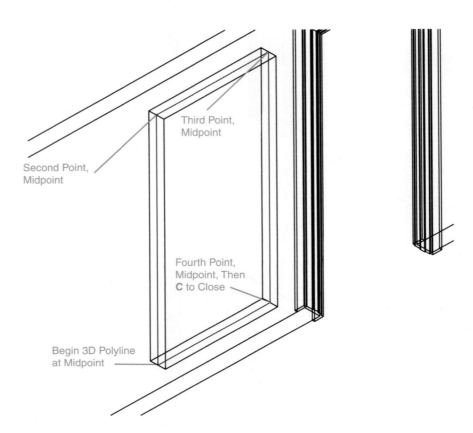

Third Point, Midpoint

Second Point, Midpoint

Fourth Point, Midpoint, Then **C** to Close

Begin 3D Polyline at Midpoint

**Figure 12-12** Selection Points for the Fixed Glass Panel 3D Polyline Path

Draw the polyline for the fixed glass panel casing profile (see Figure 12-13). The polyline profile will be drawn in front of the wall at elevation 0, and it will be moved to the bottom of the fixed glass panel opening. The command sequence is long and a little tedious, but it is worth the effort if you want accurate and appropriate detail. The **POLYLINE** command sequence will be faster and just as accurate if you turn **ORTHO** on, move the mouse in the appropriate direction, and type in the desired distance.

| Prompt | Response |
|---|---|
| Command: | Type: **ZOOM <Enter ↵>** |
| All/Center/Dynamic/Extents/Previous/ Scale(X/XP/Window/<Realtime>: | *Pick a window around the lower left fixed glass panel opening and an area in front* |

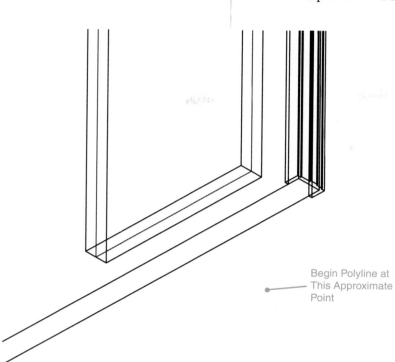

Begin Polyline at
This Approximate
Point

**Figure 12-13**    Begin the Polyline Profile in Front of the Wall

| Command: | Select the **POLYLINE** icon |
|---|---|
| PLINE | |
| Specify start point: | Pick a point in front of the wall to begin |
| Current line width is 0'-0" | (see Figure 12-13) |
| Specify next point or [Arc/.../Undo/Width]: | Type: **@2-1/2<80 <Enter ↵ >** (or with **Ortho** on, move the mouse in the appropriate direction and type in the desired distance) |
| Specify next point or [Arc/.../Undo/Width]: | Type: **@3/4<270 <Enter ↵>** |
| Specify next point or [Arc/.../Undo/Width]: | Type: **@3<0 <Enter ↵>** |
| Specify next point or [Arc/.../Undo/Width]: | Type: **@3/4>90 <Enter ↵>** |
| Specify next point or [Arc/.../Undo/Width]: | Type: **@1/4<0 <Enter ↵ >** |
| Specify next point or [Arc/.../Undo/Width]: | Type: **@1-1/2<90 <Enter ↵>** |
| Specify next point or [Arc/.../Undo/Width]: | Type: **@1/4<0 <Enter ↵>** |
| Specify next point or [Arc/.../Undo/Width]: | Type: **@1/2<90 <Enter ↵>** |
| Specify next point or [Arc/.../Undo/Width]: | Type: **@1/4<180 <Enter ↵>** |
| Specify next point or [Arc/.../Undo/Width]: | Type: **@1/4<90 <Enter ↵>** |
| Specify next point or [Arc/.../Undo/Width]: | Type: **@1/4<0 <Enter ↵>** |
| Specify next point or [Arc/.../Undo/Width]: | Type: **@1/2<90 <Enter ↵>** |
| Specify next point or [Arc/.../Undo/Width]: | Type: **@1/4<180 <Enter ↵>** |
| Specify next point or [Arc/.../Undo/Width]: | Type: **@3/4<90 <Enter ↵>** |
| Specify next point or [Arc/.../Undo/Width]: | Type: **@2-1/4<90 <Enter ↵>** |
| Specify next point or [Arc/.../Undo/Width]: | Type: **@1/8<180 <Enter ↵>** |
| Specify next point or [Arc/.../Undo/Width]: | Type: **@1/4<180 <Enter ↵>** |
| Specify next point or [Arc/.../Undo/Width]: | Type: **@3/4<90 <Enter ↵>** |
| Specify next point or [Arc/.../Undo/Width]: | Type: **@3<180 <Enter ↵>** |
| Specify next point or [Arc/.../Undo/Width]: | Type: **@3/4<270 <Enter ↵>** |
| Specify next point or [Arc/.../Undo/Width]: | Type: **@2-1/2<0 <Enter ↵>** |
| Specify next point or [Arc/.../Undo/Width]: | Type: **C <Enter ↵>** (to close the polyline) |

The polyline profile should appear similar to Figure 12-14. We will move the profile to the bottom right corner of the fixed glass panel opening to extrude it along the 3D polyline path.

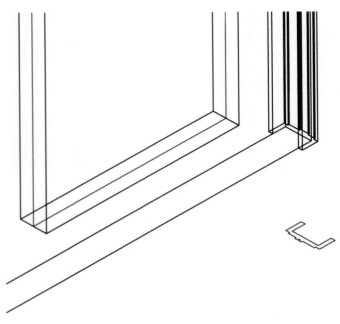

**Figure 12-14**   Completed Polyline Profile for the Fixed Glass Panel Casing

| Prompt | Response |
|---|---|
| Command: | Type: **m** *(move)* **<Enter ↵>** |
| MOVE | |
| Select objects: | *Pick the polyline profile (see Figure 12-15)* |
| 1 found | |
| Select objects: | Type: **<Enter ↵>** |
| Specify base point or [Displacement] <Displacement>: | *With **Osnap**, **Midpoint**, pick the inside midpoint of the casing* |
| Specify second point or <use first point as displacement>: | *With **Osnap**, **Endpoint**, pick the lower right endpoint of the 3D Polyline* |

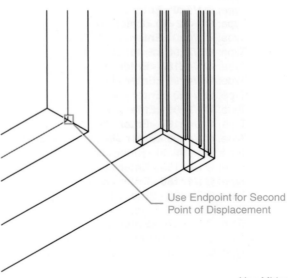

Use Endpoint for Second Point of Displacement

Use Midpoint for Base Point

**Figure 12-15**   Selection Points for Moving the Polyline Profile

After moving the polyline profile to the bottom end of the 3D polyline path, your drawing should appear similar to Figure 12-16.

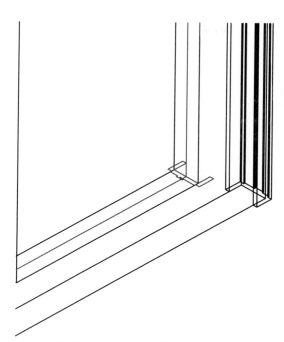

**Figure 12-16**   Polyline Profile After Using the **MOVE** Command

We will now extrude the profile along the 3D polyline path.

| Prompt | Response |
|---|---|
| Command: | *Select the **EXTRUDE** icon* |
| EXTRUDE | |
| Current wireframe density: ISOLINES = 4 | |
| Select objects to extrude: | *Pick the profile* |
| 1 found | |
| Select objects to extrude: | Type: **<Enter ↵>** |
| Specify height of extrusion or | |
| [Direction/Path/Taper angle]: | Type: **P <Enter ↵>** |
| Select extrusion path or [Taper angle]: | *Pick the 3D polyline* |

Your drawing should appear similar to Figure 12-17. Use the **HIDE** command to produce a view similar to Figure 12-18.

To complete the fixed glass panel, we need to draw the solid representing the glass. Create a new layer for the glass solid, and make it current. Change to the plan view, World UCS, and zoom closely around the left side of the fixed glass panel with the casing. We will draw a closed polyline rectangle inside the glass stops, then extrude the rectangle $6'1\frac{1}{2}''$. Before you begin drawing, erase the 3D polyline path used to extrude the fixed glass panel casing profile.

| Prompt | Response |
|---|---|
| Command: | *Select **Plan View**, **World UCS** from the **Menu** Browser, **View** menu, **3D Views** flyout* |
| Command: | *Select **Zoom Window** from the **Ribbon**, **View** tab, **Navigation** menu* |
| ZOOM | |

Figure 12-17      Completed Fixed Glass Panel Casing

Figure 12-18      Hidden View of the Fixed Glass Panel Casing

Specify corner of window, enter a scale
   factor (nX or nXP), or [All/Center/Dynamic/
   Extents/Previous/Scale/Window/Object]
   <real time>:
Specify opposite corner:

*Pick a window closely surrounding the left
  side fixed glass panel with the casing (see
  Figure 12-19)*

**Figure 12-19**    Object to Erase and Selection Points for the Glass Polyline

| Prompt | Response |
| --- | --- |
| Command: | *Select **ERASE** from the **Modify** menu* |
| ERASE | |
| Select objects: | *Pick the end of the 3D polyline* |
| 1 found | |
| Select objects: | Type: **<Enter ↵>** |

| Prompt | Response |
| --- | --- |
| Command: | *Select the **POLYLINE** icon* |
| Specify start point: | *With **Osnap** on, pick the left lower inside end of the glass stop (see Figure 12-19)* |
| Current line width is 0'-0" | |
| Specify next point or [Arc/Halfwidth/ Length/Undo/Width]: | *Pick the left upper inside end of the glass stop* |
| Specify next point or [Arc/Close/ Halfwidth/Length/Undo/Width]: | Type: **'Z** *(transparent zoom)* **<Enter ↵>** |
| Specify corner of window, enter a scale factor (nX or nXP), or [All/Center/Dynamic/Extents/Previous/ Scale/Window/Object] <real time>: | Type: **D** *(dynamic)* **<Enter ↵>** *and zoom to the right side (see Figure 12-20)* |
| Resuming PLINE command. | |
| Specify next point or [Arc/Close/ Halfwidth/Length/Undo/Width]: | *Pick the right upper inside end of the glass stop* |
| Specify next point or [Arc/Close/Halfwidth/ Length/Undo/Width]: | *Pick the right lower end of the glass stop* |
| Specify next point or [Arc/Close/Halfwidth/ Length/Undo/Width]: | Type: **C <Enter ↵>** *(to close the polyline)* |

We need to extrude the closed polyline shape to complete this fixed glass panel. Using the **l** (last) option makes selecting the polyline shape very easy.

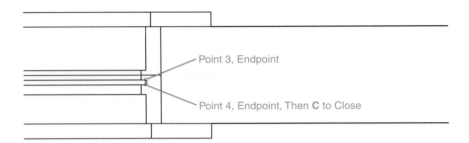

**Figure 12-20** Selection Points for the Right Side of the Glass Polyline

Point 3, Endpoint

Point 4, Endpoint, Then **C** to Close

| Prompt | Response |
|--------|----------|
| Command: | *Select the **EXTRUDE** icon* |
| EXTRUDE | |
| Current wireframe density: ISOLINES = 4 | |
| Select objects to extrude: | Type: **l** *(last)* **<Enter ↵>** |
| 1 found | |
| Select objects to extrude: | Type: **<Enter ↵>** |
| Specify height of extrusion or | |
| [Direction/Path/Taper angle]: | Type: **6′1-1/2<Enter ↵>** |

To verify that the glass was placed at the correct location and extruded the appropriate distance in the +Z direction, change to a NE isometric view (**VPOINT**, then **1,1,1**, or select **NE Isometric** from the **Menu Browser**, **View** menu, **3D Views** flyout) and use the **HIDE** command. Your drawing should be similar to Figure 12-21. Oops, we made a mistake! When using **Osnap** options, such as **Osnap**, **Endpoint** used previously, you need to watch the coordinate display to verify that you are selecting the desired end of the object. This mistake is not uncommon; we will just move it to the appropriate location.

Before we proceed, we need to correct the last mistake. Use the **MOVE** command to move the glass solid down (in the –Z direction) $6'1\frac{1}{2}''$. You can also use the **3DMOVE** grip tool to accomplish this task by selecting the grip tool, placing the grip tool at a top endpoint of the fixed glass, highlighting the Z axis, moving the mouse downward (–Z direction), and typing **−6′1-1/2″**.

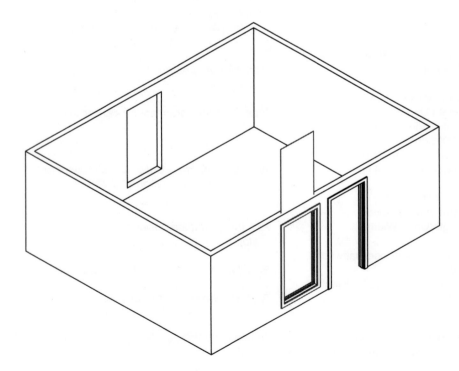

**Figure 12-21** Hidden View of the Completed Fixed Glass Panel

| Prompt | Response |
|---|---|
| Command: | Type: **m** *(move)* **<Enter ⏎>** |
| MOVE | |
| Select objects: | *Pick the glass solid* |
| 1 found | |
| Select objects: | Type: **<Enter ⏎>** |
| Specify base point or | |
| [Displacement] <Displacement>: | Type: **0,0,0 <Enter ⏎>** |
| Specify second point or | |
| <use first point as displacement>: | Type: **0,0,–6'1-1/2 <Enter ⏎>** |

Use the **HIDE** command at this point. Your drawing should appear similar to Figure 12-22. It appears that the mistake has been corrected.

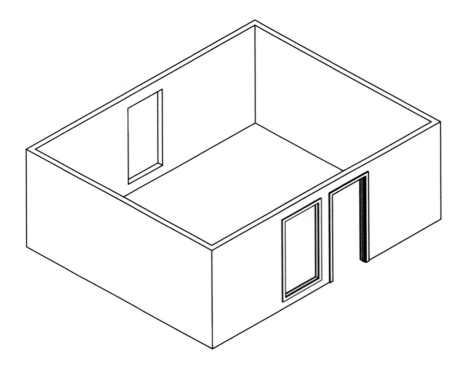

**Figure 12-22**    Glass Solid
After Correcting the Mistake

Rather than repeating the process used to draw the fixed glass panel casing profile, extruding the profile, and creating the glass solid, it will be much more time-efficient to use the **COPY** command to produce the casing and glass for the other fixed glass panel. The fixed glass panel casing and glass solid need to be rotated and copied. We will copy the glass panel casing and glass solid to a point in the middle of the office, rotate both (as one copy) 180°, and then move the copy to the opening on the opposite wall. Change to the plan view, **Zoom All**, then proceed.

| Prompt | Response |
|---|---|
| Command: | Type: **cp <Enter ⏎>** *(or select the **COPY** icon from the **Menu Browser, Modify** menu)* |
| COPY | |
| Select objects: | *With a standard window (pick window points left to right) select the fixed glass panel (see Figure 12-23)* |
| Specify opposite corner: 2 found | |
| Select objects: | Type: **<Enter ⏎>** |
| Current settings: Copy mode = Multiple | |

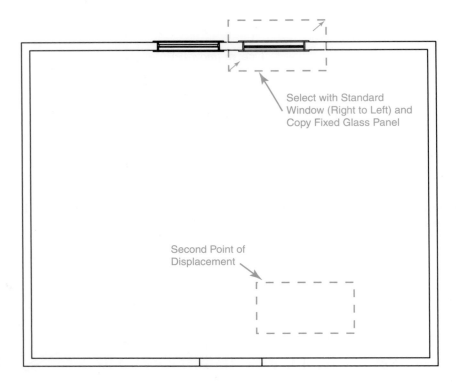

**Figure 12-23** Selection Set for Use with the Fixed Glass Panel **COPY** Command

Specify base point or
  [Displacement/mOde] <Displacement>:           *Pick a point near the panel (with **Osnap** off)*
Specify second point
  or <use first point as displacement>:          *Pick a point in the middle of the office*
Specify second point or [Exit/Undo] <Exit>:     Type: **<Enter ↵>**

---

The fixed glass panel sill dimensions are different on the outside than they are on the inside, so we need to rotate the panel 180°.

| Prompt | Response |
|---|---|
| Command: | Type: **ro <Enter ↵>** *(or select **ROTATE** from the **Menu Browser**, **Modify** menu)* |
| ROTATE<br>Current positive angle in UCS:<br>  ANGDIR = counterclockwise, ANGBASE = 0<br>Select objects: | *With a standard window, select the copy of the fixed glass panel* |
| Specify opposite corner: 2 found<br>Select objects: | Type: **<Enter ↵>** |
| Specify base point: | *With **Osnap** off, pick a point near the center of the copied fixed glass panel* |
| Specify rotation angle or<br>  [Copy/Reference] <0>: | Type: **180 <Enter ↵>** |

---

To make moving the copied fixed glass panel easier, change the view to SW isometric, and zoom closely around the bottom of the fixed glass panel.

| Prompt | Response |
|---|---|
| Command: | *Select **SW Isometric** from the **Menu Browser**, **View** menu, **3D Views** flyout* |
| Command: | *Select the **Zoom Window** icon from the* |

*Ribbon, View tab, Navigation menu*

ZOOM
Specify corner of window, enter a scale
    factor (nX or nXP), or [All/Center/
    Dynamic/ Extents/Previous/Scale/
    Window/Object] <real time>:
Specify opposite corner:

*With a window, select the bottom portion of
the fixed glass panel (see Figure 12-24)*

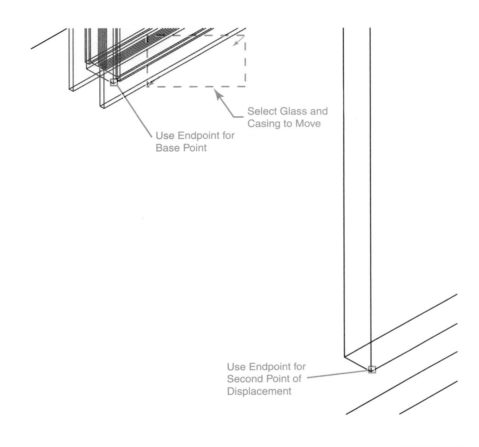

Select Glass and
Casing to Move

Use Endpoint for
Base Point

Use Endpoint for
Second Point of
Displacement

**Figure 12-24**  Selection
Set for Moving the Fixed
Glass Panel

| Prompt | Response |
|---|---|
| Command: | *Select **MOVE** from the **Ribbon**, **Home** tab, **Modify** menu* |
| MOVE Select objects: | *With a crossing window (pick window right to left), select the glass and casing* |
| Specify opposite corner: 2 found Select objects: | *Type: <**Enter ↵**>* |
| Specify base point or [Displacement] <Displacement>: | *With **Osnap** on, pick the bottom endpoint of the sill plate* |
| Specify second point or <use first point as displacement>: | *With **Osnap** on, pick the outside bottom endpoint of the opening* |

Use **Zoom All.** Your drawing should appear similar to Figure 12-25.

We need to add a solid representing the door. While in a SW isometric view, zoom around the inside bottom portion of the door casing. Draw and extrude a closed polyline rectangle for the door; use the door casing as a guide (see Figure 12-26).

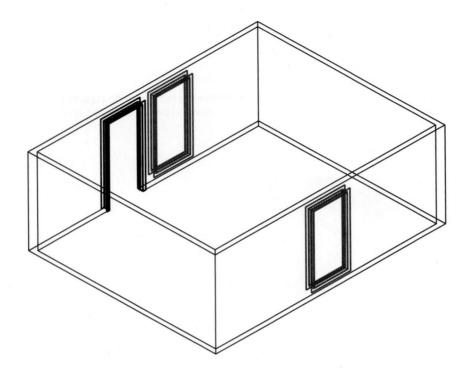

**Figure 12-25** Office Drawing with Completed Fixed Glass Panels

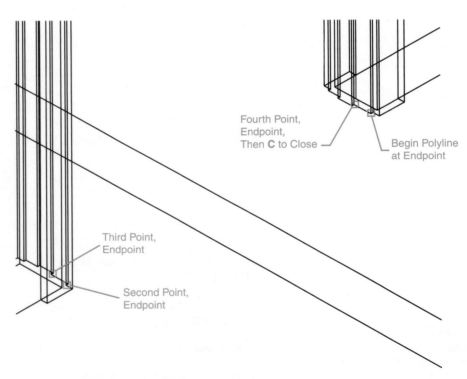

**Figure 12-26** Selection Points for Drawing the Door Polyline

| Prompt | Response |
| --- | --- |
| Command: | *Select the **POLYLINE** icon* |
| PLINE | |
| Specify start point: | *With **Osnap** on, pick the outside endpoint of the outside right doorjamb, use '**Z** if necessary, and zoom in close (see Figure 12-26)* |

Current line width is 0'-0"
Specify next point or [Arc/Halfwidth/
    Length/Undo/Width]:                          *Pick the endpoint of the outside left
                                                        doorjamb*

Specify next point or [Arc/Close/
    Halfwidth/Length/Undo/Width]:                *Pick the endpoint of the inside left
                                                        doorjamb*

Specify next point or [Arc/Close/
    Halfwidth/Length/Undo/Width]:                *Pick the endpoint of the right doorjamb*

Specify next point or [Arc/Close/
    Halfwidth/Length/Undo/Width]:                Type: **C <Enter ↵>** *(to close the polyline)*
Command:                                         *Select the* **EXTRUDE** *icon*
EXTRUDE
Current wire frame density: ISOLINES = 4
Select objects to extrude:                       Type: **I** *(last)* **<Enter ↵>**
1 found
Select objects to extrude:                       Type: **<Enter ↵>**
Specify height of extrusion or
    [Direction/Path/Taper angle]:                Type: **7' <Enter ↵>**

Use the **ZOOM** command and zoom to include the door and fixed glass panel. Use the
**HIDE** command to verify that the door solid is correctly drawn and extruded. Your drawing
should appear similar to Figure 12-27.

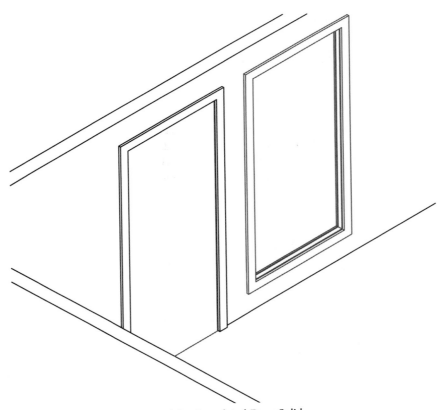

**Figure 12-27**    Hidden View of the Completed Door Solid

To complete the door, we need to draw and place a doorknob on the inside of the door. To
produce the doorknob, we will draw and extrude three concentric circles, rotate the circles with
the **3DROTATE** command, and move the extruded circles to the face of the door.

| CIRCLE | |
|---|---|
| **Ribbon/ Home tab/ Draw/ Circle** |  |
| **Menu** | Draw/ Circle |
| **Toolbar: Draw** | |
| **Command Line** | circle |
| **Alias** | c |

| Prompt | Response |
|---|---|
| Command: | *Select the **CIRCLE** icon* |
| CIRCLE | |
| Specify center point for circle or [3P/2P/Ttr (tan tan radius)]: | *Pick a point in front of the door (see Figure 12-28)* |
| Specify radius of circle or [Diameter] <0'-0">: | Type: **2.5 <Enter ↵>** |
| Command: | *Select the **EXTRUDE** icon* |
| EXTRUDE | |
| Current wire frame density: ISOLINES = 4 | |
| Select objects to extrude: | Type: **I** *(last)* **<Enter ↵>** |
| 1 found | |
| Select objects to extrude: | Type: **<Enter ↵>** |
| Specify height of extrusion or [Direction/Path/Taper angle] <0'-3">: | Type: **1/4 <Enter ↵>** |
| Command: | *Select the **CIRCLE** icon* |
| CIRCLE Specify center point for circle or [3P/2P/Ttr (tan tan radius)]: | *With **Osnap** on, pick the top center of the last circle* |
| Specify radius of circle or [Diameter] <0'-2½">: | Type: **1 <Enter ↵>** |
| Command: | *Select the **EXTRUDE** icon* |
| EXTRUDE | |
| Current wire frame density: ISOLINES = 4 | |
| Select objects to extrude: | Type: **I** *(last)* **<Enter ↵>** |
| 1 found | |
| Select objects to extrude: | Type: **<Enter ↵>** |
| Specify height of extrusion or [Direction/Path/Taper angle] <0'-0¼">: | Type: **1 <Enter ↵>** |

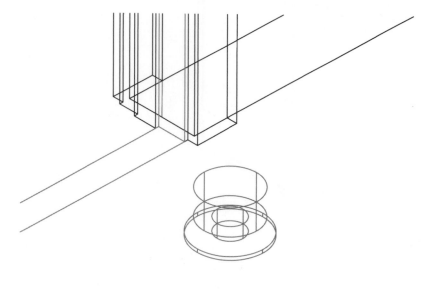

**Figure 12-28**    Concentric Extruded Circles for the Doorknob

| Prompt | Response |
|---|---|
| Command:<br>CIRCLE | Select the **CIRCLE** icon |
| Specify center point for circle<br>  or [3P/2P/Ttr (tan tan radius)]: | With **Osnap** on, pick the top center of the 1″<br>  extrusion |
| Specify radius of circle or<br>  [Diameter] <0′-1″>: | Type: **2 <Enter ↵>** |
| Command:<br>EXTRUDE | Select the **EXTRUDE** icon |
| Current wire frame density: ISOLINES = 4 | |
| Select objects to extrude:<br>1 found | Type: **I** *(last)* **<Enter ↵>** |
| Select objects to extrude: | Type: **<Enter ↵>** |
| Specify height of extrusion or<br>  [Direction/Path/Taper angle] <0′-1″>: | Type: **2 <Enter ↵>** |

In this next step, we will use the **3DROTATE** grip tool to rotate the doorknob so that it is parallel with the door. Then, we will use the **MOVE** command to move the doorknob to the inside face of the door 5″ from the doorjamb and 36″ from the floor. It will be easier to rotate and move the doorknob if it is one object, rather than three concentric extruded circles. Begin this process by using the **UNION** command to join the three extruded circles.

| Prompt | Response |
|---|---|
| Command:<br>UNION | Select the **UNION** icon |
| Select objects: Specify opposite corner: | With a crossing window, select the three<br>  extruded circles |
| 3 found | |
| Select objects: | Type: **<Enter ↵>** |
| Command: | Select the **3DROTATE** icon |
| Command: _3drotate | |
| Current positive angle in UCS:<br>  ANGDIR = counterclockwise, ANGBASE = 0 | |
| Select objects: | Pick the doorknob |
| Select objects: 1 found | |
| Specify base point: | With **Osnap** on, place the grip tool at the center<br>  of the bottom circle (see Figure 12-29) |
| Pick a rotation axis: | Highlight the X axis |

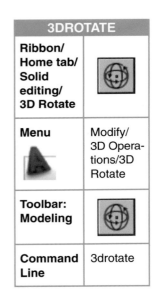

| UNION | | |
|---|---|---|
| Ribbon/<br>Home tab/<br>Solid edit-<br>ing/Union | | ⬭⬭ |
| Menu | | Modify/<br>Solid<br>Editing/<br>Union |
| Toolbar:<br>Modeling | | ⬭⬭ |
| Command<br>Line | | union |
| Alias | | uni |

| 3DROTATE | | |
|---|---|---|
| Ribbon/<br>Home tab/<br>Solid<br>editing/<br>3D Rotate | | |
| Menu | | Modify/<br>3D Opera-<br>tions/3D<br>Rotate |
| Toolbar:<br>Modeling | | |
| Command<br>Line | | 3drotate |

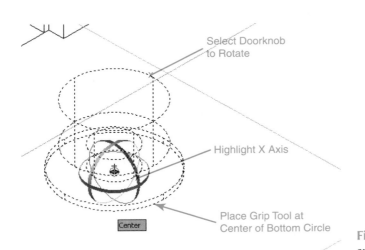

Select Doorknob<br>to Rotate

Highlight X Axis

Place Grip Tool at<br>Center of Bottom Circle

Center

**Figure 12-29**    Object Selection<br>and **3DROTATE** Grip Tool Placement

Specify angle start point or type an angle:                      Type: **90 <Enter ↵>**
Current positive angle: ANGDIR =
   counterclockwise, ANGBASE = 0
Select objects:
1 found
Select objects:                                                  Type: **<Enter ↵>**
Specify first point on axis or define axis by
   [Object/Last/View/Xaxis/
   Yaxis/Zaxis/2points]:                                         Type: **X <Enter ↵>**
Specify a point on the X axis <0,0,0>:                           Type: **CEN <Enter ↵>**
of                                                               *Pick the center of the bottom circle*
Specify rotation angle or [Reference]:                           Type: **90 <Enter ↵>**

After you rotate the doorknob, your drawing should appear similar to Figure 12-30.

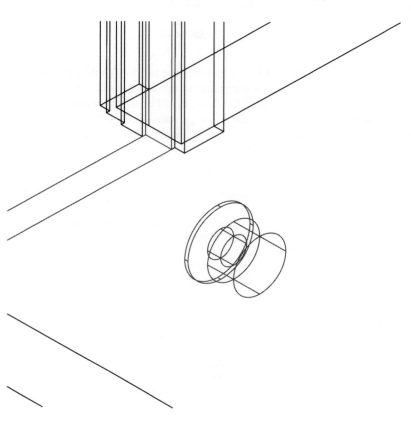

**Figure 12-30** Doorknob
After Using the **3DROTATE**
Command

| Prompt | Response |
|---|---|
| Command:<br>MOVE | Type: **m** *(move)* **<Enter ↵>** |
| Select objects:<br>1 found | *Pick the doorknob (see Figure 12-31)* |
| Select objects: | Type: **<Enter ↵>** |
| Specify base point or [Displacement]<br>   <Displacement>: | *With **Osnap** on, pick the center of the large outside circle* |
| Specify second point or<br>   <use first point as displacement>: | Type: **FROM <Enter ↵>** |
| Base point: | *With **Osnap** on, pick the inside endpoint of the bottom of the door (zoom in with '**Z** if necessary)* |
| <Offset>: | Type: **@−5,0,36 <Enter ↵>** |

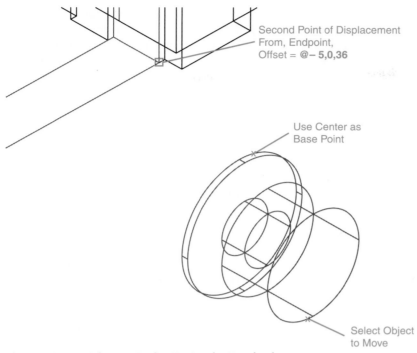

Second Point of Displacement
From, Endpoint,
Offset = @− 5,0,36

Use Center as
Base Point

Select Object
to Move

**Figure 12-31**    Selection Set for Moving the Doorknob

Use the **ORBIT** and **HIDE** commands to produce a view similar to Figure 12-32.

**Figure 12-32**    Hidden Orbital View of the Completed Doorknob

Our office space is almost complete. We need to add a $\frac{3}{4}'' \times 3''$ base trim around the base of the walls. We will create a path using the **POLYLINE** command, and then we will draw a closed polyline shape representing the base trim. We will use the **SWEEP** command to sweep the base

trim profile around the perimeter of the room. The **SWEEP** command allows you to create a 3D solid or surface by sweeping a 2D curve along a path. Change to a SW isometric view and draw a polyline beginning at the inside bottom endpoint of the door trim. The polyline should be drawn around the perimeter of the wall base, and it should terminate at the opposite side of the door trim endpoint. It may be helpful to use **'Z** (transparent **ZOOM**) to move between the endpoints of each section of the base polyline while in the **POLYLINE** command sequence.

| Prompt | Response |
|---|---|
| Command:<br>PLINE | Select the **POLYLINE** icon |
| Specify start point: | With **Osnap** on, pick the inside bottom endpoint of the door trim (see Figure 12-33) |
| Current line width is 0'-0"<br>Specify next point or [Arc/Halfwidth/<br>Length/Undo/Width]: | Pick the endpoint of the left wall intersection |
| Specify next point or [Arc/Close/<br>Halfwidth/Length/Undo/Width]: | Pick the endpoint of the next wall intersection |
| Specify next point or [Arc/Close/<br>Halfwidth/Length/Undo/Width]: | Pick the endpoint of the next wall intersection |
| Specify next point or [Arc/Close/<br>Halfwidth/Length/Undo/Width]: | Pick the endpoint of the next wall intersection |
| Specify next point or [Arc/Close/<br>Halfwidth/Length/Undo/Width]: | Pick the endpoint of the inside bottom corner of the door trim |
| Specify next point or [Arc/Close/<br>Halfwidth/Length/Undo/Width]: | Type: **<Enter ↵>** |

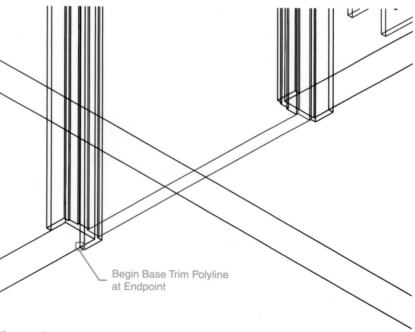

Begin Base Trim Polyline
at Endpoint

**Figure 12-33**     Selection Points for the Base Trim Polyline

Use the **POLYLINE** command to draw a profile representing the base trim (see Figure 12-34). Use the **FILLET** command to place a $\frac{1}{2}$" rounded corner on the base trim profile, as illustrated in Figure 12-35.

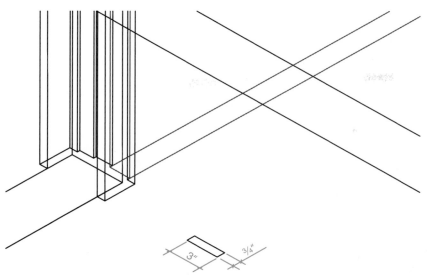

**Figure 12-34**    Selection Points for the Base Trim Profile Polyline

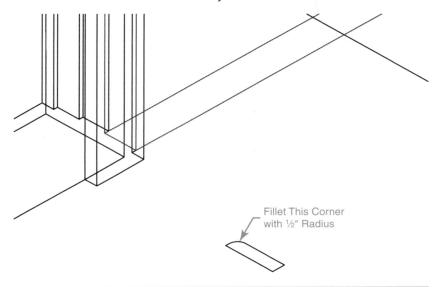

Fillet This Corner
with ½" Radius

**Figure 12-35**    Selection
Corner for Use with the
**FILLET** Command

| Prompt | Response |
|---|---|
| Command: | *Select the **POLYLINE** icon* |
| PLINE | |
| Specify start point: | *Pick a point in front of the left doorjamb to begin the **POLYLINE** (see Figure 12-34)* |
| Current line width is 0'-0" | |
| Specify next point or [Arc/Halfwidth/Length/Undo/Width]: | Type: **@3/4<0 <Enter ↵>** *(or with **Ortho** on, move the mouse in the appropriate direction and type in the desired distance* |
| Specify next point or [Arc/Close/Halfwidth/Length/Undo/Width]: | Type: **@3<90 <Enter ↵>** |
| Specify next point or [Arc/Close/Halfwidth/Length/Undo/Width]: | Type: **@3/4<180 <Enter ↵>** |
| Specify next point or [Arc/Close/Halfwidth/Length/Undo/Width]: | Type: **C <Enter ↵>** *(to close the polyline)* |

| SWEEP | |
|---|---|
| **Ribbon/ Home tab/ 3D Modeling/Sweep** | |
| **Menu** | Draw/ Modeling/ Sweep |
| **Toolbar: Modeling** | |
| **Command Line** | sweep |

On your own, use the **FILLET** command to place a ½" rounded edge on the corner, as illustrated in Figure 12-35. Use the **SWEEP** command to sweep the base trim profile around the perimeter of the room.

| Prompt | Response |
|---|---|
| Command: | *Select the **SWEEP** icon* |
| Command: SWEEP | |
| Current wire frame density: ISOLINES = 4 | |
| Select objects to sweep: | *Pick the base trim profile (see Figure 12-36)* |
| Select objects to sweep: 1 found | *Type: **<Enter ↵>*** |
| Select sweep path or [Alignment/ | |
|    Base point/Scale/Twist]: | *Type: **B <Enter ↵>*** |
| Specify base point: | *With **Osnap** on, pick the endpoint opposite the rounded corner* |
| Select sweep path or [Alignment/ | |
|    Base point/Scale/Twist]: | *Pick the perimeter polyline* |

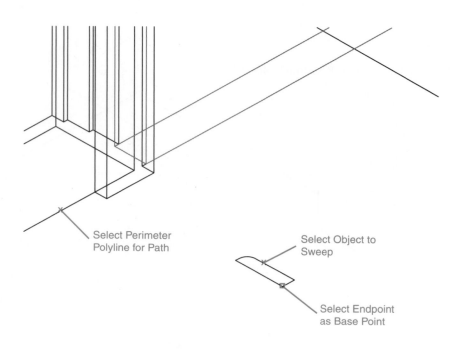

Select Perimeter
Polyline for Path

Select Object to
Sweep

Select Endpoint
as Base Point

**Figure 12-36**  Selection Set for Use with the **SWEEP** Command

Use the **ZOOM** command to widen the view. Your drawing should appear similar to Figure 12-37.

To complete the office space drawing, we need to produce a solid for the ceiling. Using an extruded polyline will work because we are concerned with only interior perspectives. While in this isometric view, **Zoom All**, and begin the polyline process to create a closed polyline.

| Prompt | Response |
|---|---|
| Command: | *Select the **POLYLINE** icon* |
| PLINE | |
| Specify start point: | *With **Osnap**, **Endpoint**, pick the top outside corner of the lower right wall* |
| Current line width is 0'-0" | |
| Specify next point or [Arc/Halfwidth/ | |
|    Length/Undo/Width]: | *With **Osnap**, **Endpoint**, pick the top outside corner of the upper right wall* |
| Specify next point or [Arc/Close/ | |
|    Halfwidth/Length/Undo/Width]: | *With **Osnap**, **Endpoint**, pick the top outside corner of the upper left wall* |
| Specify next point or [Arc/Close/ | |
|    Halfwidth/Length/Undo/Width]: | *With **Osnap**, **Endpoint**, pick the top outside corner of the lower left wall* |

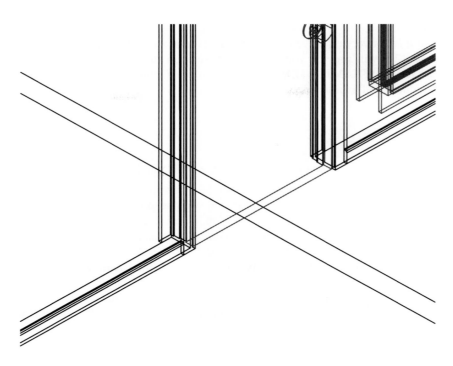

**Figure 12-37**  Base Trim After Using the **SWEEP** Command

| | |
|---|---|
| Specify next point or [Arc/Close/ Halfwidth/Length/Undo/Width]: | Type: **C** <Enter ↵> *(to close the polyline)* |
| Command: | Type: **ext** <Enter ↵> *(or select the **EXTRUDE** icon)* |
| EXTRUDE | |
| Current wire frame density: ISOLINES = 4 | |
| Select objects to extrude: | Type: **l** *(last)* <Enter ↵> |
| 1 found | |
| Select objects to extrude: | Type: <Enter ↵> |
| Specify height of extrusion or [Direction/Path/Taper angle] <0′-3″>: | Type: **1** <Enter ↵> |

**Zoom All**, and use the **HIDE** command. Your drawing should appear similar to Figure 12-38.

**Figure 12-38**  Hidden Isometric View of the Office Space

An isometric view is fine for looking at the outside of the office space in a wireframe view, but it is not very effective for looking at a hidden view of the inside of the space. Chapter Exercise 12-1 will provide you with an introduction to producing a 2D working plan using the **DVIEW (DYNAMIC VIEW)** command with a *clipping plane*. You will also be introduced to the production of a hidden perspective view.

## CHAPTER EXERCISE

### Exercise 12-1: Learn to Produce Perspective Views with DVIEW

We will use the **DVIEW** command to produce a perspective view of the inside of the office space and a working 2D plan view (sectional view with the top half of the office removed with a clipping plane). The **DVIEW** command allows you to define parallel projection or perspective views by using *a camera and a target. Once the DVIEW command has been invoked, you are given the following options: CAmera/TArget/Distance/POints/PAn/Zoom/TWist/CLip/Hide/Off/Undo. For this introduction,* we will use the **Points** option to specify the **CAmera** and **TArget**, enter a numerical value for **Distance**, and set a front clipping plane at a point just inside the office space. Use the following instructions to look at the office space as a hidden line perspective. Change to plan view (Type: **plan <Enter ↵>**, or select **Plan View**, **World UCS** from the **Menu Browser**, **View** menu, **3D Views** flyout) and begin.

| Prompt | Response |
|---|---|
| Command: | Type: **DVIEW: <Enter ↵>** |
| Select objects or <use DVIEWBLOCK>: | |
| Specify opposite corner: | *With a window, select the entire office space* |
| 16 found | |
| Select objects or <use DVIEWBLOCK>: | Type: **<Enter ↵>** |
| Enter option | |
|    [CAmera/TArget/Distance/POints/ | |
|    PAn/Zoom/TWist/CLip/Hide/Off/Undo]: | Type: **PO <Enter ↵>** |
| Specify target point <0″, 0″, 0″>: | *Move your cursor near the door, look at the coordinate display, and enter the location in the X,Y,Z format (for z, Type: **5′6**). The target location coordinates for this drawing should be about 20′5,26′5,5′6. Type: <Enter ↵>* |
| Specify camera point <0″, 0″, 0″>: | *Move your cursor near the bottom wall, look at the coordinate display, and enter the location in the X,Y,Z format (for z, Type: **5′6**). The camera location coordinates for this drawing should be about 20′5,10′8,5′6* Type: **<Enter ↵>** |

The view produced at this point is an elevation view looking from the bottom wall toward the door wall. To produce a perspective view, we need to continue in **DVIEW** and set a distance. After we set an appropriate distance in which to view the office (approximately 45′–50′), we must set a front clipping plane inside the camera side of the office wall. Remember, the office is 16′-0″ in this direction, so the clipping plane distance from the target cannot exceed this distance. Continue in **DVIEW** mode and set the distance and clipping plane. If you accidentally exit **DVIEW**, repeat the above steps and continue.

| Prompt | Response |
|---|---|
| [CAmera/TArget/Distance/POints/ | |
|    PAn/Zoom/TWist/CLip/Hide/Off/Undo]: | Type: **D <Enter ↵>** |
| Specify new camera-target distance <0′-0″>: | Type: **50′ <Enter ↵>** |
| Enter option | |
| [CAmera/TArget/Distance/POints/PAn/ | |
|    Zoom/TWist/CLip/Hide/Off/Undo]: | Type: **CL <Enter ↵>** |

| | |
|---|---|
| Enter clipping option | |
| [Back/Front/Off] <Off>: | Type: **F <Enter ↵>** |
| Specify distance from target or | |
| [set to Eye(camera)] <50'-0">: | Type: **15' <Enter ↵>** |
| Enter option | |
| [CAmera/TArget/Distance/POints/PAn/ | |
| Zoom/TWist/CLip/Hide/Off/Undo]: | Type: **H <Enter ↵>** |
| Enter option | |
| [CAmera/TArget/Distance/POints/PAn/ | |
| Zoom/TWist/CLip/Hide/Off/Undo]: | Type: **<Enter ↵>** |

Your hidden line perspective should appear similar to Figure 12-39.

**Figure 12-39**    Hidden Line Perspective View of the Office Space

Having the capability to return to a specific view can be very beneficial in the development of a project. To save a view such as the perspective we just created, type **View** at the command prompt immediately after exiting **DVIEW**. The **View Manager** dialog box will appear on the screen (see Figure 12-40). In the **View Manager** dialog box, select the **New** tab. The **New View** dialog box (see Figure 12-41) will show on the screen. Type in a name for the view in the **View Name** bar and select **Close** to return the drawing screen.

**Figure 12-40    View Manager** Dialog Box

To produce a working plan (plan view with the top half of the walls clipped), we will use a similar process. The primary difference is that the target point is in the center of the office at elevation 0, and the camera point is directly above the target at elevation 20'; distance is not used. Set the clipping plane to **Front** at a distance of about 4'. If we were to set **Distance** in this view, we would produce a bird's-eye perspective. Return to the plan view and repeat the **DVIEW** process.

**Figure 12-41**    **New View** Dialog Box

| Prompt | Response |
|---|---|
| Command: | Type: **DVIEW <Enter ↵>** |
| Select objects or <use DVIEWBLOCK>: | *With a window, select the entire office* |
| Specify opposite corner: 16 found | |
| Select objects or <use DVIEWBLOCK>: | Type: **<Enter ↵>** |
| Enter option | |
| [CAmera/TArget/Distance/POints/PAn/ | |
| Zoom/TWist/CLip/Hide/Off/Undo]: | Type: **PO <Enter ↵>** |
| Specify target point <0, 0, 0>: | Type: **20′,18′,0 <Enter ↵>** |
| Specify camera point <0, 0, 0>: | Type: **20′,18′,20′ <Enter ↵>** |
| Enter option | |
| [CAmera/TArget/Distance/POints/ | |
| PAn/Zoom/TWist/CLip/Hide/Off/Undo]: | Type: **CL <Enter ↵>** |
| Enter clipping option | |
| [Back/Front/Off] <Off>: | Type: **F <Enter ↵>** |
| Specify distance from target or | |
| [set to Eye(camera)/ON/OFF] <20′-0″>: | Type: **4′ <Enter ↵>** |
| Enter option | |
| [CAmera/TArget/Distance/POints/ | |
| PAn/Zoom/TWist/CLip/Hide/Off/Undo]: | Type: **<Enter ↵>** |
| Command: | Type: **HIDE <Enter ↵>** |

Your drawing should appear similar to Figure 12-42.

To conclude Chapter Exercise 12-1, we will produce a conceptual perspective view of the office space using the **Visual Styles Manager** dialog box. Create new layers for the walls, trim, glass, door, and ceiling. Use the **CHANGE**, **Properties** command to place the walls, trim, glass, door, and ceiling on the new layers created for each entity or object group.

**Figure 12-42**    Working 2D Plan View Using **DVIEW**

To create a new layer, from the **Menu Browser**, **Format** menu, select **Layer**, or at the command prompt, type **layer**. In the **Layer Properties Manager** dialog box, click the **New Layer** button. A layer name, such as **LAYER1**, is automatically added to the layer list. Enter a new layer name by typing over the highlighted layer name. To change an object's property, at the command prompt, type **Change <Enter ↵>**, then **Properties <Enter ↵>**, then **Layer <Enter ↵>**, then type in the layer name you wish the object to be placed on.

After you place the objects on the layers, select **Layer** from the **Menu Browser**, **Format** menu, and change the colors of each of the new layers. From the **Visual Styles Manager** dialog box, select **Conceptual.** Your drawing should appear similar to Figure 12-43.

**Figure 12-43**    Conceptual Perspective View of the Office Space

## SUMMARY

This chapter provided you with additional practice using the **BOUNDARY, POLYLINE, EXTRUDE,** and **SUBTRACT** commands. You gained an introductory knowledge base for producing 3D solids through two extrusion methods: using the **SWEEP** command to sweep a closed polyline shape along a path and using the **EXTRUDE** command to extrude a closed polyline around a path.

By working through Chapter Exercise 12-1, you learned how to produce a 2D working plan of a 3D space. You also learned how to produce and manipulate elevation

and perspective views of a 3D space using the **DVIEW** command.

In Chapter 13, you will learn how to use the **INSERT** command to furnish the office space with furnishings completed in previous chapters. You will also learn to view the furnished office space three-dimensionally using the **VIEW**, **DVIEW**, and **CAMERA** commands.

## CHAPTER TEST QUESTIONS

### Multiple Choice

1. The **BOUNDARY** command allows you to create which of the following from an enclosed area?

   a. A rectangular shape from a circular shape
   b. A region or a polyline from an enclosed area
   c. An extruded circle
   d. A 3D solid
   e. An open polyline

2. Which of the following is *not* a **DVIEW** option?

   a. **Camera**
   b. **Clip**
   c. **Target**
   d. **Copy**
   e. **Hide**

3. To save a view, you should type in which of the following at the command prompt?

   a. **Save**
   b. **View**
   c. **Image**
   d. **Dview**
   e. **Properties**

4. While in **DVIEW**, after picking a camera and a target point, which of the following **DVIEW** options must you use to produce a perspective view?

   a. **Hide**
   b. **Shade**
   c. **Twist**
   d. **Distance**
   e. **Clip**

5. Which of the following is required to sweep an object along a path?

   a. A 2D curve and a path
   b. A 3D solid and a path
   c. An object that contains no curved sections
   d. A helix-shaped object
   e. An object located above the XY plane

### Matching

**Column A**

a. **DVIEW**

b. **SWEEP**

c. **EXTRUDE**

d. **SUBTRACT**

e. **BOUNDARY**

**Column B**

1. Creates a region or a polyline from an enclosed area

2. Defines parallel projection or perspective views by using a camera and a target

3. Combines selected regions or solids by subtraction

4. Creates a 3D solid or surface by extruding an object or planar face a specified distance and in a specified direction

5. Creates a 3D solid or surface by sweeping a 2D curve along a path

### True or False

1. T or F: Typing **VIEW** at the command prompt retrieves the **View Manager** dialog box.

2. T or F: The **SWEEP** command allows you to sweep 3D solids along a path.

3. T or F: You can extrude a closed polyline along a path.

4. T or F: You cannot extrude an open polyline.

5. T or F: You cannot save a view created with the **DVIEW** command.

# Furnishing the Office Space 13

## Chapter Objectives

- Practice using the **INSERT** command
- Practice using the **MOVE** and **ROTATE** commands
- Learn to use the **VIEW** command
- Practice using the **DVIEW** command
- Learn to use the **CAMERA** command

## INTRODUCTION

In this chapter, we will use the **INSERT** command to insert the interior components—the furniture and other interior design objects—drawn in the previous chapters. We will insert the components and use the **ROTATE** and **MOVE** commands to place the objects. After inserting the components, we will produce various interior views using the **DVIEW** and **CAMERA** commands.

## DRAWING SETUP

Drawing setup for this chapter will not be necessary.

## BEGIN DRAWING

To begin, open the drawing that you created in Chapter 12, "Building an Office Space." After opening the drawing, save the drawing as **Chapter 13 Furnishing the Office Space** with the **SAVEAS** command. If necessary, change the view to plan view by typing **plan**, World UCS, at the command prompt, or by selecting **Plan View, World UCS** from the **Menu Browser**, **View** menu, **3D Views** flyout. Select the **2D Wireframe Visual Style** from the **Ribbon**, **Home** tab, **View** menu. It may also be necessary to turn off the clipping plane by typing **DVIEW**, selecting the space with a window, then typing **CL**, then **OFF**, and **REGEN**. Your drawing should appear similar to Figure 13-1.

Begin by inserting the desk that you drew in Chapter 6. Make sure that **Osnap** is off. Be careful when inserting and moving 3D objects in a drawing. If **Osnap** is on, you might unintentionally relocate an object by osnapping to an entity rather than selecting a point on the XY plane.

Figure 13-1    Plan View of Chapter 13 Furnishing the Office Space

Figure 13-2    Insert Block Using the **Ribbon**

| Prompt | Response |
|---|---|
| Command: | *From the **Ribbon**, **Blocks & References** tab, left-click on **Insert** (see Figure 13-2). If necessary, click on **Browse** and select the desk drawing file. Click open in the **Select Drawing File** dialog box. Left-click on OK in the **Insert** dialog box (see Figure 13-3).* |
| Command: _insert<br>Specify insertion point or<br>    [Basepoint/Scale/X/Y/Z/Rotate]: | *Move the mouse so that the desk is centrally located in the room, and then left-click to position the desk* |

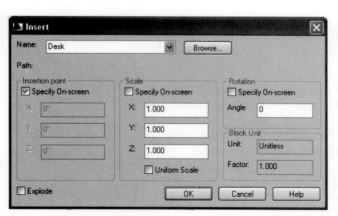

Figure 13-3    Insert Dialog Box

Figure 13-4    Office Drawing After Inserting the Desk Drawing

Your drawing should appear similar to Figure 13-4.

Use the **MOVE** command to place the desk approximately 2″ from the right wall and approximately 6′ up from the wall located at the bottom of the drawing screen.

| Prompt | Response |
|---|---|
| Command: | Type: **m <Enter ↵>** *(or select **Move** from the **Ribbon**, **Home** tab, **Modify** menu)* |
| MOVE | |
| Select objects: | *Pick the desk* |
| 1 found | |
| Select objects: | Type: **<Enter ↵>** |
| Specify base point or [Displacement] <Displacement>: | *Pick a point near the center of the desk* |
| Specify second point or <use first point as displacement>: | *Move the desk to a location approximately 6' up from the wall located at the bottom of the screen and 2" from the right wall (see Figure 13-5)* |

**Figure 13-5**   Office Space After Using the **MOVE** Command to Position the Desk

Follow the same process that we just used to insert the desk to insert the credenza drawn in Chapter Exercise 6-1. Center the credenza on the wall located at the bottom of the screen behind the desk (see Figure 13-6).

**Figure 13-6**   Office Space After Inserting the Credenza Behind the Desk

On your own, relocate the desk and credenza to the lower right corner of the office. Use the **ROTATE** and **MOVE** commands to insert and place the desk chair from Chapter 7, the sofa from Chapter 9, the glass top coffee table from Chapter 5, the end tables from Chapter Exercise 5-1, the desk side chairs from Chapter Exercise 7-1, the bookcase from Chapter Exercise 8-1, and the wing chair from Chapter 11. The placement of all these furniture items is illustrated in Figure 13-7.

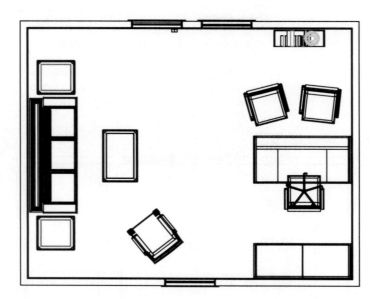

**Figure 13-7**    Office Space with Furniture Inserted

Insert the lamp on the front right corner of the desk, then change to a NW isometric view (**VPOINT**, then **−1,1,1**, or select **NW Isometric** from the **Menu Browser**, **View** menu, **3D Views** flyout). Your drawing should appear similar to Figure 13-8.

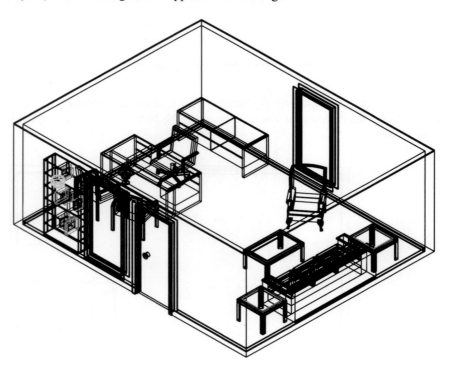

**Figure 13-8**    NW Isometric View of the Furnished Office Space

All the interior components were drawn and inserted in the current drawing at elevation 0. The lamp was drawn at elevation 0; however, for the lamp to be placed on top of the desk, it must be moved three-dimensionally in the +Z direction. If you recall, the elevation of the top of the desk is 2′-5″. Use the **MOVE** command to move the lamp to elevation 2′5″. Zoom in close around

**Figure 13-9** NW Isometric View of the Lamp on the Floor

the desk/lamp area to begin (see Figure 13-9). Remember, you can also use the **3DMOVE** grip tool to accomplish this task. To use the grip tool, select the lamp to move, place the grip tool at any point in the drawing, highlight the Z axis, push the mouse in the +Z direction and type in **2′5**. A working knowledge of multiple methods for invoking and executing commands only increases your proficiency as an AutoCAD user.

| Prompt | Response |
|---|---|
| Command: | Type: **m** *(move)* **<Enter ↵>** |
| MOVE | |
| Select objects: | *Pick the lamp* |
| 1 found | |
| Select objects: | Type: **<Enter ↵>** |
| Specify base point or [Displacement] | |
| <Displacement>: | Type: **0,0,0 <Enter ↵>** |
| Specify second point or | |
| <use first point as displacement>: | Type: **0,0,2′5 <Enter ↵>** |

After you move the lamp 2′-5″ in the +Z direction, your drawing should appear similar to Figure 13-10.

On your own, insert (or copy) the desk lamp and locate a lamp on each of the end tables. **Zoom All**, and change the view to **NE Isometric**. Your drawing should appear similar to Figure 13-11.

Remember, you can change to an elevation view at any time by using the **VPOINT** command or by selecting **Front**, **Right**, **Left**, or **Back** from the **Menu Browser**, **View** menu, **3D Views** fly-out to verify visually the elevation (Z location) of entities within the space. Use this process to make sure that you do not have floating objects or objects that are below the floor. You cannot always change the elevation of an entity, such as a 3D solid, with the **CHANGE/ELEVATION** command, but you can always move objects in three-dimensional space using the **MOVE** command or **3DMOVE** grip tool.

**Figure 13-10**     NW Isometric View of the Lamp After Using the **MOVE** Command

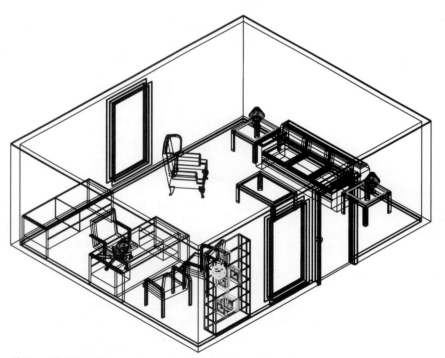

**Figure 13-11**     NE Isometric View of the End Table Lamps

Produce a back-side elevation view using the **VPOINT** command. Change the view to **VPOINT**, then type **0,1,0** to produce a view similar to Figure 13-12. This view is also produced when you select **Back** from the **Menu Browser**, **View** menu, **3D Views** flyout.

**Figure 13-12**    Elevation View of the Office Space

**TIP**  Any time you select a view, such as **Plan**, and the view on the screen does not agree with the view selected, type **UCS** at the command prompt and then type **World**. This will reset the UCS to World. It is to your advantage to be aware of the UCS icon during any drawing operation.

As illustrated in Figure 13-12, wireframe views can be confusing. Use the **DVIEW** command to produce a sectional view (section cut at a clipping plane location) with the lines hidden. Change to plan view, then follow the next set of instructions. The target and camera points for the following instructions were determined by moving the cursor to the desired locations, typing in the X and Y coordinates from the coordinate readout, and adding an assumed eye-level (5′-3″) Z coordinate.

| Prompt | Response |
|---|---|
| Command: | Type: **DVIEW <Enter ↵>** |
| Select objects or <use DVIEWBLOCK>: | *With a window, select the office space* |
| Specify opposite corner: 30 found | |
| Select objects or <use DVIEWBLOCK>: | Type: **<Enter ↵>** |
| Enter option | |
| [CAmera/TArget/Distance/POints/ | |
| PAn/Zoom/TWist/CLip/Hide/Off/Undo]: | Type: **PO <Enter ↵>** |
| Specify target point | |
| <22′-0″, 17′-0″, 4′-8$\frac{3}{8}$″>: | Type: **20′,11′,5′3 <Enter ↵>** |
| Specify camera point | |
| <22′-0″, 17′-0″, 4′-9$\frac{3}{8}$″>: | Type: **20′,25′,5′3 <Enter ↵>** |
| Enter option | |
| [CAmera/TArget/Distance/POints/ | |
| PAn/Zoom/TWist/CLip/Hide/Off/Undo]: | Type: **CL <Enter ↵>** |
| Enter clipping option [Back/ | |
| Front/Off] <Off>: | Type: **F <Enter ↵>** |
| Specify distance from target or | |
| [set to Eye(camera)/ON/OFF] <14′-0″>: | Type: **14′ <Enter ↵>** |
| Enter option | |
| [CAmera/TArget/Distance/POints/PAn/ | |
| Zoom/TWist/CLip/Hide/Off/Undo]: | Type: **H <Enter ↵>** |
| Enter option | |
| [CAmera/TArget/Distance/POints/PAn/ | |
| Zoom/TWist/CLip/Hide/Off/Undo]: | Type: **<Enter ↵>** |

Your drawing should be similar to Figure 13-13.

While in the same view, using the same **DVIEW Points** options, produce a hidden line perspective by setting the **Distance** to **50′** and then use the **Hide** option. Your perspective should appear similar to Figure 13-14.

Figure 13-13     3D Hidden Section View of the Office Space

Figure 13-14     Hidden Perspective View of the Office Space

## CHAPTER EXERCISES

### Exercise 13-1: Adding Interior Enhancements and Creating Perspective Views Using the CAMERA Command

In this exercise, you will add some interior enhancements to the space, such as adding a floor, light fixtures, a planter, and a piece of artwork above the sofa. Create a perspective view of the office space using the **CAMERA** command.

Using the capability to revert to previous views, such as a perspective view or 2D working plan, can save a lot of time because you will not have to repeat the **DVIEW** command each time you need to change the view to add a new component. You can save and restore named views, camera views, layout views, and preset views with the **VIEW** command.

When the **VIEW** command is invoked, the **View Manager** dialog box is shown on the drawing screen (see Figure 13-15). To save a new view, click the **New** tab to retrieve the **New View**

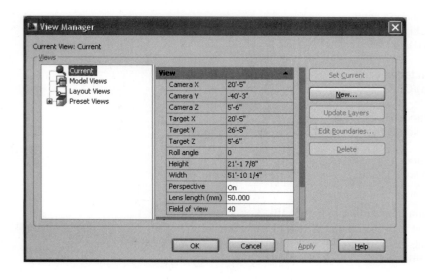

Figure 13-15     **View Manager** Dialog Box

dialog box (see Figure 13-16). Name the view, include a category if you wish, then select the **Apply** tab to close the dialog box. Use the **VIEW** command to save a perspective view similar to Figure 13-14 by either typing **VIEW** at the command prompt or selecting **Named Views...** from the **View** menu.

Figure 13-16    **New View** Dialog Box

Change to plan view, World UCS, and, with the **POLYLINE** command, draw a closed poly-line around the outside bottom perimeter of the walls. Use the **REGION** command to make the closed polyline a solid representing the floor. (In Figure 13-14, you should have noticed that the walls and ceiling appear in the view, but the floor does not.)

Using the **VIEW** command, restore (set current) the perspective view. After you use the **REGION** command to create a representation of the floor, your drawing should appear similar to Figure 13-17.

**Figure 13-17**    Hidden Perspective View After Adding a Solid Floor

On your own, using the **BOX** command, create four solids representing 2′ × 2′ × 3″ surface-mounted light fixtures. Change toplan view, World UCS, and draw a box at elevation 8′ with

a thickness of −3″. Use the **COPY** command or the **ARRAY** command to place the three additional light fixtures, with 8′ between the fixtures each way (see Figure 13-18).

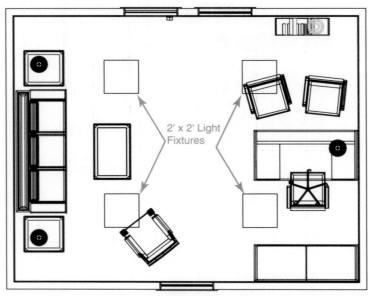

**Figure 13-18**     plan View of the Office Space with 2′ × 2′ Light Fixtures

With the **Cylinder** icon, which is located on the **Ribbon**, **Home** tab, **3D Modeling** menu, draw a 12″-diameter 10″-high cylinder, to the left of the desk to represent a planter. Using the **BOX** icon, which is located on the **Ribbon**, **Home** tab, **3D Modeling** menu, draw and place a 3′-wide × 2′-high × 1″-deep box on the wall behind the sofa to represent a work of art (see Figure 13-19).

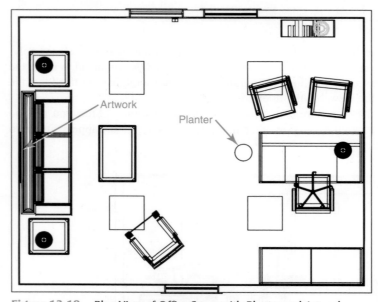

**Figure 13-19**     Plan View of Office Space with Planter and Artwork

Restore the saved perspective view (**VIEW** command, then set **current**). Your drawing should appear similar to Figure 13-20.

Experiment with various perspective views using the **DVIEW** command to produce views similar to Figures 13-21 and 13-22.

**Figure 13-20**    Hidden Perspective View of Completed Office Space

**Figure 13-21**    Perspective View of the Desk Area

**Figure 13-22**    Perspective View of the Sofa Area

The last step in this exercise will provide you with an introduction to the **CAMERA** command. The **CAMERA** command sets a camera and target location to create and save a 3D perspective view. Essentially, placing a camera in the drawing is very similar to using the **DVIEW** command to produce 3D perspective views. The primary differences are that with the **CAMERA** command, the camera and target locations are extracted when the mouse is moved to the desired location and you left-click. You can type in the camera height (Z location) at the command prompt with the **Height** option. The **CAMERA** and **DVIEW** command view results are based on the coordinate locations selected.

To place a camera in a drawing, select the **Camera** icon from the **Ribbon**, **View** tab, **Navigation** menu, and specify the camera's location, then specify the target location. After entering a location and target for a new camera placement, you are provided the following options: **Name**, **Location**, **Height**, **Target**, **Lens**, **Clipping**, **View**, and **Exit**.

Change the **View** of the office space to **2D Wireframe**, **Plan**, **World UCS** to begin. Your drawing should appear similar to Figure 13-23.

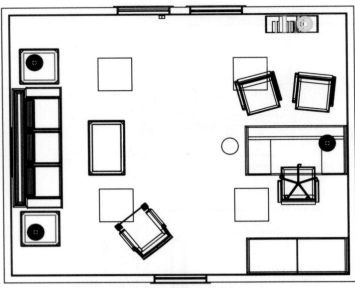

**Figure 13-23**     Wireframe Plan View of the Office Space

| Prompt | Response |
|--------|----------|
| Command: | Type: **CAMERA <Enter ↵>** *(or select the* **CAMERA** *icon)* |
| Command: _camera | |
| Current camera settings: Height = 5'-3" | |
| Lens Length = 50.000 mm | |
| Specify camera location: | Type: **21',18',5'3 <Enter ↵>** |
| Specify target location: | Type: **30',18',5'3 <Enter ↵>** |
| Enter an option [?/Name/LOcation/Height/ Target/LEns/Clipping/View/eXit]<eXit>: | Type: **C <Enter ↵>** |
| Enable front clipping plane? [Yes/No] <No>: | Type: **Y <Enter ↵>** |
| Specify front clipping plane offset from target plane <0">: | Type: **9' <Enter ↵>** |
| Enable back clipping plane? [Yes/No] <No>: | Type: **<Enter ↵>** |
| Enter an option [?/Name/LOcation/Height/ Target/LEns/Clipping/View/eXit]<eXit>: | Type: **V <Enter ↵>** |
| Switch to camera view? [Yes/No] <No>: | Type: **Y <Enter ↵>** |
| Command: | *Use the scroll wheel to move away from the drawing until your view fills the screen* |
| Command: | Type: **HIDE <Enter ↵>** |

| CAMERA | |
|--------|--|
| **Ribbon/ View tab/ Create Camera** | |
| **Menu** | View/ Create Camera |
| **Toolbar: View** | |
| **Command Line** | camera |

Your drawing should appear similar to Figure 13-24.

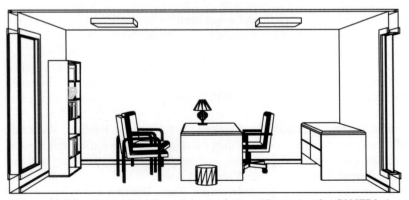

**Figure 13-24**     Perspective View of the Desk Area After Using the **CAMERA** Command

# SUMMARY

By working through the chapter and Chapter Exercise 13-1, you gained additional practice inserting drawings in another drawing. The practice and process of drawing individual components in separate drawing files can increase project efficiency. Depending on the project size, drawing a building or an office space as one file and inserting interior components that are drawn in separate files into the building drawing or the office space drawing can save time, especially if you build a library of furniture and accessories that can be used again and again to furnish a space.

This chapter provided you with experience using the **VIEW** command. The **VIEW** command allows you to save and restore views. You learned the concept and process for establishing views using the **DVIEW** (Dynamic View) command. The exercise in this chapter provided you with an introduction to placing a camera in a space, setting a target point, placing a clipping plane in the view to visually remove objects blocking the desired view, and producing a 3D hidden perspective view. You learned the similarities and differences between the **CAMERA** command and the **DVIEW** command.

In Chapter 14, you will learn to use 2D commands such as **POLYLINE**, **FILLET**, **TRIM**, and **THICKNESS** to produce simple representations of straight draperies. You will also learn how to use the **EDGESURF** command to create surfaces or models of pulled-back draperies and a tablecloth for a round and a rectangular table. You will gain additional practice using polyline editing options and rotating objects three-dimensionally.

# CHAPTER TEST QUESTIONS

## Multiple Choice

1. The **INSERT** command can be used to insert which of the following?

   a. A line of text
   b. One drawing file into another drawing file
   c. Only objects created in the current drawing
   d. Only extruded objects
   e. Only objects that were created in the *XY* plane

2. Which of the following is *not* a **DVIEW** option?

   a. **Clip**
   b. **Hide**
   c. **Rotate**
   d. **Off**
   e. **Points**

3. The **VIEW** command allows you to do which of the following?

   a. Save a named view
   b. Generate several perspective views at one time
   c. Save a named view as a block
   d. Create an animation file
   e. Print the screen

4. Which of the following is displayed when the **VIEW** command is invoked?

   a. **DVIEW** options
   b. **New Drawing** dialog box
   c. **View Manager** dialog box
   d. **Camera** options
   e. None of the above (nothing); **VIEW** is not a command

5. The **ROTATE** command can be used to accomplish which of the following?

   a. Rotate objects around a specified base point
   b. Rotate only 2D objects
   c. Rotate only 3D objects
   d. Rotate objects drawn in the XY plane
   e. Rotate objects drawn only above the XY plane

## Matching

| Column A | Column B |
|---|---|
| a. **DVIEW** | 1. Places a drawing or named block into the current drawing |
| b. **VIEW** | 2. Moves objects a specified distance and in a specified direction |
| c. **CAMERA** | 3. Sets a camera and a target location to create and save a 3D perspective view of objects |
| d. **INSERT** | 4. Saves and restores named views, camera views, layout views, and preset views |
| e. **MOVE** | 5. Defines parallel projection or perspective views by using a camera and a target |

## True or False

1. T or F: You can save and restore a named view with the **DVIEW** command.

2. T or F: You can insert one drawing in another drawing only when the drawing was saved as a block.

3. T or F: The **VIEW** command allows you to name and save a new view.

4. T or F: Both the **DVIEW** command and the **CAMERA** command allow you to specify a camera point and a target point.

5. T or F: Both the **DVIEW** command and the **CAMERA** command allow you to establish a clipping plane.

# Working with Soft Goods

<span style="float:right">**14**</span>

## Chapter Objectives

- Learn to use polyline extrusions to represent draperies
- Learn to use the **EDGESURF** command to produce surfaces
- Practice using the **COPY**, **TRIM**, **FILLET**, and **ARRAY** commands
- Practice using polyline edit options
- Practice rotating objects with the **3DROTATE** command
- Practice drawing 3D polylines
- Practice using points as construction guides

## INTRODUCTION

In the previous chapters, we used solid modeling techniques for producing interior components and spaces. In this chapter, we will use surfaces to produce draperies and tablecloths.

This chapter contains four parts. Part I will consist of using trimmed circles and lines to produce a very simple straight drapery. The degree of difficulty increases in Part II, but we will also be able to produce a much higher level of realism. In Part II, we will use the **EDGESURF** command to produce conceptual pulled-back draperies. Parts III and IV will provide additional practice using the **EDGESURF** command as we draw tablecloths for a round and a rectangular table.

## PART I: SIMPLE STRAIGHT DRAPERIES

### DRAWING SETUP

Begin a new drawing. Set the **Units** to **Architectural**, **Precision** to $\frac{1}{2}''$. Set the **Limits** to **0,0** and **8',6'**. Set the **Grid** to **5"**, and **Zoom All**.

### BEGIN DRAWING

Each drapery panel will be 25" wide and 84" high. We will use the **MIRROR** command to produce the second panel. Begin by drawing a 25" horizontal line to use as a guide.

| Prompt | Response |
|---|---|
| Command: | *Select the **LINE** icon* |
| LINE Specify first point: | Type: **2',2' <Enter ↵>** |
| Specify next point or [Undo]: | Type: **@2'1<0 <Enter ↵>** |
| Specify next point or [Undo]: | Type: **<Enter ↵>** |
| Specify first point | Type: **2',2' <Enter ↵>** |
| Specify next point or [Undo]: | Type: **@2'1<0 <Enter ↵>** |

| LINE | |
|---|---|
| Ribbon/ Home tab/ Draw/ Line | |
| Menu | Draw/ Line |
| Toolbar: Draw | |
| Command Line | line |
| Alias | l |

Use the **CIRCLE**, **TRIM**, **LINE**, **PEDIT**, and **CHANGE** commands to produce the first drapery panel.

| Prompt | Response |
|---|---|
| Command: | *Select the **CIRCLE** icon* |
| CIRCLE Specify center point for circle or | |
| [3P/2P/Ttr (tan tan radius)]: | Type: **FROM <Enter ↵>** |
| Base point: | Type: **END <Enter ↵>** *(or use **Osnap, Endpoint**)* |
| of | *Pick the left end of the line* |
| <Offset>: | Type: **@2.5<0 <Enter ↵>** |
| Specify radius of circle or [Diameter]: | Type: **2.5 <Enter ↵>** |

Your drawing should appear similar to Figure 14-1.

**Figure 14-1**   Line with First Circle

We will use the **COPY** command to place the remaining four circles.

| Prompt | Response |
|---|---|
| Command: | Type: **cp** *(copy)* **<Enter ↵>** |
| COPY | |
| Select objects: | *Pick the circle* |
| 1 found | |
| Select objects: | Type: **<Enter ↵>** |
| Current settings: Copy mode = Multiple | |
| Specify base point or [Displacement/mOde] | |
|    <Displacement>: | Type: **INT <Enter ↵>** *(or with **Osnap, Int**)* |
| of | *Pick the left intersection of the circle and line* |
| Specify second point or | |
|    <use first point as displacement>: | Type: **INT <Enter ↵>** |
| of | *Pick the right-side intersection of the last circle and line* |
| Specify second point or [Exit/Undo] <Exit>: | Type: **INT <Enter ↵>** |
| of | *Pick the right-side intersection of the last circle and line* |
| Specify second point or [Exit/Undo] <Exit>: | Type: **INT <Enter ↵>** |
| of | *Pick the right-side intersection of the last circle and line* |
| Specify second point or [Exit/Undo] <Exit>: | Type: **INT <Enter ↵>** |
| of | *Pick the right-side intersection of the last circle and line* |
| Specify second point or [Exit/Undo] <Exit>: | Type: **<Enter ↵>** |

You can also use the **ARRAY** command to produce the additional four circles.

Your drawing should appear similar to Figure 14-2.
Use the **TRIM** command to remove alternating circle halves (see Figure 14-3).

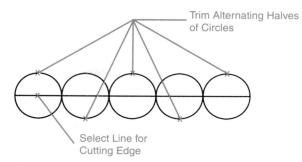

Trim Alternating Halves of Circles

Select Line for Cutting Edge

**Figure 14-3**    Select Cutting Edge and Objects to Trim

**Figure 14-2**    Line with the Circle Copied

| Prompt | Response |
|---|---|
| Command: | Select the **TRIM** icon |
| TRIM | |
| Current settings: Projection = UCS, Edge = None | |
| Select cutting edges . . . | |
|    Select objects or <select all>: | Pick the line |
| 1 found | |
|    Select objects: | Type: **<Enter ↵>** |
| Select object to trim or shift-select to extend or [Fence/Crossing/Project/Edge/eRase/Undo]: | Pick alternating halves of the circles as illustrated in Figure 14-3 |
| Select object to trim or shift-select to extend or [Fence/Crossing/Project/Edge/eRase/Undo]: | Type: **<Enter ↵>** |

Your drawing should appear similar to Figure 14-4.

On your own, complete the shape that will be used to form the drapery panel by adding $2\frac{1}{2}''$-vertical lines to the ends of the horizontal line. After drawing the vertical lines, erase the original line (see Figure 14-5).

**Figure 14-4**    Drawing After Trimming the Circles

Draw 2 ½" Vertical Lines

Erase Line

**Figure 14-5**    Draw Vertical Lines and Erase Original Line

With the **POLYLINE EDIT (PE)** command, join the circle halves and end lines.

| Prompt | Response |
|---|---|
| Command: | Type: **pe <Enter ↵>** |
| PEDIT Select polyline or [Multiple]: | Pick a half circle |
| Object selected is not a polyline | |
|    Do you want to turn it into one? <Y> | Type: **<Enter ↵>** (to accept the default) |
| Enter an option [Close/Join/Width/Edit vertex/Fit/Spline/Decurve/Ltype gen/Undo]: | Type: **J <Enter ↵>** |
| Select objects: Specify opposite corner: 7 found | |
|    Select objects: | Type: **<Enter ↵>** |
| 6 segments added to polyline | |
| Enter an option [Close/Join/Width/Edit vertex/Fit/Spline/Decurve/Ltype gen/Undo]: | Type: **<Enter ↵>** |

One drapery panel profile is complete. Use either the **COPY** command or the **MIRROR** command to produce the adjacent drapery panel (copy or mirror horizontally and leave about 1″ between the panels). Change to a NE isometric view by selecting **View, 3D Views** flyout, **NE Isometric**, from the **Menu Browser**. Your drawing should appear similar to Figure 14-6.

**Figure 14-6**    NE Isometric View of the Drapery Panels

Use the **CHANGE/Properties** command to change the thickness of the drapery panels to 84″. From the **Ribbon, Home** tab, **View** menu, select **Visual Styles,** then **Conceptual**, or select **Conceptual** from the **Visual Styles Manager**.

Your drawing should appear similar to Figure 14-7.

**Figure 14-7**    Conceptual Isometric View of the Completed Draperies

## PART II: PULLED-BACK DRAPERIES

In Part I of this chapter, we changed the thickness property of the polyline to produce the shape of the draperies. In Part II, we will use the **EDGESURF** command to produce the curvilinear shape of the pulled-back side of the draperies. The **EDGESURF** command creates a three-dimensional polygon mesh. Before we begin using the **EDGESURF** command, however, the four edges that define the drapery form must be drawn.

The draperies will be drawn at an appropriate size for the window drawn in the office space, even though the style may not be appropriate. As previously mentioned, the process used to produce the objects in this book is much more important than are the objects produced.

## DRAWING SETUP

Begin a new drawing. Set the **Units** to **Architectural, precision** to $\frac{1}{2}''$. Set the **Limits** to **0,0** and **8′,6′**. Set the **Grid** to **5″**, and **Zoom All.**

## BEGIN DRAWING

The total width of the drapery pair will be 43″. We will draw one panel $21\frac{1}{2}''$ wide, and we will use the **3DMIRROR** command to produce the matching panel.

| Prompt | Response |
|---|---|
| Command: | *Select the **LINE** icon* |
| LINE Specify first point: | Type: **2′,2′ <Enter ↵>** |
| Specify next point or [Undo]: | Type: **@21.5<0 <Enter ↵>** |
| Specify next point or [Undo]: | Type: **<Enter ↵>** |

For the next step, set **PDMODE** to 34 and **PDSIZE** to 1. We will use the node points created with the **DIVIDE** command to begin the drapery profile.

| Prompt | Response |
|---|---|
| Command: | Type: **PDMODE <Enter ↵>** |
| Enter new value for PDMODE <0>: | Type: **34 <Enter ↵>** |
| Command: | Type: **PDSIZE <Enter ↵>** |
| Enter new value for PDSIZE <0′-0″>: | Type: **1 <Enter ↵>** |
| Regenerating model. | |
| Command: | Type: **DIVIDE <Enter ↵>** |
| Select object to divide: | *Pick the line* |
| Enter the number of segments or [Block]: | Type: **6 <Enter ↵>** |

Your drawing should appear similar to Figure 14-8.

Figure 14-8    Line Divided with Node Points

Following the next set of instructions, use the **COPY** command to copy the line and node points. We will use both divided lines as construction lines for selection points to produce the top profile of the drapery panel.

| Command | Response |
|---|---|
| Command: | Type: **cp <Enter ↵>** *(or select the **COPY** icon from the **Modify** toolbar)* |
| COPY | |
| Select objects: | |
| Specify opposite corner: | *With a window, select the line and node points* |
| 6 found | |

| | |
|---|---|
| Select objects: | Type: **<Enter ↵>** |
| Current settings: Copy mode = Multiple | |
| Specify base point or[Displacement/mOde] <Displacement>: | *Pick any point on the screen* |
| Specify second pointor <use first point as displacement>: | Type: **@−1.75,−4 <Enter ↵>** |
| Specify second point or [Exit/Undo] <Exit>: | Type: **<Enter ↵>** |

Your drawing should appear similar to Figure 14-9.

**Figure 14-9** Line and Node Points Copied

Create a new layer named **panel** and set it **current**. Following the next set of instructions, use the construction lines and node points to create the beginning polyline for the top of the drapery panel (see Figure 14-10).

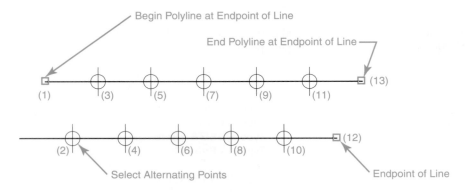

**Figure 14-10** Selection Points for the Top Panel Polyline

| Prompt | Response |
|---|---|
| Command: | *Select the **POLYLINE** icon* |
| PLINE | |
| Specify start point: | *Select the left end of the top line (see Figure 14-10)* |
| Current line width is 0'-0" | |
| Specify next point or [Arc/Halfwidth/Length/ Undo/Width]: | *Select (with **Osnap**) alternating node points* |
| Specify next point or [Arc/Close/Halfwidth/ Length/Undo/Width]: | *Continue selecting all alternating node points* |
| Specify next point or [Arc/Close/Halfwidth/ Length/Undo/Width]: | *Select the endpoint of the bottom line* |
| Specify next point or [Arc/Close/Halfwidth/ Length/Undo/Width]: | *Select the endpoint of the top line* |
| Specify next point or [Arc/Close/Halfwidth/ Length/Undo/Width]: | Type: **<Enter ↵>** |

Your drawing should appear similar to Figure 14-11.

Turn off layer 0, set **FILLET** to a radius to $\frac{1}{2}$″, and fillet each of the 11 vertices. When you are done, your drawing should appear similar to Figure 14-12.

**Figure 14-11**    Completed Top Panel Polyline

**Figure 14-12**    Top Panel Polyline After Filleting

Create a new layer named **bottom panel** and set it **current**. Turn off layer 0 (the layer with the original line and node points). Using the same process that we used to create the top panel polyline, create the bottom panel polyline. For the bottom polyline, begin a new line at the left end of the top original line (using the same endpoint: 2′,2′) and draw a line 18″ in the 0 direction. Divide the line into six segments. Copy the line and node points (any base point, and second point of displacement) to @−1.5,−4. Use the **FILLET** command with a radius of $\frac{1}{2}$″ to fillet each vertex of the new polyline. Figure 14-13 illustrates the bottom panel polyline with layer 0 and the **panel** layer turned off; Figure 14-14 illustrates the **panel** and **bottom panel** layers turned on.

**Figure 14-13**    Bottom Panel Polyline with Construction Lines and Node Points

Bottom Polyline

Top Polyline

**Figure 14-14**    Panel and Bottom Panel Polylines

The node points and construction lines are confusing. Erase the node points and construction lines, leaving only the two panel polylines visible on the screen. Follow the next set of instructions and move the top panel polyline (see Figure 14-15) to an elevation of 84″.

Move Top Polyline

**Figure 14-15**    Select the Top Panel Polyline to Move

| Prompt | Response |
|---|---|
| Command:<br>MOVE | Type: **m** *(move)* <**Enter ↵**> |
| Select objects:<br>1 found | *Pick the top (longer) polyline* |
| Select objects: | Type: <**Enter ↵**> |

| | |
|---|---|
| Specify base point or [Displacement] | |
|   &lt;Displacement&gt;: | Type: **0,0,0 &lt;Enter ↵&gt;** |
| Specify second point or | |
|   &lt;use first point as displacement&gt;: | Type: **0,0,84 &lt;Enter ↵&gt;** |

In plan view, your drawing did not appear to change. Change to a NE isometric view (select **NE Isometric** from the **Menu Browser, View** menu, **3D Views** flyout, or type **VPOINT** then **1,1,1**) to see the results of the **MOVE** command. Your drawing should appear similar to Figure 14-16.

The two polylines just drawn will be used for two of the four edges needed for using the **EDGESURF** command. Drawing the two remaining polylines will be easier if the **3DROTATE** command is used to rotate both polylines three-dimensionally so that the endpoints of the polylines are at elevation 0.

| Prompt | Response |
|---|---|
| Command: | Type: **3DROTATE &lt;Enter ↵&gt;** *(or select the* **3DROTATE** *grip tool)* |
| Current positive angle: | |
| ANGDIR = counterclockwise ANGBASE = 0 | |
| Select objects: | *Pick both polylines* |
| Select objects: 1 found, 2 total | |
| Select objects: | Type: **&lt;Enter ↵&gt;** |
| Specify first point on axis or define axis by | |
|   [Object/Last/View/Xaxis/Yaxis/Zaxis/ | |
|   2points]: | Type: **X &lt;Enter ↵&gt;** *(or highlight the X axis)* |
| Specify a point on the X axis &lt;0,0,0&gt;: | Type: **END &lt;Enter ↵&gt;** |
| of | *Pick the endpoint of the bottom polyline (see Figure 14-17)* |
| Specify rotation angle or [Reference]: | Type: **−90 &lt;Enter ↵&gt;** |

Your drawing should appear similar to Figure 14-18. Change to plan view, World UCS (**VPOINT,** then **0,0,1,** or select from the **Menu Brower)** to proceed.

**Figure 14-16** NE Isometric View After Moving the Top Polyline

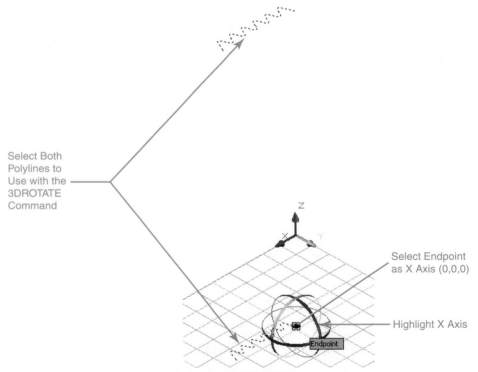

Select Both Polylines to Use with the 3DROTATE Command

Select Endpoint as X Axis (0,0,0)

Highlight X Axis

Endpoint

**Figure 14-17** Selection Set for Use with the **3DROTATE** Command

To complete the four edges needed for the **EDGESURF** command, draw two additional polylines (see Figure 14-19).

| POLYLINE | |
|---|---|
| **Ribbon/ Home tab/ Draw/ Polyline** | |
| **Menu** | Draw/ Polyline |
| **Toolbar: Draw** | |
| **Command Line** | pline |
| **Alias** | pl |

**Figure 14-18**    Isometric View After Rotating the Polylines

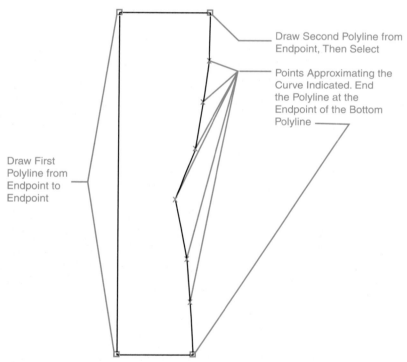

Draw Second Polyline from Endpoint, Then Select

Points Approximating the Curve Indicated. End the Polyline at the Endpoint of the Bottom Polyline

Draw First Polyline from Endpoint to Endpoint

**Figure 14-19**    Selection Points for the Last Two Polylines

| 3DROTATE | |
|---|---|
| **Ribbon/ Home tab/ Solid editing/ 3D Rotate** | |
| **Menu** | Modify/ 3D Oper- ations/ 3D Rotate |
| **Toolbar: Modeling** | |
| **Command Line** | 3drotate |

| Prompt | Response |
|---|---|
| Command: | Select the **POLYLINE** icon |
| PLINE | |
| Specify start point: | Select the left endpoint of the top polyline (see Figure 14-19) |
| Current line width is 0'-0" | |
| Specify next point or [Arc/Halfwidth/Length/ Undo/Width]: | Select the left endpoint of the bottom polyline |
| Specify next point or [Arc/Close/Halfwidth/ Length/Undo/Width]: | Type: **<Enter ↵>** |

| Command | Response |
|---|---|
| Command: | Select the **POLYLINE** icon |
| PLINE | |
| Specify start point: | Select the right endpoint of the top polyline |
| Current line width is 0'-0" | |
| Specify next point or[Arc/Halfwidth/Length/ Undo/Width]: | Select points approximating curve |
| Specify next point or [Arc/Halfwidth/ Length/Undo/Width]: | Continue selecting points approximating curve |
| Specify next point or [Arc/Halfwidth/Length/ Undo/Width]: | Select right endpoint of bottom polyline |
| Specify next point or [Arc/Halfwidth/Length/ Undo/Width]: | Type: **<Enter ↵>** |

Use the **PE (POLYLINE EDIT)** command and **Fit** option to smooth out the curved (last) polyline created. Your drawing should appear similar to Figure 14-20.

Change to a NE isometric view by selecting **NE Isometric** from the **Menu Browser**, **View** menu, **3D Views** flyout. Your drawing should appear similar to Figure 14-21.

**Figure 14-20** Plan View of the Completed Polylines

**Figure 14-21** NE Isometric View of the Completed Polylines

> **Note:**
> **EDGESURF** creates a polygon mesh approximating a Coons surface patch mesh from four adjoining edges. A Coons surface patch mesh is a bicubic surface interpolated between four adjoining edges.

Before we create a three-dimensional polygon mesh with the **EDGESURF** command, we need to set the **SURFTAB1** and **SURFTAB2** variables. The **SURFTAB1** and **SURFTAB2** variables determine the **M** and **N** direction and the number of linked surfaces in each direction. At the command prompt, Type: **SURFTAB1** and then Type: **40** to set the variable. Then, Type: **SURFTAB2** and set the vairable to **40** and continue with the following instructions.

| Prompt | Response |
|---|---|
| Command: | Type: **EDGESURF <Enter ↵>** |
| Current wireframe density: | |
| SURFTAB1 = 40 SURFTAB2 = 40 | |
| Select object 1 for surface edge: | Pick edge 1 (see Figure 14-22) |
| Select object 2 for surface edge: | Pick edge 2 |
| Select object 3 for surface edge: | Pick edge 3 |
| Select object 4 for surface edge: | Pick edge 4 |

**Figure 14-22** Edge Selection for Use with the **EDGESURF** Command

Your drawing should appear similar to Figure 14-23.

To complete the drapery panels, we need to use the **3DROTATE** command to rotate the panel back to a vertical position. Then we need to use the **3DMIRROR** command to produce the second, or matching panel.

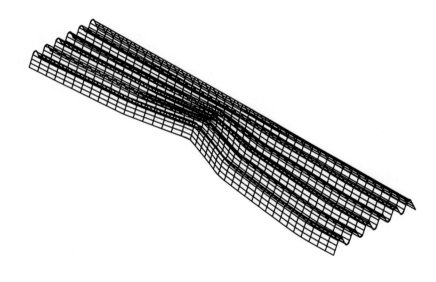

**Figure 14-23** Drapery Panel After Using the **EDGESURF** Command

| Prompt | Response |
|---|---|
| Command: | Type: **3DROTATE <Enter ↵>** *(or select the **3DROTATE** grip tool)* |
| Current positive angle: ANGDIR = counterclockwise ANGBASE = 0 | |
| Select objects: | *Pick the drapery panel (see Figure 14-24)* |
| 1 found | |
| Select objects: | Type: **<Enter ↵>** |
| Specify first point on axis or define axis by [Object/Last/View/Xaxis/Yaxis/Zaxis/2points]: | Type: **X <Enter ↵>** *(highlight the X axis)* |
| Specify a point on the X axis <0,0,0>: | Type: **END <Enter ↵>** |
| of | *Pick the bottom inside endpoint* |
| Specify rotation angle or [Reference]: | Type: **90 <Enter ↵>** |

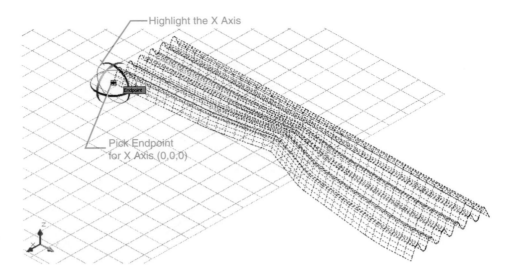

Highlight the X Axis

Endpoint

Pick Endpoint
for X Axis (0,0,0)

**Figure 14-24**    Selection
Set for Use with the
**3DROTATE** Command

Your drawing should appear similar to Figure 14-25. We no longer need the polylines that we used to create the mesh, so erase the four original polylines. If necessary, use a standard window around the base of the drapery panel to select the polyline located at the bottom of the drapery mesh, and continue.

Change the view to **SW Isometric**. Your drawing should appear similar to Figure 14-26.

To produce the matching drapery panel, we will use the **3DMIRROR** command.

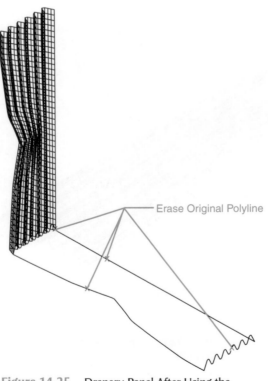

Erase Original Polyline

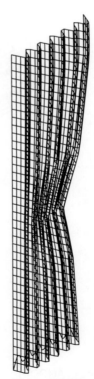

**Figure 14-25**    Drapery Panel After Using the
**ROTATE3D** Command

**Figure 14-26**    SW Isometric View
of the Drapery Panel

| Prompt | Response |
| --- | --- |
| Command: | Type: **3DMIRROR <Enter ↵>** |
| Select objects: | *Pick the drapery panel* |
| 1 found | |

Select objects:                                              Type: **<Enter ↵>**
Specify first point of mirror plane (3 points)
    or [Object/Last/Zaxis/View/XY/YZ/ZX/
    3points] <3points>:                                      Type: **YZ <Enter ↵>**
Specify point on YZ plane <0,0,0>:                           Type: **END <Enter ↵>**
of                                                           *Pick the endpoint of the top right end of the*
                                                                *drapery panel (see Figure 14-27)*
Delete source objects? [Yes/No] <N>:                         Type: **N <Enter ↵>**

---

Your drawing should appear similar to Figure 14-28.

On your own, change the color of the draperies to cyan and select **Conceptual** from the **Visual Styles Manager**. Your drawing should appear similar to Figure 14-29.

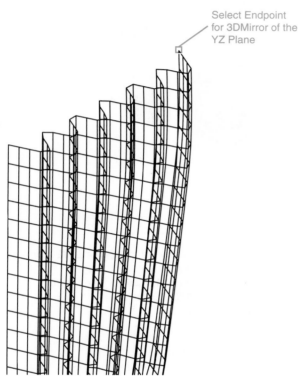

Select Endpoint
for 3DMirror of the
YZ Plane

**Figure 14-27**    Select the Endpoint for 0,0,0 on the YZ Plane

## PART III: TABLECLOTH FOR A ROUND TABLE

In Part III, we will create a tablecloth for a 4'-diameter round table using a combination of a solid and surfaces. We will begin by drawing a few lines and an arc to use as construction guidelines.

### DRAWING SETUP

Begin a new drawing. Set the **Units** to **Architectural, Precision** to $\frac{1}{2}''$. Set the **Limits** to **0,0** and **8',6'**. Set the **Grid** to **3''**, and **Zoom All.**

### BEGIN DRAWING

Begin by drawing one quarter of the tabletop shape using two lines and an arc. We will construct one-quarter of the tablecloth skirting, and then we will use the **ARRAY** command to produce the other three quarters. For the tablecloth top, we will use a 4', diameter circular solid with a thickness of $\frac{1}{2}''$.

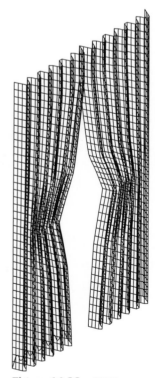

**Figure 14-28**    SW Isometric View of the Completed Draperies

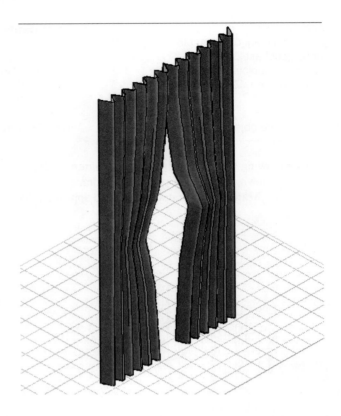

Figure 14-29    Conceptual Isometric View of the Draperies

| Prompt | Response |
|---|---|
| Command: | Type: **l** <**Enter ↵**> *(or select the **LINE** icon)* |
| LINE Specify first point: | Type: **2',3'**<**Enter ↵**> |
| Specify next point or [Undo]: | Type: **@2'<0** <**Enter ↵**> *(or use **Ortho**)* |
| Specify next point or [Undo]: | Type: **@2'<270** <**Enter ↵**> |
| Specify next point or [Close/Undo]: | Type: <**Enter ↵**> |
| Command: | Type: **ARC** <**Enter ↵**> |
| ARC Specify start point of arc or [Center]: | Type: **END** <**Enter ↵**> |
| Of | *Pick the left endpoint of the horizontal line* |
| Specify second point of arc or [Center/End]: | Type: **C** *(center)* <**Enter ↵**> |
| Specify center point of arc: | *Pick the intersection of the two lines* |
| Specify endpoint of arc or [Angle/chord Length]: | *Pick the bottom endpoint of the vertical line* |

Your drawing should appear similar to Figure 14-30.

Use the construction lines illustrated in Figure 14-30 as a guide for constructing one-fourth of the vertical component (skirting) of the tablecloth. Create a new layer named **tablecloth** and set it **current**. With the **OFFSET** command, offset the arc $1\frac{1}{2}''$ on both sides of the original arc (see Figure 14-31).

Figure 14-30    Construction Lines and Arc for Drawing the Tablecloth

With the **POLYLINE** command, begin a polyline at the left endpoint of the horizontal line, select points approximating the locations (as illustrated in Figure 14-31), and end the polyline at the bottom endpoint of the vertical line. Make sure that you use **Osnap**, **Endpoint** in the interrupt mode to begin and end the polyline.

Erase the offset arcs. Your drawing should appear similar to Figure 14-32.

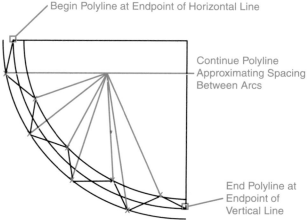

| | OFFSET | |
|---|---|---|
| **Ribbon/ Home tab/ Modify/ Offset** | | |
| **Menu** | Modify/ Offset | |
| **Toolbar: Modify** | | |
| **Command Line** | offset | |
| **Alias** | o | |

**Figure 14-31**    Arc Offset with a Polyline Drawn Between Arcs

**Figure 14-32**    Polyline and Original Construction Lines

The polyline we just drew will form the bottom edge of one quarter of the tablecloth. At this point, it would not appear soft and naturally draping. With the **PE** (**POLYLINE EDIT**) command, use the **Fit** option to smooth the polyline. Your drawing should appear similar to Figure 14-33.

| | POLYLINE | |
|---|---|---|
| **Ribbon/ Home tab/ Draw/ Polyline** | | |
| **Menu** | Draw/ Polyline | |
| **Toolbar: Draw** | | |
| **Command Line** | pline | |
| **Alias** | pl | |

**Figure 14-33**    Polyline After Using the **Fit** Option

The polyline will serve as the bottom edge of the tablecloth. We will move the construction arc to an elevation of 8″, and it will serve as the top edge of the tablecloth. By adding two 3D polylines connecting the ends of the bottom polyline with the top arc, and by using the **EDGESURF** command, we can complete the four edges needed to produce the tablecloth skirting.

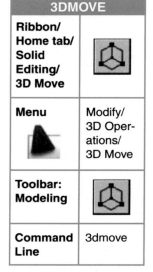

| | 3DMOVE | |
|---|---|---|
| **Ribbon/ Home tab/ Solid Editing/ 3D Move** | | |
| **Menu** | Modify/ 3D Operations/ 3D Move | |
| **Toolbar: Modeling** | | |
| **Command Line** | 3dmove | |

| Prompt | Response |
|---|---|
| Command: | Type: **m <Enter ↵>** *(or select the **3DMOVE** icon)* |
| MOVE | |
| Select objects: | *Pick the arc* |
| 1 found | |
| Select objects: | Type: **<Enter ↵>** |

| | |
|---|---|
| Specify base point or [Displacement] <Displacement>: | Type: **0,0,0 <Enter ↵>** *(or place the grip tool on the endpoint of the arc)* |
| Specify second point or <use first point as displacement>: | Type: **0,0,8 <Enter ↵>** *(or highlight the Z axis, move the mouse in the +Z direction, and Type: 8)* |

Change the view to **NE Isometric** to see the results of the **MOVE** command. Your drawing should appear similar to Figure 14-34.

Using two 3D polylines (the **3DPOLY** command), connect the ends of the arc with the ends of the polyline (see Figure 14-35).

Set the **SURFTAB1** and **SURFTAB2** variables to **40**. With the **EDGESURF** command, select the four edges (see Figure 14-36). The resulting shape should be similar to Figure 14-37.

Use the **ARRAY** command to produce the remaining sides of the lower portion (skirting) of the tablecloth. With a polar array, select the objects and center point of the array as indicated in Figure 14-38, and array the four objects, rotating the objects as they are copied.

**Note:** The **3DPOLY** command creates a polyline of line segments in 3D space.

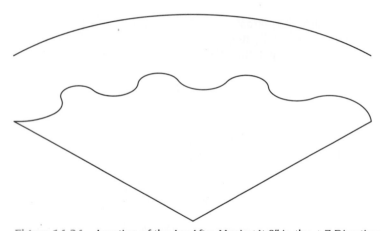

**Figure 14-34**    Location of the Arc After Moving It 8″ in the +Z Direction

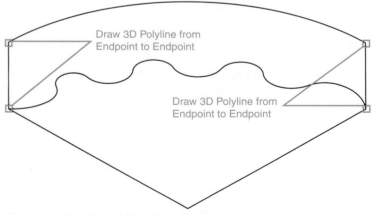

Draw 3D Polyline from Endpoint to Endpoint

Draw 3D Polyline from Endpoint to Endpoint

**Figure 14-35**    3D Polylines Connecting the Arc with the Polyline

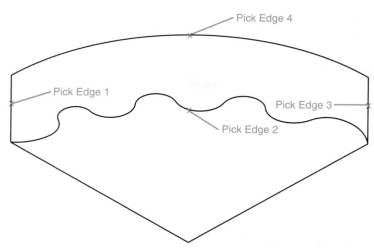

**Figure 14-36**    Edge Selection for Use with the **EDGESURF** Command

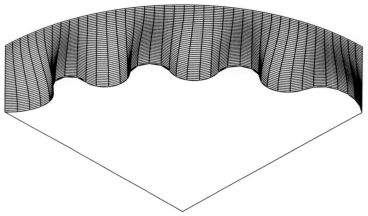

**Figure 14-37**    Drawing After Using the **EDGESURF** Command

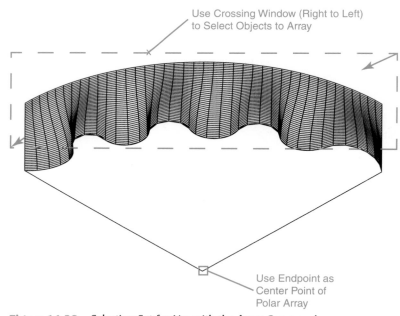

**Figure 14-38**    Selection Set for Use with the **Array** Command

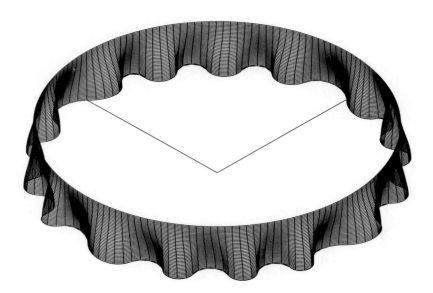

**Figure 14-39** Tablecloth Bottom After Using the **Array** Command

Your drawing should appear similar to Figure 14-39.

The tablecloth needs a top. Use **Osnap, Intersection** of the two original construction lines as the center point and draw a 2′-diameter circle. Then, use the **EXTRUDE** command to extrude the circle $\frac{3}{4}''$. To produce a soft edge at the tablecloth top, use the **FILLET** command with a radius of $\frac{1}{2}''$ and fillet the top edge.

| CIRCLE | |
|---|---|
| **Ribbon/ Home tab/ Draw/ Circle** | ⊙ |
| **Menu** 🔺 | Draw/ Circle |
| **Toolbar: Draw** | ⊙ |
| **Command Line** | circle |
| **Alias** | c |

| EXTRUDE | |
|---|---|
| **Ribbon/ Home tab/ 3D Model- ing/ Extrude** | ⬛ |
| **Menu** 🔺 | Draw/ Modeling Extrude |
| **Toolbar: Modeling** | ⬛ |
| **Command Line** | extrude |
| **Alias** | ext |

| Prompt | Response |
|---|---|
| Command: | Type: **c <Enter ↵>** *(or select the **CIRCLE** icon from the **Draw** toolbar)* |
| CIRCLE Specify center point for circle or [3P/2P/Ttr (tan tan radius)]: of | Type: **END <Enter ↵>** *Pick the endpoint of the construction lines at the center of the tablecloth* |
| Specify radius of circle or [Diameter]: | Type: **2′ <Enter ↵>** |
| Command: | Type: **m <Enter ↵>** *(or use the **3DMOVE** grip tool)* |
| MOVE Select objects: | Type: **l** *(last)* **<Enter ↵>** |
| 1 found Select objects: | Type: **<Enter ↵>** |
| Specify base point or [Displacement] <Displacement>: | Type: **0,0,0 <Enter ↵>** |
| Specify second point or <use first point as displacement>: | Type: **0,0,8 <Enter ↵>** |
| Command: | Select the **EXTRUDE** icon |
| EXTRUDE Current wire frame density: ISOLINES = 4 Select objects to extrude: | Type: **l** *(last)* **<Enter ↵>** |
| 1 found Select objects to extrude: | Type: **<Enter ↵>** |
| Specify height of extrusion or [Direction/ Path/Taper angle]: | Type: 3/4 **<Enter ↵>** |

Your drawing should be similar to Figure 14-40.

With a radius of $\frac{1}{2}''$, fillet the top edge of the extruded circle. Your drawing should appear similar to Figure 14-41.

Leave the original construction lines as reference points for locating a table base for the exercise portion of this chapter. In the meantime, change the color of the tablecloth layer to cyan and view the drawing as conceptual. From the **Visual Styles Manager,** select **Conceptual.** Your drawing should appear similar to Figure 14-42.

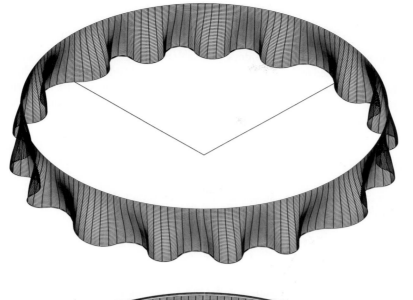

**Figure 14-40** Tablecloth with Top

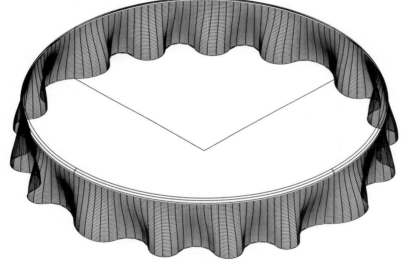

**Figure 14-41** Tablecloth After Filleting the Top Edge of the Extruded Circle

**Figure 14-42** Conceptual View of the Completed Tablecloth

## PART IV: TABLECLOTH FOR A RECTANGULAR TABLE

The process we will use to draw a tablecloth for a $3' \times 4'$ rectangular table is very similar to the process we used to draw the tablecloth for the round table. The primary difference is that for the rectangular tablecloth, we will use the **3DMIRROR** command rather than the **ARRAY** command to produce two sides of the tablecloth. The process that we will use for Part IV can be adjusted slightly for drawing items such as bedspreads, chair or sofa skirting, or similar interior design components.

### DRAWING SETUP

Begin a new drawing. Set the **Units** to **Architectural, Precision** to $\frac{1}{2}''$. Set the **Limits** to **0,0** and **8',6'**. Set the **Grid** to **3''**, and **Zoom All**.

### BEGIN DRAWING

Begin by drawing a rectangle with the **LINE** command to use as construction lines.

| Prompt | Response |
|---|---|
| Command: | Type: **l <Enter ↵>** *(or select **LINE** from the **Draw** pull-down menu or toolbar)* |
| LINE Specify first point: | Type: **1'6,2' <Enter ↵>** |
| Specify next point or [Undo]: | Type: **@4'<0 <Enter ↵>** *(or with **ORTHO** on, move the mouse in the appropriate direction and type in the desired distance)* |
| Specify next point or [Undo]: | Type: **@3'<90 <Enter ↵>** |
| Specify next point or [Close/Undo]: | Type: **@4'<180 <Enter ↵>** |
| Specify next point or [Close/Undo]: | Type: **C <Enter ↵>** *(to close the line)* |

Your drawing should appear similar to Figure 14-43.

Use the **OFFSET** and **ARC** commands to produce construction guidelines to draw two polyline profiles (see Figure 14-44). With the **OFFSET** command, offset the four lines just drawn 3'' to the outside. With the **ARC** command, draw arcs connecting the ends of the top left, bottom left,

**Figure 14-43**  Drawing Showing the Beginning Line Rectangle

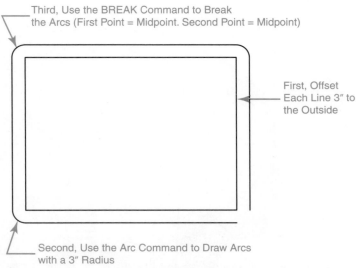

Third, Use the BREAK Command to Break the Arcs (First Point = Midpoint. Second Point = Midpoint)

First, Offset Each Line 3'' to the Outside

Second, Use the Arc Command to Draw Arcs with a 3'' Radius

**Figure 14-44**  Using the **OFFSET, ARC,** and **BREAK** Commands to Produce Construction Lines

and bottom right offset lines. Use the **BREAK** command to break the arcs at the midpoint (*Note:* Use **First point = Midpoint, Second point = Midpoint** for each of the three arcs.) By using the same midpoint for the first and second break points, the arcs are broken, but no gaps are produced between the break points.

Draw the left-side polyline profile. Begin the left-side polyline at the endpoint of the bottom arc (approximate points as illustrated in Figure 14-45), and end the polyline at the endpoint of the top left arc.

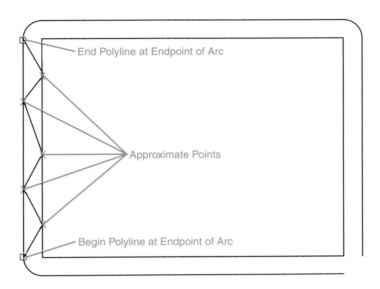

**Figure 14-45**  Draw the Left-Side Polyline

Draw the top polyline profile. Begin the top polyline at the endpoint of the top left arc (approximate points as illustrated in Figure 14-46), and end the polyline at the endpoint of the top right arc.

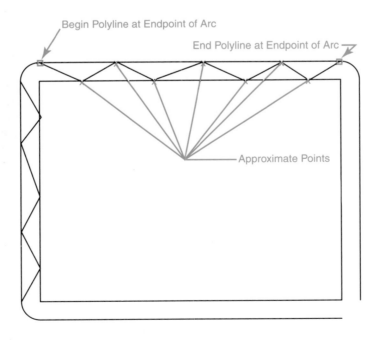

**Figure 14-46**  Draw the Top Polyline

We need to join the polylines that we just drew with the connecting halves of the arcs on each end to produce the bottom edge profiles (see Figures 14-47 and 14-48).

With the **POLYLINE EDIT (PE)** command, use the **Fit** option to smooth each of the two polylines. Your drawing should appear similar to Figure 14-49.

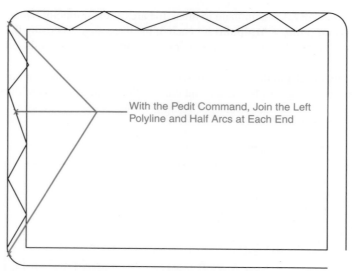

With the Pedit Command, Join the Left Polyline and Half Arcs at Each End

**Figure 14-47**     Join the Left Polyline and Half-Arcs

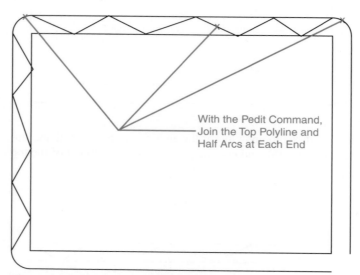

With the Pedit Command, Join the Top Polyline and Half Arcs at Each End

**Figure 14-48**     Join the Top Polyline and Half-Arcs

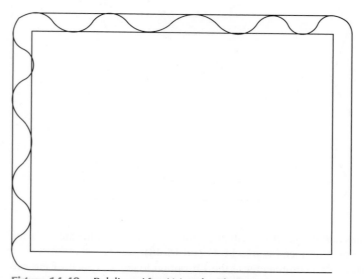

**Figure 14-49**     Polylines After Using the **Fit** Option

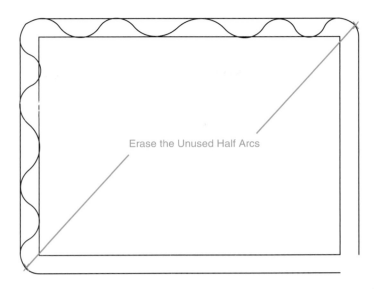

**Figure 14-50**    Erase the Unused Half Arcs

Erase the unused two half-arcs at the bottom left and top right ends of the polylines (see Figure 14-50).

Now that we have the two bottom edge profiles completed, we can move the two original (inside) construction lines next to the polyline profiles (left and top) to an elevation of 8″. With the **MOVE** command, select the two lines to move; use 0,0,0 as the base point and 0,0,8 as a second point of displacement. Change to a NW isometric view to see the results of the **MOVE** command. Your drawing should appear similar to Figure 14-51.

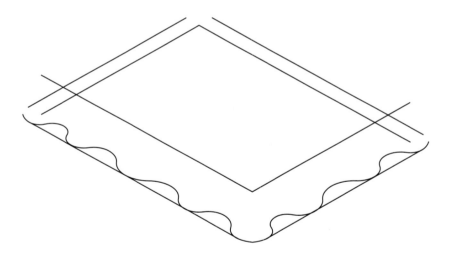

**Figure 14-51**
Construction Lines Moved to an Elevation of 8″

With the **3DPOLY** command, draw separate polylines connecting the left bottom polyline to the top left construction line, and the right end of the left bottom polyline to the top right end of the top construction line. Make sure to use **Osnap**, **Endpoint** to begin and end the 3D polylines (see Figure 14-52).

We will create the left side surface of the tablecloth. Before using the **EDGESURF** command, set the **SURFTAB1** and **SURFTAB2** variables to **40**. Then use the **EDGESURF** command and select the bottom polyline, the right 3D polyline, the construction line at the top, and the left 3D polyline for the four edges. Your drawing should appear similar to Figure 14-53.

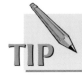

TIP    The **SURFTAB1** and **SURFTAB2** system variables set the mesh density in the **M** and **N** directions for the **REVSURF** and **EDGESURF** commands.

With the 3DPOLY Command, Draw Separate Polylines
Connecting the End of the Bottom Profile
Polyline to the Top Endpoint of the Construction Line

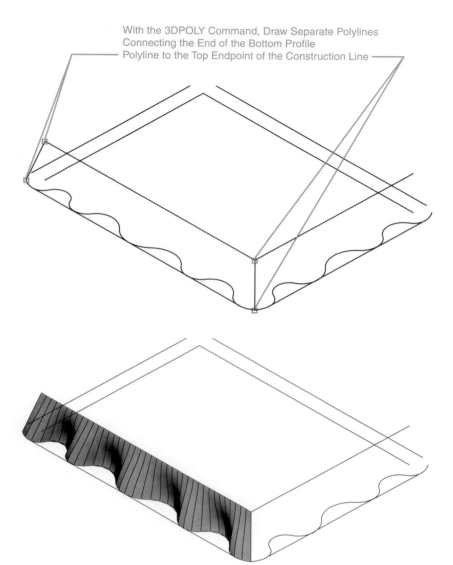

**Figure 14-52**    Draw Connecting 3D Polylines

**Figure 14-53**    Left-Side Surface After Using the **EDGESURF** Command

Repeat the process of drawing 3D polylines with the **3DPOLY** command connecting the bottom right polyline with the top right construction line. If necessary, use **'Zoom (transparent ZOOM)** and zoom in closely around the left side to make sure you select the endpoints of the top construction line and bottom polyline and not the surface previously created. After you complete using the **EDGESURF** command on the right side, your drawing should appear similar to Figure 14-54.

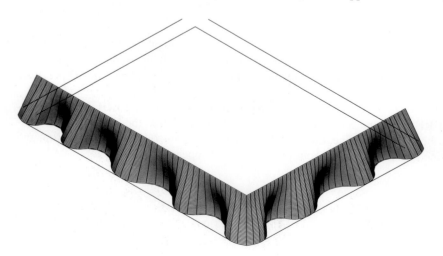

**Figure 14-54**    Right-Side Surface After Using the **EDGESURF** Command

Two sides of the tablecloth are now complete. Use the **3DMIRROR** command to produce the opposite sides of the tablecloth skirting.

| Prompt | Response |
|---|---|
| Command: | Type: **3DMIRROR <Enter ↵>** |
| Select objects: 1 found | *Pick the left side mesh* |
| Select objects: | Type: **<Enter ↵>** |
| Specify first point of mirror plane (3 points) or [Object/Last/Zaxis/View/XY/YZ/ZX/ 3points] <3points>: | Type: **ZX <Enter ↵>** |
| Specify point on ZX plane <0,0,0>: | *With **Osnap, Midpoint**, pick the midpoint of the bottom right construction line (see Figure 14-55)* |
| Delete source objects? [Yes/No] <N>: | Type: **<Enter ↵>** |

Your drawing should appear similar to Figure 14-56.

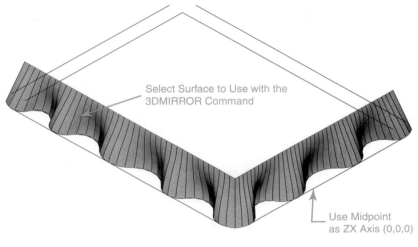

Select Surface to Use with the 3DMIRROR Command

Use Midpoint as ZX Axis (0,0,0)

**Figure 14-55**   Selection Set for the First Use of the **3DMIRROR** Command

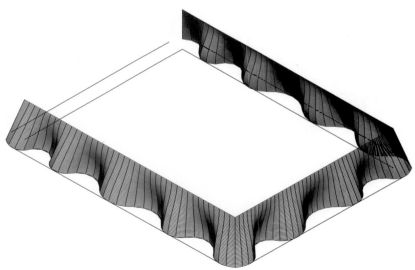

**Figure 14-56**   Tablecloth After the First Use of the **3DMIRROR** Command

Repeat the **3DMIRROR** command process for the opposite end of the tablecloth.

| Prompt | Response |
|---|---|
| Command: | Type: **3DMIRROR <Enter ↵>** |
| Select objects: 1 found | *Pick the right-side mesh* |
| Select objects: | Type: **<Enter ↵>** |

| | |
|---|---|
| Specify first point of mirror plane (3 points)<br>   or [Object/Last/Zaxis/View/XY/YZ/ZX/<br>   3points] <3points>:<br>Specify point on ZX plane <0,0,0>:<br><br>Delete source objects? [Yes/No] <N>: | **Type: YZ <Enter ↵>**<br>*With **Osnap, Midpoint**, pick the midpoint of<br>   the bottom left construction line (see<br>   Figure 14-57)*<br>**Type: <Enter ↵>** |

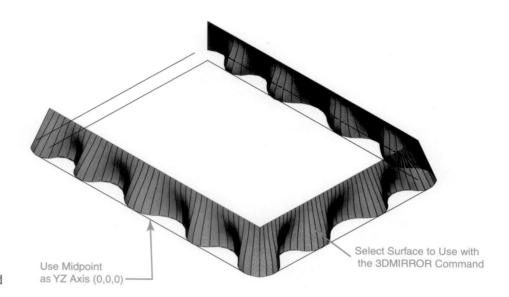

**Figure 14-57** Selection Set for the Second Use of the **3DMIRROR** Command

Use Midpoint as YZ Axis (0,0,0)

Select Surface to Use with the 3DMIRROR Command

Your drawing should be similar to Figure 14-58.

**Figure 14-58** Tablecloth After Second Use of the **3DMIRROR** Command

The tablecloth is almost complete. Create a new layer named **tablecloth**, change the meshes created with the **EDGESURF** command to the **tablecloth** layer, and turn the layer off. This will make drawing the tablecloth top easier. After creating the new layer and changing the properties of the meshes, your drawing should appear similar to Figure 14-59.

Create a top for the tablecloth by drawing a closed polyline shape that fits the top profile of the edges of the mesh. Use the **EXTRUDE** command to extrude the polyline 1″ in the +Z direction, and then use the **MOVE** command to move the extruded polyline 8″ in the +Z direction. Use the **FILLET** command with a $\frac{1}{2}$″ radius to round the top edge.

Figure 14-59    Drawing
After Turning off the
**Tablecloth** Layer

| Prompt | Response |
|---|---|
| Command: | Select the **POLYLINE** icon |
| PLINE | |
| Specify start point: | Type: **1'6,2'** <Enter ↵> |
| Current line width is 0'-0" | |
| Specify next point or [Arc/Halfwidth/ Length/Undo/Width]: | Type: **@4'<0** <Enter ↵> (with **ORTHO** on, move the mouse in the appropriate direction and type in the desired distance) |
| Specify next point or [Arc/Close/Halfwidth/ Length/Undo/Width]: | Type: **@3'<90** <Enter ↵> |
| Specify next point or [Arc/Close/Halfwidth/ Length/Undo/Width]: | Type: **@4'<180** <Enter ↵> |
| Specify next point or [Arc/Close/Halfwidth/ Length/Undo/Width]: | Type: **C** <Enter ↵> (to close the polyline) |

| Prompt | Response |
|---|---|
| Command: | Select the **EXTRUDE** icon |
| Current wire frame density: ISOLINES = 4 | |
| Select objects to extrude: | Type: l (last) <Enter ↵> (or select the polyline just drawn) |
| 1 found | |
| Select objects to extrude: | Type: <Enter ↵> |
| Specify height of extrusion or [Direction/Path/Taper angle]: | Type: **1** <Enter ↵> |
| Command: | Type: **MOVE** <Enter ↵> |
| MOVE | |
| Select objects: | Type: l <Enter ↵> (or select the extruded polyline) |
| 1 found | |
| Select objects: | Type: <Enter ↵> |
| Specify base point or [Displacement] <Displacement>: | Type: **0,0,0** <Enter ↵> |
| Specify second point or <use first point as displacement>: | Type: **0,0,8** <Enter ↵> |

Your drawing should appear similar Figure 14-60.

Set the fillet radius to $\frac{1}{2}$", and fillet the four top edges of the tablecloth. Change the **Layer Properties** of the tablecloth top to the tablecloth layer and set layer **tablecloth** to **current**. Turn layer **0** off. Your drawing should appear similar to Figure 14-61.

**Figure 14-60** Drawing After Creating and Moving the Tablecloth Top

**Figure 14-61** Completed Rectangular Tablecloth

Change the color of the tablecloth layer to cyan, and from the **Visual Styles Manager**, select **Conceptual** to view the drawing. Your drawing should appear similar to Figure 14-62.

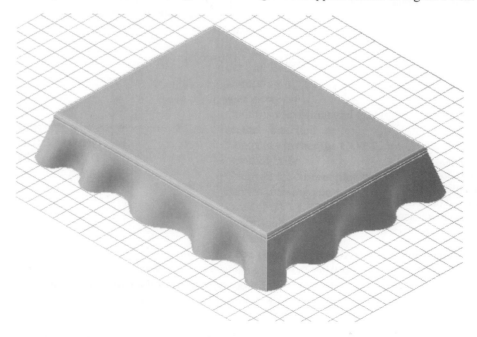

**Figure 14-62** Conceptual View of the Completed Tablecloth

## CHAPTER EXERCISES

### Exercise 14-1: Create a Small Dining Arrangement

Chapter Exercise 14-1 consists of creating a small dining arrangement using the round tablecloth produced in Part III of this chapter as the basis for the design. Begin by modeling a simple pedestal base for the table.

If you recall, the tablecloth produced in Part III was drawn with a $\frac{3}{4}''$ solid top. The solid will serve as the tabletop.

The side chair produced in Chapter Exercise 7-1 will be inserted as a dining chair. The three additional chairs will be produced using the **ARRAY** command to complete the dining composition.

Begin by opening the round tablecloth drawing. Use the **SAVEAS** command to save the drawing as **Chapter Exercise 14-1**. Change the view to **Plan, World UCS.** Your drawing should appear similar to Figure 14-63.

Figure 14-63    Plan View of the Round Tablecloth

Begin drawing the table pedestal base by drawing two circles. Use the endpoint of the two intersecting construction lines located at the center of the tablecloth as the center point of the circles, draw one circle with a diameter of 4″, and draw the second circle with a diameter of 3′. Your drawing should appear similar to Figure 14-64.

Use the **EXTRUDE** command to extrude the 4″-diameter circle $29\frac{1}{4}''$. Use the **EXTRUDE** command to extrude the 3′-diameter circle 1″. Change the view to **NE Isometric.** Your drawing should appear similar to Figure 14-65.

As you can tell from Figure 14-65, we need to move the tablecloth so that the bottom elevation of the $\frac{3}{4}''$ solid is located at elevation $29\frac{1}{4}''$ (resulting in an overall height of 30″ for the table). Use the **MOVE** command to move the tablecloth and tabletop solid. Select the four sections of the tablecloth and the tabletop solid to move, Type: **0,0,0** for the base point, and Type: **0,0,29-1/4** as the second point of displacement. Your drawing should appear similar to Figure 14-66.

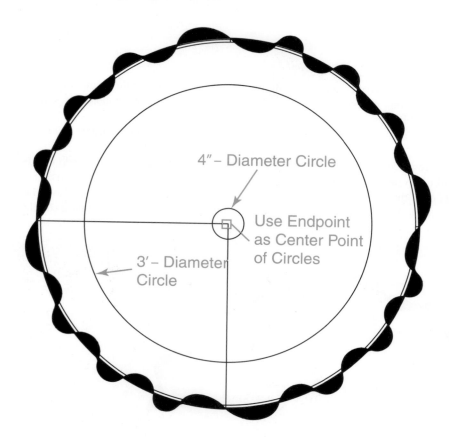

**Figure 14-64** Circles for the Table Pedestal Base

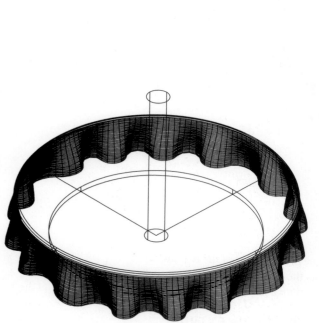

**Figure 14-65** NE Isometric View of the Extruded Table Base

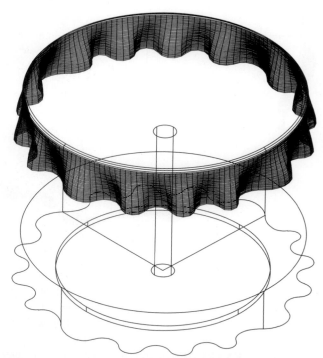

**Figure 14-66** Table After Moving the Tablecloth and the Tabletop Solid

The construction lines used to create the tablecloth are no longer needed, so use the **ERASE** command to remove the construction lines illustrated in Figure 14-67 from the drawing. Leave the two original intersecting centerlines at elevation 0.

After you erase the construction lines, your drawing should appear similar to Figure 14-68.

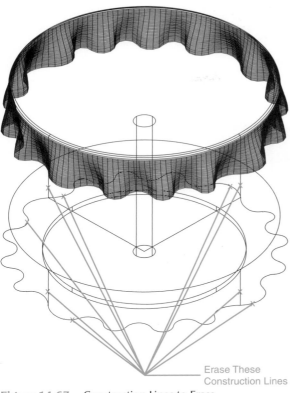

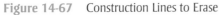

**Figure 14-67**   Construction Lines to Erase

**Figure 14-68**   Table After Erasing the Construction Lines

Change the view to **Plan, World UCS**. Use the **INSERT** command to insert the side chair created in Chapter Exercise 7-1 (see Figure 14-69).

Use a polar array to create three additional chairs. Select the chair to array, use the endpoint of the two original intersecting construction lines as the center point of the array, select **rotate objects as they are copied**, and Type: **4** for the total number of objects to fill. Your drawing should appear similar to Figure 14-70. Remember, you can use the **MOVE** command to adjust the position of each chair.

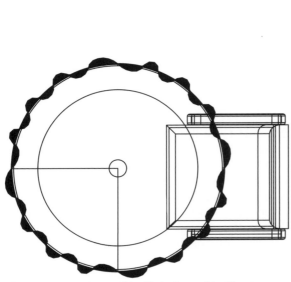

**Figure 14-69**   Insert Side Chair Created in Chapter
Exercise 7-1

**Figure 14-70**   Wireframe Plan View of the Completed Dining Set

Use the **ORBIT** command, **Constrained Orbit**, and the **HIDE** command to produce a view similar to Figure 14-71. From the **Visual Styles Manager,** select **Conceptual** and produce a view similar to Figure 14-72.

**Figure 14-71**     Hidden View of the Completed Dining Set

**Figure 14-72**     Conceptual View of the Completed Dining Set

## SUMMARY

This chapter provided you with an introduction to constructing surfaces representing soft goods such as draperies and tablecloths. The exercises in Parts I to IV and Chapter Exercise 14-1 included additional practice using the **INSERT, COPY, ROTATE, FILLET,** and **ARRAY** commands.

Part I of this chapter used polylines with a thickness to represent conceptual straight draperies. Part II provided you with additional practice using points as construction guidelines. The **EDGESURF** command was introduced and used to construct conceptual pulled-back draperies. You were given additional practice wih the **SURFTAB1** and **SURFTAB2** system variables.

Parts III and IV of this chapter illustrated a method for modeling a conceptual round and a rectangular tablecloth, respectively. 3D solids were used in conjunction with surfaces created with the **EDGESURF** command to complete the models. Additional practice, using a combination of 2D and 3D commands and processes to complete models, was provided.

In Chapter 15, you will learn the basics of rendering a model by attaching materials to objects and layers. You will also learn how to apply lighting to a three-dimensional model and how to create your own materials. You will be introduced to the new **SteeringWheels** and **ViewCube,** and to the process for creating a walk-through animation of the finished office space.

# CHAPTER TEST QUESTIONS

## Multiple Choice

1. Which of the following commands can be used to make connected arcs and line segments a single polyline?

    a. **UNION**
    b. **JOIN**
    c. **PEDIT**
    d. **ADD**
    e. **FILLET**

2. Which of the following is *true* about the **POINT** command?

    a. Creates a point object
    b. Creates a sharp corner between two lines
    c. Makes circles with varying diameters
    d. Is used only with the **POLYLINE** command
    e. Creates a point at the top of a pyramid

3. Which of the following is required for the **EDGESURF** command?

    a. Any four nonconnected lines and/or curves
    b. Four adjoining lines and/or curves
    c. Two lines and two arcs
    d. Three adjoining lines and/or curves
    e. Any closed polyline shape

4. Two types of arrays that can be accomplished with the **ARRAY** command are

    a. Triangular and square
    b. Circle and square
    c. Rectangular and polar
    d. Vertical and horizontal
    e. None of the above

5. Which of the following is not a 2D **POLYLINE, PEDIT** option?

    a. **Move**
    b. **Join**
    c. **Spline**
    d. **Close**
    e. **Width**

## Matching

**Column A**

a. **ARRAY**
b. **EDGESURF**
c. **POINT**
d. **3DPOLY**
e. **TRIM**

**Column B**

1. Trims objects at a cutting edge defined by other objects
2. Creates a point object
3. Creates a polyline of line segments in 3D space
4. Creates multiple copies of objects in a pattern
5. Creates a 3D polygon mesh using four defining curves

## True or False

1. T or F: The **TRIM** command can be used to trim objects at a cutting edge defined by other objects.

2. T or F: A 3D polyline can be drawn only on the XY plane.

3. T or F: To produce a surface and/or mesh with the **EDGESURF** command, the four edges must touch.

4. T or F: You can rotate 3D objects only with the **3DRO-TATE** command.

5. T or F: You can change the thickness of a 2D polyline.

# Introduction to Rendering

<span style="float:right">**15**</span>

## Chapter Objectives

- Practice inserting and exploding blocks
- Learn to attach materials to objects and layers
- Learn to apply lighting to a three-dimensional model
- Learn to render a three-dimensional model
- Learn to produce a walk-through animation file
- Learn to create your own materials
- Learn to use **SteeringWheels** and **ViewCube**

## INTRODUCTION

In this chapter, we will learn the basic process of attaching materials, adding light sources, and rendering a three-dimensional model. We will open the furnished office space drawing that we created in Chapter 13, add new ceiling-mounted light fixtures, and insert the pulled-back draperies completed in Chapter 14.

## DRAWING SETUP

Drawing setup for the steps in this chapter will not be necessary.

## BEGIN DRAWING

To begin, open the **Chapter 13 Furnishing the Office Space** drawing. Use the SAVEAS command to save the drawing as **Introduction to Rendering**. Change the view to **NE Isometric**. Your drawing should appear similar to Figure 15-1.

In Chapter 13, it was suggested that you draw and add ceiling light fixtures (see Figure 13-18) to the office space. The light fixtures illustrated in Chapter 13 appear to be 2′ × 2′ fluorescent ceiling-mounted fixtures. For this chapter, either erase the previously drawn light fixtures or create a new layer for the fluorescent fixtures, then change the properties of the fluorescent fixtures to the new layer, and turn off and freeze the light fixture layer and the ceiling layer.

Use the **LINE, POLYLINE,** and **REVOLVE** commands to draw a new ceiling light fixture. Begin by changing to plan view, World UCS, and zooming into an area outside the office space. Use the **LINE** and **POLYLINE** commands to draw the ceiling light profile (see Figure 15-2). We will use the line as the object to revolve the profile around and as the base point for copying and moving the light fixtures into place.

After you revolve the ceiling light profile, your drawing should be similar to Figure 15-3.

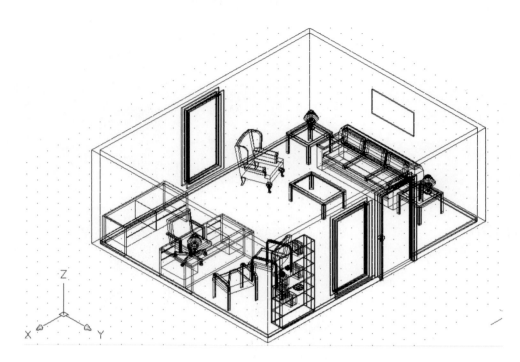

**Figure 15-1**    NE Isometric View of Introduction to Rendering Drawing

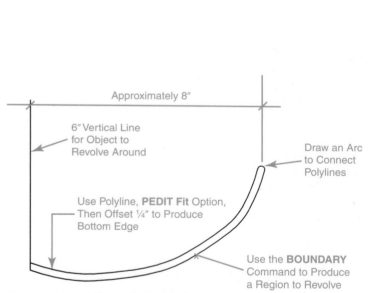

**Figure 15-2**    Ceiling Light Fixture Profile

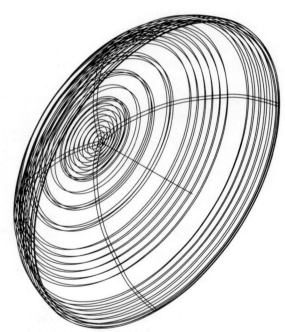

**Figure 15-3**    Ceiling Light Fixture After Using the **REVOLVE** Command

Use the **3DROTATE** command or the **3DROTATE** grip tool to rotate the light fixture and the line to the upright position (**3DROTATE,** select the line and revolved profile to rotate, use the outside endpoint of the line as the X axis, 0,0,0 point and rotate 90°). Your drawing should appear similar to Figure 15-4.

Draw a line from the midpoint of the inside top of the wall behind the sofa to the midpoint of the top of the wall adjacent to the desk. Use the **ORBIT** command to select an unobstructed view of the top of the wall (see Figure 15-5). Set the **PDMODE** to 34, and use the **DIVIDE** command to divide the line into four segments. We will use these node points to place the ceiling lights with an appropriate spacing.

Use the **COPY** command to copy the ceiling light fixtures to the two outside node points. Make sure that, with **Osnap,** you use the top endpoint of the line as the base point and the node

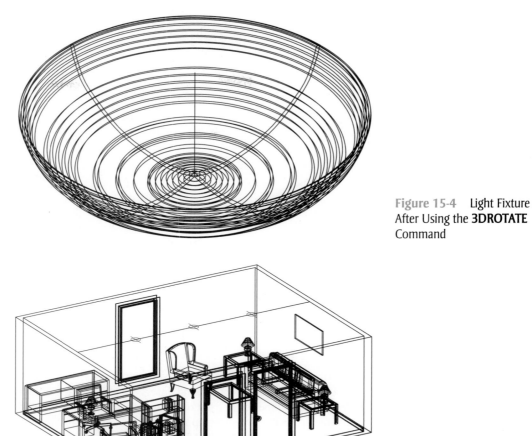

Figure 15-4   Light Fixture After Using the **3DROTATE** Command

Figure 15-5   Line at Ceiling with Node Points

points as the second point of displacement. After copying the fixtures to the ceiling, your drawing should appear similar to Figure 15-6.

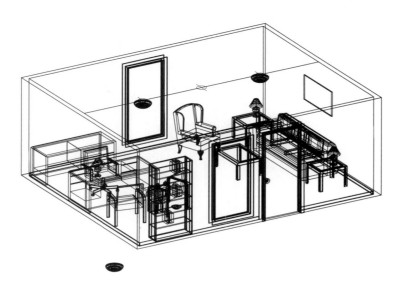

Figure 15-6   Ceiling Lights After Using the **COPY** Command

Erase the line and node points used to relocate the lights. Create two new layers named **Ceiling** and **Floor**. Turn on the ceiling layer, change the view to **NE Isometric**, and invoke the **HIDE** command. Your drawing should appear similar to Figure 15-7.

**Figure 15-7** Hidden NE
Isometric View of Office

Turn off and freeze the ceiling layer for the next several steps. Change to plan view, World UCS. Using the **INSERT** command, insert the pulled-back draperies created in Chapter 14, Part II. Position the draperies in front of the two fixed glass panels, and change the view point as necessary to locate the draperies appropriately. Change the view to **NE Isometric**. Your drawing should appear similar to Figure 15-8.

**Figure 15-8** NE Isometric Wireframe View of the Office with the Draperies Inserted

Realistic renderings with AutoCAD are produced by using and manipulating objects, lighting, and materials. In AutoCAD, you can select the degree of realism that you want by using the **Advanced Render Settings** dialog box (see Figure 15-9). The rendering quality is determined by selecting **Draft, Low, Medium, High, Presentation**, and **Other**. To view the **Advanced Ren-**

**der Settings** dialog box, type **RPREF** at the command prompt or, from the **Menu Browser, View** menu, **Render** flyout, select **Advanced Render Settings**. For this chapter, we will use the **Medium** setting. In AutoCAD, you can specify the type of light you desire; the choices are **Point Light, Spotlight, Weblight**, and **Distant Light**. For the introduction in this chapter, we will use **Point Light**. Point lights shine in all directions, much like a standard incandescent lamp. You can adjust the intensity, color, and shadows produced by each light to reach the desired level of realism.

AutoCAD has several palettes containing materials that can be attached to objects or layers. You can also create new materials and modify existing ones. The **Materials** dialog box allows you to attach or detach materials from objects. To view the **Tool** palettes, from the **Tools** pull-down menu or from the **Menu Browser, Tools** flyout, select **Palettes**, then **Tool Palettes** (see Figure 15-10). To view the available materials in the drawing, from the **Tools** pull-down menu, select **Palettes**, then **Materials** (see Figure 15-11).

**Figure 15-9**    **Advanced Render Settings** Dialog Box

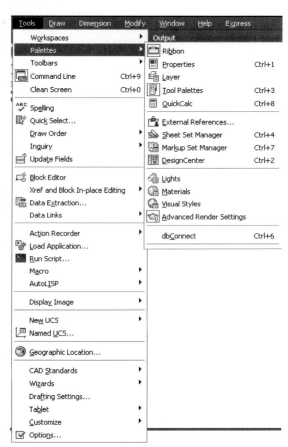

**Figure 15-10**    Select **Tool Palettes** from the **Tools** Pull-Down Menu

Open and explore the **Tool Palettes** (see Figure 15-12) and the **Materials** dialog box (see Figure 15-13).

You can apply materials to objects in the drawing directly from the **Tools Palette**, or you can drag the materials to the **Materials** dialog box.

It will be easier to assign one material to multiple objects by attaching materials to layers rather than assigning one material to multiple individual objects. Most of the objects inserted into the drawing in Chapter 13 were inserted as blocks that were created on layer 0. These blocks must be exploded so that individual components can be placed on different layers. For instance, the lamp created in Chapter 4 was inserted as a block. The lampshade should be assigned a different material than the lamp base. If you explode the block once, you can move individual components to separate layers. Determine similar groupings of materials and/or objects and create new layers similar to those in Figure 15-14. Also, consider the basic color that you wish objects to be when rendered,

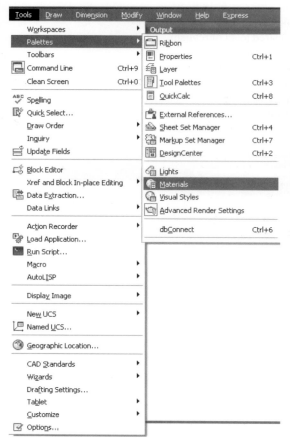

**Figure 15-11**   Select **Materials** from the **Tools** Pull-Down Menu

**Figure 15-12**   **Tool Palettes**

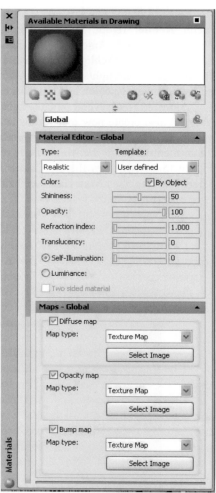

**Figure 15-13**   **Materials** Dialog Box

**Figure 15-14**   Create Layers Based on Material Assignments

and assign a similar color to the layer. This technique allows you to either shade or render a view and see a quick approximation of a finished rendering. If a material has not been assigned to an object, AutoCAD uses the layer color and the global attribute to render the object.

After you have created the layers for material assignments, begin exploding the blocks and changing the properties of similar items to the same layer. For instance, as Figure 15-14 illustrates, a layer called **Furniture wood** was created, and all objects that will be assigned the same material were changed to the **Furniture wood** layer. Change the view and zoom as necessary to select objects and change the layer properties.

Change the view to **NE Isometric** (**Menu Browser, View** menu, **3D Views** flyout). Turn off and freeze the ceiling layer, and type **SHADE** at the command prompt. Figure 15-15 illustrates a realistic view using only layer colors to portray materials. (For the realistic view, select the **View** pull-down menu, **Visual Styles, Realistic**, or select from the **Visual Styles Manager** dialog box.) Figure 15-16 illustrates a conceptual view using only layer colors to portray materials.

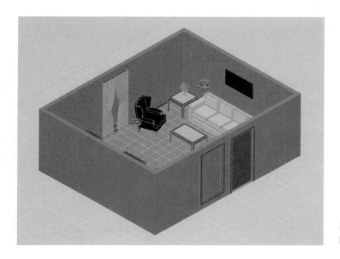

**Figure 15-15**    Realistic View Using Layer Colors

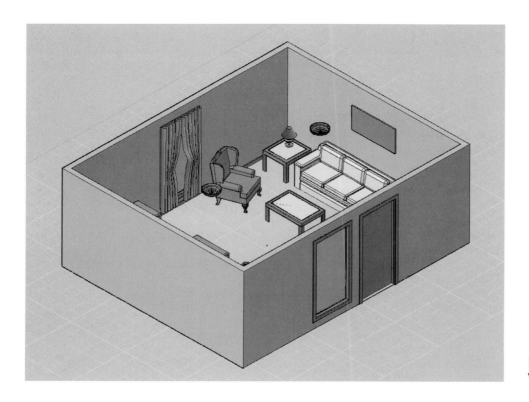

**Figure 15-16**    Conceptual View Using Layer Colors

The next step will be to add materials to the drawing. Open the **Tools** palette and drag and drop the following materials onto the **Materials Editor:**

Finishes.Flooring.Wood.Hardwood.1

Woods & Plastics.FinishCarpentry.Wood.Bocote

Doors & Windows.Glazing.Glass.Frosted

Doors & Windows.Glazing.Glass.Clear

Furnishings.Fabrics.Leather.Black

Furnishings.Fabrics.Canvas.White

Finishes.Plaster.Stucco.Troweled.White

Open the **Materials Editor** and review the available materials (see Figure 15-17).

At the command prompt, type **MATERIALATTACH** and attach materials to layers similar to those in Figure 15-18.

**Figure 15-17** Materials That Are Available on the **Materials Editor**

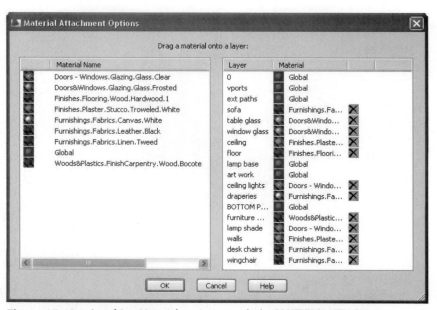

**Figure 15-18** Attaching Materials to Layers with the **MATERIALATTACH** Command

We will begin adding lights by adding point lights to the three lamps. In a NE isometric view, zoom in closely around one of the lamps. Use the top center of the stem as the 0,0,0 point. Then move the point light up 1″ in the +Z direction.

| Prompt | Response |
|---|---|
| Command: | Type: **LIGHT <Enter ↵>** |
| Enter light type [Point/Spot/Web/Target point/Freespot/freeweB/Distant] <Point>: | Type: **P <Enter ↵>** |
| Specify source location <0,0,0>: | Type: **CEN <Enter ↵>** |
| of | *Pick the center of the lamp stem* |
| Enter an option to change [Name/Intensity/ Status/shadoW/Attenuation/Color/eXit]: | Type: **I <Enter ↵>** |
| Enter intensity (0.00 — max float) <1.000>: | Type: **<Enter ↵>** |
| Enter an option to change [Name/Intensity/ Status/shadoW/Attenuation/Color/eXit]: | Type: **W <Enter ↵>** |
| Enter [Off/Sharp/soFtmapped/softsAmpled] <Sharp>: | Type: **A <Enter ↵>** |
| Enter an option to change | |

| [Shape/sAmples/Visible/eXit] <eXit>: | Type: **<Enter ↵>** |
| Enter an option to change [Name/Intensity/ Status/shadoW/Attenuation/Color/eXit]: | Type: **<Enter ↵>** |

Use the **MOVE** command to move the point light up 1″ in the Z direction. The point light needs to be moved away from the lamp stem so that the light shining downward is not blocked by the stem. Repeat the process and add point light sources to the other two lamps.

Add two additional point lights to the room by using the previous process (typing **LIGHT** at the command prompt, or selecting **Point Light** from the **Ribbon, Visualize** tab, **Lights** menu). Change to plan view, World UCS. Place a point light close to the XY location directly below each fixture with a Z elevation of 6′. Remember, you can adjust light properties such as intensity later to achieve the desired rendering outcome.

Using the **DVIEW** command and **Point Options**, create and save a perspective view similar to the views created in Chapter 13 (see Figures 13-20 and 13-21). Or from the **Ribbon, Home** tab, **View** menu, select **Create Camera** (see Figure 15-19) to produce a perspective view looking from just inside the door to the opposite wall.

Place an image on the wall art by using the **Materials** dialog box. Right-click on the **Global** material and create a new material named **Picture** (see Figure 15-20). In the **Diffuse Map** section, click on **Select Image**, and select a JPEG image of your choice to be used as the picture on the wall art (see Figure 15-21). For this illustration, a JPEG photo of Guadalupe Peak was used.

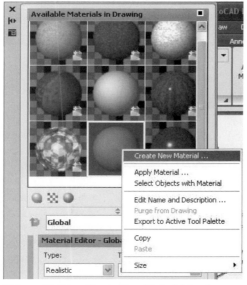

**Figure 15-19**   Produce a Perspective View Using the **Ribbon, Home** Tab, **View** Menu, **Create Camera**

**Figure 15-20**   Create New Material for the Wall Art

| SPLINE | |
|---|---|
| **Ribbon/ Home tab/ Draw/ Spline** | |
| **Menu** | Draw/ Spline |
| **Toolbar: Draw** | |
| **Command Line** | spline |
| **Alias** | spl |

From the **View Manager** (type **View** at the command prompt, or select **Named Views** from the **Menu Browser, View** menu), restore the perspective view from just inside the door. Select **Medium** on the **Render** palette (see Figure 15-22). Click on the **Render** icon. Your rendering should be similar to Figure 15-23.

We will create a walk-through AVI file of the office space. To begin, change to plan view, World UCS. Create a new layer called **Walk Path** and make it **current**. We need to create two paths for the walk-through: one for the camera, and one for the target. A spline fits a smooth curve to a sequence of points within a specified tolerance. With **Osnap** off, use the **SPLINE** command and draw two splines as illustrated in Figure 15-24.

Use the **MOVE** command to move the paths to elevation 5′-3″ (base point 0,0,0; second point 0,0,5′-3″). This will produce an eye-level view of the walk-through. We will use the longer spline for the target path and the shorter spline for the camera path, similar to the view you would have if you scanned the office while sitting at the desk.

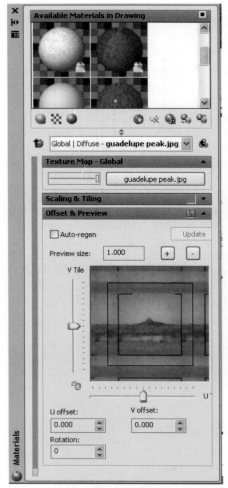

Figure 15-21    Select a JPEG Image for the Wall Art

Figure 15-22    Select Rendering Quality

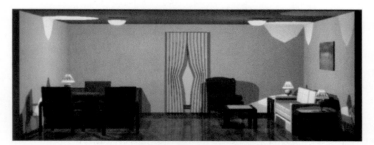

Figure 15-23    Rendered Perspective with Medium Quality

To open the **Motion Path Animations** dialog box, select **Motion Path Animations** from the **View** pull-down menu or from the **Menu Browser, View** menu, (see Figure 15-25). The **Motion Path Animations** dialog box contains the settings **Camera**, **Path, Animation settings**, and **Preview** (see Figure 15-26).

In the **Motion Path Animations** dialog box, click on **Link camera to**, select **Path** (see Figure 15-27), and pick the short spline (near the desk). Click on **Link path to**, select **Path**, and pick the long spline. Set the **Frame Rate** to **3** (frames per second). Set the number of frames to **30**. Set the **Visual Style** to **Medium**. You can save the animation file in an **AVI, MPG,** or **WMV** file format. Click on the **Preview** tab to preview the animation (see Figure 15-28). If the preview is satisfactory, click **OK**, and save the animation.

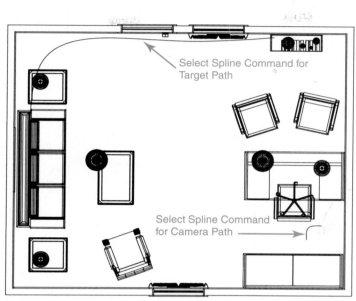

**Figure 15-24**    Create the Target and Camera Paths with the **SPLINE** Command

**Figure 15-25**    Select **Motion Path Animations**

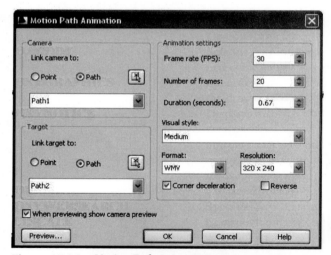

**Figure 15-26**    **Motion Path Animations** Dialog Box

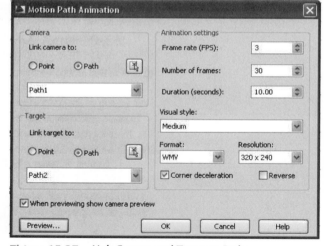

**Figure 15-27**    Link Camera and Target to Paths

**Figure 15-28**    Animation Preview

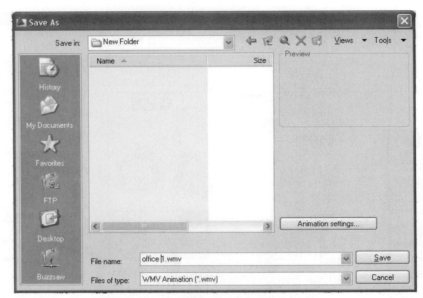

**Figure 15-29** **Save As** Dialog Box for Animation File

## CHAPTER EXERCISES

### Exercise 15-1: Practice Creating Rendered Views

Producing high-quality renderings and animations takes patience and practice. On your own, experiment with different materials, change the lighting levels and types of light and shadows, and produce renderings with various views.

It is a good idea to take notes on the processes and settings you use to document which worked best to produce each of the renderings. Produce rendered views similar to Figures 15-30 and 15-31.

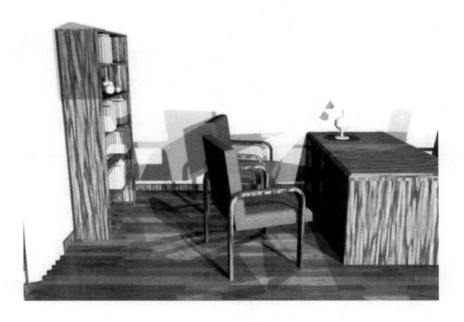

**Figure 15-30** Rendered View of the Guest Chair Area

### Exercise 15-2: Learning to Create Your Own Materials

Creating and attaching your materials is not a difficult task. Scan a piece of fabric suitable for the sofa upholstery. Save the image as a JPEG file. Make sure to align the fabric so that it will not appear misaligned or mismatched when the pattern is repeated. Figure 15-32 illustrates a

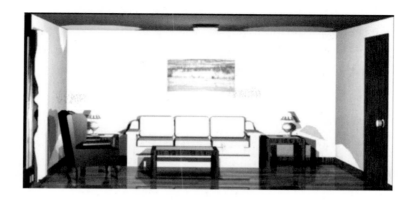

Figure 15-31    Rendered View of the Sofa Area

Figure 15-32    Scanned Image of a Striped Fabric for the Sofa

striped fabric that will be attached to the sofa. The size of the scanned image is approximately 8″ square.

Using the **CAMERA** command, produce a perspective view of the sofa similar to Figure 15-33.

We need to remove the material previously assigned to the sofa. Using the **Materials** palette, select the sofa, and then left-click on the **Remove Materials** button (see Figure 15-34).

On the **Materials** palette, left-click on the **Create New Material** button (see Figure 15-35). After you click on the **Create New Material** button, the **Create New Material** dialog box appears on the screen and allows you to type in a name and a description for the new material (see

Figure 15-33    Perspective View of the Sofa Area

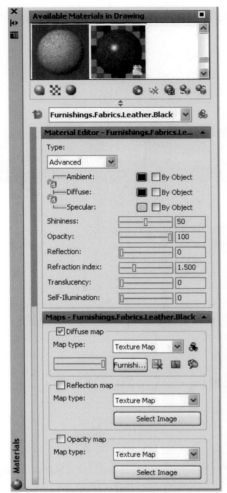

**Figure 15-34**    Removing the Material Assigned to the Sofa

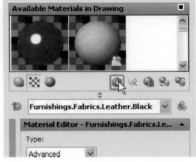

**Figure 15-35**    **Create New Material** Button

Figure 15-36). On the **Materials Editor**, **Maps** tab, select **Select Image** on the **Diffuse Map** (see Figure 15-37). The diffuse map is appropriate for material creation. Other settings include selecting an internal map type, such as **Checker, Marble, Noise, Speckle, Tiles, Waves**, or **Wood**. For this introduction, we will not use an additional texture map. Once the **Select Image** button has been selected, the **Select Image File** dialog box appears on the screen (see Figure 15-38). Use the **Browser** button to locate and select the desired image file, and click **Open**.

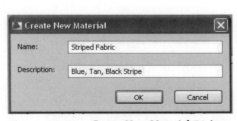

**Figure 15-36**    **Create New Material** Dialog Box

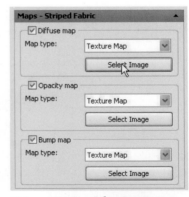

**Figure 15-37**    **Select Image** Button on the **Diffuse Map**

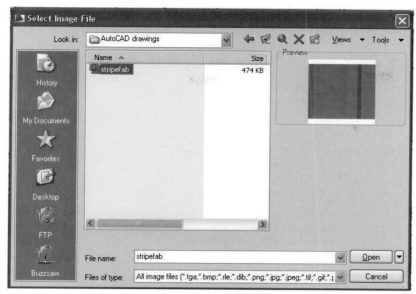

**Figure 15-38** **Select Image File** Dialog Box

Use the **MATERIALATTACH** command to open the **Material Attach Options** dialog box and attach the **Striped Fabric** to the **sofa** layer (see Figure 15-39). In the **Materials** palette, **Material Scaling and Tiling** tab, set the **Scale units** to **Inches**, and both the **Tile Width** and **Height** to **8″** (see Figure 15-40). Notice that in the **Material Offset** and **Preview** tab, you can preview the material, change the rotation, and change the offset in either the **U** and/or **V** direction.

Render the sofa view perspective. Your drawing should appear similar to Figure 15-41.

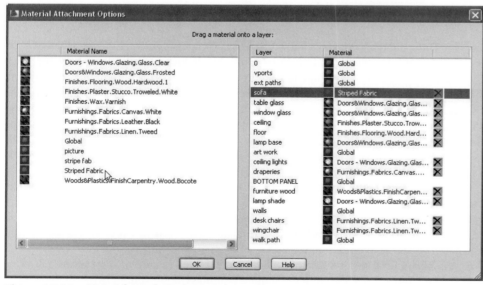

**Figure 15-39** **Material Attach Options** Dialog Box

**Exercise 15-3:** Learning to Use SteeringWheels and ViewCube

This exercise will introduce you to the **ViewCube** and **SteeringWheels**. The **ViewCube** is a 3D navigation tool that appears when the 3D graphics system is enabled, It allows you view models from standard viewpoints.

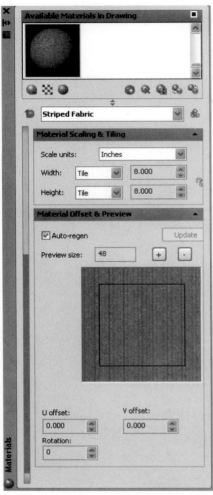

Figure 15-40     Set the Scale and Preview the Striped Fabric

Figure 15-41     Render Perspective View of the Sofa with Striped Fabric

The **ViewCube** contains hot spots that highlight as you pass your cursor over different parts of the cube. You can select views with the **ViewCube** by clicking on a hot spot. As you change the viewpoint of a model, the **ViewCube** tool automatically displays the current view orientation. In this book, you have selected isometric and standard (plan and elevation) views using the **VPOINT** command and the preset views found on the **Menu Browser**, **View** menu, **3D Views** flyout. The same views are produced using the **ViewCube** by clicking on a hot spot. For instance, a **NE Isometric** view selected from the **3D Views** flyout, or a view selected by typing in the **VPOINT** command, then **1,1,1**, is the same view that is produced by clicking on the top right corner (in plan view) of the **ViewCube**.

To control the **ViewCube** settings and behavior, right-click on the **ViewCube** and select **ViewCube Settings** (see Figure 15-42).

Practice using the **ViewCube** tool by opening the office space drawing just completed. Change the **Visual Style** to **3D Wireframe**, and change the **View** to **Plan**, **World UCS**. Your drawing should appear similar to Figure 15-43.

Using the **ViewCube**, select a front view by selecting the **S** (south) or front arrow below the cube (see Figure 15-44). After selecting the south elevation symbol, your drawing should appear similar to Figure 15-45.

Use the **Orbit** tool (**Constrained Orbit**) and move the model to see the **ViewCube** rotate as the model is rotated. Move the cursor around the **ViewCube** and select a **NE Isometric** view from it. Your drawing should appear similar to Figure 15-46.

As you can see, the **ViewCube** provides an intuitive option for viewing your model from standard viewpoints. Remember, the 3D graphics system (i.e., **3D Wireframe**, **3D Hidden**) must be enabled before you can use the **ViewCube**.

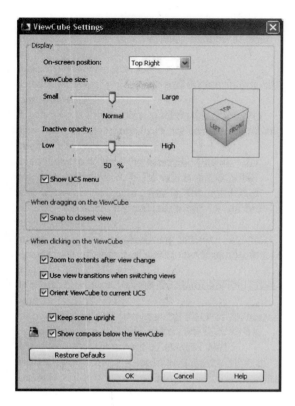

Figure 15-42    **ViewCube** Settings

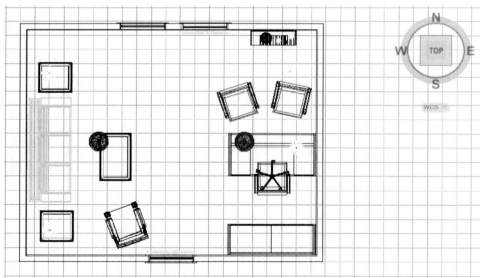

Figure 15-43    Plan View of the Office Space Showing the **ViewCube**

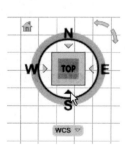

Figure 15-44    Select the **S** or Front Arrow Below the Cube

Figure 15-45    Front or South Elevation of the Office Space

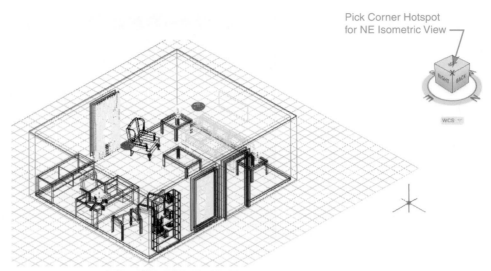

Pick Corner Hotspot
for NE Isometric View

**Figure 15-46**    NE Isometric View Selected Using the **ViewCube**

The new **SteeringWheel** tool displays a navigation wheel (located at the cursor) that allows quick access to a variety of navigation tools (see Figure 15-47). The **SteeringWheel** can be accessed from the **Ribbon**, **Home** tab, **View** panel; the **Menu Browser**, **View** flyout; or the **View** pull-down menu; or by typing **navswheel** at the command prompt.

A right-click menu on the **SteeringWheel** provides several options for different wheel sizes and modes (see Figure 15-48).

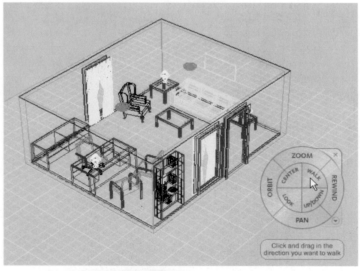

**Figure 15-47**    New **SteeringWheel** Tool

The **View Object** wheel, illustrated in Figure 15-49, is excellent for moving around a model. The **View Object** wheel includes common navigation tools such as **Zoom** and **Orbit**.

The **Tour Building** wheel is great for navigating inside a building. The **Tour Building** wheel includes tools for **Forward**, **Look**, **Up/Down**, and **Rewind** (see Figure 15-50).

You can customize the appearance and behavior of the navigation wheel using the **SteeringWheels Settings** dialog box, which is accessed from the right-click menu (see Figure 15-51).

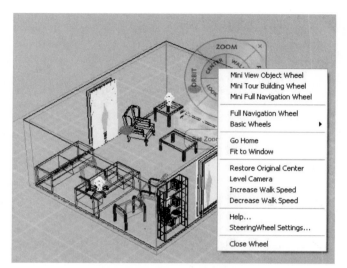

Figure 15-48    **SteeringWheel** Right-Click Menu

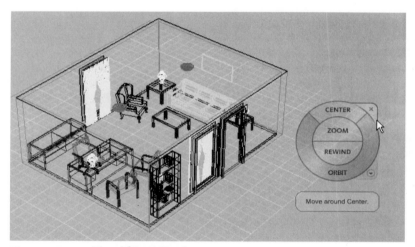

Figure 15-49    **View Object** Wheel

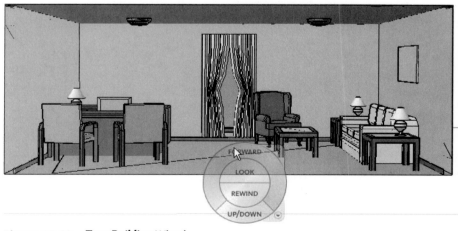

Figure 15-50    **Tour Building** Wheel

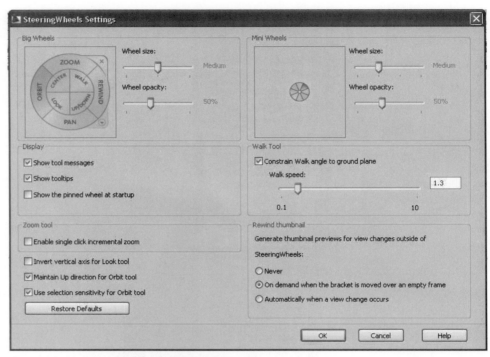

**Figure 15-51    SteeringWheels Settings Dialog Box**

# SUMMARY

This chapter provided you with additional practice using the **INSERT** command to insert previously drawn objects into a current drawing. You developed an understanding of the need to explode multicomponent blocks to change the layer properties of individual components. You also reviewed how to create views with **DVIEW** and **Cameras**. You learned how to use the **SPLINE** command to draw camera and target paths.

This chapter introduced you to the process of attaching materials to objects and layers. You became familiar with the process of—and the associated dialog boxes for—rendering a

3D model. You developed a basic understanding of inserting lights into a 3D model. The basic process for creating a walk-through animation was introduced.

You gained additional practice creating rendered perspective views of 3D models. This chapter also provided you with the knowledge needed to create and attach your own materials to models. You gained a basic understanding of the **ViewCube** tool for selecting standard and isometric views, and you received a basic introduction to the **SteeringWheel** navigation tools.

# CHAPTER TEST QUESTIONS

## Multiple Choice

1.  What must be done to an inserted block before you can change the layer properties of individual parts of multi-component blocks?

    a.  The block must be redrawn
    b.  The block must be exploded once
    c.  The block must be rotated
    d.  The block must be scaled
    e.  None of the above

2.  Which of the following is *not* a rendering quality setting found in the **Advanced Rendering Settings** dialog box?

    a.  **Draft**
    b.  **Medium**
    c.  **Black and White**
    d.  **Low**
    e.  **High**

3.  Which of the following types of light shines in all directions, much like a standard incandescent lamp?

    a.  **Spotlight**
    b.  **Weblight**
    c.  **Freespot**
    d.  **Point Light**
    e.  **Distant Light**

4. Which of the following can be typed at the command prompt to attach materials to layers?
   a. **INSERT**
   b. **MATERIALATTACH**
   c. **RENDER**
   d. **VIEW**
   e. **DVIEW**

5. Which of the following is *not* an option contained on the **Motion Path Animations** dialog box?
   a. **Camera**
   b. **Path**
   c. **Dynamic view**
   d. **Animation settings**
   e. **Preview**

## Matching

**Column A**

a. **EXPLODE**

b. **HIDE**

c. **RENDER**

d. **MATERIALS**

e. **SPLINE**

**Column B**

1. Creates a photorealistic or realistically shaded image of a three-dimensional wireframe or solid model

2. Breaks a compound object into its component objects

3. Regenerates a three-dimensional wireframe model with hidden lines suppressed

4. Fits a smooth curve to a sequence of points within a specified tolerance

5. Manages, applies, and modifies materials

## True or False

1. T or F: You can select **Motion Path Animations** from the **View** pull-down menu or from the **Menu Browser**, **View** menu.

2. T or F: Realistic renderings using AutoCAD are produced by using and manipulating objects, lighting, and materials.

3. T or F: Once a light source has been established in a drawing, you cannot adjust the intensity, color, or shadows.

4. T or F: The **Materials** dialog box allows you to attach or detach materials from objects.

5. T or F: If a material has *not* been assigned to an object, AutoCAD renders the object with random materials.

The following reference list provides brief definitions for AutoCAD commands. Use AutoCAD's **Help** feature for more details about these commands.

| | |
|---|---|
| **3D** | Creates three-dimensional polygon mesh objects in common geometric shapes that can be hidden, shaded, or rendered |
| **3DALIGN** | Aligns objects with other objects in 2D and 3D |
| **3DARRAY** | Creates a 3D array |
| **3DCLIP** | Starts an interactive 3D view and opens the **Adjust Clipping Planes** window |
| **3DCONFIG** | Provides 3D graphics system configuration settings |
| **3DCORBIT** | Starts an interactive 3D view and sets the objects into continuous motion |
| **3DDISTANCE** | Starts the interactive 3D view and makes objects appear closer or farther away |
| **3DDWF** | Creates a 3D DWF or 3D DWFx file of your three-dimensional model and displays it in the **DWF Viewer** |
| **3DFACE** | Creates a three-sided or four-sided surface anywhere in 3D space |
| **3DFLY** | Interactively changes your view of a 3D drawing so that you appear to be flying through the model |
| **3DFORBIT** | Using an unconstrained orbit, controls the interactive viewing of objects in 3D |
| **3DMESH** | Creates a free-form polygon mesh |
| **3DMOVE** | Displays the **MOVE** grip tool in a 3D view and moves objects a specified distance in a specified direction |
| **3DORBIT** | Controls the interactive viewing of objects in 3D |
| **3DORBITCTR** | Sets the center of rotation in **3D Orbit** view |
| **3DPAN** | When a drawing is in a **Perspective** view, starts the interactive 3D view and enables you to drag the view horizontally and vertically |
| **3DPOLY** | Creates a 3D polyline |
| **3DROTATE** | Displays the **ROTATE** grip tool in a 3D view and revolves objects around a base point |
| **3DSIN** | Imports a 3D Studio (3DS) file |
| **3DSWIVEL** | Changes the target of the view in the direction that you drag the mouse |
| **3DWALK** | Interactively changes the view of a 3D drawing so that you appear to be walking through the model |
| **3DZOOM** | Zooms in and out in a perspective view |
| **ABOUT** | Displays information about AutoCAD |

| | |
|---|---|
| **ACISIN** | Imports an ACIS file and creates a body object, solid, or region in the drawing |
| **ACISOUT** | Exports a body object, solid, or region to an ACIS file |
| **ACTRECORD** | Starts the **Action Recorder** |
| **ACTSTOP** | Stops the **Action Recorder** and provides the option of saving the recorded actions to an action macro file |
| **ACTUSERINPUT** | Inserts a request for user input into an action macro |
| **ACTUSERMESSAGE** | Inserts a user message into an action macro |
| **ADCCLOSE** | Closes the **DesignCenter** |
| **ADCENTER** | Manages and inserts content such as blocks, xrefs, and hatch patterns |
| **ADCNAVIGATE** | Loads a specified **DesignCenter** drawing file, folder, or network path |
| **ALIGN** | Aligns objects with other objects in 2D and 3D |
| **AMECONVERT** | Converts AME solid models to AutoCAD solid objects |
| **ANIPATH** | Saves an animation along a path in a 3D model |
| **ANNORESET** | Resets the location of all scale representations for an annotative object to that of the current scale representation |
| **ANNOUPDATE** | Updates existing annotative objects to match the current properties of their styles |
| **APERTURE** | Controls the size of the **Object Snap** target box |
| **APPLOAD** | Loads and unloads applications and defines which applications to load at startup |
| **ARC** | Creates an arc |
| **ARCHIVE** | Packages the current sheet set files to be archived |
| **AREA** | Calculates the area and perimeter of objects or of defined areas |
| **ARRAY** | Creates multiple copies of objects in a pattern |
| **ARX** | Loads, unloads, and provides information about **ObjectARX** applications |
| **ATTACHURL** | Attaches hyperlinks to objects or areas in a drawing |
| **ATTDEF** | Creates an attribute definition for storing data in a block |
| **ATTDISP** | Retains the current visibility setting of each attribute |
| **ATTEDIT** | Changes the attribute information in a block |
| **ATTEXT** | Extracts attribute data, informational text associated with a block, into a file |
| **ATTIPEDIT** | Changes the textual content of an attribute within a block |
| **ATTREDEF** | Redefines a block and updates associated attributes |
| **ATTSYNC** | Updates block references with new and changed attributes from a specified block definition |
| **AUDIT** | Evaluates the integrity of a drawing and corrects some errors |
| **AUTOPUBLISH** | Automatically publishes drawings to DWF or DWFx files to the location specified |
| **BACKGROUND** | Sets up the background for your view |
| **BACTION** | Adds an action to a dynamic block definition |
| **BACTIONSET** | Specifies the selection set of objects associated with an action in a dynamic block definition |
| **BACTIONTOOL** | Adds an action to a dynamic block definition |
| **BASE** | Sets the insertion base point for the current drawing |

| | |
|---|---|
| **BASSOCIATE** | Associates an action with a parameter in a dynamic block definition |
| **BATTMAN** | Manages the attributes for a selected block definition |
| **BATTORDER** | Specifies the order of attributes for a block |
| **BAUTHORPALETTE** | Opens the **Block Authoring Palettes** window in the **Block Editor** |
| **BAUTHORPALETTECLOSE** | Closes the **Block Authoring Palettes** window in the **Block Editor** |
| **BCLOSE** | Closes the **Block Editor** |
| **BCYCLEORDER** | Changes the cycling order of grips for a dynamic block reference |
| **BEDIT** | Opens the block definition in the **Block Editor** |
| **BGRIPSET** | Creates, deletes, or resets grips associated with a parameter |
| **BHATCH** | Fills an enclosed area or selected objects with a hatch pattern or gradient fill |
| **BLIPMODE** | Controls the display of marker blips |
| **BLOCK** | Creates a block definition from selected objects |
| **BLOCKICON** | Generates preview images for blocks displayed in **DesignCenter** |
| **BLOOKUPTABLE** | Displays or creates a lookup table for a dynamic block definition |
| **BMPOUT** | Saves selected objects to a file in device-independent bitmap format |
| **BOUNDARY** | Creates a region or a polyline from an enclosed area. |
| **BOX** | Creates a 3D solid box |
| **BPARAMETER** | Adds a parameter with grips to a dynamic block definition |
| **BREAK** | Breaks the selected object between two points |
| **BREP** | Removes the history from 3D solid primitives and composite solids |
| **BROWSER** | Launches the default Web browser defined in your system's registry |
| **BSAVE** | Saves the current block definition |
| **BSAVEAS** | Saves a copy of the current block definition under a new name |
| **BVHIDE** | Makes objects invisible in the current visibility state or all visibility states in a dynamic block definition |
| **BVSHOW** | Makes objects visible in the current visibility state or all visibility states in a dynamic block definition |
| **BVSTATE** | Creates, sets, or deletes a visibility state in a dynamic block |
| **CAL** | Evaluates mathematical and geometric expressions |
| **CAMERA** | Sets a camera and target location to create and save a 3D perspective view of objects |
| **CHAMFER** | Bevels the edges of objects |
| **CHANGE** | Changes the properties of existing objects |
| **CHECKSTANDARDS** | Checks the current drawing for standards violations |
| **CHPROP** | Changes the properties of an object |
| **CHSPACE** | Moves objects between model space and paper space |
| **CIRCLE** | Creates a circle |
| **CLASSICLAYER** | Manages layer and layer properties |
| **CLEANSCREENOFF** | Restores the display of toolbars and dockable windows (excluding the command line) |

| | |
|---|---|
| **CLEANSCREENON** | Clears the screen of toolbars and dockable windows (excluding the command line) |
| **CLOSE** | Closes the current drawing |
| **CLOSEALL** | Closes all currently open drawings |
| **COLOR** | Sets the color for new objects |
| **COMMANDLINE** | Displays the command line |
| **COMMANDLINEHIDE** | Hides the command line |
| **COMPILE** | Compiles shape files and PostScript font files into SHX files |
| **CONE** | Creates a 3D solid cone |
| **CONVERT** | Optimizes 2D polylines and associative hatches created in AutoCAD Release 13 or earlier |
| **CONVERTCTB** | Converts a color-dependent plot style table (CTB) to a named plot style table (STB) |
| **CONVERTOLDLIGHTS** | Converts lights created in previous drawing file formats to the current format |
| **CONVERTOLDMATERIALS** | Converts materials created in previous drawing file formats to the current format |
| **CONVERTPSTYLES** | Converts the current drawing to either named or color-dependent plot styles |
| **CONVTOSOLID** | Converts polylines and circles with a thickness to 3D solids |
| **CONVTOSURFACE** | Converts objects to surfaces |
| **COPY** | Copies objects a specified distance in a specified direction |
| **COPYBASE** | Copies objects with a specified base point |
| **COPYCLIP** | Copies selected objects to the **Clipboard** |
| **COPYHIST** | Copies the text in the command prompt history to the **Clipboard** |
| **COPYLINK** | Copies the current view to the **Clipboard** for linking to other OLE applications |
| **COPYTOLAYER** | Copies one or more objects to another layer |
| **CUI** | Manages customized user interface elements such as workspaces, toolbars, menus, **Ribbon** panels, shortcut menus, and keyboard shortcuts |
| **CUIEXPORT** | Exports customized settings to an enterprise or partial CUI file |
| **CUIIMPORT** | Imports customized settings from an enterprise or partial CUI file to acad.cui |
| **CUILOAD** | Loads a CUI file |
| **CUIUNLOAD** | Unloads a CUI file |
| **CUSTOMIZE** | Customizes tool palettes and tool palette groups |
| **CUTCLIP** | Moves the selected objects to the **Clipboard** and removes them from the drawing |
| **CYLINDER** | Creates a 3D solid cylinder |
| **DATAEXTRACTION** | Exports object property, block attribute, and drawing information to a data extraction table or to an external file, and specifies a data link to an Excel spreadsheet |
| **DATALINK** | Displays the **Data Link Manager** dialog box |
| **DATALINKUPDATE** | Updates data to or from an established external data link |
| **DBCONNECT** | Provides an interface to external database tables |
| **DBLIST** | Lists database information for each object in the drawing |
| **DDEDIT** | Edits single-line text, dimension text, attribute definitions, and feature control frames |

| | |
|---|---|
| **DDPTYPE** | Specifies the display style and size of point objects |
| **DDVPOINT** | Sets the three-dimensional viewing direction |
| **DELAY** | Provides a timed pause within a script |
| **DETACHURL** | Removes hyperlinks in a drawing |
| **DGNADJUST** | Changes the display options of selected DGN underlays |
| **DGNATTACH** | Attaches a DGN underlay to the current drawing |
| **DGNCLIP** | Defines a clipping boundary for a selected DGN underlay |
| **DGNEXPORT** | Creates one or more DGN files from the current drawing |
| **DGNIMPORT** | Imports the data from a DGN file into a new DWG file |
| **DGNLAYERS** | Controls the display of layers in a DGN underlay |
| **DGNMAPPING** | Allows users to create and edit user-defined DGN mapping setups |
| **DIM** and **DIM1** | Accesses **Dimensioning** mode |
| **DIMALIGNED** | Creates an aligned linear dimension |
| **DIMANGULAR** | Creates an angular dimension |
| **DIMARC** | Creates an arc length dimension |
| **DIMBASELINE** | Creates a linear, angular, or ordinate dimension from the baseline of the previous dimension or a selected dimension |
| **DIMBREAK** | Breaks or restores dimension and extension lines where they cross other objects |
| **DIMCENTER** | Creates the center mark or the centerlines of circles and arcs |
| **DIMCONTINUE** | Creates a linear, angular, or ordinate dimension that starts from the second extension line of the previous or selected dimension |
| **DIMDIAMETER** | Creates a diameter dimension for a circle or an arc |
| **DIMDISASSOCIATE** | Removes associativity from selected dimensions |
| **DIMEDIT** | Edits dimension text and extension lines |
| **DIMINSPECT** | Adds or removes inspection information for a selected dimension |
| **DIMJOGGED** | Creates jogged dimensions for circles and arcs |
| **DIMJOGLINE** | Adds or removes a jog line on a linear or aligned dimension |
| **DIMLINEAR** | Creates linear dimensions |
| **DIMORDINATE** | Creates ordinate dimensions |
| **DIMOVERRIDE** | Overrides dimensioning system variables |
| **DIMRADIUS** | Creates a radius dimension for a circle or an arc |
| **DIMREASSOCIATE** | Associates selected dimensions to geometric objects |
| **DIMREGEN** | Updates the locations of all associative dimensions |
| **DIMSPACE** | Adjusts the spacing between linear dimensions or angular dimensions |
| **DIMSTYLE** | Creates and modifies dimension styles |
| **DIMTEDIT** | Moves and rotates dimension text and relocates the dimension line |
| **DIST** | Measures the distance and angle between two points. |
| **DISTANTLIGHT** | Creates a distant light |
| **DIVIDE** | Places evenly spaced point objects or blocks along the length or perimeter of an object |
| **DONUT** | Creates filled circles and rings |
| **DRAGMODE** | Controls the way dragged objects are displayed |
| **DRAWINGRECOVERY** | Displays a list of drawing files that can be recovered after a program or system failure |

| | |
|---|---|
| **DRAWINGRECOVERYHIDE** | Closes the **Drawing Recovery Manager** dialog box |
| **DRAWORDER** | Changes the draw order of images and other objects |
| **DSETTINGS** | Sets grid and snap, polar and object snap tracking, object snap modes, **Dynamic Input**, and **Quick Properties** |
| **DSVIEWER** | Opens the **Aerial View** window |
| **DVIEW** | Defines parallel projection or perspective views by using a camera and a target |
| **DWFADJUST** | Allows adjustment of a DWF or DWFx underlay at the command prompt |
| **DWFATTACH** | Attaches a DWF or DWFx underlay to the current drawing |
| **DWFCLIP** | Uses clipping boundaries to define a subregion of a DWF or DWFx underlay |
| **DWFFORMAT** | Sets the default DWF format to either DWF or DWFx for the following commands: **PUBLISH**, **3DDWF**, and **EXPORT** |
| **DWFLAYERS** | Controls the display of layers in a DWF or DWFx underlay |
| **DWGPROPS** | Sets and displays the properties of the current drawing |
| **DXBIN** | Imports specially coded binary files |
| **EATTEDIT** | Edits attributes in a block reference |
| **EATTEXT** | Exports property data from objects, block attribute information, and drawing information to a table or to an external file |
| **EDGE** | Changes the visibility of three-dimensional face edges |
| **EDGESURF** | Creates a three-dimensional polygon mesh |
| **ELEV** | Sets the elevation and extrusion thickness of new objects |
| **ELLIPSE** | Creates an ellipse or an elliptical arc |
| **ERASE** | Removes objects from a drawing |
| **ETRANSMIT** | Packages a set of files for Internet transmission |
| **EXPLODE** | Breaks a compound object into its component objects |
| **EXPORT** | Saves objects to other file formats |
| **EXPORTLAYOUT** | Exports all visible objects from the current layout to the model space of the new drawing |
| **EXPORTTOAUTOCAD** | Creates a new DWG file with all AEC objects exploded |
| **EXTEND** | Extends objects to meet the edges of other objects |
| **EXTERNALREFERENCES** | Displays the **External References** palette |
| **EXTERNALREFERENCESCLOSE** | Closes the **External References** palette |
| **EXTRUDE** | Creates a 3D solid or surface by extruding a 2D object |
| **FIELD** | Creates a multiline text object with a field that can be updated automatically as the field value changes |
| **FILL** | Controls the filling of objects such as hatches, two-dimensional solids, and wide polylines |
| **FILLET** | Rounds and fillets the edges of objects |
| **FILTER** | Creates a list of requirements that an object must meet to be included in a selection set |
| **FIND** | Finds, replaces, or zooms to specified text |
| **FLATSHOT** | Creates a 2D representation of all 3D objects in the current view |

| | |
|---|---|
| **FREESPOT** | Creates a free spotlight, which is similar to a spotlight but without a specified target |
| **FREEWEB** | Creates a free weblight, which is similar to a weblight but without a specified target |
| **GEOGRAPHICLOCATION** | Specifies the geographic location information for a drawing file |
| **GOTOURL** | Opens the file or Web page associated with the hyperlink attached to an object |
| **GRADIENT** | Fills an enclosed area or selected objects with a gradient fill |
| **GRAPHSCR** | Switches from the text window to the drawing area |
| **GRID** | Displays a grid pattern in the current viewport |
| **GROUP** | Creates and manages saved sets of objects called groups |
| **HATCH** | Fills an enclosed area or selected objects with a hatch pattern, solid fill, or gradient fill |
| **HATCHEDIT** | Modifies an existing hatch or fill |
| **HELIX** | Creates a 2D spiral or 3D spring |
| **HELP** | Displays the **Help** options |
| **HIDE** | Regenerates a three-dimensional wireframe model with hidden lines suppressed |
| **HIDEPALETTES** | Hides currently displayed palettes (including the command line) |
| **HLSETTINGS** | Controls the display properties of models |
| **HYPERLINK** | Attaches a hyperlink to an object or modifies an existing hyperlink |
| **HYPERLINKOPTIONS** | Controls the display of the hyperlink cursor, tooltips, and shortcut menu |
| **ID** | Displays the coordinate of a location |
| **IMAGE** | Displays the **External References** palette |
| **IMAGEADJUST** | Controls the image display of the brightness, contrast, and fade values of images |
| **IMAGEATTACH** | Attaches a new image to the current drawing |
| **IMAGECLIP** | Uses clipping boundaries to define a subregion of an image object |
| **IMAGEFRAME** | Controls whether image frames are displayed and plotted |
| **IMAGEQUALITY** | Controls the display quality of images |
| **IMPORT** | Imports files in various formats |
| **IMPRESSION** | Gives a CAD drawing a hand-drawn look by exporting it for rendering in Autodesk Impression. |
| **IMPRINT** | Imprints an edge on a 3D solid |
| **INSERT** | Inserts a block or a drawing into the current drawing |
| **INSERTOBJ** | Inserts a linked or embedded object |
| **INTERFERE** | Highlights 3D solids that overlap |
| **INTERSECT** | Creates a 3D solid or 2D region from their overlapping volume or area |
| **ISOPLANE** | Specifies the current isometric plane |
| **JOGSECTION** | Adds a jogged segment to a section object |
| **JOIN** | Joins similar objects to form a single, unbroken object |
| **JPGOUT** | Saves selected objects to a file in JPEG file format |
| **JUSTIFYTEXT** | Changes the justification point of selected text objects without changing their locations |
| **LAYCUR** | Changes the layer of selected objects to the current layer |
| **LAYDEL** | Deletes all objects on a layer and purges the layer |

| | |
|---|---|
| **LAYER** | Manages layers and layer properties |
| **LAYERCLOSE** | Closes the **Layer Properties Manager** dialog box |
| **LAYERP** | Undoes the last change or set of changes made to layer settings |
| **LAYERPMODE** | Turns the tracking of changes made to layer settings on and off |
| **LAYERSTATE** | Saves, restores, and manages named layer states |
| **LAYFRZ** | Freezes the layer of selected objects |
| **LAYISO** | Hides or locks all layers except those of the selected objects |
| **LAYLCK** | Locks the layer of a selected object |
| **LAYMCH** | Changes the layer of a selected object to match the destination layer |
| **LAYMCUR** | Makes the layer of a selected object with the current layer |
| **LAYMRG** | Merges selected layers into a target layer and removes the previous layers from the drawing |
| **LAYOFF** | Turns off the layer of a selected object |
| **LAYON** | Turns on all layers in the drawing |
| **LAYOUT** | Creates and modifies drawing **Layout** tabs |
| **LAYOUTWIZARD** | Creates a new **Layout** tab and specifies page and plot settings |
| **LAYTHW** | Thaws all layers in the drawing |
| **LAYTRANS** | Changes a drawing's layers to layer standards that you specify |
| **LAYULK** | Unlocks the layer of a selected object |
| **LAYUNISO** | Restores all layers that were hidden or locked with the **LAYISO** command |
| **LAYVPI** | Freezes selected layers in all layout viewports except the current viewport |
| **LAYWALK** | Displays objects on selected layers and hides objects on all other layers |
| **LEADER** | Creates a line that connects annotation to a feature |
| **LENGTHEN** | Changes the length of objects and the included angle of arcs |
| **LIGHT** | Creates a light |
| **LIGHTLIST** | Displays the **Lights in Model** palette |
| **LIGHTLISTCLOSE** | Closes the **Lights in Model** window |
| **LIMITS** | Sets and controls the limits of the grid display in the current **Model** or **Layout** tab |
| **LINE** | Creates straight line segments |
| **LINETYPE** | Loads, sets, and modifies linetypes |
| **LIST** | Displays property data for selected objects |
| **LIVESECTION** | Turns on live sectioning for a selected section object |
| **LOAD** | Makes shapes available for use by the **SHAPE** command |
| **LOFT** | Creates a 3D solid or surface in the space between several cross sections |
| **LOGFILEOFF** | Closes the text window log file opened by the **LOGFILEON** command |
| **LOGFILEON** | Writes the text window contents to a file |
| **LTSCALE** | Sets the global linetype scale factor |
| **LWEIGHT** | Sets the current lineweight, lineweight display options, and lineweight units |
| **MARKUP** | Displays the details of markups and allows you to change their status |
| **MARKUPCLOSE** | Closes the **Markup Set Manager** dialog box |

| | |
|---|---|
| **MASSPROP** | Calculates the mass properties of regions or 3D solids |
| **MATCHCELL** | Applies the properties of a selected table cell to other table cells |
| **MATCHPROP** | Applies the properties of a selected object to other objects |
| **MATERIALATTACH** | Applies materials to objects by layer |
| **MATERIALMAP** | Displays a material mapping gizmo to adjust the mapping on a face or an object |
| **MATERIALS** | Manages, applies, and modifies materials |
| **MATERIALSCLOSE** | Closes the **Materials** window |
| **MEASURE** | Places point objects or blocks at measured intervals on an object |
| **MENU** | Loads a customization file |
| **MINSERT** | Inserts multiple instances of a block in a rectangular array |
| **MIRROR** | Creates a mirrored copy of selected objects |
| **MIRROR3D** | Creates a mirrored copy of selected objects about a plane |
| **MLEADER** | Creates a multileader object |
| **MLEADERALIGN** | Organizes selected multileaders along a specified line |
| **MLEADERCOLLECT** | Organizes selected multileaders containing blocks as content into a group attached to a single leader line |
| **MLEADEREDIT** | Adds leader lines to, or removes leader lines from, a multileader object |
| **MLEADERSTYLE** | Creates and modifies multileader styles |
| **MLEDIT** | Edits multiline intersections, breaks, and vertices |
| **MLINE** | Creates multiple parallel lines |
| **MLSTYLE** | Creates, modifies, and manages multiline styles |
| **MODEL** | Switches from a **Layout** tab to the **Model** tab |
| **MOVE** | Moves objects a specified distance in a specified direction |
| **MREDO** | Reverses the effects of several previous **UNDO** or **U** commands |
| **MSLIDE** | Creates a slide file of the current model viewport or the current layout |
| **MSPACE** | Switches from paper space to a model space viewport |
| **MTEDIT** | Edits multiline text |
| **MTEXT** | Creates a multiline text object |
| **MULTIPLE** | Repeats the next command until canceled |
| **MVIEW** | Creates and controls layout viewports |
| **MVSETUP** | Sets up the specifications of a drawing |
| **NAVSMOTION** | Displays the **ShowMotion** interface |
| **NAVSMOTIONCLOSE** | Closes the **ShowMotion** interface |
| **NAVSWHEEL** | Displays the **SteeringWheels** |
| **NAVVCUBE** | Controls the visibility and display properties of the **ViewCube** |
| **NETLOAD** | Loads a .NET application |
| **NEW** | Creates a new drawing |
| **NEWSHEETSET** | Creates a new sheet set |
| **NEWSHOT** | Creates a named view with motion that is played back when viewed with **ShowMotion** |
| **NEWVIEW** | Creates a named view with no motion |
| **OBJECTSCALE** | Adds or deletes supported scales for annotative objects |

| | |
|---|---|
| **OFFSET** | Creates concentric circles, parallel lines, and parallel curves |
| **OLELINKS** | Updates, changes, and cancels existing OLE links |
| **OLESCALE** | Controls the size, scale, and other properties of a selected OLE object |
| **OOPS** | Restores erased objects |
| **OPEN** | Opens an existing drawing file |
| **OPENDWFMARKUP** | Opens a DWF or DWFx file that contains markups |
| **OPENSHEETSET** | Opens a selected sheet set |
| **OPTIONS** | Customizes the program settings |
| **ORTHO** | Constrains cursor movement to the horizontal or vertical direction |
| **OSNAP** | Sets running **Object Snap** modes |
| **PAGESETUP** | Controls the page layout, plotting device, paper size, and other settings for each new layout |
| **PAN** | Moves the view in the current viewport |
| **PARTIALOAD** | Loads additional geometry into a partially opened drawing |
| **PARTIALOPEN** | Loads geometry and named objects from a selected view or layer into a drawing |
| **PASTEASHYPERLINK** | Inserts data from the **Clipboard** as a hyperlink |
| **PASTEBLOCK** | Pastes copied objects as a block |
| **PASTECLIP** | Inserts data from the **Clipboard** |
| **PASTEORIG** | Pastes a copied object in a new drawing using the coordinates from the original drawing |
| **PASTESPEC** | Inserts data from the **Clipboard** and controls the format of the data |
| **PCINWIZARD** | Displays a wizard to import PCP and PC2 configuration file plot settings into the **Model** tab or current layout |
| **PEDIT** | Edits polylines and 3D polygon meshes |
| **PFACE** | Creates a three-dimensional polyface mesh, vertex by vertex |
| **PLAN** | Displays the plan view of a specified user coordinate system |
| **PLANESURF** | Creates a planar surface |
| **PLINE** | Creates a 2D polyline |
| **PLOT** | Plots a drawing to a plotter, printer, or file |
| **PLOTSTAMP** | Places a plot stamp on a specified corner of each drawing and logs it to a file |
| **PLOTSTYLE** | Sets the current plot style for new objects or assigns a plot style to selected objects |
| **PLOTTERMANAGER** | Displays the **Plotter Manager** dialog box, where you can add or edit a plotter configuration |
| **PNGOUT** | Saves selected objects to a file in a Portable Network Graphics format |
| **POINT** | Creates a point object |
| **POINTLIGHT** | Creates a point light |
| **POLYGON** | Creates an equilateral closed polyline |
| **POLYSOLID** | Creates a 3D wall-like polysolid |
| **PRESSPULL** | Presses or pulls bounded areas |
| **PREVIEW** | Shows how a drawing will look when it is plotted |
| **PROPERTIES** | Controls the properties of existing objects |
| **PROPERTIESCLOSE** | Closes the **Properties** palette |
| **PSETUPIN** | Imports a user-defined page setup into a new drawing layout |

| | |
|---|---|
| **PSPACE** | Switches from a model space viewport to paper space |
| **PUBLISH** | Publishes drawings to DWF or DWFx files or plotters |
| **PUBLISHTOWEB** | Creates HTML pages that include images of selected drawings |
| **PURGE** | Removes unused named items, such as block definitions and layers, from a drawing |
| **PYRAMID** | Creates a 3D solid pyramid |
| **QCCLOSE** | Closes **QuickCalc** |
| **QDIM** | Quickly creates a series of dimensions from selected objects |
| **QLEADER** | Creates a leader and leader annotation |
| **QNEW** | Starts a new drawing with the option of using a default drawing template file |
| **QSAVE** | Saves the current drawing using the file format specified in the **Options** dialog box |
| **QSELECT** | Creates a selection set based on filtering criteria |
| **QTEXT** | Controls the display and plotting of text and attribute objects |
| **QUICKCALC** | Opens the **QuickCalc** calculator |
| **QUICKCUI** | Displays the **Customize User Interface** dialog box in a collapsed state |
| **QUIT** | Exits the program |
| **QVDRAWING** | Displays open drawings and layouts in a drawing in preview images |
| **QVDRAWINGCLOSE** | Closes preview images of open drawings and layouts in a drawing |
| **QVLAYOUT** | Displays preview images of model space and layouts in a drawing |
| **QVLAYOUTCLOSE** | Closes preview images of model space and layouts in a drawing |
| **RAY** | Creates a line that starts at a point and continues to infinity |
| **RECOVER** | Repairs a damaged drawing |
| **RECOVERALL** | Repairs a damaged drawing and xrefs |
| **RECTANG** | Creates a rectangular polyline |
| **REDEFINE** | Restores AutoCAD internal commands overridden by the **UNDEFINE** command |
| **REDO** | Reverses the effects of previous **UNDO** or **U** commands |
| **REDRAW** | Refreshes the display in the current viewport |
| **REDRAWALL** | Refreshes the display in all viewports |
| **REFCLOSE** | Saves or discards changes made during in-place editing of a reference (an xref or a block) |
| **REFEDIT** | Selects an external reference or block reference for editing |
| **REFSET** | Adds or removes objects from a working set during in-place editing of a reference (an xref or a block) |
| **REGEN** | Regenerates the entire drawing from the current viewport |
| **REGENALL** | Regenerates the drawing and refreshes all viewports |
| **REGENAUTO** | Controls automatic regeneration of a drawing |
| **REGION** | Converts an object that encloses an area into a region object |
| **REINIT** | Reinitializes the digitizer, digitizer input/output port, and program parameters file |

| | |
|---|---|
| **RENAME** | Changes the names of named objects |
| **RENDER** | Creates a photorealistic or realistically shaded image of a three-dimensional wireframe or solid model |
| **RENDERCROP** | Selects a specific region (crop window) in an image for rendering |
| **RENDERENVIRONMENT** | Provides visual cues for the apparent distance of objects |
| **RENDEREXPOSURE** | Provides settings to interactively adjust the global lighting for the most recently rendered output |
| **RENDERPRESETS** | Specifies render presets, reusable rendering parameters, for rendering an image |
| **RENDERWIN** | Displays the **Render** window without invoking a render task |
| **RESETBLOCK** | Resets one or more dynamic block references to the default values of the block definition |
| **RESUME** | Continues an interrupted script |
| **REVCLOUD** | Creates a revision cloud using a polyline |
| **REVOLVE** | Creates a 3D solid or surface by sweeping a 2D object around an axis |
| **REVSURF** | Creates a revolved mesh about a selected axis |
| **RIBBON** | Opens the **Ribbon** window |
| **RIBBONCLOSE** | Closes the **Ribbon** window |
| **ROTATE** | Rotates objects around a base point |
| **ROTATE3D** | Moves objects about a three-dimensional axis |
| **RPREF** | Displays the **Advanced Render Settings** palette for access to advanced rendering settings |
| **RPREFCLOSE** | Closes the **Advanced Render Settings** palette if it is displayed |
| **RSCRIPT** | Repeats a script file |
| **RULESURF** | Creates a ruled mesh between two curves |
| **SAVE** | Saves the drawing under the current file name or a specified name |
| **SAVEAS** | Saves a copy of the current drawing under a new file name |
| **SAVEIMG** | Saves a rendered image to a file |
| **SCALE** | Enlarges or reduces selected objects, keeping the proportions of the object the same after scaling |
| **SCALELISTEDIT** | Controls the list of scales available for layout viewports, page layouts, and plotting |
| **SCALETEXT** | Enlarges or reduces selected text objects without changing their locations |
| **SCRIPT** | Executes a sequence of commands from a script file |
| **SECTION** | Uses the intersection of a plane and solids to create a region |
| **SECTIONPLANE** | Creates a section object that acts as a cutting plane through a 3D object |
| **SECURITYOPTIONS** | Controls security settings using the **Security Options** dialog box |
| **SELECT** | Places selected objects in the **Previous** selection set |
| **SETBYLAYER** | Changes the property overrides of selected objects to **ByLayer** |
| **SETIDROPHANDLER** | Specifies the default type of i-drop content for the current Autodesk application |
| **SETVAR** | Lists or changes the values of system variables |
| **SHADEMODE** | Starts the **VSCURRENT** command |

| | |
|---|---|
| **SHAPE** | Inserts a shape from a shape file that has been loaded using the **LOAD** command |
| **SHEETSET** | Opens the **Sheet Set Manager** dialog box |
| **SHEETSETHIDE** | Closes the **Sheet Set Manager** dialog box |
| **SHELL** | Accesses operating system commands |
| **SHOWPALETTES** | Restores the display of hidden palettes |
| **SIGVALIDATE** | Displays information about the digital signature attached to a file |
| **SKETCH** | Creates a series of freehand line segments |
| **SLICE** | Slices a solid with a plane or surface |
| **SNAP** | Restricts cursor movement to specified intervals |
| **SOLDRAW** | Generates profiles and sections in viewports created with the **SOLVIEW** command |
| **SOLID** | Creates solid-filled triangles and quadrilaterals |
| **SOLIDEDIT** | Edits faces and edges of 3D solid objects |
| **SOLPROF** | Creates profile images of three-dimensional solids in paper space |
| **SOLVIEW** | Creates layout viewports using orthographic projection to lay out multi- and sectional view drawings of 3D solids and body objects |
| **SPACETRANS** | Calculates equivalent model space and paper space lengths in a layout |
| **SPELL** | Checks spelling in a drawing |
| **SPHERE** | Creates a 3D solid sphere |
| **SPLINE** | Creates a smooth curve that passes through or near selected points |
| **SPLINEDIT** | Edits a spline or spline-fit polyline |
| **SPOTLIGHT** | Creates a spotlight |
| **STANDARDS** | Manages the association of standards files with drawings |
| **STATUS** | Displays drawing statistics, modes, and extents |
| **STLOUT** | Stores a solid in an ASCII or binary file |
| **STRETCH** | Stretches objects crossed by a selection window or polygon |
| **STYLE** | Creates, modifies, or specifies text styles |
| **STYLESMANAGER** | Displays the **Plot Style Manager** dialog box |
| **SUBTRACT** | Combines selected 3D solids or 2D regions by subtraction |
| **SUNPROPERTIES** | Opens the **Sun Properties** window and sets the properties of the sun |
| **SUNPROPERTIESCLOSE** | Closes the **Sun Properties** window |
| **SWEEP** | Creates a 3D solid or surface by sweeping a 2D object along a path |
| **SYSWINDOWS** | Arranges windows and icons when the **Application** window is shared with external applications |
| **TABLE** | Creates an empty table object |
| **TABLEDIT** | Edits text in a table cell |
| **TABLEEXPORT** | Exports data from a table object in CSV file format |
| **TABLESTYLE** | Creates, modifies, or specifies table styles |
| **TABLET** | Calibrates, configures, and turns on and off an attached digitizing tablet |
| **TABSURF** | Creates a tabulated mesh from a path curve and a direction vector |
| **TARGETPOINT** | Creates a target point light |
| **TASKBAR** | Controls how drawings are displayed on the **Windows** taskbar |
| **TEXT** | Creates a single-line text object |

| | |
|---|---|
| **TEXTSCR** | Opens the **Text** window |
| **TEXTTOFRONT** | Brings text and dimensions in front of all other objects in the drawing |
| **THICKEN** | Creates a 3D solid by thickening a surface |
| **TIFOUT** | Saves selected objects to a file in TIFF file format |
| **TIME** | Displays the date and time statistics of a drawing |
| **TINSERT** | Inserts a block in a table cell |
| **TOLERANCE** | Creates geometric tolerances contained in a feature control frame |
| **TOOLBAR** | Displays, hides, and customizes toolbars |
| **TOOLPALETTES** | Opens the **Tool Palettes** window |
| **TOOLPALETTESCLOSE** | Closes the **Tool Palettes** window |
| **TORUS** | Creates a donut-shaped 3D solid |
| **TPNAVIGATE** | Displays a specified tool palette or palette group |
| **TRACE** | Creates solid lines |
| **TRANSPARENCY** | Controls whether background pixels in a bitonal image are transparent or opaque |
| **TRAYSETTINGS** | Controls the display of icons and notifications in the status bar tray |
| **TREESTAT** | Displays information about the drawing's current spatial index |
| **TRIM** | Trims objects to meet the edges of other objects |
| **U** | Reverses the most recent operation |
| **UCS** | Manages user coordinate systems |
| **UCSICON** | Controls the visibility and placement of the UCS icon |
| **UCSMAN** | Manages defined user coordinate systems |
| **UNDEFINE** | Allows an application-defined command to override an internal command |
| **UNDO** | Reverses the effect of commands |
| **UNION** | Combines selected 3D solids or 2D regions by addition |
| **UNITS** | Controls coordinate and angle display formats and precision |
| **UPDATEFIELD** | Manually updates fields in selected objects in the drawing |
| **UPDATETHUMBSNOW** | Manually updates thumbnail previews for sheets, sheet views, and model space views in the **Sheet Set Manager** dialog box; and thumbnail previews for drawings and layouts in **Quick View** |
| **VBAIDE** | Displays the **Visual Basic Editor** |
| **VBALOAD** | Loads a global VBA project into the current work session |
| **VBAMAN** | Loads, unloads, saves, creates, embeds, and extracts VBA projects |
| **VBARUN** | Runs a VBA macro |
| **VBASTMT** | Executes a VBA statement at the AutoCAD command prompt |
| **VBAUNLOAD** | Unloads a global VBA project |
| **VIEW** | Saves and restores named views, camera views, layout views, and preset views |
| **VIEWGO** | Restores a named view |
| **VIEWPLAY** | Plays the animation associated with a named view |
| **VIEWPLOTDETAILS** | Displays information about completed plot and publish jobs |
| **VIEWRES** | Sets the resolution for objects in the current viewport |

| | |
|---|---|
| **VISUALSTYLES** | Creates and modifies visual styles and applies a visual style to a viewport |
| **VISUALSTYLESCLOSE** | Closes the **Visual Styles Manager** dialog box |
| **VLISP** | Displays the Visual LISP interactive development environment (IDE) |
| **VPCLIP** | Clips viewport objects and reshapes the viewport border |
| **VPLAYER** | Sets layer visibility within viewports |
| **VPMAX** | Expands the current layout viewport for editing |
| **VPMIN** | Restores the current layout viewport |
| **VPOINT** | Sets the viewing direction for a three-dimensional visualization of the drawing |
| **VPORTS** | Creates multiple viewports in model space or paper space |
| **VSCURRENT** | Sets the visual style in the current viewport |
| **VSLIDE** | Displays an image slide file in the current viewport |
| **VSSAVE** | Saves a visual style |
| **VTOPTIONS** | Displays a change in view as a smooth transition |
| **WALKFLYSETTINGS** | Specifies walk and fly settings |
| **WBLOCK** | Writes objects or a block to a new drawing file |
| **WEBLIGHT** | Creates a weblight |
| **WEDGE** | Creates a 3D solid wedge |
| **WHOHAS** | Displays ownership information for opened drawing files |
| **WIPEOUT** | Creates wipeout objects |
| **WMFIN** | Imports a Windows metafile |
| **WMFOPTS** | Sets options for WMFIN |
| **WMFOUT** | Saves objects to a Windows metafile |
| **WORKSPACE** | Creates, modifies, and saves workspaces and makes a workspace current |
| **WSSAVE** | Saves a workspace |
| **WSSETTINGS** | Sets options for workspaces |
| **XATTACH** | Attaches an external reference to the current drawing |
| **XBIND** | Binds one or more definitions of named objects in an xref to the current drawing |
| **XCLIP** | Defines an xref or block clipping boundary, and sets the front and back clipping planes |
| **XEDGES** | Creates wireframe geometry by extracting edges from a 3D solid or surface |
| **XLINE** | Creates a line of infinite length |
| **XOPEN** | Opens a selected drawing reference (xref) in a new window |
| **XPLODE** | Breaks a compound object into its component objects |
| **XREF** | Starts the **EXTERNALREFERENCES** command |
| **ZOOM** | Increases or decreases the apparent size of objects in the current viewport |

# SYSTEM VARIABLES

| | |
|---|---|
| **3DCONVERSIONMODE** | Used to convert material and light definitions to the current product release |
| **3DDWFPREC** | Controls the precision of 3D DWF or 3D DWFx publishing |
| **3DSELECTIONMODE** | Controls the selection precedence of visually overlapping objects when you are using 3D visual styles |
| **ACADLSPASDOC** | Controls whether the acad.lsp file is loaded into every drawing or just the first drawing opened in a session |
| **ACADPREFIX** | Stores the directory path, if any, specified by the ACAD environment variable, with path separators appended if necessary |
| **ACADVER** | Stores the AutoCAD version number. This variable differs from the DXF file $ACADVER header variable, which contains the drawing database level number |
| **ACISOUTVER** | Controls the ACIS version of SAT files created using the **ACISOUT** command. ACISOUT supports only a single value among the following numbers: 15 through 18, 20, 21, 30, 31, 40, 50, 60, and 70. |
| **ACTPATH** | Specifies the additional paths to use when locating available action macros for playback |
| **ACTRECORDERSTATE** | Specifies the current state of the **Action Recorder** |
| **ACTRECPATH** | Specifies the path used to store new action macros |
| **ACTUI** | Controls the behavior of the **Action Recorder** panel when recording and playing back macros |
| **ADCSTATE** | Indicates whether the **DesignCenter** window is open or closed. For developers who need to determine status through **AutoLISP** |
| **AFLAGS** | Sets options for attributes. The value is the sum of the following: 0, No attribute mode selected; 1, Invisible; 2, Constant; 4, Verify; 8, Preset; 16, Lock position in block; and 32, Multiple lines. |
| **ANGBASE** | Sets the base angle to 0 with respect to the current UCS |
| **ANGDIR** | Sets the direction of positive angles. Angle values are measured from angle 0 relative to the orientation of the current UCS. |
| **ANNOALLVISIBLE** | Hides or displays annotative objects that do not support the current annotation scale |
| **ANNOAUTOSCALE** | Updates annotative objects to support the annotation scale when the annotation scale is changed |
| **ANNOTATIVEDWG** | Specifies whether or not the drawing will behave as an annotative block when inserted into another drawing |
| **APBOX** | Turns the display of the **AutoSnap** aperture box on or off. The aperture box is displayed in the center of the crosshairs when you snap to an object. |

| | |
|---|---|
| **APERTURE** | Sets the display size for the object snap target box, in pixels. This system variable has the same name as a command. Use the **SETVAR** command to access this system variable. |
| **APSTATE** | Stores a value that indicates whether the **Block Authoring Palettes** window in the **Block Editor** is open or closed |
| **AREA** | Stores the last area computed by the **AREA** command This system variable has the same name as a command. Use the **SETVAR** command to access this system variable. |
| **ATTDIA** | Controls whether the **INSERT** command uses a dialog box for attribute value entry |
| **ATTIPE** | Controls the display of the in-place editor used to create multiline attributes |
| **ATTMODE** | Controls display of attributes |
| **ATTMULTI** | Controls whether multiline attributes can be created |
| **ATTREQ** | Controls whether the **INSERT** command uses default attribute settings during the insertion of blocks |
| **AUDITCTL** | Controls whether the **AUDIT** command creates an audit report (ADT) file |
| **AUNITS** | Sets units for angles |
| **AUPREC** | Sets the number of decimal places for all read-only angular units displayed on the status line, and for all editable angular units whose precision is less than or equal to the current AUPREC value. For editable angular units whose precision is greater than the current AUPREC value, the true precision is displayed. **AUPREC** does not affect the display precision of dimension text (*see* **DIMSTYLE**). |
| **AUTODWFPUBLISH** | Controls whether DWF (Design Web Format) files are created automatically when you save or close drawing (DWG) files. The **AUTOPUBLISH** command controls additional options. |
| **AUTOSNAP** | Controls the display of the **AutoSnap** marker, tooltip, and magnet. Also turns on polar snap and object snap tracking, and controls the display of polar tracking, object snap tracking, and **Ortho** mode tooltips. The setting is stored as a bitcode using the sum of the following values: 0, turns off the **AutoSnap** marker, tooltips, and magnet; also turns on polar and object snap tracking, and tooltips for polar tracking, object snap tracking, and **Ortho** mode; 1, turns on the **AutoSnap** marker; 2, turns on the **AutoSnap** tooltips; 4, turns on the **AutoSnap** magnet; 8, turns on the polar tracking; 16, turns on object snap tracking; and 32, turns on tooltips for polar tracking, object snap tracking, and **Ortho** mode. |
| **BACKGROUNDPLOT** | Controls whether background plotting is turned on or off for plotting and publishing. By default, background plotting is turned off for plotting and turned on for publishing. |
| **BACKZ** | Stores the back clipping plane offset from the target plane for the current viewport, in drawing units |
| **BACTIONCOLOR** | Sets the text color of actions in the **Block Editor**. Valid values include **BYLAYER**, **BYBLOCK**, and an integer from 1 to 255. |
| **BDEPENDENCYHIGHLIGHT** | Controls whether dependent objects are dependency highlighted when a parameter, action, or grip is selected in the **Block Editor** |

| | |
|---|---|
| **BGRIPOBJCOLOR** | Sets the color of grips in the **Block Editor**. Valid values include **BYLAYER**, **BYBLOCK**, and an integer from 1 to 255. |
| **BGRIPOBJSIZE** | Sets the display size of custom grips in the **Block Editor** relative to the screen display |
| **BINDTYPE** | Controls how xref names are handled when binding xrefs or editing xrefs in place |
| **BLIPMODE** | Controls whether marker blips are visible. This system variable has the same name as a command. Use the **SETVAR** command to access this system variable. |
| **BLOCKEDITLOCK** | Disallows opening of the **Block Editor** and editing of dynamic block definitions |
| **BLOCKEDITOR** | Reflects whether the **Block Editor** is open |
| **BPARAMETERCOLOR** | Sets the color of parameters in the **Block Editor**. Valid values include **BYLAYER**, **BYBLOCK**, and an integer from 1 to 255. |
| **BPARAMETERFONT** | Sets the font used for parameters and actions in the **Block Editor** |
| **BPARAMETERSIZE** | Sets the size of parameter text and features in the **Block Editor** relative to the screen display. Valid values include an integer from 1 to 255. |
| **BTMARKDISPLAY** | Controls whether value set markers are displayed for dynamic block references |
| **BVMODE** | Controls how objects that are made invisible for the current visibility state are displayed in the **Block Editor** |
| **CALCINPUT** | Controls whether mathematical expressions and global constants are evaluated in text and numeric entry boxes of windows and dialog boxes |
| **CAMERADISPLAY** | Turns the display of camera objects on or off. The value changes to 1 (to display cameras) when you use the **CAMERA** command. |
| **CAMERAHEIGHT** | Specifies the default height for new camera objects. The height is expressed in current drawing units. |
| **CANNOSCALE** | Sets the name of the current annotation scale for the current space |
| **CANNOSCALEVALUE** | Returns the value of the current annotation scale |
| **CAPTURETHUMBNAILS** | Specifies if and when thumbnails are captured for the **Rewind** tool |
| **CDATE** | Stores the current date and time in decimal format |
| **CECOLOR** | Sets the color of new objects. Valid values include **BYLAYER**, **BYBLOCK**, and an integer from 1 to 255. |
| **CELTSCALE** | Sets the current object linetype scaling factor. Sets the linetype scaling for new objects relative to the **LTSCALE** command setting. A line created with **CELTSCALE** = 2 in a drawing with **LTSCALE** set to 0.5 would appear the same as a line created with **CELTSCALE** = 1 in a drawing with **LTSCALE** = 1. |
| **CELTYPE** | Sets the linetype of new objects |
| **CELWEIGHT** | Sets the lineweight of new objects |
| **CENTERMT** | Controls how grips stretch multiline text that is centered horizontally. **CENTERMT** does not apply to stretching multiline text by using the ruler in the **In-Place Text Editor**. |
| **CHAMFERA** | Sets the first chamfer distance when **CHAMMODE** is set to 0 |
| **CHAMFERB** | Sets the second chamfer distance when **CHAMMODE** is set to 0 |

| | |
|---|---|
| **CHAMFERC** | Sets the chamfer length when **CHAMMODE** is set to 1 |
| **CHAMFERD** | Sets the chamfer angle when **CHAMMODE** is set to 1 |
| **CHAMMODE** | Sets the input method for **CHAMFER** |
| **CIRCLERAD** | Sets the default circle radius. A zero indicates no default. |
| **CLAYER** | Sets the current layer |
| **CLEANSCREENSTATE** | Stores a value that indicates whether the clean screen state is on or off |
| **CLISTATE** | Stores a value that indicates whether the command window is open or closed |
| **CMATERIAL** | Sets the material of new objects. Valid values are **BYLAYER**, **BYBLOCK**, and the name of a material in the drawing. |
| **CMDACTIVE** | Indicates whether an ordinary command, transparent command, script, or dialog box is active. The setting is stored as a bitcode using the sum of the following values: 1, ordinary command is active; 2, Transparent command is active; 4, script is active; 8, dialog box is active; 16, DDE is active; 32, **AutoLISP** is active (visible only to an **ObjectARX**-defined command); and 64, **ObjectARX** command is active. |
| **CMDDIA** | Controls the display of the **In-Place Text Editor** for the **LEADER** and **QLEADER** commands |
| **CMDECHO** | Controls whether prompts and input are echoed during the **AutoLISP** command function |
| **CMDINPUTHISTORYMAX** | Sets the maximum number of previous input values that are stored for a prompt in a command. Display of the history of user input is controlled by the **INPUTHISTORYMODE** system variable. |
| **CMDNAMES** | Displays the names of the active and transparent commands. For example, **LINE'ZOOM** indicates that the **ZOOM** command is being used transparently during the **LINE** command. |
| **CMLEADERSTYLE** | Sets the name of the current multileader style |
| **CMLJUST** | Specifies multiline justification |
| **CMLSCALE** | Controls the overall width of a multiline. A scale factor of 2.0 produces a multiline twice as wide as the style definition. A zero scale factor collapses the multiline into a single line. A negative scale factor flips the order of the offset lines (that is, the smallest or most negative is placed on top when the multiline is drawn from left to right). |
| **CMLSTYLE** | Sets the multiline style that governs the appearance of the multiline |
| **COMPASS** | Controls whether the 3D compass is on or off in the current viewport |
| **COORDS** | Controls the format and update frequency of coordinates on the status line |
| **COPYMODE** | Controls whether the **COPY** command repeats automatically |
| **CPLOTSTYLE** | Controls the current plot style for new objects. If the current drawing you are working in is in color-dependent mode (**PSTYLEPOLICY** is set to 1), **CPLOTSTYLE** is read-only and has a value of **BYCOLOR**. If the current drawing you are working in is in named plot styles mode (**PSTYLEPOLICY** is set to 0), **CPLOTSTYLE** can be set to the following values (**BYLAYER** is the default): **BYLAYER**, **BYBLOCK**, **NORMAL**, and **USER DEFINED**. |

| CPROFILE | Displays the name of the current profile. For more information on profiles, see the **OPTIONS** command. |
|---|---|
| CROSSINGAREACOLOR | Controls the color of the selection area during crossing selection. The valid range is 1 to 255. The **SELECTIONAREA** system variable must be on. |
| CSHADOW | Sets the shadow display property for a 3D object. To be visible, shadows must be turned on in the visual style that is applied to the viewport. |
| CTAB | Returns the name of the current (**Model** or **Layout**) tab in the drawing. Provides a way for the user to determine which tab is active |
| CTABLESTYLE | Sets the name of the current table style |
| CURSORSIZE | Determines the size of the crosshairs as a percentage of the screen size. Valid settings range from 1 percent to 100 percent. When set to 100, the crosshairs are full-screen and the ends of the crosshairs are never visible. When less than 100, the ends of the crosshairs may be visible when the cursor is moved to one edge of the screen. |
| CVPORT | Displays the identification number of the current viewport |
| DATALINKNOTIFY | Controls the notification for updated or missing data links |
| DATE | Stores the current date and time in Modified Julian Date format. This value is represented as a Modified Julian Date (MJD), which is the Julian day number and decimal fraction of a day in the following format: *<Julian day number>,<Decimal fraction of a day>*. |
| DBCSTATE | Stores the state of the **dbConnect Manager**: whether it is open or closed |
| DBLCLKEDIT | Controls the double-click editing behavior in the drawing area. Double-click actions can be customized using the **Customize User Interface** (CUI) editor. The system variable can accept the values On and Off in place of 1 and 0. |
| DBMOD | Indicates the drawing modification status. The setting is stored as a bitcode using the sum of the following values: 1, Object database modified; 4, Database variable modified; 8, Window modified; 16, View modified; and 32, Field modified. |
| DCTCUST | Displays the path and file name of the current custom spelling dictionary |
| DCTMAIN | Displays the three-letter keyword for the current main spelling dictionary |
| DEFAULTLIGHTING | Controls the default lighting in the current viewport. |
| DEFAULTLIGHTINGTYPE | Specifies the type of default lighting, old or new |
| DEFLPLSTYLE | Specifies the default plot style for all layers in a drawing when you are opening a drawing that was created in a release prior to AutoCAD 2000, or for Layer 0 when creating a new drawing from scratch without using a drawing template |
| DEFPLSTYLE | Specifies the default plot style for new objects in a drawing when you are opening a drawing that was created in a release prior to AutoCAD 2000, or when creating a new drawing from scratch without using a drawing template |
| DELOBJ | Controls whether geometry used to create 3D objects is retained or deleted |

| | |
|---|---|
| **DEMANDLOAD** | Specifies if and when to demand-load certain applications. If you set this system variable to 0, third-party applications and some AutoCAD commands cannot function |
| **DGNFRAME** | Determines whether DGN underlay frames are visible or plotted in the current drawing. |
| **DGNIMPORTMAX** | Limits the number of elements that are translated when importing a DGN file. This limit prevents the program from running out of memory and suspending when importing large DGN files. |
| **DGNMAPPINGPATH** | Stores the location of the dgnsetups.ini file, where DGN mapping setups are stored |
| **DGNOSNAP** | Controls object snapping for geometry in DGN underlays |
| **DIASTAT** | Stores the exit method of the most recently used dialog box |
| **DIMADEC** | Controls the number of precision places displayed in angular dimensions |
| **DIMALT** | Controls the display of alternate units in dimensions |
| **DIMALTD** | Controls the number of decimal places in alternate units. If **DIMALT** is turned on, **DIMALTD** sets the number of digits displayed to the right of the decimal point in the alternate measurement. |
| **DIMALTF** | Controls the multiplier for alternate units. If **DIMALT** is turned on, **DIMALTF** multiplies linear dimensions by a factor to produce a value in an alternate system of measurement. The initial value represents the number of millimeters in an inch. |
| **DIMALTRND** | Rounds off the alternate dimension units |
| **DIMALTTD** | Sets the number of decimal places for the tolerance values in the alternate units of a dimension |
| **DIMALTTZ** | Controls the suppression of zeros in tolerance values |
| **DIMALTU** | Sets the units format for alternate units of all dimension substyles except **Angular** |
| **DIMALTZ** | Controls the suppression of zeros for alternate unit dimension values. **DIMALTZ** values 0 to 3 affect feet-and-inch dimensions only. |
| **DIMANNO** | Indicates whether or not the current dimension style is annotative |
| **DIMAPOST** | Specifies a text prefix or suffix (or both) to the alternate dimension measurement for all types of dimensions except angular |
| **DIMARCSYM** | Controls the display of the arc symbol in an arc length dimension |
| **DIMASSOC** | Controls the associativity of dimension objects and whether dimensions are exploded |
| **DIMASZ** | Controls the size of dimension line and leader line arrowheads. Also controls the size of hook lines |
| **DIMATFIT** | Determines how dimension text and arrows are arranged when space is not sufficient to place both within the extension lines |
| **DIMAUNIT** | Sets the units format for angular dimensions |
| **DIMAZIN** | Suppresses zeros for angular dimensions |
| **DIMBLK** | Sets the arrowhead block displayed at the ends of dimension lines. To return to the default closed, filled arrowhead display, enter a single period (.). Arrowhead block entries and the names used to select them in the New Dimension Style, **Modify Dimension Style**, and **Override Dimension Style** dialog boxes are shown in |

|  | the AutoCAD **Help** file. You can also enter the names of user-defined arrowhead blocks. |
| **DIMBLK1** | Sets the arrowhead for the first end of the dimension line when **DIMSAH** is on. To return to the default closed, filled arrowhead display, enter a single period (.). For a list of arrowheads, *see* **DIMBLK** in the AutoCAD **Help** file. |
| **DIMBLK2** | Sets the arrowhead for the second end of the dimension line when **DIMSAH** is on. To return to the default closed, filled arrowhead display, enter a single period (.). For a list of arrowhead entries, *see* **DIMBLK** in the AutoCAD **Help** file. |
| **DIMCEN** | Controls the drawing of circles or arc center marks and centerlines by the **DIMCENTER**, **DIMDIAMETER**, and **DIMRADIUS** commands. For **DIMDIAMETER** and **DIMRADIUS**, the center mark is drawn only if you place the dimension line outside the circle or arc. |
| **DIMCLRD** | Assigns colors to dimension lines, arrowheads, and dimension leader lines. Also controls the color of leader lines created with the **LEADER** command. Color numbers are displayed in the **Select Color** dialog box. For **BYBLOCK**, enter 0. For **BYLAYER**, enter 256. |
| **DIMCLRE** | Assigns colors to dimension extension lines. Color numbers are displayed in the **Select Color** dialog box. For **BYBLOCK**, enter 0. For **BYLAYER**, enter 256. |
| **DIMCLRT** | Assigns colors to dimension text. The color can be any valid color number |
| **DIMDEC** | Sets the number of decimal places displayed for the primary units of a dimension. The precision is based on the units or angle format you have selected. |
| **DIMDLE** | Sets the distance that the dimension line extends beyond the extension line when oblique strokes are drawn instead of arrowheads |
| **DIMDLI** | Controls the spacing of the dimension lines in baseline dimensions. Each dimension line is offset from the previous one by this amount, if necessary, to avoid drawing over it. Changes made with **DIMDLI** are not applied to existing dimensions. |
| **DIMDSEP** | Specifies a single-character decimal separator to use when creating dimensions whose unit format is decimal |
| **DIMEXE** | Specifies how far to extend the extension line beyond the dimension line |
| **DIMEXO** | Specifies how far extension lines are offset from origin points. With fixed-length extension lines, this value determines the minimum offset. |
| **DIMFRAC** | Sets the fraction format when **DIMLUNIT** is set to 4 (**Architectural**) or 5 (**Fractional**) |
| **DIMFXL** | Sets the total length of the extension lines starting from the dimension line toward the dimension origin. The length is set in drawing units. |
| **DIMFXLON** | Controls whether extension lines are set to a fixed length. When **DIMFXLON** is on, extension lines are set to the length specified by **DIMFXL**. |
| **DIMGAP** | Sets the distance around the dimension text when the dimension line breaks to accommodate dimension text. Also sets the gap between annotation and a hook line created with the **LEADER** command. If you enter a |

|  | negative value, **DIMGAP** places a box around the dimension text. |
|---|---|
| **DIMJOGANG** | Determines the angle of the transverse segment of the dimension line in a jogged radius dimension. Jogged radius dimensions are often created when the center point is located off the page. |
| **DIMJUST** | Controls the horizontal positioning of dimension text. |
| **DIMLDRBLK** | Specifies the arrow type for leaders. To return to the default closed, filled arrowhead display, enter a single period (.). For a list of arrowhead entries, *see* **DIMBLK**. |
| **DIMLFAC** | Sets a scale factor for linear dimension measurements. All linear dimension distances, including radii, diameters, and coordinates, are multiplied by **DIMLFAC** before being converted to dimension text. Positive values of **DIMLFAC** are applied to dimensions in both model space and paper space; negative values are applied to paper space only. |
| **DIMLIM** | Generates dimension limits as the default text. Setting **DIMLIM** to On turns **DIMTOL** off. |
| **DIMLTEX1** | Sets the linetype of the first extension line. The value is **BYLAYER**, **BYBLOCK**, or the name of a linetype. |
| **DIMLTEX2** | Sets the linetype of the second extension line. The value is **BYLAYER**, **BYBLOCK**, or the name of a linetype. |
| **DIMLTYPE** | Sets the linetype of the dimension line. The value is **BYLAYER**, **BYBLOCK**, or the name of a linetype. |
| **DIMLUNIT** | Sets units for all dimension types except angular |
| **DIMLWD** | Assigns lineweight to dimension lines. Values are standard lineweights. |
| **DIMLWE** | Assigns lineweight to extension lines. Values are standard lineweights. |
| **DIMPOST** | Specifies a text prefix or suffix (or both) to the dimension measurement. For example, to establish a suffix for millimeters, set **DIMPOST** to mm; a distance of 19.2 units would be displayed as 19.2 mm. |
| **DIMRND** | Rounds all dimensioning distances to the specified value. For instance, if **DIMRND** is set to 0.25, all distances round to the nearest 0.25 unit. If **DIMRND** is set to 1.0, all distances round to the nearest integer. Note that the number of digits edited after the decimal point depends on the precision set by **DIMDEC**. **DIMRND** does not apply to angular dimensions. |
| **DIMSAH** | Controls the display of dimension line arrowhead blocks |
| **DIMSCALE** | Sets the overall scale factor applied to dimensioning variables that specify sizes, distances, or offsets |
| **DIMSD1** | Controls suppression of the first dimension line and arrowhead |
| **DIMSD2** | Controls suppression of the second dimension line and arrowhead |
| **DIMSE1** | Suppresses display of the first extension line |
| **DIMSE2** | Suppresses display of the second extension line |
| **DIMSOXD** | Suppresses arrowheads if not enough space is available inside the extension lines |
| **DIMSTYLE** | Stores the name of the current dimension style. This system variable has the same name as a command. Use the **SETVAR** command to access this system variable. The **DIMSTYLE** system variable is read-only; to change the current dimension style, use the **DIMSTYLE** command. |

| | |
|---|---|
| **DIMTAD** | Controls the vertical position of text in relation to the dimension line |
| **DIMTDEC** | Sets the number of decimal places to display in tolerance values for the primary units in a dimension. This system variable has no effect unless **DIMTOL** is set to On. The default for **DIMTOL** is Off. |
| **DIMTFAC** | Specifies a scale factor for the text height of fractions and tolerance values relative to the dimension text height, as set by **DIMTXT**. For example, if **DIMTFAC** is set to 1.0, the text height of fractions and tolerances is the same height as the dimension text. If **DIMTFAC** is set to 0.7500, the text height of fractions and tolerances is three quarters the size of dimension text. |
| **DIMTFILL** | Controls the background of dimension text |
| **DIMTFILLCLR** | Sets the color for the text background in dimensions. Color numbers are displayed in the **Select Color** dialog box. For **BYBLOCK**, enter 0. For **BYLAYER**, enter 256. |
| **DIMTIH** | Controls the position of dimension text inside the extension lines for all dimension types except **Ordinate** |
| **DIMTIX** | Draws text between extension lines |
| **DIMTM** | Sets the minimum (or lower) tolerance limit for dimension text when **DIMTOL** or **DIMLIM** is on. **DIMTM** accepts signed values. If **DIMTOL** is on and **DIMTP** and **DIMTM** are set to the same value, a tolerance value is drawn. |
| **DIMTMOVE** | Sets dimension text movement rules |
| **DIMTOFL** | Controls whether a dimension line is drawn between the extension lines even when the text is placed outside. For radius and diameter dimensions (when **DIMTIX** is off), draws a dimension line inside the circle or arc and places the text, arrowheads, and leader outside |
| **DIMTOH** | Controls the position of dimension text outside the extension lines |
| **DIMTOL** | Appends tolerances to dimension text. Setting **DIMTOL** to On turns **DIMLIM** off. |
| **DIMTOLJ** | Sets the vertical justification for tolerance values relative to the nominal dimension text. This system variable has no effect unless **DIMTOL** is set to On. The default for **DIMTOL** is Off. |
| **DIMTP** | Sets the maximum (or upper) tolerance limit for dimension text when **DIMTOL** or **DIMLIM** is on. **DIMTP** accepts signed values. If **DIMTOL** is on and **DIMTP** and **DIMTM** are set to the same value, a tolerance value is drawn. |
| **DIMTSZ** | Specifies the size of oblique strokes drawn instead of arrowheads for linear, radius, and diameter dimensioning |
| **DIMTVP** | Controls the vertical position of dimension text above or below the dimension line. The **DIMTVP** value is used when **DIMTAD** is off. The magnitude of the vertical offset of text is the product of the text height and **DIMTVP**. Setting **DIMTVP** to 1.0 is equivalent to setting **DIMTAD** to on. The dimension line splits to accommodate the text only if the absolute value of **DIMTVP** is less than 0.7. |
| **DIMTXSTY** | Specifies the text style of the dimension |
| **DIMTXT** | Specifies the height of dimension text, unless the current text style has a fixed height |

| | |
|---|---|
| **DIMTZIN** | Controls the suppression of zeros in tolerance values. Values 0 to 3 affect feet-and-inch dimensions only. |
| **DIMUPT** | Controls options for user-positioned text |
| **DIMZIN** | Controls the suppression of zeros in the primary unit value. Values 0 to 3 affect feet-and-inch dimensions only. |
| **DISPSILH** | Controls the display of silhouette edges of 3D solid objects in a 2D wireframe or 3D wireframe visual style |
| **DISTANCE** | Stores the distance computed by the **DIST** command |
| **DONUTID** | Sets the default for the inside diameter of a donut |
| **DONUTOD** | Sets the default for the outside diameter of a donut. The value must be nonzero. If **DONUTID** is larger than **DONUTOD**, the two values are swapped by the next command. |
| **DRAGMODE** | Controls the display of objects being dragged. This system variable has the same name as a command. Use the **SETVAR** command to access this system variable. |
| **DRAGP1** | Sets the regen-drag input sampling rate |
| **DRAGP2** | Sets the fast-drag input sampling rate |
| **DRAGVS** | Sets the visual style while you are creating 3D solid primitives and extruded solids and surfaces. You can enter a period (.) to specify the current visual style. **DRAGVS** can be set only to a visual style that is saved in the drawing. |
| **DRAWORDERCTL** | Controls the display order of overlapping objects. Use this setting to improve the speed of editing operations in large drawings. The commands that are affected by inheritance are **BREAK**, **FILLET**, **HATCH**, **HATCHEDIT**, **EXPLODE**, **TRIM**, **JOIN**, **PEDIT**, and **OFFSET**. |
| **DRSTATE** | Determines whether the **Drawing Recovery Manager** window is open or closed |
| **DTEXTED** | Specifies the user interface displayed for editing single-line text |
| **DWFFRAME** | Determines whether the DWF or DWFx underlay frame is visible |
| **DWFOSNAP** | Determines whether object snapping is active for geometry in DWF or DWFx underlays that are attached to the drawing |
| **DWGCHECK** | Checks drawings for potential problems when opening them |
| **DWGCODEPAGE** | Stores the same value as **SYSCODEPAGE** (for compatibility reasons) |
| **DWGNAME** | Stores the name of the current drawing |
| **DWGPREFIX** | Stores the drive and folder prefix for the drawing |
| **DWGTITLED** | Indicates whether the current drawing has been named |
| **DXEVAL** | Controls when data extraction tables are compared against the data source, and if the data are not current, displays an update notification |
| **DYNDIGRIP** | Controls which dynamic dimensions are displayed during grip stretch editing. The **DYNDIVIS** system variable must be set to 2, which displays all dynamic dimensions. |
| **DYNDIVIS** | Controls how many dynamic dimensions are displayed during grip stretch editing. **DYNDIGRIP** controls which dynamic dimensions are displayed during grip stretch editing. |
| **DYNMODE** | Turns **Dynamic Input** features on and off. When all features are on, the context governs what is displayed. |

| | |
|---|---|
| **DYNPICOORDS** | Controls whether pointer input uses relative or absolute format for coordinates |
| **DYNPIFORMAT** | Controls whether pointer input uses polar or Cartesian format for coordinates. This setting applies only to a second or next point. |
| **DYNPIVIS** | Controls when pointer input is displayed |
| **DYNPROMPT** | Controls display of prompts in **Dynamic Input** tooltips |
| **DYNTOOLTIPS** | Controls which tooltips are affected by tooltip appearance settings |
| **EDGEMODE** | Controls how the **TRIM** and **EXTEND** commands determine cutting and boundary edges |
| **ELEVATION** | Stores the current elevation of new objects relative to the current UCS |
| **ENTERPRISEMENU** | Displays the file name for the enterprise CUI (if defined), including the path for the file name |
| **ERRNO** | Displays the number of the appropriate error code when an **AutoLISP** function call causes an error that AutoCAD detects. **AutoLISP** applications can inspect the current value of **ERRNO** with (getvar "errno"). |
| **ERSTATE** | Determines whether the **External References** palette is open or closed |
| **EXPERT** | Controls whether certain prompts are issued |
| **EXPLMODE** | Controls whether the **EXPLODE** command supports nonuniformly scaled (NUS) blocks |
| **EXTMAX** | Stores the upper right point of the drawing extents. Expands outward as new objects are drawn; shrinks only with **ZOOM All** or **ZOOM Extents**. Reported in world coordinates for the current space |
| **EXTMIN** | Stores the lower left point of the drawing extents. Expands outward as new objects are drawn; shrinks only with **ZOOM All** or **ZOOM Extents**. Reported in world coordinates for the current space |
| **EXTNAMES** | Sets the parameters for named object names (such as linetypes and layers) stored in definition tables |
| **FACETRATIO** | Controls the aspect ratio of faceting for cylindrical and conic solids. A setting of 1 increases the density of the mesh to improve the quality of rendered and shaded models. |
| **FACETRES** | Adjusts the smoothness of shaded objects and objects with hidden lines removed. Valid values are from 0.01 to 10.0 |
| **FIELDDISPLAY** | Controls whether fields are displayed with a gray background. The background is not plotted. |
| **FIELDEVAL** | Controls how fields are updated. The setting is stored as a bitcode using the sum of the following values: 0, Not updated; 1, Updated on open; 2, Updated on save; 4, Updated on plot; 8, Updated on use of **ETRANSMIT**; and 16, Updated on regeneration. |
| **FILEDIA** | Suppresses display of file **Navigation** dialog boxes. |
| **FILLETRAD** | Stores the current fillet radius |
| **FILLMODE** | Specifies whether hatches and fills, two-dimensional solids, and wide polylines are filled in |
| **FONTALT** | Specifies the alternate font to be used when the specified font file cannot be located. When a drawing file with a defined text style is opened and an alternate font is not specified, the **Alternate Font** dialog box is displayed. |

| | |
|---|---|
| **FONTMAP** | Specifies the font mapping file to be used. A font mapping file contains one font mapping per line; the original font used in the drawing and the font to be substituted for it are separated by a semicolon (;). For example, to substitute the Times TrueType font for the Roman font, the line in the mapping file would read as follows: romanc.shx;times.ttf |
| **FRONTZ** | Stores the **front clipping plane** offset from the **target plane** for the current viewport, in drawing units. Meaningful only if the *front clipping* and *front clip not at eye* bitcodes in **VIEWMODE** are on. The **FRONTZ** value is the last front clipping plane value set **current** with the **CAMERA**, **DVIEW**, or **3DCLIP** command. The distance of the front clipping plane from the camera point is found by subtracting **FRONTZ** from the camera-to-target distance. |
| **FULLOPEN** | Indicates whether the current drawing is partially open. |
| **FULLPLOTPATH** | Controls whether the full path of the drawing file is sent to the plot spooler |
| **GEOLATLONGFORMAT** | Controls the format of the latitude and longitude values in the **Geographic Location** dialog box, and the coordinate status bar in **Geographic** mode |
| **GEOMARKERVISIBILITY** | Controls the visibility of geographic markers |
| **GRIDDISPLAY** | Controls the display behavior and display limits of the grid |
| **GRIDMAJOR** | Controls the frequency of major grid lines compared with minor grid lines. Valid values range from 1 to 100. |
| **GRIDMODE** | Specifies whether the grid is turned on or off |
| **GRIDUNIT** | Specifies the grid spacing (X and Y) for the current viewport |
| **GRIPBLOCK** | Controls the display of grips on nested objects in blocks when selected |
| **GRIPCOLOR** | Controls the color of nonselected grips. The valid range is 1 to 255. |
| **GRIPDYNCOLOR** | Controls the color of custom grips for dynamic blocks. The valid range is 1 to 255. |
| **GRIPHOT** | Controls the color of selected grips. The valid range is 1 to 255. |
| **GRIPHOVER** | Controls the fill color of an unselected grip when the cursor pauses over it. The valid range is 1 to 255. |
| **GRIPOBJLIMIT** | Suppresses the display of grips when the selection set includes more than the specified number of objects. The valid range is 0 to 32,767. For example, when set to 1, grips are suppressed when more than one object is selected. When set to 0, grips are always displayed. |
| **GRIPS** | Controls the use of selection set grips for the **Stretch**, **Move**, **Rotate**, **Scale**, and **Mirror Grip** modes |
| **GRIPSIZE** | Sets the size of the grip box in pixels. The valid range is 1 to 255. |
| **GRIPTIPS** | Controls the display of grip tips when the cursor hovers over grips on dynamic blocks and custom objects that support grip tips |
| **GTAUTO** | Controls whether grip tools display automatically when you select objects before starting a command in a viewport set to a 3D visual style |
| **GTDEFAULT** | Controls whether the **3DMOVE** and **3DROTATE** commands start automatically when the **MOVE** and |

| | |
|---|---|
| | **ROTATE** commands (respectively) are started in a 3D view |
| **GTLOCATION** | Controls the initial location of grip tools when objects are selected prior to running the **3DMOVE** or **3DROTATE** commands |
| **HALOGAP** | Specifies a gap to be displayed where an object is hidden by another object. The value is specified as a percentage of one unit and is independent of the zoom level. |
| **HANDLES** | Reports whether object handles can be accessed by applications. Because handles can no longer be turned off, it has no effect except to preserve the integrity of scripts. |
| **HIDEPRECISION** | Controls the accuracy of hides and shades. Hides can be calculated in double precision or single precision. Setting **HIDEPRECISION** to 1 produces more accurate hides by using double precision, but this setting also uses more memory and can affect performance, especially when hiding solids. |
| **HIDETEXT** | Specifies whether text objects created by the **TEXT**, **DTEXT**, or **MTEXT** commands are processed during a HIDE command |
| **HIGHLIGHT** | Controls object highlighting; does not affect objects selected with grips |
| **HPANG** | Specifies the hatch pattern angle |
| **HPASSOC** | Controls whether hatch patterns and gradient fills are associative |
| **HPBOUND** | Controls the object type created by the **BHATCH** and **BOUNDARY** commands |
| **HPDOUBLE** | Specifies hatch pattern doubling for user-defined patterns. Doubling specifies a second set of lines drawn at 90° to the original lines |
| **HPDRAWORDER** | Controls the draw order of hatches and fills. Stores the **Draw Order** setting from the **Hatch and Fill** dialog box. |
| **HPGAPTOL** | Treats a set of objects that almost enclose an area as a closed hatch boundary. The default value, 0, specifies that the objects enclose the area, with no gaps. Entering a value, in drawing units, from 0 to 5000 sets the maximum size of gaps that can be ignored when the objects serve as a hatch boundary. |
| **HPINHERIT** | Controls the hatch origin of the resulting hatch when using **Inherit Properties** in **HATCH** and **HATCHEDIT** |
| **HPMAXLINES** | Controls the maximum number of hatch lines that will generate. Values can be set at a minimum of 100 and at a maximum of 10,000,000. |
| **HPNAME** | Sets a default hatch pattern name of up to 34 characters without spaces. Returns "" if there is no default. Entering a period (.) resets **HPNAME** to the default value. |
| **HPOBJWARNING** | Sets the number of hatch boundary objects that can be selected before displaying a warning message. The maximum value can vary, but it is significantly larger than 100000000 (one hundred million). |
| **HPORIGIN** | Sets the hatch origin point for new hatch objects relative to the current user coordinate system |
| **HPORIGINMODE** | Controls how **HATCH** determines the default hatch origin point |
| **HPSCALE** | Specifies the hatch pattern scale factor, which must be greater than zero |

| | |
|---|---|
| **HPSEPARATE** | Controls whether **HATCH** creates a single hatch object or separate hatch objects when operating on several closed boundaries |
| **HPSPACE** | Specifies the hatch pattern line spacing for user-defined simple patterns, which must be greater than zero |
| **HYPERLINKBASE** | Specifies the path used for all relative hyperlinks in the drawing. If no value is specified, the drawing path is used for all relative hyperlinks. |
| **IMAGEHLT** | Controls whether the entire raster image or only the raster image frame is highlighted |
| **IMPLIEDFACE** | Controls the detection of implied faces. This variable must be set to 1 to select and modify implied faces. |
| **INDEXCTL** | Controls whether layer and spatial indexes are created and saved in drawing files |
| **INETLOCATION** | Stores the Internet location used by the **BROWSER** command and the **Browse the Web** dialog box |
| **INPUTHISTORYMODE** | Controls the content and location of the display of a history of user input |
| **INSBASE** | Stores the insertion base point set by **BASE**, which is expressed as a UCS coordinate for the current space |
| **INSNAME** | Sets a default block name for the **INSERT** command. The name must conform to symbol naming conventions. Returns "" if no default is set. Entering a period (.) sets no default. |
| **INSUNITS** | Specifies a drawing-units value for automatic scaling of blocks, images, or xrefs inserted in or attached to a drawing |
| **INSUNITSDEFSOURCE** | Sets source content units value when **INSUNITS** is set to 0. Valid range is 0 to 20. |
| **INSUNITSDEFTARGET** | Sets target drawing units value when **INSUNITS** is set to 0. Valid range is 0 to 20. |
| **INTELLIGENTUPDATE** | Controls the graphics refresh rate. The default value is 20 frames per second. If you encounter problems related to graphics generation or timing, turn off the variable by setting it to 0. **INTELLIGENTUPDATE** works by suppressing the graphics update until the timer expires. Subsequent updates reset the timer. |
| **INTERFERECOLOR** | Sets the color for interference objects. Valid values include **BYLAYER**, **BYBLOCK**, a color name, and integers from 0 to 255. |
| **INTERFEREOBJVS** | Sets the visual style for interference objects **INTERFEREOBJVS** can be set only to a visual style that is saved in the drawing. |
| **INTERFEREVPVS** | Specifies the visual style for the viewport during interference checking. **INTERFEREVPVS** can be set only to a visual style that is saved in the drawing. |
| **INTERSECTIONCOLOR** | Controls the color of polylines at the intersection of 3D surfaces when the visual style is set to **2D Wireframe** |
| **INTERSECTIONDISPLAY** | Controls the display of polylines at the intersection of 3D surfaces when the visual style is set to **2D Wireframe** |
| **ISAVEBAK** | Improves the speed of incremental saves, especially for large drawings. **ISAVEBAK** controls the creation of a backup file (BAK). In the operating system, copying the file data to create a BAK file for large drawings takes a major portion of the incremental save time. |

**ISAVEPERCENT**  Determines the amount of wasted space tolerated in a drawing file. The value of **ISAVEPERCENT** is an integer between 0 and 100. The default value 50 means that the estimate of wasted space within the file does not exceed 50 percent of the total file size. Wasted space is eliminated by periodic full saves. When the estimate exceeds 50 percent, the next save will be a full save. This resets the wasted space estimate to 0. If **ISAVEPERCENT** is set to 0, every save is a full save.

**ISOLINES**  Specifies the number of contour lines per surface on objects. Valid integer values are from 0 to 2047.

**LASTANGLE**  Stores the end angle of the last arc entered relative to the XY plane of the current UCS for the current space

**LASTPOINT**  Stores the last point entered, expressed as a UCS coordinate for the current space; referenced by the at symbol (@) during keyboard entry

**LASTPROMPT**  Stores the last string echoed to the command prompt. This string is identical to the last line seen at the command prompt and includes any user input.

**LATITUDE**  Specifies the latitude of the drawing model in decimal format. The default is the latitude of San Francisco, California. The valid range is –90 to +90. Positive values represent north latitudes.

**LAYEREVAL**  Controls when the **Unreconciled New Layer** filter list in the **Layer Properties Manager** dialog box is evaluated for new layers

**LAYEREVALCTL**  Controls the overall unreconciled new layer filter list in the **Layer Properties Manager** dialog box, which is evaluated for new layers

**LAYERFILTERALERT**  Deletes excessive layer filters to improve performance. When a drawing has 100 or more layer filters, and the number of layer filters exceeds the number of layers, **LAYERFILTERALERT** provides a method for deleting layer filters to improve performance.

**LAYERMANAGERSTATE**  Returns a value indicating whether the **Layer Properties Manager** dialog box is open or closed

**LAYERNOTIFY**  Specifies when an alert displays for new layers that have not yet been reconciled

**LAYLOCKFADECTL**  Controls the dimming for objects on locked layers

**LAYOUTREGENCTL**  Specifies how the display list is updated in the **Model** tab and **Layout** tabs. For each tab, the display list is updated either by regenerating the drawing when you switch to that tab or by saving the display list to memory and regenerating only the modified objects when you switch to that tab. Changing the **LAYOUTREGENCTL** setting can improve performance.

**LEGACYCTRLPICK**  Specifies the keys for selection cycling and the behavior for **<CTRL>** + left click

**LENSLENGTH**  Stores the length of the lens (in millimeters) used in perspective viewing

**LIGHTGLYPHDISPLAY**  Controls whether light glyphs are displayed. When this system variable is set to **Off**, the glyphs that represent lights in the drawing are not displayed.

**LIGHTINGUNITS**  Controls whether generic or photometric lights are used, and indicates the current lighting units

**LIGHTLISTSTATE**  Indicates whether the **Lights in Model** window is open

| LIGHTSINBLOCKS | Controls whether lights contained in blocks are used when rendering |
|---|---|
| LIMCHECK | Controls the creation of objects outside the grid limits |
| LIMMIN | Stores the lower left grid limits for the current space, expressed as a world coordinate. **LIMMIN** is read-only when paper space is active and the paper background or printable area is displayed. |
| LINEARBRIGHTNESS | Controls the global brightness level of the drawing in the standard lighting workflow |
| LINEARCONTRAST | Controls the global contrast level of the drawing in the standard lighting workflow |
| LOCALE | Displays a code that indicates the current locale. This code appears as a three-letter abbreviation returned by the **Windows GetLocaleInfo** function using the **LOCALE_SABBREVLANGNAME** constant. |
| LOCALROOTPREFIX | Stores the full path to the root folder where local customizable files were installed. These files are stored in the product folder under the **Local Settings** folder; for example, "c:\Documents and Settings\username\ LocalSettings\Application Data\application_name\ release_number\language". |
| LOCKUI | Locks the position and size of toolbars and dockable windows such as **DesignCenter** and the **Properties** palette. Locked toolbars and windows can still be opened and closed, and items can be added and deleted. To unlock them temporarily, hold down **<CTRL>**. |
| LOFTANG1 | Sets the draft angle through the first cross section in a loft operation. The 0 direction is measured outward from the curve on the plane of the curve. The positive direction is measured toward the next cross section. Valid values include 0 to less than 360. |
| LOFTANG2 | Sets the draft angle through the last cross section in a loft operation. The 0 direction is measured outward from the curve on the plane of the curve. The positive direction is measured toward the previous cross section. Valid values include 0 to less than 360. |
| LOFTMAG1 | Sets the magnitude of the draft angle through the first cross section in a loft operation. Controls how soon the surface starts bending back toward the next cross section |
| LOFTMAG2 | Sets the magnitude of the draft angle through the last cross section in a loft operation. Controls how soon the surface starts bending back toward the next cross section |
| LOFTNORMALS | Controls the normals of a lofted object where it passes through cross sections. This setting is ignored when specifying a path or guide curves. These settings can also be specified in the **Left Settings** dialog box. |
| LOFTPARAM | Controls the shape of lofted solids and surfaces |
| LOGEXPBRIGHTNESS | Controls the global brightness level of the drawing when photometric lighting is being used. |
| LOGEXPCONTRAST | Controls the global contrast level of the drawing when photometric lighting is being used. |
| LOGEXPDAYLIGHT | Controls whether exterior daylight is used when photometric lighting is being used. |
| LOGEXPMIDTONES | Controls the global midtone level of the drawing when photometric lighting is being used. |
| LOGEXPPHYSICALSCALE | Controls the relative brightness of self-illuminated materials in a photometric environment |

| | |
|---|---|
| **LOGFILEMODE** | Specifies whether the contents of the **Text** window are written to a log file |
| **LOGFILENAME** | Specifies the path and name of the **Text** window log file for the current drawing. The initial value varies depending on the name of the current drawing and the installation folder. |
| **LOGFILEPATH** | Specifies the path for the **Text** window log files for all drawings in a session. You can also specify the path by using the **OPTIONS** command. The initial value is based on the installation folder. |
| **LOGINNAME** | Displays the user's name as configured or as input when the program starts. The maximum length for a login name is 30 characters. |
| **LONGITUDE** | Specifies the longitude of the drawing model in decimal format. The default is the longitude of San Francisco, California. The valid range is –180 to +180. Positive values represent east longitudes. |
| **LTSCALE** | Sets the global linetype scale factor. The linetype scale factor cannot equal zero. This system variable has the same name as a command. Use the **SETVAR** command to access this system variable. |
| **LUNITS** | Sets linear units |
| **LUPREC** | Sets the number of decimal places displayed for all read-only linear units, and for all editable linear units whose precision is less than or equal to the current **LUPREC** value. For editable linear units whose precision is greater than the current **LUPREC** value, the true precision is displayed. **LUPREC** does not affect the display precision of dimension text (*see* **DIMSTYLE**). |
| **LWDEFAULT** | Sets the value for the default lineweight. The default lineweight can be set to any valid lineweight value in hundredths of millimeters, including 0, 5, 9, 13, 15, 18, 20, 25, 30, 35, 40, 50, 53, 60, 70, 80, 90, 100, 106, 120, 140, 158, 200, and 211. |
| **LWDISPLAY** | Controls whether the lineweight is displayed. The setting is saved with each tab in the drawing |
| **LWUNITS** | Controls whether lineweight units are displayed in inches or millimeters |
| **MATSTATE:** | Indicates whether the **Materials** window is open |
| **MAXACTVP** | Sets the maximum number of viewports that can be active at one time in a layout. **MAXACTVP** has no effect on the number of viewports that are plotted. |
| **MAXSORT** | Sets the maximum number of symbol names or block names sorted by listing commands. If the total number of items exceeds this value, no items are sorted. |
| **MBUTTONPAN** | Controls the behavior of the third button or wheel on the pointing device |
| **MEASUREINIT** | Controls whether a drawing you start from scratch uses imperial or metric default settings. Specifically, **MEASUREINIT** controls which hatch pattern and linetype files are used. The Drawing1.dwg that opens when you start the program is a drawing that is started from scratch. |
| **MEASUREMENT** | Controls whether the current drawing uses imperial or metric hatch pattern and linetype files |
| **MENUBAR** | Controls the display of the menu bar |
| **MENUCTL** | Controls the page switching of the screen menu |

| | |
|---|---|
| **MENUECHO** | Sets menu echo and prompt control bits. The value is the sum of the following: 1, Suppresses echo of menu items (^P in a menu item toggles echoing); 2, Suppresses display of system prompts during menu; 4, Disables ^P toggle of menu echoing; and 8, Displays input/output strings - debugging aid for **DIESEL** macros. |
| **MENUNAME** | Stores the customization file name, including the path for the file name |
| **MIRRTEXT** | Controls how the **MIRROR** command reflects text |
| **MLEADERSCALE** | Sets the overall scale factor applied to multileader objects. |
| **MODEMACRO** | Displays a text string on the status line, such as the name of the current drawing, time/date stamp, or special modes |
| **MSLTSCALE** | Scales linetypes displayed on the **Model** tab by the annotation scale |
| **MSMSTATE** | Stores a value that indicates whether the **Markup Set Manager** dialog box is open or closed |
| **MSOLESCALE** | Controls the size of an OLE object with text that is pasted into model space. **MSOLESCALE** controls only the initial size. If the scale factor value is changed, existing OLE objects in the drawing are not affected. |
| **MTEXTED** | Sets the application for editing multiline text objects. You can specify a different text editor for the **MTEXT** command. If you set **MTEXTED** to **internal** or to **null** (.), the **In-Place Text Editor** is displayed. If you set **MTEXTED** to **OldEditor**, the **Multiline Text Editor** is displayed. If you specify a path and the name of the executable file for another text editor or word processor, that path and file name are displayed instead. |
| **MTEXTFIXED** | Sets the display size and orientation of multiline text in a specified text editor |
| **MTEXTTOOLBAR** | Controls the display of the **Text Formatting** toolbar |
| **MTJIGSTRING** | Sets the content of the sample text displayed at the cursor location when the **MTEXT** command is started. The text string is displayed in the current text size and font. You can enter any string of up to 10 letters or numbers or you can enter a period (.) to display no sample text. |
| **MYDOCUMENTSPREFIX** | Stores the full path to the **My Documents** folder for the user currently logged on. These files are stored in the product folder under the **Local Settings** folder; for example, "c:\Documents and Settings\username\My Documents". |
| **NAVSWHEELMODE** | Specifies the current mode of the **SteeringWheel** |
| **NAVSWHEELOPACITYBIG** | Controls the opacity of the big **SteeringWheels** |
| **NAVSWHEELOPACITYMINI:** | Controls the opacity of the mini **SteeringWheels** |
| **NAVSWHEELSIZEBIG** | Specifies the size of the big **SteeringWheels** |
| **NAVSWHEELSIZEMINI** | Specifies the size of the mini **SteeringWheels** |
| **NAVVCUBEDISPLAY** | Controls the display of the **ViewCube** for the current viewport when the 3D graphics system is active |
| **NAVVCUBELOCATION** | Identifies the corner in a viewport where the **ViewCube** is displayed |
| **NAVVCUBEOPACITY** | Controls the opacity of the **ViewCube** when inactive |
| **NAVVCUBEORIENT** | Controls whether the **ViewCube** reflects the current UCS or WCS |
| **NAVVCUBESIZE** | Specifies the size of the **ViewCube** |
| **NOMUTT** | Suppresses the message display (muttering) when it would not normally be suppressed. Displaying messages |

|  | is the normal mode, but message display is suppressed during scripts, **AutoLISP** routines, and so on |
|---|---|
| **NORTHDIRECTION** | Specifies the angle of the sun from north. This value is affected by the settings of the **AUNITS** and **AUPREC** system variables. |
| **OBSCUREDCOLOR** | Specifies the color of obscured lines. Value 0 designates **ByBlock**, value 256 designates **ByLayer**, and value 257 designates **ByEntity.** Values 1 to 255 designate an AutoCAD Color Index (ACI). |
| **OBSCUREDLTYPE** | Specifies the linetype of obscured lines. Unlike regular linetypes, obscured linetypes are independent of zoom level. See the AutoCAD **Help** file for a listing of the defined linetype values. |
| **OFFSETDIST** | Sets the default offset distance |
| **OFFSETGAPTYPE** | Controls how potential gaps between segments are treated when closed polylines are offset |
| **OLEFRAME** | Controls whether a frame is displayed and plotted on all **OLE** objects in the drawing. The frame on an **OLE** object must be displayed for grips to be visible. |
| **OLEHIDE** | Controls the display and plotting of OLE objects |
| **OLEQUALITY** | Sets the default plot quality for OLE objects. When **OLEQUALITY** is set to 3, the quality level is assigned automatically based on the type of object. For example, spreadsheets and tables are set to 0, color text and pie charts are set to 1, and photographs are set to 2. |
| **OLESTARTUP** | Controls whether the source application of an embedded OLE object loads when plotting. Loading the OLE source application may improve the plot quality. |
| **OPENPARTIAL** | Controls whether a drawing can be worked on before it is fully open |
| **OPMSTATE** | Stores a value that indicates whether the **Properties** palette is open, closed, or hidden |
| **ORTHOMODE** | Constrains cursor movement to the perpendicular. When **ORTHOMODE** is turned on, the cursor can move only horizontally or vertically relative to the UCS and the current grid rotation angle. |
| **OSMODE** | Sets running object snaps. The setting is stored as a bitcode using the sum of the values as illustrated in the AutoCAD **Help** file. |
| **OSNAPCOORD** | Controls whether coordinates entered on the command prompt override running object snaps |
| **OSNAPNODELEGACY** | Controls whether the **Node** object snap can be used to snap to multiline text objects |
| **OSNAPZ** | Controls whether object snaps are automatically projected onto a plane parallel to the XY plane of the current UCS at the current elevation |
| **OSOPTIONS** | Automatically suppresses object snaps on hatch objects and geometry with negative Z values when a dynamic UCS is being used. |
| **PALETTEOPAQUE** | Controls whether windows can be made transparent. When transparency is unavailable or turned off, all palettes are opaque. Transparency is unavailable when palettes or windows are docked, when transparency is not supported by the current operating system, and when hardware accelerators are in use. |
| **PAPERUPDATE** | Controls the display of a warning dialog box when a user is attempting to print a layout with a paper size different |

| | |
|---|---|
| | from the paper size specified by the default for the plotter configuration file |
| **PDMODE** | Controls how point objects are displayed. For information about values to enter, see the **POINT** command. |
| **PDSIZE** | Sets the display size for point objects |
| **PEDITACCEPT** | Suppresses display of the **Object Selected Is Not a Polyline** prompt in **PEDIT**. The prompt is followed by "Do you want it to turn into one?" Entering **y** converts the selected object to a polyline. When the prompt is suppressed, the selected object is automatically converted to a polyline. |
| **PELLIPSE** | Controls the ellipse type created with the **ELLIPSE** command |
| **PERIMETER** | Stores the last perimeter value computed by the **AREA** or **LIST** command |
| **PERSPECTIVE** | Specifies whether the current viewport displays a **Perspective** view |
| **PERSPECTIVECLIP** | Determines the location of eyepoint clipping. The value, expressed as a percentage, determines where the eyepoint clipping occurs. Values can range between 0.01 and 10.0. If you select a small value, the $Z$ values of objects will be compressed at the target view and beyond. If you select a value such as 0.5 percent, the clipping will appear very close to the eyepoint of the view. In some extreme cases, it might be appropriate to use 0.1 percent, but it is recommended to change the setting to a higher value such as 5 percent. |
| **PFACEVMAX** | Sets the maximum number of vertices per face |
| **PICKADD** | Controls whether subsequent selections replace the current selection set or add to it |
| **PICKAUTO** | Controls automatic windowing at the **Select Objects** prompt |
| **PICKBOX** | Sets the object selection target height, in pixels |
| **PICKDRAG** | Controls the method of drawing a **Selection** window |
| **PICKFIRST** | Controls whether objects are selected before (noun-verb selection) or after a command is issued |
| **PICKSTYLE** | Controls the use of group selection and associative hatch selection |
| **PLATFORM** | Indicates which platform is in use |
| **PLINEGEN** | Sets how linetype patterns generate around the vertices of a 2D polyline. Does not apply to polylines with tapered segments |
| **PLINETYPE** | Specifies whether optimized 2D polylines are used. **PLINETYPE** controls both the creation of new polylines with the **PLINE** command and the conversion of existing polylines in drawings from previous releases. |
| **PLINEWID** | Stores the default polyline width |
| **PLOTOFFSET** | Controls whether the plot offset is relative to the printable area or to the edge of the paper |
| **PLOTROTMODE** | Controls the orientation of plots |
| **PLQUIET** | Controls the display of optional plot-related dialog boxes and nonfatal errors for scripts |
| **POLARADDANG** | Stores additional angles for polar tracking and polar snap |
| **POLARANG** | Sets the polar angle increment. Values are 90, 45, 30, 22.5, 18, 15, 10, and 5. |

| | |
|---|---|
| **POLARDIST** | Sets the snap increment when the **SNAPTYPE** system variable is set to 1 (**PolarSnap**) |
| **POLARMODE** | Controls settings for polar snap and object snap tracking. The setting is stored as a bitcode using the sum of the values as illustrated in the AutoCAD **Help** file. |
| **POLYSIDES** | Sets the default number of sides for the **POLYGON** command. The range is 3 to 1,024. |
| **POPUPS** | Displays the status of the currently configured display driver |
| **PREVIEWEFFECT** | Specifies the visual effect used for previewing the selection of objects |
| **PREVIEWFILTER** | Excludes specified object types from selection previewing. The setting is stored as a bitcode using the sum of the following values: 0, Excludes nothing; 1, Excludes objects on locked layers; 2, Excludes objects in xrefs; 4, Excludes tables; 8, Excludes multiline text objects; 16, Excludes hatch objects; and 32, Excludes objects in groups. |
| **PREVIEWTYPE** | Specifies the view to use for the drawing thumbnail. |
| **PRODUCT** | Returns the product name |
| **PROGRAM** | Returns the program name |
| **PROJECTNAME** | Assigns a project name to the current drawing. Used when an xref, image, or DWF underlay file is not found in its original path. The project name points to a section in the registry that can contain one or more search paths for each project name defined. Project names and their search directories are created from the **Files** tab of the **Options** dialog box. |
| **PROJMODE** | Sets the current **Projection** mode for trimming or extending |
| **PROXYGRAPHICS** | Specifies whether images of proxy objects are saved in the drawing |
| **PROXYNOTICE** | Displays a notice when a proxy is created. A proxy is created when a drawing is opened containing custom objects created by an application that is not present. A proxy is also created when a command is issued that unloads the parent application of a custom object. |
| **PROXYSHOW** | Controls the display of proxy objects in a drawing |
| **PROXYWEBSEARCH** | Specifies how the program checks for object enablers |
| **PSLTSCALE** | Controls linetype scaling of objects displayed in paper space viewports |
| **PSOLHEIGHT** | Controls the default height for a swept solid object created with the **POLYSOLID** command. The value reflects the last entered height value when the **POLYSOLID** command is being used. The value 0 cannot be entered. |
| **PSOLWIDTH** | Controls the default width for a swept solid object created with the **POLYSOLID** command. The value reflects the last entered width value when using the **POLYSOLID** command. The value 0 cannot be entered. |
| **PSTYLEMODE** | Indicates whether the current drawing is in a **Color-Dependent** or **Named Plot Style** mode |
| **PSTYLEPOLICY** | Controls the plot style mode, **Color-Dependent** or **Named**, that is used when opening a drawing that was created in a release prior to AutoCAD 2000 or when creating a new drawing from scratch without using a drawing template |

| | |
|---|---|
| **PSVPSCALE** | Sets the view scale factor for all newly created viewports. The view scale factor is defined by comparing the ratio of units in paper space to the units in newly created model space viewports. The view scale factor you set is used with the **VPORTS** command. A value of 0 means the scale factor is **Scaled to Fit**. A scale must be a positive real value. |
| **PUBLISHALLSHEETS** | Controls how the **Publish** dialog box list is populated when the **PUBLISH** command is issued |
| **PUBLISHCOLLATE** | Controls whether sheets are published as a single job |
| **PUBLISHHATCH** | Controls whether hatch patterns published to DWF format (DWF File or DWFx File) are treated as a single object when opened in **Autodesk Impression** |
| **PUCSBASE** | Stores the name of the UCS that defines the origin and orientation of orthographic UCS settings in paper space only |
| **QCSTATE** | Determines whether the **QuickCalc** calculator is open or closed |
| **QPLOCATION** | Sets the location mode of the **Quick Properties** panel |
| **QPMODE** | Sets the on or off state of the **Quick Properties** panel |
| **QTEXTMODE** | Controls how text is displayed |
| **QVDRAWINGPIN** | Controls the default display state of preview images of drawings |
| **QVLAYOUTPIN** | Controls the default display state of preview images of model space and layouts in a drawing |
| **RASTERDPI** | Controls paper size and plot scaling when changing from dimensional to dimensionless output devices, or vice versa. Converts millimeters or inches to pixels, or vice versa. Accepts an integer between 100 and 32,767 as a valid value |
| **RASTERPERCENT** | Sets the maximum percentage of available virtual memory that is allowed for plotting a raster image |
| **RASTERPREVIEW** | Controls whether BMP preview images are saved with the drawing |
| **RASTERTHRESHOLD** | Specifies a raster threshold in megabytes. If the plotted raster image exceeds this threshold, the availability of system memory is checked. The plot is aborted if the image is too big for the available memory. |
| **RECOVERYMODE** | Controls whether drawing recovery information is recorded after a system failure |
| **REFEDITNAME** | Displays the name of the reference being edited |
| **REGENMODE** | Controls automatic regeneration of the drawing |
| **RE-INIT** | Reinitializes the digitizer, digitizer port, and acad.pgp file. The setting is stored as a bitcode using the sum of the following values: 1, Digitizer input/output port reinitialization; 4, Digitizer reinitialization; 16, PGP file reinitialization (reload). |
| **REMEMBERFOLDERS** | Controls the default path displayed in standard file selection dialog boxes |
| **RENDERPREFSSTATE** | Stores a value that indicates whether the **Render Settings** palette is open or closed |
| **RENDERUSERLIGHTS** | Controls whether to override the setting for viewport lighting during rendering |
| **REPORTERROR** | Controls whether an error report can be sent to Autodesk if the program closes unexpectedly |
| **RIBBONSTATE** | Indicates whether the **Ribbon** palette is open or closed |

| | |
|---|---|
| **ROAMABLEROOTPREFIX** | Stores the full path to the root folder where roamable customizable files were installed. When files that are in a roaming profile are customized and if the current network supports roaming, those files are available regardless of which machine is currently being used. |
| **ROLLOVERTIPS** | Controls the display of object rollover tooltips in the application. The content in tooltips can be customized in the **Customize User Interface** (CUI) editor. |
| **RTDISPLAY** | Controls the display of raster images and OLE objects during real-time **ZOOM** or **PAN** |
| **SAVEFIDELITY** | Controls whether the drawing is saved with visual fidelity |
| **SAVEFILE** | Stores the current automatic save file name |
| **SAVEFILEPATH** | Specifies the path to the directory for all automatic save files for the current session. The path can also be changed on the **Files** tab in the **Options** dialog box. |
| **SAVENAME** | Displays the file name and directory path of the most recently saved drawing |
| **SAVETIME** | Sets the automatic save interval, in minutes |
| **SCREENBOXES** | Stores the number of boxes in the screen menu area of the drawing area. If the screen menu is turned off, **SCREENBOXES** is zero. On platforms that permit the drawing area to be resized or the screen menu to be reconfigured during an editing session, the value of this variable might change during the editing session. |
| **SCREENMODE** | Indicates the state of the display. The setting is stored as a bitcode using the sum of the following values: 0, Text screen is displayed; 1, Drawing area is displayed; and 2, Dual-screen display is configured. |
| **SCREENSIZE** | Stores current viewport size in pixels (X and Y) |
| **SELECTIONANNODISPLAY** | Controls whether alternate **scale representations** are temporarily displayed in a dimmed state when an annotative object is selected |
| **SELECTIONAREA** | Controls the display of effects for selection areas. Selection areas are created by the **Window**, **Crossing**, **WPolygon**, and **CPolygon** options of the **SELECT** command. |
| **SELECTIONAREAOPACITY** | Controls the transparency of the selection area during window and crossing selection. The valid range is 0 to 100. The lower the setting, the more transparent the area. A value of 100 makes the area opaque. The **SELECTIONAREA** system variable must be on. |
| **SELECTIONPREVIEW** | Controls the display of selection previewing. Objects are highlighted when the pickbox cursor rolls over them. This selection previewing indicates that the object would be selected if you clicked it. The setting is stored as a bitcode using the sum of the following values: 0, Off; 1, On when no commands are active; and 2, On when a command prompts for object selection. |
| **SETBYLAYERMODE** | Controls which properties are selected for **SETBYLAYER** |
| **SHADEDGE** | Controls the shading of edges in rendering |
| **SHADEDIF** | Sets the ratio of diffuse reflective light to ambient light. The ratio is a percentage of diffuse reflective light when **SHADEDGE** is set to 0 or 1. |
| **SHADOWPLANELOCATION** | Controls the location of an invisible ground plane used to display shadows. The value is a location on the current |

Z axis. The ground plane is invisible, but it casts and receives shadows. Objects that are located below the ground plane are shadowed by it. The ground plane is used when the **VSSHADOWS** system variable is set to display either full shadows or ground shadows.

**SHORTCUTMENU**  Controls whether **Default**, **Edit**, and **Command** mode shortcut menus are available in the drawing area. The setting is stored as a bitcode using the sum of the following values: 0, Disables all **Default**, **Edit**, and **Command** mode shortcut menus, restoring AutoCAD Release 14 behavior; 1, Enables **Default** mode shortcut menus; 2, Enables **Edit** mode shortcut menus; 4, Enables **Command** mode shortcut menus whenever a command is active; 8, Enables **Command** mode shortcut menus only when command options are currently available at the command prompt; and 16, Enables display of a shortcut menu when the right button on the pointing device is held down longer.

**SHOWHIST**  Controls the **Show History** property for solids in a drawing

**SHOWLAYERUSAGE**  Displays icons in the **Layer Properties Manager** dialog box to indicate whether layers are in use. Setting this system variable to **Off** improves performance in the **Layer Properties Manager** dialog box.

**SHOWMOTIONPIN**  Controls the default display state of the thumbnail shots

**SHPNAME**  Sets a default shape name that must conform to symbol-naming conventions. If no default is set, it returns "". Enter a period (.) to set no default.

**SIGWARN**  Controls whether a warning is presented when a file with an attached digital signature is opened. If the system variable is on and you open a file with a valid signature, the digital signature status is displayed. If the variable is off and you open a file, the digital signature status is displayed only if a signature is invalid. You can set the variable using the **Display Digital Signature Information** option on the **Open and Save** tab of the **Options** dialog box.

**SKETCHINC**  Sets the record increment for the **SKETCH** command

**SKPOLY**  Determines whether the **SKETCH** command generates lines or polylines

**SNAPANG**  Sets the snap and grid rotation angle for the current viewport. The angle you specify is relative to the current UCS.

**SNAPBASE**  Sets the snap and grid origin point for the current viewport relative to the current UCS

**SNAPISOPAIR**  Controls the isometric plane for the current viewport

**SNAPMODE**  Turns the **Snap** mode on and off

**SNAPSTYL**  Sets the snap style for the current viewport

**SNAPTYPE**  Sets the type of snap for the current viewport

**SNAPUNIT**  Sets the snap spacing for the current viewport. If **SNAPSTYL** is set to 1, the X value of **SNAPUNIT** is adjusted automatically to accommodate the isometric snap.

**SOLIDCHECK**  Turns the solid validation on and off for the current session

**SOLIDHIST**  Controls the default **History** property setting for new and existing objects. When set to 1, composite solids retain a history of the original objects contained in the composite

| | |
|---|---|
| **SORTENTS** | Controls object sorting in support of draw order for several operations. The setting is stored as a bitcode using the sum of the following values: 0, Turns off all object sorting; 1, Sorts for object selection; 2, Sorts for object snaps; 4, Obsolete, has no effect; 8, Obsolete, has no effect; 16, Sorts for **REGEN** commands, 32, Sorts for plotting; and 64, Obsolete, has no effect. |
| **SPLFRAME** | Controls the display of splines and spline-fit polylines |
| **SPLINESEGS** | Sets the number of line segments to be generated for each spline-fit polyline generated by the **Spline** option of the **PEDIT** command |
| **SPLINETYPE** | Sets the type of curve generated by the **Spline** option of the **PEDIT** command |
| **SSFOUND** | Displays the sheet set path and file name if a search for a sheet set is successful |
| **SSLOCATE** | Controls whether the sheet set associated with a drawing is located and opened when the drawing is opened |
| **SSMAUTOOPEN** | Controls the display behavior of the **Sheet Set Manager** dialog box when a drawing associated with a sheet is opened |
| **SSMPOLLTIME** | Controls the time interval between automatic refreshes of the status data in a sheet set |
| **SSMSHEETSTATUS** | Controls how the status data in a sheet set is refreshed |
| **SSMSTATE** | Determines whether the **Sheet Set Manager** window is open or closed |
| **STANDARDSVIOLATION** | Specifies whether a user is notified of standards violations in the current drawing when a nonstandard object is created or modified |
| **STARTUP** | Controls whether the **Create New Drawing** dialog box is displayed when a new drawing is started with **NEW** or **QNEW**. Also controls whether the **Startup** dialog box is displayed when the application is started |
| **STATUSBAR** | Controls the display of the **Application** and **Drawing Status bars** |
| **STEPSIZE** | Specifies the size of each step when in **Walk** or **Fly** mode, in drawing units. You can enter any real number from 1E–6 to 1E+6. |
| **STEPSPERSEC** | Specifies the number of steps taken per second when you are in **Walk** or **Fly** mode. You can enter any real number from 1 to 30. |
| **SUNPROPERTIESSTATE** | Indicates whether the window is open or closed. |
| **SUNSTATUS** | Controls whether the sun casts light in the current viewport |
| **SURFTAB1** | Sets the number of tabulations to be generated for the **RULESURF** and **TABSURF** commands. Also sets the mesh density in the **M** direction for the **REVSURF** and **EDGESURF** commands |
| **SURFTAB2** | Sets the mesh density in the **N** direction for the **REVSURF** and **EDGESURF** commands |
| **SURFTYPE** | Controls the type of surface-fitting to be performed by the **Smooth** option of the **PEDIT** command |
| **SURFU** | Sets the surface density for **PEDIT Smooth** in the **M** direction and the **U** isolines density on surface objects. Valid values are 0 through 200. Meshes are always created with a minimum surface density of 2. |
| **SURFV** | Sets the surface density for **PEDIT Smooth** in the **N** direction and the **V** isolines density on surface objects. |

|  | Valid values are 0 through 200. Meshes are always created with a minimum surface density of 2. |
|---|---|
| **SYSCODEPAGE** | Indicates the system code page, which is determined by the operating system. To change the code page, see the **Help** menu in your operating system. |
| **TABLEINDICATOR** | Controls the display of row numbers and column letters when the **In-Place Text Editor** is open for editing a table cell |
| **TABLETOOLBAR** | Controls the display of the **Table** toolbar |
| **TABMODE** | Controls the use of the tablet. For more information on using and configuring a tablet, see the **TABLET** command. |
| **TARGET** | Stores the location (as a UCS coordinate) of the target point for the current viewport |
| **TBCUSTOMIZE** | Controls whether **Tool** palette groups can be customized |
| **TDCREATE** | Stores the local time and date the drawing was created |
| **TDINDWG** | Stores the total editing time, which is the total elapsed time between saves of the current drawing. The format is <number of days>.<decimal fraction of a day>. |
| **TDUCREATE** | Stores the universal time and date that the drawing was created |
| **TDUPDATE** | Stores the local time and date of the last update or save. |
| **TDUSRTIMER** | Stores the user-elapsed timer |
| **TDUUPDATE** | Stores the universal time and date of the last update or save |
| **TEMPOVERRIDES** | Turns temporary override keys on and off. A temporary override key is a key that you can hold down to temporarily turn on or turn off one of the drawing aids that are set in the **Drafting Settings** dialog box; for example, **Ortho** mode, **object snaps**, or **Polar** mode. |
| **TEMPPREFIX** | Contains the directory name (if any) configured for placement of temporary files, with a path separator appended. |
|  | **TEXTEVAL**  Controls how text strings entered with the **TEXT** command (using **AutoLISP**) or with the **-TEXT** command are evaluated |
| **TEXTFILL** | Controls the filling of **TrueType** fonts while plotting and rendering |
| **TEXTOUTPUTFILEFORMAT** | Provides **Unicode** options for **Plot** and **Text** window log files |
| **TEXTQLTY** | Sets the resolution tessellation fineness of text outlines |
| **TEXTSIZE** | Sets the default height for new text objects drawn with the current text style. **TEXTSIZE** has no effect if the current text style has a fixed height. |
| **TEXTSTYLE** | Sets the name of the current text style |
| **THICKNESS** | Sets the current 3D thickness |
| **THUMBSIZE** | Specifies the maximum generated size for thumbnail previews in pixels |
| **TILEMODE** | Makes the **Model** tab or the last **Layout** tab current |
| **TIMEZONE** | Sets the time zone for the sun in the drawing. The values in the table are expressed as hours and minutes away from Greenwich Mean Time. The geographic location you set also sets the time zone. If the time zone is not accurate, you can correct it in the **Geographic Location** dialog box or set the **TIMEZONE** system variable. |
| **TOOLTIPMERGE** | Combines drafting tooltips into a single tooltip. The appearance of the merged tooltip is controlled by the settings in the **Tooltip Appearance** dialog box. |

| | |
|---|---|
| **TOOLTIPS** | Controls the display of tooltips on toolbars |
| **TPSTATE** | Determines whether the **Tool Palettes** window is open or closed |
| **TRACEWID** | Sets the default trace width |
| **TRACKPATH** | Controls the display of polar snap and object snap tracking alignment paths |
| **TRAYICONS** | Controls whether a tray is displayed on the Status bar |
| **TRAYNOTIFY** | Controls whether service notifications are displayed in the Status bar tray |
| **TRAYTIMEOUT** | Controls the length of time (in seconds) that service notifications are displayed. Valid values are 0 to 10. |
| **TREEDEPTH** | Specifies the maximum depth, that is, the number of times the tree-structured spatial index can divide into branches |
| **TREEMAX** | Limits memory consumption during drawing regeneration by limiting the number of nodes in the spatial index (oct-tree) |
| **TRIMMODE** | Controls whether selected edges for chamfers and fillets are trimmed |
| **TSPACEFAC** | Controls the multiline text line-spacing distance measured as a factor of text height. Valid values are 0.25 to 4.0. |
| **TSTACKALIGN** | Controls the vertical alignment of stacked text |
| **TSTACKSIZE** | Controls the percentage of stacked text fraction height relative to selected text's current height. Valid values are from 25 to 125. |
| **UCSAXISANG** | Stores the default angle when rotating the UCS around one of its axes using the **X**, **Y**, or **Z** option of the **UCS** command. Its value must be entered as an angle in degrees (valid values are 5, 10, 15, 18, 22.5, 30, 45, 90, 180). |
| **UCSBASE** | Stores the name of the UCS that defines the origin and orientation of orthographic UCS settings. Valid values include any named UCS. |
| **UCSDETECT** | Controls whether dynamic UCS acquisition is active |
| **UCSFOLLOW** | Generates a plan view whenever you change from one UCS to another. The **UCSFOLLOW** setting is saved separately for each viewport. If **UCSFOLLOW** is on for a particular viewport, a plan view is generated in that viewport whenever coordinate systems are changed. |
| **UCSICON** | Displays the **UCS** icon for the current viewport or layout. This system variable has the same name as a command. Use the **SETVAR** command to access this system variable. |
| **UCSNAME** | Stores the name of the current coordinate system for the current viewport in the current space. Returns a null string if the current UCS is unnamed |
| **UCSORG** | Stores the origin point of the current coordinate system for the current viewport in the current space. This value is always stored as a world coordinate. |
| **UCSORTHO** | Determines whether the related orthographic UCS setting is restored automatically when an orthographic view is restored |
| **UCSVIEW** | Determines whether the current UCS is saved with a named view |
| **UCSVP** | Determines whether the UCS in viewports remains fixed or changes to reflect the UCS of the current viewport. The setting of this system variable is viewport-specific. |

| | |
|---|---|
| **UCSXDIR** | Stores the **X** direction of the current UCS for the current viewport in the current space |
| **UCSYDIR** | Stores the **Y** direction of the current UCS for the current viewport in the current space |
| **UNDOCTL** | Indicates the state of the **Auto**, **Control**, and **Group** options of the **UNDO** command. The setting is stored as a bitcode using the sum of the following values: 0, **UNDO** is turned off; 1, **UNDO** is turned on; 2, Only one command can be undone; 4, **Auto** is turned on; 8, A group is currently active; 16, **Zoom** and **Pan** operations are grouped as a single action; and 32, **Layer property** operations are grouped as a single action. |
| **UNDOMARKS** | Stores the number of marks placed in the **UNDO** control stream by the **Mark** option. The **Mark** and **Back** options are not available if a group is currently active. |
| **UNITMODE** | Controls the display format for units. By default, the format for displaying measured values differs slightly from the format used for entering them. (You cannot include spaces when entering measured values.) |
| **UPDATETHUMBNAIL** | Controls updating of the thumbnail previews in the **Sheet Set Manager** dialog box |
| **USERI1-5:** | Provides storage and retrieval of integer values. There are five system variables: **USERI1**, **USERI2**, **USERI3**, **USERI4**, and **USERI5**. |
| **USERR1-5** | Provides storage and retrieval of real numbers. There are five system variables: **USERR1**, **USERR2**, **USERR3**, **USERR4**, and **USERR5** |
| **USERS1-5** | Provides storage and retrieval of text string data. There are five system variables: **USERS1**, **USERS2**, **USERS3**, **USERS4**, and **USERS5** |
| **VIEWCTR** | Stores the center of view in the current viewport. Expressed as a UCS coordinate |
| **VIEWDIR** | Stores the viewing direction in the current viewport, expressed in UCS coordinates. This describes the camera point as a 3D offset from the target point. |
| **VIEWMODE** | Stores the **View** mode for the current viewport. The setting is stored as a bitcode using the sum of the following values: 0, Turned off; 1, **Perspective** view active; 2, Front clipping on; 4, Back clipping on; 8, **UCS** Follow mode on; and 16, Front clip not at eye. If on, the front clip distance (**FRONTZ**) determines the front clipping plane. If off, **FRONTZ** is ignored, and the front clipping plane is set to pass through the camera point (vectors behind the camera are not displayed). This flag is ignored if the front-clipping bit (2) is off. |
| **VIEWSIZE** | Stores the height of the view displayed in the current viewport, measured in drawing units |
| **VIEWTWIST** | Stores the view rotation angle for the current viewport, measured relative to the WCS |
| **VISRETAIN** | Controls the properties of xref-dependent layers. Controls visibility, color, linetype, lineweight, and plot styles |
| **VPLAYEROVERRIDES** | Indicates if there are any layers with viewport (VP) property overrides for the current layout viewport |
| **VPLAYEROVERRIDESMODE** | Controls whether layer property overrides associated with layout viewports are displayed and plotted |

| | |
|---|---|
| **VPMAXIMIZEDSTATE** | Stores a value that indicates whether the viewport is maximized. The maximized viewport state is canceled if the **PLOT** command is started. |
| **VSBACKGROUNDS** | Controls whether backgrounds are displayed in the visual style applied to the current viewport |
| **VSEDGECOLOR** | Sets the color of edges in the visual style in the current viewport |
| **VSEDGEJITTER** | Controls the degree to which lines are made to appear as though sketched with a pencil. The jitter effect is turned on by preceding the setting with a minus sign. |
| **VSEDGEOVERHANG** | Makes lines extend beyond their intersection, for a hand-drawn effect. The range is 1 to 100 pixels. The overhang effect is turned on by preceding the setting with a minus sign. |
| **VSEDGES** | Controls the types of edges that are displayed in the viewport |
| **VSEDGESMOOTH** | Specifies the angle at which crease edges are displayed. The range is 0 to 180. |
| **VSFACECOLORMODE** | Controls how the color of faces is calculated |
| **VSFACEHIGHLIGHT** | Controls the display of specular highlights on faces without materials in the current viewport. The range is −100 to 100. The higher the number, the larger the highlight. Objects with materials attached ignore the setting of **VSFACEHIGHLIGHT** when **VSMATERIALMODE** is on. |
| **VSFACEOPACITY** | Controls the transparency of faces in the current viewport. The range is −100 to 100. At 100, the face is completely opaque. At 0, the face is completely transparent. Negative values set the transparency level but turn off the effect in the drawing. |
| **VSFACESTYLE** | Controls how faces are displayed in the current viewport |
| **VSHALOGAP** | Sets the halo gap in the visual style applied to the current viewport. The range is 0 to 100. |
| **VSHIDEPRECISION** | Controls the accuracy of hides and shades in the visual style applied to the current viewport |
| **VSINTERSECTIONCOLOR** | Specifies the color of intersection polylines in the visual style applied to the current viewport. The initial value is 7, which is a special value that inverts the color (black or white) based on the background color. |
| **VSINTERSECTIONEDGES** | Controls the display of intersection edges in the visual style applied to the current viewport |
| **VSINTERSECTIONLTYPE** | Sets the linetype for intersection lines in the visual style applied to the current viewport. The range is 1 to 11. |
| **VSISOONTOP** | Displays isolines on top of shaded objects in the visual style applied to the current viewport |
| **VSLIGHTINGQUALITY** | Sets the method for interpolating colors for faces on 3D solids and surfaces in the current viewport |
| **VSMATERIALMODE** | Controls the display of materials in the current viewport |
| **VSMAX** | Stores the upper right corner of the current viewport's virtual screen. Expressed as a UCS coordinate |
| **VSMIN** | Stores the lower left corner of the current viewport's virtual screen. Expressed as a UCS coordinate |
| **VSMONOCOLOR** | Sets the color for monochrome and the tint display of faces in the visual style applied to the current viewport. The initial value is white. |
| **VSOBSCUREDCOLOR** | Specifies the color of obscured (hidden) lines in the visual style applied to the current viewport |

| | |
|---|---|
| **VSOBSCUREDEDGES** | Controls whether obscured (hidden) edges are displayed |
| **VSOBSCUREDLTYPE** | Specifies the linetype of obscured (hidden) lines in the visual style applied to the current viewport. The range is 1 to 11. |
| **VSSHADOWS** | Controls whether a visual style displays shadows |
| **VSSILHEDGES** | Controls the display of silhouette edges of solid objects in the visual style applied to the current viewport |
| **VSSILHWIDTH** | Specifies the width, in pixels, of silhouette edges in the current viewport. The range is 1 to 25. |
| **VSSTATE** | Stores a value that indicates whether the **Visual Styles** window is open or closed |
| **VTDURATION** | Sets the duration of a smooth view transition, in milliseconds. The valid range is 0 to 5,000. |
| **VTENABLE** | Controls when smooth view transitions are used. Smooth view transitions can be on or off for panning and zooming, for changes of view angle, or for scripts. The valid range is 0 to 7. |
| **VTFPS** | Sets the minimum speed of a smooth view transition, in frames per second. When a smooth view transition cannot maintain this speed, an instant transition is used. The valid range is 1 to 30. |
| **WHIPARC** | Controls whether the display of circles and arcs is smooth |
| **WHIPTHREAD** | Controls whether to use an additional processor to improve the speed of operations such as **ZOOM** that redraw or regenerate the drawing. **WHIPTHREAD** has no effect on single processor machines. |
| **WINDOWAREACOLOR** | Controls the color of the transparent selection area during window selection. The valid range is 1 to 255. **SELECTIONAREA** must be on. |
| **WMFBKGND** | Controls the background display when objects are inserted in Windows metafile (WMF) format. The objects may be inserted using any of the following methods: output to a Windows metafile using the **WMFOUT** command; copied to the **Clipboard** and pasted as a Windows metafile, or dragged as a Windows metafile. |
| **WMFFOREGND** | Controls the assignment of the foreground color when objects are inserted in Windows metafile (WMF) format. The objects may be inserted using any of the following methods: output to a Windows metafile using the **WMFOUT** command; copied to the **Clipboard** and pasted as a Windows metafile, or dragged as a Windows metafile. **WMFFOREGND** applies only when **WMFBGND** is set to **Off**. |
| **WORLDUCS** | Indicates whether the UCS is the same as the WCS |
| **WORLDVIEW** | Determines whether input to the **DVIEW** and **VPOINT** commands is relative to the WCS (default) or the current UCS |
| **WRITESTAT** | Indicates whether a drawing file is read-only or can be written to. For developers who need to determine write status through **AutoLISP** |
| **WSCURRENT** | Returns the current workspace name at the command prompt and sets a workspace to **current** |
| **XCLIPFRAME** | Controls the visibility of xref clipping boundaries |
| **XEDIT** | Controls whether the current drawing can be edited in-place when being referenced by another drawing |
| **XFADECTL** | Controls the fading intensity percentage for references being edited in-place. Valid values are from 0 to 90. |

| | |
|---|---|
| **XLOADCTL** | Turns xref demand-loading on and off, and controls whether it opens the referenced drawing or a copy |
| **XLOADPATH** | Creates a path for storing temporary copies of demand-loaded xref files. For more information, *see* **XLOADCTL**. |
| **XREFCTL** | Controls whether external reference log (XLG) files are created |
| **XREFNOTIFY** | Controls the notification for updated or missing xrefs |
| **XREFTYPE** | Controls the default reference type when attaching or overlaying an external reference |
| **ZOOMFACTOR** | Controls how much the magnification changes when the mouse wheel moves forward or backward. Accepts an integer between 3 and 100 as a valid value. The higher the number, the more the change. |
| **ZOOMWHEEL** | Toggles the direction of transparent **Zoom** operations when the middle mouse wheel is scrolled |

# Glossary

**3D primitives**  A collection of predefined solids contained in the AutoCAD program. The collection includes **Polysolid**, **Box**, **Wedge**, **Cone**, **Sphere**, **Cylinder**, **Pyramid**, and **Torus**.

**absolute coordinate**  A coordinate entry specified in the X, Y, Z, format. A point's distance and its direction (+ or −) are relative to the origin (0,0,0).

**Array**  A rectangular or circular pattern of objects.

**Boolean operations**  **INTERSECT**, **SUBTRACT**, and **UNION** operations that allow you to combine 3D solids or regions that coexist on the same plane.

**Cartesian coordinate system**  A coordinate system typically defined by two perpendicular axes in a plane. Usually, the horizontal axis is called the X axis, and the vertical axis is called the Y axis.

**chamfer**  A beveled edge on a corner of an object.

**command alias**  An abbreviated method, typically the first letter or two of a command name, for entering commands at the command prompt.

**composite 3D solids**  3D solids created by combining one or more 3D solids using one or more of the Boolean operations.

**coordinate filters**  *See* point filters.

**coordinate systems**  AutoCAD has two coordinate systems: the **User Coordinate System (UCS)**, which is movable, and the **World Coordinate System (WCS)**, which is fixed.

**crossing window**  Selection set obtained by picking a window selection from right to left. Objects either partially or totally included in the window will be selected.

**crown molding**  A molding located between a wall and the ceiling.

**customized user interface (CUI)**  An interface that allows a user to manage items such as workspaces, toolbars, menus, shortcut menus, and keyboard shortcuts.

**direct distance entry**  A coordinate entry method of specifying the next point by moving the mouse in the desired direction and typing in the desired distance.

**drawing template file**  A file (.dwt) that contains standard settings such as, units, limits, dimensioning, and plotting. Typically, template files are stored in the template folder.

**FILLET**  Command that rounds the corner of an object with a specified radius; can also be used to connect two nonparallel lines.

**grips**  Small squares displayed at strategic points on an object when it is selected prior to invoking a command. Grips can be dragged to edit objects directly.

**isometric view**  A 3D view in which the three primary axes of the object are equal (e.g., **VPOINT**; **1,1,1**).

**LOFT**  An operation in which a set of two or more open or closed objects are blended by transition to create surfaces or 3D solids.

**medallion**  An ornamental and decorative element.

**Menu Browser**  A button located in the upper left corner of the AutoCAD display that contains a vertical list of menus. This list of menus provides easy access to commands, documents, and a variety of other content.

**OFFSET**  Command that creates parallel copies of objects, such as lines, arcs, and circles, at a specified distance.

**perspective view**  A 3D view illustrating width, height, depth, and distance.

**point**  An entity defined as a single point (coordinate location). Selected as a **node** with **Osnap** (object snap).

**point filters**  Filters that extract designated parts of 3D coordinates. For instance, typing **.xy** and selecting an entity point will extract the XY coordinate location and request a new Z location. *Also called* coordinate filters.

**Quick Access toolbar**  A toolbar located in the upper left corner of the AutoCAD display that provides access to commonly used tools such as **New**, **Open**, **Save**, **Plot**, **Undo**, and **Redo**.

**rabbet**  A grove or slot on the edge of an object made to receive another object.

**Ribbon**  A palette that displays tabs and menus specific to a workspace.

**SWEEP**  An operation in which an open or closed profile shape is swept along a path curve to form 3D solids or surfaces.

**transparent command**  A command that is performed during a command sequence without terminating the original command sequence. Commands such as **ZOOM** and **PAN** can be used transparently by typing an apostrophe before the command (e.g., **'zoom**).

**visual style**  Settings and modifiers that control the manner in which edges and shading are displayed on 3D objects.

**workspace**  A set of menus, toolbars, palettes, and ribbon control panels grouped to form a task-oriented drawing environment.

# Index